THE FORBIDDEN IMAGE

THE
FORBIDDEN
IMAGE

AN
INTELLECTUAL HISTORY OF
ICONOCLASM

Alain Besançon
Translated by Jane Marie Todd

THE UNIVERSITY OF CHICAGO PRESS
CHICAGO AND LONDON

ALAIN BESANÇON is director of studies at L'École des Hautes Études en Sciences Sociales, Paris, and a widely published author on intellectual history and Russian politics. JANE MARIE TODD has translated a number of major French works, including Brassaï's *Conversations with Picasso* (1999), also published by the University of Chicago Press.

The University of Chicago Press, Chicago 60637
The University of Chicago Press, Ltd., London
© 2000 by The University of Chicago
All rights reserved. Published 2000
Printed in the United States of America
09 08 07 06 05 04 03 02 01 00 1 2 3 4 5

ISBN: 0-226-04413-0 (cloth)

Originally published as *L'Image interdite: une histoire intellectuelle de l'iconoclasme,*
© Librairie Arthème Fayard, 1994.

Library of Congress Cataloging-in-Publication Data

Besançon, Alain.
 [Image interdite. English]
 The forbidden image : an intellectual history of iconoclasm / Alain Besançon;
translated by Jane Marie Todd.
 p. cm.
 Includes bibliographical references and index.
 ISBN 0-226-04413-0 (cloth : alk. paper)
 1. Iconoclasm I. Title.
BR115.A8B4713 2000
291.2′18—dc21 00-008793

Thought long ago stopped assigning to art the
sensible representation of the divine.

—G. W. F. Hegel, *Aesthetics*

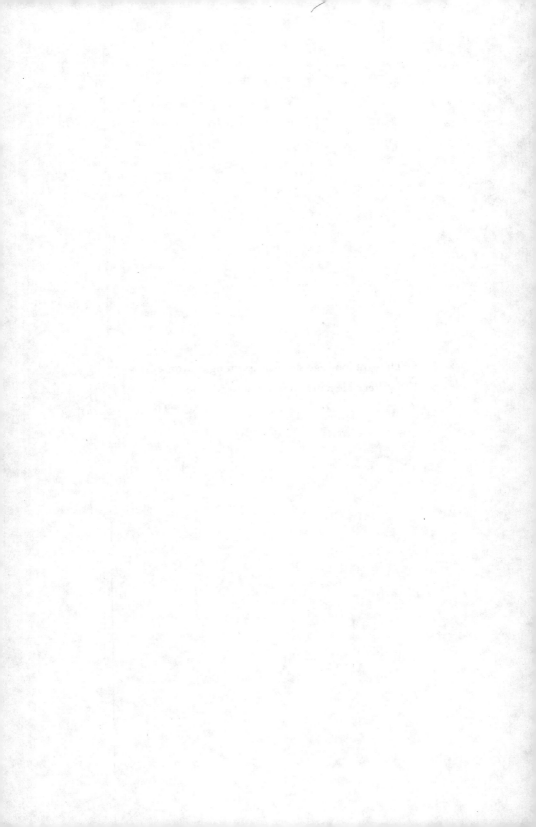

CONTENTS

Plates follow page 216

INTRODUCTION

Because this book has taken on greater scope than I expected, let me set out its argument and major theses.

My plan was to write the history of the representation of the divine. I limited the inquiry to European civilization. I did not delve into the history of plastic forms, which is a matter of art history. I simply sought to retrace the history of doctrines and ideas having to do with divine representation, and, more precisely, of those doctrines and ideas that permitted or prohibited it.

That history seems to have unfolded as follows.

In the beginning, there was Greece, and a condition of innocence. Like Egypt and Mesopotamia before it, Greece gave a form to its gods. Yet even while Greek religious art was asserting itself, developing, and moving toward its perfection, one faction of Hellenism—philosophy, which was also a religious faction—was beginning to reflect on representation, to assess its agreement or disagreement with the civic notion of the divine and the accepted forms of representing it. With philosophy, then, a cycle opened that would subsequently be called "iconoclastic." The pre-Socratics had a conception of the divine that did not coincide with mythology, not even with Homer's reformed mythology. Plato gave the theme such profound importance that its repercussions can still be felt today. His posterity put forward two contrary imperatives, postulated two incoercible facts about our nature: first, that we must look toward the divine, that it alone is worth contemplating; and, second, that representing it is futile, sacrilegious, inconceivable.

Such a powerful idea might have led to the destruction of images. But that was not the case. Philosophy was an elitist movement and had no hold on the life of the commonwealth, which continued to produce images in abundance—even though the initial fire that had created and metamorphosed forms in the golden age seems to have grown cold rather quickly. And philosophy itself did not speak with a unanimous voice. Aristotle placed artistic labor within a cosmic framework, where it partook of a certain divine dignity. The Stoic movement, which had some qualms about breaking ranks with the spiritual forces of the commonwealth, accepted a moral interpretation of images; as a result, its doctrine did not oppose civic religion or its plastic manifestations. Spirituality, which had a magical component and was less removed from the popular conception of a certain vulgar Platonism, also sought a compromise with the image. And, last, the imperial cult imposed its obligatory ubiquity in the matter of worship throughout the ecumene, based on a living, divine image, namely, that of the emperor. Philosophical thought and civic religion were urgently and conjointly summoned to the foot of the altar, on which the image of the imperial and political god stood.

At this point, I move to a different world to consider Israel. Two contradictory themes, point and counterpoint, are developed in the Old Testament: the absolute prohibition of images and the assertion that images of God exist. I analyze the major biblical texts and compare the Jewish interpretation to the Muslim. Even though they agree that images should be banished, it seems to me that the reasons for that banishment are not the same in Judaism and Islam. For Islam, it is God's insurmountable distance that renders impossible the fabrication of an image worthy of its object; for Judaism, it is God's intimate familiarity.

The two worlds meet with the coming of Christ to Israel, and the conquest by Christianity of Roman society and then of the Roman state. That state inherited both the biblical pronouncements regarding the invisible nature of the divine and the assertion that man was created in God's image. That claim became central because Christ, who is God, is a visible man. He declared: "He that hath seen me hath seen the Father." And so it was that, succinctly but for all time, the points of reference were set down from which the theology of the image was elaborated: the Hellenic ideas conveyed by the Greek vocabulary of the Septuagint; and the Hellenized Judaism of the last books of the Bible, that is, the Gospel of John and Saint Paul's epistles.

All this is theology: art is not yet at issue. But the theology of the church fathers, governing every image yet to be made, set the conditions of possibility or impossibility for the divine image, for the material artwork in which that image

is captured, or, simply, for the changes the image introduces in the contemplative soul. Of the vast body of patristic literature, I study only four authors, two "early" fathers, Irenaeus and Origen, and two "classical" ones, Gregory of Nyssa and Augustine. They are not in agreement. Some set out the reasons for a future iconoclasm, while others lay the foundations not only for iconophilia but for a metaphysics of sacred and profane art.

Nevertheless, far below and to one side of these speculations, Christian art was slowly developing. Immediately after Constantine's conversion, the Christian image, which had originated in the age of graffiti, proliferated and entered into constant dialogue with the imperial image. Constantine, in fact, consented to destroy all pagan images except one, the image of the emperor, in an ecclesiastic deal whereby that image continued to be glorified.

But Christian art also fed on its own religious sources: the mysticism of the "open heavens" and the very strong sense given to the *persona*—the irreducible individual—which allowed art to give a new impetus and a new meaning to the Roman portrait and to the mortuary effigies of Faiyūm, both ancestors of the acutely carnal and individualized icon, of which so few examples survived after the iconoclastic crisis.

I describe the theological issues surrounding that crisis, when, for the first time, divine images were actually destroyed: the fundamentals of dogma; the arguments in favor of iconoclasm, particularly the one advanced by Constantine Copronymus, which was so strong and so specious that it took the efforts of two generations of theologians to defeat it; and, finally, the triumph of iconophilia. My thesis is that this triumph was ambiguous, that it was secured by an unstable compromise, always on the point of splitting into two opposing factions, iconoclasm and iconolatry; that the theological resolution of the problem, which entails a reaffirmation of the Incarnation, does not of itself guarantee that the image expresses and realizes that goal of incarnation. Iconic arguments relied both on the biblical prohibition and on the Greek philosophical critique. Enough has remained of them, even among iconophiles, for the status of the image to suffer, in practice, from a certain precariousness. Thus, a certain iconoclastic cycle ended, not with the celebration of the victory of the icon in 843, but with the gradual extinction of iconoclastic art. And so ends as well part 1 of this book.

A second cycle opened at the dawn of modern times. Let me note this paradox in passing: it took art a very long time to notice it. At a time when ancient iconoclasm was almost completely formed in theory, Greek art was producing its most beautiful and most convincing divine images. Modern iconoclasm

came into being simultaneously with the most magnificent age in the history of art, and never were so many sacred images produced as when all the reasons for despising them had already been advanced. Thus the principle of iconoclasm became truly active only after a considerable delay.

At the same time, there was a long period in Latin and Catholic Europe when these images were produced with an utter lack of concern and without serious protests being raised against them. That era coincided with the Middle Ages and continued within the world that received the Council of Trent and even beyond. I briefly consider why in part 2. That innocent spontaneity of the sacred image (equal to that of pagan images in other times and places) sheds some light on the causes of the iconoclastic period that preceded it, and, especially, of that which followed it. My main thesis is that this period of peace was contingent on the fact that the Roman Church refused to view the image from the same metaphysical perspective as did the Greek Church, situating it primarily in the realm of rhetoric. As a result, the theological issues surrounding the plastic representation of the divine lost much of their importance and gravity. The Roman Church (and primarily the popes) better saw the pastoral importance of the image, the possibilities it offered for educating and stirring people to piety. In addition, that church, to add a further note of *catholicity,* appealed to classical mythologies. Nonetheless, some looked severely on what they suspected was an instrumentalization, an obliteration of divine majesty, a pagan turn given to the image, an idolatrous deviation.

The second iconoclastic cycle, anticipated by a few precursory signs, began abruptly with John Calvin's attack. With this great author, we do not leave the classical terrain of Christian iconoclasm, whose arguments he forcefully adopted. But, after Calvin, the modern cycle took a different path and did not reproduce the ancient one. It was not circumscribed by theological themes but participated fully in the new climate provided by science, the decline of rhetoric, the calling into question of ancient philosophy, the new vision of the world, a new society, and a different religion. It is not that religious motifs disappeared, but they were buried or forgotten, or they escaped the traditional framework. In the end, this history became so complex that it has resisted efforts to tell it as a continuous narrative. Choices must be made and different aspects spotlighted, with many questions and events left in the shadows.

I first discuss three authors who can be considered together, since they overlap somewhat: nevertheless, their diversity shows the distance between their respective aims, centuries, and milieus. The clearly and serenely iconoclastic chapters of *Institutes of the Christian Religion* present no difficulty of analysis. But Calvin's pure theology was already combined with a modern horror of me-

dieval "hodgepodge" and the dark compost heap feeding images and superstition. Jansenism formed a united front with Protestantism on this point. Pascal made extraordinarily profound breakthroughs that suggest a parallel with Kant. *The Critique of Judgment* is informed by a spirituality that opposes images. It also introduced a new aesthetics still prevalent in our own century, which bows under the heavy yoke of two inevitable imperatives: the *sublime* and *genius.*

After these three coherent and resolute iconoclasts, a discussion of Hegel seemed unavoidable. First, because he recapitulated with incomparable authority and sagacity the entire history of the divine image from its origins, placing it at the center of every reflection on the history of art and on philosophical aesthetics—in short, because he articulated before I did, and infinitely better than I, the main points of my thesis. Second, because he anticipated with baffling lucidity what took place after him in the realm of the divine image and art. And, finally, because his verdict on the end of art and its possible replacement by philosophy (or by his philosophy) is also the equivalent of a kind of iconoclasm of lament.

It seemed to me that my next task was to observe, in modern art and in the fate of the sacred image, the new aesthetics at work. But I was in for some surprises. In the first place, France is an exception, and for several reasons. The earliest factor may have been the French Revolution, which fixed the aesthetic landscape in place and isolated it from the shifting sands of European romanticism during its crucial years. French painting remained astonishingly faithful to classical aesthetics. The (recent) notion of the avant-garde has been retrospectively applied to nineteenth-century French painting as a whole. I was forced to conclude that it is inaccurate. The glory of the French school has nothing whatever to do—except as a counterexample—with any "advanced" aesthetic. That is true for Delacroix as for David, for Manet and Degas as for Courbet and Corot. It is also true for Baudelaire, whom I am happy to place beside Diderot, if not beside Boileau. In the case of Matisse and Picasso, who constructed an aesthetic Maginot Line that held until World War II, giving way only when its geographical equivalent ceded, the demonstration is even easier to make.

Although the French school is very little concerned with religion, and not at all with the problem of the divine image, its production of images is still "orthodox," in a sense that can be precisely defined. At least, that is the case for profane images, since sacred images are less clear-cut in this respect. It is in nineteenth-century religious art, in fact, that the new tendencies can be seen at work. That is true somewhat in France, much more clearly in England and Germany. In Germany, I focus on Caspar David Friedrich, the great "Kantian" painter. In England, after the rapid dissolution of the Pre-Raphaelite Brother-

hood, devout painting allowed itself to be permeated by conscious (or, worse, unconscious) eroticism, which led England to the brink of symbolism much sooner than France, though not before Germany.

We now come to the 1890s, that is, to the moment just before iconoclasm enjoyed its first victories. Events came in a rush and their consequences are difficult to disentangle. The most important event was the "religious revival" surrounding symbolism, or "late romanticism," which supplanted the positivism, realism, and scientism that had dominated the mid-century. The novelty was that this religiosity was no longer Christian, though, in its desire for syncretism, which was one of its components, it sometimes called itself such. That religiosity had an effect on artists, who were no longer content with what they considered the "formal" and "superficial" games of impressionism. The symbolist generation was the most "thoughtful," the most sincerely tormented by religion, to be seen in a long time. But how are we to define such vague feelings and confused doctrines, which were supposedly expressed as such in artistic creations?

Schopenhauer's profound influence, direct or indirect, can be discerned almost everywhere—in literature, in music, and in painting—and his Nietzschean and Freudian successors prolonged and extended that pervasiveness. He appealed to artists' hubris, their claim to be clairvoyants and initiates. He directed them toward a kind of holiness (sexual, satanic, or nihilistic) that considered the world its enemy—the mark of its religious aspect.

Fin de siècle esotericism gave a form to symbolist religiosity. It is well known that the founders of abstract painting—Mondrian, Kandinsky, and Malevich—were steeped in it. I have made the effort, which was no slight matter, to descend to the depths of that arduous body of literature, to learn what Steiner, Mme Blavatsky, Edouard Schuré, Péladan, and Uspenski had in common. There is a certain unity of doctrine—of a rather vulgar gnostic kind, but clear enough to produce effects that can justifiably be linked to the hermetic gnosis of late antiquity, which esotericism in fact embraced.

Nonetheless, at about the same time, the deliquescence of mauve volutes coincided with mystic "whiplash lines" and with brutal "primitivism." It was hoped that the same religious energies promised by "secret" doctrines might be found in African masks or Polynesian totems. Hegel had foreseen it.

Thus, "abstract" art developed within a religious and, more precisely, a mystical movement. It was not inevitable that symbolist religiosity should have taken the path of iconoclasm via abstraction. It was the result of several circumstances, the first of them being the encounter between the new pan-European

aesthetic and French art. The French exception became somewhat muted in about 1890. Gauguin can serve as the turning point. My thesis is that European aesthetics seized on the stylistic innovations of the French school, which had been elaborated within a completely different aesthetic, and twisted them to fit their own purposes, their own pathos, *Gefühl, Kunstwollen*. Paul Gauguin, Vincent van Gogh, and Paul Cézanne were perceived by the Germanic and Slavonic world as offering forms suited to that new sensibility, pictorial vectors befitting the religious spirit at work. To borrow Oswald Spengler's terminology, it was a remarkable case of "pseudomorphosis."

What crucible can we peer into to observe the mysterious alchemy that, within a few years, led from symbolism, primitivism, cubism, and futurism to abstraction? I chose the Russian crucible, because I was most familiar with it, but, regretfully, devoted too little space to Mondrian, who does not seem very far from Kandinsky and Malevich. Russia, the distant outskirts of the West, received its influence rather belatedly, as a collision or concentration of various experiments. The labor of several generations was compressed and applied to a rapid series of "flashpoints," which, arriving on the market almost simultaneously, had to be quickly grasped by the Russian public. Kandinsky began with symbolism and developed his system in Germany. Malevich developed his in Russia, within the revolutionary context before and after 1917. They left behind a vast body of theoretical and justificatory writings, which I have analyzed in some detail. I found the writings somewhat dull, because so dense and muddled. Never mind: the work was necessary, since proof of the religious character of their iconoclasm is to be found in both their paintings and writings. It was a new iconoclasm, given that their renunciation of reference to "objects" and to nature did not stem from a fear of the divine but from the mystical goal of providing an image that was finally worthy of it.

That is the overall schema that I see organizing this history. I did not invent it in advance: it imposed itself as my inquiry developed. Like many schemata, it is valid only to the extent that it accounts for the details. That is why I did not want to overly truncate quotations and arguments, even though they might appear to be excursuses or digressions. It seemed to me that this entire history is filled with marvelous things, philosophical and theological splendors, as if the question of the divine image formed a guiding thread to which they were attracted, and drew the beholder up a very steep mountain ridge, from one peak to the next. I hope that the reader will be as captivated as I was by the magnificence of the landscape traveled. I can say, with Montesquieu, that "I was transported by the majesty of my subject."

Several circumstances impelled me to undertake this task. A seminar on the Russian avant-garde I conducted at the École des Hautes Études left me with the sense that Malevich and Kandinsky, in rejecting the figure as incapable of embracing the absolute, were, unbeknownst to themselves, repeating the classical argument of iconoclasm.

A visit to the Byzantine Museum in Athens gave me a sign. It is well known that the thesis of iconophilia rests on the reality of the Incarnation. Yet the ancient Greeks (at the neighboring museum of the Acropolis), who had not witnessed the Incarnation, were more surely its interpreters than the painters of icons, despite all their theology. Which better renders the inhabitation of the divine in bodies, an Attic funerary stela or Byzantine images, bristling and shiny as beetles?

Another sign—this time a bad omen—came during a visit to the contemporary section of the Vatican Museum, which comes after the antiques and the collections of paintings assembled by former popes. Looking at these amateurish paintings, I was struck by a dread that transcends art. Nowhere does the distress of modern Christianity appear in so harsh a light—a hospital light. Looking at these poor, aggressive things (it gets as bad as Bernard Buffet!), I sought the most fleeting reflection of the majesty Raphael—close by in the Loges—transmitted of the divine and to the divine.

Finally, there is the experience everyone has had. For me, it was at the Paris Biennial. I walked through rooms capriciously strewn with debris, little piles of sand, roaring machines. On the walls were charred objects, the macabre remains of some death camp, obstetrical objects to turn your stomach, a neon tube in a corner. I could strike up a song on the death of art, take the side of the haggard guard, sitting overwhelmed in a corner of the room. But let us be cautious. The theme of the decadence of art is as old as art itself: Plato already lamented it, and, as in Baudelaire's "Beacons," that heart-felt sob has rolled from age to age, arriving on our doorstep. This time, it might be for good. I will not venture to say so, even though, like everyone else, I sometimes believe it.[1]

The artists in the Biennial, after all, were tackling major, fundamental subjects: death, sex, the void, fear. They were treating them with the enormous seriousness and poignant anguish of twentieth-century artists. So, even while reserving our right to dissolve in tears, we can try to understand. The experiences I have just recalled, in Athens, in Rome, and in Paris, overlap, have common roots, and belong to the same order of phenomena. I have undertaken to clarify them in this book, explain them by their causes, at least their religious causes.

Although I had to deal with a great deal of philosophy and theology, as the

subject required and for my own greater pleasure, this book belongs to the genre of history. But it is not part of art history, which has its own goals and disciplines, to which I have not turned except in an ancillary manner. I systematically refrained from making judgments of taste about artworks. I remained within the genus of general history: species, history of civilization; section, religious history.

The level of scholarship behind these chapters ought not to be exaggerated. Everyone urged me to read entire libraries, and the material in one paragraph has filled the lives of generations of scholars. In reality, every chapter opened infinite perspectives, and the difficulty was to stay the course and not lose my bearings. I propose a certain number of theses: I hope to convince readers that they are true, or at least plausible. At this degree of generality, one must place oneself under the protection of the adage: *Verum index sui.*

Nonetheless, I must acknowledge that I depended on certain books more than others, and that, if they had not existed, or if I had not run into them, my argument would have turned up short. Without Jaeger, Puech, Goldschmidt, Gilson, Schönborn, de Bruyne, Foucart, Menozzi, Seznec, and many others, I would not have found my way. Finally, I must thank those on whom I tried out my book, in the form of lectures or conference papers, who lent an attentive ear and proposed their criticisms, from which I extracted what I was able to understand.

To Pierre Manent, who helped me from the beginning to the end of this book, and to the first readers of my manuscript—Father François Rouleau, Society of Jesus, Philippe Raynaud, and Antoine Schnapper—I owe a particular debt of gratitude.

PART ONE

Iconoclasm: The Ancient Cycle

The Philosophical Critique of the Image

1. Preliminaries: "Civil Theology"

The plastic representation of the gods is a function of the conception that the commonwealth makes of gods. That theology was established by Homer and Hesiod, who gave the gods their characteristics, divided honors and abilities among them, suggested their shape. In the judgment of Kostas Papaioannou, Homer was the great religious reformer of Greece.[1] He cleansed the Greek world of amorphous, zoomorphous, and monstrous gods, peopled it with "godlike" men and manlike gods.

It was not God who created the world. It was the world that gave birth to the gods. Hesiod: "From Chaos came black Night and Erebos. / And Night in turn gave birth to Day and Space / Whom she conceived in love to Erebos."[2] Gods were born, engendered one another, proliferated, and, generation after generation, descended from Physis: Zeus, Poseidon, Heracles, but also Murder, Famine, and other children of Eris, thirty thousand nymphs, the Gorgons, Aurora, Helios. Physis and Moira—the impersonal and indifferent order—stand above the gods. They give gods their being, their shape, their powers.

Among living species, gods have a privilege: they are the ones who live "without toil." They are pure living things, to whom death is absolutely unknown. Pindar defined the distance between gods and men, and their proximity: "There is one race of men, another of gods; but from one mother we both draw our breath. Yet the allotment of a wholly different power separates us, for the one

race is nothing, whereas the bronze heaven remains a secure abode forever. Nevertheless, we do somewhat resemble the immortals, either in greatness of mind or bodily nature, although we do not know by day or in the night, what course destiny has marked for us to run."[3]

Proximity and distance make prayer possible. Odysseus prays unceasingly, and it is a beseeching prayer, rather than a prayer of worship. His prayers are answered, since Athena keeps him safe amid the worst perils. There are good and bad gods, and they do not always get along. But the bad ones are good at least in the fact that they exist and are part of the order of the world, which is good. The gods are blissful. They are occasionally asked to intervene on earth to reestablish justice, but they are not obliged by nature to do so. Their nature simply impels them to contemplate the perfection of the cosmos, its intelligible reality, more easily than do men.

The gods of the commonwealth are more active, closer to the concerns of citizens, more likely to intervene in human affairs. But they do so "without toil," by virtue of their motionless being. They form a family, or rather a commonwealth, with men. They guide men in their efforts at contemplation. In fact, according to Aristotle, man must not limit his thinking to human things. He must "try to become immortal." In so doing, man can participate in divine bliss, by imitating the divine activity of contemplation.[4]

The world has no purpose: it is enough that it is, and it is infinitely above men. Being, which is also Good, survives only precariously in our sublunary world, as the reflection from which earthly phenomena draw the reality and goodness they possess. It is up to man to "contemplate, in order to become like the object of his contemplation"; and, "holding converse with the divine order, he becomes . . . divine as far as the nature of man allows."[5]

We stand at a crossroads. Contemplation so defined by philosophy can do without images and can finally renounce the image. And yet the idea of *theoria,* of the value of contemplation, belongs not only to philosophers but also to poets, artists, all the witnesses to Greek civilization. It is a fundamental element of its legacy.

The truth is that the Greek god was represented, was the most represented of all the gods, so much so that he was not really distinguishable from his representation. The mediation of the god contemplating the cosmos is of the same nature as the mediating act of representation, which is the act of the artist contemplating the god. That is why Hegel saw the artist as the true theologian of Greek religion.

Art was public, publicly exhibited. The state made commissions and it alone possessed artworks for the glory of the commonwealth, since there were almost

no large private homes. Artists and the public agreed on the canons and on genres. It did not occur to the artist to overturn them or create new ones. He had the right only to perfect them, to modify them—since the tradition was designed to be enriched with accretions and new solutions. The attitude of the artist—even of the most notorious, the most "divine" artist—toward his art was "analogous to that of the priest in relation to sacred customs." Both celebrated a divine liturgy, and they did not impart their own state of mind to that celebration. "Artistic genres themselves were the sacred forms of a sacred tradition": that is why they survived until the end of antiquity, and well beyond the death of the commonwealth.[6]

In reading late authors, we find that the "progress" of that art was the progress of exactitude. The rule of mimesis—art must imitate and represent nature—is interpreted as a perfecting of the techniques of illusion. According to Pliny, the painter Polygnotus was the first to represent human figures with open mouths and visible teeth; the sculptor Pythagorus, the first to show the lines of muscles and veins; the painter Nicias, the first to capture the outline of shadow and light.[7] By means of this technical progress, an early form of historicism was introduced into art criticism, the first "already" and the first "not yet." Pythagorus *already* reproduced hair, but *not yet* as well as Lysippus would. Thus the direct, timeless link with the eternal cosmos, as postulated by *theoria,* was lost from sight. Artistic technique, valued in itself, provided a criterion that made it possible—and has made it possible for centuries, even to our own century—to classify Greek artworks as "archaic" or "classical."

But these considerations ought not to veil another periodization, the principle of which is not stylistic but spiritual. From the sixth century to the early fourth century (until the Peloponnesian War), a combined religious and civic life allowed the representation of living gods, of gods to whom citizens felt the need to give praise and to express their gratitude. After the victories of Salamis and Platea, Themistocles declared: "It is not we who accomplished this, but gods and heroes."[8] At Delphi, at Olympia, on the Acropolis, the gods received their reward. During the time of Pliny and the Roman collectors, these same gods were only canonical motifs in artworks. Then the stylistic evolution took on meaning: it provided points of reference in the field of aesthetics. But it was no longer a matter of *representing* a god in the proper sense of the term. The god may have presided symbolically over the statue—that is why the Romans never tired of reproducing the classical models of Aphrodite—but the collector's piety was directed as much toward Praxiteles, Scopas, and Lysippus as toward the goddess.

The "reformation" of the pantheon carried out by Homer had left a few sur-

viving monsters. Odysseus paid tribute to the divine Charbydis and the divine
Scylla. The Greeks had recognized the role of shadow. Now these dark gods
were about to be vanquished. On the pediment of the temple of Artemis
in Corcyra, a young, beardless Zeus struggles against the Giants, and, in the cen-
ter, Gorgo appears for the last time: after that, she was cast out onto the acrote-
ria, her head cut off. The Lapiths conquered the Centaurs. In the late seventh
century, classical "anthropotheomorphism" began to take root. In the sixth cen-
tury, kouroi and korai were built throughout Greece. There was no clear and
distinct line between the representation of the athlete, the warrior—man—and
the representation of the god. All were depicted with a smile. All were equally
young. Perfection was bestowed on them all.

Perfection extended to all beings.[9] Its preeminent feature was a focus on the
human, and preferably the male, figure. The only representation worthy of the
god was a man's body. And when a man—hero or athlete—attained perfect
beauty, divine energy entered him. What is divine about the large bronze god of
Histaea, Poseidon, or Zeus? His very nudity is more divine than, for example,
that of the ephebe of Kritios (480) or *Doryphorus* (about 450). True, nothing in
the anatomy supports such an impression. The canon is similar: the torso has an
athletic elegance, the attachment of the legs is emphasized by the muscular
bulge of the groin and hips, the penis is small and, in both the god and *Do-
ryphorus,* adorned with pubic hair arranged into tiers of curls.

Let us consider the head. Perhaps the treatment of the hair and beard marks
the difference in rank. The beard has two levels, two rows of deeply carved wavy
locks, sometimes turning up and curling at the ends. Under the lower lip, two
small locks form symmetrical curls, a "natural," not geometrical symmetry. The
hair is encircled by a fine braid caught in the mass of hair and wrapped around
it twice. Below the braid, the hair falls low over the forehead—but leaves the
ears uncovered—in locks similar to those of the beard, each lock also carved and
individualized. The god is truly a god. But he lives in the same cosmos as men,
and he shares his perfection with men. One is tempted to link the words of Pin-
dar—"We do somewhat resemble the immortals, either in greatness of mind or
bodily nature"—to the words of the Psalm: "For thou hast made him a little
lower than the angels." But the biblical "thou" is addressed to a god who lies be-
yond the cosmos. The dignity—or strangeness—of cherubim and seraphim
lies in an unknowable God and in the message these angels transmit: they are far
away from the men to whom they nonetheless speak. On the other hand, the
great divine figures represented on the Parthenon possess a superhuman and yet
human majesty within themselves. They do not need to speak, they have no

message to transmit. Their self-sufficiency *(aseitas)* is silent and obvious. They may be mutilated, they may have lost their faces, like the great goddesses of the Parthenon; even so, their nobility shines bright from their divine knees.

Greek art was unique in the way it finessed the incarnation, or rather, the inhabitation, of the divine in the human form. When man is represented, he is theomorphic, and the god, anthropomorphic. That is why Schiller wrote: "Since the gods were then more human / Men were more godlike."[10] Inhabitation assumes that the artist is the mediator—the priest and theologian—that the work of art is the sacrament of that mediation, that the god shares the cosmos with men, and that the artist is the instrument of the commonwealth. With all these conditions combined, the god depicted is a concentrated form of the macrocosm, and corresponds entirely to the microcosm of the commonwealth, or the microcosm of the citizen's body.

This perfect moment, for which every age has remained nostalgic, did not last. In fact, the art of the Parthenon was already losing some of its life in the fourth century and, even though it was repeated and copied indefinitely throughout the Hellenistic and Roman world, it rarely achieved its original vigor. This was, of course, a crisis of the commonwealth, but also a spiritual crisis affecting the idea of the body.

Man's body is subject to death, decrepitude, fatigue, sleep: because it is perishable, it is not a true body. The gods, who are an immortal race, possess complete, whole, definitive bodies. If that body bleeds, the life is not sapped from it. If the god eats, he eats ambrosia, and if he sits down for a meal, he does so for pleasure. "Man's body," writes Vernant, "turns to its divine model as to the inexhaustible source of vital energy. When that source comes to shine momentarily on a mortal creature, the brilliance of that body illuminates it, as a pale and fleeting reflection of the splendor that adorns the bodies of gods." The gods are not anthropomorphic; it is men who are at times theomorphic.[11]

When the human hero dies or grows old, nature abandons him. What is left is the name and glory conferred upon him by the commonwealth. The body of a god possesses by nature a constant beauty and glory, and also a name and a form. This body has attributes that set it apart from the race of men, and sometimes place it at the far limit of what the word "body" signifies. It is larger and stronger than the human body. It can make itself invisible to men's eyes, can take the form of a mist, or a strictly human yet deceptive form. In hiding from mortal eyes, it protects them. For the Greeks, in fact, as in the Bible, to look directly upon the gods can be fatal. Because Actaeon saw Artemis bathing, he was metamorphosed into a stag, then devoured by his dogs. Because Tiresias saw

Athena, he lost his sight. Divine splendor is blinding. Divine bodies have a dwelling place (the sea for Poseidon, hell for Hades, the woods for Artemis), yet they can appear anywhere, and their movements are as swift as thought.

Why, then, attach a corporeal form to the divine? According to Vernant, it is for the following reason: the gods form an organized society with different ranks. They need names and bodies, that is, recognizable traits that differentiate them from one another. That is why Hesiod's orthodox theogony provides a theological foundation for the corporeal nature of the gods. The gods emerged in their fullness, their perfection, their inalterability only because they were accompanied by the emergence of a stable, organized cosmos where every being —and in particular, every divine being—has a clearly defined individuality.

This is what the marginal sects and the philosophers protested: the source of evil in the world is the individuation of a plurality of beings. Perfection belongs solely to the One, to a unified being. The gods must therefore renounce their individuated forms and join the divine One of the cosmos.

From Anaximander to Plotinus, the question of the divine image, of the nature of the gods, is approached from the perspective of the cosmos, the human soul, the status of matter and of art. The innocence of direct representation, as it had been produced by the art of the commonwealth, was lost. In expanding the glory and grandeur of the divine, and hence the gravity of what was at stake, philosophical reflection—with few exceptions—no longer found any practicable path leading to an image that the divine could inhabit or that was worthy of sustaining the divine object.

2. Early Philosophy

Before Plato

Following Varro, Saint Augustine distinguished among three sorts of theology, defined as "the rational science of the gods": "mythical" theology, found especially among poets; "civil" theology, that of the common people; and "natural" theology, that of philosophers.[12] In the first of these, again according to Varro, "are many fictions, which are contrary to the dignity and nature of the immortals." We find a god born from a head, gods who stole or committed adultery. The second form of religion is that which "citizens in the cities, and especially the priests, ought to know and administer. From it is to be known what god each one may suitably worship, what sacred rites and sacrifices each one may suitably perform."

The first form of religion is suited to the theater, the second to the commonwealth. But, notes Augustine, the theater is an institution of the commonwealth.

Civil theology is therefore identified with mythical theology, whose obscenities it shares. Thus there are only two theologies: civil and mythical, which is impure and unworthy of God; and natural or philosophical. All the images of the divine that art offers us belong to the first type of theology. What sort of image does the second convey?

Mythical and political theology, according to Augustine, is entirely artificial: it is a convention stemming from the human imagination. The other theology, in contrast, wishes to delve into the very nature of things, via the path of physis. Natural theology proceeds by way of abstraction. And abstraction does not favor the image.

According to Augustine—whom Werner Jaeger follows on this point—philosophical theology does not begin with Plato but with the very origins of philosophy, with the pre-Socratics.[13] These "philosophers of nature," or "physicists," agree with priests and poets on the fundamental status of the divine: it is situated in this world. Like Hesiod, they believe the gods came—or proceeded—from heaven and earth, the most noble and all-encompassing parts of the cosmos. Gods were engendered by the primordial generating force that is part of the world's structure: Eros. They are therefore subject to natural law, and the object of physics is to discover it. This physics should not be confused with modern physics, which is by nature positivistic and agnostic in matters of religion. This was a religious physics, as attested in the apothegm of Thales, the most ancient philosopher: "Everything is full of gods."[14]

In Anaximander, we find the first system of the world encompassing all reality and based on a natural process of deduction capable of explaining all phenomena. There is no place in this system for the ancient gods, though their names and cults survive. At the origin of the world, there is a principle, an *archē*, which cannot be confused with any reality limited to this world—with water, for example, as Thales proposed—but which is nonetheless capable of giving birth to everything that exists. Characteristically, this *archē* has no limits; therefore, Anaximander calls it *apeiron*. It is an infinite, inexhaustible reservoir that propels all change. But, as an *apeiron*, it is without delimitation, shapeless. Thus, Anaximander is the first to use the adjective as a noun, to say "the divine."[15] He moves closer to the divine substance even as he makes it unrepresentable.

Xenophanes was an artist: he recited his own poems in person. But his theology obliged him to attack Homer as the one who had established religious education in Greece and who had taught anthropomorphism. Xenophanes' God is completely other. "One god is greatest among gods and men, / Not at all like mortals in body [form] or in thought."[16] This is the very first formulation in

history of negative theology. It means that the human form (and the form of the human mind) is incapable of receiving within itself the totality of the principle that philosophy recognizes as the origin of every thing. Xenophanes does not deny that God has a form, a notion a Greek might have found difficult to conceive. And he does not reduce God to the form of the world. But he positively denies him any human form.

This supreme and unique God is also not the only god: he is "among gods and men." There is room beside him for men and other gods. According to Jaeger, he is endowed with consciousness and a personality, which distinguishes him from Anaximander's impersonal "divine."[17] He does not move, he does not mingle with men. "Completely without toil he shakes all things by the thought of his mind."[18] "Always he abides in the same place, not moving at all, nor is it seemly for him to travel to different places at different times."[19]

The critique of anthropomorphism rests on the affirmation of God's universality. Only a god unrelated to the human race, unrelated to any race or people, is worthy of being God. Xenophanes provides a reductio ad absurdum: "If horses or oxen or lions had hands or could draw with their hands and accomplish such works as men, horses would draw the figures of the gods as similar to horses, and oxen as similar to oxen, and they would make the bodies of the sort which each of them had."[20] So it is with every nation: "Ethiopians say that their gods are snub-nosed and black; Thracians that theirs are blue-eyed and red-haired."[21]

This God, exceeding any particular shape men can imagine, exceeding even the most beautiful shape of all, namely, their own, must also possess an ethical dignity, which Homer and Hesiod did not respect: "Homer and Hesiod have attributed to the gods all sorts of things which are matters of reproach and censure among men: theft, adultery, and mutual deceit."[22] Such things are incompatible with the moral greatness of the divine. Hence Xenophanes introduces the notion of *seemliness,* which has taken on incalculable importance, even down to our own time. Everything that comes from man—appearance, form, clothing, but also passions and mores—is not *seemly* for divine nature. Euripides, Plato, and Cicero also raised the question of what was and was not seemly for God. The theological concept of what is seemly to divine nature *(theoprepres)* was passed down to the church fathers, who made it a pillar of Christian theology. Iconoclasm is founded on the fact that every figure, and in particular, every human figure, or every figure made by human hands, is unseemly and blasphemous. This sentiment becomes even stronger if theology declares it is incapable of a positive determination of God and systematically seeks refuge in negative

formulations. Xenophanes, as we have seen, was the first in the Greek world to make such a formulation.

Jaeger writes, "Though philosophy means death to the old gods, it is itself religion."[23] That is why the death of the ancient gods took such a long time. In the fourth century, their souls began to desert them. But another soul entered their bodies, which remained alive until the victory (which was never complete) of Christianity. That life was breathed into them by philosophical religion. The two religions coexisted, and even fused to a certain degree. As we shall see, it was not civil religion that stabilized the philosophical soul, but rather the philosophical soul that turned to a certain form of internalized popular religion: the mystery cults, initiatory religions.

With the Orphic movement, the Greek capacity to imagine new theogonies and cosmogonies underwent a shift. From the time of Hesiod on, moral personifications—Dike, Eumonia, Irena—appeared beside popular gods. Pherecydes of Syros (sixth century) proceeded to a general reinterpretation of the gods. He created allegorical deities representing certain cosmic forces, and he established equivalences between the names of ancient gods and the natural forces of the new cosmology. This process transformed the divine personages of popular religion into divine powers, and it led to the question of divine nature that preoccupied philosophers and theologians. As a result, the images of Zeus or of Hera, which had been accepted as part of the personality of these gods, as a portrait of them, became conventional representations—consecrated merely by custom—of forces that by nature have no face.

A new doctrine of the soul was linked to the same movement. Homer had made a distinction between the soul as vital principle *(psychē)*, which abandoned the body after death but which neither thought nor felt, and the soul as consciousness *(thumos)*, which was completely tied to bodily organs. In the new conception, the soul became the spiritual and moral self, separable from the body and as incorporeal as possible. A person therefore became responsible for the future destiny of his soul in the hereafter. The soul, from a higher and more divine place, was only a temporary guest in the home of the body. The Orphic theory of the soul directly anticipated the views of Plato on the divine nature of the soul, a soul henceforth devoid of any material attribute and which, via an inner experience devoid of imagery, arrived at a knowledge of the divine. Socrates invited men to care for their souls, the most important part of man. As a result, he was not satisfied with an art that did not take the soul into consideration. "Cleiton," he told the sculptor, "that your statues of runners, wrestlers, boxers, and fighters are beautiful, I see and know. But how do you produce in them that

illusion of life which is their most alluring charm to the beholder? . . . Must not the threatening look in the eyes of fighters be accurately represented and the triumphant expression on the face of conquerors be imitated?" "Most certainly." "It follows, then, that the sculptor must represent in his figures the activities of the soul."[24]

Since the true essence of man lies in his immaterial soul, a new task falls to the artist: give a form to what has no form, find a formal equivalent for the formless. The inner world is separate from the outer, yet that is the world that must be represented.

Prophetically, Parmenides proposes a "way" that "leads the knowing man entirely safe and sound." It is thus a way of salvation, and of salvation via knowledge, which is itself a gift of divine origin: a gnosis. The Ionians took not traditions and fictions as their starting point, but empirical data: *ta onta*. But Parmenidian Being cannot be plural. It is unique: *to on*. Reason, the logos, shows us "being" but never "Being," just as our senses show us "being" as multiple and in movement. Thus, appearance and physis are on one side, truth and metaphysics on the other. Yet, unlike what Aristotle later did, Parmenides does not consider "being" and the model as two aspects of the same world, situated on the same plane. For him, "becoming" is pure appearance and the world of being is truth itself. He raises Being above the realm of sensible and immediate experience. He extracts a "Mystery of Being."[25] That Being is not identified with God, however. The religious experience of that mystery resides in the way man was caught up in the alternative between truth and appearance, and in the decisive choice he made.

The only shape Parmenides consents to give to Being is the sphere: "Since, then, there is a furthest limit, [it] is completed, / From every direction like the bulk of a well-rounded sphere, / Everywhere from the centre equally matched; for [it] must not be any larger / Or any smaller here or there."[26] The adequate and perfect form is the most interchangeable and the most impersonal.

That stable sphere could not be farther from the God of Heraclitus. His God is a single reality, but he asserts himself in struggle and change—a pair of opposites that are constantly taking on a new face. The unrepresentable figure for this God is paradox and war. He is an enigma: "The lord whose oracle is in Delphi neither indicates clearly nor conceals but gives a sign,"[27] as if to guide men to a profound but always ineffable intuition. All in all, Heraclitus locates the unity of the world in incessant change itself, in the *law* of change. The idea of unity is not embodied in a principle but is simply the object of mystical understanding. That is why he neither attacks nor defends popular religion, which has no importance: "One thing, the only wise thing, is unwilling and willing to be called

by the name Zeus."[28] Of course, any representation of Zeus is infinitely inadequate: "A man hears himself called silly by a *divinity* as a child does by a *man*,"[29] and "in contrast with God the wisest of mankind will appear an ape."[30] All the same, this apophatic Zeus, radically distinct from any human figure, bears a name, and this name is acceptable because it is in keeping with intuition. Thus this name, and only this name, stands in the place of the icon of an ineffable reality.

Let us cite two fragments from Empedocles:

> It is not possible to approach the deity and grasp it with one's eyes or touch it with one's hand, which is the best means to persuade man in his heart.[31]

> God has no body equipped with a human head; he has no back from which two arms extend like branches; he has no feet, no agile knees, no male member covered in hair. He is simply an august mind and an inexpressible power, whose swift thought travels through the universe.[32]

In the beginning, the parts and elements of the world grew together in love, finally forming a single, total harmony, the Sphairos: "The Sphairos, in the shape of a ball, delights in the solitude that reigns about it." Equal in every part, limitless, the Sphairos is "completely round, joyful and motionless."[33] But this state of repose lasts only for a determinate cosmic phase. Hatred takes on its full force and acts as a principle of dissociation, undoes the Sphairos, initiates change. Similarly, man's soul has a history. Empedocles grants it a previous life, which extends for eons. It remembers its home on high, the original golden age, and suffers from being temporarily relegated to the shadows of the earthly world. In the end, perfection and the good triumph over discord and reestablish the stable and definitive state of cosmic forces.

There is therefore a solution to the problem of the divine form. That form is not unique, but multiform, with three different aspects: first, the primitive and stable forms of corporeal existence; second, the world in movement, agitated by love and hatred; and finally, the definitive state. This is all grasped within man himself, in his soul, as the *daimon* within him, and it shows him that the life of the soul is guided by the same divine and eternal forces that nature obeys: love, discord, and the law governing them. There is no place for an anthropomorphic iconography of the divine so conceived.

Let us now consider the Athenian world. During the years when classical art came into being and blossomed, Anaxagoras pushed the concept of the divine even deeper into abstraction. The divine *nous* is an organizing force. It is the intelligence that, in the swirling operation of the world, governs the particular processes of mixing, separation, and individuation. It orders everything accord-

ing to an established, universal, foreseeable plan. This mind is identical, whether it is large or small. It is of the same nature, of the same substance, whether in god or in man: our minds are the divine part of ourselves, and through reason we have direct access to this divine reason.

The originality of the Sophists consisted in questioning the religious phenomenon itself, the fact of the universal belief in God. Their solution was to consider religion as a product of human nature and hence as a natural phenomenon. The Greek god had always been a fact of nature: now, it was specifically a fact of human nature. In the words Plato attributes to Protagoras, the gods give Epimetheus the task of offering every species the qualities and aptitudes necessary for its survival: speed to some, strength to others, and to each the type of food appropriate to it. When it is the turn of the human species, Epimetheus remains undecided about its needs. Then Prometheus, seeing that man is naked and without protection, takes the arts of Hephaestus and Athena from their workshop, so that man will have a means to live. "Now man, having a share of the divine attributes, was at first the only one of the animals who had any gods, because he alone was of their kindred; and he would raise altars and images of them."[34]

Hence, only man had religion and worshiped the gods. This assertion is repeated in Socrates' speech on providence, which Xenophon attributes to him in the *Memorabilia:* "What other creature's soul has apprehended the existence of gods? . . . And what race of living things other than man worships gods?"[35] These are almost innate ideas, sanctified by tradition. But how did they come to man? Democritus (according to Cicero)[36] imagined they came in the form of images *(eidōla),* somewhat in the manner of dreams: "Sometimes he thinks that the universe contains images with a divine character, sometimes he says that the principles of the intellect that dwell in the universe are gods, sometimes it is animate images, which may be either useful or harmful to us, sometimes it is certain vast images, so large they embrace the universe as a whole."[37] This is the root of a psychological explanation of religion: the original image of the divine is reduced to a fantasy, occurring—under divine pressure?—to men's minds.

But, on the question of what the gods are, and whether they are, Protagorus was so avowedly agnostic that, according to Eusebius, he was accused of atheism.[38] His treatise on the gods begins as follows: "Regarding the gods, I am not capable of knowing whether they exist or whether they do not exist, or what aspect [form] they might take. Too many things prevent us from knowing: their invisibility and the brevity of human life." The gods' existence belongs more to the order of the *nomos* (human convention) than to the order of physis. And, if they exist, their form is unknown. To the Greek mind, contemplating God and

contemplating nature amounted to the same thing. The gods manifest the glory of the cosmos, and the cosmos reveals its divine nature in contemplation. It is never necessary to produce a proof of the existence of God, since the divine is so obvious.

But philosophical religion chose to contemplate the cosmos in the unifying light of reason. The perfection attributed to divine personages, inherited from the tradition of Homer and Hesiod, from the cult of the commonwealth, was synthesized and attributed to a first principle, a power beyond all existence, which thus appeared as the only power capable of being designated by the predicate "divine" and of embodying it. The idea of the All *(holon, pan)* blurred the face of the deity, for no longer could a limited, defined form be taken for divine.

All the same, the battle of philosophical religion against civil and popular religion was not a battle of dogmas. On either side, multiple myths proliferated and borrowed from one another. That is why the Zeus of art and statuary received a philosophical soul by metempsychosis. That was how philosophers replied to Christians, who accused them of idolatry. At the same time, philosophy was not at all opposed to taking its metaphors and images from art. Recall that Heraclitus said the divine "is unwilling and willing to be called by the name Zeus." Philosophers, in their quest for the unifying principle, the *apeiron* or *nous,* came across the father and master of gods: they recognized him as the figure most resembling their conception of the divine, a figure that was simply taken to a higher level, a loftier plateau. Thus one moved from Zeus to Zeus, a move that authorized the return of images. And, in fact, these images, though they became increasingly symbolic, did not change in their outward appearance until the end of antiquity. They were resuscitated in Western Europe with every renaissance and laden with the same symbolism. At the very beginning of Christian art, these images sometimes even represented the Word incarnate as Hermes or Heracles.

Plato

Since my subject is the image of the divine, my first question will have to do with the Platonic notion of the divine. Then, dividing up the difficulties, I will seek the meaning of the image, of art, and finally, of the image of the divine.

A. The Divine

"God [is] the measure of all things."[39] But he himself has no measure.

Plato does not posit God in any dialogue. And yet all things are conceived

through Forms, and Forms are thought by God. But he is beyond Form. "Above and behind" the prisoners in the cave, "a fire is blazing at a distance." The light from that fire cannot be looked at, for it is blinding: if a prisoner is "compelled to look straight at the light . . . his eyes will be dazzled, and he will not be able to see anything at all of what are now called realities."[40] "For the souls of the many have no eye which can endure the vision of the divine."[41]

Many things earn the designation "divine" from Plato: the Good, Forms, the demiurge, the soul, the universe, astral bodies, heroes, gods.[42] But the Good is the divine par excellence, to such a degree that it may be identified with God. Except in *Laws,* Plato is more likely to speak of "the divine" than of "God."[43] The gods are a function of the divine.

The material world is a "vast imprint" of obscure images made by Forms, images that are born, live, and are obliterated. If we cry out "That's Peter!" when we look at a portrait, we mean that the canvas, with its paint and shading, depicts Peter, and we are able to say so only because we know in advance who Peter is. We attribute a name, the name of the model, to the copy. The copy is never perfect. The Form is not extracted or abstracted from the sensible object. Rather, that object works to reproduce—but without success—the brilliance of the Form. The Form is eternal, and the copy, a collection of sensible qualities, is rapidly undone by change.[44]

In the intelligible world, Forms compose an organized set. At the uppermost point of that set stands the Form of the Good. It communicates essence and existence to all Forms. But it "far exceeds essence in dignity and power."[45] The Good stands above all definition, all formal representation. It can be suggested only through metaphor: "A powerful and immortal Atlas who holds up all things," "the brightest and best of being."[46]

Everything proceeds from the Good, including knowledge of the Good. Dialectics recapitulates, in the order of knowledge, the timeless movement of the procession. But the dialectical inquiry is interrupted by solemn prayers and invocations because, in moments of indecision, divine assistance becomes necessary. Dialectics prepares the way for an intuition, a vision. It is necessary for each Form. Every Form must be the object of a pure intention, of a vision, then of an argument, and finally, of an act of imitation. For the supreme Idea of the Good, that vision is long in coming and obtained only with difficulty. Both the fire illuminating the cave and the sun signify

> in the world of knowledge the idea of good . . . [which] is seen only with an effort; and, when seen, is also inferred to be the universal author of all things beautiful and right, parent of light and of the lord of light in this visible world,

and the immediate source of reason and truth in the intellectual; and . . . this is the power upon which he who would act rationally either in public or private life must have his eyes fixed.[47]

In fact, the Good is inaccessible under the conditions of mortal life. Plato calls for a definition of the Form of the Good. But he abandons it. None of his dialogues makes the attempt. Dialectics is used, in the light of the Good, to define one particular form or another, but it stops at the brink of the Good itself. Every dialogue begins again from square one and rises toward the Good in its inquiry. Not one situates itself within the Good to deduce from it, dogmatically or scholastically, the system of Forms that proceeds from it.

The "perfect initiation" Diotima speaks of is set aside for the future. Only the soul separated from the body can see Forms. "If we would have pure knowledge of anything we must be quit of the body—the soul in herself must behold things in themselves: and then we shall attain the wisdom which we desire, and of which we say that we are lovers."[48] To "hold converse with the pure," one must oneself be pure, "having gotten rid of the foolishness of the body."[49] The vision of God is not within man's reach. And God is also not the object of an act of faith: he is at the beginning of the search, and at the beginning of conversion, when man observes how little reality sensible things have. He is accepted in advance, as a starting point, by the man of good will and good nature. The self-evidence of the divine is as clear to Plato as it is to the most humble man (of good character) participating in Greek civilization.

Forms, to use Aristotle's language, are formal causes. The carpenter who makes a bed looks to the Form of the bed and "impresses" that Form on matter. He uses his cunning against the obstacles matter imposes, but he does not use his cunning against the Form, nor against the techniques of imitation the Form dictates to him, at least not so long as he has decided to remain faithful and obedient to the Form. Socrates remains in prison because he has seen the Good and cannot know the Good without imitating it, even when this Good consists of remaining in prison.

Matter follows, in the way it is said that consequences follow. The imitation of the Form is imposed on matter, and matter submits as far as it is able. The visible universe, in its original state, is absolute disorder: it benefits from the order gradually imposed by Forms. The organizer is not all-powerful, because being is not strong enough to entirely resorb the nonbeing of disordered matter. Matter resists with an invincible residual force, the limitation on the ordering action of Form.

The soul or the demiurge or the artisan must choose between the Good and

matter. For the Good to be known, one must have Socrates' soul, and for the Form of the bed to be imposed on the wood, one needs the artisan. The soul commits itself to Forms and loyally supports them. For the ancients, the soul is "the principle of movement," the principle of its own movement, or of the movement of bodies. But this movement is determined by the object known. Movement can be conceived only when joined to a knowledge of the object. Directing itself toward Forms, the intelligent soul extends the goodness of Forms to matter and spreads the Good. It is in this respect that the sensible world has value. Evil is not an active agent, a bad soul. It is also no longer identified with matter. Matter is not evil, but simply disorder, absence of the Good, ignorance of the Good. It is in man that sin may possibly reside, if he falls into ignorance, if he forgets Forms. For Plato, sin is forgetfulness.

B. The Image

In the tradition of the Academy and the Portico, the notion of an "image" is richer than what we understand by that term. It implies something more than a resemblance to the model; it implies a kinship. The link to the model is a religious and almost magical operation. This is similar to the speculations of Pythagorus and of the mystery religions.

Plato uses the word *eikon*. It is associated with the theory of Forms (Ideas), because sensible objects are images of these eternal models. At the end of *Timaeus,* it is the sensible world that is an image of the intelligible God, the site of Ideas: "Thus we have finished the discussion of the universe, which, according to our original intention, has now been brought down to the creation of man. . . . And so the world received animals, mortal and immortal, and was fulfilled in them, and became a visible God, comprehending the visible, made in the image of the Intellectual, being the one perfect only-begotten heaven."[50]

The image indicates a participation of the model, but a diminished participation, since the resistance of matter can never be completely eliminated. The image is not the equal of the model. It is not created by the model but proceeds from it, radiating from the Form that permeates and organizes matter. The *eikon* is always sensible. Plato never says that a spiritual reality can be the image of another spiritual reality. The *eikon* is to the paradigm what the sensible is to the intelligible. Unlike later Platonism, Plato never called the soul the "image of God."

The notion of the image is enriched by the idea of kinship: *oikeiosis* or *suggeneia,* a kinship that establishes a unity with the divine world. That kinship is drawn from a fundamental principle in the theory of knowledge—like attracts

like—a principle to which all Plato's pagan and Christian posterity remained faithful. The soul is capable of intellection and of sensation, because it is related to both the world of the intelligible and to that of the sensible. That kinship is also drawn from astral religion. The heavenly world of astral gods is located between the invisible world of Ideas and the sensible cosmos; these astral gods live in the contemplation of Forms and imitate their movements. The immortal soul of man, created by the demiurge, is of the same nature as sidereal souls. Before it descended into a body, the soul was linked to a star god and to the vision it had of Forms.

Even after it has fallen into the sensible world, the human soul is homesick for the heavenly world. In fact, the image has the natural property of reestablishing, on its own, contact with its model. It wishes to return to the star and rediscover, through intimate contact with it, the contemplation of Ideas. At that point, it reaches its goal: *homoiosis Theoi,* "assimilation to God," restoration of its similarity to the god. To achieve that assimilation, it must liberate itself from the body and become unstuck from the material world. Plato calls the assimilation to God a flight from this world of imperfection. The soul must also imitate the regular and reasonable movement of the stars in a positive manner; this is accomplished through the practice of justice and virtue. "And to fly to [the gods] is to become like them; and to become like them is to become holy, just, and true."[51]

The sensible image, made by human hands, is by nature limited and cannot achieve full similitude. Otherwise, it would cease to be an image. Socrates argues in *Cratylus* that if one gives a painting "all the appropriate colours and figures," one produces a good painting or a beautiful image. But it is not seemly to reproduce in images "the exact counterpart of the realities which they represent."

> Let us suppose the existence of two objects: one of them shall be Cratylus, and the other the image of Cratylus; and we shall suppose, further, that some God makes not only a representation such as a painter would make of your outward form and colour, but also creates an inward organization like yours, having the same warmth and softness; and into this infuses motion, and soul, and mind, such as you have, and in a word copies all your qualities, and places them by you in another form; would you say that this was Cratylus and the image of Cratylus, or that there were two Cratyluses?[52]

A number 10, Socrates explains, is exactly the number 10: if one adds to it or takes something away from it, it immediately becomes a different number. But one must seek "a different principle of truth in images," and "not insist that an

image is no longer an image when something is added or subtracted." The image is thus condemned to a certain superficiality. It is not what is represented. It signifies that a certain amount of play is possible in the arrangement. That gives the artist a certain freedom to add or subtract, so that the image will resemble the object represented more exactly, even while retaining the necessary distance from it.

C. Art

Socrates—that is, Plato—respects the artist. He respects Homer above all. And yet, he banishes him.[53]

Plato has artistic tastes.[54] They are, as one might expect, deliberately backward-looking. He does not like the contemporary evolution of the arts toward trompe l'oeil and illusion. The painting of his time had borrowed techniques from theater sets. Apollodorus the Skiagrapher had discovered a few rules of perspective. He reproduced the external world on flat surfaces, creating the illusion of three-dimensional space. Plato does not like this: "Things appear to be all one to a person standing at a distance, and to be in the same state and alike . . . but when you approach them, they appear to be many and different."[55] In matters of taste, Plato was behind his time. He would have approved of the art of korai, the majestic stiffness of the severe style. Yet he knows Phidias and Zeuxis.

He does not like change in art any more than in politics.[56] In a well-ordered commonwealth, art is regulated and the lawmaker must concern himself with setting aside novelties. Art deeply moves the passions: it is therefore too serious a thing to be left to artists. In that respect, Plato's model is Egypt. He admires the fixity of Egyptian art. Saite art, of which he had almost contemporaneous examples, was very consciously returning to the art of the Old Kingdom, which predated it by a good millennium.

> No painter, no other representative artist is allowed to innovate upon them, or to leave the traditional forms and invent new ones. To this day no alteration is allowed either in these arts, or in music at all. And you find that their works are painted or moulded in the same forms which they had ten thousand years ago;—this is literally true and no exaggeration,—their ancient paintings and sculptures are not a whit better or worse than the work of today, but are made with just the same skill.[57]

In the commonwealth with good laws, art is present, but it is not just any art. There will be good music, good hymns, good statues. The old representations will persist: they have great age on their side. In fact, however, Plato is not always

rigidly opposed to innovation. He is opposed to the lawmaker dictating his laws to the artist: art must be regulated by art. "It is plain that all the arts would utterly perish, and could never be recovered, because inquiry would be unlawful. And human life, which is bad enough already, would then become utterly unendurable."[58] He expressly condemns state art of the Soviet variety.

And yet this great artist, like Tolstoy much later on (and for the same reasons, though they were less subtly expressed by Tolstoy), condemns art at its foundation. He sometimes suggests a Tolstoyan utilitarian critique: "For that is, and ever will be, the best of sayings, *That the useful is the noble*"[59] (regarding women who go naked in the ideal commonwealth, their virtue taking the place of clothing). "For we mean to employ for our souls' health the rougher and severer poet or storyteller, who will imitate the style of the virtuous only, and will follow those models which we prescribed at first when we began the education of our soldiers."[60] If art truly has an effect on men, and if someone undertakes to make them decent men, only a certain type of art, entrusted to "well-born" artists, can be accepted in the commonwealth.

But these considerations remain at a practical level. The real stakes are "theoretical." Art is evaluated by the criterion of truth, and Plato finds it lacking. The essential texts appear in *The Sophist* and, even more decisively, in *The Republic*.

The Sophist proposes an analysis conducted by the method of dichotomies.[61] The art of imitation is part of the art of production. The art of creation must be divided into two parts: divine and human. The creation of natural things, animals, plants, and seeds, is divine. Human creations are fabricated. But there is another division possible, which entails both divine and human creation: the creation of realities and the creation of simulacra *(eidôlon)*. The gods create simulacra: these are our dreams, our visions, the slight shadows projected by deceptive reflections. Men also create simulacra: compared to the house built by the architect, the house the painter reproduces is "a sort of dream created by man for those who are awake."[62] After two additional dichotomies, Plato comes to the definition of the imposter, who imitates the wise man without having his knowledge, who fabricates fraudulent "marvels." This is the Sophist. In that progression, the artist is only one degree away from the Sophist and the tyrant: his works have a false beauty; one cannot even say whether they are or are not; they are objects, not of knowledge, but of opinion.

Book 10, the last book of *The Republic*, defines the status of art's truth in terms of Platonic metaphysics as a whole.[63] The worker produces the object—for example, a bed—by casting his eyes on the Form, since "no artificer makes the Ideas themselves." But let us imagine a worker capable of producing not only all sorts of furniture but also everything that grows in the ground, all living

things, the sky, the gods, Hades. One has only to take a mirror and move it this way and that, and one "makes" the sun, the earth, oneself, quickly and without the slightest difficulty.

The painter can be compared to that artisan with the mirror. If he paints the carpenter's bed, in a certain way he "makes" a bed, and he also does not make it. "He cannot make true existence, but only some semblance of existence." There are, then, three sorts of beds. The first exists in the nature of things, and God is its maker. The second is that of the carpenter, and the third, that of the painter. God created a single, unique bed. The carpenter fabricated it, and the painter "imitated" the first two. The painter is thus "third in the descent from nature."

That imitation is an illusion. It is far from the truth. It paints only appearance and, hence, on the surface, a small part of the object, a shadow of the object. That imitation deceives children and men deprived of reason. It is well equipped to represent everything, but that universal capacity is only charlatanry, which impresses only those who are incapable of distinguishing among knowledge, ignorance, and imitation.[64] The artist is a trickster. He is also an ignoramus. The flute maker has dealings with flute players; he knows his instrument and its use, its perfection and imperfection, because he is dealing with people who know: the musician who plays the flute and knows how to use it. But the imitator is not subject to that truth test. He is not obliged to have any real knowledge of what he imitates. His art is only child's play devoid of seriousness. The painter's very techniques betray the true nature of that art: the same objects may appear concave or convex depending on the visual illusion produced by colors. "The art of painting in light and shadow, the art of configuring, and many other ingenious devices . . . hav[e] . . . an effect on us like magic."[65]

Homer gives us pleasure. But pleasure is not an acceptable basis on which to make judgments of taste. Pleasure is subjective, since a child will prefer the puppet show to any other kind of show: the adolescent, comedy; a woman, tragedy. The judgment of an imitation is not at all the province of pleasure, nor of an opinion without truth. What matters is the relation to truth. If an artist wishes to command respect, three conditions are necessary: that he know the reality imitated, that he know in what way the imitation is correct (proper proportions, suitable colors), and, finally, that he know what value it has in terms of goodness and usefulness.[66]

If pleasure is the criterion by which to judge art, if the "voluptuous Muse" reigns, then Homer is the greatest of poets and the educator of Greece. But, in that case, pleasure and pain will be kings of the commonwealth; they will replace law and "the reason of mankind, which by common consent have ever

been deemed best."[67] True utility, true goodness, is knowledge of the truth. And, on this point, Homer is not a sure guide. The art of imitation exerts a charm. But—this is the conclusion—"we may not on that account betray the truth."[68]

D. The Image of the Divine

I have approached my question initially by following the terms used to formulate it: the divine, the image, art. But I have not yet dealt with the question itself. I needed to set out the various Platonic positions before tackling the question that unites them.

The pertinent texts are some of the most famous from the dialogues, those that have most contributed to forming our image of Plato: the myth of the demiurge in *Timaeus*, the journey of the soul in *Phaedo* and *Phaedrus*, the speech of Diotima in *The Symposium*. These texts, which do not directly address the question of the plastic representation of the divine, nonetheless express the spirit of Platonism on the question as a whole, and they are the seeds for Plato's posterity.

After praying that the gods and goddesses will correctly inspire his words, Timaeus dares speak of the origin of the world.[69] This world had a beginning: it was not created, but it was organized. Its "creation" was an imposition of order, and that order constitutes its beauty. "If the world be indeed fair and the artificer good, it is manifest that he must have looked to that which is eternal." This world is "the fairest of creations and [its author] is the best of causes." It was formed from an eternal model, understood by reason and intelligence.

The demiurge is "free from jealousy." He wanted all things to be as similar to himself as possible. "Now the deeds of the best [the demiurge] could never be or have been other than the fairest. . . . For which reason . . . he put intelligence in soul, and soul in body, that he might be the creator of a work which was by nature fairest and best."

Whatever the fate of art, Plato posits the fundamental theological principle on which all art rests: that the world is good. It hardly matters whether it was created or not, it is the goodness of the world that is the principle of its beauty. The position of the Bible is identical.

On one hand, then, Plato challenges the artist because he does not have the capacity to attain truth—and consequently, the truly beautiful or the Good—and, on the other, seeking an image to represent the unknowable God, he makes him an artist, a maker of images imitating an eternal model. The plasterer applies the Idea like a mold. The world is a work of art, it is shaped by an intelli-

gent, ordering substance. Like a good worker, this God does everything, even small things, with care.[70] He pays attention to the details, gives to every thing its form, to the earth the shape of a soccer ball (the ball made up of twelve pentagonal skins), to astral gods a round shape, carved into matter and composed almost entirely of fire.[71]

The demiurge is the true artist, the artist par excellence. But he cannot be imitated by the human artist, who is a prisoner of the sensible world. In the last instance, his beauty is not on the sensible order. It is on the intellectual order. It reveals itself as an intellectual grasp of the golden mean, of harmony. The value of the simulacra *(eidôlon)* created by art is merely to produce in the beholder a desire to grasp a beauty that is itself not sensible but intelligible. And when he follows that path, sensible forms are obliterated. That is the journey of the soul described in *Phaedo* and *Phaedrus*.

We believe we can see the heavens from earth. But we are like fish that live in the ocean and take the surface of the water for the heavens. We take air for the heavens. Our weakness and slowness prevent us from rising to the top of the air: "If any man could arrive at the exterior limit, or take the wings of a bird and come to the top, then like a fish who puts his head out of the water and sees this world, he could see a world beyond; and, if the nature of man could sustain the sight, he would acknowledge that this other world was the place of the true heaven and the true light and the true earth."[72]

But the soul cannot see that sight, which is completely unlike all its representations, all its imagination, unless it purifies itself and liberates itself from the body.

The myth of *Phaedrus* makes the vision of "the true light" even clearer.[73] Divine souls rise "without toil," because their chariot is always properly balanced and easy to drive. Human souls climb only with difficulty, because one of the horses that pulls their chariot is clumsy, poorly trained, recalcitrant.

What do the gods contemplate? The space extending above the heavens, which is beyond description. "But of the heaven which is above the heavens, what earthly poet ever did or ever will sing worthily?"[74] It is indescribable because the essence that resides in that place, that which is truly existent, is "colourless, formless, intangible essence, visible only to mind, the pilot of the soul . . . intelligence." The soul thus contemplates justice in itself, wisdom in itself, a knowledge whose object is "reality."[75] All that does not lend itself to plastic representation. In becoming purified, intelligence detaches itself from the sensible and, depending on its strength, becomes capable of contemplating pure Forms, which are invisible. The art of the beautiful is not art in general but rather dialectics, which does not seek to produce beautiful things that give plea-

sure but rather to purify pleasure and replace it with the intellectual grasp of Essences. The supreme art, dialectics, turns its back on the fine arts. The arts invite us to dwell in the sensible world they reproduce. They are an obstacle in the quest for beauty.

But the last word belongs to *The Symposium* and, in *The Symposium,* to Diotima.[76] First, the true nature of Love is established. It is not a god beautiful and good in itself. It is unsatisfied desire. "Love is of something which a man wants and has not."[77] But not everyone is capable of desiring what is truly desirable, namely, the Good: the term "lover" is reserved for those who are capable of it. Those who seek money, athletic feats, and even philosophy cannot be said to love. The aim of love is not the beautiful. The beautiful accompanies and spurs on the quest. It is the medium in which the quest is productively carried out. The true aim is immortality, which, under the conditions of human life, is obtained through reproduction, and in particular by giving birth spiritually. Love is therefore a desire to imitate God, to participate in the essential attribute of divine nature, immortality. This is a reasonable desire because it remains within the bounds of human nature, as the share of immortality assured by carnal reproduction, or, more surely, spiritual reproduction.

This quest takes the form of a journey of initiation, whose stages are marked by successive visions of beauty. First, there is the passionate love for a particular beautiful body. Then, in letting go of that violent love for an individual, the initiate broadens his vision to the beauty shared by all bodies endowed with beauty. Then he seizes the beauty of souls, the beauty of actions, of laws, of science: the initiate now beholds the ocean of beauty. From that fertile contemplation, he produces magnificent speeches and wise thoughts in abundance, until his mind, fortified and expanded, arrives at the brink of the knowledge of absolute beauty. He suddenly has the vision of a beauty whose nature is marvelous, an eternal beauty to which generation and corruption, growth and diminution, are unknown, the absolutely beautiful: a simple and eternal beauty in which all other beautiful things participate, so that their birth or death neither increases nor decreases nor alters it in any way.

Plato condemns art for being incapable of attaining truth and—this is a more serious matter—for turning men away from truth. Anyone who wishes to attain the true image of the divine must take not this path, but that of asceticism, an asceticism of body, soul, and intelligence.

At the same time, the divine is "beauty absolute," and it irresistibly attracts human love.[78] Eros inevitably propels men onto the path of beauty, and they encounter it with their bodies, with their impurity, all along the ascending ladder. Eros moves automatically toward the human body: this fact justifies images

in the short term, particularly the nude, the nude bodies of gods and heroes. For "political" reasons, these images must be honored, in keeping with tradition. At this stage, only false images are condemnable, those that stem from a trompe l'oeil aesthetic or from a displaced pathos—an art that is doubly superficial because it artificially exaggerates its fundamental superficiality. The image is only an image and can never be a thing; otherwise, it would be the double of the object it represented. But let us at least ensure that it is as faithful and as exact as possible. This requires that the artist know his business thoroughly, that he have a noble mind, that he be "well born."

But eros draws man upward, where he conceives of the beauty of the sciences, of laws, of virtuous actions, of the structures of the world (geometrical figures—icosahedron, cube, and so forth—provide a sensible equivalent of these). Finally, love brings man face to face with marvelous, ineffable beauty. This is the divine itself, which his soul contemplated before earthly life, and which it hazily recalls.[79]

Thus, the nature of the divine makes the image of the divine impossible. Art has an upper limit: it is confined to the earthly zone, where it performs a propaedeutic, educational, civic function. It prepares for its own dissolution. The lover of beauty relies on art in taking his first steps, then abandons it. In that sense, it is accurate to say that Plato is the father of iconoclasm. Sooner or later, all enemies of the image will employ Platonic arguments. Hegel, who is not an iconoclast, also follows Plato in assigning to philosophy the responsibility for representing the divine, once that responsibility has slipped out of the hands of art.

At the same time, however, Plato is the father of iconophilia, since he completely justifies man's desire to contemplate divine beauty. In the religious ascension that leads man toward the divine, reverential piety and the search for the beautiful are not separated, practically or theoretically. Ineffable ecstasy, which transcends any verbal or plastic definition or transcription, is indissociably an aesthetic ecstasy that feeds on poetry and enthusiasm. Plato thus confers the highest dignity on the artist, if not on art. He glorifies the artist's aspirations. The most humble of artists, in fact, is still turned toward the heavens, capable of rising indefinitely. In the spirit of Platonism, the origin of the erotic dynamism that propels man toward the image is the divine itself—so much so that the dynamic of art is sanctified through and through by it.

According to Kant, metaphysical ideas are illusory but necessary. "The wisest of men could not free himself from them." The task of criticism is to prevent illusion from deceiving us, but criticism cannot make it disappear. So is it too for the representation of the divine in Plato. Outside the realm of philosophy, out-

side dialectics, which defines its conditions and limits, it is error. And that is why Plato places the artist beside the Sophist. But it belongs to man's nature to wish to represent the divine. Propelled by eros, he cannot fail to want it, unless he deliberately turns his back on the Good. In that sense, his effort is not that of a Sophist. Whatever he may manage to represent, it is the divine he really wanted to represent, and that desire is no sacrilege.

Aristotle

In appearance, Aristotle has little to say about the image of the divine. He wrote nothing about the plastic arts. His definition of the beautiful (which has to do with order, measure, dimension) seems similar to that of Plato and to Greek thought in general, up to but excluding Plotinus.[80] At first glance, his theology seems to preclude the image of God. The unmoving Prime Mover which, out of love and desire, sets the material and spiritual worlds in motion, is a pure, direct thought that intuits itself. It is the object of its own thought, and it is doubtful whether it knows anything other than itself. It is an immanent teleological principle, a goal toward which nature unconsciously aims. But man aims toward it consciously.

In fact, the exertions of the best part of man, his reason, must bear on the best of all objects, those that are eternal and immutable.[81] The activity proper to virtuous reason is thus contemplation. It provides a stable, autonomous happiness, unlike moral virtue, which needs others to express itself.

The pure contemplative life is reserved for the gods. Man, held down by a body and an irrational soul, can participate in the contemplative life only through the divine portion given him, namely, reason. But it is his duty to participate in it as much as he is able. In this, Aristotle is no different from Plato:

> If reason is divine, then, in comparison with man, the life according to it is divine in comparison with human life. But we must not follow those who advise us, being men, to think of human things, and, being mortal, of mortal things, but must, so far as we can, make ourselves immortal, and strain every nerve to live in accordance with the best thing in us; for even if it be small in bulk, much more does it in power and worth surpass everything.[82]

The man who lives the life of the mind is the "happiest" of all men. The happiness that practical moral life provides is secondary, and its worth lies primarily in how it prepares the way for the theoretical happiness of contemplation. But of what does that contemplative life consist? It does not seem to be an aesthetic contemplation. In the *Poetics,* where Aristotle considers a particular form of aesthetic experience, namely, tragedy, he locates its value in its medical effect.[83]

Contemplation is the contemplation of truth in two or three realms: mathematics, perhaps physics, and, above all, theology. The ideal life is a purely intellectual, religious life, "the contemplation and service of God."[84]

Man must turn toward God: that precept is as firm in Aristotle as it is in Plato. But in Plato, there is the hope of a vision. In Aristotle, it seems, that hope must be abandoned. Contemplation is reduced to an abstract, purely conceptual mysticism, since, with respect to vision, the Prime Mover is something of a black hole.

Nonetheless, in relation to Plato, Aristotle introduces two novelties that open the field of art somewhat to the image of the divine, even though he himself has no interest in entering that field. These novelties lie at the very foundation of his philosophy. But it was only within a context other than the ancient world that they would later be able to bear their aesthetic fruit and philosophically justify the representation of the divine. This context occurred with the event of the Incarnation, Christianity, and it was in the medieval West that Aristotle's innovations began to bear fruit.

1. Aristotle establishes the dignity of sensible things, of material things. The universe is composed of substances, that is, of individual quiddities, which combine their properties and qualities around a substratum the philosopher calls "matter." The world is a hierarchy of substances, the loftiest of them immaterial; all things with an actual existence are complex beings, within which form is engaged in layers of diverse materials or, to say it another way, beings in which matter displays itself, molded into increasingly complex forms.

Nowhere does primal matter exist in a state separate from everything else. It is present, joined to form, in the nature of all individual, concrete objects. There are simple bodies, for example, earth or water; and composite bodies, for example, bodily organs. Living bodies are more complex still, that is, they form more "informed" units. Man has been endowed with an additional form, the agent of the intellect. Finally, there are pure substances, intelligences responsible for the movement of the planets, and the loftiest of these is God.

Matter does not stand opposed to a fuller reality, a transcendent idea: it does not have a lesser reality. It is the necessary component that, joined to immanent form, bestows being on every thing and ensures it its individuality. Essence, or form, the principle of immaterial structure, transforms matter into a determinate thing. Material things are as real as immaterial ones, sensible things as real as intelligible ones.

Matter is also not evil. Everything becomes, that is, moves from potential to act, via the action of something existing. (This is a key Aristotelian theorem, that the act is prior to the potential.) Man engenders man: one man, potential in

sperm, is produced by another man in an act. The higher one rises in the hierarchy of beings, the more these beings are purged of potential. God is what he is, always and for all time; he does not possess a single element of unrealized potential: he is pure act. Form is also perfectly active. That which is eternally active cannot display the internal contradiction called "evil." For Aristotle, there is no principle of evil.[85]

Nonetheless, evil can arise from potentiality: in fact, contraries are lodged within potential, and a bifurcation can occur, preventing the potential being from reaching the perfection within its grasp. Matter, or necessity, can form an obstacle, preventing individual things from moving as close as they might to divine life, from becoming "immortal as far as possible."[86] Matter and necessity are not evil principles, however, even though they sometimes cause accidents in the cosmic process. In the *Physics,* Aristotle attributes to matter itself a spontaneous aspiration toward form, that is, toward the good: "Matter calls to form as its complement, just as the female calls to the male."[87]

2. Aristotle establishes the dignity of mimetic art and of the artist engaged in imitation. For Plato, art is imitation, but imitation of a reality separated by several degrees from true reality, from the transcendent Idea. It is the imitation of an imitation. For Aristotle, in contrast, the artist imitates reality, but a reality that is there, a matter permeated by the form that constitutes it as a reality. The artist patterns himself on that active form, that prior structure, which acts as a final cause, which the artist has present in his mind and toward which he aims as a particular efficient cause. He thus stands in the same relation to reality as the demiurge in *Timaeus.* That is why, referring to the production of things, Aristotle places natural and artistic processes side by side. They are different, but they lie on the same plane in relation to reality.

All the same, Aristotle does not claim that human works are equal in dignity to the works of nature. On the contrary, human works acquire a form, an intelligibility, and a value only inasmuch as they are part of the organizing productivity of nature and manifest the teleology immanent within it.[88] This is a long way from modern (or even Sophistic) artificialism, in which human productions are not sustained by the cosmos but are related only to themselves or to the artist.

Let us return to the parallel between art and nature: "Of things that come to be, some come to be by nature, some by art *[technē],* some spontaneously."[89] An animal, for example, comes by nature; a house or statue, by art; health, spontaneously. In natural products, the agent is nature, and the form in keeping with which they are produced is also nature. In artistic products, "the form is in the [artist's] soul."[90] The principle of action is thus not the artist, but art itself. The

house comes from the house. "The active principle and the starting point . . . [is] the form in the soul."[91] In other words, the deliberation that takes place in the artist's mind is not essential: if it could operate apart from the artist, art would act without deliberation, like nature itself. Or, the cause of the work of art is less the intellect than the intelligible, and deliberation is only an accident of causality. The logos lies at the origin of all creation. In natural creation, it is identified with a nature. In the creation of artifacts, it lies in the artist, it is present to a consciousness: "Thus if a house, e.g., had been a thing made by nature, it would have been made in the same way as it is now by art; and if things made by nature were made also by art, they would come to be in the same way as by nature."[92]

The parallelism between art and nature is therefore perfect. Nature acts like a cosmic artisan who fabricates, sketches, arranges harmoniously. From the procedures of one it is possible to draw conclusions about the procedures of the other, and vice versa. Symmetry explains the duplication of organs: symmetry is a principle of art and a principle of nature. In reproduction, "the seed is productive in the same way as the things that work by art, for it has the form potentially, and that from which the seed comes has in a sense the same name as the offspring."[93]

Reciprocally, art acts by imitating nature. It acts in two stages, first, a mental stage *(noesis)*, then a stage governed by the first, that of external realization *(poiesis)*. Works of art are different from works of nature in that they do not have an internal dynamism. They have no tendency toward change, since they do not have the principle of movement in themselves.[94] If a bed changes, it is not because it is a bed but because it is made of wood, and the wood deteriorates. The active principle of the work of art is external to it: "All art is concerned with the realm of coming-to-be, i.e., with contriving and studying how something capable both of being and of not being may come into existence, a thing whose starting point or source is in the producer and not in the thing produced."[95] In that sense, Aristotle claims, the artist, under the guidance of the logos, is not only an actor but a creator. "Creation" should not be understood in terms of its Christian connotations. It means simply an external result, the "action," viewed primarily from a subjective perspective. It is not insignificant, however, that Aristotle uses the word "creation": "There is no art that is not a characteristic or trained ability of rational creation."[96]

All this applies to art in the general sense of *technē*. The fine arts (there is no special word to designate them) are a special area of *technē*. Their aim is enjoyment, pleasure *(edonē)*, relaxation *(diatribē)*, rest, and education *(paideia)*. Their principle is still imitation. "They differ from one another in three ways, either

by a difference of kind in their means, or by differences in the objects, or in the manner of their imitations."[97]

The aim of art is the beautiful, that is, harmony, which, according to Aristotle, leads to "idealization." He advises the tragedian to conduct himself like the "good portrait-painters" who "reproduce the distinctive features of a man, and at the same time, without losing the likeness, make him handsomer than he is."[98] The artist, one might say, supplements the lack in matter, which does not unfailingly receive the perfect form. That is why artistic imitation is a source of pleasure and admiration. "Such things as acts of imitation must be pleasant— for instance, painting, sculpture, poetry—and every product of skilful imitation; this latter, even if the object imitated is not itself pleasant; for it is not the object itself which here gives delight; the spectator draws inferences ('This is a so-and-so') and thus learns something fresh."[99] And the process of learning is agreeable.

A parallel passage from the *Poetics* adds another nuance: it is pleasant to contemplate the image of lowly animals and cadavers, for instance, not only because man, the most imitative of animals, enjoys imitations, but also because he admires the very activity of the artist, his craft. "One's pleasure will not be in the picture as an imitation of it, but will be due to the execution or colouring or some similar cause."[100] In some sense, admiration deflects off the work and onto the artist.

Nowhere does Aristotle express that dignity of man, of the artist, as a "collaborator" with nature, so well as in his reflection on the human hand. Anaxagoras claimed that man was the most intelligent of animals because he had hands. Aristotle writes: "It is more rational to suppose his endowment with hands is the consequence rather than the cause of his superior intelligence. For the hands are instruments or organs, and the invariable plan of nature in distributing the organs is to give each to such animal as can make use of it."[101] Nature, as artist, judged it expedient to make man an artist. Because he is capable of the logos, he is capable of impressing form.

Plato judged art inferior because it is mimetic. Aristotle justifies it for the same reason. Plato discerned that the true aspiration of art is to represent the divine with an image. But that image lacks reality. Aristotle, in contrast, places that image on the same plane as all realities existing in this world, because, fundamentally, they are produced in the same way—because they are a function of a logos, in harmony with the cosmic order, situated within the Prime Mover's gravitational pull. The artist—if not the work of art—imitates not the divine but divine activity. Plato leaves his pagan and Christian posterity to face the aporia of the divine image: tantalizing, neither avoidable nor practicable. Aris-

totle leaves his posterity to consider the eminent dignity of the image and of the image maker, who works like divine nature but cannot rise higher than he already is in the hierarchy of beings: above him, nature continues to create things that transcend him absolutely. In *The School of Athens,* Raphael found the gesture to sum up, synthesize, and symbolize this difference. Plato and Aristotle are equally majestic, equally divine and earthly: Plato points to the heavens with one finger; Aristotle reaches toward the earth with his broad hand. In front of them, the *Disputà* unfolds, enveloping and justifying them both.

It is clear that, among the posterity descending from the two founders, the point of equilibrium has not always held; inevitably, it has given way. Those who despair of art find an authority in Plato. Those who retreat to the representation of things, who avoid directly confronting the divine, who are content with art, the painter's craft, and good taste, may lay claim, though wrongly so, to Aristotle. When the sublime is at issue, people turn to Plato. When the subject at hand is the "creative" artist like unto the gods, they remember Aristotle, even though he would have strongly disapproved of such senseless hubris.

3. Late Philosophy

Cicero

Cicero does not often have occasion to confront the question of divine images. In his treatise *De natura deorum,* he gives the floor to the Stoic Babus, who sets out the doctrine of the sect, drawing inspiration from Panetius, Posidonius, and sometimes from Zeno and Cleanthes. "The specific function of an art or craft is to create and generate, and . . . what in the processes of our arts is done by the hand is done with far more skilful craftsmanship by nature, that is, . . . by . . . the teacher of the other arts. And on this theory, . . . each department of nature is 'craftsmanlike,' in the sense of having a method or path marked out for it to follow." Not only is nature made artfully, "the nature of the world itself . . . is . . . actually 'a craftsman,' whose foresight plans out the work to serve its use and purpose in every detail."[102] Nature, or the world's soul, is an artist, and, inasmuch as it watches over order and the good, it is also providence. The art of nature is superior to human art, of course: above men, "a vast company of gods" are at work; they "are never idle nor yet perform their activities with irksome and laborious toil. For they have no framework of veins and sinews and bones." "They are endowed with supreme beauty of form, they are situated in the purest region of the sky," and they preserve and protect all things.[103]

According to Diogenus Laertius, Zeno claimed that "a perfect and complete

being is bound to possess that which is the best thing in all the world; but no being is more perfect than the world, and nothing is better than virtue."[104] In the Stoic view, the divine cosmic force creates works through artistic fire, the igneous principle, which gives form to everything. The human artist cannot equal these works, but in struggling, he fashions himself, *artifex sui*. The artist becomes the artist of himself, patterning himself on the divine structure of the world. This is an exemplary case of the fundamental precept of the Portico: to live in accordance with nature. The divine image is not the image of a god but of the totality of the divine diffused throughout nature. According to such a conception, there is no reason to challenge the popular images given credence by the commonwealth. On the contrary, Stoicism welcomes popular theology and complies with it. It simply reinterprets these images, giving them a purified meaning. The most "impious" fables—such as that of Saturn castrating his father, Caelus—have a "physical," that is, a spiritual doctrine: in the case of Saturn, the fable is that the heaven made of ether and fire, which engenders everything, does not need a bodily organ to engender.[105] The ordinary form of worshiping the gods is acceptable, but it is better to venerate them with the soul and with pure and sincere words. Religion can always be—and always has been—distinguished from superstition. In art as in nature, reason is at work, and in equal measure. If Posidonius and Archimedes were able to construct an orrery that accounts for all celestial movement, how can we doubt that reason governs both the sky and the orrery? The only mistake would lie in equating one with the other.[106]

An orrery can serve as an image of the divine. But so can any statue decorating a forum: its value resides in its conformation to moral good, which is the highest form of the beautiful. The representation of the divine is thus governed by tact, taste, propriety, the *quod decet*, which establishes proper proportion. That is why it is inappropriate to listen to Homer when he tells us the story of Ganymede: rather than impute human attributes to the gods, "I had rather he had attributed divine feelings to us [men]."[107] The beautiful is the bloom of the good. *Decorum* is the form taken by *honestum*.

Stoicism is not part of the iconoclastic world. God is everywhere and nowhere. The philosopher looks upon images in an attitude of respect, reserve, reverential skepticism. Renan rediscovered that state of mind on his own: he welcomed manifestations of popular piety, because they are the expression of the best that is in the human soul. But these manifestations must not be taken literally: they are imperfect and symbolic images of higher realities, which only the philosopher can grasp and render. They are infinitely far from God, but they

are nonetheless good, because they ennoble those who make them or those who contemplate them with a pure, sincere, and naive soul. They promote good morals.

Cicero, who is not always in agreement with the Portico, does consider himself associated with the Academy. In this vein, he produced a text to which Panofsky attributes great importance, and which he has masterfully explicated.[108] It is found in Cicero's *Oratore ad Brutum.*

> I do believe that there is nothing in any genre so beautiful that that from which it was copied, like a portrait of a face, may not be more beautiful; this we cannot perceive either with eyes or ears or any other sense, but we comprehend it with our mind and with our thoughts; thus we can imagine things more beautiful than Phidias's sculptures, which are the most beautiful we have seen in their genre, and those pictures which I have spoken about [works by Protagenes, Apelles, Phidias, and Polyclitus]; and indeed that artist, when he produced his Zeus or his Athena, did not look at a [*scil.* real] human being whom he could imitate, but in his own mind there lived a sublime notion of beauty; this he beheld, on this he fixed his attention, and according to its likeness he directed his art and hand. As there is in the world of shapes and figures something perfect and sublime *[excellens]*, to which imagined form those objects not accessible to sensory perception [*scil.* the divine beings to be represented] and be related by way of imitation, so do we see the image of perfect eloquence in the mind and only seek to comprehend its copy with the ears. Plato, that mighty master and teacher not only of thought but also of speech, calls these forms of things "ideas"; he denies that they come into being and asserts that they exist eternally, being contained in our reason and our intellect: all else is born and dies, remains in a state of flux, glides down and does not long remain in one and the same state.[109]

The notion seems to be the following: nature is a better maker than the artist, but a model exists in the artist that is superior to the image he creates, superior to any created image. That form is a pure thought, which does not stem from the consideration of sensible forms. That mental form is the Platonic Idea—eternal, imperishable, intelligible. Hence, the Platonic Idea can be turned against the Platonic condemnation of art. The artist is not an impotent and frivolous imitator, at one remove from reality: his mind contains the model of beauty toward which he can direct his internal gaze and thereby act as true creator.

Such a reversal can be explained in part by the higher status of the artist in the Greco-Roman world. The great painter and the great sculptor were considered higher beings, with greatness bestowed on them by the gods. Seneca cannot resign himself to assigning painting and statuary the same status as the liberal arts,[110] but Pliny accepts them as such.[111] Roman aristocrats were passionate collectors. Whenever someone is willing to pay a high price for a work of art, the

artist will be highly honored, and the work of art will attain a greater status. The act of collecting produces connoisseurs. Paintings acquire an autonomy in relation to the appearance and imperfections of reality. Philostratus claims: "Whoever scorns painting is unjust to truth."[112] Of course, there is no doubt that the work of art is inferior to nature. But, paradoxically, it is also clear that the work of art corrects nature by erasing the "defects" of the natural objects represented and by composing a more perfect image than that offered by nature. Hence the oft-cited anecdote about Zeuxis, who, obliged to represent Helen, summoned the five most beautiful girls in Croton in order to render the perfections of each one in his painting.[113]

But the Ciceronian reversal is also an expression of the strong infusion of Aristotelianism into academicism, or rather, the search for a compromise between Plato's positions and those of Aristotle, a compromise that will eliminate the discredit attributed to art. The Platonic Idea moves away from its status as metaphysical essence and closer to a mere concept. It leaves its supercelestial place and settles in the artist's mind, since, according to Aristotle, the only difference between the products of nature and works of art lies in the fact that, in art, Form resides in the human soul before permeating matter. The Idea that existed in Phidias's mind when he created his *Zeus* was "a hybrid of the Aristotelian 'internal form' with which it shares the attribute of being a notion immanent in consciousness, and of the Platonic Idea, with which it shares the attribute of absolute perfection, *perfectum et excellens*."[114]

Thus the artist, debased by Plato and restored—along with any artisan whatever—to his dignity by Aristotle, was now glorified far beyond ordinary humanity: for neither the shoemaker nor the carpenter will ever entertain the "Ideas of thought" that place Phidias and Zeuxis among the ranks of divine heroes. That promotion of the artist was not forgotten during the Renaissance and romanticism, and it endures to this day.

If we must speak of the image of the divine, we now see where we must seek it in the first place: in the artist's mind, in the Idea of his thoughts. The work of art is only the imperfect reflection of that Idea, or its symbolic expression. Or so suggests Dio Chrysostom, a Cynico-Stoic rhetor or preacher from the imperial era.

In his *Olympic Discourse*, Dio wonders how the notion of the divine was formed and developed. He sees four sources: the sight of nature, the inventions of poets, the laws of lawmakers, and, finally, the images produced by great artists and the arguments of philosophers. He places one speech in the mouth of Phidias. Phidias did not invent the Idea of Jupiter. That Idea is innate, necessary to intelligence. Its cause lies in man's kinship to divine nature. On this point,

Dio is following the Stoic doctrine of innate "prior notions," contents imma-
nent to consciousness and prior to experience (already a subjectivization of the
Platonic Idea). The Idea exists before the artist, and he simply becomes its inter-
preter. Yet the Idea is invisible: nothing can represent it in a sensible manner.
Thus, the way Phidias finds is to use the body as a symbol by which the invisible
becomes visible and the spiritual, material:

> As for that in which this intelligence manifests itself [i.e., the body], men, hav-
> ing no mere inkling thereof but actual knowledge, fly to it for refuge, attribut-
> ing to God a human body as a vessel to contain intelligence and rationality, in
> their lack of a better illustration, and in their perplexity seeking to indicate
> that which is invisible and unportrayable by means of something portrayable
> and visible.[115]

Dio did not elaborate further on this formulation, and it had no immediate
influence. But every word is in keeping with later aesthetics. To situate the mind
in a human form became the task of the icon; to express the invisible through
the visible would be the goal of the romantics.

Plotinus

Is the internal image Cicero speaks of simply an Idea in the mind? Is the perfec-
tion the artist seems to see in it true perfection? Plotinus replies it is the only per-
fection, and that it has a metaphysical right to claim the status of perfect and
supreme model.

Plotinus's cosmos can be compared to a luminous, transparent, homoge-
neous, yet still centered sphere.

> Bring this vision actually before your sight, so that there shall be in your mind
> the gleaming representation of a sphere, a picture holding all the things of the
> universe. . . . Keep this sphere before you, and from it imagine another, a
> sphere stripped of magnitude and of spatial differences; cast out your inborn
> sense of Matter, taking care not merely to attenuate it: call on God, maker of
> the sphere whose image you now hold, and pray Him to enter. And may He
> come bringing His own Universe with all the gods that dwell in it—He who is
> the one God and all the gods, where each is all . . . distinct in powers but all
> one god in virtue of that one divine power of many facets. . . . There is no out-
> ward form to set one here and another there.[116]

The world can also be compared to "a life, as it were, of huge extension, a to-
tal in which each part differs from its next, all making a self-continuous whole
under a law of discrimination by which the various forms of things arise with no
effacement of any prior in its secondary."[117] It can also be compared to sun-
light, to an eternal emanation of indivisible light, and to the might of a hand

that extends indivisibly to all bodies, which it can hold and move.[118] Although homogeneous, this world is also hierarchical. In the center stands the One, the first principle; the intelligence and the soul proceed from it, because the overabundance of the One radiates like a spontaneous, continuous, eternal ray, which disperses as it loses strength, like spraying water. It is unified and concentrated in the intelligence, more diffuse in the soul, and it expires in the vicinity of matter. But that hierarchy forms a continuum: it is all the same dynamic reality, but perceived at different levels.[119]

At the center is the principle, the One: it lies beyond being, beyond essence. It brings everything into being, but it is not being. It is more than a god, more than intelligence. It is self-sufficiency in the extreme. "This is utterly a self-existent, with no concomitant whatever. This self-sufficing is the essence of its unity. Something there must be supremely adequate, autonomous, all-transcending, utterly without need."[120] It is called the Good, but that is not an attribute: it is the good in itself. It does not dwell within the good. It has no thoughts and no movement, since it is prior to thought and movement. "This we can but name The Unity, indicating it to each other by a designation that points to the concept of its partlessness."[121] In fact, it "does not deign to be beautiful."[122]

Plotinus offers salvation, like the Gnostics, and like Christians contemporary with him. As for the Gnostics, salvation is possible because man is superior to his destiny, insofar as he is able to perceive his fallen state. This fall from on high, from our original home, is also the key to conversion and to the return to the transcendent world. Plotinus proposes a journey of the soul, whose mythic model is that of Odysseus returning to his homeland, an internal anabasis.[123] But this journey is the opposite of the Gnostic journey, which wants to break free of an evil world, and which is conceived as the story of a fall, a struggle, and a final redemption coming about within time. For Plotinus, in contrast, the world is good, perfect even. Moreover, it is eternal, and time does not alter it. Salvation is within reach in the cosmos as it is, and at every moment.[124]

> Many times it has happened: lifted out of the body unto myself; becoming external to all other things and self-centred; beholding a marvellous beauty; then, more than ever, assured of community with the loftiest order; enacting the noblest life, acquiring identity with the divine; stationing within It by having attained that activity; poised above whatsoever within the Intellectual is less than the supreme: yet, there comes the moment of descent from intellection to reasoning, and after that sojourn in the divine, I ask myself how it happens that I can now be descending, and how did the soul ever enter into my Body, the Soul which, even within the body, is the high thing it has shown itself to be.[125]

The site of salvation is clear: it is neither, as the Gnostics would have it, in the supercosmic good from which we are separated by heavenly spaces nor, as the Christians claim, in the return to a lost state to which only divine grace can lead us. Salvation is within us: it is in the depths of ourselves. We have only to return to ourselves.

Because of the continuous nature of the world, which extends from the first hypostasis to the last, all the way down to matter, our soul—wherever it may be—belongs to divine thought by virtue of a portion of itself. It is capable of the One. It is necessary and sufficient to shift one's attention: "You must set aside and refuse to see: you must close the eyes and call instead upon another vision which is to wake within you, a vision, the birthright of all, which few turn to use."[126] This can be achieved only if the soul is purified. In Plotinus's time, the philosophical life was the life of a religious community, marked by spiritual exercises within a constant practice of asceticism.

According to Porphyry, Plotinus "seemed ashamed of being in the body." Contemplation is possible only if the "internal mirror" offers a smooth, polished surface in which the intelligence and the One can be reflected. We suffer not from having a body—since the body is itself part of the cosmos, which is good—but from the attention we give it. "Knowing and knowable must all be left aside; every object of thought, even the highest, we must pass by, for all that is good."[127] In a gradual relinquishment, the soul, after repudiating the sensible world, dialectical discourse, knowledge, and intellectual intuition, after abandoning even the contemplation of the beautiful, finally achieves oneness with the One only. "In our present state, part of our being weighed down by the body, as one might have the feet under water with all the rest untouched—we bear ourselves aloft by that intact part and, in that, hold through our own centre to the centre of all the centres, just as the centres of the great circles of a sphere coincide with that of the sphere to which all belong—Thus we are secure."[128]

There is no analogical relationship between sensible beauties and the beauty of the One: the former are simply the infinitely diluted reflection of the latter. They cannot serve as a medium to attain it. In no case are we to be satisfied with them. The soul that possesses love of the Good "waits for no reminding from the beauty of our world." "Holding that love—perhaps unawares—it is ever in quest and, in longing to be borne Thither, passes over what is lovely here, and with one glance at the beauty of the universe dismisses all; for it sees that all is put together of flesh and Matter, befouled by its housing."[129] The only image of the divine is the one created by the purified soul in itself, by becoming the perfect mirror on a smooth, calm surface. But note that this is not an image. Con-

templation, in fact, is nothing but emanation in reverse. Moved by desire, the soul makes itself present to God, and God makes himself present to the soul. As for the object seen by man, "we should not speak of seeing; but we cannot help talking in dualities, seen and seer, instead of, boldly, the achievement of unity. In this seeing, we neither hold an object nor trace distinction; there is no two. The man is changed, no longer himself nor self-belonging; he is merged with the Supreme, sunken into it, one with it: centre coincides with centre, for centres of circles, even here below, are one when they unite."[130]

In its ecstasy, the soul is not the image of God: God is entirely present in it, and it entirely present in God. For Plotinus, vision consists in the contact between the internal light of the eye and external light. On this point, Plotinus is in agreement with Plato and in disagreement with Aristotle, who maintained that the eye is passive, that it belongs by nature to the world of water, not of fire. But Plotinus concludes that, when vision becomes spiritual, there is no longer any distinction between internal and external light. "Vision is light, light is vision. There is a sort of autovision of light: light is as it were transparent to itself."[131]

Thus, for Plotinus, the path of salvation is an identificatory contemplation. The soul "has turned away from all about [it] and made [it]self apt, beautiful to the utmost, brought into likeness with the divine";[132] it awaits the divine in a purely passive stance. Only then can it be visited by God. This is ecstasy, the sensible, "theopathic" presence of the divine, the unveiling in the instant of an eternal reality, which Plotinus has personally experienced four times in his life.

The soul breaks free from the material world and from sensible beauties only because it is seeking its salvation. Compared to the soul and its destiny, the world is an illusion. But that does not mean the world is evil or ugly in itself. It is so only because it risks locking the soul inside Circe's stable. Its beauty comes to it through emanation and procession, from the toiling of the soul, which organizes the pure nothingness of matter and gives it a semblance of form. The world is not evil except as a temptation: it runs the risk of deluding the soul which, in turning toward it, turns away from the place "Thither" that awaits it. In believing it is growing richer, it becomes impoverished. But the soul, once converted and on the path toward the One, no longer has anything to fear from the world and does not hold it in contempt. Having purified itself of the matter that held it back, the soul contemplates it from above, but without disgust. The sensible world must be accepted inasmuch as it manifests the world of Forms: "Their teaching [that of the Gnostics] leads to a hate and utter abandonment of the body. . . . In other words: two people inhabit the one stately house; one of them declaims against its plan and against its Architect, but none the less main-

tains his residence in it; the other makes no complaint, asserts the entire competency of the Architect, and waits cheerfully for the day when he may leave it, having no further need of a house."[133] In a hierarchical and homogeneous world, everything has its place: one is "not to slander, as negligent in the quest, others who are able for it and faithful to it." One must kindly accept the nature of all things.

To look at things entails extending eyesight through the mind's vision. That is why Plotinus invites us to a vision "of the sun and of all the stars with earth and sea and all living things as if exhibited upon a transparent globe."[134] This is what he calls the "method of Lyncea," who saw even what was inside the earth. To see the layers of successive planes, from first appearances to bottomless depths, is the very ideal of artistic vision, at least in the modern era.

What, then, is the status of art? Given the alternative between the soul, which escapes by breaking free of appearances and of matter, and that matter itself, indistinctly formed, as far as possible, by the intelligence and the soul, art may appear to be either a collateral salvation of matter or a subsidiary activity related to man's salvation.

Plato invites the philosopher to go directly—dialectically—to meet reality. In comparison, art is only a degraded mimesis of things. Plotinus completely reverses that point of view. The criterion governing the work of art is not discursive, theoretical truth, but rather its proximity to the place where truth metaphysically reveals its oneness with beauty. In the vast circulation of spirits in the Plotinian world, in the movement of procession and reintegration, *exitus* and *reditus,* art stands at the point where things turn around and go back, where things return to the starting point on the path to the One and begin the move toward reintegration.

But this move first occurs in the artist's soul. Matter follows the internal idea the best it can. Let us take two masses of stone, says Plotinus. One is in its crude state. The other has received the artist's imprint, has been transformed into a statue of a god or of a man, which art created by combining everything beautiful it found. The stone has become beautiful as a result of the form art has introduced into it. "[This Form] is in the designer before ever it enters the stone; and the artificer holds it not by his equipment of eyes and hands but by his participation in his art."[135] Plotinus, then, formally challenges Plato:

> Still the arts are not to be slighted on the ground that they create by imitation of natural objects, for, to begin with, these natural objects are themselves imitations; then, we must recognize that they give no bare reproduction of the thing seen but go back to the Reason-Principles *[logoi]* from which Nature itself derives, and furthermore, that much of their work is all their own; they are

holders of beauty and add where nature is lacking. Thus Pheidias wrought the
Zeus upon no model among things of sense but by apprehending what form
Zeus must take if he chose to become manifest to sight.[136]

Phidias does not represent Zeus in a degraded form: he has in mind Zeus's
essence, he is visited by Zeus. For Plotinus, the intelligence engenders ideas di-
rectly from itself, and even the Platonic demiurge is guided by it in fashioning
things. The beauty of things is the idea radiating throughout matter, to the de-
gree that matter is able to be shaped by it. There is a similarity between beauties
"thither" and those "here below," since both participate in an idea. In the same
way, the artist may express an idea in matter, and he works to animate it.[137]

Plotinus refutes Plato by adopting the Aristotelian point of view: the artist,
like nature, gives a form to matter. But Aristotle considered the object formed a
sufficient reality and did not look beyond it; he founded a statics of the work of
art and refrained from holding matter in disrepute, because it always has the ca-
pacity to take on form and even calls for form. In contrast, Plotinus considers
matter evil, an absolute lack of being. The artistic idea wrests matter from its
nothingness and leads it on the path to the One, as far as it is able.

That is why Plotinus formally challenges the Stoic convention that sees
beauty in symmetry, measure, the harmonious arrangement of parts and of
beautiful colors. In fact, it is not the composition of parts that is beautiful. Each
part is illuminated by a transcendental, unifying principle, its participation in
the Idea.[138] The whole focus of Greco-Roman classicism on the harmony of
parts in relation to the whole is thus turned on its head.

In a famous article, André Grabar shows how the Plotinian state of mind
(since a direct influence is difficult to document) changed the art of the Later
Empire. Matter was worked in such a way as to transmit the *nous,* the only real-
ity, and the "work of art's only reason for being."[139] From this, he deduces sev-
eral techniques and stylistic traits enumerated and developed by Byzantine art.

But the same spirit found new life in the aesthetics drawn from Hegel and
Schelling. Clearly, the treatise on the beautiful continues to haunt modern art.
For Plotinus, religion has no rites, no cult, no relation to the commonwealth,
and the artist, like the philosopher, is the solitary priest of that religion. He too
"is merged with the Supreme, sunken into it, one with it."[140] He opens the way
for the modern artist—asocial and in revolt. But this artist is unhappy, because
he cannot pull matter "thither" to the degree he wishes. The artist's plan is al-
ways superior to its execution, because of the resistance of matter and, finally,
because of its very existence: "For the beauty inherent in art does not itself enter
into the stone, but it remains unto itself, and that which enters into the stone is
only a lesser beauty derived from it; and even this does not remain pure unto it-

self and such as the artist desired it, but is revealed only insofar as the stone was obedient to art."[141]

The more beauty permeates matter, the more it loses its relation to Beauty in itself. The plan gets bogged down and extenuates itself. As Panofsky writes, Raphael's thoughts, deprived of hands, have more value than Raphael's paintings in the flesh.[142] Plotinus justifies the pride of the impotent artist.

Every work of art introduces the divine into an image: Plotinus, even more than Plato, encourages and even exhilarates the iconophile. But he immediately discourages him as well because the undertaking is futile. When the task is to make an icon of the divine, it becomes completely absurd: Plotinus, even more than Plato, can be invoked by the iconoclast. His aesthetic is without "works." The undertaking is absurd not only because of matter's incapacity but, in the case of the divine, because of the incapacity of form itself. The loftier the artist's idea, the more it will participate in the One, and the higher it will rise toward the regions where forms themselves no longer hold sway. True beauty is constituted by unity, which transcends the composition of the parts, and by the form of something that transcends form.

> Amid all these things of beauty we cannot but ask whence they come and whence the beauty. This source can be none of the beautiful objects; were it so, it too would be a mere part. . . . The origin of all this must be the formless—formless not as lacking shape but as the very source of even shape Intellectual. . . . So with shape: granted beauty, the absence of shape or form to be grasped is but enhancement of desire and love; the love will be limitless as the object is, an infinite love.[143]

Puech summarizes this idea perfectly in noting that Plotinus's vision, in which "the lover" relentlessly pursues the "invisible image," is, in the end, an "aesthetics of the formless." Contemporary abstract art could call itself "Plotinian."[144]

That is why, in his contempt for a body subject to change and corruption, Plotinus refuses to consider the iconological reproduction of a particular being—the "idol of an idol"—a work of art, and why he never wanted to have his portrait done. What would he have thought of Christians' mad quest to represent the divine Word itself by imitating the style of Faiyūm funerary portraits and Roman *personae*?

4. The Persistence of the Pagan Image

The philosophical critique ushered in a transcendental—and, by that very fact, unrepresentable—conception of the divine. It could have fed an iconoclastic

movement, but that did not happen. This critique, like that occurring later in the Christian world, was erudite, elitist—too erudite and elitist. It did not have the connections to the social world that might have led to a destruction of images.

Representation continued. Canonical prototypes were recopied ad infinitum. Their religious value may have lost some of its potency; that is not certain, however, since in the ancient world all images were charged with divinity, even those that did not claim to depict a god. The mosaics found in abundance in Tunisian or Aquitaine villas may show fish, vine branches, or zodiac signs: all these images elevate the soul, place it in the presence of the sacred, at least within a religious climate. A continuous chain unites the baskets of fruits, Tritons, and major gods, under a heaven that infuses these objects with the divine, because heaven is itself divine. Thus, as the icon became impossible as far as relating to God himself was concerned, it became charged with the divine by virtue of representing the things of the earth. Let us keep that other tradition in mind. As we shall see, it holds one of the secrets to Western art.

Although the gods of the commonwealth gradually lost their "religious tenor," new forms of religion replaced them and, as the transition to Christianity approached, religiosity gained in intensity and called forth new images. The new theology also justified the older images.

The Cosmic God

Epinomis proposes to give "an imaginative presentation of the gods, nobler and better than those which have been given in the past."[145] One has only to look toward the heavens to discover the divine race of stars, fiery, alive, intelligent, and visible. Either they are gods or the images of gods, "likenesses of gods, images, as it were, fashioned by the gods themselves. . . . None can ever be found fairer and more accessible to all mankind, or set in a more excellent region."[146] If stars are likenesses and not gods, as is probable, they are natural icons, icons not made by human hands. But they occupy the top of the hierarchy of living things; they envelop and dignify the old gods, who are subordinate to them. Every act, and in particular every act of representation inspired by that piety, favors the ascension of the soul and benefits from that ascension.

At the beginning of his poem *Astronomica,* the poet Manilius (first century B.C.) did not simply go to the Helicon to invoke the Muses, as had been the practice; he went to the "Temple of the World." Manilius was the priest of that temple, and spinning around him was the huge, roaring orb of the universe *(immenso vatem circumstrepit orbe).*[147] The idea that the world was a temple was be-

coming a commonplace. Chrysostom claimed that it constituted an initiation, which meant one did not have to lock oneself into the cramped chapel where mysteries were usually celebrated.[148] And Plutarch wrote: "The universe is a most holy temple and most worthy of a god."[149]

That sentiment permeates all of Stoicism. It is not that God himself is representable, but that any representation, any act of thought or of virtue, naturally carries the divine within itself, provided the soul turns toward lofty things, provided it feels its kinship with the supreme figures of the cosmos. Whatever distance the sage took care to establish among God, images produced by the hands of the gods (the stars), and the imperfect images of human industry, the latter images were still worthy of respect. Within their own limitations, they achieved their goal. It was impious not to venerate them.

To see God face to face: that was the universal desire. Justin Martyr sought the true God. He turned to the philosophers because, as he wrote, "Is not this the duty of philosophy—to investigate the Deity?" He went to a Stoic, then a Peripatetic, then a Pythagorian, but he was always disappointed. Finally, he followed a Platonist, because seeing God face to face "is the aim of Plato's philosophy." He fled men, seeking refuge at the seashore, where he meditated at his leisure. It was there he met the worthy man who would lead him to Christ.[150]

One of the most important accounts of this religious quest is the *Corpus hermeticum*. It reflects the cosmic piety shared by Cicero, Seneca, Philo, and Epictetus, and touches on popular religion and Gnostic theosophy. How can we see God? Treatise 5 responds: God makes himself visible in the beautiful organization of the universe and also in man, whose every part was created in view of a beautiful and good end, in both the macrocosm and the microcosm. "If, therefore, you wish to see God, consider the sun, consider the phases of the moon, consider the order of the stars . . . consider how man is fashioned in his mother's womb . . . and learn to know who it is who fashions that divine image of man."[151] Treatise 11 magnificently repeats the same lesson: "There is nothing invisible, even in the incorporeal. The intellect makes itself visible in the act of thought, God in the act of creation."[152]

The rather confused philosophy of Hermeticism does not distinguish among several religious positions. The first appears to be in accord with the most ancient form of paganism, universal animation, the diffuseness of the sacred, as it appears in Homer and Hesiod. But this position is contaminated by philosophical religion, which tends to place the divine above the world. Treatise 11 presents God as an incorporeal, "uncircumscribed" form that contains beings only as thoughts, and which a person can resemble only by giving to his own thoughts an extension equal to its own.[153] As Festugière comments, it stands at the con-

fluence of two currents, "an idealist current with a transcendent God, a pure 'amorphous' intellect reached only through the *nous,* and a pantheistic current with an immanent God identical to the world, who is attained directly through contemplation of the world."[154] Although these two positions are compatible with divine images, a third is not: this is Gnosticism, remnants of which can be found in the Hermetic corpus. In the Gnostic vein, the world is evil, God did not fashion it, God is infinitely far away. Contemplation of the world does not lead to God. God is *agnōstos,* and we can know him only by delving deep into ourselves, into our souls, which are particles of that God which have strayed into this world. Through prayer and asceticism, the exceptionally favored individual can obtain an "autoptic" vision.[155]

Theurgy and Magic

Another approach can also be found in the Hermetic movement, namely, magic. This time, the fabricated image of the god must be infused with the energy of the god it represents. Here again, popular and philosophical religions are combined.

The recipes found in magical Greek papyri, extending from the fourth century B.C. to the seventh century A.D., with most dating to the second, third, and fourth centuries A.D., can be attributed to popular religion.[156] As for philosophical religion, *Asclepius* declares: "Just as the Lord our Father—or God, to give him his supreme title—has created the gods of heaven, so man has formed gods, which are in the temples and happy to be near men." Or again: " 'You speak of statues, Trismegistus?' And he replies: 'Yes, truly of them, Asclepius . . . but of statues equipped with souls, full of vital breath and spirit, which bring about such great and beautiful things.' "[157]

Augustine, who cites *Asclepius* in Latin translation, knows of these practices. Of Hermes, he says, "visible and tangible images are, as it were, only the bodies of the gods, and . . . there dwell in them certain spirits, which have been invited to come into them, and which have power. . . . To unite therefore, by a certain art, those invisible spirits to visible and material things, so as to make, as it were, animated bodies, dedicated and given up to these spirits who inhabit them—this, he says, is to make gods, adding that men have received this great and wonderful power."[158]

"Gnosticism and magic go together," remarks Frances Yates.[159] The pessimistic form of gnosis needs to know the formulas that will allow the soul to set aside the maleficent power of matter as the soul ascends through the spheres. The optimistic, pantheistic form of gnosis seeks to attract the powers of the

universe—beneficent in its view—to things. That is why the most quintessential philosophy is not afraid to compare these magical practices to theurgical operations. Iamblicus writes: "The wholly incorporeal gods are united to sensible gods, who have bodies, . . . and intelligible gods, as a result of their infinite unity, enfold these visible gods into themselves, and the two stand united and together."[160] All the same, Iamblicus, faithful to the Platonic hierarchy, keeps his distance and does not judge the maker of images capable of demiurgic art: "The fabrication of images is at many removes from the art of the creator of true realities: it does not even bear any similarity to divine creation." "If a soul looks upon these images as gods, the offense cannot be expressed in words or tolerated in deed. Never will a divine light shine on such a soul."[161]

Proclus practiced theurgy. He wanted to be the "hierophant of the entire world."[162] He overlooked no god, old or new. He invoked and evoked the gods. They visited him in a dream; thus he saw them. Divine images were therefore possible, since nothing prevented the person visited from reproducing these images, like the widely diffused statue of the Virgin, composed at Bernadette of Lourdes's instruction. But Proclus, whose life rich in miracles did not prevent him from being a very abstract thinker, had a theory to account for divine visibility and invisibility. The gods are incorporeal, hence invisible. Visibility comes from us, from our bodies. Divine images are luminous mediations between our souls—suitably purified by asceticism and theurgy—and our earthly bodies, which insert the soul in the cosmos. The souls bestow upon themselves what they receive from the gods, calling forth from within themselves the figures by which they visualize invisible powers. That figuration is the work of the imagination (*phantasia*).

Phantasia is an inner sensibility, which actively elaborates patterns and figures; it is to be distinguished from the sensibility that proceeds from without, passively, and which is distributed among the sense organs. Proclus concisely sums up his position: "Every god is shapeless. For the shape is not in him, but departs from him because the observer is unable to see what has no shape *[amorphōton]*, but perceives him through a shape *[morphōtikōs]* in accordance with the nature of the observer." To paraphrase Kant, we do not see the "god-in-itself." We impose the form of our understanding on the phenomenon.[163]

In late antiquity, people aspired to reconnect with the divine via multiple channels. The immediate familiarity of classical art, when the gods of the commonwealth lived freely among men, had been lost for several centuries. The labor of philosophy had greatly contributed to that estrangement. On all sides, through the most dubious practices of popular witchcraft, and through the speculations of neo-Platonic philosophy, efforts were made to reestablish the

ties. Such efforts were also made in the rather uncertain and incoherent in-between movement recorded in the *Corpus hermeticum*. The church fathers later said this was part of the pagan world's *preparatio evangelica*. Art bears witness to it, showing us Mithras, Attis, Isis, Artemis, Ephesus, and the hierophants of every school. Their eyes, looking directly at the beholder, shine with the glimmer of initiatory mysteries and visions. Their postures are those of contemplation.

With the rediscovery of that literature and art in the early Renaissance, the connection was made between the cosmic god and Western art. Magically chan-neled natural energies, considered good, were picked up not by philosophers and theologians (although Ficino and Pico discreetly practiced natural magic) but by artists. Images of gods, preserved in barbarized form throughout the Middle Ages, were vested with new powers. On the walls of a hall in the Schi-fanoia Palace, Duke Borso d'Este had a lower band painted with animated scenes from the court of Ferrara; but above them, dominating and organizing them, the thirty-six decans of the zodiac were arranged in tiers. These large, strange figures in fine modern costume were Hermetic gods, which Saint Au-gustine identified as demons. In the judgment of Frances Yates, "the operative Magi of the Renaissance were the artists, and it was a Donatello or a Michelan-gelo who knew how to infuse the divine life into statues through their art."[164]

The Political God

In 290 B.C., the Athenians sang the following hymn in honor of Demetrius Po-liorcetes: "Other gods are far away or have no ears, or do not exist, or pay no at-tention to our needs; you, Demetrius, we see right here, not in wood or stone, but actually present."[165]

In the Later Roman Empire, there was one icon throughout every common-wealth of the empire that indisputably and officially incarnated a god: the em-peror's statue. This was not a symbolic figure: the actual individual traits of the god were reproduced. His *persona* was present in the image, which was endowed with his powers. Just as the prefect was a representative of the state in the Napoleonic administration, and just as the priest represents Christ in the liturgy, the statue, as the emperor's legal representative, received divine honors in his place. The divine Augustus was present in the statue in front of which im-perial subjects made their sacrifices.

For thousands of years, the king of Egypt was considered God himself, and the king of Mesopotamia, God's vicar. In Greece, the royal cult predates Alexan-der. Clearchus established Greco-barbarian tyranny in Heraclea Pontica. He proclaimed himself son of Zeus, surrounded himself with liturgical ceremony,

required the proskynesis, the veneration, of his subjects. Philip II had his statue carried in a procession behind that of the twelve gods. Alexander founded the cult: the oracle of Siwah convinced him he was the son of Amun. He compared his triumphant march on Asia to that of Dionysus. He adapted the quasi-divine ceremony of the Achaemenids and imposed proskynesis on his companions.

The theological infrastructure existed in Greece as well and was sometimes elaborated in accordance with the sovereign's will: the idea of *daimon,* of *tukhē* ("fortune"), of divinity inspiring the individual and protecting him; the cult of the dead, of ancestral images; the cult of the hero, who accomplished superhuman feats and was accepted among the gods after his death, and particularly that of the founding hero, that is, the creator of a new human community, of a new commonwealth.

In Hellenistic monarchies, the non-Greek infrastructure, often more widespread and easily exploitable, was preexistent. In Egypt, the Ptolemaic king was the pharaoh's successor, and his cult was practiced by the indigenous peoples in accordance with the traditional rites. But, among all subjects, including the Greeks, new cults were added, celebrated in the Greek language, and overseen by the administration. Ptolemy II Philadelphus organized the cult of Alexander in Alexandria. He combined it with the cult of his father, Soter (Savior), then of his sister-wife, Arsinoe. She was deified after her death. She had a temple, in the nome of Arsinoe in Crocodilopolis. Adonis was her consort and the flowers cherished by that god of vegetation were grown there.

The Ptolemaic sovereigns took the names "Soter," "Euergetes," "Epiphanes," "Neos." When Cleopatra joined Antony in Tarsus, she was Aphrodite coming to feast with Dionysus. The triumvir took the name "New Dionysus" and entered Alexandria crowned with ivy and carrying a thyrsus. On the eve of his defeat, the bacchic procession was heard passing through the heavens in the middle of the night, with shouts of "Evohé!" the stamping of satyrs' feet, and the sound of every sort of instrument. Then, all of a sudden, the uproar subsided. Plutarch recounts: "Those who sought the meaning of the sign were of the opinion that the god to whom Antony always most likened and attached himself was now deserting him."[166]

The Seleucids superimposed a uniform state cult onto extremely varied pre-Hellenic cults, with districts patterned on administrative districts and a special clergy.

In Rome, Augustus was the initiator. Learning from the experience of Caesar, and especially Antony, he proceeded cautiously. As a priest, *pontifex maximus,* the emperor appeared in the guise of a leader of religious life, the intermediary between the state and the gods. His name—Augustus—was borrowed from the

old religious vocabulary and guaranteed his piety, which assured the Roman people of heaven's benevolence. Victorious and predestined for victory, he deified the quality as "Victoria Augusti," and it was thus possible to transmit it from one emperor to the next. His virtues also entered the realm of religious veneration: *pius, justus, clemens, conservator* (of the state), *pater patriae, felix*. Horace wrote to Augustus: "When your face, like that of springtime, shines on the people, the days will be more temperate and the suns brighter."

Augustus played to Roman sensitivities. Whereas, in the east, the emperor was worshiped directly as a god, in the western provinces a distinction was made between the physical person of the prince and his *genius,* and subjects expressed their devotion to the latter. Gradually, these distinctions became blurred. Gaius had himself deified during his own lifetime. Domitian insisted he be called *dominus* and *deus,* Aurelian, *deus* and *dominus natus*—which postulates a personal cult of the living god. That tendency accelerated until the Later Empire.

An imperial theology was constructed during the same period: the emperor was the delegate of the supreme God and, more precisely, an earthly replica of the sun, placed above the other stars and governing the physical universe through them. Nero was represented on coins wearing the radiating crown, which expressed his consubstantiality with the sun. Hadrian and Commodus did the same. The emperor was all-powerful. He was the *nomos empsukhos,* the "living law." Everything that touched him was *sacer:* his palace, his bedchamber, his clothing. Images of him show his head surrounded by a nimbus. *Adoratio* was practiced in his presence. In his hand, he holds the globe, symbol of cosmic power. With minimal modifications, all this was passed on to the Christian emperor. The overly precise divine paternity was suppressed, but Constantine remained God's chosen, his lieutenant, the beneficiary of his energies and revelations. He bore the title *divus* both before and after his conversion.

The imperial cult profoundly changed the universe of the old religion. First, in a diversified and free world, it introduced an element of unification and obligation. From then on, there was a state religion. It modified religious representations and reorganized into a new pattern those it was built upon and from which it claimed its legitimacy. The divine world was represented on the model of an imperial monarchy. The king's power mediated between gods and men. The emperor was the second God, whom the transcendent God used to govern the world. According to his panegyrists, he was the Platonic demiurge who cast his laws onto the world, which he contemplated in its divine model. Paganism became systematized under the influence of imperial ideology: a transcendent God, beyond all gods; a second, organizing God; and finally, a divine power who assured the continuity of the divine to the outer limits and linked all the in-

termediaries to one another. The logic of monarchy implied and informed a monotheistic logic. It was consonant with the theology of Plotinus: the One, the transcendent God, Thought, the mediating God, the Soul, which diffused the divine to every level of reality. It was also consonant with the Christian theology of Origen and Eusebius: the transcendent God the Father, the Logos that created and governed the world through the Spirit.

Christianity, the advent of the royal Messiah on earth, could not avoid confronting the imperial cult. It considered Roman emperors sometimes as representatives of God on earth, sometimes as lieges of Satan, or as Antichrists. On one hand, early Christians prayed for the emperor, because all power came from God and, whether Nero or Gaius, the emperor was the guardian of the commonwealth. On the other, they refused to sacrifice before his image, which seemed scandalous and unacceptable. Celsus remarked that, since Christians, though they claimed to be strangers to the world, lived in the world and benefited from the social and political order, they were obliged to pay a fair tribute of honor to the emperors who oversaw that order. "Christians must acquit themselves of all the duties of life until they are delivered from the chains that bind them to it; otherwise, they would appear peculiarly ungrateful toward these higher beings, since it is unfair to participate in the benefits they enjoy and not pay any tribute in return."[167]

The imperial statue, authoritatively focusing popular and philosophical religion on the earthly god, incarnating the order of the Stoic world, the demiurge, or the Platonic *nous,* could not be challenged without attacking the ancient norms on which the universe rested, without subverting the "true logos," the true tradition, as Celsus also said.

That led Christians to a greater estrangement from that world. They rejected the imperial rite, purely civil in the eyes of pagans, seeing it as a desire on the emperor's part to lay sole claim to a realm that belonged exclusively to Christ, the only God of creation.[168] That is why Christian apocalypticism makes the emperor the anti-Messiah par excellence. It easily came to fit the mold of Jewish apocalypticism, except that, in the latter, an opposition was established between the present enemy of Yahweh and the Messiah to come, while in the former it lay between the Messiah who had already come and the false diabolical messiah who wanted to take his place.

In fact, the two figures—the Messiah and the emperor—bear the same names: Lord, Savior. Theology must therefore make explicit what is of this world and what is of the next, must distinguish between the earthly *soteria,* whereby the tempter turns the divine structure to his own benefit, and the *soteria* of Christ, the true Savior, the only Lord. Even though apologists used solid

arguments to show Christians were good citizens, Christian apocalypticism, in the footsteps of its Jewish predecessor, propelled the emperor into the role of prince of this world. The earthly god, because he was the visible enemy of the Messiah, and because he was the embodiment of the pagan pantheon, dragged that pantheon as a whole to the side of the demons.

In the early fourth century, however, the emperor became a Christian. Constantine foresaw the political advantages of his conversion. He thought he was reestablishing the spiritual unity of the empire on the foundation of a religion whose dynamism seemed irresistible. He thus imitated his principal rival, the Sassanid emperor, who had instituted Mazdaism as a national religion. He certainly did not intend to abdicate any of his own power. He remained *divus:* he simply changed his divine patronage. He kept the court ceremonial inherited from Diocletian and adapted the imperial ideology. He became a double for the triumphant Messiah. Christ was conceived as a transcendent emperor surrounded by the heavenly court, which mediated between God and men; the emperor was a second Christ, the incarnation of the Logos. Neo-Platonic hierarchy and hieratism, in the manner of Proclus, permeated Christian political theology and reflected back on Pseudo-Dionysius the Areopagite. The new imperial religion, in continuity with doctrine, was also in continuity with the practice constraining the old imperial cult: the emperor had the obligation to impose religion. He had been responsible for the temporal salvation of his subjects; now he was responsible for their spiritual salvation. His court theologians went so far as to attribute to him a sort of episcopal power extending throughout the empire. He took the initiative at church councils, seized upon the problems of dogma to be treated, promoted unanimity, opined as a theologian. The church saw no disadvantage to maintaining the formulas of the imperial cult on his behalf.[169]

The Antichrist's sudden submission to Christ and the promotion of the emperor to the rank of the apostles *(isapostolos)* at one stroke represented both a providential victory for the church and a danger of which it swiftly became aware, but which it took centuries to ward off. When it had demolished the old images of gods throughout the empire (including the ancient statue of Victory in the Senate), it still had to live with the colossal statue of the emperor, the only image persisting from pagan antiquity. That image was ambiguous because it was never purged of its pagan prestige and because it bore a disturbing resemblance to the image of Christ. It was a more "individuated," "prosopoaic," and "hypostatic" (personal) image than any divine image had been. It was closer to its prototype than was the image of Christ, whose physical prototype had been lost. The emperor, in his claim to be the vicar of Christ, himself became his liv-

ing image, closer to the model than any other portrait and, to quote the words of the old Athenian hymn, "right here, not in wood or in stone, but actually present." The conflict, when it erupted, was fatal. The image of the emperor again split in two, and the Antichrist, the beast of Babylon, could be made out behind the vicar of Christ.

The means of survival of the divine pagan image—pantheistic, magical, political—had uneven fortunes under the Christian regime. The political god began to vanish as the idea of empire died out. The Baroque glorification of the prince borrowed from the imperial image, but it was no longer taken literally: metaphors, retrospective allusions, and differences in nature were recognized as such. Theurgy and magic had their moment during the late Renaissance, but, there too, they were domesticated by play, learned allusions, and their reduced status as art. They have reemerged in a more serious spirit in the contemporary era, in symbolism, surrealism, and other schools. These have turned the amnesia regarding Christian disciplines and dogma to their advantage. In contrast, the idea that God was visible throughout the world because he was everywhere passed unchanged into a large part of the realm—and era—of Christianity. The price to be paid was a very complex transposition of theology, which I am now obliged to describe. This idea placed sacred art—pagan and Christian— and profane art along a continuum, and it has meant that, in Western eyes at least, there is only one kind of art.

CHAPTER TWO

The Biblical Prohibition

I. THE PROHIBITION OF THE TORAH

The Texts

Two themes are intertwined in the Old Testament: the absolute prohibition of images and the assertion that there are images of God. The assertion appears in the Bible (in the first chapter of Genesis), even before the prohibition in Exodus and Deuteronomy.

Let us begin with the prohibition and quote the most formal one:

> Thou shalt not make unto thee any graven image, or any likeness of any thing that is in heaven above, or that is in the earth beneath, or that is in the water under the earth; Thou shalt not bow down thyself to them, nor serve them: for I the Lord thy God am a jealous God, visiting the iniquity of the fathers upon the children unto the third and fourth generations of them that hate me; and shewing mercy unto thousands of them that love me, and keep my commandments. (Exodus 20:4–6)

Such is the second of the Ten Commandments in the Covenant offered Israel. It can be analyzed as follows: God is a jealous God who, not tolerating that his people have "other gods before" him, prohibits images of them and their worship. As a result, he proscribes any representation, either of what is in heaven—the gods—or of what is on earth. Even an image obtained by happenstance is unacceptable: "And if thou wilt make me an altar of stone, thou shalt not build it of hewn stone: for if thou lift up thy tool upon it, thou hast polluted it."[1]

The Covenant had hardly been sealed when the people broke it—and precisely that article of it. The people made this request of Aaron: "Make us gods, which shall go before us." Then Aaron "received [gold] at their hand, and fashioned it with a graving tool, after he had made it a molten calf: and they said, These be thy gods, O Israel, which brought thee up out of the land of Egypt."[2] It is clear that the people did not apostatize or change gods in the narrow sense. They wanted to possess an image that would make that God visible and accessible. But God assimilated that appropriation of Him, the making of an image, to apostasy. He made ready to exterminate his people, and to prepare another for himself. Nonetheless, he acquiesced to Moses' intercession and agreed to reestablish the Covenant, but only if a large share of the community—three thousand persons in one day—should perish by the sword.[3]

In Leviticus, God enumerates the conditions for the blessings he wants to bestow on Israel, stipulating, first: "Ye shall make you no idols nor graven image, neither rear you up a standing image, neither shall ye set up any image of stone in your land, to bow down unto it: for I am the Lord your God."[4]

Through the voice of Moses, he also adds, in Deuteronomy:

> Take ye therefore good heed unto yourselves; for ye saw no manner of similitude on the day that the Lord spake unto you in Horeb out of the midst of the fire: Lest ye corrupt yourselves, and make you a graven image, the similitude of any figure, the likeness of male or female, the likeness of any beast that is on the earth, the likeness of any winged fowl that flieth in the air, the likeness of any thing that creepeth on the ground, the likeness of any fish that is in the waters beneath the earth.[5]

The precaution against idolatry goes beyond fabricated images and encompasses natural images. The Greeks considered the worship of stars more pure, because stars were divine or adjoining the divine. But Moses said:

> [Take ye therefore good heed] lest thou lift up thine eyes unto heaven, and when thou seest the sun, and the moon, and the stars, even all the host of heaven, shouldest be driven to worship them, and serve them, which the Lord thy God hath divided unto all nations under the whole heaven. But the Lord hath taken you, and brought you forth out of the iron furnace, even out of Egypt, to be unto him a people of inheritance, as ye are this day.[6]

The commandment is again repeated in Deuteronomy 5:8, and its violation recalled in Deuteronomy 9:12. Shortly before his death, Moses gave the leaders of the tribes the following instruction: when they had crossed the Jordan and entered the Promised Land, the law should be engraved on large stones from Mount Ebal. Later, on this same mount, Reuben, Gad, Asher, Zebulun, Dan, and Nephtali uttered a certain number of curses. The first of these, said out loud

to all of Israel, was as follows: "Cursed be the man that maketh any graven or molten image, an abomination unto the Lord, the work of the hands of the craftsman, and putteth it in a secret place." And all the people answered and said "Amen."[7]

The prohibition extended to the images of nations whose territory the Jews seized: "Thou shalt not bow down to their gods, nor serve them, nor do after their works: but thou shalt utterly overthrow them, and quite break down their images."[8] "Take heed to thyself, lest thou make a covenant with the inhabitants of the land whither thou goest, lest it be for a snare in the midst of thee: But ye shall destroy their altars, break their images, and cut down their groves: . . . for the Lord, whose name is Jealous, is a jealous God."[9]

The Concept of Idolatry

The purpose of these provisions of the law is to protect the people God has chosen against idolatry. The word "idolatry" requires some clarification, which will serve for the discussion that follows: it had little meaning in the Greco-Roman tradition. *Eidōlon latreia:* "idol worship." What is meant by "worship," and what is meant "idol"? By "worship" *(latreia),* profane authors from Plato to Lucian, as well as the Scriptures and the church fathers, meant service to a god. The religious homage paid to idols and the supreme and absolute homage paid to the only true God were both expressed by the word *latreia.* The compound word "idolatry," however, is found only in the New Testament.[10]

The definition of an "idol" *(eidōlon)* is less clear. The Greek word in the Septuagint translates thirty different Hebrew words. The literal meanings of these nouns clarify the sense the Jews gave to the thing: *'â ven,* "vanity," "nothingness," "lie," "iniquity"; *gillulim,* sometimes interpreted as "tree trunk," sometimes as "round stones," and, depending on the rabbi, as "refuse" or "excrement"; *hevel,* "breath," "vain thing"; *kezavim,* "lies"; *to-ēvah,* "abomination." Another series of nouns is associated less with the moral aspect than with the material description of the idol: *terafim,* "portable amulets" (forbidden by the law); *tavnit,* "images of living beings" (also prohibited); *semel,* "statue," "sculpted object"; *massekah,* "cast metal."

The Bible does not attribute a divine nature to any of these objects, and Isaiah emphasizes that the gods of other nations are not gods but "the work of men's hands, wood and stone."[11] All the same, the word "idol" acquired a stable and precise meaning through usage: it is the image, statue, or symbol of a false god. Let us insist on the adjective "false," since otherwise the term loses its specificity and designates simply an image. As such, it would be synonymous with

eikōn, omoiōma, sēmeion, imago, and *species.* Properly speaking, "idol" implies the representation of a false god whom one worships as only the true God should be worshiped. That is what the church fathers mean by it. For Gregory of Nazianzus, it is a "transferral to the creature of the honor due the creator." Origen is even more precise. He distinguishes between the "image," *(eikōn),* the truthful representation of an existing thing, and the "idol" *(eidōlon),* a false representation of what does not exist.[12]

The biblical texts directly targeted popular idolatry, which confused God and the idol. For example, images were taken to the sites of battles and shared the army's fate. Pausanias reports the case of images that were chained to restrain the god, and of images that were mistreated when it was necessary to punish him.[13] The theologians of paganism took care to avoid that confusion, however: the idol was only the image, the representation, of the deity. They argued that worship and honor were not directed toward the image, but toward the deity of which it was the image (that argument was later adopted by Christian iconodules). All the same, they admitted that the gods inhabited the statues through their *pneuma* and that this inhabitation made them venerable and beneficent. For example, Plotinus writes:

> Those ancient sages, who sought to secure the presence of divine beings by the erection of shrines and statues, showed insight into the nature of the All; they perceived that, though this Soul is everywhere tractable, its presence will be secured all the more readily when an appropriate receptacle is elaborated, a place especially capable of receiving some portion or phase of it, something reproducing it, or representing it and serving like a mirror to catch an image of it.[14]

The images of nature form a continuum with higher "reasons" and even with images made by men.

Christians responded to this argument made by pagan theology. Saint Thomas Aquinas, who follows *The City of God* on this question, sums up his view by quoting Augustine: "Anything invented by man for making and worshiping idols, or for giving Divine worship to a creature or any part of a creature, is superstitious [i.e., idolatry]."[15] Later, he adds: "It was owing to the general custom among the Gentiles of worshiping any kind of creature under the form of images that the term *idolatry* was used to signify any worship of a creature, even without the use of images."[16] Christians, even when they accepted Varro's distinction among mythological, natural, and civil theology, imputed to idolatry the learned and symbolic forms of pagan cults. In that, they respected the Torah, which did not yet make these distinctions. Idolatry is any sort of worship whose object is not the one true God, the jealous God.

Idolatry in Israel

From the first, the history of Israel was punctuated by transgressions of the prohibition. A few weeks after the Covenant of Sinai came the golden calf. Forty years later, emerging from the desert, the people again sinned: Israel, incited by the daughters of Moab, "bowed down to their gods." "Israel joined [it]self unto Baal-peor," and lived to regret it: "And the Lord said unto Moses, Take all the heads of the people, and hang them up before the Lord against the sun, that the fierce anger of the Lord may be turned away from Israel." A priest named Phinehas ran a javelin through a Jewish man and a Midianitish woman who had been turned over to him. God pardoned this priest, "zealous for my sake." Twenty-four thousand men and women had already perished.[17]

During the time of the Judges, the people again bowed down before the Baalim and the Ashtaroth, and they were again punished. Solomon, like his wives, "served" Ashtoreth, goddess of the Zidonians, and Milcom, idol of the Ammonites. To punish the people for these crimes, God decided to divide the kingdom. In the kingdom of Judah, idolatry reemerged incessantly, tolerated and even introduced by the kings. So too in the kingdom of Israel, where it culminated in the impious Ahab, who allowed an official cult to Baal to be established with its own clergy, whom Elijah finally had slain at the brook Kishon. On several occasions, children were sacrificed to Molech. In reality, there was not a formal repudiation of the worship of the true God, but rather a mixing of that worship with idol worship. Yahweh remained the legitimate God of Israel. But, by inclination or out of self-interest, other gods were added. In Jewish theophoric names, there is no mention of foreign deities. Even the impious Ahab gave his children compound names that included the name "Yahweh."

The Babylonian captivity seems to have definitively purified Israel. Ezra, Haggai, Nehemiah, and Malachi did not pronounce the names of idols. The prohibition was rigorously enforced: every image of a living being, even a mere ornamental motif, was strictly banned. It was prohibited to bow before a pagan statue even to drink, to pick up a fallen object, or to pull a thorn from one's foot.

The temptation returned in another form after the conquest of Alexander, in the attraction of Hellenic civilization. Jason, who had bought the office of high priest from Antiochos Epiphanes, did what he could to Hellenize his compatriots. It was at that time that Jews participated nude in the games of the palaestra. In 145 B.C., a pagan altar was built in the temple itself and dedicated to Jupiter of Olympus. Then the revolt of the Maccabees broke out. But, even among the soldiers of Judas Maccabees, some who were killed in the battle of Odollam bore under their coats "some of the donaries *[terafim]* of the idols of Jamnia,

which the law forbiddeth to the Jews, so that all plainly saw that for this cause they were slain."[18]

King Herod, protected by the Romans, ordered temples devoted to the cult of the emperor to be erected in Jewish cities. And he had the Jewish temple superbly rebuilt. "The devout," writes Mommsen, "reproached Herod much more harshly for adding a gold eagle to the monument than for having so many people sacrificed; a popular revolt ensued and the eagle fell victim to it, but it cost the life of the pious Jews who stole it away."[19]

The Polemic

Throughout this same history, prophets excoriated idolatrous practices. I will cite only the last biblical witness, the deuterocanonical Book of Wisdom. One of its interesting aspects is that it was written by a Hellenized Jew who lived in Alexandria, perhaps in the middle of the first century B.C., and who was not unaware of philosophy or the latest developments in classical religion. He wrote in Greek. The passages on idolatry are inserted into a long antithesis between the fate God reserves for Israel and the fate reserved for Egypt. The Egyptians were idolaters, worshiping the "worthless and disgusting among beasts," namely, crocodiles and scarab beetles. God sent them many other unreasoning beasts (grasshoppers, frogs) "as a mockery."[20]

Men, "from studying the works[,] did not discern the artisan." Here, the author sounds a Greek note: until that time, the Bible had celebrated the greatness and power of God through his creation—but not the beauty of creation considered as a work of art. "Either fire, or wind, or the swift air, or the circuit of the stars, or the mighty water, or the luminaries of heaven, the governors of the world, they considered gods. Now if out of joy in their beauty they thought them gods, let them know how far more excellent is the Lord than these; for the original source of beauty fashioned them." Thus astral cults and the cosmic god are condemned. Those devoted to these cults were content to worship the creature and were not capable of contemplating its author "by analogy." Fabricated images are ridiculed in the same way: a woodcutter sculpts a scrap of wood that is useless. He paints it, and attaches it to his house so that it will not fall off: "It is an image and needs help." He is not embarrassed to speak to that lifeless object: "For vigor he invokes the powerless, and for life he entreats the dead; and for aid he beseeches the wholly incompetent."[21]

The imperial cult is also pointless: "Men who lived so far away that they could not honor him in his presence copied the appearance of the distant king and made a public image of him they wished to honor." The invention of idols

was the origin of fornication (in the sense of religious infidelity), and the discovery corrupted life. The result was murder, treason, perjury, initiations, infanticides, mystery, secrets, pollution, adultery, sexual perversion, debauchery. Israel alone was protected by its faith: "For neither did the evil creation of men's fancy deceive us, nor the fruitless labor of painters, a design portrayed in varied colors, the sight of which arouses yearning in the senseless man." Was the bronze serpent raised by Moses in the desert, and which healed the Israelites from snakebites, an idol? No, it was only a "sign of salvation, to remind them of the precept of your Law. For he who turned toward it was saved, not by what he saw, but by you, the savior of all."[22]

The Book of Wisdom faithfully recapitulates the polemic of the prophets: the vanity of idols, objects of wood or clay devoid of divine power, and a source of prostitution, abomination, which the Lord held in horror. Anything that turned worship and adoration toward the creature and away from the Creator was held in contempt. The pride of Israel was that it knew and loved the true God.

Meaning

However succinct my reading of the biblical texts, I cannot skirt the question of the meaning of that divine pedagogy—so imperious and so harsh—reserved for the Jewish people. It can be linked to the laws of purity. The history of the Bible is the history of a people whom God "chose" and set apart from other nations. Between these nations and that people stood the hurdle of the Torah. It prohibited intermixing. Just as the laws of purity carefully discriminated between the pure and the impure, rejected hybrid and unclean beasts, forbade cooking the kid in the milk of its mother, so too any contamination of the religion of Yahweh by a foreign religion absolutely polluted what was seen as future salvation and turned it into a condemnation.

That would suffice to explain the absolute condemnation of the images Israel might encounter among other nations, but not that of the images of its own God. And yet, the first and most serious of all the transgressions was not to bow down before some Baal, but rather to fabricate an image designed precisely to depict the God of the Covenant, one that would walk with the people and go ahead of them. Let us therefore turn to considerations of a different order, having to do with that God's nature or mode of being.

The notion that divine transcendence is the reason for the prohibition does not appear to be a satisfactory explanation. This God, who created earth and heaven from the void, might be philosophically transcendent, of course, but a

philosophical argument would be necessary to determine such a thing, and the compilers of the law were not concerned with providing it. Even if accepted, that argument would not entail the impossibility of images. The God of philosophy, Good, the superessential One, and the pure Act are no less transcendent. But one might conceive of a hierarchy descending from this inaccessible principle, down to representative images, on the basis of their participation in that hierarchy. The world of the cosmic and political god, which recognized the transcendent God, saw the participating image everywhere, even in the least and most humble elements of reality. Biblical iconophobia is not philosophical. Nothing prevents one from measuring the proportion and disproportion of the image against its supreme prototype. The Book of Wisdom, in maintaining that the heavens and the cosmos open a path toward the Creator "by analogy," gives an example of such an image. Who would prevent man from conceiving in turn and realizing another image that was equally proportionate?

It was God himself who gave that positive commandment, which, so to speak, became a constitutional provision of the Covenant. It is not by virtue of his nature that God is unrepresentable, but by virtue of the relationship he intends to maintain with his people. It is not because of the impersonality of the divine, but, on the contrary, because of his relation as one person to another or as one person to his people. It is God's plans for his people—impenetrable plans—that justify the prohibition.

There are divine epiphanies. The Covenants were the occasion for "signs": the rainbow for the Covenant with Noah; the brand of fire that passed between the halves of the animals cut in two by Abraham; the burning bush; the lightning and storm on Mount Sinai; the pillar of clouds and the pillar of fire that guided the people in the desert. These epiphanies are the sign of a presence; they are not Presence itself. Abraham and Moses know that the Lord is nigh, and they hide their faces and listen. The epiphanic signs are diverse and unexpected. They are not repeated. Elijah, walking toward Horeb, is warned that Yahweh is going to manifest himself. There was a terrible windstorm, "but the Lord was not in the wind." And after the storm there came an earthquake, "but the Lord was not in the earthquake." Then came a fire, and finally, a still small voice: then Elijah heard it and "wrapped his face in his mantle."[23]

The theophanic signs are the opposite of those given to Moses. But the gesture of veiling one's face is the same: "For he was afraid to look upon God."[24]

All these theophanies are perfectly representable: they have enriched Christian iconography. In the world of the Bible, they are not commemorated or duplicated by any image. This God nonetheless has a dwelling place, the construction of which is carefully described in luscious detail. But the holiest

part of the temple, its *naos,* is a perfect cube that houses only the ark; when the ark is lost, the *naos,* in the temples of Solomon and Herod, remains absolutely empty. *Vere, tu es Deus absconditus:* "Verily thou art a God that hidest thyself, O God of Israel, the Saviour."[25]

On Christian cathedrals, the figuration of the synagogue, which faces that of the church—whose eyes are wide open—is represented blindfolded. This means she did not recognize the Messiah, but also—praise is counterbalanced with blame—that she refuses to look upon idols. It means, finally, that her intimacy with her God does not depend on sight but on hearing: *Fides ex auditu.*

"Harken, Israel!" There is a striking contrast between the overwhelming and imprecise majesty of theophanies and the unequivocal familiarity of the word. Visible signs are rare: they generally precede and anticipate words. At the sign of them, the prophet prepares to listen. Discussions with God fill the lives of Abraham, Moses, and the prophets. God is endlessly consulted and endlessly replies. This word is given concrete form in the law, presented as a written document. For every Jewish era, there are only two "incarnations" of the Lord: first, the law, ceaselessly studied and examined because it offers not only rules for living but a detailed description of the divine mode of being, the only legitimate image one can form of it; and, second, the people, who "carry" the law and who, studiously meditating on it, murmuring it day and night, are informed by it. Naturally, that study can never be interrupted on the pretext that it has achieved its goal: "He who is" is as inaccessible to knowledge as the One of philosophy. He remains "completely other," and hermeneutics inevitably reaches the limit set by Isaiah: "My thoughts are not your thoughts."[26]

Does this mean that the link philosophers acknowledged between the divine and the beautiful is to be abandoned? No, but it is circumscribed within the field of the spoken and written word. Many biblical books take the form of poetry; and beauty is not lacking in the others. In *On the Sublime,* Longinus cites "Moses" between two passages from Homer. He writes: "The lawgiver of the Jews, no ordinary man, having formed a worthy conception of divine power and given expression to it, writes at the very end of his *Laws:* 'God said'—what? 'let there be light' and there was light."[27] Metaphors, imagery, and all other figures of rhetoric abound in biblical stylistics. Divine beauty in itself authorizes literary reflections.

The limitation to hearing, writing, reading, and reflective study, even though or because it procures greater intimacy with the divine than any pagan philosopher would have dared imagine, does not eliminate the desire to "see" God. To be convinced of this, we have only to follow the motif of the face in Scripture. It is written that, when Adam and Eve had sinned,

the eyes of them both were opened, and they knew that they were naked; and they sewed fig leaves together, and made themselves aprons. And they heard the voice of the Lord God walking in the garden in the cool of the day: and Adam and his wife hid themselves from the presence of the Lord God amongst the trees of the garden.[28]

This passage juxtaposes Adam opening his eyes (to his human nakedness, in the first place), listening to the divine voice, and fleeing the sight of God. The new knowledge acquired by man, it seems, blocks him from looking at God face to face.

At the ford Jabbok, Jacob fights all night long with a "man" who may be an angel, or perhaps God himself. "Jacob called the name of the place Periel: for I have seen God face to face, and my life is preserved."[29]

"And the Lord spake unto Moses face to face, as a man speaketh unto his friend."[30] That remained the sole privilege of Moses. And yet, a few verses later, when Moses asks him: "Shew me thy glory!" God replies:

Thou canst not see my face: for there shall no man see me, and live. . . . And it shall come to pass, while my glory passeth by, that I will put thee in a clift of the rock, and will cover thee with my hand while I pass by: And I will take away mine hand, and thou shalt see my back parts: but my face shall not be seen.[31]

This is traditionally interpreted to mean that God's very being is unknowable as long as man remains alive on earth, but that He can be seen from the back, after he has passed by: that is, one can note the effects of his "glory" in history or in creation. When he stands before God, man falls "face to the ground" or "veils his face."

The Psalmist prays God not to turn away his face, but to make it "shine" or "glow." A yearning for the face fills this plea: "My heart said unto thee, Thy face, Lord, will I seek. Hide not thy face far from me."[32]

All the same, looking upon God's face is possible only to the person who enters a new eon through death, or in the extremity of the prophetic vision, when "the heavens were opened." So it was that Moses, after the Covenant and the law had been accepted, went up on Mount Sinai at God's command, accompanied by Aaron, Nadab, Abihu, and seventy elders: "And they saw the God of Israel: and there was under his feet as it were a paved work of a sapphire stone, and as it were the body of heaven in his clearness." That unique, exceptional vision is not lethal: "And upon the nobles of the children of Israel he laid not his hand: also they saw God, and did eat and drink."[33] And so it was that, in a "rapture" that momentarily cast him out of his earthly condition, Ezekiel was favored with the vision of a chariot, which has continued to enrich both Jewish and Christian

mysticism and esoteric speculation. "The Almighty" seemed to sit on a "likeness of a throne," and "the likeness as the appearance of a man above upon it."[34]

We are back to the claim made in Genesis, when God created man "in his image and likeness," as if, at the height of the mystical vision, that claim found its mysterious counterpart, that is, a God in the appearance of a man. We shall later see what the Christian interpretation made of this.

2. THE JEWISH AND MUSLIM INTERPRETATIONS

The Jewish Interpretation

After the prohibitions and the absolute curses of the Torah, we might expect the Jewish world to be a desert, artistically speaking. But that is not the case. The very text of the Scriptures contains notable exceptions. Almost without transition from Exodus 20, which articulates the second of the Ten Commandments, a description of religious furnishings follows: "And thou shalt make two cherubims of gold, of beaten work shalt thou make them, in the two ends of the mercy seat. . . . And the cherubims shall stretch forth their wings on high, covering the mercy seat with their wings, and their faces shall look one to another" (Exodus 25:18–20). The Lord has his dwelling place between these two cherubim: "There I will meet with thee." Thus images are set on the ark of the Covenant, above the very scrolls of the law that prohibit them. They are by no means images of God: they delimit an empty space, and this void is the place of Presence. The cherubim play the role of guards in front of that invisible Presence.

When God sent "fiery serpents" against the people in the desert to punish sin, Moses interceded. It was the Lord himself who then ordered: "Make thee a fiery serpent, and set it upon a pole: and it shall come to pass, that every one that is bitten, when he looketh upon it, shall live."[35] And this was done. The serpent coiled on its perch must not have been very different from the serpent of Aesculapius and of the caduceus. But the image was expressly desired by God and, as the Book of Wisdom interprets it, it was God who healed, not the serpent. This serpent was nonetheless worshiped under the name of "Nehushtan" by the Jews, and that is why Hezekiah had it destroyed.[36]

Solomon turned to foreign architects and artisans to build the temple. The physical appearance of the cherubim is not described, only their dimensions: they are gigantic, and their wings, with a span of twenty cubits (ten meters), touch the opposite walls of the Holy of Holies, which are plated with gold leaf. The capitals of the tall pillars of the vestibule are adorned with interlacing pomegranates and lily blossoms. The molten sea is furnished with colocynths

along its entire circumference, and it rests on twelve oxen.[37] Solomon, who was later blamed for other offenses, and in the first place, for serving false gods, did not attract the Lord's wrath for these figurative ornaments in the temple. The rabbinical tradition did not blame him either. It was only with Flavius Josephus that the reproach was made.[38]

If we step back from Scripture and seek answers from history and archaeology, we find an ever-shifting practice. In times when the Jews were deeply involved in the civilization that surrounded them, they followed the general tendencies, though with a certain delay. In times of separation, withdrawal, or fervor, a rigorous and literal obedience to the second commandment prevailed. After the exile and during the Roman wars, for example, there were no sculptures or paintings of any kind. Tacitus writes: "Therefore they set up no statues in their cities, still less in their temples."[39]

In other periods, there were images, a situation that required a casuistics distinguishing between art, which was permitted, and idolatry, with which no compromise was possible. Since idolatry was no longer to be feared, and idols were an object of ridicule, Jewish artisans were even permitted to fabricate idols for gentiles and to make a living thereby. Rabbi Akiba himself authorized it, provided the Jewish artisan did not worship the idols.[40] It was said Rabbi Akiba possessed a goblet decorated with the image of Fortune: it was desacralized by pouring water over it. Other doctors even allowed the human face and angels to be represented, with the exception of the higher angels. The imperial cult, however, remained proscribed.[41]

Herod's Jerusalem was a Hellenistic city, which, at first sight, seemed to be built on the usual model. The gigantic cornice of the temple, which broadly obeyed the Greco-Roman architectural canons, was adorned with a gold vine from which hung bunches of grapes the size of a man. The apogee of Jewish iconography took place in the synagogues, in the first centuries of the Christian era. The institution of the synagogue, devoted to teaching, did not fail to take advantage of the didactic capacities of the image. Lively decorations appeared in the fourth century. In the middle of the mosaic in the synagogue of Beth Alpha, a panel contained a double circle divided into twelve compartments devoted to the signs of the zodiac; in the center appeared Helios on his quadriga, holding the globe in one hand and raising the other as if in an imperial salute. On the cornerstones are figures of women with the attributes of the four seasons. In front, on another panel, the ark is flanked by candelabras and animals. In back, Abraham holds Isaac and the knife in front of the altar, on which a fire is blazing.

Located on the disputed boundary between the Roman and the Sassanid Em-

pires, the largest known biblical display of iconography was discovered in 1921: this is the synagogue of Dura Europos. It dates to the mid-third century. The entire prayer hall was covered with paintings. A large share of them illustrate biblical scenes: the sacrifice of Isaac; a human figure wearing the Phrygian cap, playing the flute, and surrounded by animals—in another place, this would be Orpheus charming animals, but an inscription transposes the Orphic motif onto David; Moses, in a short Roman-style toga, is making water spurt up from a well, and it streams toward the twelve tribes. Below him, a beardless Elijah in beautiful antique draping is reviving the child of a widow with the help of divine power, represented by a hand. The widow is wearing the clothing and hairstyle of a Roman matron. The paintings as a whole follow a precise theological program based on the liturgy.[42]

This iconographical laxity came to an end in the late fifth century, under pressure not only from an iconophobic current within Judaism but, just as intensely, from the beginnings of Christian iconophobia and, soon after, from the triumph of Muslim iconophobia. In Muslim regions—with the exception of a few books in miniature—Jewish art, examples of which are in fact modest, no longer bends the second commandment. In Christian regions, the Jews, surrounded by images, allow themselves illustrated manuscripts. When questioned, Rabbi Meir of Rothenburg (d. 1293) replied: "I do not think it is useful to introduce such ornaments into a book of prayer, since the sight of them distracts from concentration on Our Father in heaven. But they do not fall under the prohibition of the second commandment, since they are colors with nothing material about them. And even the Jews can paint such figures."[43]

That pronouncement combines an absolute contempt for the material idol and a distinction between the didactic or even aesthetic image, which is tolerated, and the image for the purpose of worship, which is prohibited.

I have considered the commandment in its positive form, as it was elaborated in law or casuistics. But Jewish thought also elaborated it philosophically. Philo of Alexandria adopted the abstentionist considerations of Plato. Gershom Scholem notes that the name God gave himself, the tetragrammaton, gradually slipped away from the human voice. The high priest pronounced it once a year in the Holy of Holies, on Yom Kippur. After the temple was destroyed, it became unpronounceable.[44] For Maimonides, no discussion of God was really possible. The divine attributes we use to speak of him do not describe him, add nothing to him. He contains them all in a superessential mode: "He exists, but not through an existence other than His essence; and He lives, but not through life. . . . He knows, but not through knowledge," just as He is one, but not through unity.[45] One of the early lines of *The Guide of the Perplexed*, part 1,

chapter 56, notes "that likeness between Him and us should also be considered nonexistent." In this case, "likeness" designates any relationship whatever. Even the word "existent" is merely a homonym, applied to God and also to everything outside him. Maimonides appeals to the authority of the Psalmist: "For thee silence is praise."[46]

Thomas Aquinas supported the negative theology of "Rabbi Moses," already set forth by the neo-Platonic tradition, but he allowed a positive path using analogy. In the case of human words and even thoughts, that path was rejected by Maimonides. How much more unacceptable was it in the case of the material, anthropomorphic image, which was further burdened by the suspicion of idolatry!

There was not so much a Jewish art as there were Jewish artists. The Jewish artists who have come forward in our own time of "emancipation" have either borrowed from the repertoire of Christian iconography (Chagall, for example) or have followed the path of abstraction (Rothko). But Judaism, in distinguishing from the start between art (tolerated, perhaps) and the representation of the divine (unacceptable), accepted the fact that its art was confined to the immanent world. That entailed imposing a limit on art, if we can agree, with Plato, that, though the divine image is inaccessible, the artist aspires to attain it, and it draws him toward the higher realms. That aspiration is manifest in the mystical tendencies of Judaic literature. But Jewish art seems to have been crippled by the metaphysical dispute, because, from the very first, the religious warning and the authority of the positive commandment of the law were added to that dispute.

Unless, that is—and nothing forbids a Jewish artist from taking this step—the words, "for thee silence is praise," apply precisely to the silent praise of the work of art, which then takes on a certain level of divine Presence. But this step is easier to take from within a different theology.

Note, however, that there is one Judaic tradition that had a close brush with anthropomorphism. In the Zohar, beginning from the indeterminate and absolutely transcendent *En-Sof,* God initiates a process of external manifestation and pours out his heart in the nine *sefiroth.* But, because the human form is the perfect form, the macrocosm—the first complete manifestation of God—is the cosmic, or "Kadmon," Adam.[47] The *sefiroth* are located in each of his limbs. Hence, the human figure is the image of the world of the *sefiroth* as a whole, just as the *sefiroth* as a whole constitutes the totality of the man from on high, Adam Kadmon. Scholem writes: "This God who unveils himself in the world of the Sefiroth represents man in his purest form, Adam Kadmon, the original man. The God who can be man's aim, presents himself precisely as the original man. The great name of God in his creative development is precisely Adam, as the

Kabbalists say, drawing from a stupefying *gematria*."[48] (The four letters of the tetragrammaton have a numeric value of 45, as does the word "Adam.")

Islam

There was not so much a Jewish art as there were Jewish artists. Conversely, there were not so much Muslim artists as there was a Muslim art. That imposing art, which from India to Morocco takes the most varied forms, bears the distinctive mark of Islam across the entire expanse of its domain. In the eighteenth century, in the kingdoms of northern India, a great variety of miniaturist schools flourished. At first glance, we can distinguish between the schools drawing from Hinduism and those stemming from Islam. There is a spareness to the Muslim schools—space between the figures, bare areas, an imperious geometry—which links it to an artistic world that becomes increasingly devoid of all figuration as it moves closer to the Maghrebian West. And yet, from the Ganges to the Atlantic, that world maintains a certain unity of style; and the only thing these regions have in common is the God of Islam.

The Torah makes multiple and explicit prohibitions against figuration. The Koran, in contrast, is almost mute on the subject. Sura 5:90 declares:

> O ye who believe!
> Intoxicants and gambling,
> Sacrificing to stones,
> And (divination by) arrows,
> Are an abomination,—
> Of Satan's handiwork:
> Eschew such (abomination),
> That ye may prosper.[49]

The stones in question are the upright stones of pre-Islamic Arabia, idols no doubt, but which do not seem to have been figurative. It is not figuration as such that is targeted. Figuration appears to be separate from idolatry, which is not the supreme abomination. Note that stones are combined with intoxicants, gambling, and divination by arrows (mantics), all practices that are condemned but heterogeneous in nature, not all linked to idolatry in the same way. The other verse from the Koran that serves as a point of reference for the strictest iconophobes reads as follows:

> He is Allah, the Creator,
> The Originator,
> The Fashioner
> To Him belong
> The Most Beautiful Names. (Sura 59:24)

Names are the (uncreated) attributes of God, "the Exalted in Might," "the Wise" (ninety-nine names in all), by which the human apprehends the divine.

It requires a theological exegesis to deduce the prohibition on figuration from this verse. The existence of God can be grasped by the reason, if it consents to reflect righteously on the "signs of the universe." Human reflection will also be able to grasp the existence of most of the ninety-nine attributes designated by the Names. But the separateness, the inaccessibility of divine nature is loftily maintained.[50] That divine nature can be known only through the divine Word, through the Names and acts God himself reveals. That is why the God of the Koran appears distant, when compared to the God of the Jews, who lives among his people, converses with them through the prophets, and allows his own thoughts to be elaborated through their thoughts. The Koran, however, is uncreated, and Muhammad is its passive medium, as if he were an angel. Judaism always seems on the brink of Incarnation. That is why the Jewish people need the commandments from their God, to resist the temptation to make an image of him or to imagine him. In Islam, the image becomes inconceivable because of the metaphysical notion of God. As soon as proof of submission *(islam)* to that God is given, the association *(shirk)* between God and any external notion of his essence, any person (as among Christians), and a fortiori any matter, is perceived with horror as an attack on unity, as a return to polytheism.

It is the very idea of God that rules out representations of him, an idea contained in sura 112, the confession of Muslim faith par excellence:

> Say: He is Allah,
> The One;
> Allah, the Eternal, Absolute;
> He begetteth not,
> Nor is he begotten;
> There is none
> Like unto Him.

"Absolute" means, among other things, "having no hollow parts"; the negation of any mixture and any possible division into parts; "dense," opaque, like a cliff without fissures. God is for the Muslim what Islam itself is for the nonbeliever: a fortress without doors or windows.[51] Hence, there is no need for commandments: submission to God discourages any inclination to reproduce his fiery transcendence with one's hands.

There are, however, a few religious texts from Islamic antiquity that positively advise against representation. They do not have the authority of the Koran. In one hadith, the Prophet says: "The angels will not enter a home where there is

an image." Per contra, the oldest chronicle, that of Al-Azraqi, recounts that the Prophet, returning victorious to Mecca and finding the Kaaba shrine covered with fresco paintings, ordered that they be effaced but made an exception for one of them, executed on a pillar, which represented Mary and Jesus.[52]

In any case, archaeology has established that the Syrian palaces of the first Umayyad caliphs were abundantly adorned with extremely figurative sculptures, fresco paintings, and mosaics. There were even women with naked breasts depicted in the round, and a whole imperial iconography applied to the caliphs. Figurative art in all its forms—frescoes, manuscript paintings, bronze objects— was practiced for seven centuries, both in Iranian and in Arabian regions. In the latter, the art dried up toward the end of the fourteenth century but was replaced by a magnificent blossoming of painting in Iran, in the Ottoman Empire, and in the Muslim kingdoms of India. Of course, the divine image was never and nowhere at issue.[53]

Nonetheless, just as the mosque faced Mecca and prayers were directed toward that city, it was through pilgrimage that the Muslim anticipated the return to God, who was waiting for him after death; all art, even a simple carpet, seems to have been oriented toward an inaccessible transcendence and designed to direct attention to it. A Sufi master declared: "I have never seen anything without seeing God in it." And another: "I have never seen anything but God."[54] It is as if the invisibility of God resulted in the invisibility of things made to be seen, earthly things, except when they were seen in the mode of divine invisibility. In post-iconoclastic Byzantine art, neither art nor the sacred existed any longer: the profane became unrepresentable, or at least unrepresented. In Muslim art, sacred art existed solely in hiding, behind profane art, which in fact lost its profane status: two opposing but secretly equivalent paths. In one case, the earthly was evacuated; in the other, it was transmuted in the crucible of divine contemplation.

Every graphic sign, every work of art, refers to God, looks in his direction, yet never hopes to attain him. But there are also more specific and direct signs. The first appears in verse 35 of sura 24:

Allah is the Light
Of the heavens and the earth.
The parable of His Light
Is as if there were a Niche
And within it a Lamp:
The Lamp enclosed in Glass;
The glass as it were
A brilliant star;

Lit from a blessed Tree,
An Olive, neither of the East
Nor of the West,
Whose Oil is well nigh Luminous,
Though fire scarce touched it.

That light can be apprehended only analogically. In the arch of the *mirhab,* that is, the niche that orients the mosque toward Mecca, the lamp is often found sculpted in bas-relief. As Melikian emphasizes, this "lamp enclosed in glass" must not be considered a divine image, but rather "a representation of the Ko-ranic parable, used to propose a metaphor for the idea of God to the human mind." It is, he explains, an iconography of the metaphor, not of the spiritual reality to which it refers.[55]

Nonetheless, of all the Muslim arts, it is the architecture of the mosque that most directly exhorts the believer to turn to God. It is strictly aniconic. But, in its grandiose emptiness, it symbolizes the essence of the Koranic message. And, from the tenth century on, that message has been inscribed on the wall itself. The revealed word, written in calligraphy or painted, sculpted in stone or stucco, articulates the essential features of the monument. In the thirteen and fourteenth centuries, particularly in Iranian regions, beautiful geometric Kufic writing, traced in brick and built into the wall itself, proclaimed the Name and its messenger. On the drum that supports the "turquoise cupola," symbol of the cosmos, for example, one reads verse 255 of sura 2: "Allah! There is no God / But He,—the Living, the Self-Subsisting, Supporter of all. . . . His are all things / In the heavens and on earth!" The word, and, to be more precise, the written word, is projected onto the architectural space (which the Jews had never done with the Torah), a space that became an icon without a figure, authorized by the two degrees that separated it from the divine and from divine beauty "beyond the concept."[56]

In Judaism, there is a low upper limit to art, because Israel is in waiting, and the "face-to-face" vision that art might procure would be an illusion, in other words, idolatry. That is not the case for Islam. There is no waiting but an eternal present, under the dazzling light of Revelation.

An analogy might be found in the theory of the intellect as unique agent.[57] Its source is Hellenic philosophy, of course, but it is in keeping with the spirit of Islam. According to al-Farabi, prophetic revelation is to be rationally explained not in terms of free divine intervention but through the pouring out of the sep-arate intellect, which is necessarily operative when human intellects—apt by nature to receive it—meet. Similarly, for Ibn Sina, human knowledge is an illu-mination of the possible individual intellect by the intellect as separate agent.

The human intellect is not joined to the unique intellect, as al-Farabi believed: it is its locale, its receptacle, and, when it is purified, the mirror in which light is reflected.

In that Islamic version of Platonism, man is not really entrusted with the search for the True and the Good. He must simply open himself passively to the true and the good, either through the philosophical and rational path of an encounter with the unique agent of the intellect, or through the religious path of submission *(islam)* to the Prophet's revelation. That is why Saint Thomas Aquinas battled Ibn Rushd, in an effort to establish the individual presence of the agent of intellect in every man, making him an autonomous center of knowledge and thought, which actively participates, in an analogical manner, in the illuminating power of God.

This can be transposed to the aesthetic realm: the Islamic artist, unlike the Jewish artist, does not practice ascetic restraint; and, unlike the Christian artist, he does not actively participate in the original power of creation. He opens himself to transcendental beauty—beautiful "beyond the concept"—and attempts to build a form—the cupola, *mirhab,* or *iwan*—where divine beauty will be captured metaphorically via several mediations and then silently reflected in the soul.

Jewish iconoclasm is a result of the Covenant. In the contract he makes with his people, God positively prohibits them from having other images before them, because he is a jealous God. Conversely, Muslim iconoclasm is a result of the absence of a Covenant. That is why the Koran does not take the trouble to positively prohibit the image. It is because the notion of God, as the Muslim imagines it from the Koran, is sufficiently transcendent to discourage image making at its root. In Judaism, God reserves the right to propose his own images: anthropomorphic figures of himself, such as the angel of the Lord or the vision of Ezekiel. For Christians, Christ is the culmination of these successive divine initiatives. In short, no image of human fabrication can "stand" before the Jewish God, because he is too near, or before the Muslim God, because he is too far away.

3. In the Image and Likeness

The advent of Christianity reorganized most of the phenomena I have analyzed to this point. In fact:

1. The Christian religion inherited the claims of the Old Testament having to do with divine nature and its invisibility. Saint John writes: "No man hath seen God." And Saint Paul: "No man hath seen [him], nor can see." Augustine com-

ments: "To see God with human eyes is absolutely impossible, one sees him only with eyes that are no longer those of men but of supermen *(ultra homines)*."[58]

2. Nevertheless, it is written that man was created "in the image of God."[59]

3. Christ is God, and he is also a visible man. "Philip saith unto him, Lord, shew us the Father, and it sufficeth us. Jesus saith unto him . . . He that hath seen me hath seen the Father."[60]

From these three irreconcilable claims an infinite number of questions arise, questions that were elaborated within Christian dogma throughout its history and which sometimes overlapped with the great crises shaking the edifice as a whole. To establish the foundations, let me clarify the exact meaning of the word "image" in the expression: "the image of God that is in man." The key text is Genesis 1:26–27: "And God said: Let us make man in our image, after our likeness. . . . So God created man in his own image, in the image of God created he him; male and female created he them." The Hebrew word for "image" is *se-lem,* and for "likeness" *demut. Selem,* explain the philologists, has the very concrete sense of a plastic image. So too does *demut,* but in a more attenuated and imprecise sense, undoubtedly to avoid any dangerous concession to anthropomorphism.[61]

Philo

This text did not elicit much response in the Hebrew Bible, which was more concerned to glorify absolute divine transcendence. Nonetheless, Psalm 8 does not overlook the dignity that man's "likeness" confers on him: "Thou hast made him a little lower than Elohim," which both the Septuagint and the Vulgate translate as "a little lower than the angels."

The church fathers read the Bible in the version of the Septuagint, where, through its language, the sacred text was placed in contact with Hellenism. Hence, *selem* and *demut* are translated as *eikōn, homoiōsis,* and *idea,* that is, with words charged with a philosophical history outside the Bible. In addition, the "in" and "after" (in Hebrew *bᵉ* and *kᵉ*) are translated as *kata.* To the ears of Greek philosophers, this *kata* suggests an intermediate image, a model outside God, in him, or near him, but which is not him and to which man is assimilated: in short, the image of that image. The Greek Book of Wisdom offers a personification of divine wisdom that suggests this intermediary image, somewhat similar to the second hypostasis of middle Platonism.

The theme of the image is rarely exploited by the rabbis. But the Hellenistic branch of Judaism did speculate about it. The God of Philo combined the tran-

scendence of the Hellenic god and that of the biblical God. Hypostatic inter-mediaries proliferated between God and the world: wisdom, the Logos, the Spirit, the angels, the powers. The Logos is disseminated throughout the world, establishing the unity of the cosmos, a Stoic concept. It also maintains divisions and oppositions within the world: this is the divisive *(tomeus)* Logos of Heracli-tus. It is the god of Ideas, in the Platonic view, and the Word of the biblical God. Finally, it is the mediator between God and the world, the path by which man goes to God.

The Logos is called the image of God, which implies a hierarchy between God and his degraded image. In *De opificio mundi,* the Logos (or intelligible world) is called *Theia eikōn,* and the sensible world *mimēma Theias eikonos.*[62] It is the seal that gives its form to every being, the younger son of God. Man is cer-tainly in the image of God, but only through the Logos. He is therefore the im-age of an image; and, at this point, Philo invokes the *kata* of the Septuagint.

"Nothing earth-born is more like God than man. Let no one represent the likeness as one to a bodily form; for neither is God in human form, nor is the human body God-like. No, it is in respect of the Mind, the sovereign element of the soul, that the word 'image' is used; for after the pattern of a single Mind, even the Mind of the Universe as an archetype, the mind in each of these who successively came into being was moulded."[63] Thus, for Philo—and this con-ception was transmitted to later Platonism—the image is lodged within the soul alone. He is thus led to contrast the "generic" man of Genesis 1:26–27 with the man fashioned from clay in Genesis 2:7: "The man so formed is an object of sense-perception, partaking already of such or such quality, consisting of body and soul, man or woman, by nature mortal; while he that was after the (Divine) image [i.e., the generic man] was an idea or type or seal, an object of thought (only), incorporeal, neither male nor female, by nature incorruptible."[64] The characteristic of an image is refused the body: it is only the sanctuary of the im-age, and will be abandoned when the image has attained perfection.

Only the higher part of the soul, the *nous,* and not the soul in its totality, is the image of God. Finally, Philo claims that, though man receives the image at his birth, it has lost the perfection that belonged to the first man. It must there-fore be made perfect. The image is the starting point but, above all, it is the goal of human life. Man must attain *homoiōsis.* Philo is Hellenizing here. At the same time, he maintains that man cannot arrive at God by his own powers: God must reveal himself to him by grace. In this, Philo is no longer Greek but Jewish.

And, in that way, perhaps, we move closer to the possibility of a divine image, which Philo, a Greek and Jewish philosopher, did not yet conceive. The tran-

scendent, invisible, inaccessible God wishes through grace to be contemplated by man, and holds out a mirror within man's reach: that is a possibility for which the Christian world planted the seeds.

Paul

The Pauline corpus gathers together almost all the texts relating to the image in the New Testament. Let us distinguish between those that apply to Christ and those that apply to man.

1. Let me cite the two great hymns that govern all of Christology, the Epistle to the Philippians 2:6–11, and the Epistle to the Colossians 1:15–20:

> Being in the form *(morphē)* of God, [he] thought it not robbery to be equal with God: but made himself of no reputation and took upon him the form of a servant, and was made in the likeness of men: And being found in fashion as a man, he humbled himself, and became obedient unto death, even the death of the cross. Wherefore God also hath highly exalted him, and given him a name which is above every name: That at the name of Jesus every knee should bow, of things in heaven, and things in earth, and things under the earth; and that every tongue should confess that Jesus Christ is Lord, to the glory of God the Father.

> [The Son] is the image of the invisible God, the firstborn of every creature: For by him were all things created, that are in heaven and that are in earth, visible and invisible, whether they be thrones, or dominions, or principalities, or powers: all things were created by him, and for him. . . . And he is the head of the body, the church: who is the beginning, the firstborn from the dead; that in all things he might have the preeminence. For it pleased the Father that in him should all fulness dwell; And, having made peace through the blood of his cross, by him to reconcile all things unto himself; by him, I say, whether they be things in earth, or things in heaven.

The guiding idea is that Christ alone is the image of God, infinitely higher than the angels and all other intermediaries between man and God. According to the exegesis, *morphē theou*, "the form of God," means "the divine quality"; and the distinction of being *to einai isa theō* is the affirmation of an equality of honor and treatment, which presupposes an equality of essence.

Hence, this is a break with the Philonian Logos and with the second hypostasis of the Platonists. Christ is not a diminished copy of God. He is "the image of the invisible God," a title linked to his status as the firstborn. That claim is repeated at the beginning of the Epistle to the Hebrews: "[The Son] is the brightness of his glory, and the express image of his person." The word "brightness" *(apaugasma)* is borrowed from the Book of Wisdom. "The express image of his person": *kharaktēr tēs hupostaseōs auton. Kharaktēr* designates the imprint that

gives an exact reproduction of the object. In this instance, "hypostasis" is the substance or essence concealed behind appearances (the word does not yet have the definitive meaning of "person" it acquired after the Arian crisis).[65]

2. With respect to man, a distinction must be made between the aspect of the image given him by nature and the aspect that constitutes his goal of identification. A single text attributes the image to man as a gift of nature. In I Corinthians 11:7, Paul recommends that men pray with their heads uncovered, and women with their heads covered, "for he is the image and glory of God: but the woman is the glory of the man." The apostle's intention is to assert the husband's authority over his wife.

In the other texts, the image has more to do with the second creation than with the first: one must put on or develop within oneself the image of God or of Christ. Romans 8:29 speaks of those God "did predestinate to be conformed (*summorphous*) to the image of his Son, that he might be the firstborn among many brethren." In I Corinthians 15:49, it is said: "And as we have borne the image of the earthy, we also bear the image of the heavenly." This verse has to do with the two Adams: the first, the earthly Adam, is the model for our present corporeal condition; the second, the heavenly Adam—that is, Christ—is the *prototype* for our future condition as resurrected beings. Thus we see how Christ has brought about a renewal of the creation. For the first time, another outcome to spiritual ascension is possible: not a removal from the sensible world toward the intelligible, not a renunciation of the body and the material universe, but a redemption of the creation, inasmuch as the new creation is to the old what Christ—the heavenly, resurrected Adam—is to the earthly Adam and to us. This opens a new perspective to art, which was later recognized: in principle, there is a relation of likeness between the earthly image and the heavenly image, and a temporal relation between the present and the future. These relations are governed by the virtues of faith and hope. The artist can imagine that his work represents a deposit made toward future resurrection, when everything will be repaired and reintegrated. He situates his work and his own body within the hope for glorious resurrection.

In Pauline doctrine, one finds no Greek or even Philonian spiritualization. In place of the Hellenic distinction between soul and body, the apostle usually prefers the distinction between the body (under the Spirit) and the flesh, as two poles or postulates offered men's freedom with or without grace. The shift from the flesh to the body comes about with the incorporation into Christ: "Ye have put off the old man with his deeds; and have put on the new man, which is renewed in knowledge after the image of him that created him" (Colossians 3:9–10). But the image of Christ to which man must assimilate himself exists not

only in his godly condition but in his glorious resurrected humanity, both in body and in soul.

A last passage hinges on the interpretation given to the Greek word *katoptri-zomenoi*. It appears in II Corinthians 3:18. It can be understood as follows: "But we all, with open face *beholding* as in a glass the glory of the Lord, are changed into the same image from glory to glory even as by the Spirit of the Lord" (emphasis mine). In this case, we have returned to the Hellenic theme of the transformative vision. But if we take into consideration the fact that the context refers to the veil of Moses, this passage takes on a different meaning. Moses lifted his veil before God, and the glory of the Lord was reflected on his face. He put the veil back down when he returned to the Hebrews, because they would not have been able to bear the light shining from his face. This is the same veil that is torn away when we turn to Christ: then, unveiled, we, like Moses, reflect the glory of the Lord. We could therefore interpret the word in this passage in a passive sense: "We all, with open face *reflecting* as in a glass the glory of the Lord, are changed into the same image from glory to glory even as by the Spirit of the Lord." This deifying reflection is not achieved through philosophical effort, but through the grace of the Son, who, through the Cross, reconciles God with man and, secondarily, with his works and the entire cosmos. The powerlessness of art, noted by philosophy, can thus be nullified by the divine gift, by grace.

4. THE IMAGE OF GOD: FOUR CHURCH FATHERS

Faced with the towering cliff of patristic literature, the some four hundred volumes in two columns of Migne's Greek and Latin patrology, I am overtaken by fright, especially since each of the authors provided enough material to fill libraries with scholarly commentary for fifteen centuries.

But I have no choice. Which fathers to consult? I will not go seeking what Melito of Sardis, Methodius, or Ephraem of Nisibis think of the divine image. I will limit myself to two "early" fathers (from the second and third centuries), Irenaeus and Origen, and to two fathers from the golden age, Gregory of Nyssa and Augustine. Can you already guess at the thin fissure that, much later, having widened in a terrible manner, separated East from West?

Irenaeus: The Corporeal Image

The main enemy of Irenaeus is "the pseudo-gnosis." Valentinian, his principal adversary, introduced Greek antimaterialism into his system, but made it into an extreme anticosmism that horrified Plotinus. For Plotinus, the sensible

world was suspended from the intelligible world and thus took a certain dignity from it: "It is a clear image . . . of the Intellectual Divinities."[66]

Valentinian introduced a break. The sensible world, produced by the demiurge, is cut off from the higher world because it is part of another creation and another creator. Valentinian contrasts the likeness and the image. Likeness is produced by generation, by pairs of aeons *(suzugia),* which are derived from the supreme and separate God, the pleroma. The image, in contrast, is conceived on the model of artistic fabrication. The demiurge unconsciously produced images of aeons in his sleep, through the action of a superior being he did not know (the Mother, Wisdom Achamoth).

Man is therefore not in the likeness and image of God. In fact, he loses his unity, originating from several different natures. The demiurge fashioned the hylic man from clay—in his image. He breathed the psychic man, made in his likeness, into this hylic man. But, unbeknownst to him, Achamoth mixed seeds consubstantial with herself into this breath, seeds she had engendered by contemplating the angels who stood by the Savior, that is, by the aeon with which she was going to unite: these seeds produced the pneumatic man, consubstantial with the deity.

It follows that man is deprived of free will. He is the plaything of forces outside him, which make him hylic, psychic, or pneumatic, and only in this last case worthy of being saved. Only the initiate to Gnosticism, a member of the sect, is pneumatic, and he is so not by virtue of his freedom but by virtue of the germination of the spiritual principles deposited in him.

Valentinian forces this mythical schema into the Christian framework. The demiurge is the God of the Old Testament, the God of the Jews, excluded from the pleroma, the fashioner of hylic images. Jesus emanates from the pleroma, the higher Christian God, in a mode that only the Gnostics have the privilege of knowing.

Irenaeus (born 130, died shortly after 200) rejects that doctrine, which is repugnant to the Bible and to philosophy. It stands in opposition to the primary dogma, articulated and repeated at every stage of Creation from the first chapter of Genesis: "And God saw that it was good." In contrast, Valentinian observes that "it" was bad. His doctrine stands opposed to history, the concrete meaning of successive and individuated events. These events are first devalorized in favor of a timeless schema that signifies in their place and are then reduced to the allegorical signs of this schema. His doctrine stands opposed to virtue, since men are the prisoners of external forces and lack free will.

The following passage offers an overall view, allowing us, perhaps, to get a sense of Irenaeus:

How, in fact, will you be god, when you have not yet been made man? How will you be perfect, when you have just been created? How will you be immortal when, in your mortal nature, you did not obey your Creator? For you must first hold your rank as a man, and then only receive a share of the glory of God: for it is not you who makes God, but God who makes you. If, therefore, you are the handiwork of God, wait patiently for the Hand of your Artist, who makes all things in good time—in good time, I say, in relation to you who are made. Present him with a supple and docile heart, and keep the form this Artist has given you, holding within you the Water that comes from him, for without it you would grow hard, and would reject the imprint of his fingers. In holding to that conformation, you will rise to perfection, for through the art of God the clay that is in you will be hidden. His Hand created your substance; it will dress you in pure gold within and without, and will adorn you so well that the King himself will be taken with your beauty. But if, in hardening yourself, you reject his art and prove dissatisfied with the fact that he made you a man, by virtue of your ingratitude toward God you have rejected both his art and life itself: for making belongs to the goodness of God and being made to the nature of man. If, therefore, you open to him what is of you, that is, faith in him and submission, you will receive the benefit of his art and you will be the perfect work of God. If, on the contrary, you resist him and flee his Hands, the cause of your imperfection will reside within you who did not obey, not in him who called you.[67]

In this text, we find a compendium of the teachings of Irenaeus. There is only one God, *unus et idem:* this is repeated a thousand times. It is blasphemous to distinguish between the Creator and the Savior, the demiurge and the pleroma. God the Creator is the same as God the Savior. That is why he made the creation beautiful and made it for man.[68] He did not need the angels and the intermediate aeons of the Gnostics to create: he created the world directly, "aided as he was by those who are both his progeny and his Hands, that is, the Son and the Spirit, the Word and Wisdom, in whose service and under whose Hand stand the Angels." Irenaeus returns on many occasions to the metaphor of the hands of the Father, the Son, and the Spirit shaping the world. God is the Artist.

Irenaeus also rejects the second Gnostic blasphemy, the passionate and contemptuous rejection of nature, and, in the first place, of human nature. He rehabilitates the body and the flesh, never tires of collecting biblical texts that prove the dignity of carnal humanity and the salvation that awaits it. The Gnostics drew on the word of the apostle Paul: "Flesh and blood cannot inherit the kingdom of God." This is true, replies Irenaeus in a long exegesis, but it is the kingdom of God that will inherit flesh and blood, once they have been transformed by the action of the Spirit.[69]

Finally, Irenaeus refutes the third Gnostic blasphemy: the claim to accede, or

even to belong by rights, to the divine world, which not only transcends the world of matter and the flesh but is without any relation to it. He refutes the claim to seize upon salvation by the single fact that, in exchange for the illumination of gnosis, one regains an awareness of one's true being, the pneumatic self, which is unrelated to the hylic and psychic self, and by virtue of which one has never ceased to belong to the divine world. In contrast, orthodoxy makes salvation the result of a fierce struggle, obedience to divine commandments, conformation to the model designed to assure the rule of the Spirit and to prepare the body to "receive a share of the glory of God."

In this way, he rehabilitates history: salvation does not entail wresting oneself from time to accede to eternity or to an atemporality achieved through illumination. Salvation comes about in history, in "holy history," of which Christ is the recapitulation. There is no human experience, either in physical and moral being or in historical being, which Christ in the Incarnation did not recapitulate and, as it were, incorporate. This incorporation is precisely the instrument of salvation. Similarly, every man, when he has become aware of his imperfection, asks time to grant him the indispensable delay allowing him to become perfect in accordance with the benevolent design conceived for him by God, who is the Creator and the Savior combined. This labor in view of perfection is the joint handiwork of God and man: it consists of making man the image of God. Only God—and not the lower angels—can make an image of God. For that, he uses his two hands, the Son and the Spirit.

God the Son is thus at once a collaborator and a model, not only in his capacity as preexistent Logos but as incarnate Word: "The image of God is the Son, in whose likeness man was made. And it is for that reason that the Son appeared at the end of time, to show that his image resembles him."[70] The Word manifested itself when it became man, making itself similar to man, and making man similar to it, so that, through his likeness to the Son, man might become dear to the Father:

> In earlier centuries, it was said that man had been made in the image of God, but it was not shown, because the Word in the image of which man had been made was still invisible; thus likeness itself was quickly lost. But when the Word of God became flesh, it reestablished one and the other [the image and likeness] since it showed the image in all its truth, having itself become what was in its image [having become man], and it impressed profound likeness in making man similar, through the visible Word, to the invisible Father.[71]

Hence, the image of God in man is like a photographic plate that has been exposed but not developed, and which the incarnation of the Word is going to "re-

veal." For, as Irenaeus points out, Christ is the visible aspect of the Father, and the Father the invisible aspect of Christ.

But what was immediately revealed was the image, not the likeness. The image is of nature, it is human nature, body and soul, and cannot be lost. But the likeness has long been lost. The gap between the image and the likeness, both given in Christ, cannot be bridged except by the action of the Spirit. It is the presence of the Spirit, its inhabitation in man, that gives likeness and conformity to Christ. The body and the soul, or the hylic and the psychic, make up the image. The spirit, or the pneumatic, is the seat of likeness.

The infusion of the Spirit returns man's true essence to him. It is a long process that cannot be achieved on earth. The assimilation to God or, what amounts to the same thing, the vision of God face to face, which brings glory, incorruptibility, and immortality, will come about only in the world of the resurrected. Then, man will be complete, perfect, similar to the Father through the mediation of the Son.

The body is not excluded from that conformity to God:

> Through the Hands of the Father, that is, the Son and the Spirit, it is man and not a part of man who becomes in the image and likeness of God. The soul and spirit can be a part of man, but not man: the perfect man is the mixture and union of the soul, which received the Spirit of the Father and which was mixed with the flesh molded in the image of God. . . . The molded flesh in itself is thus not the perfect man: it is only the body of man, hence a part of man. The soul by itself is no more man: it is only the soul of man, hence a part of man. The Spirit also is not man, it is given the name of Spirit, not of man. It is the mixture and union of all these things that constitute the perfect man.[72]

Irenaeus, confronted with Gnosticism, an immoderate Hellenism, which became even more immoderate when it became Christian, finds solid ground only by meditating on Scripture. Other church fathers ventured a philosophical synthesis: in the perilous position in which he finds himself, the bishop of Lyons can only counter with apt quotations.

With Irenaeus, we seem to be far from aesthetics. But it is clear how an aesthetics can find a place within his thinking, or rather, how an artist can develop within a setting that conforms to the spirit of Irenaeus. Irenaeus's world is a concrete, carnal world. Plasma has a place in it. Its Creator, who nonetheless retains all the attributes of transcendence, is familiar and, one might say, familial. He is to the world what Noah was to his ark: he oversees it, guards it, preserves it in view of a plan. This God is paternal and benevolent. He creates man only to have someone on whom he can bestow his gifts, and in particular, the gift of the

Spirit, which configures him to the Son and elevates him to a communion with the Father. In Irenaeus we get a taste of an intimacy with a God who lives among his people, something found only in the biblical texts. The God of Irenaeus is the God of Abraham, Samuel, and David, the God of the Psalms.

In this climate, the artist is invited to trust: to trust in the world that offers itself for contemplation and which, as such, "reveals God."[73] Without regret, he abandons "the vain idols he took for gods" and learns to honor "the true God that shaped and made the whole human race and which, through his creation, *nourishes* it, increases it, solidifies it, and gives it substance."[74] This artist will be patient. He will allow himself to be molded by divine "Hands." He will wait calmly for the infusion and work of the Spirit within him. He will accept his human condition as a childish condition, will be ready to let himself be nourished and taught by the creation and the Creator. His work of art will be praise. It will not be without hope, because the fullness of art, the divine image, is not beyond his reach. The world is an image, man is an image. Only a show of grace is needed to attain likeness, and there is no reason to think that grace is denied. Once things are faithfully represented, the divine, which is never far away, will come to join in the artist's work. He lets things express themselves and trusts them to transmit his impressions or expressions. Not far from him, the world contains the means for its own transfiguration.

But, *a contrario,* Irenaeus gives us an inkling of another race of artist, the "Gnostic" artist. He will rebel against the world's appearances and will believe he is a citizen of a different fatherland. Creation as such oppresses and revolts him. He will await the illumination, which will bring him back to his superhuman essence, which is unrelated to common humanity, and which, much later, he will name his "artistic nature." He will labor to enter into communication with the pleroma, with the God who is set apart, even as he is set apart. He will try to be pneumatic and saved by rights, by developing within him the divine seeds that reveal the nothingness of this world to him, his radical difference, his rightful place within the ideal. He is initiated into the great secret, which his art simultaneously dissimulates and reveals. But he labors at great risk and under the threat of despair. The pleroma is ineffable, and he is not sure he stands in the small circle of the chosen. He will be caught between his sublime intuition and the weakness of the means at his disposal to communicate it to ordinary humans. And, in fact, are they worth the trouble? Must not initiation be reserved solely for those worthy of it? In the end, is not silence a sign preferable to the word, which is condemned to be lost? He will be an expressionist, will force things to convey what he wants to say, to make others feel or see. He will force the hidden world to appear by tearing away the veil of this world.

There is no reason to think that he is a lesser artist than the other sort. But they form a couple, of which the history of art provides illustrations. Without prejudging what each of them thought and believed, we might contrast Memling and Altdorfer, Bellini and Crivelli, Zurbarán and El Greco, Corot and Friedrich, Monet and Redon, Matisse and Malevich. But that entails looking at things from too far away. When we look at the details, the opposition does not hold, and perhaps the painter placed in one column fits better in the other, given some other aspect of his work. Although it is certainly an exaggeration to speak of two races, it may not be going too far to distinguish between two attitudes toward the world, or, at the very least, two ways of directing one's sight.

Origen: The Invisible Image

Interpreting Origen is tricky. In the first place, his personality stands in sharp contrast to the serene personality of the bishop of Lyons. He was a child prodigy, enthusiastic, systematic, mystical. Second, his philosophical training was complex, and it still spurs scholarly discussion: Philo, Plato, middle Platonism, Stoicism, and the mysterious Ammonius Saccas, his master, all exerted an influence. Under Ammonius (and whether he was or remained Christian is still a matter of dispute), Origen may have been the fellow student of Plotinus. Or perhaps that was a different Origen. Finally, his writings are in poor condition. A large portion has been lost. For most of the extant texts, we have only the Latin translation by Rufinus, which is sometimes imprecise, sometimes tendentious.

His theology as a whole was condemned three centuries after his death. But Henri Crouzel, an expert on the matter, objects that the historical value of the condemnation "is close to nil as far as Origen is concerned, since its real target was the Origenians of the time, who were called the 'Isochrists.' "[75] Although some scholars of considerable standing (Faye and Koch) go so far as to expel Origen from the body of Christian thought, others (such as Crouzel) reintegrate him to a substantial degree into orthodoxy. We do not have the means to decide the question.

Plato writes: "Having no place among the gods in heaven, of necessity they [i.e., evil spirits] hover around the mortal nature, and this earthly sphere. Wherefore we ought to fly away from earth to heaven as quickly as we can; and to fly away means to become like God, as far as this is possible; and to become like him, means to become holy, just, and wise."[76] This famous passage from *Theaetetus* shows that even for the Greeks the goal of human life was true likeness, *homoiōsis,* with God. Origen inherits a tradition via Philo and a whole se-

ries of philosophers and church fathers. According to Origen, that tradition accords with Saint Paul, for whom Christ is "the image of the invisible God."[77] But if Christ alone is the perfect image of God properly speaking, he is so only by virtue of his divinity. Christ is therefore the invisible image of the invisible God, since God, who is incorporeal, can have only an incorporeal image. Man, however, is created "*after* the image of God," that is, after the image of the Word, which is both the agent and the model of man's creation. Hence, for Origen, one cannot say that man is *in* the image of God (the privilege of the Son), but only *after* the image, or "in the image of the image."[78]

Therefore, Origen does not understand Christ's humanity as being in the image of God—it is solely, as among all men, an image of the image. Nonetheless, it enjoys a preeminent role as the intermediary image (after the Word) and as the immediate model for us to imitate. It is also "the shadow of Christ the Lord" under which we live.

The phrase "after the image" has nothing to do with the body—since, in that case, one would have to suppose that God is corporeal. It has to do with the soul, or rather, its higher, "hegemonic" element: intelligence, the logos. The "after-the-image" participates in the Father, "He who is"—like the words Moses heard coming from the burning bush. Rational creatures receive deification through the action of the Son and progress toward him until the "after-the-image" becomes a perfect likeness. The image, in fact, naturally tends to move toward the model and to reproduce it. "After the image" also designates a participation by the Son, by virtue of what Origen calls his denominations *(epinoiai),* which correspond to the attributes the Son takes on in relation to us: the quality of adoptive Son of the Father, of Anointed, of Wisdom, of Truth, of Life, of Light. As Logos, the Son makes of us *logika.* But if, like demons, we turn away from God, we then become *aloga,* animals deprived of reason, spiritual beasts. The "after-the-image" defines us. It is the foundation of our nature, our "principal substance." The "after-the-image" makes us find God deep within our being, since, in accordance with the principle of Greek philosophy, "only like knows like."[79]

Sin cannot destroy the "after-the-image." Beneath the diabolical or beastly images that cover it, it remains pure, like the water in the well of Abraham, which the Philistines filled with mud. Painted by the Son, it is "indelible." But it is this same Son incarnate who, like Isaac, will clear out the accumulated debris from the well of the soul and will uncover the living water.

> The painter of this image is the Son of God. The painting is so fine and so powerful that its image can be obscured by neglect, but not destroyed by malice. The image of God still subsists in you, even when you superimpose the image of the earthly on it. It is you who are the painter of that painting. Has

lust tarnished you? You have applied an earthly color. Does greed burn within you? You have mixed in another color. . . . Hence, by every species of malice and by the combination of various colors, you paint yourself that image of the earthly *(imaginem terreni)*. Man paints his image with the palette of his sins.[80]

At the end of the dynamic argument on the "after-the-image," likeness is finally found—but not in this world. *Homoiōsis* coincides with the face-to-face knowledge of God, just as the "after-the-image" coincides with the beginning of knowledge. Hence the goal Plato set for human life is attained through the redemption of Christ.

Origen precipitated a theological explosion, whose effects have spread out in all directions, even down to our own time. In particular, he stands at the source of a distinct current, which can be called "Origenism," and which cast the question of the divine image onto a path leading to iconoclasm. There is an Origenian system, an Origenian cosmology that makes the plastic representation of the divine problematic. Two points in that systematic cosmology are decisive. The first is Origen's Christology. "The Lord is called 'true,'" he writes,

in opposition to shadow, the figure, and the image; for such is the Word in the open heavens. It is not on earth as it is in heaven, because, having become flesh, it expresses itself through the intermediary of shadows, figures, and images. The mob of so-called believers is instructed by the shadow of the Word, and not by the true Word of God, which is in the "open heavens."[81]

Thus Origen, although he is against the Gnostics, seems to draw an opposition between a form of exotericism belonging to the simple and ignorant folk, who cannot get beyond Christ's humanity, and an esotericism, or at the very least, a higher knowledge, which accedes to the contemplation of the Word, as it is "in the open heavens." The Incarnation is conceived as a pedagogical adaptation by means of which God bows to human capacities. It points out the spiritual path along which human weakness will progress, beyond that Incarnation, to reach the knowledge of the Word in itself. The facts of Christ's life, including his Passion, are the lower degrees of an elementary initiation. The Incarnation appears as a mere phase, since, at the Resurrection, the Word returns to its original state. The goal of knowledge is to contemplate the "naked Logos," stripped of its garment of flesh. The body of Jesus is "the image here below" of "the realities above."[82] Hence, a gap exists between the Word and the man Jesus. The latter is the instrument, the manifestation of the Word: he is not the revealed object in itself. From this perspective, a representation of Christ can be only the image of the image of an Image.

The second point, which in fact governs the first, is Origen's anthropology.

How could a good and just God, the Gnostics said, have created a world so nonegalitarian, hierarchized from angels down to man? How could he have allowed one man to be born among the Hebrews, in proximity to divine law, or among the Greeks, in proximity to wisdom, while another is born among African cannibals or patricidal Scythians?

Origen, to defend the justice of God and freedom against Gnostic pessimism and fatalism, advances the theory of the preexistence: originally, spirits were created equal, similar, and free. Freedom presupposes mutability: "Freedom impelled each one either to progress through imitation of God or to fall through negligence."[83] If the spirit continued to turn toward God, it constantly received from God. Whatever it is, it is through grace. The status of nature remains problematic in Origen. But should the spirit turn away from God, should it stop out of weariness or fear of effort, it becomes a physis, a determinate nature. Origen says these spirits are "frozen." And all spirits—with the exception of the preexistent soul of Christ—have fallen. Depending on how far they have fallen, they become angelic hierarchies, heavenly bodies, or human races. Each earned his lot, in accordance with his sin. Certain souls had not sinned enough to fall to the level of demons but were also not lofty enough to remain among the angels: for them, God made the present world, and he joined them to bodies to punish them. That explains the cosmic hierarchy of the *coelestia* (angels and stars) and of the *terrestria* and demons.

These three classes of spiritual beings are not separated by rigid partitions. The love of God and free will remain inamissible and, as a result, by doing good or evil, every such being can rise higher or fall even lower.

What is the status of the body, in this world of the fallen *logika?* The body is not part of the nature of any being, since there is no nature; nature is absolutely dependent on God and his gifts of grace. All spirits are originally incorporeal. But in the fall, all take on bodies. Can one say that the body is an evil, as the Platonists and Gnostics claimed? It is not an evil in itself, since it was created by God. But it is a punishment, and for Origen, punishment is also a means toward healing. The *apocatastasis,* the reintegration of everything, is a return to pure spirituality. The resurrection of bodies is not denied, but it is only a stage in the return: the glorious body is an intermediate degree between the earthly and animal body and the state of pure spirit.

It follows that man is his soul. He is corporeal only by accident, and this corporeality is not really part of God's design for creation. That is why Origen sets the dead images of pagans against the true images of God, that is, the Christians, who bear the beauty of divine virtues in their souls. Since the soul alone is in the image of the image of God ("image of which the Son of God is the

painter"),[84] the only appropriate worship is that practiced in Christian souls, and the only statues and images that must be built are those of the virtues, which shape the soul in the image of God. "We are convinced that it is by such images that one must honor the prototype of all images, the image of the invisible God, the monogeneous God (the Son)."[85]

Origin prefers the more intellectual term "contemplate" *(theōrein)* to the overly corporeal "see." Origen and Irenaeus seem to mark the beginnings of a bifurcation in early Christianity. Irenaeus chooses to trust in matter and in the body, whose ontological status is assured, encompassed by the divine and capable plan of God. If there is an Origenian art, its aim is the spiritual, the invisible, the internal, the soul. Painters with no fear of the nude and no fear of familiarity with divine things—Veronese, Rubens—will side with Irenaeus. The symbolists, and, in any case, musicians, in choosing the oblique, indirect, and allusive approach to holy things, will take Origen's side.

Gregory of Nyssa: The Evanescent Image

For Gregory, the image does not signify—as it does for Plato—an analogy between the lower sensible world and the intelligible world. Rather, as for Philo, it is a participation, a shared nature. In the case of the divine Logos, that is, the image of the Father, there is a perfect equality of natures. In the case of man, the likeness, however inexact it might be, is direct. Philo posits the cosmos as an intermediate image; Gregory reserves that privilege for man alone: "Heaven was not made as an image [icon] of God, nor was the moon, the sun, or anything of what was made in creation."[86] The similarity is total. "What was created in the image of God possesses a complete likeness to its archetype. It is spiritual like him, incorporeal as he is incorporeal." "Image" designates a supernatural participation in the sanctity of God. That is why Gregory compares God to "a painter who decorates his picture with flowers, transforms it into his own beauty, and unveils his own excellence in it."[87] The image has to do with intellectual *(nous)* and spiritual *(pneuma)* life, which, of themselves, constitute the nature *(physis)* of man, in the state in which he was created. Animal life, that is, psychic or somatic life, is an accident added on to that nature. In Western theology, by contrast, nature encompasses animal and intellectual life, and it is the supernatural spiritual life that is added on.

Human nature, in its state of creation, is immortal and asexual. The creation of "male and female" is a second stage of creation, which anticipates the eventual failure of the first state: God, foreseeing that man, given his freedom, would not turn toward the good, and to give him a chance to return to him, took away

the angelic mode of propagation and gave him another means, of an animal nature. Sexuality is thus the result of a shortcoming. It is also the source of other shortcomings, because it is the seat of passion.

In Western theology, there is a human nature, to which grace, which serves to perfect likeness, is added on. For Gregory, it is man's divine life after the image that is the original state. Positive, natural man comes second. Life on earth is neither stable nor real: paradise is man's true home. Man originally lived in bliss. This bliss was well adapted to his nature, and he lived without passion, without sex, incorruptible. Christ was the one who "reestablished in his initial bliss the man exiled from Paradise and plunged into the abyss of earthly life."[88]

But where is this man who is in conformity with his nature? He cannot be seen, because he has taken on "tunics of skin," that is, biological existence and participation in animal life. "These things added to our true nature are the union of bodies, conception, childbirth, suckling, food, desire, adolescence, middle age, old age, illness, and death."[89] All these things, devalued by Gregory, became radically evil in Gnosticism. In Irenaeus's orthodoxy, only illness and death counted as the consequences of the fall, incompatible with the nature of man. The union of bodies, reproduction, and food, in contrast, were counted as blessings.

The tunics of skin represent animal life as a whole, everything that is common to man and beast. All the same, the body is capable of more elevated states. In place of tunics of skin, man can wear what, in *The Life of Moses,* Gregory calls "the tunic of the High Priest."[90] For Philo, this tunic was a symbol of the cosmos. It was blue. For Gregory, it symbolizes the heavenly character of a purified life. It is a light, airy tunic, which corresponds to the pneumatic body. Man, in short, shorn of the tunics of skin by asceticism, recovers a body appropriate to his nature. It is not included within the image of God, since only the soul participates in it. But the dignity of the soul reflects onto the body. The body is suspended from the soul as the soul is suspended from God. It is the mirror of a mirror, the image of an image. As a result, the body tells of the glory of God, just as, in the Psalms, the cosmos tells of the glory of God. Gregory, following middle Stoicism and the "Dream of Scipio," sees the body as a microcosm.[91] "If, therefore, the whole universe is like a musical composition, with God as its composer and performer, if man is a universe in miniature and, simultaneously, a replica of the One who organized the universe, whatever our minds discover in the larger cosmos, it is natural to see in the smaller as well, since the part is of the same nature as the whole."[92] The body is in the image of the world, just as the soul (alone) is the image of God.

Tunics of skin, that is, the body in its mortal—sexed—condition, are both a

burden and a remedy. They were given to man so that evil would not force him to stay with his first choice, which God foresaw to be bad, and which would have yoked man to evil forever, had he been pure spirit. Taking the path of purgation, of asceticism, man wrests himself away from the tunics of skin. He returns by stages to paradise, to primitive bliss. Renouncing the passions, and even marriage, "he steps out of his clothes, his flesh." At the end of time, humanity will no longer be confined within animality and, having reached its pleroma, it will be reestablished in its original angelic life.[93]

Such is the inferior, precarious, and ephemeral status of the body in its present condition. The divine Incarnation did not really change it. On this point, Gregory is the heir to spiritualism, or, at least, to antihylism and antisomatism, as expressed by Plato, Philo, Plotinus, and Origen. If the divine image is reflected anywhere, it is in the virtuous, purified, "apathetic" soul.

> If, through an upright life, you wash away the filth around your heart, godlike beauty will shine again within you. In fact, what is similar to the good is good. Thus in seeing itself, it sees in itself the one it is seeking. And that is why anyone who is pure in heart deserves to be called blessed, since in looking at his own beauty he sees the model in it. Just as he who looks at the sun in a mirror, although he does not fix his eyes on heaven itself, nevertheless sees the sun in the clear surface of the mirror, so you too, even if your eyes cannot perceive the light, you possess in yourself what you desire, if you return to the grace of the image *(kharis tēs eikonos),* which was placed inside you from the beginning.[94]

At this point, we are close to the doctrine of Plato's *Phaedo,* where the pure is united with the pure; and to the doctrine of Plotinus, where purification is compared to the polishing of a statue. There is a difference, however. As a matter of fact, it is not through the effort of purification alone that the soul again becomes the mirror in which divine beauty is reflected. Rather, it is divine Presence, divine sanctity, that brings about purification. Purity and Presence are therefore identical, and it is not surprising that the soul, in contemplating its purity, sees God, since God is in the soul, and the soul indistinguishable from God. God is not intrinsic to the soul—as in Plotinus—rather, the soul holds within itself a freedom that can turn toward God and to which God then communicates his life. "The rays of true and divine virtue, reflected in a life purified by *apatheia,* which stems from it, make visible the invisible and accessible the inaccessible, forming an image of the sun in our mirror."[95]

Therefore, one finds God in one's self only because God has come into it. The soul does not possess a divine nature, whose contemplation would be the equivalent of contemplating God. It is divine only by the grace of an extrinsic deifi-

cation. But is it truly possible to contemplate the divine image? Gregory proposes a path, to be traveled in successive stages. The return to paradise and to the original condition of man is attained: first, through purgation and baptism; second, through a struggle against the passions, until one reaches the complete detachment of *apatheia;* and, finally, through intellectual contemplation, or *theoria.* But this intellectual contemplation leads to ecstasy, and there vision evaporates. The divine image dissolves into mystical shadows, as explained by negative theology.

To understand this movement, let us follow Gregory's last treatise, *The Life of Moses.* Gregory confers an allegorical meaning on every episode of the prophet's life. Here, then, is Moses moving into the shadow on Mount Sinai: "The text teaches us that, for those who receive it, religious knowledge *(gnōsis)* is light in the first instance. . . . But the farther the spirit . . . progresses toward contemplation, the more it sees that divine nature is invisible. . . . True knowledge of him whom it seeks, and the true vision of him, consist in this, *in the fact of not seeing.*"[96] Hence, "every concept formed by the understanding, in its effort to attain and circumscribe divine nature, succeeds only in fashioning an idol *(eidōlon)* of God, not in making him known."[97]

Moses has the desire to see God face to face. God accedes to his request, but, at the same time, he explains that "what he seeks exceeds human capacity." Thus, Gregory claims, he leads him to "despair."[98] Moses must understand that the divine voice "grants what is requested by the very fact of refusing it." The sight of God is limited to the desire to see, and is, moreover, identified with it: "For the true vision of God consists in the fact that he who lifts his eyes toward him never stops desiring him."[99]

Man must therefore despair of acquiring a stable icon of the divine, since "the desire for the Beautiful that leads to its ascension expands continually as one advances toward the Beautiful."[100] It is only in this indefinite movement that man finds his stability, which is "like a wing in his journey toward the heavens."[101] The icon dissolves as one approaches—and the only true icon is the dissolution itself.

The Bible, Plato, Philo, and Origen all mingle together in Gregory of Nyssa's writings. It is possible to bring him into line with orthodoxy, as Daniélou and Leys have done; it is also possible to bring him closer to one's own philosophy, as Urs von Balthasar has done. I will refrain from entering into a discussion with these scholars, who have lived in close quarters with Gregory. But if we look at the fate of Eastern Christian art, both its iconoclastic tendencies and the hieratism that establishes the limits of the icon, the Cappadocian is certainly one of those who, standing at the brink of that art, determined the direction it took.

The radical infirmity of the body, the impulse to be free of it, the concept of the pneumatic body, which reappeared later among the esotericists in an adulterated version (as an astral body), the disrepute of sexuality as such—which is surprising in Gregory, one of the few church fathers to have been married (unless that is the reason)—constitute one of the poles of his thought. The desire for God, an "unfulfilled" desire governed by "despair," the endless dialectic of *epektasis,* the pursuit of a divine image that is swallowed up by the darkness as one advances to meet it, the reducing of satisfaction to desire and of vision to shadow, all form the other pole. If there had been only Gregory of Nyssa (and Origen), and if, moreover, there had been no Christian art at all, it would be natural to explain the second fact by the first.

There is an aesthetics in Gregory, but it excludes, more radically even than in Plotinus, artworks and representations, to the point that even the works that managed, in spite of everything, to come into being in this climate, are consumed by their own negation.

Origen and Gregory love beauty and, at the same time, they despair of the work of art. Consider this passage from *On the Making of Man:*

> Since the divine is supreme beauty and the highest of goods, to which everything that desires the beautiful yields, we say that the spirit *(nous),* formed in the image of the highest beauty, remains within the beautiful as long as it participates in likeness to the archetype, as far as that is possible, but that it comes to lack beauty as soon as it leaves that realm in some way. . . . As long as one is suspended from the other, participation in true beauty is communicated analogically to every degree, and the higher degree makes what is suspended from it beautiful. But if a break should occur in that good cohesion, and if the higher begins to follow the lower in opposition to the proper order of things, then the deformity of matter abandoned by nature reveals itself (matter in itself is formless and artless) and that formlessness also destroys the beauty of nature, which, for its part, received its beauty from the spirit. And hence, through the communion of nature, the ugliness of matter penetrates spirit itself, in such a way as to make the image of God disappear into its structure.[102]

If an artist takes this text to heart, he will judge that what matters is not *making*—since making presupposes a certain conversion of matter—but rather turning toward the source of beauty. Hence, the true work of art will be the internal attitude the artist takes, the pure will to art, which he will exemplify in his person. And to make the new state of his soul—the unique work of art—public, he will produce manifestations of it, which may be acts of hatred, or acts of destruction, or acts of parody, of anything that is not this internal attitude—that is, of what is vulgarly, "hylically," considered a work of art. To get rid of the work of art in order to better sculpt the internal statue, and to that end, to smash

every external statue, every past and present work of art, to hold art in contempt in order to glorify the artist: such is one of the movements of art that began with Dada and Duchamp. To burn a canvas, to tear it to pieces, to soil it with excrement, to take the most violently sadistic attitude toward painting, and then to surround the object thus obtained with the utmost attention, jealously overseeing its display at a Biennial: this contrast, which so amused Robert Klein, can be easily explained.[103] What the artist fabricates and then protects is a visible and verifiably authentic manifestation of an internal, invisible posture, an aspiration or attachment to the divine source of beauty.

Augustine: The Poet's Inspiration

In reading Augustine, the Western European has the feeling he has come home. This is not only because Augustinianism is so intricately woven into the fabric of our traditions that it is there in some degree in most of our works. Had he not been one of the architects of our home, and had that home been built with materials older than he—as it was, in fact—we would still feel he was a friendly host inviting us to live in it. His theology passes for harsh and somber, but it is not foreign to us. It "repatriates" us. And yet, when we seek in Augustine the themes corresponding to those in Gregory or Origen, we find him adopting similar positions. It is the differences, however, that are significant.

The Augustinian doctrine of the image stands in the tradition of Origenism, since it places the image of God not in man's body but in his soul, and in particular, in his *mens.* Man's domination over the animals is a sign of this phenomenon, since the animal soul does not possess *ratio* or *mens,* the seat of the image.

The soul is an image by virtue of its capacity to know God. God creates it in two different ontological moments. In the first, the soul is characterized by an absence of determination and form. This is the phase of *materia spiritualis* or *informitas.* But, as a spirit, and one capable of knowledge, the soul becomes unified in a movement of conversion to God, by virtue of which it receives its form and accedes to knowledge of God and of itself. This is the phase of *formatio.* The formation of the created spirit (angel or man) "coincides with the intellectual illumination through which that spirit knows the Word of God and knows itself to be within it, even while distinguishing itself from it" (Gilson). "That first light was created in such a way that a knowledge of the Word of God, by which it was created, came into being; for [the spirit], that knowledge consisted of being turned away from its formlessness and toward God, who formed it, and thus of being created and formed."[104] That conversion, which lies at the foundation of a knowledge of God and of self, does not come after the creation of

the spirit, but is constitutive of it. Nevertheless, it is a freely chosen conversion. The creature must ratify its conversion in an act of freedom, by virtue of which it remains turned toward God. This is where the possibility of sin comes in, for the angel and for man.

The essence of the human soul is thus to know God: *Principale mentis humanae quo novit Deum vel potest nosse.*[105] Knowledge will become perfect only at the final moment, when the soul sees God as he is, and when it has overcome the obscured vision occasioned by sin. The nature of man, unlike that of the angel—whose choice is definitive and immediate—permits this choice to occur and to extend across time. Man is a historical being, since his freedom is always being tested. Even under the weight of sin, the image is inamissible: "The image can be worn down to the point that it is almost invisible, it can be plunged into darkness and disfigured, it can be clear and beautiful, but it does not cease to be *(semper est).*"[106]

This doctrine bears the mark of Plotinus, who distinguished between a movement of dispersion from the One and a movement of return to the One, by virtue of which the multiple becomes being and intelligence. But Augustine introduces a personal relationship between God and his creature, posits an act of freedom on both sides, and locates that *exitus-reditus* within individual historical and cosmic time.

Augustine's conception of the body is much less ethereal than that of his Platonic colleagues. With respect to God's creation of "male and female," Augustine maintains that the two sexes have an equal dignity (woman also possesses a *mens*), and, basing himself on the phrase *fecit eos et benedixit eos,* he rules out the idea that God created an androgynous being.[107] In answer to the question of whether the body of the first man was an animal or a spiritual body, he concludes, in opposition to Gregory of Nyssa, that since the first man was an earthly man, his body could only have been an animal body.[108] More precisely, and again in opposition to Gregory, Augustine maintains there is no valid reason to deny the possibility of sexual propagation of the human race in paradise. At most, the libido would not have played a role in sexual union, for which *solo piae caritatis affectu* would have amply sufficed. Augustine's objection to the libido, to sexual activity under sinful conditions, is that it falls outside the *arbitrium* of will: "Man, having disobeyed God, felt his own members disobey him." Sexuality as such is not a shortcoming. Man's body is a good, even, for each man considered individually, a great good. The soul makes use of it.[109]

But Augustine's originality should not be sought in the inflection he gave to the theological and philosophical commonplaces inherited from Christian Platonists. It lies, rather, in the phenomenally personal twist he gave to his con-

templation. Augustine, steeped in Plotinus, read into him what came from the depths of his own being, believing he could see the Father in the One, and the Word in intelligence and creation. But Plotinus resists such an act of annexation.[110] The relation to the divine and to the world cannot be the same regardless of whether the relation between God and the world is generation and emanation, or, in contrast, creation. In Plotinism, there are only relations of generation and emanation. There is therefore a continuum extending from the One to the limits of the world: everything is divine, though less and less so as one moves farther out. For Augustine, who is Christian, the Creator is separated from the creature by a radical ontological break. In Plotinus's doctrine, therefore, it is possible to stray much farther from the first principle without leaving the divine. In that doctrine, the soul is within the divine realm of the intelligible. The soul finds the illuminating light within itself, because it is that very light. To return to the "fatherland," man has only to become aware of his true nature.

This cannot be the case for Augustine. The Augustinian soul cannot count upon itself to receive the light of God, since it does not possess it. It must receive it from God, and that light is created, just as the soul itself is created. Illumination thus presupposes creation. Furthermore, it comes about via creation. "Between the Plotinian soul's turning 'upon itself' toward its own light and principle, and the gradual elevation of Augustinian thought toward the transcendent cause of its truth, there is a difference in nature, and not only in degree."[111]

It follows that Augustinian contemplation cannot simply flee within, breaking its attachments to the external world. It needs mediation. Incapable of reaching God within itself (except, perhaps, in the unusual case of ecstasy), it must consider God in his works, that is, in the world of bodies, of which man is part, and then in the soul, which is the clearest image of God. "To contemplate is to direct an act of sustained attention toward things, an act that forms the question, to which the sight of things is itself the reply."[112] That dialectic is summed up in the famous line: "For men can evoke things through signs, that is, through words, but he who teaches, the only true Master, is the incorruptible Truth, the only internal master, who has become the external master [the Word incarnate] as well, to call us from the external toward the internal."[113]

In that view, all three elements find their consistency: the Word that teaches; the world that contains "causes," the "seminal causes" that the Word placed there and through which it was created; and the disciple who, discerning them in himself and around him, rises toward his Creator in the light of the master. Augustine rediscovers, in a different doctrine, the ancient intuition that had al-

lowed works to be created under the gods' demoniac inspiration, since works are part of the self-presence to the world, to which Origen's and Gregory's hyper-spiritualism could not resign itself.

That is why, in his strictly aesthetic work, *De musica,* Augustine borrows extensively from Varro, Posidonius, and the Stoic tradition. Unlike Plotinus, he reestablishes unity, harmony, equality, and number as "the source of beauty."[114] God is not jealous of temporal beauties. The different kinds of beauty must simply be hierarchized properly; one must not have disdain for higher ones or remain captive to lower ones. Every "number" is beautiful in its kind, and should be loved in its order, whether that order be of earth (the progression from one to four—center, length, width, and depth—the complete body), water, air, or finally heaven, which is the purest and the most perfect order. But even higher than it are the rational harmonies of holy and blessed souls, and infinitely higher is God, who governs everything. At every level, one should rejoice proportionately, "since delight is like a weight for the soul," and naturally gives it balance.[115]

In Augustine, the path taken by the soul, from things to God and back again, is marked out in such a way as to form a cosmos completely filled with the divine image, and a God completely filled with cosmic images, that is, with Ideas. As Gilson suggests, this may be an impossibility, resulting from the fact that Augustine has tacked Plotinism onto the Bible: "The problem of the reciprocal relationships among a plurality of gods, all contained within the order of the multiple, in no way corresponds to the problem of the relationship among a multiplicity of beings, of which none is a god, to the sole Being that is God. . . . Augustine has undertaken the undoubtedly impossible task of interpreting creation in terms of participation."[116] This is a fault, perhaps, but a *felix culpa,* since it opens the way to the most grandiose and all-encompassing of poetics.

The God of Augustine is the God of Abraham, Isaac, and Jacob, the God who created heaven and earth. In creating matter, did he create something? Yes, no doubt, since the creative act causes being, as the Bible obliges us to believe. But Augustine also inherits the Platonic notion of matter, conceived as something close to nonbeing. Augustine, whose philosophy is essentialist, then says that the creative act bears on matter and form: matter, which is *that of which* creation is made; and its synthesis with form, which is *that which* was made. The composite of matter and form, that is, a creature, is a *concreatum,* and the cause of its total being is God. It thus slips away from Platonic participation.[117]

God creates "formless" matter. Already it is something. In giving it form, "he makes and perfects." He makes: he brings to being, to unity, what was being in its raw state, a pure capacity to receive form. But, at the same time, he perfects:

the creating Word impresses on matter—which tended toward nothingness—a movement of conversion toward itself, which in turn imitates the cohesion of the Word itself with its Father. "Just as the Word is the perfect image of the Father by virtue of its perfect adherence to him, so matter becomes an imperfect image of the Word and of its Ideas, owing to its conversion to it; to create is indivisibly to produce the formless and to call it back to oneself to form it."[118]

It turns out, therefore, that the world is like God and that this likeness is the basis for its intelligibility and even its existence. Everything that is, is only by participation in the Ideas of God. Souls are chaste through their participation in Chastity itself, wise through their participation in Wisdom, beautiful through their participation in Beauty. But they are like one another and like God only through their participation in Likeness itself, which is nothing other than the Word, the perfect image of the Father. The world is composed of images that *are* images only by reason of the Ideas they represent, and by reason of the fact that an Image-in-itself exists, by virtue of which everything that is, can be like God.

For a likeness to be an image, it must be a begotten being with a likeness to its begetter. A mirror in which a man contemplates himself produces an image, because that man begot it. The Word is the image of God because the Father begets it in his likeness. That relation of God to himself is the source of all relations that allow creatures to come to being and to remain there.

Likeness is a substitute for perfect unity, which belongs to God. To be is to be one. God *is* absolutely because only he is absolutely one. An absolute plurality would tend toward nothingness. Likeness is a middle term between absolute unity and pure multiplicity. It makes possible the existence of created things, which, without being *one,* have enough unity, as a result of likeness, to continue to exist. A material body is divisible: it is therefore not really *one.* But likeness confers enough unity on it for it to nevertheless *be* to some degree. Water is composed of parts of water. A tree or a man is a tree or a man only because it belongs to a genus and a species by virtue of the likeness of specimens to one another. The soul is *one* only if it is in possession of its *habitus* and is like unto itself over time. Friendship is founded on the likeness of values. And so on.

The relation of the Word to the Father, because it is the source of Being and of the One, is also the source of the beautiful. When an image equals its model, then symmetry, equality, and proportion—that is, beauty—are established between them. That is true of natural bodies, which are beautiful inasmuch as they have identical or similar constitutive elements arranged in relation to one another, inasmuch as they are related by a likeness to the unity of creation. And that is also true of art. An arch is more beautiful if another arch is placed on the opposite side, because they form a connection within the building. But why is

that symmetry—which the mason senses instinctively—agreeable? Because it brings about the unity of harmony and because we see it with the eyes of the spirit.[119]

Augustine's world is an image based not simply on the One, but on the One and the Three—that is, on the transcendent relation of the divine Persons with one another. It is these intradivine relations of likeness and image that are the source of likenesses and images, which participate in a living manner in the world. This makes for a more dynamic, more pathos-driven, and more personal world than that of Plotinian procession. In fact, the world is God's intentional handiwork, and his motive for creating it was love: "Do not imagine that at the origin of God's works lies a love born from need, since that love is born rather from the overabundance of his benevolence."[120] Poros—Indigence—plays no role in creation. Through that love, the world can participate in Being, in the One, the beautiful, and the true; and there is nothing in the world for which the love of God is not the sufficient cause. But if the world, which is ultimately an image, can be explained only by God, it must in turn tell us the nature of its author. We must find in nature the traces or vestiges God left there to convert us to him, and to make us participate in his beatitude. God is the Trinity: thus, if there are vestiges of God in nature, they must bear witness to his trinity as much as to his unity.

The analogies noted by Augustine are very imperfect. None can express unity without excluding multiplicity, none can express multiplicity without degrading unity. The most imperfect analogies are found in nature. Augustine proposes a whole series of them: *mensura, numerus, pondus; unitas, species, ordo;* and so on. He prefers analogies borrowed from the sphere of knowledge or of sensation. In the order of vision, he distinguishes among the thing seen, the sight of that thing, and the mind's attention, which keeps sight fixed on the object. A better analogy comes from man's inner world: the memory, the internal vision of this memory, and the will that unites them by turning to that vision to contemplate it anew.[121]

If something in nature bears the image of the threefold God to some degree, inasmuch as that thing is good, the dignity of the image belongs to man, and within man, to his soul, and within his soul to thought *(mens)*, which is the higher part and the part closest to God. It is in that realm that Augustine seeks the least unfaithful analogies. His three favorites are: *mens, notitia, amor; memoria sui, intelligentia, voluntas;* and *memoria Dei, intelligentia, amor.* This last is the highest analogy because it offers not only the image of relations within the soul but also the soul's relations to God, of which the soul is the image. This is very close to the trinitary council, though infinitely far from it. To grasp the in-

finite distance that separates the image from its model, one need only contemplate the perfect simplicity of God. The human soul *is not* any of these vestigial trinities that Augustine discerned in it. Rather, these trinities are in the soul. In contrast, the Trinity is not in God, it is God. At this point, the human mind, having confessed unity and the three Persons, must stop at the brink of the mystery: it can go no farther.

Augustinian poetics recapitulates antiquity and projects it in a new form into the following centuries. With Plato and his school—to which Augustine belonged—Augustine articulates the sensible and the intelligible, but he establishes passageways and bridges between the two worlds. The divine image, which philosophy must renounce, is never abandoned by Augustine, and the whole earth invites him to contemplation, since it contains the inexhaustible signs of its Creator, and since the Creator placed the human soul in a body and had him inhabit the earth. When Aristotle lends to matter itself a spontaneous aspiration toward form, that is, toward the Good, he is in agreement with Augustine, who sees the creation of forms as an initiative by God to bring the material world back to himself and to make it participate in his glory.

The image of God is not concealed, since it appears in every thing, once the internal light has made us capable of seeing things as they are. The image is obscure, but the master teaches us to recognize it gradually, in an exchange between what we see on the outside, what we see within ourselves, and what we see in him. The universe multiplies in these reflecting mirrors. This progress toward the Image by means of images, and under the guidance of the Word, which is the Image-in-itself, generates joy. In fact, it is a progress toward truth and toward the consolidation of being, or of nature, in grace.

This progress is precisely what the artist seeks. Augustine gives us more than a theory of art: he gives us a metaphysics of the artist. This joint exploration of the world and of oneself, under the attraction of the lofty things we call "inspiration," is the very life of the artist. In the painting by Poussin whose subject is the poet's inspiration, the poet writes at Apollo's dictation, but he is not looking at Apollo: he keeps his eyes lifted toward heaven, which is the cause both of Apollo's dictation and of the poet's capacity to transcribe it. The Augustinian artist has found his good (earth), his time (here below), and his hope (God in person).

Augustine, in short, having linked the contemplation of the world to the contemplation of God, adopts the inaugural assertion of Thales—"Everything is full of gods"—but he makes it singular: everything is full of God. In exchange, the artistic life as an intuition of Being within a being (or any other formula equivalent to that one, which comes from Heidegger) is fully justified.

The need to extend Augustinian meditation to a meditation on the artist is felt so keenly that Bossuet, after developing analogies to the Trinity in *Elévations sur les mystères,* by closely following Augustine's *De Trinitate,* allows an elevation of his own making, which he calls "Fertility of the Arts." In the soul of the artist at work, he discovers the most eloquent of analogies:

> I am a painter, a sculptor, an architect. . . . I have my art, I have my rules, my principles, which I reduce as much as I am able to a first principle which is *one,* and in that way I am fertile. With that primary rule and that fertile principle, which makes my art, I give birth within myself to a painting, a statue, a building, which in its simplicity is the form, the original, the immaterial model of what I will execute in stone, marble, wood, or on a canvas on which I will arrange all my colors. I like this design, this idea, the son of my fertile mind and my inventive art. And all that makes me only a single painter, a single sculptor, a single architect; . . . and all that, at bottom, is in my mind itself, and has no other substance; and all that is equal and inseparable.

The Aristotelian theory of causes (formal, material, final, and efficient) is replicated by Bossuet in an Augustinian light, which links them to the transcendent cause and leads them back to unity. "Art, which is like the father, is not more beautiful than the idea, which is the son of the mind; and the love that makes us love that beautiful product is as beautiful as it. By virtue of their mutual relationships, each has the beauty of the three. And when it is time to produce that painting or that edifice externally, art, idea, and love will participate equally, and in a perfect unity."[122]

CHAPTER THREE

The Image in Dispute

I. THE PRODUCTION OF CHRISTIAN IMAGES

I am not writing a history of art. But, so that my inquiry will not completely lose its connection to art, from which it began and to which it must return, let me nevertheless recall a few points:

1. The development of a specifically Christian art was modest and extremely slow in the early centuries. The walls of the catacombs were marked with graffiti, sketches, signs, and symbols for initiates. Pagan symbols were often charged with a new meaning. The garden, the palm tree, and the peacock symbolized earthly paradise. The ship, a symbol of prosperity and of a fortunate journey through life, became the church. The erotic theme of Eros and Psyche came to signify the soul's thirst and the love of God in Jesus Christ. Hermes, a symbol of humanity, began to represent the Good Shepherd. The sleeping Endymion became Jonah under the booth. There were many other scenes from the Old Testament as well: Daniel in the lion's den, the three children in the fiery furnace, Adam and Eve. Only in the late second century did specifically Christian symbols appear: the miracle of the bread and fishes (a prefiguration of the Last Supper), the Adoration of the Magi (the gentile entering into the Covenant), Lazarus raised from the dead. Finally, arcane symbols arose, comprehensible only for the few: the vineyard, and above all, the fish, ichthus, an acronym for Christ. These signs were found from Spain to Asia Minor and from Africa to the Rhine River, with no change in style or subject matter. The paintings were

rudimentary: a few strokes in a limited spectrum of colors. They were not images of worship. The church was imposing no program. They were reminders, mementos of Christ or the Virgin, not portraits of them.

Artists by trade did not participate in that operation, which was not yet an art. In fact, they worked for the pagan world and manufactured the images in front of which martyrs were condemned to death. Tertullian recommends that, if artists wish to convert to Christianity, they should find a different trade, and Hippolytus declares: "For anyone who is a sculptor or painter, let him know he must not make idols, and if he does not change his ways, he shall be expelled."[1]

2. With peace within the church and the conversion of Constantine, Christian art in the strict sense began; its fundaments determined the centuries that followed. The powerful called for an art as lofty as their own "connoisseurship," and artists now worked without constraint for the glory of the new faith.

There was already an imperial pagan art: only a slight shift was needed to make it a Christian art. The philosopher became Christ, the apostle, or the prophet. The theme of imperial apotheosis was transformed into the Ascension of Christ. The offering of presents corresponded to the Adoration of the Magi, the *adventus* (the triumphal entrance of the sovereign) to Christ's arrival in Jerusalem. In fact, court ritual provided a framework for Christian art. Just as artists represented the emperor and empress on their thrones, surrounded by their entourage, they depicted Christ and the Virgin among the saints and angels. In Santa Maria Maggiore, the Virgin is represented as the empress. One of the first Christian paintings (from the first half of the sixth century), housed in Santa Maria Antiqua, shows the Virgin as the emperor's wife, wearing the imperial diadem and the robes and jewels of her office.

There were constant exchanges between the Christian image and the imperial image. The latter transmitted its force to the former. In the imperial world, it was understood that the emperor's image could be a legal substitute for the emperor's actual presence. It took the place of his person. In legal proceedings, if the emperor's portrait was present, the judge rendered his judgment without appeal, like Caesar in person. The legal and religious efficacity of the image was naturally transferred to Christian images. The icon was later heir to it.

3. The representation of God par excellence, the figure of Christ, became fixed very gradually. First evoked by monograms or metaphors (Orpheus in the Underworld in the Saint Callixtus cemetery in Rome; Hermes/the Good Shepherd in the Saint Priscilla cemetery), it appeared in the second century as a young, beardless man with curly hair and bare feet, dressed in a tunic and pallium (catacomb of Saint Praetextatus), or in the form of an ancient orator.

In the fifth century, that diversity settled into two prototypes: the beardless

adolescent draped in the himation, derived from Hellenistic art (Saint Apollinaris of Averna); and the bearded figure, severe and melancholic, with long hair and majestic appearance. This prototype prevailed in the East from the sixth century on and evolved toward the Pantocrator of Byzantine art, which was less royal than imperial, culminating in the overpowering and ferocious image on the central cupola of Daphnē (eleventh to twelfth centuries). In the West, Christ often remained beardless until the twelfth century, at which time the added beard made him resemble the Eastern prototype.[2]

According to tradition, this prototype was associated with the image sent by Christ himself to King Agbar, prince of Osroene, king of Edessa. The Eastern church celebrates that translation of the "acheiropoetic" image (that is, the image not made by human hands) on 16 August. A sticheron from the eighth tone of vespers says: "Having represented your very pure face, / You sent it to the faithful Agbar who had wanted to see you, / You who, in keeping with Thy Divinity, are invisible to the Cherubim."[3] Such was the origin of the so-called icons of the Holy Face, and of Veronica's veils in the West.

That fixing of the divine image ended an ancient controversy regarding the beauty or ugliness of Christ. Justin, Clement of Alexandria, Tertullian, Cyril of Alexandria, and Irenaeus claimed Christ was ugly, by virtue of his kenosis, because of Isaiah—"He hath no form nor comeliness; and when we shall see him, there is no beauty that we should desire him"[4]—and Saint Paul: "[He] made himself of no reputation, and took upon him the form of a servant."[5] In contrast, Ambrose, Jerome, Gregory of Nyssa, and John Chrysostom claimed he was handsome, based particularly on Psalm 45: "Thou art fairer than the children of men." One senses that this controversy is not directly concerned with the physical appearance of Jesus Christ. It entails defending the idea of a spiritual beauty capable of showing through an external ugliness, or, conversely, maintaining the compatibility between that beauty and the classical conception of beauty, a beauty further augmented by splendor.[6] That is why Saint John of Damascus, in reporting the story of Agbar, king of Edessa, writes that the painter he had sent to Christ to do his portrait did not succeed "because his face glowed with an unsustainable brilliance; the Lord covered his divine face with his mantle, and the face was reproduced on the mantle, which he sent to Agbar, who had asked for it."[7]

The acheiropoetic icon entered Byzantine history when it served as palladia for the empire during the Hundred Years' War against the Persians. In that war, which brought two universal religions, Christianity and Zoroastrianism, into conflict with each other, with world domination at stake (until they teamed up against the Arabs when the latter made off with the purse), emperors entrusted

their fate to images of Christ and the Virgin: the acheiropoetic image was now what the *labarum* had been two centuries earlier, in Constantine's time. Reproduced ad infinitum, it canonized Christ's appearance.[8]

4. Christian images participated in the general climate of art, which underwent a profound reorientation between the second and fourth centuries. The architecture of the dome and cupola asserted a sacred symbolism against the calm and earthly flat surfaces of classical Greco-Roman architecture. The simplicity of classical decoration was replaced by exuberant ornamentation, pictorial effects that, with the trepan technique, spread to sculpture itself. In fact, the old antithesis between cosmos and chaos, order and disorder, drifted toward the antithesis between light and shadow, a concept at once neo-Platonic, biblical, and Zoroastrian. Correlatively, the notion of the soul became richer. The soul was not confined to a relation to the body, since it could be open to divine influences. Man *has* his body, he can live *in accordance with* the imperatives of his soul, and the soul can *receive* the Spirit, the pneumatic breath that makes him a "new man," to use Saint Paul's terminology, which in this case corresponds to a preoccupation shared by philosophy and the universal religious movement.[9]

Greek art intentionally ignored subjectivity, anguish, mystery, hope, the private sphere. Its most beautiful figures, one might say, participate in the impersonality of the cosmos: "Eyes both opened and closed, like those of an animal, as indifferent to hope and despair as a beating pulse or the course of the planets, resolutely rule out any possibility of personal expression."[10] Nonetheless, the Roman portrait, which was intensely individualistic, and the art of Faiyūm and Palmyra, which focused not on a glorification of the body but on the intensity of the gaze, anticipated the pneumatic interiority of Byzantine icons and mosaics.

Within that spirituality, sculpture in the round and in relief gave weight and material form to the figure. In Byzantine mosaic, bodies, depicted flat, no longer had volume or weight, were not flush with the wall but floated in a spiritual space magnified by a color permeated by light. The opaque marble and hard stone of the Flavian period gave way to crushed glass and enamel cubes, whose dark blue and gold light was not of this world. "The gentle Hellenistic figures, once transfigured, could finally penetrate the transparent sphere of which Plotinus had dreamed, the sphere where Byzantium placed its imperial processions and holy images."[11]

5. That aspiration to "vision" acquired a precise meaning in Christianity: it consisted of seeing "the heavens opened"—as occurred, it is said, at Christ's baptism—that is, of entering into intimate contact with divine mystery.[12] The opening of the heavens, which was also announced by the voice of the Father,

who came down from heaven to bear witness to the Son, punctuated Jesus' life: the Transfiguration and Passover. The martyr—that is, the witness—can bear witness because he has *seen*. Stephen, the first martyr, exclaims: "I *see* the heavens opened and the Son of man standing on the right hand of God." Carpus, burned alive under Marcus Aurelius, smiled. When questioned, he replied: "I *saw* the glory of the Lord and I am filled with joy."

When the age of persecution had passed and Christian art had left the allegory of initiation behind and had become an epiphany, it located mystery in the apocalyptic vision offered by the martyr. In the catacombs of Saint Peter and Saint Marcellinus, almost contemporaneous with Constantine, martyrs acclaim the lamb, from whom the source of living water flows, while above it Christ reigns in his glory, flanked by Peter and Paul. Only martyrs and apostles were allowed to see celestial glory. But apocalyptic iconography went even further, daring to display the celestial throne on which the Anonymous—that is, the invisible Father—sits, unnameable and unrepresentable. But upon this empty throne rests the glorious Cross (Santa Maria Maggiore, fifth century) or the Book, to remind us that Christ, in opening its seals, reveals the mystery of God to men. In fifth-century Fundi, the vision became trinitary: the lamb lies at the foot of the empty throne, on which the Cross stands amid the clouds of heaven; above it the dove of the Spirit descends, and, at the top of the scene, the invisible Father's hand holds out the crown of pascal victory.

"The vision of the open Heavens is not achieved by training the eyes or by an art of representation and of the image, but is given to those who assent to the mystery of the cross." That is why, Saint Gregory of Nyssa writes, "the Son of man must not simply die, he must be crucified, so that the cross becomes a 'theologian' for those who see by means of it."[13] The term "theologian," in the sense the Greek fathers give it, means that the cross gives access to the Trinity.

6. In the sixth and seventh centuries, the icon and the worship of icons became extraordinarily widespread. The portable Christian image goes back a long time. In an apocryphal life of the apostle Saint John (dating to the second century), there is a portrait of that apostle kept at the home of a disciple, set on a table and flanked by two lit candles.[14] That was how imperial images were venerated. The cult of the emperor had established the habit of considering sacred not only the emperor's images but everything that had been in physical contact with him: palaces, insignia, writings. The cult of relics was cast in the same mold. In the fifth century, reliquary boxes were decorated with religious images. Contact with Christ authorized the cult of the acheiropoetic icon, contact with the Mother of God that of the so-called icon of Saint Luke. Beginning in the sixth century, emperors tolerated the reproduction of icons, and they used them

for their personal acts of devotion. Moreover, emperors themselves began to appear on icons. In the late fifth century, there was mention of an image of the enthroned Virgin with Emperor Leo I, his wife, his daughter, and his son and heir arranged around her. It was located in the convent of Blachern, the most important site of the cult of the Virgin in Constantinople.[15] In the late sixth century, not only did emperors encourage the veneration of religious images similar to that of imperial images, but they allowed Christ and the Virgin to occupy the place of their own images and hence to be the objects of the overtly pagan worship these images had always received.

The vogue for icons had multiple causes. Peter Brown associates it with the need for intercession specific to Christianity—in contrast to the Muslim heaven, which is devoid of intercessors—and to the structure of the Greek Empire, which was still a collection of city-states: the holy intercessor served as a civic and municipal patron as well.[16] Let us add the perils and terrors of the Byzantine Middle Ages—the Persian wars, the Arab attack, the Slavonic, Bulgar, and Avar invasions. Icons presided over the games in the hippodrome, went to battle at the head of armies. Heraclius carried the acheiropoetic image with him on his expeditions. Several times, Thessalonica, besieged by the Slavs, owed its salvation to the miraculous intervention of Saint Demetrius. During the great siege of 626, the patriarch Sergius, followed by the Senate, formed a procession around the walls, carrying images of Christ and the Virgin, and the barbarians turned away their heads to escape the sight of the invincible Theotokos. Icons were found in bedrooms, in front of shops, at markets, on books, clothing, household utensils, jewelry, vases, walls, seals; they were taken on journeys; it was believed they spoke, cried, bled, crossed the seas, flew through the air, appeared in dreams. Priests—though the practice was condemned—scraped off bits of the icons and let them fall into sacred vases, mixing them with the eucharistic species as if to add to the real Presence the miraculous presence of the icon.

It was within this context that the iconoclastic crisis erupted. Its causes were so complex that they can dishearten the sage historian. Of course, dogma was at the root of the problem. But combined with it was the basileus's agrarian policy targeting monasteries, which were large landowners, major producers of images, and major beneficiaries of their veneration; his centralizing policy, directed against the municipal structure of the empire and consecrated by the protection of saints; his religious policy on the relations between church and state, Constantinople and Rome; and his foreign policy, and, in the first place, the question of Islam.

In 721, Caliph Yezid II had all images in the sanctuaries and homes of occupied provinces destroyed. The energetic Leo III the Isaurian, originally from the

eastern provinces where Monophysitism was strong, and leader of an army where the tendency was alive, took the initiative in the crisis. In 725, with the support of a few bishops, he published the first decrees. In 730, he had a venerated image of Christ, placed above the Golden Gate of the imperial palace, destroyed. The results were a civil war, which, with its highs and lows, lasted until 843; vast ruins; countless martyrs; the destruction of nearly all of the icons (those saved, like the icons of Saint Catherine of Sinai, were for the most part in Muslim territory and escaped the less destructive rage of Islam); and, finally, the most profound discussion of aesthetic theology. It is to this topic we now turn.

2. The Icon and Dogma

"[He] is the image of the invisible God," Saint Paul said of Christ. That statement opened endless disputes, heresies, and corrections, which occasioned new heresies, then a final, but still precarious, victory of orthodoxy. We must follow these complicated paths, knowing that the compass guiding even the most subtle theologians can never be anything but the simplicity of faith, as it dwells in the most ignorant of the faithful. In this realm, even more obviously than in others, knowledge moves from the complex to the simple and, at the end of intricately woven arguments, reaches the unassailable wall of divine simplicity.

I will leave aside many developments, to which many errors and truths—both equally profound—cling. My sure guide in this labyrinth has been the masterful work of Christoph von Schönborn. He focuses on a single icon, that of Christ, which legitimates all the others.[17]

The iconoclasts declared that to paint an icon of Christ was to wish to circumscribe (confine) the inaccessible divinity of Christ. The iconodules replied that the Word, in becoming flesh, had in fact circumscribed itself in a form accessible and visible to our carnal eyes. To understand this debate, we must inquire into the dogma of the Trinity, then into Christological dogma. That, in any case, entails following the chronology.

Arius, declaring his belief in a single, unbegotten God without beginning, does not admit that the begotten Son can be the perfect image of the Father, since he is separated from him by the infinite distance that separates the created from the uncreated. Hence the one and only God is radically separated from the Son, and also from the world, since the world is not the direct handiwork of God but the product of an intermediate power, the created Word.

Athanasius responds that God begat in God's way, not in man's. "For it is not God who imitates man; on the contrary, it is because of God, who is supremely and truly the only Father of his own Son, that men have in turn been called fathers of their children."[18] If God is therefore God, and if he is the Father, he is

so for all eternity, and his Son is coeternal with him. The relation between God and the Word is not that between the Plotinian One and its first emanation. We are thus faced with the paradox of an identity—but without confusion of one with the other—between the Father and the Son. The Son is not simply like God: he *is* God. In the absolutely simple nature of God, image and model are one. Athanasius reverses Arius's argument: divine simplicity does not exclude the Word as divine nature, it includes it. It is noteworthy that the metaphor Athanasius uses to support this point is the image of the emperor, a very rich metaphor at the time throughout the empire, and the familiar legal assimilation between that image and the imperial presence: "'I [the image] and the emperor, we are one.' . . . Whoever venerates the icon, venerates the emperor in it: for it is his form and aspect."[19]

But that raises another question: how, in the divine unity and perfection of the image, can one further distinguish between the divine Persons? How can a person, *in what is specific to him,* be the *perfect* image of another person? Gregory of Nyssa offers the solution, if, that is, he is truly the author of the famous "Letter 38 from Saint Basil to his brother Gregory." The first step is to distinguish between nature and hypostasis. Nature *(ousia)* is what is held in common. Hypostasis stands "underneath" *(hupo)* and designates a reality whose specificity is signified prior to that common nature. "Man" designates an *ousia,* but "*this* man," with a name, detached or demarcated from that common nature, is a hypostasis. It is therefore necessary that the hypostasis form the outline *(perigraphē)* of that relation, which the common notion of substance (or of nature) leaves blurred *(aperigraphon).* Hypostasis is distinguished from the common nature by every characteristic used to describe a person so that he can no longer be confused with another person. "Characteristic" is borrowed from the idea of a seal, an engraved portrait, a printed mark, "character" in the most concrete sense of the word.

Yet how are the divine Persons distinguished from each other? What is specific to each one within the unity of nature and intimate community that connect them? There is no other distinction than their mode of action, which in God is indistinguishable from divine being, since God acts as he *is.* The specificity of the Spirit, as it appears in the divine revealed act, is to proceed from the Father and to be known with the Son; the specificity of the Son is to be begotten of the Father and to make known the Spirit. As for the Father, the character of his hypostasis is to be the Father and not to exist as the effect of any cause. Hence, the specificity of each hypostasis is nothing other than its manner of relating to the others. The specificity of the divine hypostases is to manifest one another, each being *the expression* of the other.

How should we understand that the Son is the image of the Father? Gregory notes that "the image is identical with the prototype, even though it is different." The beauty of the image is the same as the beauty of the prototype, since otherwise the notion of image would not be preserved. But there is no simple identity; otherwise, the notion of image would also be lost. Think of Plato's argument: if an image were identical, it would be the prototype. Hence, the beauty of Christ is the beauty of the Father (unique divine beauty), but, in the Father, it is in an unbegotten manner and, in the Son, in a begotten manner. "Thus the person or 'hypostasis' of the Son becomes as it were the form and countenance by which the Father is made known in the form of the Son, although their observed individuality abides in each to serve as a clear differentiation of their persons or 'hypostases.' "[20]

And yet, what are we to make of these words of Christ: "For my Father is greater than I,"[21] and of all the passages that show Christ's humiliation and obedience? The Son's obedience is in no way a constraint and a subordination. The acts of the Son, eternally begotten but not inferior to the Father, are similarly divine. What Arians interpret as constraint, instrumentality, is, for the orthodox believer, the image of the Father, since the Son assumes the paternal will to the point of divinely *being* that will. But he does so specifically in his mode of being the Son. His mode of existing as obedient Son makes paternal goodness visible to us. He makes visible to us, Saint Basil says, not the figure or form of the Father but "the goodness of his will." The eternal Son's obedience to God is, in short, identical with freedom. Basil adds: "Through the imprint *(kharaktēr)*, one is led to the glory of him to whom the imprint belongs [the Father] and the seal of the same form [the Son and Holy Spirit]."[22]

As has been established, in the Trinity, the Son is the perfect image of the Father. But we need a place where that image of the invisible God itself ceases to be invisible. Is this place the Incarnation? In its abasement, in kenosis, in its "form of a servant," does the Word remain the perfect image, or does the form of a servant mask the Word, and thus the Father himself? To what extent is the portrait of Christ incarnate a portrait of God, a divine image?

In the Christian world surrounding Constantine the Great, that is, several centuries before the great controversy erupted, a coherent and precise response to that question was given, and it remains, as it were, the charter of iconoclasm: the letter from Eusebius of Caesarea to Constantia, the emperor's sister.

> What image of Christ are you seeking? Could it be the true and immutable, the one that possesses by nature its own characteristics, or could it be the one that [Christ] assumed for us, when he assumed the shape *(skhēma)* of the servant? . . . For he possesses two forms *(morphōn)*, but I myself cannot think

that you are asking for an image of the divine form; in fact, Christ himself taught you that no one knows the Father except the Son, and that no one was worthy to know the Son except the Father who begat him: I must therefore think you are asking for [the image] of the servant form and of the flesh he assumed for us. Yet, of it we have learned that it was mixed with the glory of divinity and that what is mortal was swallowed up by life.[23]

Hence, not only does Eusebius not accept the portrait of Christ, he even denies its possibility. The divinity of Christ is invisible, as everyone agrees. But for Eusebius, the human, the "human form," has been "swallowed up" by divine life after the Resurrection and the Ascension. How, then, could someone "paint the image of a form so marvelous and incomprehensible [and unsustainable by human eyes]—if, in any case, we are to call the divine and intelligible essence 'form'?"

Eusebius's view is colored by Arianism. The Son is second in relation to the Father, who is "God beyond all," just as, in Plotinus, the *nous* is second to the One. He bears the image by virtue of a sort of first emanation, similar to the prototype, of course, but inferior nonetheless. In the creation of the world, the Son was the intermediate Logos that animated the cosmos, penetrated it, and organized it, more like the Stoic Logos than the Logos of Yahweh. He was an instrument who adapted the unsustainable divine power to the weakness of mutable beings. These beings—prophets, just men, philosophers—have already received the vision of the Logos in history: the Incarnation is only the last and most complete of these theophanies. The body of Christ is a pedagogical tool, "like to a musician who manifests his wisdom through the lyre," in short, an instrument capable of leading man to a superior gnosis, where he will no longer need the instrument (the "lyre"), since he will have obtained the reality. For Eusebius, God never truly becomes man: he appears. Humanity is not delivered from death: on the contrary, "death is what liberates the soul by making it come out of the body," and by allowing it to accede to the true knowledge of God. "On the path that leads to that true gnosis, an icon of the mortal flesh of the Logos can only be an obstacle."[24]

In man, according to Eusebius, the soul alone is in the image of God. Yet it is formless and shapeless. If depicting it is senseless, how much more so is representing God! The body of Christ is the temple of the Logos, whereas idols are the temple of demons: it is his only dignity, but anyone who would attach himself to that corporeal image would be an idol worshiper, bowing down to the sensible. The soul can know the intelligible, but flesh can know only flesh. The icon, the sensible image of flesh temporarily and pedagogically assumed by the

Word, confines us within the very thing from which it came to deliver us, the prison of the flesh.

Eusebius's "Letter to Constantia" was a valuable patristic witness for the iconoclasts and was continually evoked. It belongs to the tradition of Origen, Eusebius's master. We have seen that Origen too had conceived the Incarnation as a pedagogical adaptation of divinity to human capacities, and that, for him, the goal of knowledge was to contemplate the "naked" Logos, stripped of its clothing of flesh.

The question arises yet again: is the incarnate Word still the image of God? What must the relation between the two natures of Christ be for the expression of the Son of God to remain complete in the Incarnation? The Antiochene school of theology, which eventually led to Nestorianism, increasingly distinguished the Word from the "assumed man," if not from the merely "adopted" man Jesus. Cyril of Alexandria, as Cardinal Newman nicely expressed it, would probably not have agreed to have his sanctity judged on the basis of his acts.[25] In fact, he was a dreadful person. But what Athanasius represented in the defense of the Son's consubstantiality against the heresy of the Trinity, Cyril represented in the defense of the real union of the Word and the flesh against the Christological heresy.

Flesh is not "foreign garb" but "the very flesh of the Word." Christ is a single and unique being. The Logos "did not inhabit a man, it became man." Faith consists not only in believing in the "naked" Word, as Origen put it, but in believing in Jesus Christ, who is one, in an undivided manner, both God and man. Flesh is not a veil, it *is* the flesh of God and, in a certain manner, the Word. The Word did not come to wrest souls from the prison of the body, but to save bodies fallen into death by sin. In Jesus Christ alone did human nature become the Son of God *by nature.* And, through that nature, we can in turn become sons *through grace.*

"He that hath seen me hath seen the Father": this does not mean that the flesh of Christ has become the image of the invisible God. But it is his *person*—God made flesh—that offers itself to our view: not his *nature,* which, whether human or divine, could not be an image. Christ is the image of the invisible God, not *through* his flesh, but *because* he became flesh for our salvation, to reveal God through his works. Knowing the Son of God does not entail moving beyond Christ's humanity to see him "naked" but instead plumbing the mystery of his kenosis to discover the supreme greatness of the love of God within it.

In declaring the Word was united with the flesh "in accordance with hypostasis," Cyril showed it was the hypostasis of the Son that was incarnated, and that

the flesh became that of the second Person of the Trinity. He therefore rejected the Origenian idea of an instrumental body added onto the soul as a result of sin. The flesh, in its biblical sense of being concrete and alive, is, in Christ, destined to divine incorruptibility. Hence, man as a whole, body and soul, is "in the image" of God. In separating the man Jesus from the Word, Nestorianism made any icon of him impossible; according to Cyril, it was conceivable only if the *personal* identity of the human Jesus and the Son of God was clearly asserted.

Cyril's argument leaves a large question unresolved, and new heresies later became engulfed in it. What, in fact, is the mode of participation, the relation between the flesh and the Word? If the flesh becomes the site of the revelation of the Son, can it still keep its own nature, or is it transformed into God? In the latter case, does not the life-giving divine energy deprive the flesh of its own operation? Monergism, Monophysitism, and Monothelitism posited their own systems. There was a clear tendency to understand the Incarnation as a natural preponderance of the divine over the human. In this case, it was Saint Maximus who declared the orthodox faith. The hypostatic union in man of body and soul does not suppress the nature specific to each of the two parts. That is a fortiori true in the Incarnation, where the hypostatic union is free and subject to no natural law; the specific nature of humanity is safe and remains infinitely different from divine nature. Here is the Chalcedonian formula: "Without separation, without confusion, without mixture."

Maximus declares that, just as in the Trinity the divine Persons are not linked but free in the intercommunication of their gift, so too in the Incarnation the Son contracts freely and willingly the hypostatic union with humanity: "He became man willingly by his philanthropic design, by taking on flesh." In a formula as concise as it is mysterious, Maximus concludes: "Christ is nothing other than [the natures] from which, in which, and which he is." Christ *is* God and man and he remains so forever. Not man in general, but *that* man individuated from all others and whose icon represents his personal traits, except that the source of this face's existence is not another human existence, but the second of the divine Persons.

The reason for the Incarnation is God's benevolent plan to lead his creation back to its true end. Charity is the medium through which God makes himself visible to our eyes and perfects our likeness to him. Christ is the icon of that charity, the prototype of that image of God, which man *is* by virtue of his vocation. That is why, in his dense and obscure language, Maximus writes: "Identical to us in aspect, he has become the prototype and symbol for himself. He showed himself as himself a symbol based on himself: he led the creation as a

whole by the hand, manifested through himself in sight of himself, totally hidden and not showing himself."[26]

"Manifested": that is his human face. "Hidden": that is this same face, since there will never be any other than that of the Word definitively made flesh, but perceived, this time, in the dark night and subsequent glory of Easter, where he leads us and where, as Saint Paul says, beholding as in a mirror the glory of the Lord, we will be "changed into the same image from glory to glory."[27]

For Origen, the face of Christ was what had to be overcome to accede to the divine. Maximus declares it is the divine itself, accessible to charity alone, inseparably manifested and hidden, leading from abyss to abyss, "from itself to itself." Maximus explores the most sublime regions of mysticism. In the regions where the artist labors, a transposition is possible. Maximus, so to speak, recommends seeing the transcendent in the immanent and declares there is no need to look higher and deeper than what the face of Christ, like our own faces, gives us to behold: therein lies the divine. When the artist seeks from things the things themselves, which are endowed with more reality than the ordinary man discerns and which reflect the entire depths of the world on their surface, he is following the Maximian method in his own domain.[28]

In response to these learned controversies, the authoritative laws of the church were very sober. The church linked the image to the Incarnation. What authorized the image under the New Covenant was precisely its prohibition under the Old. The Christian image, at least by rights, did not stem from the pagan idol but, as Ouspensky notes, from the absence of a direct and concrete image under the Old Covenant.[29] It was both a rupture and a fulfillment: an *Aufhebung*.

Two canonical statements are worthy of note, that of the Quinisext Synod in 692 and that of the second Council of Nicaea in 787. The first was a disciplinary adjunct to the fifth and sixth ecumenical councils, which were primarily dogmatic in character. Held in the imperial palace, it was also called the Trullan Council. Three canons interest us. Rule 73 concerns the use of the cross and forbids anyone to draw it on the ground, since it would thereby run the risk of being trampled underfoot by passersby. Rule 82 calls for symbols to be replaced by figures:

> On some paintings, one finds the Lamb indicated by the Precursor's finger; this lamb has been placed there as the prototype of grace, showing us in advance, through the Law, the true Lamb, Christ our Lord. Although we surely honor the figures and shadows as symbols of truth, and as rough sketches given with the Church in view, we prefer grace and truth, receiving that truth

as the fulfillment of the Law. We therefore decide that, from now on, that ful-
fillment shall be visible to all in paintings, that therefore, in the place of the old
lamb on icons, Christ our Lord, who took away the sins of the world, shall
stand in his human aspect *(anthrōpinon kharaktēra)*.

Hence, the church judges that the time of symbols is past and invites us to
represent directly what these symbols prefigured. Since the Word became flesh
and dwelt among us, the image must show what happened in time, what has be-
come accessible to sight.

Finally, rule 100 is ascetic in its inspiration: "We prescribe that the deceptive
paintings exhibited to the eyes, which corrupt the intelligence by exciting
shameful pleasures—whether depictions or anything similar—not be repre-
sented in any way, and if someone undertakes to do so, may he be excommuni-
cated." The church moralizes, imposes decency, a perilous undertaking since the
correction of abuses makes other abuses in the opposite direction even easier.
Some might imagine—and this did in fact occur—that any profane art at all
"corrupts the intelligence by exciting to shameful pleasures."

The *horos* of the second Council of Nicaea is dated 13 October 787. That de-
finition, then, occurs in the midst of the iconoclastic crisis, which had already
lasted fifty years. Here are the most important passages:[30]

> Christ our Lord, who gave us the gift of the light of his knowledge and who
> wrested us from the shadows of the folly of idolatry. . . . Counting this gift for
> nothing, and seemingly excited by the deceiving enemy, some have wandered
> far from the right reasonings, and oppose the tradition of the Catholic
> Church, since they have dared reject ornaments [the *"eukosmie"*] befitting the
> sacred temples of God. . . . They no longer distinguish between the sacred and
> the profane and call the icon of the Lord and of his saints and the wooden stat-
> ues of Satanic idols by the same name [idol]. . . .
>
> And, in conclusion, all the traditions of the Church that have been given us
> as law, in writing or not in writing, we keep without changing them: one of
> these traditions is the impression of the represented model by means of the
> icon, inasmuch as it agrees with the letter of Gospel teaching and serves as
> confirmation of the real, and not ghostly, Incarnation of the Word of God,
> and that it procures us an equal benefit, since each refers to the other in what
> they manifest and in what they signify without ambiguity. . . .
>
> . . . We therefore define, with complete rigor and exactitude:
>
> —that, like the prototype of the venerable and life-giving Cross, venerable
> and holy images are consecrated: those made of paint, of mosaic, and of all ap-
> propriate matter, in the holy churches of God, on sacred vases and clothing,
> on walls and boards, in houses and streets: the icon of Our Lord God and Sav-
> ior Jesus Christ, that of Our immaculate Lady, Saint Theotokos, the honor-
> able angels, and all holy and sanctified men. Whenever they see through the

impression of the icon, those who look at icons are led to the memory and de-
sire of the prototypes;

—to kiss or bow down to icons in honor: not true worship according to our
faith, which befits only divine nature, but in accordance with the mode valid
for the sign of the honorable and life-giving Cross, for the holy Gospels and
other sacred objects of worship;

—to bring them incense and lights, in accordance with the pious custom of
the ancients. For the honor shown to the icon reaches the prototype, and he
who bows before the icon bows before the hypostasis of the one inscribed
within it.

The arguments of the *horos* of 787 are thus the following:

1. The fabrication and worship of icons are a matter of tradition. Iconoclasm
claims to return to the true tradition, which was adulterated by the idolatrous
practice of iconodules. But it is they who are "innovating."

2. It is not the iconoclasts, but Christ alone who has wrested us from idolatry.
His icon cannot be compared to idols, which are Satanic.

3. The purpose of the icon is to preach the Gospel: words and image are thus
paired, but they speak of the same thing, the mystery of Christ. Sight and hear-
ing are thus made equivalent.

4. In the icon, it is the person (the hypostasis) represented who is venerated:
that, as we shall see, is the reply to iconoclastic objections.

5. The icon belongs to the world of sacred things, beside the Cross, the
Gospels, vases. The council adopted the distinction made by Saint John of
Damascus between worship (latria) and proskynesis (bowing down, venera-
tion): the external worship of the icon is the veneration due sacred objects,
nothing more.

The council's definition is minimalist: nothing is said about the philosophi-
cal status of the image, the sanctity specific to the icon, or the Christological
aporia formulated by the iconoclasts. These aporias, in fact, call for new specu-
lations.

3. ICONOCLASM: *PRO ET CONTRA*

The Iconoclastic Arguments

The destruction in 726 of the Christ of the Chalkitis, the image protecting
Constantinople, placed above the Golden Gate of the imperial palace, can be
compared to the posting of Luther's theses on the door of the Wittenberg
Church: it had the value of a reformation. Iconoclasm considered itself a purifi-
cation of the church, a return to its true tradition, which had been corrupted by

iconolatry. That was the conviction of the emperors, who took their title of "equal to the apostles" seriously. The *horos* of the iconoclastic synod of 754 declared that the devil, "under the appearance of Christianity, has surreptitiously led humanity back to idolatry. Through his own sophisms, he has convinced those who lifted their eyes to him not to turn away from the creature but to venerate it, to worship it and consider as God this work named by the name of Christ [the icon]." The iconoclasts had no difficulty vituperating against the abuses of popular religion. Had not a rigged icon of the Virgin, from which milk "miraculously" flowed, recently been unmasked?

But even more unacceptable than the existence of icons was the worship of them. Let us concede that for the common people, who were accustomed to kissing icons, to bowing down before them, as they had once done before pagan idols, the distinction between dulia and latria (worship in the strict sense) was not always very clear. "Thou shalt make no images." The biblical prohibition was self-evident, and it was shameful to be reminded of it by Jews and Muslims. Like every reform movement, iconoclasm was supported by a bellicose fervor, and the rallying cry was close at hand: "knock down the idols, burn the images."

But only *those* images. Iconoclasm did not proscribe art. The destroyed decorations were often replaced by floral or animal motifs: admirable examples are displayed in the Umayyad palaces. That art did not allow worship to get a foothold. Thus, even though profane art may have developed in conjunction with sacred art, Byzantium was destined to oppose one to the other, to prohibit one while promoting the other. In any case, one category of images was maintained: those having to do with the emperor. The human figure reasserted its rights. Constantine V Copronymus (that is, "also called Shit") had the famous representation of the six ecumenical councils in the Milion of Constantinople replaced by a depiction of the hippodrome games, on which his favorite driver figured prominently.[31] Not only did images of emperors persist, but emperors required the traditional worship of them. Increasing their own sovereignty at the expense of Christ's, they replaced the traditional cross on coins with their own portraits, which now occupied the front and back.[32] The biblical prohibition, taken literally, would not have allowed these images. Iconoclasm was using more detailed and selective arguments.

The place left by the Christ of the Chalkitis above the Golden Gate did not remain empty: Leo III placed a cross there and beneath it this inscription: "The Lord does not allow a portrait of Christ to be drawn without voice, deprived of breath, made of earthly matter, which is despised by Scripture. Therefore, Leo, with his son the new Constantine, engraved on the gates of the kings the blessed prototype of the cross, the glory of the faithful."

Two themes merit commentary here: matter and portrait *(eidos)*. The worship of dead and inanimate matter is contrasted with the worship in spirit and in truth. The evangelical theme is combined with the Hellenistic theme of contempt for what is material. Furthermore, for iconoclasm, the image must be an exact likeness of the original. Yet the icon of a saint or of Christ is only a material and dead likeness. Between the greatness of the model and the baseness of the means of representation, there is a contrast that profane art can bear but which becomes intolerable in sacred art.

Constantine V writes: "[An image] must be *consubstantial* with the depicted (prototype) so that everything can be safeguarded, otherwise it is not an image."[33] If that is what an image must be, then no icon is possible. No image made by human hands can be consubstantial *(homoousios)* with God, nor with any living being. That conception of the image is far removed from the classical Greek conception, which saw it in terms of a deficient participation and thus insisted on the *likeness* to the model. But it corresponds to the uses of the imperial image, which expresses, with the force of law, the *presence* of power. That is why Constantine allows only a single image of Christ, the eucharistic species, in which Christ's body is substantially present.

There is a Platonism of iconodules. But there is also a Platonism of iconoclasts, very different in its emphasis. Iconoclasts insist on the incommensurable distance between the "abject, dead matter" of paints and wooden boards and the heavenly and glorious condition of the holy models. Presence does not exist, but neither does likeness. The material world cannot reflect the glory of the intelligible world. Plotinus warned of the danger of being satisfied with earthly beauties: "When he perceives those shapes of grace that show in body, let him not pursue: he must know them for copies, vestiges, shadows, and hasten away towards That they tell of."[34] For Eusebius, for Epiphanius, and for Evagrius as well, the image is what must be transcended. That is why iconoclasts contrast the worship of images with the worship of the cross—a pure symbol not soiled by any disproportionate ambition of representation.

Constantine V was as skilled a theologian as he was a military leader. Since his strategy was to rally bishops and theologians behind his cause by presenting the iconodule as a heretic who went against the great councils, he forged a theological argument so well constructed that it took the work of a full generation of theologians to demolish it. Here it is, in syllogistic form: the *prosōpon* or hypostasis of Christ is inseparable from the two natures; now, one of the two natures, the divine, cannot be drawn, it is uncircumscribed; it is therefore impossible to paint the *prosōpon* of Christ. The iconodules thus have a choice between two heresies. Either they maintain the unity of Christ, and must admit

they have "circumscribed the Word with the flesh," confused the two natures: in that case, they fall into Monophysitism. Or they admit they have painted (circumscribed) only human nature, and that this nature has a *prosōpon* proper to it; in this case, "they make Christ a simple creature and separate him from the divine Word that is joined to him." In so doing, they fall into Nestorianism. Without exception, all the bishops gathered to discuss these propositions gave them their approbation. They added that the flesh of Christ is all the more uncircumscribable in that it has been deified.

Where is the flaw in the argument? In the idea of the inseparability of the two natures in the *prosōpon*. In that case, the *prosōpon* is equivalent to a unique third nature, and it is Constantine who has slipped into Monophysitism without realizing it. The painted face does not "circumscribe" divine nature, or even human nature: it circumscribes the composite hypostasis of the incarnate Word. But it took time, tears, and blood for that error to be discerned and the truth confessed.

Iconoclasts felt that the divine was too lofty and too far away for a representation to translate the slightest presence, or even likeness. But in erecting that powerlessness into dogma, in the end they discouraged all representation. Considering what an image ought ideally to be to represent even a man, even a living being, the artist gave up. He composed ornamentation, decoration. It is as if, resigned to no longer depict heaven, he also had to resign himself to no longer represent earth.

The Orthodox Response

The general conviction of the iconodules—as expressed first by the patriarch Germanus at the beginning of the crisis, in 725—was that to reject icons was also to reject the Incarnation. They absolutely refused to assimilate the image of Christ, which delivered men from idolatry, to idols. The prohibition of Horeb became invalid from the moment God manifested himself in the flesh, sensible not only to hearing but to sight. Thereafter, God had a visible "character," an "imprint carved" in matter, in his flesh.

"To Mansur of bad reputation, who thinks like the Saracens, anathema!" Thus spoke the iconoclastic council of 754. "Mansur," adviser to the court of the caliph of Damascus, was John of Damascus, author of the first theological overview of the icon. He wrote his three discourses against those who rejected images in about 730: he was thus dealing with early iconoclasm, prior to Copronymus's subtle argument.[35]

In his third discourse, the Damascene distinguishes among six categories of

images, from the most to the least perfect: first, the consubstantial image, such as the Son, icon of the Father, and the Spirit, icon of the Son; second, "God's thoughts of things that are to be through him," that is, his eternal counsel— these are divine Ideas; third, man, "who proceeds from God by imitation"; fourth, "Scripture, filled with the formed figures of invisible and incorporeal things." To this fourth category he adds visible things, "which are the images of invisible and formless things, so that, in depicting them in body, we have a veiled knowledge of them." John of Damascus, following Pseudo-Dionysius, maintains that we need corporeal things as intermediaries to lead us to intelligible things. Hence, the icon of the Holy Trinity is the sun, its light, and its rays, or the rosebush, its rose, and its perfume. The fifth category consists of images of things that will come later: hence the burning bush represents the Virgin, and the bronze serpent, the Cross. Finally, there are the images of past things we want to remember. There are two kinds of them, those inscribed as words in books and those rendered in paintings to offer to everyone's eyes: icons in the proper sense.

Thus, for the Damascene, the image is hierarchized depending on its degree of participation—in intensity and completeness—in the prototype. The icon is at the very bottom. He makes no distinction between the natural image, which enjoys a certain substantial participation in the prototype, and the artificial image, which has no other connection to the model than a fictive likeness.

It is within the framework of that theory of the image that the Damascene seeks a justification for the icon, for its worship, and for its very existence. In terms of worship, he systematically develops the distinction between latria, worship of God, and proskynesis, worship of sacred things. Christ's words, "Render therefore unto Caesar the things which are Caesar's; and unto God the things that are God's," suggest the following interpretation to him: "Since it is the image of Caesar one has, it is of Caesar. When it is the icon of Christ, render unto Christ, for it is of Christ." Once more, we are confronted with the metaphor of the imperial image! In terms of the icon's existence and fabrication, John labors to show that matter can take us to intelligible realities. His argument extends to matter the grace of the Incarnation: "I do not venerate matter, but rather the creator of matter, who was made matter for me and who deigned live in matter and bring about my salvation through matter. I will not cease to venerate the matter through which salvation came to me." Up to this point in his argument, the "matter" John is speaking of is the body of Christ. But he further extends the concept: "But I also venerate the matter through which salvation came to me, as if filled with divine energy and grace. Is not the wood of the Cross made of matter? . . . Is not the ink and very holy book of the Gospels of matter?" And so on, for sacred vases, paintings, and above all, the eucharistic species.

There is a troubling drift here. The body of Christ is not matter in the same univocal sense as a painted wooden board. It is as if, for John of Damascus, there is a kind of communication diffusing the holiness of the body of Christ to other materials in the same way that the imperial mantle (and the example is significant), without value in itself, becomes worthy of every honor when it has touched the emperor. In other words, what is communicated in the icon is less the face, the identity of the divine Person, than his energy, transmitted through the matter of the icon in the manner of a sacrament. It is not clear how the Damascene's theology could oppose the superstitious, and in fact condemned, practice of scraping bits of paint from the icon and letting it fall into the eucharistic jars, next to the bread and wine. The Damascene justifies the icon through its hierurgical and theophoric virtues. Matter leads us toward the immaterial God, by having us go back up the current, so to speak, along which it has conducted divine energy. John is on equal footing with popular devotion, and that is why the orthodox tradition praises him as the defender par excellence of the icon. But he lays himself open to the iconoclastic criticism, and even the orthodox criticism, which considers it an error to make the icon another sacrament.

The vast iconoclastic reformation became wider and deeper after the Damascene, who wrote twenty-five years before the decisive synod of 754. The iconoclastic argument seems to have won out intellectually. The resistance was populist. Under the Arab occupation, it was concentrated among the monks of Palestine, beyond the reach of imperial persecutions, who confined themselves to repeating the old Damascene theses. The magic circle drawn by Copronymus, which paralyzed thought, was not broken until sixty years later, in about 820, by Nicephorus, patriarch of Constantinople, and Theodore, abbot of the great monastery of Studium.

Nicephorus's originality lay in breaking with a very ancient tradition of the image, which claimed that the latter was "consubstantial" with the prototype, or at least that it almost magically captured its force and presence.[36] The strategic point on which he mounted his attack was the concept of *aperigraphos,* "uncircumscribed." Since the time of Eusebius, the iconoclastic current had maintained that human flesh, the "form of the servant," had been totally transformed into the divine form. Through the union of natures, the flesh of the Word had received the quality of being "uncircumscribed," and, as a result, enclosing its form within the outlines of a drawing was out of the question. Constantine V wrote: "You say you circumscribe Christ before his Passion and his Resurrection. But what do you say after the Resurrection? . . . What remains circum-

scribable at that time? How could He who entered the home of the disciples through closed doors have allowed himself to be circumscribed?"

Nicephorus, taking an extreme case, asks: can one paint incorporeal angels? Of course not, respond the iconoclasts, since they are uncircumscribable. But, notes Nicephorus, "the question is not whether one circumscribes angels, but whether one draws and represents them as an image." Drawing is not the same as circumscribing. "Painting has to do with likeness . . . ; it is the painting of the archetype but is separate from it, exists apart and at a given moment. . . . Painting consists entirely of sensible apprehension *[aisthesis]*, in showing, in circumscription, it lies above all in the realm of the notion." A body can be circumscribed in its own mode, since it has a content. But the painting of that body does not circumscribe the body, but rather what is understood by the intelligence—knowledge and meaning in the mode of likeness alone. The icon is not a natural image of the prototype; if it were, the iconoclasts would be right to say it is impossible. It is an artificial image, which is not of the nature of the prototype: it does no more than imitate it.

In the iconoclastic conception of the image as entitative participation, a choice had to be made between iconoclasm and idolatry. The iconoclasts could not imagine an image that was not infused with mana. Yet it cannot and must not be so. In contrast, Nicephorus greatly reduces the value of the image. It has no relation to the prototype except through the notional connection of likeness. It is not *perigraphē*, but merely *graphē*.

Let us return to Christ: does he have a representable, visible aspect? Yes, responds Nicephorus, since the deified body does not cease to be a body. In this, Nicephorus breaks with the Origenian tradition and with the old Platonic fount: the body and circumscriptability are not a consequence of sin. The biblical dichotomy between created and uncreated is not superimposed on the Platonic dichotomy between material and spiritual. Nicephorus follows Aristotle's reasoning: is the glorious transformation of the body at the Resurrection accidental or substantial? If it is accidental, then it is not total, as Eusebius claimed. If it is substantial, then one would have to believe that Christ's humanity had disappeared. In that case, one would be a Monophysist. In the Transfiguration, the human nature of Christ has not changed. It has been "renewed," not transformed. One must admit therefore that the corruptible, mortal, circumscribed flesh is capable of a divine "mode of being." We have now returned to the solid ground of the Council of Chalcedon: the union of the two natures, without confusion and without separation. But what, then, of divine nature? If it is unrepresentable, is it still Christ we see on the icon, or simply his human nature?

Well, replies Theodore the Studite, in Christ "the invisible shows itself."[37] What we see on the icon is his very person. In other words, his hypostasis, and not his nature. That is the key to the iconic problem.

What does an icon represent? Someone. "Not man as a reasonable, mortal being endowed with intelligence: for this does not define Peter alone, but also Paul and John and all those who fall into the same category. What one paints is the man inasmuch as he possesses certain properties beyond the general definition, such as a hooked or pug nose, curly hair," and so on. Here, Theodore was responding to an opinion of the iconoclasts, that Christ had assumed a nonparticularized flesh, that of man in general. The Studite, who is nominalist and anti-Platonic on this point, holds that the true man is not the idea of man but the existing individual. The icon paints what is specific to that individual. The Incarnation did not produce generic Man, but a certain man, the man of Nazareth.

The Studite's approach, unlike that of Nicephorus, is maximalist. In fact, it completely adopts Constantine's arguments, provided that what is inconceivable in nature is conceivable—within the limits of mystery—in the hypostasis. Yes, the icon circumscribes the Word of God, but it is God who started it, since he circumscribed himself in becoming a man, and moreover, an individual. In fact, he is circumscribed not only as created nature but as the bearer of distinctive traits. It is these traits that express not the nature (which has no traits), but the person, the hypostasis.

Theodore therefore grants everything to the icon as hypostasis and refuses it everything as nature. When an icon no longer bears the "character," that is, the distinctive traits of the model, it is fit to be cast into the fire. Contrary to the Damascene, the Studite grants the matter of the icon no power to transmit Presence and energy. Recall that the iconoclasts maintained there was only one icon befitting the dignity of Christ, namely, the Eucharist. To which the iconodules had long since replied that the eucharistic bread could not be the image of Christ, since it was Christ himself. The icon is not a sacrament. In contrast, in the order of hypostasis, the Studite is an extremist. He does not hesitate to assert that the hypostasis is really in the image, that the icon has the "same hypostasis" as Christ. He even insists that the words "image of Christ" should not be inscribed on the icon, only the word "Christ": "Christ is one thing and the icon of Christ is another, considered according to nature. But there is an identity as to the name, which is undivided. And when one considers the nature of the icon, one should not call what one sees 'Christ,' or even 'image of Christ.' For it should be called 'wood,' 'paint,' 'gold,' 'silver,' or any of the different materials."

But when one looks at its likeness to the archetype depicted, it should be called 'Christ.'"

Yes, in contemplating the icon, we contemplate Christ. From Plato to Dionysius to Origen to Eusebius, the image is like a ladder leading the intellect from the sensible to the intelligible, and, once the intellect has arrived, the image can be left behind. For Theodore, contemplation via the intelligence leads to the same place as contemplation via the senses: what matters is what the icon shows, Christ incarnate. What transcends the vision procured by the icon is the vision of the reality of Christ in resurrected glory. Nothing transcends the corporeal vision, and it is in the glory of his resurrected body that the faithful will contemplate the glory of the Lord. The senses play an inalienable role—our nature remains the same on earth as in the next world—on the path to knowledge. "If contemplation via the intellect [via "theory"] had sufficed in itself, it would have been enough that the Word come to us solely in that manner." Yet it was incarnated. The root of iconoclasm, whether Christian or Jewish, is the overwhelming feeling of divine transcendence. The path proposed, after Maximus, by the abbot of Studium, leads to the recognition of an even loftier, though paradoxical, transcendence in the kenosis of a God who "empties" himself in the direction of his creature: "He becomes matter, that is, flesh, he who founded the universe. And he is not ashamed of having himself become what he assumed to the point of being called such." There is no shame for the divine in having agreed to be circumscribed in humanity, in the womb of a Virgin, nor is there any shame in circumscribing him in the icon: "If Christ became poor for us, how could there not be marks of poverty on him, such as color, sense of touch, body, through which and in which he is circumscribed?"

4. THE ICON

The Icon's Claims

In 842, upon the death of Emperor Theophilus, power fell into the hands of Theodora and her son Michael. During the persecution, Theodora secretly venerated icons. The theological victory of iconophilia was now established. After a year of political preparation (the army and part of the clergy held out for iconoclasm), she deposed the patriarch John and replaced him with the higoumene Methodius: "His lips mutilated by the iron of iconoclasts, obliged at public functions to hold his jaw together with white bandages, which became for his successors the insignia and decoration of their pontificate, he had enough verve and voice left to dictate his hymns and his speeches—always formidable for the

enemies of images."[38] A council was convened. The first Sunday of Lent, 11 March 843, the henceforth annual feast reestablishing orthodoxy was celebrated. At the canon of matins, people sang: "We paint images, venerate them with our mouths, our hearts, our will, those of Christ and of the saints. The honor and veneration directed toward the image rise to the prototype: that is the doctrine of the Fathers inspired by God."

Thus ended a century of ferocious struggles, the close of the great cycle of Trinitarian and Christological heresies. Although Islam had taken advantage of the fissures opened by Monophysitism and Nestorianism, detaching all of Africa and the Mideast from Christianity, when it later recovered the Balkans and Russia, it could not achieve the mass conversions that had marked its beginnings. Orthodoxy, purged of heresies and of iconoclasm—which had included every kind of heresy, in fact—remained firm in its faith.

As we have seen, the crisis was the occasion to "revise" and reexamine the delicate intellectual balance surrounding the mystery of the Incarnation. It was on this point of theology, and with a complete indifference to aesthetic questions, that the discussion of the validity, legitimacy, and value of the divine image made by human hands rested.

The reestablishment of the icon and its worship occurred without any need to choose between the different systems invented to defend it. All systems converged toward the icon, even though they may have diverged from one another. Saint John of Damascus valued the material aspects of the icon, in the name of the Incarnation. Saint Nicephorus took away the drama of representing the divine by assigning a less ambitious status to the image than that which had alarmed iconoclasts. Saint Theodore, unlike the Damascene, completely devalued wood and paint, only to exalt almost hyperbolically the identity between the "character" of the icon and the Person of the incarnate Word. In the restored practice of worship, there were no distinctions, only juxtapositions. All, or almost all, icons had been destroyed; as a result, a new Byzantine art emerged under the Comneni, reemerged in the Palaeologus Renaissance, and flourished until the fall of Constantinople. The icon continued to prosper even under the Turks: in Greece, Bulgaria, and Serbia. In Russia, it reached its apogee in the early fifteenth century, giving rise to distinct schools in Moscow, Pskov, Novgorod, and even in the frozen North, all of them capable of notable masterpieces. Then, the icon degenerated in the sixteenth and seventeenth centuries, clumsily associating itself with procedures borrowed from Western art. In the nineteenth century, apart from small portable icons in copper and bronze, mass-produced by Russian workshops, the genre was completely dead. That in no way prevented the icon from remaining an object of worship, present in every

home; people honored it with lamps, prayed to it, bowed to it, made the sign of the cross to it, venerated it in every church, carried it in public processions. It marched at the head of armies, and certain images, at least, were the source of astounding miracles.

The introduction of modern Western art into Russia awakened aesthetic interest in the icon. That movement of rediscovery began at the turn of the twentieth century. There were many reasons behind the resurgence of interest. Nationalism played the greatest role. In the nineteenth century, nationalism everywhere drew upon art. This was particularly the case for German nationalism. But the English and French versions were hard on its heels. The Russians, especially Tretiakov, collected icons as manifestations of national art. Yet that art interested the European avant-garde for purely technical reasons. Matisse, invited to Russia by his client, the great collector Khchukin, found, in the flat color and the organization of the surface area, an affinity with his own preoccupations, as well as justifications for his own paintings. The metal *riza* that covered icons were pulled off, and icons were actively restored. The restoration was at times so brutal and so complete that it is often difficult to reestablish the objects' authenticity. That is the case, for example, for the most famous of icons, Rublyov's *Trinity*. In any case, Russian national feeling—which fed on the glorious literature of the nineteenth century, and which suffered profoundly because Russia had produced only a second-rate, provincial art—in the early twentieth century found itself endowed with a great art, as old as Italy's, recognized by everyone who counted in the Western art world. A divine surprise.

It was divine because, from the outset, Russian nationalism had sought its credentials from religion. Russia could not produce a society or a political life that elicited admiration. In the early nineteenth century, when Slavophilism came into being and took root, it did not yet have achievements of civilization to highlight. But it had Orthodoxy, with its claim to have preserved the true faith pure from all Catholic or Protestant adulteration. Yet, on this point, the illustrious Westerners were bowing to the icon, which to a great extent was Russian and ancient, and which bore witness to the Orthodox faith, of which Russia had produced very few presentable literary accounts. It spurred national pride and religious pride simultaneously, since, in nineteenth-century Russia, a religious value was consistently given to everything national, and a national value to everything religious.[39]

In the vast body of literature the Russians compiled on the icon, from Troubetzkoi to Veidle to Bobrinskoy to Meyendoff to Ouspensky to Evdokimov, there are rich historical and scholarly developments. There is also an indistinguishably national and religious judgment of the superiority of the icon—as re-

ligious art and as art, period—to Western art. In a dignified repetition of an intellectual framework invented in the first years of the nineteenth century, arguments were drawn from the criticism the West consistently made of itself: the West's dissatisfaction with its own established artistic formulas, especially those having to do with its sacred art; concerns dating back several centuries, which Europe had articulated about the fate of art; and the diagnosis of a general crisis, which it advanced periodically. Russian literature drew on these arguments to triumphantly put forward the icon as what had preserved Russia from these distressing evils, and as the sole remedy to the general crisis. The crisis was judged all the more lethal in that Orthodoxy alone discerned the obscure reasons behind it and its profound causes, appealing in particular to the icon. The Slavophile critique was of a nature to receive a warm welcome in Europe, which heralded it as an echo of its own self-critique and as its objective confirmation. Hence the modern-day vogue for icons, which are today infiltrating our churches, occupying the place of honor on the altar, to such a point that mediocre reproductions of doubtful icons sometimes drive out not only religious trinkets in the Saint-Sulpice style but also good and sincere paintings from the nineteenth century, and even superb canvases from earlier periods.

Before examining the claims of that contemporary body of literature (since ancient literature did not give them a thought), let us look objectively at the icon as it is and as it presents itself to us.[40] The iconographer, after an appropriate prayer, fastened canvas onto a wooden board, on which he spread a white preparation *(leukos—*the origin of the Russian term *lekvas)* made of alabaster or chalk. For his drawings, he was guided by collections of "models" (in Russian, *podlinnik,* "authentic"), since the iconographer had to remain within the tradition, although some room was allowed for his personal interpretation. Then he applied the gold and paint, perfected the hues, the luminosity, applied cross-hatching in light-colored paint or in gold, took particular care in rendering the carnation of face and hands, and finally, with an inscription, gave the icon its name. It was through this name that the painting became an icon and was linked hypostatically (or substantially, depending on the theology followed) to its prototype. In fact, the expression used is not "to paint" an icon, but "to write" an icon: the writing refers not only to the inscription of the name but to the very lesson the icon teaches, placed side by side with the teaching of Scripture.

Despite theological developments in the opposite direction, the icon remains steeped in the Platonic spirit. It is an instrument of contemplation through which the soul breaks free of the sensible world and enters the world of divine illumination. "We feed ourselves by necessity so that our life retains its force for contemplation, for which, in reality, we are born" (Nicephorus Blemmides).[41]

The first icons were not of Christ but of the stylites, who, isolated at the top of columns, were "angels in earthly form."

The icon imitates the prototype. But the historical origin of this prototype is not known. Of course, Saint Peter was not represented as Saint Paul: he had his distinctive traits, but no one knew where they came from. In fact, they come from the theological ideas defining them, which are found in liturgical books and also in painters' collections. The individual character is swallowed up by the theological essence their existence expresses.

The body counts very little. Diminished by asceticism, it only rarely appears nude, at Christ's baptism, for example. Ordinarily, it vanishes under clothing. The head, or rather the face where the Spirit shines through, is at the center of the representation. The rosy carnation of antiquity gave way to ocher, but light still shone in this earth tone, marked by fine cross-hatching that suggests an intense life. John Mauropus (in about 1555) said the good artist should represent not only the body but also the soul—thus repeating Socrates' words reported by Xenophon.[42] All attention is drawn to the sometimes enormous eyes fixed on the beholder, set off by the arch of the eyebrows, and by the point between them where the Spirit seems to be concentrated. The forehead is high and bulging, the seat of wisdom and intelligence. The nose is long, thin, severe, noble; the nostrils quiver. The cheeks of ascetics and monks tell of fasting and sleepless nights. The very thin mouth is always closed, because in the world of glory all is vision and silence. There are no angels singing at the top of their lungs, as in Fra Angelico and Della Robbia. The beard is majestic, the locks fall to forceful effect.

Nature is stylized in such a way that trees, rocks, and houses defy gravity. The buildings are not represented within a unified space: each floats in its own perspective. The colors have a symbolic value. Light casts no shadows. The perspective is generally reversed: the line of force extends from within the icon toward the beholder's eye. Through the icon, the truths of faith radiate toward the person contemplating it. The vanishing point thus moves toward him.

Light is the soul of the icon. According to the ancients, the eye and the object emit light conjointly, and vision is produced when a luminous, homogeneous medium is formed between the eye and the object. But with Plato and especially Plotinus, light communicates beauty and goodness to things. That is why the opposition between light and shadow replaced the classical opposition between order and disorder. Light frees matter from its darker nature. But material, natural, and created light itself becomes shadow when compared to the intelligible, uncreated light that radiates from the unknowable God. This reversal of light created in superluminous shadows is made explicit in icons of the Transfiguration. Christ is at the center of an aureole with three concentric circles. And it is

the light of the outermost circle that is the most dazzling. As one moves toward the divine center, light blue becomes dark blue, then midnight blue traversed by golden rays, and finally the pure white of Christ's robe.

Gold is not a color. It is brilliance, active light. In the Slavonic iconography manuals, it is called *svet* ("light"). On ancient icons, gold was used with discretion. It became more widespread after the iconoclastic crisis. Light does not serve to draw the outline and reliefs, it is not given the task of creating an illusion. It radiates from the image itself toward the beholder. The bodies on the icon do not bathe in a light whose source is external to them. They bear their own light, which wells up from within them. That light reflects the eternal ideas underlying these bodies. It transposes divine energies—of which the uncreated light of Tabor is the vision—which support the distinct beings and lead them toward deification. The iconic meaning of light came directly from Pseudo-Dionysius, who was later replaced by Hesychasm and Palamatism.

The icon is writing. It borrows its themes from the Bible, the Apocrypha, the liturgy, hagiography, the sermons of the church fathers. It conforms to literary genres. The panegyric shapes the saint's life to fit the exemplary model. The epic or dramatic style gives scenes their particular color. But, as one moves closer to modern times, theological lessons move to the foreground. The theological topos—and no longer the hypostatic presence of the prototype—becomes the very object of representation. The icon no longer represents persons; it illustrates treatises. In the fourth century, the visit of three men to Abraham and the hospitality *(philoxenia)* he showed them were represented in a fairly "naturalist," or at least historical, fashion in Santa Maria Maggiore, and even in Ravenna, though the fathers already considered it an epiphany of the Trinity. In the famous icon by Rublyov, the dogmatic intention resorbs, so to speak, the details into the dominant theological schema. Abraham has disappeared, the table has become an altar bearing the eucharistic cup. The three angels—or three divine Persons—stand together in a silent exchange. The rock, the oak of Mamre, and the home of Abraham are reduced to residual symbols. All the pathos is obtained through the play of colors and, above all, through the circular geometrical structure, which conveys the theological interpretation of the mystery. The letter of Scripture is, as it were, effaced by the spirit, or at least by the interpretive system. In the sixteenth century in Russia, dogmatic icons proliferated, and their titles indicate their speculative character: *Word, Only Son; Our Father; Every Creature Rejoices in Thee.*[43]

Hardly had Russian authors been informed of the existence of the icon, which had long been confined within a single social milieu (lower class, Old Believer, and clerical) far removed from that in which the intelligentsia was evolv-

ing, than they understood what a boon it was for national consciousness. That art, in fact, as old as French medieval art, had its roots in an even older history. The fount of Russian culture, so cruelly recent in nineteenth-century eyes, was pushed back several centuries, and this time authentically and not just mythologically. Russian culture, at least its artistic culture, with titles of nobility of much greater standing than the approximations of Slavophilism, was endowed with a true and glorious tradition. "The painting of icons," Eugene Troubetzkoi wrote in 1915, "expresses what is most profound in the culture of Old Russia. In addition, these icons are among the most preeminent treasures of universal religious art. And, until a recent date, they were incomprehensible to the educated Russian. He barely cast an absent-minded glance on them."[44] All the great nineteenth-century writers had been impatiently awaiting that revelation! "Dostoyevsky said: 'Beauty will save the world.' Solovyov, developing the same theme, proclaimed the ideal of 'theurgical art.' When these words were spoken, Russia did not yet know of the art treasures it possessed. We already had a theurgical art."[45] Troubetzkoi's nationalism, exacerbated by World War I, saw icons as the palladium of the nation and as its supreme expression. In icons of Christ, his "attentive eye" recognized "the typical traits of a Russian face," but now spiritualized. "Hence, not only the universally human but also its national dimension are introduced into the immutable peace of God and preserved in glorified form by religious art, which has reached its apex." "A nation capable of giving birth to such luminaries no longer needed foreign masters,"[46] Troubetzkoi also declared, boasting of the independence Russian iconography had assumed in the fifteenth century in relation to the Greek: "This nation itself was capable of illuminating the world."[47]

Troubetzkoi's artistic nationalism is not at all exceptional. After all, the discovery of Gothic art had given the Germans, then the French and the English, reasons for patriotic faith, which the Russians had only to imitate. But, because of the nature of this art and the old habits of Russian nationalism, these authors insisted that the greatness and, in the end, *aesthetic* superiority of the icon to Western art stemmed from the *religious* superiority of Orthodoxy over the Roman Church.

The principal themes of that nationalist literature seem to fall into three categories.

1. The icon is more than art, since it is in itself an effective means of salvation. Father Bobrinskoy, for example, following the theology of the Damascene on this point, restores a "sacramental status" to the icon.[48] Ever since the flesh of Christ and, with it, matter, were transfigured in the Resurrection, elevated to participation in divine life in the Ascension—in Christ—the creature has had

the capacity to accede to divine likeness and progress toward it. Human art, "baptized in the church" by the fire of the Spirit, now has the capacity to offer the Presence of the divine Trinity itself to our senses and intelligence. Between the external prototype (Christ) and the internal prototype (the image of Christ engraved in the human heart), an exchange and progressive fusion come about, bringing salvation with them. The icon is the vehicle for the sanctifying Presence of God and, in the other direction, for prayer. Certain icons even have the property of "capitalizing" the Presence of God and the church's prayers, and are thus particularly venerated. In the end, "in sight of the Kingdom, of which the icon is one of the sacramental manifestations here on earth, an epiphany, man will be an altogether transparent and faithful icon."[49]

The salvation Plotinus illusorily hoped to obtain from contemplative asceticism—and which moderns have even more illusorily demanded of pure art—is procured for all via the icon, which is equal to Scripture, equal to the sacraments. Through the icon, an access road leading to God is carved out, and deifying energies descend from him. We have moved well beyond art. We are just this side of the Kingdom, on its very threshold. Through it we already participate in the life of the Trinity.

2. As art, the icon has a greater capacity to show lofty things than any other artistic form. All art undoubtedly has an ambition to show the invisible. And that is what the icon does, and it does only that. "What the icon represents—sacred figures or events—was at first present only to the spirit," writes Veidle. "What it shows is never anything but the invisible. It is not at all 'abstract,' it does not abandon the idea of depicting, even less of resembling, but seeks likeness to something that is not of this world, and that could not be reached by reproducing the objects that constitute it or by submitting to the laws that govern it."[50]

In other words, the iconographer, like the impressionist painter, paints "the motif," but the motif is transcendent: it is the world transfigured. The icon is a window. But not in the sense that the beholder looks through it to see a spectacle: on the contrary, the icon reveals a presence that acts on anyone who passively receives it. It is the fixing of a vision. That is why the reversed perspective suits it, directing forces toward the target, the beholder in contemplative prayer.

The art of the icon, Olivier Clément concludes, transcends the opposition set out by André Malraux between the arts of the non-Christian East, "manifestations of an impersonal eternity," and those of the modern West, "prey to anxiety, quests, the individual's secret." It transcends the opposition between figurative and nonfigurative art by offering a "transfigurative art." "[The icon] abstracts, but only to extract from the carnally minded (in the Pauline sense),

which is death, the pneumatic corporeality assumed and illuminated by the hypostasis. Abstraction thus leads to the highest reality, figuration opens onto a place beyond figuration."[51]

3. Western art, particularly religious art, cannot rival such a sublime accomplishment. From its beginnings, it was penetrated by pagan, Hellenistic influences, which, according to Ouspensky, "debase" Revelation, "deform" gospel teaching. From the Italian "Renaissance" on (Ouspensky's quotation marks), "carnal" and "illusionist" elements have permeated sacred art and corrupted its purity. These foreign elements were rooted out of the icon after the iconoclastic crisis, under the vigilant eyes of the church. Alas! Beginning in the seventeenth century, under the particular influence of Vladimirov, who dared admire Western art, they returned in droves and caused the decadence of sacred Orthodox art itself![52]

Ouspensky compares two nearly contemporaneous images of the Virgin, Raphael's *Madonna del Granduca* and a Muscovite icon. In their pose and the folds of the mantle, they conform to the same iconography. And yet:

> Raphael's image is only human; it is carnal and sentimental. The sacred subject is only a pretext for the expression of the painter's own feelings and ideas. The only thing the image teaches us about the Mother of God is that she was a woman, and about the divine Child, that he was a baby no different from all other children. The icon, in contrast, communicates to us by its adequate symbolism the teachings of the Church on the Incarnation of God and divine Maternity. The Child is not one baby among others: its majestic pose, its nimbus, the scroll in its hand, its benediction, the way its clothing is treated, all reveal to us divine Wisdom incarnate.[53]

If Western religious art became trapped in the dead ends of naturalism and psychologism, it was because Rome separated itself from the true church. Even in 692, Rome did not fully accept the decisions of the Synod of Quinisext. As a result, Ouspensky comments, "the Church of Rome excluded itself from the process of elaborating the artistic and spiritual language . . . and the leading role fell providentially to the Church of Constantinople." Later, the poor reception of the Council of Nicaea II "poisoned Western art at the source." The fatal blow was the separation of the two churches in the eleventh century, at a time when Orthodoxy entered "a pneumatological period." That is why the creative spark of Romanesque art "was only a short-lived flame," and Western sacred art, from the Gothic period to modern times, moving from one betrayal to the next, lost its meaning, its destiny, its reason for existence.[54]

The art of the Roman empire became decadent because of a deviation, and not simply a cooling, of faith. The icon, in fact, represents a human person bear-

ing a nature reestablished in its first being, on the path to deification. But the Roman doctrine, as Ouspensky understands it, denies that possibility of deification. Human nature has not been changed by the fall, it is simply deprived of the gifts of grace. The Incarnation returns these gifts, but grace is created and simply added on to human nature. For Rome, human nature remains human nature. Its behavior is corrected, but it does not undergo any ontological change. That is why the saint is represented as one of us, in the image of the earthly Adam and in his corruptible aspect. The transfigurative art of the true church is entirely different; there, the saint is truly deified. Ouspensky concludes that images corresponding to that misguided theology must therefore be banished from the churches.[55]

Examining the Claims

In 843, a date marking more or less the middle of our inquiry, an interminable trial seems finally to have reached its judgment. Is it possible, is it licit, to represent God? Yes, comes the reply, after a very long wait, to the two questions Anaxagorus, Parmenides, and Plato had first raised.

If it is true—and it is Plato who urged us to believe it—that the goal of art, its loftiest goal at least, which gives value to all the other possible goals and on which the latter depend, is to produce an authentic and visible image of the divine world, then the icon represents the fulfillment of a long-felt wish. The Word incarnate can be "circumscribed" on a painted wood board, and it is truly God, the only conceivable visibility of God. Its presence on the wood gives matter a dignity it does not possess in itself, and the property of actually conducting a share of divine power. Its face, specified by individual features, is that of the divine Person in whom the two natures are joined, without confusion and without separation.

In addition, the image does not fall capriciously from heaven. It is in the grip of holy history and authenticated by it. It is not outside religion, is not superfluous, is not a psychological stimulant for piety, which the worship in spirit and in truth could do without. It is internal to religion. It is part of its theological explication. It is integrated into the liturgy. It is guaranteed by both theology and the liturgy, and it draws its life from them: the icon unveils what it is supposed to represent in the light of faith. He who is without faith sees nothing. It is in prayer that the deifying contact with the prototype comes about through the image.

All these superiorities possessed *on principle* by the icon can, it seems, feed a hubris that prevents one from seeing it for what it is. The literature of the icon becomes an ideology of the icon, a fanaticism of the icon that prevents one from

assessing its natural limitations. Although Christ, "circumscribed" on the icon, can be the object of indefinite contemplation, the icon, a product of art, is circumscribed in a more restrictive manner. Its field, however profound, is limited. That form of art came about—since its ambitions were not certain before its theological elaboration—in about the eleventh century. It faded away in the sixteenth and seventeenth century. It flourished in the Russo-Byzantine domain, almost never straying beyond its borders. But beyond these borders, there were also people trying their hand at representing the divine.

The means available to the icon (colors with their symbolic importance, the geometrism organizing the image, and so on) in no way ensure that the goal is unfailingly reached. It is not enough to elongate the body disproportionately (as many as ten heads in length) so that the body becomes, as Clément says, "a flame bearing a face, the hypostatic concentrate of being, the *ek-stasis* of the person."[56] It is not enough to replace the rosy carnation with the brown color of face and body to ensure that they are the color of "clay transfigured." Ascetic spiritualization—the distended forehead, the thin, tight mouth, the emaciated cheeks, the attentive grave eyes—must not be taken as a self-evident equivalent of deification. They are symbolic renderings, whose efficacity does not depend on the rightness and sublimity of the underlying theology.

The icon, limited to one region of civilization and to one historical era, is also limited in its vocabulary and grammar. The icon reproduces canons. It prides itself on doing so. It bows to Nicaea II, which condemns the "cursed heretics" who violate the tradition of the church, think up novelties, overturn one of the legal traditions of the universal church in a tortuous and double-dealing manner. The icon draws on the Nicene Council to condemn Roman Catholics, "who have set out on the road of innovation." The artist, writes Clément, must, via a true transcendence of his closed subjectivity, submit to certain canons that allow the work to be faithful to its object. "Liberating submission: genius has nothing to lose by it, only narcissism is crucified." That is a grandiose way of putting it, but it does not allow us to lose sight of the permanent character of the icon, rejected by Western tastes, and even poorly tolerated by Eastern tastes—which is why the East finally moved away from the icon—the extreme monotony of forms and the repetition of prototypes. The anarchy of modern art, of course, produced a nostalgia for this closely regulated art. The trait remains nonetheless.

That trait is responsible for the paradox that the icon, which seems inseparable from the spiritual life of both the iconographer and of the beholder, is, of all art forms, the one that most easily lends itself to mechanical and industrial reproduction (icon shops working from *podlinniki,* dividing up the various tasks,

mass-producing). It is also responsible for another paradox, that the icon, an authentic product of the most personal prayer, is extraordinarily easy to falsify. Western museums and collectors possess an infinite number of perfect icons fabricated in the workshops of counterfeiters, established by the Soviet government for the purpose of procuring foreign currency. Everywhere fakes are abundant, even overabundant, since the icon, because of the almost ritual rigidity of its methods of fabrication, offers the counterfeiter less difficulty than does Western painting, where the individual hand of the artist obviously counts in the work's success. The reproduction, a discreet form of falsification, does not cost the icon very much. There is an enormous drop in quality between a Monet or a Titian and a photograph of the same; not so between the Virgin of Vladimir or Kazan and the countless reproductions that today enliven Catholic chapels.

Why is it that the literature of the icon rarely chooses to recognize these obvious and in no way insignificant limitations, except to draw a surplus of glory from them? It seems that a confusion is constantly perpetuated between the theological and artistic orders. How shall I say this? Let me use a comparison. In a novel by Aldous Huxley entitled *Antic Hay,* there is a character, a modern painter: he is all the more striking in that everyone has run into him at one time or another. This painter develops the most profound, the truest theories on art. Standing before any painting, he can detail with unparalleled perspicacity its merits and shortcomings, can indicate what it would have taken to give it life, truth, and beauty. But the young woman who listens to him and looks at his own canvas is heartbroken, because his speeches make her even more aware of what is irremediably lacking in them: life, truth, and beauty.

At stake is not aesthetic theory but the highest theology. And that theology is not sufficient to guarantee that the icon has achieved the goals theology declared within reach. It sometimes happens that theology acts as a heady incense that clouds the positivist view of the icon as it is and engages the soul in admiration, which ought to be conditional but which becomes automatic and blind when confused with the veneration that is always due.

Let us go even further. The existence of an iconic theology, accepted and ratified by the church and elaborated at length and in intricate detail, also does not guarantee that iconographic practice will be true to it on a regular basis. That theology was formed in opposition to the twin errors of iconolatry and iconoclasm. But it takes a considerable effort to remain upright on the precarious summit between them and not to slip down either of the opposing slopes, into two different errors. You think you are still holding on, and you are already gone. Simply put, in the place of iconophiliac equilibrium, one finds a mixture or unstable juxtaposition of iconolatry and iconoclasty.

Iconolatry

I am not speaking of the repercussions of popular piety. Of course, there was a certain drifting after the crisis, just as there had been before it. Projections, somewhat tinged with magic, onto miraculous images existed throughout the Christian world, except when iconoclasm had the upper hand, as in the Calvinist world. These were inevitable. They were rarely serious. I will not condemn Félicité (in Flaubert's famous story *Un coeur simple*) for seeing the Holy Spirit in her stuffed parrot.

More subtle and difficult to discern is the iconolatry not of the icon, not of the prototype present on the icon, but of the theology of the icon, or the religious domain delimited by the icon. I have pointed out the evolution of the icon toward the theological schema. The danger comes from the fact that, through the exaltation of a particular theology, one allows the honor due the icon to reflect not onto the prototype but onto the system, which is, in fact, the only thing represented. The face becomes a pretext to rejoice in being a disciple of Saint Gregory Palamas rather than of Augustine, to be Orthodox rather than Catholic or Protestant. A bad icon, utterly incapable of transmitting energies and the hypostasis, still transmits the schema. And just hope that nationalist fanaticism is not combined with insular sectarianism! "So that we do not fall into despair," Troubetzkoi writes, "and do fight to the end, we need to carry the banner before us, on which the beauty of Heaven is combined with the solar and glorious face of Holy Russia."[57]

At that point, the icon becomes the ensign of an entrenched camp, a closed world within which it takes its meaning, for the learned, solely from an initiatory theology, or, for the simpler folk, from magic, but in both cases from an imperialist world, where it sounds the advances and retreats of the correct doctrine. That iconolatry, like all idolatry, is worship of oneself and, rather than glorying in Christ, glories in its own idea of orthodoxy. In following that path, the icon empties itself until nothing is left. But from this void it crushes everything lying beyond its borders. I mentioned the comparison Ouspensky made between a Virgin by Raphael and a Muscovite Virgin, which is alarming, once one has taken a look at both of them.

Iconoclasty

The style of icons changed after the crisis. In the few primitive icons, which come for the most part from Egypt (such as *Christ and Abbot Mena* in the Louvre), Christ or the saints have stocky, thick-set, vigorous, extremely carnal physiques. All the somewhat heavy realism of the art of Faiyūm was transposed onto these

robust effigies. But, after the crises, the forms become more elongated, the faces more hollow. Even though the victory of orthodoxy in 843 was a victory of the Incarnation, the icons—theoretically bearing witness to that victory—move toward the ethereal, the symbol, geometrism, hyperbolic asceticism. It often seems that the style adopted by the artists expresses a compromise between the full vision of Christ's humanity and the symbolic abstractions tolerated by iconoclasm. The compromise is justified by the place the icon chose to represent: neither wholly earth nor wholly heaven, but the mystically contemplated place between, the Transfiguration.

But the true and most irremediable trace of the iconoclastic spirit lies in the icon's incapacity to also depict the profane world. Even though this world, as Western art has abundantly proven, also tells of divine glory, it is absent from the almost exclusively religious art of late Byzantium, the Balkans, and Russia prior to Peter the Great. An art that is wholly sacred, wholly made to be worshiped, forms a desert around itself.

Of course, that is the limit of the icon, the fact that it cuts off from its sight the greater part of creation. Hidden iconoclasm—combined with iconolatry when it cares to cast anathema on Western art—conceals an anticosmism, which all the discourses on the Incarnation cannot completely dissimulate. Let us listen as Troubetzkoi speaks of his visit to the Rubens in the Hermitage: "The nausea I felt at the sight of Rubens's bacchanalia made me immediately understand the property of icons I had in mind. The bacchanalia are an extreme form of life, which the icon rejects. The ample, quivering flesh that delights in itself, gorges itself on meat, and necessarily kills to gorge itself—it is all this that the fingers bestowing blessings reject. . . . So long as we are seduced by the delectations of the flesh, the icon will not speak to us."[58] A neo-Platonic horror of the body and nationalist religious pride are in league together, constituting a practical iconoclasm theoretically capable of casting almost all images made by men onto the pyre: all profane images, whose claim to express divine grace is not examined; all religious images, because they do not bear the stamp of good theology.

But there is a more serious reason behind that elimination of nonreligious art, or of noniconic religious art. It comes from the intimate feeling that the icon truly allows us to hold the divine image, and that, as a result, nothing is worth the trouble of being represented. God, his glory, the transfigured world, the resurrected body, the Kingdom: after that complete vision, which fulfills every expectation and elicits every prayer, what is the point of falling back into the ordinary world, what reason is there to condescend to look at inferior sights?

We are touching on the hubris of the icon, which is part of the hubris of

Byzantinism. Solovyov reproached Byzantium for the ruinous contrast between a fastidious surface orthodoxy and a practical heterodoxy. Hence, the theology of the icon pushes the elucidation of the Incarnation as far as possible, even as the icon itself often gives way to errors. The theological self-assurance blinds one to the practical laxness: because the divine image was possible, people incautiously believed it existed. It also blinds one to divine images from different worlds, because they are dependent on a different theology, or worse, independent of theology, and thus a priori marked by incompetence.

Yet we must not adopt toward the icon the attitude its thurifers take toward everything that is not the icon. Modern Western art opened Russian eyes to the aesthetic importance of the old icons. In turn, these icons, now better understood, opened Western eyes to everything that is iconic in our own religious art. Although it did not tie itself to its canonical forms, that art (from Fra Angelico to Memling and Van Eyck, to choose contemporaries of the great Byzantine and Russian iconographers) displays the same internal gravity, the same silent presence, the same spirit of mystery and contemplation. Iconic-style regularities can also be seen in the clothing and poses of sacred personages. The barely transposed prototype of the so-called Hodigitria Theotokos, "she who shows the Way"—that is, her Son—is recognizable in Raphael's madonnas. Suddenly, in the mid-seventeenth century, at a time when the icon had long been dormant, and in the posterity of Caravaggianism—that is, an aesthetic revolution that led to the diametrical opposite of the iconic mode of painting—there arose what may be the images most perfectly consonant with the spirit of the icon that European art has produced. One has only to cite Georges de La Tour's *Nativity* in Rennes, or Zurbarán's *House of Nazareth* in the Cleveland Museum. I leave it to others to decide who is more faithful to the theology of Theodore the Studite, Zurbarán or Feofan the Greek, and which of them rendered the mystery of the Incarnation with more feeling.

Filled with gratitude, let us look kindly on the icon, without giving in to the slightest iconoclastic or iconolatrous temptation, even though we are prodded in that direction by the indiscreet literature that grew up around it.

First, one thing is glaringly obvious: the scarcity of large icons, and, of them, the few that are great works of art. Of course, vast numbers were destroyed. How many of Rublyov's icons remain? But there is not a greater number of Fouquet's paintings left. Second, it is the very icons that are great art that bear witness to the validity of the genre. The whole theology of the icon would vanish into thin air if certain icons had not effectively opened the heart to the divine Presence. Few of them did, however, and did so only for a short period of time. Our modern tastes can distinguish the great masterpieces. They seem to have

been contemporary to the Hesychastic movement, which, transposed onto the art world, brought a penetrating sweetness analogous—but not identical—to that conveyed in the West by the Franciscan and Dominican movements. These works can be found in Constantinople and in Moscow. We find appealing both the brilliant colors and the stunning flat surfaces originating in the schools in Pskov, Novgorod, and the White Sea. In these beautiful images, the formal appeal prevails over the depth of sentiment. But, standing in front of the great icons, which are, in fact, very rare, we can acquiesce to their claims. Yes, they are divine images. Yes, they are epiphanic. But they are divine because art made them so. They are not divine in themselves; experience, knowledge, work, and the mysterious talent of the artist were needed as well.

It is in their function as objects of worship that icons are all equal. As an instrument of prayer, the clumsiest scrawl does the trick. In that same context, there is no difference between the *Sistine Madonna* and some plaster "Virgin of Lourdes" painted white and blue. But it would be a mistake to conclude that the theoretical validity of the divine image, assured by theology, also guaranteed its aesthetic validity. There again, the Byzantine gap, noted by Solovyov, between perfection in principle and imperfection in actuality is apparent. In order to elevate the thing to the level of the principle, the enormous labor of art is required. If we trust theology to take us up to the heavens, it is as if we have put on the wings of Icarus: we risk falling back down to earth.

But then, what is the point of this great speculative effort, spurred by the reformist zeal of Leo the Isaurian and the impious ingenuity of Constantine Copronymus? To build one house—and there are others—where the iconographer feels at home and at peace with what he has to do. All icon painters took advantage of that. The most humble did so because their works, backed up by the canons, were rescued from certain shortcomings. In the judgment of Beckwith, all Byzantine products bear their mark: "A serene, austere expression of religious dogma and imperial power, a concept of the godhead which was never cheap, sentimental or tawdry, an unabashed love for magnificence, for splendor and for high estate and shafts of Beauty conceived and apprehended through the senses by the Mind."[59] The great iconographers also benefited from the fact—though some also suffered from it—that they could go to the limits of that art, to the boundaries of that house, but no farther. In the end, within the magnificent theological scaffolding, the iconographic artist operates all alone. At the level where he works, when he must combine theological guarantees with aesthetic success, thus sealing the icon's ontological validity, the inequality of images reappears, and he is responsible for assigning, among divine and profane images, the rank of success or failure to the icon.

PART TWO

Pax Romana of the Image

In 843, one iconoclastic cycle closed, at least in theory. The theological elaboration that had caused so much trouble was becoming a constrictive framework for the image.[1] Another iconoclastic cycle began in the West in the sixteenth century, reaching its first high point in the early twentieth century, in modes whose religious infrastructure I will attempt to indicate.

But within that long interval, the West peacefully produced a phenomenal number of images, its heart and mind rarely troubled. The diversity of the works, the invention of forms and themes, were incomparably richer than those of old pagan or Eastern Christian civilizations. Images were sacred, they were profane, and most often they were partly both. In that vast time span separating the Carolingian Renaissance from World War I can be located the principal domain of art history.

It would be impossible for us to enter that domain without getting lost. All the same, let us ask the following question: how was the Christian West able to fend off the torments and scruples of iconoclasm for several centuries? I cannot cover all the responses. But, in spite of everything, by limiting myself to religious causes, I can propose a few explanations. The iconoclasm preceding that blessed age and, above all, the iconoclasm following it, put us on the scent: it was because the causes behind those two iconoclastic periods were now lacking that the plastic arts flourished.

The first point is this: in the West, there was never a debate about the divine image comparable in depth, extension, detail, and violence to that which had

long occupied the East. Between the Roman Church and the Greek, there were a few surface differences in dogma regarding the image, a few misunderstandings, and a fundamental parallelism. But there was always a profound difference in intensity. The West was orthodox enough about the image, but never fixed on it as a central theological issue.

CHAPTER FOUR

The Middle Ages

I. THE LETTER TO SERENUS

If there is a founding text, constantly invoked as an authority, giving the last word of the Roman Church on the question, it is the letter from Pope Gregory the Great to Serenus in about the year 600.[1] Serenus, bishop of Marseilles, had all the images in his episcopal city destroyed and shattered. The pope addressed this remonstrance to him: "It is one thing to worship a painting, and quite another to learn from a scene represented in a painting what ought to be worshiped. For what writing provides for people who read, paintings provide for the illiterate *(idiotis)* who look at them, since these unlearned people see what they must imitate; paintings are books for those who do not know their letters, so that they take the place of books, especially among pagans."

Hence, for Gregory, the image has a pedagogical function: *aedificatio, instructio,* specially for the illiterate, that is, for those who, since they are not clerics, only rarely have access to Scripture. *In ipsa legunt qui litteras nesciunt.* In addition, the image appeals to memory, since what can be represented is a story. It refers to the past, to the lives of the holy martyrs, to the life of Christ: *res gestae.* By means of that story, pagans learn to worship only God, to "transport [themselves] in the worship of God alone." Finally, looking at the image elicits a feeling of "ardent compunction": *Ex visione rei gestae ardorem componctionis percipiant.* By "compunction," Gregory means a feeling of both humility and repentance in the soul that discovers its sinfulness.

Gregory does not go into the Christological problem. His words are pastoral and pedagogical. He is concerned for the pagans. Serenus has so scandalized his flock that "the majority" have broken away from him. "When, therefore, will you take the lost lambs back to the fold of the Lord, you who are unable to keep even those you have?" The Roman Church has always been afraid of shocking and scandalizing, and did not ask souls whose faith was considered fragile to abandon their customs, at least so long as the church hoped to modify them and give them a new meaning.

Basil the Great wrote: "What telling offers the ears, painting reveals silently by imitation." And Gregory of Nyssa added: "The image is a book of language."[2] But the Roman pope Gregory also remembered Horace: *Ut pictura poesis.*[3] The image fortifies, edifies the faithful, it touches their intelligence, their feelings *(componctio),* their memories, that is, their "selves," in the sense the ancients gave that word. The image is rhetorical in the strong sense. It persuades, it instructs, it moves, it pleases. It counsels (deliberative mode), it accuses or defends (legal mode), it praises or blames (epideictic mode): the categories of Ciceronian rhetoric perfectly apply to Gregory's program. The image places the beholder in a favorable state of mind. It orients his passions toward virtue. It awakens his piety.

Three key consequences follow from this. If we truly grasp the spirit of that epistle, the image, as it approaches the dignity of writing, and of sacred writing in particular, moves away from the status of sacred object. Of course, the theology that wanted the prototype to be present in the image—wanted the image to be a rung in the ladder allowing the soul to move from the material to the spiritual sphere, a link, a repository for the perpetual presence of the divine—that theology enjoyed a certain success only after the doctrine of Pseudo-Dionysius was accepted.[4] But the constantly invoked authority of one of the four fathers of the Roman Church played a role in maintaining the possibility of a strictly rhetorical status for the image, hence in underplaying its role and putting out the fire of the Christological controversies that devastated the East. As rhetoric, the image does not demonstrate a thesis, it simply defends a cause.

In addition, because the image serves to persuade the pagans to embrace the faith and not leave it, a formal connection is maintained with the images they once worshiped in an idolatrous manner. There is no reason to "change their art" once they have become Christian. Every gain that had been made in the matter of beauty, technical skill, and reflection on the beautiful was welcomed into the new economy and found its place there. A stone was set in place, awaiting future "renaissances."

Finally, because the image as such occupies a modest place among the means

for sanctification, to compensate it must be able to perform the role reserved for it as effectively as possible. Reduced to a material object, it will not be asked to conform too closely to a theological truth that stands well above it. Unlike icons, it does not have to conform to fixed schemata. On the contrary, the image would lose some of its persuasive force if deprived of all the resources rhetoric offers it, in particular, diversity, invention, surprise, and the variety of media— from sculpture in the round to stained glass windows—which move, please, and instruct through color, perspective, light.

2. THE *CAROLINI LIBRI*

I will not deal with the complicated question of how the Second Nicene Council was received in the West, nor will I relate the repercussions of the Eastern iconoclastic crisis in the Carolingian world.[5]

Pope Adrian I sent Charlemagne an inaccurate version of the proceedings of the Second Nicene Council. The emperor had a refutation prepared by Alcuin or Theodulf of Orléans. Two points in this text are germane to my thesis. The first, which draws on the letter to Serenus, defends the didactic virtue of sacred images, rejecting both the iconoclastic thesis of destruction and the iconophiliac thesis of veneration: it is the "moderate path with a correct itinerary" which the Frankish Church proposes to follow.[6] One must worship only God. At most, one may, "out of courtesy," and in a gesture inspired by humility, bow before a man, because God loves the human race and created it in his image and likeness. But in relation to images, such an attitude is "superstitious and superfluous." "Thus we allow images in the basilicas of saints, not for the purpose of worship but to recall their actions and adorn the walls." The notion of *memoria* is thus supplemented by that of *ornamentum,* which is destined for a long career in the West.

Images are venerable not "for what they are" but "for what they suggest." It follows that the painter's private state of mind is not to be taken into account. The Eastern iconographer prepares for his task with a purifying prayer. The *Carolini libri* maintain that the act of painting in itself is neither pious or impious. What advantage does the art of painters have over that of carpenters, joiners, and other laborers in the matter of piety? "All these arts, accessible only through apprenticeship, can be possessed by professionals in piety or in impiety." The painter paints, indiscriminately, pious acts and the crimes of scoundrels. And "just as it is not impious to paint abominable scenes, so is it not pious to depict the lives of goodly men." That attitude of moral neutrality toward art as such was a boon to the artist's freedom, since personal morality was not engaged

or monitored in the exercise of his craft. The church could, without fear, offer commissions to Il Sodoma or Caravaggio. It considered only the completed work of art.

These positions are acceptable—this is the second point—only if painting is placed within the context of the other means spiritual life has at its disposal. The Carolingian bishops rejected the idea of a *transitus,* a passage between a material form and a divine prototype of a radically different nature. The *transitus,* if conceivable, must come about via holy matter. And what is the hierarchy of sacred objects? First, the holy species, then the cross—not as object but as *mysterium* and emblem of Christ—then the Scriptures, then sacred vessels, and finally, saints' relics.[7] Images do not appear on the list. They are not suitable for the *transitus.* Thus the sacred image, so to speak, keeps one foot in the profane world. It is by nature secularized or secularizable. "What harmony can there be between [painters] and Scriptures, when the latter are true to life and the former very often fabricate lies?" All the same, whatever lack of seriousness is granted to images, the church must make certain they do not contravene either truth or morality. This further indicates how the image accords with the ethics of rhetoric, which begins with the probable and propels toward the true and the good the person who, by his own powers, would not have reached either. The church's authority over the artist, or rather over his works, is simply disciplinary. The church sees that *decorum* and *honestum* are respected in the temple.

3. Relics

It is not true that idolatrous tendencies were less strong in the West, or that they had fewer opportunities to emerge there than in the East. But, because of the image's lower status, idolatry was partly deflected toward the bodies of saints, which ranked just above the image. In principle, the theological oppositions between the Roman Church and the Byzantine Church were attenuated in the synod convoked in 863 by Pope Nicholas I, who "received" the conclusions of the Second Nicene Council without really acknowledging the fact. In fact, he went beyond the Gregorian tradition. He proclaimed that, through colors in paintings, man rose to a contemplation of Christ, and that anyone who has not seen the sensible figure of Christ on earth will not be able to see it in heavenly glory. But, even though the worship of images (and, in the first place, of the crucifix) spread, piety assigned a much higher sacral virtue to relics.

Of course, images formed spontaneously around the relic, but it was the relic that communicated its virtue to the image. Reliquary statues proliferated from the ninth century on. The statue of Saint Foy in Conques was a pilgrimage site

and a source of wealth for the abbey. The sick who were healed brought offerings to it. It was carried about by monks across monastery lands to secure the boundaries and defend the lands against the claims of neighboring lords. It appeared in dreams and performed many miracles. The magical power of the relic was passed to the image by contagion, but the relic was still at its foundation, even when the relic itself was forgotten. The relic was a material foundation and, unlike the icon, did not stem from representation as such or from the spiritual relation it maintained with the prototype.[8]

4. Bernard and Dionysius

One cannot speak seriously of a Cistercian iconoclasm. Saint Bernard protests against luxury—and as a result, against ornament—for social reasons. The wealth of the church ought to be devoted to the comfort of the poor, not the vanity of pastors: "See them advance covered in gleaming finery, in sparkling fabrics. . . . The pastors of the flock cut the throats of their own lambs to gobble them up." Throughout French history, this scruple about spending on ornaments returned on several occasions to lay waste the churches of France.

Nonetheless, Bernard advances a different argument. He banishes ornament because he judges that sensible pleasure does not befit the monastic life, which is devoted to God alone. The bareness of the Cistercian church is an expression of the vow of poverty, understood as a mortification of the senses useful for the progress of contemplation. To monks, and only to them, he proposes an intellectualized piety that finds nourishment in meditation on divine law, beyond the senses. It is therefore not iconoclasm, but an ascetic rule, and applies only to those who have chosen the path of perfection. It governs an art that sets aside *curiositas* and is satisfied with *necessitas,* enemy of the superfluous and, Bernard maintains, in keeping with reason. In contrast, he allows images in cathedrals, where the simple folk go, to incite them to devotion.[9]

That reaction is amply explained by what was happening beyond the walls of Clairvaux and Cîteaux. The economic expansion of Europe, the birth of a complex, diverse, decentralized society rich in institutional inventions, was expressed in art as an unprecedented proliferation of images and styles. The new authorities used profane and sacred images to make emblems for themselves, signs of community membership, protective palladia. The image of devotion, especially the crucifix, became the support for an affective psychological experience, which now counted as a religious experience. And the papacy sanctioned that evolution. In 1216, Innocent III carried a "veronica"—that is, the acheiropoetic image of Christ's face—in a procession. All of a sudden, it turned itself

upside down, forehead down, beard up. Terror-stricken, the pope composed a beautiful prayer in honor of the effigy and granted a ten-day indulgence to anyone who would recite it.[10] That *social* ascension of the image was shored up by the growing influence of Pseudo-Dionysius the Areopagite, which radiated outward from the abbey of Saint-Denis and its abbot, Suger.

What Dionysius offered, even more clearly than Augustine or Boethius, was the vision of a "scalar" universe leading from the superbeing, the super One, down to formless matter. That series of steps was a cascade of light: not a mere illumination of beings but their being itself.[11] Everything that exists, from souls to stones, is a crystallization of the illuminating effusiveness of the Good.[12] Images have a sanctifying role: they "elevate us spiritually from the sensible to the intelligible and from sacred and symbolic images to the sheer peaks of celestial hierarchies."[13]

But here is what Latin ears heard: Dionysius wants there to be not only a gap but a dissemblance between images and their models. In fact, images (he includes the metaphors of Scripture) are lessons, subject to the discipline of the arcana; they conceal holy mysteries from the unworthy. Another reason images ought to be "without resemblance" is that, if they were closer to the object represented, they would lead to idolatrous error.[14] They must be lowly and inadequate so that no one can confuse them with celestial and supercelestial essences. Dionysius defends the rights of negative theology. But although that theology moved Latin conceptions closer to the Greek in one way, in another, when understood in a Gregorian sense, it gave art rather modest goals. The image was thus protected from Eastern hubris, which the iconoclastic controversy had exacerbated. The more lowly and material it was, the less it deceived. That is why Saint Thomas Aquinas adopted Dionysius's argument in the first question of the *Summa:* in preferring that divine things be made available to us in the shape of vile bodies, we protect ourselves from error, we are more in harmony with the level of knowledge of God that is accessible to us (and we know better what he is not than what he is), and divine things are protected from the unworthy.[15]

Nonetheless, it was not sobriety that prevailed at the time but luxuriance and every sort of iconolatrous deviation, which produced equally heretical iconophobic countercurrents. In addition, the controversy between Jews and Christians (in the time of Rupert of Deutz, for example) made it necessary to take up the question once again. This time, use was made of philosophy. From that vast literature, which extended beyond the theological question of the image and became a fully developed philosophical aesthetics, let us select two authors: Saint Bonaventura and Saint Thomas Aquinas.

5. BONAVENTURA

In Bonaventura, as in Aquinas, it is necessary to distinguish between the aesthetic question and the image question. This is more necessary than among ancient authors because, in classical scholastics, aesthetics became a separate field and, along with epistemology and ethics, began to assert its independence as one of the three modes of approaching being. At the same time, the legitimacy of the image and of its worship remained a lively object of controversy in the face of Jewish and Manichean protests as well as protests internal to Christianity itself. But since the question of the image was raised within the context of that aesthetics, let us first say a word about it.

Bonaventura participates in the "spirit of medieval philosophy," the famous title of Gilson's study, which showed the fundamental unity of that philosophy. The first principle, which philosophy had variously named the Good, the Prime Mover, and the One, was henceforth the biblical God, creator of heaven and earth. The creation of a good God can only be beautiful. That beauty extends to the sensible universe, to the entire range of the hierarchy of things, from the body of man, a sensible masterpiece, to the lowliest speck of mud. Medieval aesthetics might have appropriated this line from Constable: "I have never seen anything ugly." The world presents itself as a *decorum simulacrum* of God, in keeping with the words of Saint Paul: "For the invisible things of him from the creation of the world are clearly seen, being understood by the things that are made, even his eternal power and Godhead" (Romans 1:20). Hence the Greeks' depreciation of the sensible in relation to the intelligible was overcome, and the gnostic hatred of matter was refuted to an even greater extent. The beauty of the world had been celebrated by the Greeks. Plato, Aristotle, the Portico, and Plotinus had all given the reasons for it. But, as Sherringham notes, it is the totality that is beautiful, whereas, for Christians, every thing is beautiful, even the most insignificant thing, provided it possesses being and participates in being through the loving will of God.[16] Since that will is everywhere recognizable, things present a double beauty: as creatures existing in themselves, and as signs in which the absolute beauty of the Creator can be deciphered. Medieval aesthetics is simultaneously realist and symbolist, since everything can be regarded as a created thing and as an allegory of the divine.

As for the beautiful itself, the Middle Ages sought its definition in the Book of Wisdom (11.20): *Sed omnia in mensura, et numero, et pondere disposuisti* ([God] ordered everything by measure, number, and weight).[17] Augustine transposes or makes explicit that biblical formulation: *modus,* that is, the manner of being

proper to each substance as a function of its place, stands in for *mensura; species,* the mathematical principle of form, for *numerus;* and *ordo,* the stability that allows a thing to contribute to the order of the world, for *pondus.* The beautiful thus resides in harmony. The Book of Wisdom, far from contradicting that ancient mode of thought, puts a stamp on it. Similarly, the speculation on light—another direction of research on the nature of the beautiful—places Plato, Plotinus, Dionysius (the shining rays of the sensible and intelligible sun), and Saint John (who calls the Word "the light of the world") in agreement.

Against this shared backdrop, how does Bonaventura present himself? He is on Augustine's side. Nothing is beautiful if it does not have "number, measure, and weight," interpreted in the Augustinian manner as "mode, form, and order." Augustinian eudaemonism is thus combined with the Bonaventurian analysis of aesthetic pleasure. Man possesses five senses, which are "like the five doors through which the knowledge of all sensible beings penetrates the soul."[18] The perception of an object that suits us leads to pleasure. And all pleasure stems from a relation of proportion *(ratio proportionalitatis).*[19] The pleasure of sight is produced if the image is proportionate to the model, to our sensibility, and finally, to itself. In terms of form, proportion is called "beauty," which Bonaventura defines using two quotations from Augustine: *aequalitas numerosa* ("equation of number" or "equality in countable sizes"), and "a balance of parts combined with the softness of colors." In terms of intensity, the excitation procured by the image needs to be proportionate to our sensibility. Thus the subject feels a sweet satisfaction, a happy medium between two excesses, which Bonaventura calls *suavitas. Sensus tristatur in extremis et in mediis delectatur.*[20] This is very far from Burke and the delight attached to the sublime. Finally, that sweetness does good, "fills" our organism, and leads to a balance: *salubritas.*

A work is beautiful when it equals its model. But *conformatio expressa* is not simply the imitation of the thing but the faithful expression of the artist's self, a conformity to his internal ideal. In a portrait, the painter elevates the model in his conception and imagination, then has it descend to the work he is executing. The image, then, imitates and expresses: *Dicitur imago quod alterum exprimit et imitatur.*[21] God creates, nature procreates. Art is more modest. It takes marble, which is already made by God and nature, and makes a statue or house out of it. It produces only rearrangements of a preexisting substance. The artist's creative will is limited, but is nevertheless similar to that of nature and to that of God. It receives its dignity from them.

What feeds artistic activity is the contemplation of God, perceived in the world and in the soul. Bonaventura adopts Augustinian dialectics in toto:

"Among created beings, some are a *vestige,* others an *image* of God."[22] Traversing the entire expanse of the universe, strengthened by faith and reason, man's eye discovers weight, number, and measure everywhere. "He who is not enlightened by so many created splendors is blind."[23] He who refuses to recognize God in the sensible universe, which is entirely filled with "vestiges" of him, is without excuse.

But although the world is beautiful, it is not fitting to stop there, because to rise higher is to follow the Good. The "images" the Trinity has deposited in our soul—memory, knowledge, love—serve that purpose. These natural images are brought to a higher degree of resemblance through the gift of grace. Then the spirit becomes capable of contemplating divine unity in its first name, Being, and finally, the blessed Trinity in its name, the Good. Having completed its journey, the soul contemplates the "expressive image" of the invisible God in Jesus Christ, where the first and last, the circumference and the center, alpha and omega, the Creator and his creature, are joined together. "Now he has only to desire the day of rest, when ecstasy will appease the curiosity of the spirit and will give it rest from all its labors."[24]

The Bonaventurian hierarchy does not differ from that of Pseudo-Dionysius. Nonetheless, it refrains from obliterating the image in the dazzling brilliance of internal ecstasy. All along the hierarchical ladder, images accompany the journey of the spirit, and the final image is Christ incarnate, "the union of the First Principle, of God, with man, formed on the sixth day, . . . of the Eternal with a temporal creature, born of a Virgin, . . . and of the supreme One with a composite individual distinct from all others."[25] Hence, at the end, the contemplative is not lost in the "superluminous" cloud, but fixes on a circumscribed and concrete image. From the bottom of the ladder to the top, it enjoys the pleasure dispensed by number, weight, and measure, recognizable even in the humblest vestige. The artist can increase this pleasure by imitating and by expressing himself, since in this twofold act he links the external *vestige* and the *image* he himself is. Hence, far from becoming buried inside, art emerges and acts as a conduit toward spiritual ascension, delighting the artist with the spectacle of beauty *(species),* filling him with *suavitas,* strengthening him with *salubritas.*

Finally, having given the image (and the production of the image) a precise place in spiritual life, Bonaventura defines the worship that ought to be given it in the temple. He reaffirms Gregory's justification, which, integrated into the *Decretum Gratiani,* had become normative. Images were rightly introduced into the church because of the "lack of education of the simple folk, lukewarm feelings, and the impermanence of memory."[26] Nonetheless, in his pedagogical concerns, Bonaventura moves beyond the Gregorian equivalence between

Scripture and the image, because the latter has a greater potential force than the former.

Although the notion of *aequalitas numerosa,* central to his aesthetics, originated in Augustine's *De musica* and was based on rhythm, it is from the plastic arts that Bonaventura is most likely to select his examples.[27] That is because sight is the most "convincing" of the senses. Some people who are not incited to devotion in hearing the word are at least prodded in that direction when they contemplate the acts of Christ, "present so to speak in effigies and paintings," with the eyes of the body. He cites in support these lines from Horace's *Ars poetica* (line 180): "What is transmitted through the ears incites souls less than what is placed before the eyes, which do not deceive."

Finally, seeking support not in Scripture, which is mute, but in the unwritten tradition of the apostles, in the story of Agbar and the icon not made by human hands, in the portrait of the Virgin by Saint Luke, Bonaventura defines the hierarchy of worship: dulia for saints, hyperdulia for the Virgin, and finally, latria for Christ alone.

6. Thomas Aquinas

In Thomist aesthetics, which the studies by Gilson, Maritain, Edgar de Bruyne, Eco, and many others have analyzed in such depth and in so many different ways, I seek only to shed light on what gives value to the image in general and what authorizes the sacred image.[28]

Art and Its Morality

At the root of Bonaventura's iconophilia is Augustine's benevolent attitude toward the world. Aquinas links it to Aristotle's benevolent attitude toward art and the artist. Nature is God's masterpiece; he imagines it and brings it into existence through this thought alone. In turn, nature extends the divine creative impulses, which communicate both being and action to it. The artist, like nature and like God himself, acts in view of an end and bestows order on the elements as a function of that end. Nature does so in a substantial manner, the artist in an accidental and contingent manner: in that sense, art is inferior to nature. In contrast, nature is subject to unconscious causes, whereas art is an activity of the conscious intelligence.

Art (in the general sense of *technē,* which also includes the art of governing and the military arts, for example) is compared to the intellectual virtue of prudence. Prudence is the *recta ratio agibilium,* the "right reason" of works to be created, a stable *(habitus)* arrangement that allows men to conceive the rational principles for making and the manner of applying them to a particular prob-

lem.[29] All that is also applied to art. But there is a difference: prudence governs action; art, the things to be fabricated. Prudence is within the prudent man because it is a moral virtue. Art can be examined only in works, and that is why "it does not regard the appetite."

> Art does not require of the craftsman that his act be a good act, but that his work be good. Rather would it be necessary for the thing made to act well (e.g., that a knife should carve well, or that a saw should cut well), if it were proper to such things to act, rather than to be acted on, because they have not dominion over their actions. Wherefore the craftsman needs art, not that he may live well, but that he may produce a good work of art, and have it in good keeping.[30]

It is clear that the ethics of art in Aquinas—and this is truly a Western trait—is an ethics of the "beautiful work." The artist must reflect on the manner of creating the work, on the materials from which it will be made, on the completeness and perfection he gives to it: the ultimate goal of art is the work of art. The artist may sin against art by ruining the work, without sinning against morality. But he may also sin against morality without sinning against art: in that case, he has gone astray not as an artist but as a human being, in relation to the purpose—of a higher order, it is true—of his human condition.

Nevertheless, works may be immoral by reason of their existence, such as statues of idols. But, "in the case of an art the products of which may be employed by man either for a good or for an evil use, such as swords, arrows, and the like, the practice of such an art is not sinful. These alone should be called arts." In contrast, if an art does not "contribute towards and produce necessaries and mainstays of life," it is a false art.[31]

The work of art produced for the purpose of mere pleasure is also not condemnable. Play gives the soul the rest it needs: it can be employed, provided the conduct is dictated by reason, by the virtue Aristotle calls *eutrapelia,* that is, playfulness, and finally, by the higher reason of moderation.[32] Playful diversions are thus recommended to the Christian. Aquinas commends Aristotle, who judges that "lack of play is a vice." The soul's need for rest and for diversion, the noble *otium* Castiglione judged part of the courtly life, and which requires the artist to arrange for places of play and honest recreation even in the pope's palace, finds its justification in the *Summa.*

The Beautiful: Pleasure and *Claritas*

The revolution effected by Aquinas regarding the beautiful is trickier to interpret. His predecessors (most recently, Albertus Magnus) determined the beauti-

ful in terms of the object; Aquinas determines it in terms of consciousness as well.[33] Of course, there are objective reasons for one object or another to be judged beautiful, but it is beautiful only if it produces delight in the mind contemplating it. The beautiful and the good are identical, but the good fulfills man's desire through his affective possession of the object, and the beautiful through his knowledge, or more exactly, his apprehension, of its form. The intuitive grasp of the object is the source of pleasure.[34]

There are thus two aspects to the sense of the beautiful: one is intellectual *(apprehensio, visio),* the other affective *(quod placet, delectat).* They are joined together. *Apprehensio* can be defined as a way of seeing through the mediation of the senses (sight and hearing); it belongs to the cognitive order, is disinterested, and produces a certain type of pleasure.[35] The aesthetic sense exists only insofar as knowledge itself appeases us through its quality as pure intuition: *Id cujus ipsa apprehensio placet.*[36]

Pleasure, but what kind of pleasure? It is a human pleasure. The animal, in fact, has only the pleasures provided by food and sex. "Man alone takes pleasure in the beauty of sensible objects for its own sake," to which his erect posture and head bind him.[37] For the animal, knowledge is subservient to the instincts of self-preservation and propagation. Man is capable of disinterestedness; he can contemplate the structure and harmony of things in themselves and take pleasure in that contemplation. Aquinas interposes an intermediate degree between the animal's pure biological pleasure and pure aesthetic pleasure: *pulchritudo et ornatus feminae,* in which man delights in the excellence of the female form, but in view of carnal possession—and in that, he proves to be animal and spiritual at the same time.

There is an analogy between aesthetic pleasure and play. Both are "delightful." Both are gratuitous, with no order imposed on them other than their own. Ludic pleasure, as we know, is useful and healthy, even though it can lead to reckless pursuits. That is also the case for aesthetic pleasure.[38]

For the beautiful to exist, the object must be present to consciousness. The object must also be beautiful in itself. The beautiful is not a state of consciousness. It is objective. Aquinas articulates the criteria for the beautiful in relation to the mystery of the Trinity, and these criteria are those of the Son's beauty. Beauty requires three conditions. First, there is wholeness *(integritas):* truncated things are ugly by that very fact. Second, the proportions desired *(debita proportio)* are in harmony *(consonantia).* And finally, there is brightness *(claritas):* "Things are called beautiful which have a bright color."[39] These three criteria are three ways of approaching forms insofar as they constitute a whole. *Claritas,* it seems, designates the moment when the thing is perceived in its most pro-

found and complete unity of substance, in its essence, and in that essence's relation to the ideal beauty of the species, and then to the source of all beauty, the Son's divinity. *Claritas* is the radiance of the concrete and individual form, but in relation to the norm of the species as it is reestablished in perfection through grace. For man, the beauty of the body, if it is well formed, bears witness to *integritas* and *debita proportio*. But *claritas,* already perceptible in the body, has to do with the radiance of virtue and the gleam of the soul made in the image of God and remade in his likeness.

The attribute of beauty belongs especially to the Son. An analogy is drawn between *integritas* and *perfectio* and the fact that, "as Son, [he] has in himself truly and perfectly the nature of the Father." *Debita proportio* belongs to the Son because he is "the express Image of the Father," and "an image is said to be beautiful, if it perfectly represents even an ugly thing." *Claritas* is in keeping with the property of the Son: "the [perfect] Word, which is the light and splendor of the intellect."[40]

Concerning a Remark by Umberto Eco

Umberto Eco observes a "central aporia" in Thomist aesthetics.[41] The system, he explains, asserts on one hand that all forms, earthly or heavenly, natural or artistic, can be the object of an aesthetic experience. That is what he calls Aquinas's "pancalism": everything that is, is beautiful. On the other hand, natural substances are ontologically superior to artificial forms, and divine creation is superior to human products, whose beauty is superficial as a result. But, objects Eco, to be seen as beautiful, every thing must be the object of a judgment of consciousness. Yet natural things are impenetrable, except through a "substantial knowledge" reserved for the Creator. God alone can see them *sub specie pulchri*. In contrast, human creations are within reach of the human mind: we can see their beauty. Nature shows itself in its perfection thanks to *claritas*. Yet the Thomist system places *claritas* beyond our reach. "Aesthetic pleasure caused by artificial forms is impossible in theory, but, in virtue of the same theory, it is the only such pleasure that the theory regards as a practical possibility" (p. 205).

It seems to me that Eco has forgotten the theologal relation to God and the efficacy of grace. Man stands in relation to God. Through the chain of images (human works, works of nature, and divine images, which the contemplation of the Word procures him), he moves up the chain of participations which, via that same Word, come back down toward created nature and toward man. That chain is double, a chain of the intellect and a chain of love. Everything that is, everything that is made and is therefore beautiful, is and is made only in view of

the beautiful and the good. Loving desire, which is a gift of grace, animates the entire chain, artistic nature, and man the artist, and finds its final object in God. Once it has found it, it inevitably places itself within God's point of view. In the spirit of Thomism, as in Augustinianism, there is an aesthetic transposition of the dual commandment to love God and to love one's neighbor. The latter is possible only "within God's point of view": it is from that same point of view that the natural and human world is considered with "charitable love," which reveals the order and beauty of that world.

Perhaps this corresponds to the strongest and most authentic aesthetic experience. When we contemplate a natural sight, as when we read Hector's farewell or the dialogue between Achilles and Priam in Homer, we sometimes do have the feeling that we are "within God's point of view," that we are looking at the world and the human condition as they truly are, that is, "simple" and worthy of charitable consideration. That idea is not in Saint Thomas Aquinas, but his language is in keeping with that experience. He might have established an analogy between the intensely lucid gaze of the artist and the gaze of true charity.

Of course, man cannot see nature with the "substantial knowledge" of the one who made it, but it is through a participation—however deficient, even with grace—in that knowledge that he sees its true order, the order of the world, and its ontological superiority to human works. As for these human works, it is true he sees them more clearly and precisely "at first sight." But if he deepens his vision, he encounters the human nature of the artist, who is as impenetrable as any other product of nature. In that artist, he distinguishes between the already mysterious "in-the-image" and the "in-the-likeness," produced by an incomprehensible grace. Hence, aesthetic knowledge and pleasure stand in relation to a vision *in* God, which is, in the spirit of Thomism, analogous to the vision *of* God, that is, the vision God has. This is expressed, beyond the perfection of form *(integritas, proportio)*, by *claritas,* brilliance, in short, the dark brightness of a mystery.

Works of art can be more powerful, more persuasive, than works of nature. But that is not because they are artificial rather than natural, but because nature is in some sense concentrated within them, presented as such, through imitation, re-presented by intelligent contemplation, possibly through a grace of vision. The pleasure they procure is enriched by the pleasure of making, similar to that of play, so much so that the work is admired less for the object imitated than for the success of the imitation, less for the model, which may be ugly, than for the likeness to the model, which expresses the beautiful labor and profound morality of art, which is art itself.

The Precariousness of Thomism

The Thomist balance is fragile. Its aesthetic vision is totalizing and arranged hi-erarchically. It starts from the thing, then rises to the species, the genus, the laws of the world, divine law. One must stand on the peak, at its very tip. For Duns Scot, the excellence of a thing does not exceed the limits of that thing. On the contrary, it is the thing's absolutely individual, unique character, its "thisness," that gives it its worth. For William of Ockham and Nicholas of Autrecourt, there was no longer any stable order to the world, no longer hierarchies: nothing in a thing but the sum of its parts, nothing in the universe but different things, which no hierarchy gathered together into an august and sacred whole.[42] Now, the vi-sion in God has lost its meaning, and vision "within God's point of view" is sim-ply inconceivable. What, then, remains of Thomism after its ruin in this new climate? His praise of art, of the pleasure it procures, of its persuasive power, of the satisfaction of work well done. Art, which has come unmoored from its di-vine center, its natural objectivity, finds a new center in the subject, in the art lover who enjoys it, the artist who makes it; in itself, finally, as art for art's sake.

The Worship of Images

The doctrine of Aquinas regarding the worship of images seems independent of his aesthetics, since it simply follows the tradition of the fathers, primarily Au-gustine and John of Damascus, but not the Second Nicene Council, with which he seems to be unfamiliar. And it is also in terms of the Trinity that he defines the formal meaning of the word "image."[43]

For there to be an image, there must first be a similitude and, more precisely, a similitude of species, a sign characteristic of the species. In the corporeal world, this sign is generally a figure. Second, there must be an "idea of origin." An egg is not the image of another egg, because it is not derived from it. Finally, the image must distinguish itself from the original—if not, it vanishes into it.

The image can be found in a being of the same nature—for example, the king's image in his son—or in a being of a different nature—for example, the king's image on a coin. The Son *is* the image of the Father in the first sense; man is (only) *in* the image of God in the second.[44]

One last distinction, taken from Aristotle, gives a foundation to the doctrine that follows. There is a dual movement of the soul toward the image: first, it moves toward the image as a reality; and second, it moves toward the image as the image of something else. The second movement, directed toward the image as image, is identical to the movement toward the reality represented.

> Thus therefore we must say that no reverence is shown to Christ's image, as a thing,—for instance, carved or painted wood: because reverence is not due save to a rational creature. It follows therefore that reverence should be shown to it, in so far only as it is an image. Consequently the same reverence should be shown to Christ's image as to Christ Himself. Since, therefore, Christ is adored with the adoration of *latria,* it follows that His image should be adored with the adoration of *latria.*[45]

This is utterly valid for the Cross of Christ, "that in which we place our hope of salvation."[46] One owes hyperdulia to the mother of Christ, and dulia to saints' "relics" (Aquinas does not speak of images), "for the sake of the soul, which was once united thereto."[47]

Such a doctrine could either be contested or further exaggerated. The contestation came from nominalism. In the early fourteenth century, Durand de Saint-Pouçain noted that, if the image is an arbitrary sign, with no relation to the divine prototype, it cannot be an object of latria; and that, if the material image does have some relationship to said prototype, then the worship of the image is idolatry.[48] Conversely, the doctrine maintaining that the movement toward the image is the same as the movement toward the prototype lends itself to excesses. According to the same principle, why, in fact, should there not be a latria of sacred vessels? And, since there is a reflection of divine being in every thing, why should one not worship all things? Sixteenth-century Thomists, the *Salmaticenses,* Vasquez, and Cajetan lean in that direction. Vasquez writes: *Res omnes inanimes et irrationales rite adorari posse, vera sententia est.* They believe it is possible, theoretically and metaphysically, but that one must not speak of it, or, even less, counsel the mob to do it. The assertion is astonishing, and Bellarmine will have to correct it by asserting (this time based on the Second Nicene Council) that images do not have the right to the same form of worship—latria—as the object represented.[49]

In the texts consulted, Aquinas does not cite Gregory's letter,[50] and he approaches the question of the image more from the metaphysical than from the rhetorical side. But that metaphysics, with its extraordinary confidence in man and nature, does not conclude that the image is vain or impossible. In the spirit of Augustine, the image leads one to see the world as an infinite number of images corresponding to one another, in good order, lit by the same light; and to see man, whose desire and intellect are turned toward divine beauty, hence toward all things, as capable of seeing images, of making them, and of getting joy from them.

The Renaissance and the Baroque Period

1. THE AFFIRMATION OF ART AND OF THE ARTIST

"What we see elicits our feelings more than what we hear." Bonaventura seems to suggest, that, if faith comes through the ears, fervor comes through the eyes.[1] Along the path taken by the mendicant orders—preaching and capturing hearts—the image, combined with a perfected artistic practice, elaborates a rhetoric of emotion. That rhetoric can be followed in an extreme prototype of Christian iconography: the crucifix.

A crucifix is a representation of Christ hanging on the Cross: Christ must be visible—a bare cross is not a crucifix—and there must be a cross.[2] In which case, one stands before the divine image par excellence, but also the most paradoxical image the Christian religion could have produced. In fact, two contradictory things must be represented: defeat and victory, humanity and divinity. If one is lacking, the orthodoxy of the image suffers. To succeed in holding the oxymoron together in a single image is the most difficult ordeal an artist can encounter: he is pushed to the limit, and it is rare that he finds a balancing point.

For a long time, artists were content with a cross stamped with one or another Christian symbol: the letters "I.C.," the crown, the inscription "Nika," indicating victory, or the lamb, placed at the point where the two pieces of the cross meet. But that became untenable when the Monophysite heresy, which recognized only Christ's divine nature, absolutely refused to represent Christ attached to the Cross. The Trullan Council of 692 thus ordered that the "reality" be represented. John Chrysostom wrote:

So it was that, even on the Cross, he did everything without agitation, speaking of his mother to the disciple, fulfilling prophesies, giving hope to the thief. And yet, before being crucified, he showed himself covered in sweat, stricken with terror and anguish. How is that possible? It is very clear: in one case, we see the weakness of nature, in the other, the fullness of power. Since everything was in his power, the end came about when he wished it, and he wished it after everything had been fulfilled. . . . In that way, the evangelist shows he was master in all things.[3]

In fact, over time the crucifix oscillated between the theomorphic and the anthropomorphic, triumph and sorrow. Christ is naked and crowned with thorns, or he is dressed like a king and crowned as an emperor.

The Carolingian crucifix corresponds to the glorious prototype. Charlemagne placed the imperial diadem, with which the pope had crowned him, on Christ's forehead. The victim holds himself erect. His arms and head do not bend. The Resurrection and the Ascension, even the Second Coming, frame the scene of the Passion in the Augsburg evangelistary, and on the Carolingian ivory of Cluny. In the twelfth century, the crucifix began to evolve toward the human, instructing less and moving more. The *Santo Volto* of Lucca—a prototype with a long descendancy—is dressed in a broad-collared tunic falling to the feet. The almond-shaped eyes are lowered. He is no longer triumphal and not yet pitiable. He is alive and serene, as are the magnificent Christ "of Courajod" in the Louvre and the Saint-Flour Christ.

But as one moves closer to the fifteenth century, to Rhenish crucifixes, to Grünewald, to Perpignan's *Devout Christ,* to Catalan and Spanish crucifixes, violent, dramatic effigies, tortured, disfigured bodies, and woeful death agonies proliferate. Either divinity was obscured—and the orthodoxy of the image distorted—or this was a religious sublime. Speculative romanticism would put it to its own uses. "On the one hand, in other words, the earthly body and the frailty of human nature in general is raised and honoured by the fact that it is God himself who appears in human nature, but on the other hand it is precisely this human and bodily existent which is negatived and comes into appearance in its grief." So Hegel would say.[4]

Hegel conceived of the crucifix on the naturalist, pathos-laden model of the Northern schools and *devotio moderna.* Nonetheless, Saint Francis was captivated by a crucifix that was still utterly Byzantine, with a calm face and contemplative eyes, and surmounted by the Ascension. As a result, "compassion for the crucified was anchored in his soul," so much so that, "from that moment on, it was impossible for him to hold back his tears, and he wept aloud over the Passion of Christ, as if he had the sight of it always before his eyes," and "the

wounds of his body subsequently manifested the love of which his heart was possessed."[5] Sensible devotion required an image of pathos, and that image had to be multiplied to respond to a more affective and popular devotion, at least until the Reformation put a brutal and reactive end to it.

In the evaluation of divine images, as one renaissance led to another, down to modern times, one value became increasingly autonomous and moved to the foreground: the value of art. Theological reflection itself led to it. The development of sacred rhetoric, the search for pathos, impelled theologians to diversify their means and reflect on their effectiveness. Medieval theophilosophy (on this point, Aquinas can be placed side by side with Albertus Magnus and Bonaventura) leads to a "paniconism": every thing participates in divine Being under the aspect of beauty.

Two consequences follow from this. The faithfulness of participation, the exact reflection of the divine, will be taken to a higher level if the artist, guided by his own virtue of prudence, conceives and executes the work in an artistically upright manner. The theological quality of a work becomes organically dependent on its artistic quality. Is the reverse also true? Does a completely successful work bear the divine within it by that very fact? The time was approaching when one would speak of the "divine" Michelangelo and the "divine" Raphael. There is no reason to believe that Bonaventura and Aquinas were responsible for that evolution: all the forces that emerged in Europe with the great shift in the twelfth century pushed in that direction. But they theorized it, and when a justification was needed, people were able to place themselves under their authority.

The second consequence may be even more significant. Metaphysics tended to erase the boundary between the sacred image and the profane. Artistically, the sacred image contains a share of the profane; theologically, the profane image speaks of the sacred. The alternative posited by iconoclasm, between the sacred and the profane, which led it to prohibit the sacred image and allow the profane or, when the former was authorized under certain strict conditions, to let the latter wither away, that alternative was rendered null and void. Without the slightest ambivalence, the artist could now respond to both the social commissions of his ecclesiastic patrons and to those of his secular patrons. He turned the experience acquired in one realm to his advantage in the other. What he learned of women, he incorporated into Mary Magdalene and Saint Catherine; and what he learned of the Virgin by painting her with the piety of Saint Luke was useful to him in enhancing the beauty of the ladies whose portraits he painted, if they were worthy of it.

A further consequence was that expectations about the sacred image came to rest increasingly on the artist's individual personality. To take the extreme exam-

ple of the divine image, the crucifix, there was no longer a canonical prototype. There was the Crucifix of Giotto, the Crucifix of Fra Angelico, of Donatello, of Raphael, of Michelangelo, of Vélazquez, of Zurbarán, of Rubens. These images rely on the artist's personal meditations, on the aesthetic and religious synthesis he brought about on a specific occasion. So it was for Gauguin's *Yellow Christ* and Nolde's or Beckman's *Calvary*. It was the painter who chose to accentuate the human or the divine in his effigy, to show death or foreshadow resurrection, to paint the body already in its glory or still in the throes of death. There is no longer any unity to the model: in the same century, the same city, the various possible meanings for that image were elaborated by the particular *ingenium* of painters, without the church intervening in any way, except to maintain a certain decency, and only when it had the power to do so.

Hence, in the fifteenth century, the author (possibly Gerson) of the *Tractatus pro devotis simplicibus* feared that lascivious representations, and even the nudity of the crucified Christ, might incite the faithful to shameful thoughts.[6] The power of representation, of illusion, of emotion, that the new pictorial techniques possessed was in fact incomparable to that of the old icons, and one might wonder—because of the force and presence of the new images—if the homage paid by the faithful did not end there, instead of being transferred to the prototype.

But that situation further augmented the prestige of the artist, who became the mediator in matters of devotion. He now bore a famous name. He emancipated himself from guilds and the world of artisans. At least since da Vinci, the painter, a mathematician because he is a master of perspective, has required that his art take its place among the liberal arts.[7] He sits beside poets and great men. He forms academies. The glory of the image, of the artist, the demands of collectors and patrons, shore one another up and assure the social triumph of iconophilia. Da Vinci writes: "And [painting] truly is a science and the true-born daughter of nature, since painting is the offspring of nature. But in order to speak more correctly we may call it the grandchild of nature; for all visible things derive their existence from nature, and from these same things is born painting. So therefore we may justly speak of it as the grandchild of nature and as related to God himself."[8]

2. The Support of Ancient Gods

In certain icons of the baptism of Christ, one can just make out the genie of the Jordan rising out of the river. On holy icons, as a general rule, the old gods had disappeared. In the West, they never died. Euhemerism, which at first helped

Christian apologists to overthrow them, later saved them. If the gods have a hu-
man origin, after all, they can be venerated without idolatry for their pagan
wisdom and even for the intuition some—like the Sibyls and Virgil, whom eu-
hemerism authorizes one to deify—had of Christ's coming.[9]

The first apologists attributed the magical powers of the ancient gods to
demons. But, for Isidore of Seville and his epigones, they were good magicians,
beneficent sorcerers. Like the Trojan Francus, father of the French people, they
were the ancestors of nations. Alexander VI Borgia had the story of Isis, Osiris,
and Apis, his family's ancestry, painted on the vaults of his apartments. The old
gods created civilization: Minerva was the first to learn the art of spinning wool,
Chiron invented medicine, Hermes Trismegistus, astronomy.[10] Astral religion
made inroads throughout the Middle Ages and flourished in the Renaissance.
The zodiac, the constellations, and the planets appeared on walls and ceilings, in
Il Salone of Padua, in the Schifanoia Palace of Ferrara, even in the chapel of the
Pazzi, and finally in the Vatican, in the Hall of Pontiffs decorated by Leo X. On
the vault, the names of Saint Peter's successors are surrounded by symbols:[11]
"Above Boniface IX, Cygnus takes flight between Pisces and Scorpio; on either
side of the medallions, Mars and Jupiter ride past in their chariots."

The allegorical method, which the early fathers had borrowed from pagan ex-
egesis to interpret Scripture, turned again to the ancient texts and moralized
them. In the sixth century, Fulgentius's *Mitologiarum* explained that the three
goddesses from among whom Paris chose symbolized the active life, the con-
templative life, and the life of love. Beginning in the twelfth century, the alle-
gorical exegesis of mythology became widespread. John of Salisbury meditated
on the pagan religion "not out of respect for false deities but because they con-
ceal secret lessons, inaccessible to the common people." Ovid's *Metamorphoses*
became the great treasury of holy truths. In *Purgatorio,* Dante treated the gods
with reverence and seemed to accept their historical reality. They were divided
into *superi,* who, in veiled form, anticipated the true God, and *inferi* such as
Charon, Pluto, and Minos, who collaborated with the worst demons.[12] In her
convent in Parma, Abbess Joan of Piacenza asked Correggio to paint the walls
with figures of the vestal virgins, scenes of libation and sacrifice, Fortune, Tran-
quillity, Plenty, and Juno nude, hung by her hands for persecuting Hercules.
These "spiritual beauties" were destined to teach her girls the seriousness of their
duties, the advantages of their condition, the punishment for sin.[13]

Sometimes humanism went too far. Plato was in agreement with Moses,
Socrates confirmed Jesus Christ. Erasmus: "Perhaps one will find more profit in
reading the Fable and seeking its allegorical meaning than in reading Holy
Scripture and clinging to its literal meaning."[14] Nonetheless, the balance was

never definitively disrupted. The Stanza della Segnatura placed *The School of Athens* facing the *Disputà*. Plato points his finger to heaven, Aristotle extends his hand toward the earth, signifying that any rational proposition made by Aristotle could be transposed into a proposition by Plato, provided it was placed within the register of poetic enthusiasm—and vice versa. But science and philosophy themselves gave way to the knowledge of divine things: across from them, doctors and saints calmly stand, contemplating the hidden and silent evidence of such things on the altar. In this, Raphael reestablished the order of high scholastics, which had been deteriorating for two centuries. Could he have done so if the cosmos, with the help of the ancient gods, had not recovered its original form?

In fact, in the Middle Ages, the gods had lost their classic form. They slowly recuperated it. Hercules had been dressed in baggy trousers, a turban on his head; he had lost his lion skin and traded his club for a scimitar. Dürer returned his nudity to him: the lion skin, the club, and, above all, the Herculean canon. In earlier times, pagan ideas and pagan forms had become dissociated, and often Christian ideas had come to inhabit these deconsecrated forms: Christ was presented as a Roman emperor or Orpheus, God the Father as Saturn; Jupiter became an Evangelist, and Perseus, Saint George. The Renaissance restored the godly form to these gods.[15]

All that did not come about without protest, of which we will have occasion to speak. But let us consider the support the gods offered to the destiny of the image in the West. It can best be evaluated beginning with thirteenth-century classical theology, which always claimed that, in the sensible order, the ultimate center of beauty was the human body. The reintegration of classical models, which manuals codified and dispersed throughout Europe, and the mastery that art acquired in representing and in assimilating the techniques of antiquity, restored a canon of corporeal beauty that completely confirmed what Bonaventura, Thomas Aquinas, and Duns Scot had claimed, and which, in the view of humanist theoreticians, the expressionism of the late Gothic period had disfigured.

Medieval "pancalism" or "paniconism" required a continuum between the sacred and the profane image: not only all the intermediate degrees but an intimate copenetration of one and the other. This intermediate space was peopled by the gods. Greater than men, endowed with the prestige of memory, morality, and knowledge, they gave representation a nobility that elevated the soul and led it propaedeutically toward the even higher truths of religion.

Let us add that the presence of classical gods sealed the nonsacred character, or more exactly, the nonsacramental character of the Western image. That image occupied a middle level, so that the true God himself, in being represented,

would not risk becoming the object of idolatry. That was even more true for the various gods, who completely left their place in the demoniac world, which *The City of God* had emphasized so strongly. They now ranked just below Christ.

In contrast, the introduction of classical fables enriched the rhetorical resources of Christian teaching in a phenomenal way. Virgil and Ovid, whose ideas were further elaborated through mythological erudition, offered an inexhaustible repertory of stories, already in a form that could edify, teach, and move. And also simply please. Saint Thomas Aquinas had linked art to rest and play. The histories, great feats, and even love affairs of the gods filled and enhanced the *otium* of well-born souls. Without leaving his palace, Cardinal Farnese relaxed, entertained himself, sought recreation in rooms decorated by the Carraccis, moving from the studio where he worked to the oratory where he prayed.

Hence, between the purely sacred image and the purely profane image (assuming they actually exist), the ennobling and educating image of the ancient gods slipped in. Alas! These gods died a second time when the century of Descartes preferred exact reasoning and self-evident demonstration to rhetorical persuasion and poetic suggestion. In losing their force, the mythological gods, who had finally formed a noble escort and court around divine images, left these images all alone and dangerously isolated. Images became so dry that they—along with the "figures" of rhetoric taught in the schools—now provided exercise topics for the Prix de Rome. Yet they must also be praised for having retained a place within eighteenth-century painting, the realm of friendly games, mischievous apologues, and keen sensuality, made decent by their high status. Alas! Something was lost, a classical and elegiac paradise which, in gradually receding, made Poussin's art melancholic: *Et in Arcadia ego.*[16]

And yet the gods returned one more time, dug up from the ground by the excavators of Herculanum and Pompeii. It was then apparent that the Italy of gods, exhumed in the mid-eighteenth century, had never ceased to be there. Italy had not forgotten the women in calm and noble poses, the melancholic yet serene sensuality, the wedding or burial scenes, and when it rediscovered them it could look with pride at what it had done during the gods' subterranean sleep; it could recognize their inspiration. Rising up from the earth, however, makes you wither away, and the Pompeian revival quickly evaporated into archaeology and scholarship. But at least it played a role in developing a style.

This flood of new things, this torrent of images, elicited worried responses. Wycliffe did not hesitate to turn Gregory's argument on its head: it was because simple folk were simple that they were likely to make an idolatrous use of images. "In the strict sense, they worship images, for which they have a particular

affection." That is why neither Christ nor the apostles nor their writings provided examples of images. It would be safer to destroy them, "as occurred under the ancient law."[17]

The invasion of myth in the fifteenth century might have led to the fear that a competing religion would take root. From time to time, through the voices of clerics and pontiffs, the church censured "pagans." Pius II criticized Sigismondo Malatesta for transforming the Church of Saint Francis in Rimini into a temple for gentiles. Soon thereafter, Pius V, in the panic of the Reformation, chased the "idols" from the Vatican; Sixtus V threw them off the Capitoline Hill; preachers thundered against pagan deviations. Savonarola preached an "artistic reformation" (Menozzi), which consisted of renouncing dishonest images, promoting a simple, direct art able to transmit the true meaning of the Gospel. He required that the faithful contemplate the prototype in a sacred image, not the art contained within it. "Look at all the artifice of figures in churches today, so adorned and affected that they spoil the light of God and true contemplation, as if one considers not God but only the artifice of the figures." And, anticipating Calvin, he writes: "You give the Virgin the costume of a courtesan." "You put every kind of vanity into the churches."[18] Savonarola made funeral pyres of it all.

Artists were not spared such scruples. Botticelli was won over, as was the elderly Michelangelo: "In order to imitate in some degree the venerable image of Our Lord, it is not enough to be a painter, a great and skilful master; I believe that one must further be of blameless life, even if possible a saint, that the Holy Spirit may inspire one's understanding."[19] That was a requirement of the Greek Church, stemming from its iconic system, but the Roman Church could never have posited it. Its oversight was limited to the morality of the image and its conformity to church teachings, broadly interpreted and allowing for a large gray area.

3. AROUND TRENT

On the whole, the church consistently defended the image, all images, whether sacred, mythological, or profane, save for a few disciplinary rules. That was the principle. By the mid-fifteenth century, Saint Antoninus, archbishop of Florence, agreed in his *Summa theologica* to recognize the dignity of the *artifex*. He acknowledged the validity of the contract made between the artist and his patron, and asked them to take the value of art and the particular skill of the painter into account. He asked only that the painter not indulge in lewdness and that his images not contravene the faith. For example, a representation of the Trinity

as a three-headed creature or, in an Annunciation, a completely formed Baby Jesus placed in Mary's womb (as if he had not taken on her flesh), or the presence of midwives at the Virgin's delivery were obviously not acceptable. In exchange for that superficial control, all artistic techniques—perspective, for example—were perfectly acceptable and honorable for the artist.

During the same period, Pope Nicholas V evoked in his will Gregory's own arguments to justify the magnificence of his construction projects: the untaught, ignorant masses need to be "moved by extraordinary sights," since their assent is weak and diluted over time, usually reduced to nothing at all in the end. But when the opinion of the common people, based on that of the learned, is confirmed by great buildings, "permanent, almost eternal reminders of sorts, as if they had been made by God," that opinion, constantly inculcated in them, was maintained, cultivated, and received "with admirable devotion." Finally, the glory of Rome reflected back on the church's honor and that of the apostolic see. The beauty of images reflected divine creativity; it engendered the people's assent and reverence for those who produced them.[20]

Let us move immediately to the decree of Trent. The church had first swept aside Luther's sharp but hesitant criticism—destined to resurface—which was in the end relatively tolerant; then Calvin's redoubtable offensive, which extended to a general shattering of images in Edward VI's England, further prolonged by Elizabeth. She asked "visitors" to examine "whether all the tabernacles and decorations in tabernacles, all the altars, chandeliers, reliquaries, candles, paintings, pictures, and all the other monuments of false miracles, pilgrimage, idolatry, and superstition have not been destroyed, so that there remains no trace of them on the walls, on window glass, or in any other place inside churches and houses."[21] They should even verify whether the decree was applied in private homes, thus going Calvin himself one better, since he was thinking solely of the purity of churches.

The Huguenot sack proceeded apace in France, and that is why the cardinal of Guise asked the council meeting at Trent to take a formal position. It did so during the session of 3 December 1562. The decree showed restraint.[22] It was addressed to bishops, to whom jurisdictional power in this area was remitted, rather than to the civil authorities. Images were part of the episcopal duty of instruction. It is good to pray to saints to obtain their intercession with God through his Son, the only Redeemer and Savior. It is good to venerate their holy bodies and their relics. "The images of Christ, of the Virgin Mother of God, and of the other Saints, are to be had and retained, particularly in Churches." No one believed there was anything divine about them, any "virtue" in them, but rather,

"the honor which is shown them is referred to the prototypes which those images represent," as the Second Nicene Council had defined the matter.[23]

Then came discipline: no image was to convey a false doctrine. There was to be no superstition: let it be specified to the simple folk that images do not represent the deity "as if one could perceive it with the eyes of the body or express it with colors and forms." Images were not to be "of a provocative, profane beauty"; there was to be "nothing dissolute, untimely, tumultuous, or dishonest," since "holiness befits (decet) the house of God." Hence, there was nothing new under the Roman sun. No theology, no aesthetics, simply a jurisprudence of the image, remitted to the bishop's authority, subject to review by the Roman pontiff.

On all these points, the papacy never varied, and its interventions were rare and circumscribed, responding only to flagrant abuses. In 1642, Urban VIII, through the *Sacrosancta* letter, somewhat tightened discipline by requiring that images be in keeping with "what the Catholic Church has allowed since the earliest times." To be precise, it prohibited dressing the saints or Christ "in the particular habit of any regular order," thus stopping an ugly recruiting procedure.[24]

4. THE CRESCENTIA AFFAIR

A nun named Crescentia of Kaufbeuren, from the diocese of Augsburg, had a vision of the Holy Spirit in the form of a handsome young man. She had it painted and distributed in that form as small images. The bishop was troubled and consulted the pope. Benedict XIV responded in a long, detailed letter published in 1746, *Sollicitudini Nostrae*. It was an opinion of the greatest seriousness, since it had to do with the iconography of the Trinity and the most unimaginable of the divine Persons, the Holy Spirit. Benedict XIV cited the traditional authors at length, displayed erudition and an equally extensive theological knowledge. The text has been expertly glossed by François Boespflug.[25] Before giving the pope's conclusions, let me summarize the positions presented.

Reservations about images of the Trinity had always run deep, even in Catholic orthodoxy. Among the authors the pope cites, one of them, Durand de Saint-Pourçain, straightforwardly denied the legitimacy of these images, and the other, a doctor from Louvain named Hessel, questioned their advisability. That orthodox opposition, which persisted from the thirteenth to the seventeenth century, used the same arguments: most of these images were "innovations" in relation to the views of the fathers and the discipline of the early church. These images did not represent God or the Trinity, but only the form in which they appeared, hence they were simply metaphorical; and, since the image was mute, it

could not alert the faithful to that fact. They were therefore dangerous for their addressees, the simple folk, precisely because they were simple.

Commenting on the famous question 25 in part 3 of the *Summa,* Cajetan divided images of God into three categories: the first set was naively realistic, that is, such images suggested that God has a human body; the second translated into images what the biblical narrative said in words; and, finally, a third set drew similitudes from apparitions in the Bible, so that these images represented God's majesty in a visible manner. The first set was sacrilegious: it was anthropomorphism. The two others, the biblical and the metaphorical, were permissible. That is why Cajetan tolerated the Trinity being represented as an old man holding the crucifix with the dove between them. The various parts of that image came from Scripture (the old man was the "Ancient of Days" from the Book of Daniel). Nevertheless, he added, "it would be better to paint God as unrepresentable, by means of some aura on a cloud from which the Creation issues forth, so that the common people would be instructed that God is an unrepresentable being."[26]

All the same, the pope preferred not Cajetan but Suarez, who did not have such scruples. The Jesuit scholar maintained that the Catholic Church had always permitted the image of God. Since it allowed the metaphorical image of Christ as the lamb, and the Holy Spirit as the dove, the same reasoning was valid for the image of God, which must be metaphorical. The Council of Trent allowed images of God. Yet it is an article of faith that God cannot be represented *formaliter.* Therefore, he must be depicted metaphorically, as the virtues are depicted. The proof: as the Scriptures teach us, God has often manifested himself in a sensible form. These images are "useful" in many ways: they reawaken a memory of God and piety. They must simply be painted in an appropriate way and the common people must simply be adequately instructed.[27]

Benedict XIV thus selects the following arguments:

1. "It would be an impious and sacrilegious error, and unworthy of divine nature, to imagine one could represent the Very Good, Very Great God as he is in himself."

2. "Nonetheless, God is represented in the manner and form in which he deigned to appear to mortals, as we read in the Holy Scriptures." This point is important: divine nature is not representable. In spite of that, it *deigned* show itself. Thus, in the last instance, the possibility of the image stems from God's condescension and goodness.

3. The Council of Trent, the Roman catechism, the decree of 7 December 1690 by Pope Alexander VIII, as well as Father Peteau, Suarez, Bellarmine, and other authors (including Cardinal Richelieu) all expressed similar opinions:

"Since one reads in Holy writings that God himself allowed himself to be seen by men in one form or another, why should it not be permitted to paint Him in the same forms?"

4. The image of the Holy Spirit can therefore be painted in the form of a dove, or as tongues of flame, but not in the form of a young man, since Scripture does not attest that it deigned make itself visible in that form.

In fifteenth-century Russia, images of the Trinity became widespread as a result of an evolution that in every era pushed the icon in the direction of a theological treatise. So it was for the so-called icon of Paternity (Novgorod), which was subsequently rejected by the Council of Moscow, and, above all, for the so-called icon of Abraham's Philoxenia, the most famous of which was done by Rublyov. Yet Benedict XIV had enormous reservations about images of that type, which also exist in the West. Was the visit of the three angels to the house of Abraham (Genesis 18) truly a theophany of the Trinity? The church made no decision on the matter, and the validity of that icon was linked to the outcome of the exegetical debate, which even today is not settled. Even if the three angels represented the Trinity, that was not justification enough for singling one out and making it a figure for the Holy Spirit: that would amount to the same thing as Crescentia of Kaufbeuren's "handsome young man."

Thus the Catholic authority pronounced itself on the most delicate question regarding the image: the image of God himself, by nature unrepresentable. It did so in the mid-eighteenth century, that is, just after the fireworks surrounding the sacred image. The centerpiece and, one might say, "grand finale" of that fireworks display took place in the Bavaria of the Augsburg nun. As always, Rome observed a cautious delay before speaking about the event, and only then under the constraint of an urgent judgment to be rendered.

Once again, the pastoral concerns—automatically favorable toward the image—of the papacy prevailed, along with its mission to articulate the law: what one can and cannot do in the matter. Despite his vast erudition, the pope avoided dealing with the central theological issue of the image, which is the Incarnation, as the East had rightly claimed. Old Testament theophanies were valid in themselves and did not appear to be determined by the coming of Christ, which was considered one theophany among others and not the foundation of all theophany and divine iconography. The scope of the Incarnation, Boespflug maintains, criticizing Benedict XIV, "becomes nothing more than a date after which a prohibition no longer applies."[28]

This same author makes a second criticism: if one cannot represent God in his divine nature, something the pope posits in principle, and if the notion of "image" connotes a likeness or conformity to what is being represented, then ei-

ther what the image represents is not God, or the image is not truly an image. One must therefore abandon the equivocal expression "image of God."[29]

Such a point of view brings us back to Byzantium, to the great controversy, the clamors and curses of modern Orthodoxy. Yet we know that Rome preferred to keep its distance. It did not object to the solutions of John of Damascus, Theodore Studite, and the Second Nicene Council, but it decided to leave the theological domain alone and remit the question of the pastoral value of the image to "political" prudence, thus allowing the image to flourish in complete freedom at a rhetorical level. It did not impose the yoke of theology on the image, and, in fact, through the notion of "dissemblance," which Aquinas adopted from Pseudo-Dionysius, its own theology allowed for an indeterminate gap, as wide as one might like, between the prototype and the image, which was linked to it by a chain of analogies. All the same, it still deserves the name "image of God," provided that term is not understood in the narrow or literal sense. As for the Incarnation, Rome saw the danger of erecting it into a principle to such a point of transcendence that its extension and fulfillment in the real, social world was forgotten or prohibited: Rome had never confined itself to that *disincarnated Incarnation,* which it sensed was a Byzantine vice. That explains the explosion of images contemporary with the decree of Trent.

5. THE IMAGE IN CELEBRATION

"Archbishops and bishops will oversee in person the painters to whom they have entrusted the oversight [of other painters] and will supervise them with utmost rigor. . . . In every diocese, the prelate will devote his tireless care and attention to seeing that good painters of icons reproduce the old models, that they refrain from all fancy, that they not depict God in a random manner."[30] So prescribed the so-called Council of the Hundred Chapters, held in Moscow in 1551 under Ivan the Terrible, at the same time that the Council of Trent was meeting. The icon, leading directly to the contemplation of the divine and participating in an immutable reality, must be just as invariable as that reality and safe from the artist's personal invention. The artist was thus closely overseen. Was that also the case in the West?

If we are to believe Anthony Blunt, the Council of Trent dropped a lead curtain over art.[31] Nothing could be further from the truth. One has only to consider the literature emerging in proximity of the council, and from the most authoritative authors, such as Giglio da Fabriano, Molanus, and Paleotti. Molanus, a doctor from Louvain, tried to fix, in an erudite manner, the correct iconography of each saint and of the mysteries. His principle was that "what is

prohibited in books is also prohibited in paintings." If Scripture happens to be mute, choose the most probable path, taking decency and piety as a guide. For example, it is not known whether the Virgin was standing, seated, or kneeling at the Annunciation. Since the kneeling posture is the most appropriate, it should be adopted. He also eradicated magical practices such as immersing images of Saint Paul and Saint Urban in water when it rained on their feast day.[32]

Paleotti, archbishop of Bologna, was even more harsh. He distrusted metaphor. He wanted artists to keep as close as possible to the biblical text. He allowed them to embroider a bit on a few circumstances in order to "move the emotions and soften the heart," but only on the condition that they show the respect due "to the dignity of persons and the probability or verisimilitude of the facts." Above all, he feared that painters would introduce innovations in matters of faith, would be "rash," "odd," and "incautious" in their representations of the Judgment, of hell, of the Virgin's or Christ's clothing. Was there not a report of a painter who, "wishing to represent Our Lord as Jupiter and dressed like him, saw his hand wither up on the spot?" But Paleotti, although he wanted to "curb painters' ingenious fancies," took care to add that he was in no way the enemy of new things. Nonetheless, he wanted the pope to intervene and define an iconography that would be valid for the whole church and that would play the role of a second Index. The pope refrained from following him on that road.[33]

But let us turn to a practitioner, a painter. Pacheco, father-in-law of Vélazquez, fancied himself the man of the Inquisition: "I find myself honored with special permission from the Inquisition, to warn against the breaches committed in similar paintings through the ignorance or ill-will of artists."[34] Even so, there is nothing more innocuous, more gentle, or more benign than Pacheco's formidable censure. His principal concern is that painters not show the holy figures in a state of undress, and, in particular, that they not place a completely nude Baby Jesus between a clothed Mary and Joseph: that sight is painful, since it might be said he could catch cold.[35]

To conclude, the general attitude of the church (with a few exceptions), composed of a complete abstention from aesthetic matters, a moderation in theological matters, and an indulgent reestablishment of order and concern for *convenienza* in iconographical matters, protected the divine image and, as a result, served both profane and sacred art.

We may better measure the vitality of the image by observing the attitude of the Society of Jesus, not as a cause but as a maelstrom of the forces exerted in the Catholic world.

The high church was too attached to humanism for even the image most intermingled with pagan gods to face a serious risk. The most significant pagan

decorations were executed for cardinals. The Jesuit Ottonelli, appealing to Pale-
otti's authority, maintained that painting did not promote the worship of pagan
gods.[36] In fact, superstition was disappearing from the world, and there was no
danger in maintaining the memory of such gods. Ottonelli repeated a com-
monplace in the Catholic defense of images, which had confidence in the edu-
cation received by the faithful, in somewhat the same way as Jews in the time of
Akiba, who relaxed the strictness of the second commandment. In fact, added
Ottonelli, artists had no choice. They had to paint according to the commis-
sions they accepted, and they were asked to produce mythological scenes be-
cause they alone allowed the painter to exercise his talent in all its variety and
erudition. In addition, allegorical interpretation, which allowed the artist to
give a moral significance to even scabrous scenes taken from Ovid, was by no
means abandoned. The Carracci placed small emblems in the corners of famous
galleries. These putti were the two forms of Eros, symbolizing the struggle be-
tween sacred and profane love. The fashion for emblems was favored by the So-
ciety of Jesus. To illustrate the truths of faith, it used pagan iconography. Father
Menestrier approved of it: "The figures of profane history and of the fable can
themselves serve to make sacred emblems."[37] Hence one sees Cupid endowed
with a halo, becoming the Baby Jesus. No one entered the society without hav-
ing studied his humanities.[38]

In their schools, Jesuit fathers founded their pedagogy on the education of
taste, helping the child recognize truth in its splendor. That is why the program
was based on the assimilation of classical letters, with mythology occupying a
place of honor. Rhetoric occupied an even higher place and did not bypass or-
naments; those provided by the fable "cannot be ignored without shame." To
teach their students to extract the edifying kernel hidden under the husk of the
tale, the fathers taught them emblematics, since, as Richeome says in his *Pein-
ture spirituelle,* "there is nothing that delights more and makes a thing slip more
easily into the soul, or that lodges deeper in the memory, than painting."[39] Here
again is the persuasive superiority of sight over hearing. Since, in the minds of
Jesuits, the soul of a child was a mission field, like the barbarian whom Gregory
the Great wanted to bring around to faith in Christ, the precepts for instructing
the "ignorant" were naturally inspired by the same argument.

But the image formed the center and bedrock of Jesuit spirituality in the *Ex-
ercices.* The first exercise for the first week begins with "Composition: See the
place": that is, compose an internal picture. "Through the contemplation of in-
visible things, for example, the contemplation of Christ Our Lord, who is visi-
ble, the composition will consist of seeing with the eyes of the imagination the
material place where what I want to contemplate is located. I say 'material

place,' for example, a temple or mountain where Jesus Christ or Our Lady is situated, depending on what I wish to contemplate." But the student is also invited to "imagine" the invisible, to "see, with the eyes of the imagination," his soul imprisoned in his body, and the body and soul exiled to a valley among dumb beasts. The second week begins with a composition on place: "See with the eyes of the imagination the synagogues, towns, or villages where Christ Our Lord preached." And elsewhere, "the length, breadth, and depth of hell."[40]

Saint Ignatius's method is not the only one to use a composed internal image. The Dominican Luís of Granada, inspired by John of Avila, Ignatius, and Harphius, recommended basing prayer on a "consideration" of an event in Christ's life. "The list of exercises proposed by Luís of Granada," writes Fumaroli, "consists of a complete gallery of internal pictures, which the man in prayer must methodically 'consider' and 'meditate' on day and night. That gallery covers the entire repertoire of motifs from religious painting relating to Christ."[41]

As a result, even in its worst moments, *rhetorica divina* did not fall to the level of simple declamation and pure religious propaganda. As Fumaroli notes, the *oratio interior* of the person who follows these spiritual methods has an "essential kinship with the *mute* art of painters." The habit of preparing for prayer by methodically engaging the imagination, leading to a complete picture fixed upon and examined by an internal gaze, retained and recalled by the memory, makes it possible to contemplate "external" pictures, constantly comparing them with and exchanging them for "internal" pictures, in a manner infinitely more alive and strong than what contemporary museum visitors do. These "long-winded" religious paintings, which sometimes seem so hollow to us, were at the time filled with a multitude of meanings, and the boundary that separates the object of worship from aesthetic creation was not so clear.

What did the church mean when it replied to the Protestant challenge, to the sack of Rome, by flamboyantly inflating the rhetoric of images? Fundamental theological reasons lie behind the motives I have put forward.

The Calvinist accusation had to do with idolatry and grace. Through "works," the church made an effort to avoid a breach in another area. Protestant biblicism set up a barrier between the revelation of Scripture and classical wisdom. It suspected, often rightly, that combining one with the other smacked of Marcionism, a rejection of the Old Testament, an obliteration of the God of Abraham, Isaac, and Jacob.

For its part, the church suspected that rejecting humanism was a different kind of Marcionism, which went against its catholic vocation. By "catholic," it

meant gathering to its bosom everything that came from the Jews and everything that came from the gentiles to form a single people. It did not see the close proximity of the old gods and of truly holy figures as a return to idolatry but rather as the triumph of true religion, capable of enveloping everything and of presenting a complete kingdom to the Father. It granted the Reformation its *sola gratia*—the Council of Trent confirmed it—but it reproached it for not believing enough in that grace, for being blind to its efficacy in works. The phenomenal abundance of these works in the realm of art was, in its eyes, the *visible* proof of the inexhaustible outpouring of grace, which even lifted up the draperies, impressed a whirling, swirling jubilation on even the gravest patriarchs, the most august fathers of the church, and, finally, cast its rays of joyful light onto the most dreadful torments of martyrs. It was also that faith in grace that instilled confidence in the education of Christians, who were considered capable of discernment and sufficiently safe from the temptation of idolatry, a confidence in the educative, edifying, salvation-enhancing virtue of divine rhetoric and of the infinitely multiplied image, a confidence, finally, in the artist, whose personal morality, and even personal faith, could be forgotten if he did not sin in his art. When, in *The Last Judgment,* Michelangelo leaned toward Lutheran despair and a too humanistic assimilation of Christ to Hercules, the pope confined himself to imposing a few touch-ups, given the formidable testimony to the powers of man and of art, which reflected back on divine glory.[42]

How might the Roman Church have replied to the Orthodox churches, which were not in a position to protest at the time, but whose vehement criticism has arisen in the twentieth century? Accused that it had forgotten the Incarnation, it might have replied simply by pointing out Rome, Seville, Venice, Naples, Prague, and a thousand other places, where the presence of the divine incarnate shows through, stands out, strikes almost at "first sight"—might have simply said, before all these images: *Look!*

PART THREE

Iconoclasm: The Modern Cycle

The New Theology of the Image

I. THREE ICONOCLASTS

Calvin

Christians, *tertium genus,* descended from pagans. More naturally and more legitimately than the Jews—who had "borrowed" them—they inherited "the spoils of the Egyptians": wisdom, law, philosophy, art, images.[1] They attached their gods to the triumphant chariot of Christ: the gods were chained, but present. These gods fill images. But another movement propelled Christians to cut their pagan roots. Thus, overcome by an impatient zeal to confine themselves to the Old and New Testaments, they wanted to move closer to the *secundum genus.* Such was the case for Calvin.

Although his aim was a pure Christianity, Calvin was a modern. He participated in advance in the spring cleaning of the seventeenth century, the great discarding of clutter. He was a proponent of intellectual clarity and simplicity in interpretation. He maintained that order could be introduced into the tradition if it were reconstructed from the necessary and sufficient store of Scripture.

Let us enter the vestibule of the convent, today occupied by the Accademia in Venice: we walk into an aviary of angels. There are angels everywhere, on the walls and ceiling. Likewise, they plaster the cosmos and fill its interstices. Did not the fathers maintain that angels were infinitely more numerous than human beings? That is why, in churches in Bavaria, Bohemia, and Austria, they perch in groups on the tiniest confessional and hang from cornices, their pretty pink legs

peeking out from the drapery of their robes. There is no martyr whose wreath and crown are not borne by joyful, chubby babies with small, vigorous wings, fighting with one another for the honor. Rightly so, since Stephen, the very first martyr, saw them rush in among the stones being thrown at him.

But, as he opened the Bible, Calvin's sharp eyes saw nothing like that. Very little is said about angels, in fact. They exist, granted. They are, it is written, in the service of God. They "watch for our safety." The angels of the Lord are near to those who fear them: from Genesis to Revelation, Calvin lines up all the important texts.[2] Guardian angels exist. Angels have no form: all the same, "Scripture, in accommodation to us, describes them under the form of winged Cherubim and Seraphim; not without cause. . . . Farther than this, in regard both to the ranks and numbers of angels, let us class them among those mysterious subjects, the full revelation of which is deferred to the last day, and accordingly refrain from inquiring too curiously, or talking presumptuously."

There has been too much speculation.

> None can deny that Dionysius (whoever he may have been) [note the doubt about his identity—A. B.] has many shrewd and subtle disquisitions in his Celestial Hierarchies; but on looking at them more closely, every one must see that they are merely idle talk.

Calvin's reservations stem from the fact that he wants nothing to do with a hierarchized cosmos in which the chain of angels interposes itself and links man to God by degrees. He requires an immediate relationship. We are led away from God by angels

> if angels do not conduct us directly to him—making us look to him, invoke and celebrate him as our only defender—if they are not regarded merely as hands moving to our assistance as he directs—if they do not direct us to Christ as the only mediator on whom we must wholly depend.

God and self: in the stripped-down, empty cosmos, God does not allow us to "divide our confidence between him and them." "Away, then, with that Platonic philosophy of seeking access to God by means of angels, and courting them with the view of making God more propitious": this is a "presumptuous and superstitious" philosophy.

All this is perfectly compatible with Catholic orthodoxy. What changed with Calvin was not the idea of God but the idea of the world, which was de-deified. Even before the question of images was raised, it was already unclear how an element of the created world that is not the human soul, which knows the Good through keen "experience," could serve as support for a divine image. Heaven and earth, rather than telling of divine glory, are the deserted and neutral theater

on whose stage the individual subject, if he has the gift of grace, can experience God as he declares himself through his Word.[3]

It is therefore in an almost Cartesian context that, in chapter 11 of the first book of *Institutes of the Christian Religion,* Calvin takes up the ancient debate about images. The iconoclastic argument seems to have been adopted unchanged from Eusebius of Caesarea, but it must be read against the backdrop of this new transparent cosmos, purged, as far as religion is concerned, of everything that is not God and man, "God himself being the only fit witness to himself." Hence, "as any form is assigned to God, his glory is corrupted by an impious lie." That is why God made the commandment "Thou shalt not make unto thee any graven image, or any likeness of any thing"; that is why he condemns without exception "all shapes and pictures, and other symbols by which the superstitious imagine they can bring him near to them." What about the cherubim of the ark? Their role was to conceal: "They were so formed as to cover the mercy-seat with their wings, thereby concealing the view of God, not only from the eyes, but from every human sense, and curbing presumption."

Images do not teach about God. Pope Gregory, if he had "got his lesson," would never have written that images are "the books of the unlearned." The prophets condemned "what the Papists hold to be an undoubted axiom—viz., that images are substitutes for books. For they [the prophets] contrast images with the true God, as if the two were of an opposite nature." Calvin thus lines up the authorities to whom iconoclasts had appealed: Lactantius, Eusebius, the Council of Elvira, certain passages from Augustine. Basing himself on the *Carolini libri,* he contemptuously rejects the Second Nicene Council and dismisses the arguments of Saint Theodore Studite out of hand. "Their absurdities are so extreme that it is painful even to quote them." All iconophiliac bishops were gawkers and dreamers, "handling Scripture so childishly, or wresting it so shamefully and profanely."

God does not teach through simulacra but through his own word. To claim that images serve as books for the unlearned is simply to show that the church has abdicated its duty to transmit that word: "The simple reason why those who had the charge of churches resigned the office of teaching to idols, was, because they themselves were dumb."

As for the origin of images, it was the expression of an inclination of the human mind: "The human mind is, so to speak, a perpetual forge of idols." The world had hardly been purged by the flood when men began to invent gods to suit their fancies. Immediately, they gave an outward form with their hands to the follies they conceived about God. Men believe that "God is not present with them unless his presence is carnally exhibited." Did not the people of Israel

188 • Chapter Six

themselves want to fix him in a golden calf? That was because they did not trust in divine immediacy: "They desired, therefore, to be assured, by the image which went before them, that they were journeying under Divine guidance." In every age, "in consequence of this blind passion men have . . . [they] set up signs on which they imagined that God was visibly depicted to their eyes."

Calvin's rejection of mediation extends to the symbol. Pagans argued they did not believe idols were gods, but simply that a divine virtue inhabited them. Or, even more subtly, that they did not worship either the idol or the spirit symbolized by it, but "a corporeal symbol of his presence, as an attestation of his actual government." But the argument has no validity: it is still an abuse "not contented with spiritual understanding" and with knowing God spiritually. "They thought that images would give them a surer and realer impression" of him.

The papists behaved like pagans when they went on pilgrimages, visiting some venerated image "to see a small boy whose likeness was at the gate," or, when they battled so furiously, "showing more willingness to part with the one God than with their idols."

Calvin does not prohibit the image, provided it abdicates its claim to represent the divine. "I am not . . . so superstitious as to think that all visible representations of every kind are unlawful. But as sculpture and paintings are gifts of God, what I insist for is, that both shall be used purely and lawfully." The great talents of artists can be devoted to history, the landscape, or the portrait: that is useful, or, in any case, pleasant.

But in the church, there should be nothing: "The majesty of God, which is far beyond the reach of any eye, must not be dishonored by unbecoming representations." For the first five centuries of the church, Christian churches were "completely free from visible representation." If the early fathers had believed images useful to the soul, would they have deprived the churches of them? Hence, "any other images than those living symbols the Lord has consecrated by his own word" should not be placed in the churches: "I mean the Baptism and the Lord's Supper." The notion that the Eucharist should be the only worthy image—an iconoclastic principle par excellence—had been refuted by the common belief that the holy species were not the image but the reality of God himself: Calvin, who did not have such an unconditional faith in real Presence, was consequently able to assign them the status of an image, this time in the strongest and almost iconic sense of the term.

In Calvin, there seems to be a confluence of two different currents. The first, ancient current appeals to Origen and the early fathers for its authority, and it situates the divine image in the infinitely distant space beyond the cosmos and in the infinite depths of one's heart of hearts, deeper than the spirit itself, where

the unknowable Spirit dwells and works. The other, modern current reorders the world in the light of reason, eliminates the useless, the superfluous inherited from the past; it constructs a cleaner spiritual church, more in keeping with the pure principle of Christianity, which is deducible, *more geometrico,* from Scripture taken as an axiom. Mysticism and reason, far from being mutually exclusive, are combined and reinforce each other, joining together to consider with horror the accumulation of blasphemy and idolatry that fills the papist church.

In the pure, cold light of the Reformation, everything the church holds takes on a hideous and obscene shape: "It is well known what kind of monsters they obtrude upon us as divine. For what are the pictures or statues to which they append the names of saints, but exhibitions of the most shameless luxury or obscenity? Were any one to dress himself after their model, he would deserve the pillory. Indeed, brothels exhibit their inmates more chastely and modestly dressed than churches do images intended to represent virgins."[4]

Calvin condemns divine images, but not art: "Sculpture and painting are gifts of God." He requires only that "both shall be used purely and lawfully—that gifts which the Lord has bestowed upon us, for his glory and our own good, shall not be preposterously abused, nay, shall not be perverted to our destruction."[5] Hence painting is permissible, since it is the exercise of an ability or talent given to man by God. But what and why should one paint? "Visible representations are of two classes—viz., historical, which give a representation of events, and pictorial, which merely exhibit bodily shapes and figures. The former are of some use for instruction or admonition. The latter, so far as I can see, are only fitted for amusement." Art is put back in its place, which is subservient: expelled from lofty spheres, divine realms, the life of the church, the personal effort of sanctification, art finds its place in ornament, illustration, honest recreation. In the Calvinist home, the divine blessing is expressed in solid and decent architecture; it is also bestowed on the walls, where the honest painter's craft is applied to render landscapes, still lifes, and portraits of the masters of the house.

That seems to be the program of Dutch painting. But, in a strange reversal, by means of the very representation of earthly things, an underlying sacred content emerges from the art dedicated to the profane. The tables laden with fruit, bottles, drinking glasses, and peeled lemons become altars of sorts, made for contemplation and summoning the soul to perpetual adoration. Such is the "little section of yellow wall" in front of which Bergotte dies in ecstasy. Hegel said it before Proust: "Architectural works, environment, views of churches, cities, streams, forests, mountains, [are] still conceived and executed as a whole subject to religious motization."[6]

The Calvinist spirit, even as it imposes iconoclasm, allows the iconic light to flood over secular images, which it tolerates, or rather authorizes, because of its concern to foster and extend the work of man, sanctifying and exerting itself for the glory of God alone. That divine light is the protest of nature, separated from its Creator and aspiring to join him. But nature shines through only because the individual artist has conferred light on it. Hegel adds:

> What [the Dutch] did elaborate, however, was, in one aspect of it, the expression of depth of emotion and the austere seclusion of the individual soul, and, from another point of view, they attach to this intensity of faith the separate definition of individual character in the broader significance of it, that is to say, one which does not merely disclose the fact of its close interest with the claims of faith and salvation, but also shows how the individuals represented are affected by the concerns of the world, how they are buffeted by the cares of life, and in this severe ordeal have gained worldly wisdom, fidelity, consistency, straightforwardness, the constancy of chivalry and the sterling character of good citizens.[7]

Hence, the divine aspect of the work no longer comes from what is represented but from the representer, the artist. Since the work's subject no longer has to do with faith, that divine aspect, which is no longer explicit, does not originate in the artist's faith but in the divine spark he possesses, not as a Christian but as an artist. The Calvinist path also opens a door toward the deification of the artist. Supernatural light still shines in an unexpected manner on desacralized art and feeds a different kind of idolatry than that Calvin wanted to uproot, and which would have horrified him even more.

Pascal

After Calvin, texts dealing directly with the representation of the divine become increasingly rare. A few can still be found in the Mediterranean world of the Baroque period. But there, where modern thought took shape, the problem seems to disappear. It is no longer treated. Of course, it continues to be at work underground, like the "old mole" that reemerges every now and again. In the classical world, it is no longer a focus of thought.

Let us consider Pascal: "What vanity is painting, which attracts admiration through its resemblance to things that one does not admire in their original form!"[8] This is a classic topos dating back to Plato. Pascal does not believe that nature—and even less its imitation—speaks of God: "These persons devoid of faith and grace who, seeking with all their enlightenment everything they see in nature that can lead them to that knowledge [of God], find only darkness and shadow."[9] To cite the course of the moon and planets as proof of God is to give

them reason to believe that "the proof of our religion is very weak" and "to elicit in them contempt about it." And, strangely contradicting the Psalmist and Saint Paul, Pascal declares that the evidence of God is not in nature: "No canonical author ever used nature to prove God."[10]

Pascal goes further than Calvin, who agrees with Aristotle on one point: the artist's collaboration in the work of nature, which in biblical terms authorizes recreation and diversion as a kind of Sabbath rest after sanctifying labor. There is no place for rest in the Pascalian rejection of diversions, and it does not seem possible that he would tolerate the frivolity of a painting on the walls of his room.[11]

But for Pascal, as for Calvin, the true image of God is the Word, and the authorized figure of the Word incarnate is another word. The Old Testament is filled with "figures," all referring to Jesus Christ. Faith and prophesies are a precursory portrait of him, the only conceivable one. It is a "ciphered" portrait that can be read only with grace, since the hidden God shows himself only to the chosen. It is an overwhelming and frustrating portrait because "a portrait contains both absence and presence, pleasure and displeasure." The law and the sacrifices bear witness to the Promise, and hence to Presence; they focus one's expectations, and hence point out the absence of the promised God. That God, once he has appeared in "reality," eliminates absence and displeasure.[12]

Nature does not speak directly of God. It "has perfections to show it is the image of God and defects to show it is only his image."[13] The corruption of nature discourages idolatry, but, for Pascal, nature "in its full and lofty majesty" leads to God, not through consideration of the finite form but by virtue of its infiniteness, the way it transcends apprehension and measure: the earth is a point. Its orbit is only "a tiny pinhole compared to that described by the planets moving about the firmament." But "let imagination move on; it will tire of conceiving before nature does of providing. . . . It is in vain that we expand our conceptions beyond imaginable spaces, we give birth only to atoms, at the cost of the reality of things. . . . Finally, it is the greatest sensible characteristic of God's omnipotence that our imagination loses its way in thought."[14] This famous text forms a bridge between the very ancient and the most modern conception. In that vertiginous pursuit of God, where the soul soars from one infinite space to the next, we rediscover Origen's soul and Gregory of Nyssa's *epektasis*. We rediscover neo-Platonism as well, alluded to in the metaphor of the sphere, whose center is everywhere and whose circumference, nowhere. And yet, we are also already within the Kantian sublime.

The weakness of the imagination, Kant declares, combined with the capacity of thought to perceive the gap between our "claim to absolute totality as a real

idea" and our "capacity to evaluate the size of sensible objects," "awakens our sense of a supersensible faculty present within us."[15] In Pascal, this same sense does not lead the human mind to admire itself, but rather to worship God's omnipotence. The vast depths where the imagination loses its way—its weakness, in short—are in fact "its greatest sensible characteristic."

But on the vast span Pascal builds between the Greek fathers and the modern sublime, there is no place for the image. On the contrary, it is through the imagination's very incapacity to form an idea of God, that, in a very Pascalian reversal, God makes himself "sensible." The great cosmic void is the vacuum revealed by modern science. The telescope gives an idea of the infinitely large, the microscope of the infinitely small: these are spatial infinities, devoid of interstitial matter and filled by a fearsome silence.

The word "angel" appears only twice in the *Pensées,* not to refer to an intermediate being but merely to give a point of reference that situates man somewhere between angel and beast, and then only within the context of a quotation from Montaigne.[16] Calvin gave the angels a more active role, as his biblicism obliged him to do. Pascal would not have deigned alter Catholic dogma and would not have laid a hand on the decision of the Second Nicene Council. But he is a pre-Newtonian scientist in his vision of the cosmos, and he takes the elimination of any analogy between figures in the natural world and the idea of God to its logical extreme. Moreover, that idea accords better with the yawning gap between the intersideral and the interatomic void.

Is the hidden God definitively lost from view as a result? No, because we keep a sensible Jesus Christ in our hearts, the Jesus of history, which imagination, though crippled, is capable of representing: "The God of Abraham, the God of Isaac, the God of Jacob, not the God of philosophers and scientists." As a result, on Monday 23 November 1654, "from about ten thirty in the evening until about half past midnight," Blaise Pascal was rewarded, not with a vision of Christ, but perhaps truly with an insight (an intuition?) about God, in the very form that Moses saw and did not see him in the burning bush: "fire." It was not an image but what was called, in the spiritual literature of the time, "sensible consolation."

Jansenism suspected that the common people's manners of worship, their exvotos and pilgrimages, were a form of superstition; that external forms of religion displayed the lack of an inner life; that ornaments of the church were all that, and, moreover, an insult to the poor, money used unwisely; that the search for beauty, the taste for luxury, involved a certain lasciviousness of the soul, an accommodation of earthly life, a rejection of mortification, a Jesuit laxity. In addition, Jansenism was modern, rationalist, open to science. It was thus the en-

emy of rhetoric, which dressed up discourse. It did not grant art the role of making life sweeter or expressing the natural talents God gave man—in that respect, it had lost confidence in a human life of grace, which Calvinism still possessed. That is why it extended to private homes the bareness Calvin ordered only for churches.

Of course, the fastidious Catholicism of Jansenism kept it from declaring itself iconoclastic. But, in the seventeenth century, it gave French churches the bareness, poverty, and dreariness that still distinguish them from Catholic churches in the rest of Europe and in the Americas. In the eighteenth century, Jansenist priests systematically stripped them of furnishings. Their pious vandalism anticipated revolutionary vandalism—whose agents, as a matter of fact, often came from their ranks.

Although never iconoclastic in principle, Jansenists were so by instinct, by temperament, and in practice. Religious painting dried up. The iconophiliac spirit persisted in profane painting and was victorious in painters who did not even give a thought to the matter: Chardin, Boucher, Fragonard. That was the new shoot that grew out of Catholic art in France. Its profane art sometimes intersected or produced sacred art: but, at such times, it believed it had to change its tone, assume a spirit of seriousness, an air of sad and gloomy compunction. In the twentieth century, the Jansenist tradition can be found in the intentionally sordid realism of sanctuaries or in the savage scraping of the old walls.

Kant

One would not expect Kant to take a stand on the question of the divine image. He did not raise it, and it is not clear how he could have raised it within his system. But if we ask him about it and look at the *Critique of Judgment* with it in mind, that book seems to be permeated with it through and through, and we might wonder at times whether a few obscurities in the text are not illuminated by it, the way certain opaque bodies become transparent once a light of a different wavelength is projected on them.

In natural light, the third *Critique* can be read in terms of the meaning Kant himself wanted to give to it. To make it take on a different shape—and I am very aware that this is an artifice that distorts Kant—I propose to consider the judgment of taste as a spiritual experience. Is it possible to extract a theology of the image from the third *Critique*? Up to a certain point, yes, in that, more clearly than the first and second critiques, it is an evaluation—discreet as always—of Kant's religious experience as a philosopher and as a man.

The aesthetic experience is a subjective experience. It takes place entirely

within the mind, which has "the feeling of pleasure and pain, by which nothing in the object is signified."[17] Representation and sensation have the power to unleash a vital feeling in the subject, pleasure or pain, which supplies no knowledge. It is a disinterested experience, free of desire. The judgment that joins the nature of the object and the intimate feeling of pleasure is "merely contemplative." Mute contemplation, "not based on concepts," is not a judgment of knowledge.[18] Animals are capable of taking pleasure: they can experience the agreeable. Reasonable celestial beings have an interest in the good, but pleasure is unknown to them. Aesthetic pleasure (beauty) "only concerns men, i.e., animal, but still rational, beings."[19] Gratuitous, internal, disinterested pleasure: "In saying it is *beautiful* and in showing that I have taste, I am concerned, not with that in which I depend on the existence of the object, but with that which I make out of this representation in myself."[20] Let us transpose this to a different context, with which Kant was not unfamiliar, since he was steeped in pietism: the Fénelonian language of pure love. The aesthetic experience symbolizes the disinterested and "dry" *fruitio* that Fénelon recommends to his disciples. "A judgment of taste," writes Kant, "is therefore pure only so far as not merely empirical satisfaction is mingled with its determining ground. But this always happens if charm or emotion have any share."[21] That is why he is distrustful of color: "The colors which light up the sketch belong to the charm; they may indeed enliven the object for sensation, but they cannot make it worthy of contemplation and beautiful." Colors can be useful to attract attention to what is simply form: "The composition . . . constitute[s] . . . the proper object of the pure judgment." All the rest is framing—an artifice to hold the attention, ornaments, embellishment—which does an injustice to true beauty.

Just as when he is in the presence of a truth of the faith, the subject in the presence of the beautiful perceives an obviousness that he rightly judges ought to be perceived by all men, but he is unable to account for it in demonstrative speech. That is what Kant means by the famous formulation, "the universal without a concept." The subject, "if he gives out anything as beautiful, he supposes in others the same satisfaction; he judges not merely for himself, but for everyone."[22] But, unlike for a scientific truth, he cannot impose that obviousness on someone who does not feel it: "If a man, *in the first place,* does not find a building, a prospect, or a poem beautiful, a hundred voices all highly praising it will not force his inmost agreement." In this domain—and the same is true for the existence of God—there is no empirical proof and "still less . . . can an *a priori* proof determine according to definite rules a judgment about beauty."[23] Experience shows, in fact, that most men agree about what is agreeable: the majority like caviar and foie gras, but we are willing to allow them not to like them.

The same experience shows they do not agree so well about the beautiful: "Now here is something strange . . . the taste of reflection has its claim to the universal validity of its judgment."[24]

Thus a believer judges he is right to make others share his certainty, even though he knows he does not have the means to do so. "Classical" authors are thus placed in the same situation as the witnesses and apostles of Revelation: one does not imitate them, but one follows them. "They put others on the track."[25] They teach us to "draw from the same sources." Without that education or culture, one does not leave the soil of barbarism or indifference.

The beautiful is thus placed within the same perspective as that of God for the believer: a certainty of which one can say nothing, except that it is. It is what it must be, but one does not *know* what it must be. The pleasure linked to the beautiful does not lead me to know anything about the object. It is not a property of the object. Kant here is diametrically opposed to the exploration of the world through painting as the Italian quattrocento understood it. For da Vinci, the beautiful springs forth from the idea, and the idea is extracted from things through the art of painting. In the case of the icon, it is divine truths that, through the go-between of the image, penetrate the soul during prayer. In this instance, the experience is more limited and severe: the subject learns something from his soul itself when in contact with beauty: "The representation is thereby not referred to the object, but simply to the subject, and the pleasure can express nothing else than its harmony with the cognitive faculties which come into play in the reflective judgment."[26] The purposiveness of the beautiful, the famous "purposiveness without purpose," is neither knowledge (as was believed in the early Renaissance) nor the good (to which the beautiful had been assimilated since Plato), but what Kant defined in a sentence of almost unbearable density: "It is the mere form of purposiveness in the representation by which an object is *given* to us, so far as we are conscious of it, which constitutes the satisfaction that we without a concept judge to be universally communicable."[27]

Kant departs from the old manner of defining the beautiful in terms of pleasure, utility, symmetry, or perfection. Beauty does not lie in the *pleasure* of beautiful colors or varied ornaments. That is *attraction,* not aesthetic pleasure. Beauty lies not in the *useful*—which allowed Socrates to take up the defense of the spoon made of fig wood, which was adapted to its function ("one does not risk breaking the kettle with it").[28] It also does not lie in symmetry or the harmony of the parts. An askew wall and a garden in disarray are displeasing because they go against the purpose of the thing: that is because we are still laboring under the pressure of a superfluous concept.

The judgment of taste is pure, it "combines satisfaction or dissatisfaction—

without any reference to its use or to a purpose—with the mere *consideration* of the object." Kant nonetheless prefers English gardens and Baroque furnishings because, with "this separation from every constraint of rule[,] we have the case where taste can display its greatest perfection in the enterprises of the imagination."[29]

Finally, beauty does not lie in the *perfection* of the object's conformity with its telos or idea. "Internal objective purposiveness," Kant remarks, requires the concept of what the thing must be and the observation of how the diverse elements of that thing agree with its concept: yet the judgment of taste is aesthetic, hence subjective, and exclusive of any objective concept. "It brings to our notice no characteristic of the object, but only the purposive form in the determination of the representative powers which are occupying themselves therewith."[30] Through the expansion that the judgment of (reflective) taste procures for it, the soul experiences, if not sensual pleasure, which is not in the Kantian style, then at least a self-admiring respect.

But does taste have any relation to the *good?* There are two different responses to that question. The first is negative, if one maintains that the judgment of taste is without a concept, and that the concept of the good, when combined with judgment, alters its purity. That is why Kant distinguishes between *free* and *adherent* beauty. In the latter, the concept of the object and its perfection in relation to its concept are assumed. Hence, the beauty of a woman or a palace implies a concept determining what the object must be. This concept bridles the imagination. For example, it keeps one from embellishing the human face "with all kinds of spirals and light but regular strokes, as the New Zealanders do with their tattooing."[31] But, as for free beauty, Kant sets out a theory of what the twentieth century would call "abstract art." Improbable natural beings—parrots, hummingbirds, birds of paradise—are in themselves beauties unrelated to any object whose end could be determined by concepts, objects that "please freely." Similarly, "delineations *à la grecque,* foliage for borders or wall papers, mean nothing in themselves; they represent nothing—no object under a definite concept—and are free beauties." When the imagination encounters them, it is liberated and "disports itself in the contemplation of the figure."[32]

But there is also a positive response to the question of the relation between the beautiful and the good. To understand it, we must shift our perspective and consider the relation between the beautiful and God. Mediation is achieved through *genius,* the *sublime,* and the *symbol of moral law.* I use the term "mediation" even though God, who stands at the end of that mediation, remains unnamed, unknowable, and only postulated: faceless.

Genius is a natural medium where the "rules" of nature are set down. These

rules are hidden structures, secrets of creation, matrices reminiscent of the mysterious "mothers" of the second *Faust*. If the medium of genius is lacking, art is impossible. "Genius is the innate mental disposition *(ingenium) through which* nature gives the rule to art. . . . Beautiful arts must necessarily be considered as arts of *genius*."[33] Genius is not learned: it is "innate mental disposition." It is therefore always original in its direct communication with the world beyond the visible. It is unconscious and superconscious: "It cannot describe or indicate scientifically how it brings about its products, but it gives the rule just as nature does. Hence the author of a product for which he is indebted to his genius does not know himself how he has come by his ideas; and he has not the power to devise the like at pleasure or in accordance with a plan, and to communicate it to others in precepts that will enable them to produce similar products."[34]

This path will lead to the romantic conception of genius, to Schiller's *sentimentalisch* poetry, to the artist posited by Schopenhauer, who dwells in the noumenal world of Ideas. But this path began before Kant: the state of genius corresponds to the mystical state described by the spiritual literature of the seventeenth and eighteenth centuries. The mystical state is a gift, it is the product of a special grace not granted to everyone, and not granted continuously. The mystic is aware of the precarious and intermittent nature of his moments of rapture, and of the dry spells, the states of rigor, that come between them. Nonetheless, mystical revelation, like genius, can be highly original, "rich in fancy"; at the same time, it must be an "excellent model" and must serve as a measure and evaluating rule. But since no one knows its origin, the mystical treatise contains no formulation of the rule or the precept. "The rule must be abstracted from the fact, i.e., from the product." Hence, mystical schools—in the sense that there are schools of painting—formed around Bérulle, Mme Guyon, and Spener, with their disciples using the master's work "as a model, not to be *copied* but to be *imitated*." That is, the artist's ideas "excite like ideas in his pupils if nature has endowed them with a like proportion of their mental powers."[35]

That conjunction between the state of genius and the mystical state is recognized by the classical tradition. The poet's inspiration, like that of the prophet and to an equal degree, has always been considered divine. Virgil seems to unite the two kinds of inspiration. In Poussin's painting of him, the poet, who looks up toward the sky, is writing at Apollo's dictation. Nevertheless, Kant would not have accepted that immediate relation to the divine. He would have called it "fanaticism," "ridiculous dreaming," "going mad with reason."[36]

Genius has its place in the production of the beautiful and can even impose rules on it. But it is obvious, though Kant does not make this explicit, that genius has a greater affinity with the sublime. Genius is the faculty that makes the

sublime fully conceivable. The beautiful and the sublime are two degrees of aesthetic experience. Although they belong to two distinct orders and are separated by a difference of nature, they are nonetheless hierarchized. The beautiful is related to understanding, the sublime to reason.[37] The sublime is more lofty. The experience of the sublime is an experience of the divine within the limits of Kantian religion.

To convince ourselves of that, we have only to read—without too much concern for his system—Kant's description of the sublime. In the first place, the sense of the sublime is elevation. Those who experience it "are drawn gradually, by the quiet stillness of a summer evening as the shimmering light of the stars breaks through the brown shadows of night and the lonely moon rises into view [note Kant's rare fit of sober lyricism—A.B.] into high feelings of friendship, of disdain for the world, of eternity."[38] The sublime lies in the *apeiron*, the absence of limits, provided, however, that one also conceives it as a totality: an object transcending all form, but nonetheless intelligible, like the divine Idea. The beautiful exalts life; in contrast, the sublime at first strikes it down, only to have it spring up the stronger. Unlike the beautiful, it is not an occasion for play: it is graver, it is "earnest in the exercise of the imagination."[39] It does not charm, since it repels even as it attracts. The satisfaction it procures is the "negative pleasure" of admiration and respect.

The definition of the sublime coincides with a divine name: it is "the absolutely great. . . . It is not permissible to seek for an adequate standard of this outside itself, but merely in itself."[40] There is a remarkable convergence between the Kantian sublime and the Pascalian experience of the two infinities. "Telescopes have furnished us with abundant material" regarding the infinitely great, microscopes regarding the infinitely small. That which appears infinitely great to the senses can be reduced to the infinitely small, and vice versa, since "there is nothing so small which does not admit of extension by our imagination to the greatness of a world if compared with still smaller standards."[41] Pascal writes: "Let the imagination move on; it will tire of conceiving before nature does of providing. . . . We expand our conceptions beyond imaginable space, but in vain, we give birth only to atoms, at the cost of the reality of things." That is true for the infinitely great, and Pascal also points to "new depths" in the infinitely small.[42] The two infinities belong to what Kant calls the "mathematical sublime." There is no maximum for the "mathematical estimation of magnitude," but there is one for aesthetic estimation: and it is in exceeding the maximum and all conceivable measure that one reaches the idea of the sublime and its emotion.[43] Pascal would say the "imagination loses its way."

But Kant posits another sublime, which he calls "dynamic." It originates in the fear nature can inspire when it displays formidable objects, "boldly over-

hanging . . . rocks," storm clouds, thunder, lightning, volcanoes, the ocean churned up by a tempest, and so on. Then,

> the irresistibility of its might, while making us recognize our own [physical] impotence, considered as beings of nature, discloses to us a faculty of judging independently of and a superiority over nature. . . . Thus humanity in our person remains unhumiliated, though the individual might have to submit to this dominion. . . . Therefore nature is here called sublime merely because it elevates the imagination to a presentation of those cases in which the mind can make felt the proper sublimity of its destination, in comparison with nature itself.[44]

How can we fail to link this text to Pascal's *pensée:* "Man is only a reed, the weakest of nature; but he is a thinking reed. . . . And should the universe trample him, man is even more noble than what kills him, because he knows he is dying, and the universe knows nothing of the advantage the world has over him. All our dignity consists in thought. It is in thought that we must elevate ourselves, and not in space and time, which we cannot fill."[45]

At this point, however, Pascal and Kant part ways. Facing the sublime of the two infinities, Pascal becomes frightened. "What is a man in the infinite?" It is then that he turns to Jesus Christ, as to a point of reference: as a man, Christ stands in the "middle" like him, and, as a God, he *situates* him precisely in his greatness and wretchedness, wrests him from the "eternal despair" of not knowing his beginning or his end. For his part, Kant does not become frightened—very much to the contrary—since the dignity of thought takes away all his fear and brings a full satisfaction, the sublime in the strict sense. "Sublimity, therefore, does not reside in anything of nature, but only in our own mind, in so far as we can become conscious that we are superior to nature within, and therefore also to nature without us."[46] Faced with the enormity of nature, Pascal embraces an internal icon, obscure but representable and distinct from the soul, the icon of Christ. For Kant, the icon, devoid of any representation associated with itself, is the soul itself, "reason," whose transcendence demonstrates a superior vocation, makes felt "the proper sublimity of its destination, in comparison with nature itself."[47]

That superior vocation consists of the mind's yearning for the "supersensible," the inaccessible noumenal. "The infinite is . . . absolutely great. . . . To be able only to think it as a *whole* indicates a faculty of mind which surpasses every standard of sense."[48] We possess a "supersensible faculty," "the bare capability of thinking this infinite without contradiction." Thus the mind, in possession of its own sublime (the sublime must not be sought in the external world but rather in the mind), "feels itself raised in its own judgment."

Is that where things stand, then, at that borderline, which the mind knows it

cannot cross, but which it nonetheless delights inwardly in reaching, because it feels it continues to move onward? The imagination perceives it is transcended, since the ideas of reason go farther than it (for example: the "mathematical estimation" of size surpasses the "aesthetical estimation"), and a painful frustration takes root, compensated for by a feeling of pleasure nourished by a loyal acquiescence to that inadequacy of sensible powers and ideas, "the feeling of our incapacity to attain an idea *which is a law for us,*" a feeling called "respect."[49] It is a respect immanent to the mind, which the reflective judgment has formed through its own operation, a respect with which the sensible eyes and the intelligible gaze have nothing to do, a respect in the abstract and in the dark.

Is that all? Not really. If one maintains that the experience of the beautiful and the sublime is a spiritual or religious experience, one would have to grant importance to the slender fissure Kant finessed in the blind wall of respect. In the first place, at the beginning of the *Critique,* Kant carefully separates the beautiful from the good. The beautiful is the object of free satisfaction (a kind of play), whereas a law of reason obliges us to wish for the good out of pure duty, exclusive of any inclination, reward, or even goal to be reached. In the second place, however, at the end of the *Critique,* he relates one to the other.[50] The narrow bridge between them is the notion of "symbol" or "analogy." Concepts must be based on intuitions, says Kant, empirical concepts on examples, and intelligible concepts on schemata. But in the case of the concepts of "reason," that is, of "ideas," intuition is lacking. All the same, there is another form of "presentation" for such concepts, namely, the symbol: that is, an intuition wherein the "procedure of the judgment," the operation of thought, is analogous to the concept in question, not in content, but in the "form of reflection."

In that case, thought proceeds to a double operation. First, it applies "the concept to the object of a sensible intuition," for example, the image of an animate being to a monarchical state and the image of a machine to a despotic state. Then, it applies "the mere rule of the reflection made upon that intuition to a quite different object of which the first is only the symbol": although there is no similarity between a despotic state and a machine, "there is a similarity in the rules according to which we reflect upon these two things and their causality." Hence, the analogical symbol is the "transference of reflection upon an object of intuition to a quite different concept to which perhaps an intuition can never directly correspond."

In that sense, the beautiful is the symbol of moral good. The gap between the beautiful and the good is not bridged. But, from the subject's point of view, the experience of the beautiful is a propaedeutic of the good. When it comes into contact with the good, the mind consciously acquires "a certain ennoblement,"

which elevates it above mere sensible attraction and "that is the *intelligible* to which . . . taste looks," adds Kant, in an altogether Platonic formulation. The beautiful is pleasing as a symbol of moral good—and solely in that respect. Like the good, it is disinterested, and it reveals to the subject a superior form of liberty, namely, autonomy, the power to set laws for oneself.

Nevertheless, it is a long way from the symbol to the image. Even though Kant rediscovers an Aristotelian or Thomist use of analogy, it is valid only for the *symbol's* relation to the thing and would not condescend to slip from the abstract metaphor to the concrete and palpable *image*. "All our knowledge of God is purely symbolical; and he who regards it as schematical, along with the properties of understanding, will, etc., which only establish their objective reality in beings of this world, falls into anthropomorphism."[51] If that is the case for attributes, what about the body, the statue, the face, the icon?

Even—and especially—in the experience of the sublime, where the tendency toward the world beyond the sensible is frustrated, it would be pointless to transcend the austere "presentation" of moral law, for that would entail falling into fanaticism and the illusion of "seeing something beyond all bounds of sensibility."[52] The sublime view of the starry vault cannot lay claim to a respect of a different sort than that procured by the sense of moral law: each refers to the other. When one truly perceives the idea of morality, "it would be rather necessary to moderate the impetus of an unbounded imagination, to prevent it from rising to enthusiasm, than through fear of the powerlessness of these ideas to seek aid for them in images and childish ritual." The sublime comes about when the imagination, transported beyond the sensible world, loses its bearings and "feels itself unbounded by this removal of its limitations": the "abstract" presentation of the infinite, which is purely negative but which "expands the soul." The true sublime obliterates the image. That is why Kant, in reaching the logical conclusion of his philosophical iconoclasm, writes:

> Perhaps there is no sublimer passage in the Jewish law than the command: "Thou shalt not make to thyself any graven image, nor the likeness of anything which is in heaven or in the earth or under the earth," etc. This command alone can explain the enthusiasm that the Jewish people in their moral period felt for their religion, when they compared themselves with other peoples, or explain the pride which Mohammedanism inspires.[53]

When Kant is placed after Calvin and Pascal, we seem able to see more clearly a few of the lasting motifs of modern iconoclasm. The three writers stand at the confluence of an intellectual movement, a social current, and a religious attitude.

The intellectual movement is indistinguishable from the changes in the uni-

verse brought by modern science. One has only to allude to the great Galilean shift that, within a century, moved "from the closed world to the infinite universe," to paraphrase Koyré. The closed world was also a full and hierarchized world—the "scalar" world of Pseudo-Dionysius and Saint Thomas Aquinas. Every element formed a bridge between the lower realms and the loftier ones, from the stone to man to angels, and finally, to God. Each had its own properties, its qualities, its forces, which corresponded analogically to one another, differed from and resembled one another by degree, from one end of the chain to the other. Every element was eloquent, spoke of God, and reflected an aspect of his glory. That was no longer the case when the world was reduced to extension or was perceived as imperceptible specks of dust lost in the vacuum of infinite and mute space. The last trace of the divine was the organizing force that held everything together, that is, a thought, which human thought had become capable of understanding, in part by acquiring a new dignity through mathematical calculation, or through grace. Thought discovered a more abstract majesty in God, and that majesty discredited all representation.

This work of purification, which accompanied the dispelling of error, prejudice, and superstition, required an audacity of which not everyone was capable. To abandon the protection of authority, to overcome the evidence of the senses, to substitute laws for causes, to face the infinite and the void, to be satisfied with the limited certainties science offers, to conceive God at the lofty heights where he stands, requires the virtues of an elite. That is, next to the institutional greatness of a duke, for example, the natural greatness of the geometer and the scientist—the new Enlightenment elite of those who dared know and who nodded toward one another in acknowledgement—became stronger.

As for the religious current corresponding to that dual movement, equivalences for it can be found in the history of Christianity. The Christian idea of spiritual and truthful worship was already familiar, linked to social and intellectual aristocratism. Since Eusebius and the erudite circles of the imperial court, aristocrats had always felt a repugnance for the excesses of popular piety and a horror at idolatrous practices, which were also evidence of ignorance and barbarism.

In all these cases (and even in Eusebius), that idea was inseparable from iconoclasm. This is very clear in Calvin, who banished idols from churches, and, as far as images were concerned, recognized only the immaterial Word or the non-transubstantiated eucharistic species, in which Presence is lodged only in the assembly and as an act of faith. Jansenism did not deign contravene church dogma and reacted harshly to the accusation that it held images in contempt. But its religious elitism, its strictness, limited their use, and, though it may not

have held them in contempt, it did not like them either. Pascal cast them into the consuming fire of his asceticism. Images offer the senses too much; true piety can do without them.

In the *Critique of Judgment,* Kant's religious spirit reveals itself as clearly as possible. From beginning to end, the judgment of taste is subject to the charm and attraction of the good, the supersensible, of God. At times, this is apparent even in the vocabulary Kant uses to speak of genius and in the Platonic formulation about looking toward the intelligible. But that attraction is rejected as a temptation. It is because of Kant's religious ethic that he refuses to be drawn into *Schwärmerei,* the fanaticist debauchery of sensible representation. It is his honesty that leads him to challenge mysticism and its laxness: an intellectual honesty, since the requirements of the system prevent him from cutting a door in the wall that surrounds the phenomenon; but also a religious honesty, the price of which is seriousness, restraint, and lucidity, which confines him to mysticism. That negative mysticism consists of a stubborn effort to deny all value to any positive (or unitive) mysticism: "negative pleasure";[54] "a presentation of the Infinite which can be nothing but a mere negative presentation, but which yet expands the soul."[55] We are moving toward a nighttime of images, for, if the day is beautiful, Kant remarks, the night is sublime.[56]

2. HEGEL: NOSTALGIA FOR THE IMAGE

Hegel's *Aesthetics* should not be treated simply as a historical moment or a stage of thought. It is that as well, of course, and Hegel is the great deponent of what is called "romantic aesthetics." Hegel locates the beautiful in the realm of art, excluding it from nature, and submits it to a historical process, which is also a process of gradual dematerialization (from ponderous architecture to wholly spiritual poetry) and gradual subjectification. Even after these traits, and all others connected to them, have been identified, it is still true that we stand before the *Aesthetics* as before an edifice that towers over the entire landscape of reflections on art. I see no great thought, from Plato to the church fathers to Kant, which is not taken up, synthesized, systematized, "transcended," and supremely orchestrated. The detailed analyses are marvelously rich, and, although the system seems forced and inevitably dependent on the larger overall system, we cannot help but feel at every moment that we are close to a truth. Is that because we have not yet emerged from Hegel's shadow? Or because, truly, as in Plato and Aristotle, something true seems to have been glimpsed for all eternity?

In any case, one fact is easy to establish. On the issue of the image of God, Hegel is the only one since the iconoclastic controversy to have placed it at the center. Between the Middle Ages and our own time, his position in that regard

remains dominant and unique. That is because art can have no other goal than to represent God, in whatever manner one names him or whatever form he may assume—the God of Hegel, it is true, evolves, and his advent is dialectical—a God who, in his history, recapitulates all the figures of the divine and governs all the representations collected in the history of art, not only past art but, as we shall see, future art as well.

God in the Center

"Plato . . . began to demand of philosophical inquiry that its objects should be understood not in their particularity, but in their universality," that is, as "beauty itself." Hegel begins with the "Idea of the beautiful," the "beautiful by itself," "in its essence and its Concept," which is One.[57] External nature is inanimate and inert. Art, for its part, is "born of the spirit and born again." "In the products of art, the spirit has to do solely with its own."[58]

The work of art is an "alienation of the Concept out of itself."[59] Spirit recognizes itself as such in that alienation and "comprehends both itself and its opposite." This concept and this spirit are continuous with the divine. Yet if the divine does not wish to remain an abstraction, regardless of its existence apart from appearance, "it must *appear*." A deceitful epiphany, of course: in a certain sense, art is an illusion. But, in this same sense, the external world is also illusory (here Hegel refers to both Kant and Plato), and "this whole sphere of the empirical inner and outer world . . . we must call . . . in a stricter sense than we call art, a pure appearance and a harsher deception than the appearance of art."[60]

This time, Hegel seems to contradict Plato, since artistic imitation, instead of being two degrees lower than the Idea, stands beside it and relegates external reality to the third rung. But the logic of Platonism is maintained: "Art liberates the true content of phenomena from the pure appearance of this bad, transitory world, and gives them a higher actuality, born of the spirit." Compared to ordinary reality, art has "a higher reality and truer existence." In it, as in thought, we seek truth.[61]

But what is truth if not the unveiling of the divine itself? The object becomes a work of art only as "the territory of the spirit; it has received the baptism of the spiritual." As a result, "the work of art stands higher than any natural product." Nature is also permeated with the divine, but as an external medium, inferior to consciousness: "In art-production . . . the Divine . . . has been generated out of the spirit," an infinitely superior medium.[62] Hence, art shares its destiny with religion and philosophy. Like the latter, "it is simply one way of bringing to our minds and expression the *Divine*." It is a sensible epiphany.[63]

That is why this epiphany is imperfect, because one region of the idea no longer lends itself to sensible expression: the region that forms the content of culture and religion. "In the hierarchy of means serving to express the absolute, religion and the culture resulting from reason [i.e., philosophy] occupy the highest degree, much higher than that of art." One exception is the Greek moment, when art and religion coincide. But "the Christian view of truth . . . appears as beyond the stage at which art is the supreme mode of our knowledge of the Absolute."[64]

Art, according to Hegel, is thus close to the icon: the sensible rises toward the divine and enters art only at the state of ideality, of the abstract sensible. Art thus "lies nearer to the spirit and its thinking than purely external spiritless nature does." The matter it exerts itself on is "a spiritualized sensible appearance or a sensible appearance of the spiritual."[65]

The Hegelian definitions of art may be diverse, but they are equivalent. Revealing the truth, representing concretely and figuratively what moves the human soul,[66] and giving a sensible representation of the beautiful are all the same goal. Art is not a means in relation to an end: in it the end and means combine. In that sense, Hegel might have led some to the temptation of iconolatrous sin, which makes the image a direct emanation of its divine model (art proceeds "from the absolute Idea"), had he not firmly maintained the separation: "Art has to harmonize these two sides [the idea and its sensible representation] and bring them into a free reconciled totality." That is why art cannot be abstract, only sensible and concrete, not just in contrast to the intelligible, but in contrast to everything "simple and abstract." When we say of God only that he is one, or that he is the supreme being, we articulate merely a dead abstraction, which will provide art with no content. "Therefore the Jews and the Turks have not been able by art to represent their God, who does not even amount to such an abstraction of the Understanding, in the positive way that the Christians have."[67]

The idea, the spirit, the soul, the absolute, the divine, the beautiful, and truth are so many communicating realities. They form a world, of which the world of art is the reflection and the sensible realization. It is a world diversified into particular arts, but the absolute spirit of that world—namely, God—constitutes its center. "The region of divine truth, artistically represented for contemplation and feeling, forms the centre of the whole world of art. It is the independent, free, and divine shape which has completely mastered the externality of form and material and wears it only as a manifestation of itself." Yes, Hegel solemnly asserts, "the really solid centre is the presentation of the Absolute, of God."[68] There is no beautiful or true art that is not marked by an adequation between

the sensible and divine truth. And when that is no longer possible, as is the case today, there is no longer any art.

The Image of the Divine

When the artist seeks to represent God, he extracts from him, by breaking off and abstracting a part of his spiritual activity, an image that, emanating from the mind, will for that very reason be a divine image. The first work of art, the plastic image of the god, is "abstract." "The first mode in which the artistic spirit keeps its [plastic] figure and its active consciousness farthest apart is the immediate mode, viz., the figure is *there* or is *immediately* present."[69]

From the instant spirit is objectified in the work, the divine appears. But the historical transformation of images—the history of art—is not distinct from the transformation of the divine itself: history of the divine, odyssey of the spirit. Hegel divides that dual history into three moments: "symbolic," "classical," and "romantic." In the beginning was the "presentation of the Absolute, of God himself as God in his independence, not yet developed to movement and difference, . . . but self-enclosed, in grand divine peace and tranquillity." Then comes the "external surrounding world which must be built up, adequately to the Absolute," physical nature in the narrow sense, within the system of its external forms, capable of expressing the spiritual allusively, the "beautiful artistic enclosure for spirit." Then comes the moment of the "subjective inner life" of the "human mind," as the element in which the absolute resides and manifests itself. There is a corresponding system of particular parts: architecture presents itself to us first, then sculpture. The latter makes "bodily appearance immanent in the spirit" visible to the mind. It takes heavy, three-dimensional matter for its medium. Third come the arts that represent the soul in its "inner side of personal life." Painting begins that series, which abandons the dimension of depth and limits itself to surfaces, with the goal of offering the eyes an "inner" visible appearance, and which draws light from itself, brightness and darkness. Then, in the same sphere, music appears: its "proper element is the inner life as such, explicitly shapeless feeling." Finally, there is the culmination of art, which expresses itself through the word, poetry in general, "the absolute and true art of the spirit and its expression as spirit," the richest but least sensible of all the arts, filled with thought, determined, permeated by the idea.[70]

It follows that the plastic image of God appears in three principal states: shapeless, sometimes monstrous, in symbolic architecture and sculpture; perfectly formed and anthropomorphic in Greek sculpture; internalized and spiritualized in "romantic," that is, Christian, painting.

The symbol is a sign where the relation to the signified is already enveloped in the signifier in a certain manner. The lion is a natural symbol of magnanimity, the fox of cunning, the triangle of God, "when the determinations which religion apprehends in God are liable to *numeration*."[71] But the symbol must not represent the symbolized perfectly: in fact, it encompasses a host of other properties that have nothing in common with the idea—the lion is not just strong, the fox not just cunning, and not all of God's attributes can be expressed by number. There is a free play between the thing and its symbol: several symbols are possible for each thing, and several things are possible for each symbol. Neither the idea (the thing) nor the form (the sensible symbol) are expressly named, and their relationship is not expressly defined. When they are, we are no longer dealing with a symbol: the sensible object becomes an image, and the relation to the thing represented is that of "comparison." The two terms, idea and image, are both present but clearly separated, and lend themselves to a judgment of likeness.[72]

That simultaneous separation and presence to the mind requires a spiritual development that is lacking in symbolic art. The latter is fundamentally equivocal. Within the circle of initiates, the ambiguity of the symbol tends to vanish, because the link between the two terms becomes a custom or convention. Outside this circle, the beholder, standing before the immediate sensible representation, at first does not know what ideas to link to it. Confronted with a triangle, the beholder must be Christian, and moreover, must belong to a certain era, to link it to the idea of God. Every symbolic figure thus presents itself as a problem. It invites us to move beyond it, forces us to dimly seek its meaning. It places us in the same situation as the beholder who finds himself in front of a contemporary work of art; or rather, as we shall see, it is the contemporary work of art that places the beholder in the situation of primitive man before a statue of an unfamiliar god whose mythology he does not know.[73]

Symbolic art thus harbors a dissonance between the content—still vague and indeterminate—and the form, which is not homogeneous with it. "The symbolic stops short of the point where . . . it is free individuality which constitutes the content and form of the representation." It thus uses concrete forms taken from nature, then extends their meaning to the point of revealing a glimpse of the profound ideas. And these are religious ideas: "On its *objective* side the beginning of art stands in the closest connection with religion. The earliest works of art are of a mythological kind. In religion it is the Absolute as such, even if in its most abstract and poorest definition, which is brought to men's minds."[74] The natural human form, in all its deformations, is incapable of making the divine principle present and visible. It can only allude to it. Osiris is the sun, but

he is also man, and, moreover, the judge of the dead, all of which takes him away from nature and leads to an evolution by which he becomes the symbol of cosmic life. The Egyptian sphinx, with an animal's body and a man's head—as if the human spirit were struggling to emerge from the stupid form of the animal, but without attaining a grasp of its own perfect image—is a "symbol of the symbolic itself." It becomes an *enigma,* which the Greek myth and Oedipus decipher: the enigma of man. The Hindu imagination oscillates between an overblown idealism, where thought joins with divinity only by being swallowed up by the void, and an unbridled sensualism, where generative power (the sex organ), considered a divine attribute, "is reproduced in a host of representations in a completely physical manner."[75] To resolve the contradiction between the material form and the general abstract idea, symbolic art plunges into excess. "To reach universality, the individual figures are wildly tugged apart from one another into the colossal and the grotesque."

The symbolic is one of the three stages in the life of art (or of the absolute), but there are also three stages of the symbolic. In the first, the battle between the ideal content and the inadequate form is not perceived, only their identity, "the unity of the artistic content and its attempted symbolical expression—an enigmatic unity still undivided and fermenting in this contradictory linkage." The final stage begins when the progress of spirit puts an end to confusion: "Symbolizing therefore becomes a conscious severance of the explicitly clear meaning from its sensible associated image." Thus comparison intervenes, and the unconscious or "unreflective" symbolic completes its cycle, becoming the "reflective" symbolic: its manifestation, says Hegel, is "reduced to a mere *image.*"[76]

But between the two is an intermediate stage, the *sublime.* It is a moment of dazzlement. The representation—the work—appears as an object external to universal being, to the mind conscious of itself, which knows it is pure nothingness in relation to universal being, with no other goal than to manifest it and serve it. The work must appear as "the inherently deficient . . . although [the absolute] has for its expression nothing other than precisely this world which is external to it and null." This contrast gives rise to dazzlement, "the splendour of the sublime," which precedes the "comparison" in the narrow sense required by the image. Before the image can form, the medium of the symbol is, as it were, annihilated by the all-encompassing and confounding revelation of the inaccessible absolute. Only later, when the sublimity of the symbol has in some sense cooled, will art be able to make a choice among the objects of the sensible world and distinguish "phenomena which are allied to and yet distinct from the meaning," henceforth clear and domesticated as it were, "whose image they are to provide."[77]

In the sublime moment of symbolism, the spirit ecstatically grasps "the inherently substantial *unity*, which itself, as a pure thought, can be apprehended only by pure thought." In that sudden and overwhelming intuition of the One, any anchorage in a representation taken from the external world becomes ridiculous. The symbol no longer operates, and the symbolic in the narrow sense disappears.[78]

Two outcomes are possible: either the supreme principle so glimpsed reveals and manifests itself in all beings, in which case it maintains a positive relationship with them; or the principle rises so much higher than particular entities that they are only nothingness compared to it, in which case the relation becomes negative. The first case is pantheism, the second, monotheism.

The sublime is nothing but the annihilation of a sensible manifestation by the being it represents, so that "the revelation of the content is at the same time a supersession of the revelation."[79]

Just like Kant, Hegel posits the incompatibility of the sublime and the image. But he historicizes the sublime and establishes the conditions for its appearance. As Marc Sherringham has noted, he divides the two forms of the Kantian sublime into two moments in history. The "mathematical sublime," the sense of being flabbergasted before the absolutely "great"—and the aphasia that is its consequence—is located in the moment of the symbolic. The "dynamic sublime," the internal grasp by consciousness of its own greatness in the face of that same absolutely "great," is relegated to the time of romantic—that is, Christian—art. The sublime appears at a precise moment in the development of consciousness (and hence of art), as the consequence of the surging forth of the All, the still abstract Perfect. In the positive mode of pure pantheism, the All allows for no plastic representation. It does so even less in the negative mode of Jewish monotheism.[80]

In fact, for the first time, God appears "as the purely spiritual and imageless, contrasted with the mundane and the natural."[81] Standing before God, the finite creature has no stable existence; it is perishable, powerless, unjust, blind, next-to-nothing. It is at this point that the distinction between the beautiful and the sublime becomes more precise. In the beautiful, "the inner life pervades external reality, whose inner being the inner life is, in the sense that both sides appear as adequate to one another and therefore precisely as pervading one another. In sublimity, on the contrary, external existence, in which the substance is brought before contemplation, is degraded in comparison with the substance." All symbolic art is sacred, since its aim is to represent God, but when it attains the sublime it is sacred art par excellence, because it celebrates him more purely, though at the expense of its disappearance as plastic art, since

"God is explicitly without shape and is incapable of expression in his *positive* essence." Poetry, the sacred word, remains. It is not insignificant that the perfect example Longinus found for the sublime is the biblical "Let there be light!" and that divine glory, in opposition to the nothingness of every thing, forms the background for the Psalms, "a striking example of the sublime."[82]

At this point, however, symbolism succumbs to a crisis and falls again. When it becomes "conscious" and "reflective," the relationship between the two terms (idea and form), instead of taking root as an emanation from the nature of things, becomes an "accidental concatenation produced by the subjective activity of the poet, by the immersion of his spirit in an external world, by his wit and his invention in general." The seriousness of the symbolic, which had to do with the "objective" force of the relationship between terms, is weakened when this relation becomes manipulable and mental play. "Finitude is at once established." In the place of the *divine,* representable only by allusion, or even wholly unrepresentable, now stands the *god,* which is one with his representation.[83]

The Image of the God

"In symbolic art . . . spirit was not clear to itself and therefore did not show external reality to itself as its own, posited absolutely through and in spirit."[84] But there comes a moment when the relation between meaning and form finds its "classical" balance. The form in itself signifies spirit because it is the *human* form, "alone capable of revealing the spiritual in a sensible way." The perfect human body, animated and spiritualized by spirit, becomes united with it. Through it, "spirit has grasped itself as spirit" and "it is explicitly complete and clear."[85]

The idealization of the body, culminating in the Greek profile, the image of "the gentle and unbroken connection" of "beautiful harmony" between the upper and lower parts of the face, belongs to absolute beauty, because "the expression of the spirit puts the merely natural wholly into the background." The perfect human body is the adequate form, found at last, and image of the god. The task of classical sculpture, in fact, was to offer a vision of "the eternal powers whose untroubled dominion comes into view . . . in their own unalterability and intrinsic worth."[86]

The sculptor must show an impassive god, a face not marked by the insubstantial particularity of inclinations and subjective caprices—but, all the same, a not impersonal face, since spirit, as objective as it might be, exists only as subject. "This undisturbed and unparticularized being of the spirit is what we call divinity," and the sculptor must "present the Divine as such in its infinite peace

and sublimity, timeless, immobile, without purely subjective personality and the discord of actions and situations." These are individuals, but complete ones, perfect in themselves, at rest, freed from all alien influence, in an eternal light. Unlike men, the god in human form is concentrated in himself, elevated above finite existence, eternally happy, calm, and young. The Greek statue uses the human form: in contrast to symbolic representations, which only alluded to it, it represents "the *real* existence of spirit." But not of spirit in action: it refrains from introducing subjectivity and conflict. That is why, in showing spirit absorbed in the corporeal form destined to manifest "his entire appearance," it avoids his gaze, that is, "what is most full of his soul, the concentration of his inmost personality and feeling."[87]

Greek sculpture was, in the first place, a religious act. It constantly produced new images because "artistic creation and invention is itself a religious activity and satisfaction, and for the people the sight of such works is not contemplation merely but something intrinsic to religion and life."[88]

It was in Greece and only in Greece that art and the religious found perfect agreement; more precisely, it was there that the divine image found its only satisfying realization from both the theological and the artistic point of view, as the exact image of the god and as a beautiful work of art. Greek art is located at an equal distance from the old East, where the individual was annihilated before "universal substance," and the modern West, where there is a "deepening of subjective life in which the individual subject separates himself from the whole" and aspires to withdraw to a purely spiritual kingdom. That felicitous middle ground marks the propitious moment when beauty "builds its serene kingdom." It is a very short but an accomplished moment: Art "attains the summit of beauty and in the form of its plastic individuality." For a few fleeting years, the absolute manifests itself to men in the form of the beautiful; art and religion are one, since "Greek religion is the religion of art itself." Later, under Christianity, (romantic) art was not adequate to its task, charged as it was with the task of expressing "a higher form of consciousness than art can provide."[89]

That perfect art is an art of the beautiful, not of the sublime. The Greek god enjoyed a "spiritual *substantial* individuality . . . secure in its own universality." Spirit in the calm, serene human form is alone befitting spirit. It is thus beautiful and not sublime: the universal and abstract being, which denies the particular and, as a result, all *incarnation,* alone gives the spectacle of the sublime. The statue of the Greek god is the very image, the perfect icon, of the "wandering of an immortal god amongst mortal men."[90]

But this miraculous high point cannot last indefinitely. Classical Greek art contains the seeds of its own death. A melancholy, a sigh of sadness intermingles

212 • Chapter Six

with the calm grandeur of the image of the god. He is serene, cannot allow himself joy, enjoyment, inner contentment, which are the prerogative of finite existence. Peace becomes coldness, indifference toward what is mortal and suffering. Although individuated, the god is not yet altogether a person, and, in the long run, he cannot without contradiction be happy and have a body. The plurality of gods and their relationships with one another contradict divine plenitude and compromise their greatness, their dignity, and, finally, their beauty. Silent sadness, coldness, the lack of life in the image of gods are the sign that destiny hovers over them: "An immortal seriousness, an unchangeable peace is enthroned on the brow of the gods and is suffused over their whole shape." Yet this destiny is impenetrable to them, and they can only abandon themselves to it. By means of a disorder inherent in the particular and individual side of their nature, they let themselves be drawn into the external accidents of human life, into the imperfections of anthropomorphism, into states contrary to the idea of God and his divine plenitude.[91]

Gradually, the classical pantheon became corrupted, began to grimace or, worse, to look artificial and empty. Faith in incarnated beauty dissipated all the more completely in that the religion of the beautiful is not capable of satisfying the human soul as a whole. As concrete as he might be, the god remains abstract for the soul, because the soul finds nothing in him corresponding to its experience of unhappiness, of suffering, which, it knows, does not deprive it of its dignity, very much to the contrary. Gradually, the soul suspects the hollowness of the idol hiding behind the god's beautiful, impassive face. Classical art dissolves, and the assembly of gods is forever dispersed.

The Image of God

With respect to the principle of representation of the Christian God, which is, after all, the God that philosophy ratifies, Hegel proves to be rigorously orthodox: what makes the plastic image of God possible is the Incarnation. When he goes into the details and history of that representation, he is beholden to the tastes of his time. He is a romantic, and his vision of the Middle Ages centers on the pathos of fourteenth- and fifteenth-century *devotio moderna,* on the Gothic of the northern countries, colored, moreover, by Lutheran sentimentalism.

Absolute spirit "reconciles with itself" when God appears on earth. Absolute reality combines with human and subjective individuality. A man among men is God, and God is a real man. When God becomes flesh, the purpose of divine thought, which is man, and the destiny of man, which is the union with God, are realized. It is no longer an abstract idea, a goal, but a fact: a real and living

man. In the model of Christ, "each individual must find the image of his union with God, which is no longer merely possible, but real." Hegel seems much more orthodox at this point than Kant, for whom Christ is not God become man, but the master, the ideal of a divine man whose will was directed solely by respect for the law. If there is heterodoxy, it lies elsewhere, in the system as a whole, not in one declaration or another, in which Theodore Studite would have found nothing to complain about. In fact, the "reconciliation" of the two natures lies in the person, and it is the person that allows an individuated representation of the divine, a corporeal divine.[92]

What "romantic art" represents is the history of a man who suffers and dies, "but conversely through the grief of death rises out of death, and ascends as God in his glory, as the actual spirit which now has indeed entered existence as an individual, as this subject, yet even so is essentially truly God only as Spirit in his Church."[93] This can be read as good Lutheran faith—but also as the divine's final assumption into the community, which opens a path downward, toward later atheologies, toward the death of God and the Resurrection, interpreted as a symbolic and subjective event.

There is the same ambiguity in the relation between that art and faith. But although the history of Christ is the subject of romantic art, art is secondary and separable from faith, which resides in the most intimate part of the soul. "If it is a matter of the consciousness of *truth,* then the beauty of the appearance, and the representation, is an accessory and rather indifferent." Truth is independent of art: Hegel thus marks his distance from iconophilia of the Eastern type— where the icon is a simultaneous epiphany of truth and beauty—and is more in agreement with the moderate program of the Roman (and Lutheran) Church, which assigns art a pedagogical, illustrative role, a spur to memory and piety.[94]

Greek art and Greek religion intermingle; in contrast, Christian art is not Christian religion. Nonetheless, according to Hegel, it needs art. Christian art pushes anthropomorphism to a higher point than Greek art, and more legitimately so, since the Incarnation is real. There is no longer anything abstract or ideal about it, as was the case for the statue of the god. What was represented was a person, not the idea of a divine nature: "The Divine must be presented in this its individuality, bound as it is to the deficiency of nature and the finite ['circumscribed,' Byzantium would have said] mode of appearance." Art provides the spectacle of an "actual individual shape, a concrete picture too of the external features of the events in which Christ's birth, life and sufferings . . . are displayed." Hence, it is only in art that the real and fleeting manifestation of God "is repeated and perpetually renewed."[95]

In wishing to represent the traits of a particular man, Christian art finds itself

invaded by all the accidents and particularities of the external world, from which the beauty of classical art had liberated itself. The face of Christ cannot be an "ideal beauty" since it must express a subjective and individuated personality. At best, it occupies the middle ground between natural particularity and ideal beauty. In a certain way, the external form is a matter of indifference. The problem is to express depth through ordinary materials, to breathe a spiritual life into figures, and to "make the most spiritual things perceptible and comprehensible."[96]

The climax of the life of God is the Passion, "when he ceases to be that determinate man." Christ—beaten, crowned with thorns, crucified—and the hideous faces of his enemies dispel any idea of the beautiful in the Greek sense: "The unbeautiful appears as a necessary moment." But the ugly is transfigured by the holiness that surrounds the scene, by the "infinity of grief, present as an eternal moment in the spirit as sufferance and divine peace."[97]

It is difficult for the artist to show the fusion of the divine and the human in death. The Resurrection is, Hegel bizarrely assures us, a more favorable subject, even though Eastern iconography refuses to represent it. Probably because of the metaphysical gravity of the icon, such an event is properly unrepresentable, since it involves moving dangerously close to the *invisibilia* of God. But since that gravity is not in art, according to Hegel, but in internal faith or conceptual thought, the artist has the right to suggest, with all the technical means at his disposal and all his ingenuity, the "ideality" of such a scene.[98]

Christian art wishes to give spirit a spiritual existence that is not just "pure idea" but that is accessible to sensible perception. It must find the means to express through form the interiority of spirit, and the only interiority that corresponds to the concept of free spirit, that is, *love,* "subjectivity which reconciles with itself in another." The absolute is love, "the Spirit which only in another spirit is the knowing and willing of itself as the Absolute."[99]

God is love. Christ is God incarnate. But the love of Christ has two objects, God and humanity in need of redemption. Also, Hegel maintains, Christ represents love in its universality, incarnates the very idea of love, but cannot represent "the absorption of one person in another." That is why the most accessible deponent of that divine love is Mary. At this point we find Hegel's outpouring of an altogether Lutheran tenderness concerning the maternity of Mary, whose love is at once natural and supernatural.

> A pure forgetfulness and complete self-surrender which still in this forgetfulness is from the beginning one with that which it is merged and now with blissful satisfaction has a sense of this oneness. In such a beautiful way maternal love, the image as it were of the Spirit, enters romantic art in place of the

Spirit itself because only in the form of feeling is the Spirit made prehensible by art, and the feeling of the unity between the individual and God is present in the most original, real, and living way only in the Madonna's maternal love.[100]

That is why this image is radically different from the two images symbolic and classical art propose on apparently similar themes: Isis holding Horus on her knees shows no visible internal feeling; Niobe, having lost her children, simply retains the unchanging grandeur and beauty of pure existence. Her individual sorrow and beauty "turn into stone," whereas the suffering of Mary expresses the idea not that she *has* love but that "her whole inner life *is* love."[101]

The Depletion of the Divine Image and the End of Art

Christian art vanishes in turn, Hegel claims, along with faith, not only the artist's personal faith but also that of the era, the century, the people. "So long as the artist is bound up with the specific character of such a world-view and religion, in immediate identity with it and with firm faith in it, so long is he genuinely in earnest with this material and its representation; i.e. this material remains for him the infinite and true element in his own consciousness." But when we moderns wish to represent a Greek god, or when Protestants wish to represent a Virgin, "we are not seriously in earnest with this material. It is the innermost faith which we lack here, even if the artist in days when faith was still unimpaired did not exactly need to be what is generally called a pious man." The true work of art can arise only from interiority, from the subjective sincerity of the artist who believes in his object, who is one with it and produces it as a natural force. Apart from that, there is nothing but artificiality.[102]

Obviously, Hegel judges that this faith, as it existed in the "romantic" age and as it produced the image of God, is now past, and that it is pointless to resuscitate it. Today it would be only a false faith, its inauthenticity denounced throughout history, and it would produce only a false art.[103]

For Hegel, this had to be so. In his view, there is no contradiction in the fact that he uses the most traditional religious language and so easily propounds the dogma justifying the icon of Christ. His Lutheran orthodoxy, which he always confessed, does not cost him very much, since he places himself on a higher plane, then condescends to speak that language, the way one adopts children's ways of reasoning and speaking. Or rather, he behaves like the sociologist or historian who does not want to commit an anachronism and who profoundly embraces the "mentality" of an age but without committing himself to it. Moreover, he would say that, because religions contain a foreshadowing of truth,

which the analysis discovers even in the lower realms of religious life, the philosopher must adopt a benevolent attitude toward them. He does not even have contempt for the crudest popular sects. Hegel stands as a model for the skeptical sympathy professed by French-style enlightened antireligion, in the persons of Saint-Beuve, Renan, and Anatole France.

According to Hegel, religions in the plural constitute *moments* in the development of religion as such. But that evolution has an end, namely, Christianity, which is the perfect, absolute, "manifest" religion. It is the revelation of spirit, of its threefold movement, expressed in the dogma of the Trinity, of its fusion of the divine and the human, expressed by the Incarnation. One cannot hope for a more perfect religion than Christianity. Hegel does not wish for a new revelation, and he challenges religion within the limits of the reason dear to the *Aufklärung.* He is Protestant: Luther restored the old interiority of the Germanic people, in contrast to Catholicism, which represents a transcended stage of "exteriority." But one must not expect a religious transcendence of Christianity. The only transcendence conceivable, which will be solely that of an elite, is the advent of reason. Christianity collaborates, in the capacity proper to it, in the construction of a well-ordered society of free and rational men.[104]

Christianity is the most respectable exoteric form of Hegelian esotericism. That is why Hegel has no trouble being outwardly more orthodox than Kant: Kant embraced that religion with reservations, whereas Hegel borrows from it all the more generously in that he does not belong to it. He belongs to his system. As in the case of the ancient Gnostics, it is impossible to find him wanting, since he does not hesitate to repeat the most straightforward confessions of faith, provided he can give them a meaning other than the usual one. That is also the case for dogma. Nonetheless, the touchstone is Christ. And Christ, according to Hegel, cannot be the definitive God. As a result, the image of Christ is also not the adequate divine image.

Of Christ, Hegel knows primarily the Passion. In the dialectical movement, Christianity comes after the Greek god and is the negative moment, the rupture with the world. After the image of Christ and the image of the Virgin, the image of the martyrs presents itself. "In martyrdom, this negative—grief—is an end in itself and the magnitude of the transfiguration is measured by the awfulness of what the man has suffered and the frightfulness to which he has submitted. Now given his still unfulfilled inner life, the first thing that can be negatived in the martyr, with a view to his sanctification and his release from the world, is his *natural* being, his life, and the satisfaction of the most elementary needs necessary for his existence."[105]

Christianity is dolorous, according to Hegel, because Christ is impotent. He

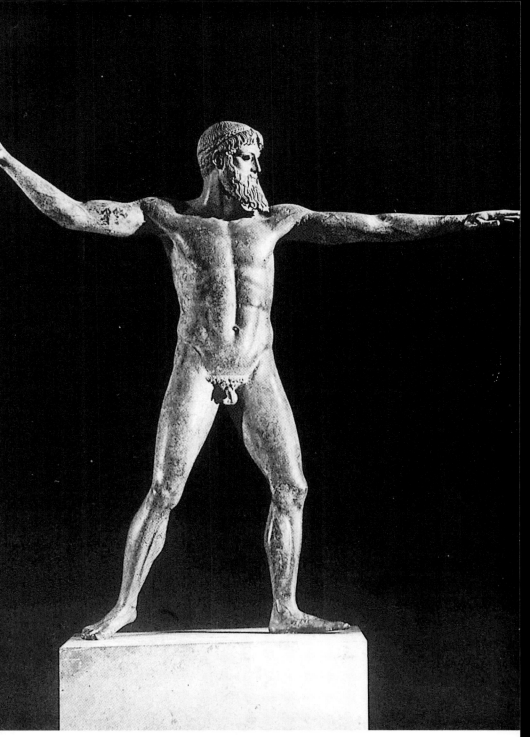

Zeus or *Poseidon.* Greek bronze, about 460 (D.R.).

Triumphant Emperor Surmounted by Christ (detail). Ivory, Constantinople, sixth century (Doc. Giraudon).

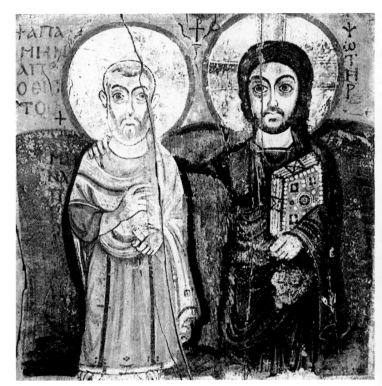

The Christ and Abbot Mena, Bawit monastery, Egypt, paint on wood, sixth to seventh century (D.R.).

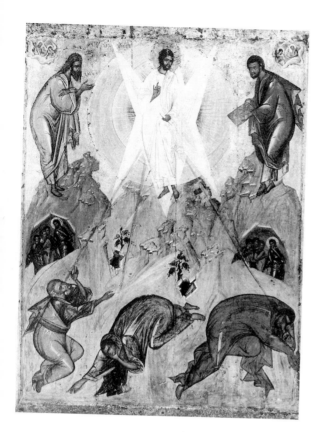

The Transfiguration, Russian icon from the school of Feofan the Greek, about 1400 (D.R.).

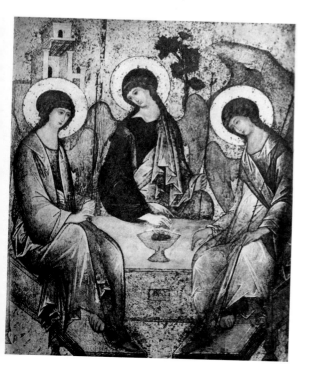

Andrey Rublyov, *The Old Testament Trinity,* Russian icon, early sixth century (Doc. Giraudon).

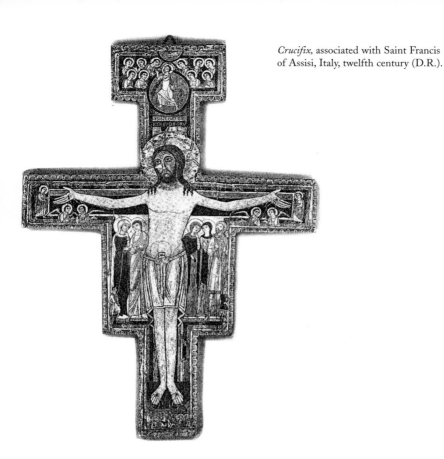

Crucifix, associated with Saint Francis of Assisi, Italy, twelfth century (D.R.).

Crucifix, said to be from Courajod, France, twelfth century (D.R.).

Grünewald, *Crucifixion,* detail of the
Isenheim altarpiece, 1512–16 (Doc. Giraudon).

Raphael, *Disputà*, also called *Triumph of Religion*,
1509, Stanza della Segnatura, the Vatican (Doc. Alinari-Viollet).

Raphael, *The School of Athens* (detail), 1509–10, Stanza della
Segnatura, Vatican (Doc. Giraudon).

Millet, *Shepherdess Seated*, 1858–60 (Doc. Giraudon).

Vincent Van Gogh, *The Starry Night*, 1889 (D.R.). Oil on canvas, 29 × 36¼″ (73.7 × 92.1 cm). The Museum of Modern Art, New York. Acquired through the Lillie P. Bliss Bequest. Photograph © 2000 The Museum of Modern Art, New York.

Rossetti, *Ecce Ancilla Domini*, 1849 (D.R.).

Hunt, *The Light of the World*, 1853–56 (D.R.)

Burne-Jones, *The Garden*, 1871–90 (D.R.).
The Faringdon Collection Trust. Photograph: Photographic Survey, Courtauld Institute of Art.

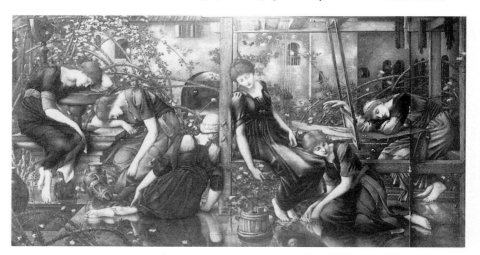

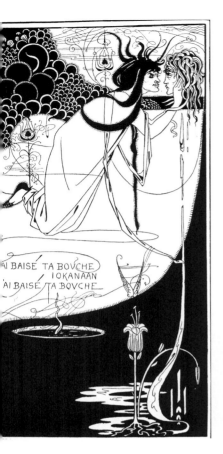

Beardsley, *I Kissed Your Mouth,
Iokanaan*, 1892 (D.R.).

Rossetti, *Astarte Syriaca*, 1877 (D.R.).

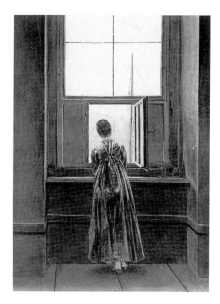

Friedrich, *Woman at the Window*, 1822 (D.R.).

Friedrich, Teschen altar-
piece, 1807–8 (D.R.).

Friedrich, *Mist Rising over the Riesengebirge,* 1820 (D.R.).

Gauguin, *The Yellow Christ,* 1889 (D.R.). Oil on canvas, 36¼ × 28⅞″. Albright-Knox Art Gallery, Buffalo, New York, General Purchase Funds, 1946.

Klinger, *Salome* (detail), 1909 (D.R.).

Klimt, *Judith II*, 1909 (D.R.).

Toorop, *The Three Fiancées,*
1893 (D.R.).

Stuck, *The Sin* (detail), 1903 (D.R.).

Kandinsky, *Life in Colors* (detail), 1907. © Artists Rights Society (ARS), New York/ADAGP, Paris.

Kandinsky, *Red Blot II*, 1921. © Artists Rights Society (ARS), New York/ADAGP, Paris.

Malevich, *Quadrangle,* also called
Black Square, 1915 (D.R.).

Kazimir Malevich, *Suprematist Composition: White on
White,* also called *White Square,* 1917 (D.R.). Oil on
canvas, 31¼ × 31¼″ (79.4 × 79.4 cm).
The Museum of Modern Art, New York. Acquisition confirmed in 1999
by agreement with the Estate of Kazimir Malevich and made possible
with funds from the Mrs. John Hay Whitney Bequest (by exchange).
Photograph © 2000 The Museum of Modern Art, New York.

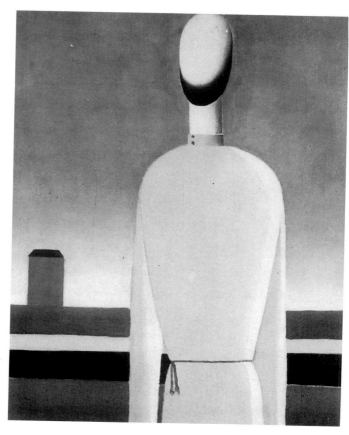

Malevich, *Complex
Presentiment,* about 1930
(D.R.).

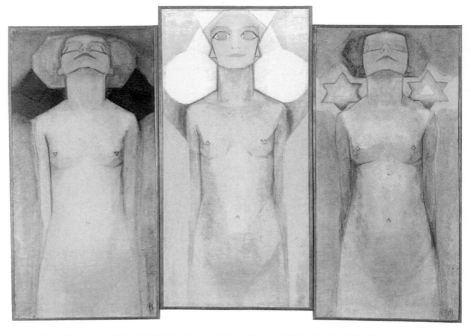

Mondrian, *Evolution*, 1910–11 (D.R.). © Artists Rights Society (ARS), New York/Beeldrecht, Amsterdam.

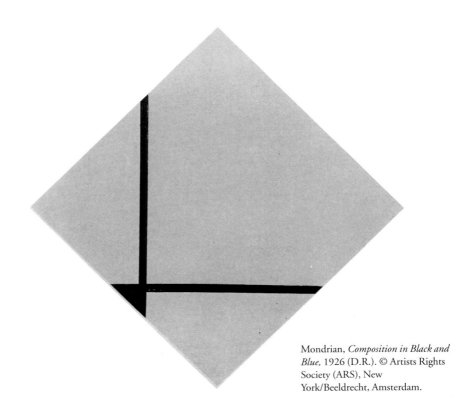

Mondrian, *Composition in Black and Blue*, 1926 (D.R.). © Artists Rights Society (ARS), New York/Beeldrecht, Amsterdam.

is a figure of ideality, without real power over the world. In no wise is he the Lord, the master of history, the Pantocrator. He does not save. The Cross, so long a symbol of victory, is seen by Hegel as a gallows of defeat, inviting man to imitate Christ's suffering and reject the full hope in the next life. Hegel's Christ is one of the first romantic Christ figures: subsequent images will be Dostoyevsky's idiot, Wagner's Parsifal, and the "crucified" who disgusted Nietzsche. He is also a kind of Kaspar Hauser who has fallen into this world and vanished without a trace: a Gnostic Christ, a fleeting emanation of the good God, and his messenger in a bad world.[106]

Hegel's personal idea of Christ is not to be found in the *Aesthetics,* even though this idea directly governs his vision of "romantic art"; rather, it is in his early theological text, *The Spirit of Christianity and Its Fate* (1796–99). Christ appears in this work as the "beautiful soul" par excellence. I shall cite only one passage, for its great beauty and because it establishes a parallel between the disappointment caused by the inadequacy of the Greek god and that left behind by the inadequacy of the Christian God. At issue are a broken statue of Apollo and the Holy Communion:

> When the Apollo is ground to dust, devotion remains, but it cannot turn and worship the dust. . . . After the supper the disciples began to be sorrowful because of the impending loss of their master, but after a genuinely religious action the whole soul is at peace. And, after enjoying the supper, Christians today feel a reverent wonder either without serenity or else with a melancholy serenity, because feeling's intensity was separate from the intellect and both were one-sided, because worship was incomplete, since something divine was promised and melted away in the mouth.[107]

There can be no definitive image of God, because God is never definitive. He is a logos, a concept, an evolving *Begriff.* All the authentic images of the divine, in their infinite variety, supposedly referred to one God, the same for all eternity. Hegel arranges these images into the chronological order of human history, which coincides with the chronology of God himself. All are justifiable; not one is true. Or, if they are true, they are so in relation not to God but to the artist who conceives them as his age allows him to do, whose conception, within these limits, is "true."

This theological bias determines the composition of the Hegelian museum. Unlike Kant, about whom one may wonder whether he ever saw a painting, and who, in fact, did not have the opportunity to see many of them in Königsberg where he lived, Hegel knows the history of art. His white Greek statues, devoid of gaze, come from Winckelmann and contemporary museums of sculpture. What he calls "romantic art" is medieval art, and primarily its late German,

Rhenish, or Flemish branch, which, in his time, was considered the primitive stock. The "classical" Gothic of Rheims or Amiens might have put him in a difficult position, since these calm, serene figures do not fit the system. Much more astonishing in Hegel is the almost complete omission of Italian art, which occupies only a few pages in the voluminous book. He rapidly characterizes it as a successful compromise between classical and romantic art, between "natural beauty" and the "adornment of the inner life by the deep feeling of religion, by that spiritual trait of a more profound piety."[108] That art does not offer a pure type capable of sustaining the philosopher's meditation. The agreement between interiority and the sense of corporeal life appears laudable to him but marginal to the main current. Regarding da Vinci, Raphael—where the balance reaches its perfection—Correggio, and Titian, Hegel confines himself to a crudely sketched art criticism without delving very deep.[109]

As a Protestant, he conceives of a Christianity that stands in sharp contrast to paganism. There is no Catholic-style assumption, only complete elimination. As a philosopher, he accentuates the contradiction and the negative moment. He considers the cozy cohabitation of ancient gods with Christ as Raphael depicted it, or of sibyls and prophets on the ceiling of the Sistine Chapel, to be a syncretism without interest and a nonfulfillment of the Christian idea. That illuminates the two a priori decisions dominating Hegelian aesthetics: first, the attribution of the beautiful to art, to the exclusion of nature; and, second, a gradual subjectification. As art dematerializes, as architecture gives way to sculpture, then to painting, then to music and poetry, the heart of the image moves deeper and deeper into the human soul. By the end, the complete image of God is the concept, the *Begriff* that unfolds in the philosopher's mind and becomes identical to the unfolding of the absolute itself. Hegel's aesthetics intersects that of Plotinus in the fact that the work of art evaporates. But he is careful to situate that fulfillment in history. It is here and now, at the moment when Hegel is speaking, that one can say: "Art, considered in its highest vocation, is and remains for us a thing of the past."[110]

When an art cycle reaches its end, that is, when the "content" is not sustained by an adequately serious belief and faith, poetry evaporates and leaves the artist facing a prosaic world. Satire appeared toward the end of classical art: the artist isolated himself from a world that no longer suited him, withdrew into himself, condemned himself to a free, but limited and finite, existence. "Contrasted with [the artist] there is an equally finite reality which now on its side becomes free, yet just, because the truly spiritual has reverted out of it into the inner life and no longer will or can find itself in it; this reality appears as a godless one and a

corrupt existence." The artist then vainly denounces the corruption of time: a tragedy without resolution, which drives him deeper into prose.[111]

As Christian art falls, the novel rises in parallel. This modern epic presupposes a prosaically organized society, in which the author seeks in vain to restore poetry's lost rights. That is why its subject is often "the conflict between the poetry of the heart and the opposing prose of circumstances and the accidents of external situations." The discordance is resolved, sometimes tragically, sometimes comically. At least, in the absence of poetry, reality overcomes the platitudes of prose and, inasmuch as it is real, recovers the path of beauty and art.[112]

Nonetheless, Hegel is not content to impute the end of art to a new social climate, or even to the depletion of Christian faith. He wonders how the disappearance of the image of God has led to a disordering of the plastic arts as a whole. The response is found in the process of subjectification, which he himself posits as a necessary development of both the image and of art. The burying away of the Idea of God in the human soul, the gradual reduction of that image to the concept, then the historicist vaporization of the concept mean that there is no longer anything in the artist's soul besides his own interiority. When the divine Idea passes into it, there remains a trace, and, to use a Freudian term, a "decathexis" of the external world. Within the framework of the classical cycle, that world was organized and stabilized by the divine, "full of gods" (Thales). It was, says Hegel, "its own inner subjective formation" and formed a single solid, interdependent world with it. But, since the Christian soul has withdrawn into itself, "the entire material of the external world acquires freedom to go its own way and maintain itself according to its own special and particular existence." The world deserted by the divine proliferates anarchically in various objects. In addition, the need for representation persists, but "subjective inwardness of heart becomes the essential feature to be represented," regardless of the external objects to which representation clings and for which it serves as support. What becomes a matter of interest, the only thing the artist wants to bring out, is his "own subjective formation, the spirit's expression and mode of receptivity, and not an objective and absolutely valid subject-matter." Anything at all becomes an object of art. In the painting of the Nativity, along with the Child and his Mother, "oxen and asses, the manger and straw must not be left out." "Within this contingency of the objects . . . there is presented the collapse of romantic art."[113]

But art falls even farther when it is no longer the artist but only his technique that becomes a goal and holds people's interest. His skill, his technical means claim to rise to the rank of a work of art. The artist confines himself to displaying his talent, and when that surface skill is taken for the very content of repre-

sentation, art falls into the domain of humor and caprice. Subjectification and secularization thus converge in a general crisis of art: "The spirit only occupies itself with objects so long as there is something secret, not revealed, in them. This is the case so long as the material is identical with the substance of our own being." But now, "the content is exhausted, . . . everything is revealed, and nothing obscure." Then, the "liberated" artist adopts an attitude of opposition to these deconsecrated contents, just as Lucian turned against the Greek past and Cervantes against chivalry. He becomes revolutionary, and, in later parlance, avant-garde. "Criticism . . . and freedom of thought have mastered the artist too, and have made them, so to say, a *tabula rasa* in respect of the material and the form of their productions."[114]

Every traditional content and form is a thing of the past for the modern artist, and he himself feels free to make use of them or not. "The artist thus stands above specific consecrated forms. . . . Every material may be indifferent to him if only it does not contradict the formal law of being . . . capable of artistic treatment." He draws as he likes from the reservoir of forms that the museum offers him, which relativizes every subject and every style in relation to the formal law that requires it to be beautiful.[115] At his own expense, and braving every sort of danger, the artist, emancipated from rules and beliefs, considers them materials, "mere moments"; he "ascribes value to them only on the strength of the higher content which in the course of his re-creation he puts into them." In other words, having lost his point of reference, the image of God, he is obliged to re-create everything, rules and values; he is condemned to be a *genius* in the Kantian sense of the term.

All the same, Hegel, who is always concerned not to let any aspect of reality escape him, cannot avoid taking another kind of art and painting into consideration. Although not under the sway of the system, this art nonetheless exists. Is it great art? This kind of painting is to great art what the novel is to the epic: it is valid for the "reality" it transmits.

This kind of painting is no longer nourished by religious objects, but by the physical objects of external nature that have an affinity with spirit. "It is the free life of nature which appears in them and produces a correspondence with the spectator who is a living being too." They are landscapes, genre scenes, which translate "the life and joy of independent existence." Paintings that abandon lofty subjects can compensate, in some sense, by being good paintings. They seek perfection by fixing on canvas the most fleeting changes in the sky during different hours of the day. At this point, painting moves from the ideal to reality without falling to the level of simple mechanical skill, since it is "the undivided concentration of the whole soul on the tiniest and most limited things [and] . . .

a through and through living characterization in the greatest truth of which art is capable."[116]

The painting of the Netherlands explored this path better than any other. This happy, free country wished "in painting too to delight in this existence which is as powerful as just, satisfying, and comfortable." "In this very heedless boisterousness there lies the ideal feature: it is the Sunday of life which equalizes everything and removes all evil." In that sort of painting, Hegel adds, lies "the vision of what man is as man."[117]

But does it not also show God by that very fact? Hegel does not think so. The relationship within which the divine image is conceived is between the soul and God. Hegel remains within the tradition of Plotinus and Origen, at the end of which the image is jettisoned and vanishes into the concept or into ecstasy. He rejects the third point, which is the world—the world that loudly proclaims the glory of the Creator—and which, since Augustine, has (along with God and the soul) grounded the triangle of representation at the place where European art rests and endlessly renews itself.

In the Shadow of Kant and Hegel

It was necessary to consider Kant and Hegel at length because these two philosophers of enormous stature have, by a remarkable stroke of luck, laid new foundations for the philosophy of art and determined, from within that philosophy, the place for the image of God. Did they also determine the direction taken by nineteenth-century art?

It is not easy to analyze the great philosophers' influence. One might suppose that the spirit of the time was concentrated within them. That is a Hegelian way of looking at things. Or that they give us the keys to think about what was happening around them and after them. Or that they influenced artists through their philosophies, by means of go-betweens or the intermediary of more or less inferior or distant disciples. These three explanations encounter strong objections. Other philosophers around Kant and Hegel thought differently. It is not necessary to refer to Hegel and Kant to understand modern art. The intermediaries were unfaithful, and the artists unconcerned by them: Taine read Hegel ("Every work of art belongs to its own time, its own people, its own environment," writes Hegel),[118] but would we ever think of calling some impressionist or another "Tainian"? Schiller's and Schopenhauer's works were far more widely read than the *Critique of Judgment* or the *Aesthetics,* which were largely inaccessible.

We will therefore leave the question hanging. But we may well wonder what art (or the image of God) becomes if it submits, in one way or another, to Kant-

ian and Hegelian principles. From the point of view of orthodox theology, Kant and Hegel are iconoclastic in various ways, one on principle and the other with regret. Kant is so officially. On the Second Nicene Council he mounted a frontal attack, Calvinist in spirit and thus "heretical" (the image is unworthy of divine majesty). Hegel is practically and "gnostically" iconoclastic. The image of God may have existed in the past, but it is not clear whether the image was of God, and if so, whether that image was an image or God himself. In any case, for Hegel, it is over now: God today escapes the image and the image escapes us. For both Kant and Hegel, there is no divine image, past or present, whose legitimacy and validity the beholder of today can declare in philosophical terms.

But the iconoclastic influence these two great men exerted was not that of prohibition or direct disqualification. More profoundly, they oriented art in such a way that the representation of God, naturally, and then of every thing, became increasingly problematic, to the point that art itself (or at least figuration) was reduced to a feverish and desperate search for the means of escaping annihilation.

Although he did not wish to do so at all—since he did not dogmatically establish their absolute supremacy—Kant bequeathed a double injunction to the artist: genius and the sublime. Genius had always been requisite, but within the framework of rules it consisted of a greater capacity to obey, a greater ease in execution, and an ability to achieve perfection. But Kantian genius is not guided by rules, it sets them.

Every genius begins art again from scratch. "Genius is a *talent* for producing that for which no definite rule can be given; it is not a mere aptitude for what can be learned by a rule. Hence *originality* must be its first property."[119] Kant adds that the work of genius is exemplary and must be proposed for others to imitate. But no artist of lofty ambitions will wish to imitate, if there is such a difference of nature and value between talent and genius. Being an artist is no longer worth the trouble. Thus a culture of genius came into being. It obliged the artist to invent his own style, rhetoric, and technique, in such a way that new rules could be extracted from his art. Since genius sets its own rules for art, art, to prove it is itself ingenious, must display its rules. There will therefore be a necessary didacticism in painting, reinforced by manifestoes or the formation of militant schools and movements, which constitute so many different systems. Thus one of the roots of the era of "isms" lies in Kantianism. The burden to create rules and reinvent everything weighs heavy on every artist and monopolizes a large part of his creative energies even before he is able to create.

The transmission of the craft of painting has become risky, since apprenticeship serves primarily to create a favorable environment in which the sudden

combustion of genius may perchance occur. It also obliges the artist to take on the trappings of genius, as if in an act of propitiation, that is, to prove he is temperamental, unpredictable, disdainful of urbanity and social conventions, ill, unhappy: the secularized version of the saint's eccentricity. That is what the public, which participates in the culture of genius, expects from him.

So much for the artist *subject,* already a heavy burden. But with respect to his *object* the imperative is even more overpowering, since the category of the sublime leads inevitably to a devaluation of the beautiful. A mind capable of beauty cannot measure up to a mind capable of the sublime, able to apprehend what is "absolutely great." From these lofty heights, the sublime mind will contemplate with disdain the lukewarm, restricted, dreary regions of the beautiful, which open no window on the infinite expanse of the world or of the heart. The artist must downgrade a large part of his museum. He can no longer be guided by the vast majority of works it contains, which, even though polished and accomplished, do not bear the mark of genius or the great flashes of the sublime mind. That is how the nineteenth century, though it put together vast collections and created great museums, produced a race of artists who consented to admire absolutely only a few "beacons" (as in Baudelaire's poem by that name), and their rare and ardent sobs "that roll from age to age," coming to die on the brink of divine eternity.

And yet, if one rises ever higher and if, via the path of the sublime and of genius, one approaches peak spiritual experiences, the paintbrush falls from one's hands. In fact, according to Kant, but also according to Hegel, the sublime excludes the image and resolves itself in a mystical attitude of pure negative contemplation. That is what happens to Frenhofer, the painter in Balzac's *The Unknown Masterpiece.* When the absolute painting on which he worked his whole life is finally discovered, it no longer represents anything. It has ceased to be an image.

If the same artist, bowing under the weight of Kantianism, turns to Hegel, he will find little comfort there. He will have radiated genius and entertained the most sublime feelings, but in vain; what is the point, if the age condemns him and if great art is a thing of the past? It is the divine Presence that makes art possible. Since the death of the ancient gods, that Presence has deserted nature, and, in its Christian form, has separated man from the world and confined him within his interiority. In addition, as it gradually manifested itself, it revealed the inadequacy of representation and disqualified the image. Natural beauty is excluded, divine beauty—which governs artistic beauty—inaccessible. In the end, we have entered a world of prose, where mystery, flattened, has lost its productive obscurity, where faith has definitively cooled. The tasks required of hu-

manity no longer include art, which belongs to the past. The nostalgia for the image that permeates Hegelianism is all the more poignant in that art and the artist have never before been placed on such a pedestal, from which they must now step down again.

In Byzantine theology, the power and efficacy of the icon came from God himself, whose energies animated the wood and colors via prayer and the iconographer's art. With Hegel, there is the same divine energy, but it emanates directly from the artist's soul. During the three great cycles of art, the artist was more than the priest of the divine, he and his work were its living epiphany. Art is the expression of God, but, since God is change, the model has moved before it can be fixed in the image, it has become "blurred" (as in a photograph), and all that remains of this state of the divine is the series of images. The history of God can be grasped only through the history of art, at least until the point when God disappeared and dragged art along with him. During all that time, there was something divine about the artist, a divinity that culminated in the classical age, when he was the inventor and repository of religion. The museum survives from that time, as the last religious site of the modern world, where man comes to recharge himself from the sacredness deposited in images, and to which philosophy gives him final access.

Hegel thus thought he was concluding the chapter on art at the same time that he was putting the final touches on philosophy. But even as he marked its death, he defined with phenomenal perspicacity all the paths that nineteenth-century art would take, in the almost always futile hope of surviving.

1. The first approach was to resuscitate the dead body and continue to pursue Christian art. That is what the Nazarenes of Hegel's day attempted, as did the Pre-Raphaelites later and, in their own way, the symbolists. But, says Hegel, "it is . . . no help to [the artist] to adopt again, as that substance, so to say, past world-views, i.e. to propose to root himself firmly in one of these ways of looking at things, e.g. to turn Roman Catholic as in recent times many have done for art's sake in order to give stability to their mind and to give the character of something absolute to the specifically limited character of their artistic product in itself." They will fabricate a counterfeit romantic art, a counterfeit sacred art.[120]

2. The second approach has been to return to "symbolic" art. For Hegel, symbolic art was the preclassical art of the Egyptians and Indians. The advances in museography added Mesopotamian, Chinese, pre-Columbian, African, and, in general, all the so-called primitive arts. What characterizes that art, according to Hegel, is the obscurity of the content, combined with a very keen sense, on the artist's part, of the sacred. The sacred survived the depletion of Christian faith.

This primitive sacredness, which frees the artist from too precise a definition of his theology, gives him access to great art, to a palpable divine Presence, in exchange for a drastic regression of religious consciousness. The primitive work of art, according to Hegel, was ahead of the still muddled content of religion. The modern world of art (surrealism, for example) offers itself as a religious object in quest of an enigmatic content. It is a stela to the unknown god. The twentieth-century vogue for black African arts, for the icon (whose exact status is not well known), for primitivism in all its forms, can thereby be explained. Similarly, the desire to imitate the primitive artist's formal style, in the hope of capturing the energy of the unknown god through the violence of the procedure, accounts for a few aspects of expressionism.

3. The third approach, which is not necessarily distinct from the second, is the quintessential approach of the modern, post-Christian artist:

> The artist need not be forced first to settle his accounts with his mind or to worry about the salvation of his own soul. From the very beginning, before he embarks on production, his great and free soul must know and possess its own ground, must be sure of itself and confident in itself. The great artist today needs in particular the free development of the spirit; in that development, all superstition, and all faith which remains restricted to determinate forms of vision and presentation, is degraded into mere aspects and features. These the free spirit has mastered because he sees in them no absolutely sacrosanct conditions for his exposition and mode of configuration, but ascribes value to them only on the strength of the higher content which in the course of his recreation he puts into them as adequate to them. In this way every form and every material is now at the service and command of the artist.[121]

The artistic genius thus becomes a demiurge, a master of forms and contents, a creator of pictorial values. This path leads from Kant to Nietzsche. Through that third approach, as in fact through the second, the artist runs the risk of being brought up short by the sublime, with all the risks of aphasia and apraxia that the encounter with the ineffable entails. In addition, a Hegelian curse is added to the Kantian curse. The absolute, which has been placed in the artist's hands as an expression of his internal genius, must nonetheless be inscribed as a *moment* in the history of art and in the development of the Idea. Thus, not only must the artist create his own values (and simultaneously, his manner and style), but he must create them *at the right time.* He must take his place in the implacable historical process of the "already" and the "not yet," not miss the moment of the "already" and anticipate, if he can, the "not yet." Who was the first to invent cubism? What about abstract art? And pop art?

4. There is a fourth approach, which Hegel must have known, since it was the echo of "romantic" art, already exemplified by Dutch painting. This social art,

devoted to the things of life, and particularly to the good things of a free society, therefore existed, as postromantic or post-Christian art, as early as the seventeenth century. All the same, as Hegel observes, almost with regret, it was not devoid of a certain spirituality. The external world imposes itself, in landscapes, still lifes, and genre scenes. Outside the Hegelian system, the path remained open for nineteenth-century painting, for the cheery painting of the "Sunday of life."

The New Theology at Work

1. THE FRENCH EXCEPTION IN THE NINETEENTH CENTURY

The Stability of French Art

I do not want to enter the infinite expanse of the history of art. But I cannot avoid giving some idea of nineteenth-century European art as a whole.

For a long time, we in France have been presented with a sort of expressway: "David to Delacroix," "Delacroix to Courbet," "Courbet to Manet," "Manet to Cézanne." The secondary roads and byways led to English, German, Scandinavian, or Italian art, which were assumed to be dominated by the overpowering influence of the French school. A simple walk through non-French museums demolishes that prejudice. In Munich, Moscow, and Oslo, we see national schools on display that French (but not German) books neglect, schools that are vigorous, rich in paintings and varied currents, and apparently very self-assured. Until we have integrated them into a unified historical vision, it will be doubtful whether we truly know the nineteenth century, which was more complex than the eighteenth, broader geographically and, one might say, covered a larger painting surface.

Our perplexity is accentuated by the caprices of critical fortunes. We are still paying the price for official art's exclusion of the impressionist movement, then "modern" art's exclusion of "academic," "hackneyed," or "official" art. My generation was raised to feel contempt for official art and is still flabbergasted when

it sees the paintings of the Paris Opera or the Hôtel de Ville rising once more in the aesthetic sky with the irresistible majesty of a hot air balloon.

How to find our bearings? To begin, it would be useful to distinguish among three notions that tend naturally to encroach on one another. The first notion is "value." Aesthetic judgment as Kant established it makes claims of universality. This judgment assures us that the painting is good or bad, and must rely on arguments. The second notion is "success." It is a historical notion: Bonnat, Meissonier, Monet, Munch, and Klimt had "success," either in their own time or after their deaths. It is a fact that, in the world's judgment, the French school of the nineteenth century had more "success" in its own time and even in ours (but will that always be the case?) than did German or American painting. The third term is "avant-garde": it is a recent, historically circumscribed notion. It assumes an ordered development of forms and an established chronology marking their first appearance. A painting will be classified according to that table either as "leading the pack" or as "lagging behind." But, at this point, we rediscover critical fortunes, since every movement, in claiming to occupy the avant-garde, retrospectively determines its own table of rankings. Thus, in 1860 Delacroix was considered "ahead" of Ingres, but Picasso believed the reverse in 1910; and in 1930 Monet was "behind" Cézanne, but in New York in 1950, Monet had already leapfrogged him, according to Pollock.

I have adopted a point of view: the image of God and its relation to the origins of modern iconoclasm. It is from that point that I attempt to get my bearings in the artistic forest of nineteenth-century Europe. From this same point of view, I believe I can perceive a kind of watershed. On one side is French art and, on the other, German, English, Scandinavian, and Slavonic art. Let me hasten to point out that such a divide is valid only in its main lines, that it is prone to a multitude of exceptions, and that, at the end of the century, the map became increasingly blurred.

That uniqueness of French art seems to coincide with the French nationalist view I challenged a moment ago. That view privileges one axis, French art, to which value, success, and the avant-garde are assigned. On the question of value, I will venture no judgment. Nor on the question of success, since the art world is subject to very capricious crazes, to bear and bull markets. Schiele and Klimt have recently been catapulted to heights that few contemporary French painters attain. But I do question whether the notion of the avant-garde can be applied to French art for the greater part of the nineteenth century.

Let me make two lists, marking the generations by the breaks determined for literature in Albert Thibaudet's *Histoire de la littérature française*.

1. Generation of 1789

David	1748–1825	Goya	1746–1828
Prud'hon	1758–1823	Friedrich	1774–1840
Gérard	1770–1837	Runge	1777–1810
Gros	1771–1835	Blake	1757–1827
Guérin	1774–1833	Füssli	1741–1825
Girodet	1767–1824	Koch	1768–1839

2. Generation of 1820

Ingres	1780–1867	Constable	1776–1837
Géricault	1791–1824	Turner	1775–1851
Delacroix	1798–1863	Overbeck	1789–1869
		Cornelius	1783–1867

3. Generation of 1850

Corot	1796–1875	Millais	1829–1896
Daumier	1808–1879	Burne-Jones	1833–1898
Couture	1815–1879	Rossetti	1828–1882
Courbet	1819–1877	Marées	1837–1887
Millet	1814–1875		
Manet	1832–1883		

4. Generation of 1885

Monet	1840–1926	Böcklin	1827–1901
Degas	1834–1917	Stuck	1863–1928
Cézanne	1839–1906	Klimt	1862–1918
Gauguin	1848–1903	Leibl	1844–1900
Moreau	1826–1898	Van Gogh	1853–1890
Redon	1840–1916	Munch	1863–1944

Take this table for what it is worth. A few painters might be placed in a different generation than that assigned them here. That would change nothing. The choice of the painters themselves is more arbitrary. All the same, these twin lists seem to be honest, in that they reflect the "classic" painters, those who are part of the universal canon of nineteenth-century history because of their celebrity or their "importance" in the development of forms.

Yet, simply by inspecting the two lists, we are presented with a puzzle. The impact of the new aesthetics, as Kant and Hegel developed it, seems incomparably stronger on the right-hand side of the list. France seems to have resisted the idea of genius, of the sublime; at least, it is not part of the romantic philosophico-religious current, if one compares France to the climate of English, German, Scandinavian, Belgian, or Russian painting. On the whole, French art seems to depart less from tradition. This fact is all the more remarkable in that it is not true of literature or philosophical ideas. In England, philosophy carried on the tradition of Hume; the novel, that of Fielding. The major breaks were in painting. In Germany, everything seems to have followed the same pace, and

hardly was the new aesthetics formulated than Friedrich illustrated it with grandiose sincerity.[1]

The contrast between the French school and the general movement in European painting is more notable in the early generations. Without wishing to give an exhaustive list of the reasons for this, I feel I must take political and intellectual history into account.

It is commonly believed that the momentousness of the French Revolution "did not turn the development of French painting on its head, since all the traits of what would later be called neoclassicism had appeared gradually, beginning in the middle of the century."[2] David painted his pictorial manifestoes before 1789. The Revolution unleashed a violent crisis in the daily life of art. It destroyed the Academy, stirred up the salons and the art market. But it was also responsible for immobilizing thought.

One does not find in David the internal revolutions that troubled the art of Goya in distant Spain. He remained comfortable within the framework whose limits were fixed early on by *The Oath of the Horatii* (1784), *Paris and Helen* (1788), and *Portrait of Lavoisier* (1788). The French Revolution, like the Russian Revolution later on, prevented the shifting ground outside the nation from altering a landscape that had become frozen at its beginning. Both revolutions were a repository of forms and even of formulas. When romanticism began in France, it had already nearly run its course in Germany and England. Goethe and Hoffmann were more like Flaubert's and Baudelaire's contemporaries than like the contemporaries of Lamartine and Stendhal.

Ingres claimed to be classical, Delacroix and Géricault romantic and classical. David was a stranger to the debate. And yet, in David's *Oath of the Horatii* and *Marat,* in Géricault's *Raft of the Medusa,* or in Delacroix's *Death of Sarandapalus,* there was a tension, a *terribilita,* a manifestation of extreme feelings, of "unbeautiful" objects—cadavers, for example—which led to the idea of the sublime.

Three Sublimes

The idea of the sublime has a long past, and its meaning has diversified. For our purposes, we need only distinguish among the rhetorical sublime, the psychological sublime, and the mystical sublime. In 1674, the first kind of sublime was matter for examination from the republic of letters by Boileau, when he decided to publish a translation, accompanied by remarks, of the rhetor Longinus, who was believed to have lived in the third century. On the basis of what he understood of Longinus, Boileau carefully separated the sublime *style* (which may jux-

tapose the bombastic and the grandiloquent) from the sublime proper. The latter is "the extraordinary, the marvelous, which strikes in discourse and carries you off, transports you, ravishes you. The sublime style always seeks big words, but the sublime can be found in a single thought, a single figure, a single turn of phrase."[3]

In fact, for Boileau, the sublime—the marvelous and surprising in discourse—can rarely be found in the sublime style. Much more often it emerges suddenly from a conciseness and simplicity that "naively" translate the natural movement of a soul constricted by the extraordinary nature of the circumstances. Boileau adds, to Longinus's famous example—"Let there be light!" ("an extraordinary turn of phrase")—the words of the old Horace in Corneille's play: "that he died" *[qu'il mourût]*. "These are very small words. Nonetheless, no one can fail to feel the heroic greatness contained in that line, *qu'il mourût*, which is all the more sublime in that it is simple and natural, and that, through it, one sees that this old man is speaking from the bottom of his heart, and in an outburst of truly Roman anger." Transposed into the sublime style (for example: "that he sacrificed his life for the good and glory of his country"), the thing would have lost its force. "Hence, it is the very simplicity of this line that accounts for its greatness."[4] Diderot later said: "Paint the way people spoke in Sparta."[5]

But that simplicity can be learned. There is an *art* of the sublime. It is not true that the sublime appears spontaneously and that nature produces sublime works by itself. Of course, "it never shows itself so free as in sublime discourse," but that freedom does not come about by chance; and, like any aesthetic product, "it is not the enemy of art and rules." Nature leads to greatness, "but if art does not take care to lead her, she is blind and does not know where she is going." There is therefore a method for reaching the sublime, which consists of "filling" our mind, of "giving it weight and gravity." At the school of the ancients, readers will learn elevation, pathos, nobility of expression, composition, and the arrangement of words "in all their magnificence and dignity." This same spiritual discipline applies to both the beautiful and the sublime. The two form a continuous domain. Although the sublime is found near the far limits, it remains a literary genre and a rhetorical mode. It is one mode of the beautiful; far from being opposed to it, it is its superlative form.[6]

According to Baldine Saint-Girons, however, Boileau conceded in his scholarly controversy with Huet, the bishop of Avranches, that the true sublime lay solely in God, and that words would always be inadequate to express his greatness. Hence, on one side is the enormous thing, and, on the other, the imitator who labors to render it: a sublimity of words opposite a sublimity of the thing,

which tends toward inexpressibility and unrepresentability. Fénelon also allows the notion of the sublime to slip away from rhetoric and toward an unknowable and inexpressible God. As a result, "the beautiful that is only beautiful, that is, brilliant, is only half beautiful"—and it pales before the sublime.[7]

But there is a different path leading to the second sort of sublime, which I have called (probably with too little precision) "psychological." It began to take shape in the eighteenth century, with authors such as Du Bos, Shaftesbury, Addison, Young, and Rousseau. It found its canonical expression in Edmund Burke's *Philosophical Inquiry into the Origin of Our Ideas of the Sublime and Beautiful* (1757).[8]

That path involves a reflection on the psychology of artistic emotion. Back in 1719, Abbot Du Bos wrote: "Every day one feels that verse and painting cause sensible pleasure; but it is difficult to explain what composes that pleasure, which often resembles affliction, and whose symptoms are sometimes the same as those of the keenest pain. Art and poetry are never so applauded as when they have succeeded in causing us grief."[9] Hence, in this evaluation, the qualitative —taste—gives way to the quantitative: the intensity of emotion. As a result, even though pleasure and pain occupy opposite poles, they stand side by side and together form a pole contrasting with the baseline of emotional intensity.

Such is Burke's starting point. Burke distinguishes between *pleasure,* associated with the beautiful, which is based on love, social communication, and freedom in relating with others, and *delight,* associated with the sublime, which is a passion of a higher degree of intensity. Pleasure is positive, *delight* is "relative" or negative: it is the sensation that accompanies a release from pain or danger. *Delight* is based on terror. "Whatever is fitted in any sort to excite the ideas of pain and danger, that is to say, whatever is in any sort terrible, or is conversant about terrible objects, or operates in a manner analogous to terror, is a source of the *sublime;* that is, it is productive of the strongest emotion which the mind is capable of feeling."[10] The sublime arises, then, from fear and from a simultaneous consciousness that one is not in danger. It is, one might say, following the psychological view, a sort of sadomasochistic game in the service of maximum excitation. After all, "the ideas of pain are much more powerful than those which enter on the part of pleasure," and the idea of death is even more powerful. By association, the sublime is thus linked to vastness, infinity, darkness, and many other things from which no danger is to be feared, but which "produce the same effects. . . . We are deceived in the like manner."[11]

In the realm of taste, the Burkean sublime marks a departure from French-style good taste. Racine, Voltaire, and Pope are abandoned for stronger fare: Shakespeare and Milton. This sublime makes it possible, in a more down-to-

earth register, to praise works whose principal merit is to incite fear: the "Gothic" novel or its legitimate descendant, the hard-boiled American detective novel. The psychological sublime, intentionally breaking its link with taste, breaks away from morality at the same time. It can become the pure quest for *delight*, that is, for a certain quality pleasure acquires when it is combined with horror.

The third sort of sublime, Kant's sublime—and the part of Kantianism retained by Hegel—is a religious, or rather a mystical, sublime. It corresponds to a spiritual experience in which the subject, in the presence of the absolutely great, is led to rid himself of everything but the experience itself as it occurs within his soul. The rhetorical sublime accords with morality, since morality obeys the law of reason and draws a greater purity and simplicity from the spiritual experience. All the same, it is autonomous in relation to morality, since its domain is the work of art. The psychological sublime, attending only to the force of feeling, and finding pleasure in the "scare," lies outside morality. But the religious sublime is all of a piece, uniting all human faculties and realms of experience. It rids itself of the image and of the work of art, which are marked by their inadequacy. It also rids itself of common morality, which now seems a mere propaedeutic to a higher morality, which may be its exact opposite; rids itself of the common faith, whose canonical statements seem trivial when compared to the ineffable; of common politics, also disqualified by revelation. The modern artist, if he follows this sublime, is pushed outside society as he becomes aware of his artist's vocation. He becomes the modern equivalent of the stylite, isolated at the top of his pillar in the middle of the desert, surrounded by the common herd who make pilgrimages to him, and who no longer dare ask him what he is doing. The religious sublime is a total sublime, and that is why it is of interest to great philosophy. Anyone who arrives at this sublime is simultaneously or indiscriminately an artist, a moralist, a saint, a leader of the people. Tolstoy, who founded a religion after renouncing art, and who served as Russia's moral guide, is the perfect example.

The image is not under threat of the first two forms of the sublime. It is only impelled to be spare in its expressiveness and vehement in its affectivity. The rhetorical sublime may very well intermingle with the psychological sublime. The soul's energy, retaining its natural quality and methodically trained by the rules, is then expressed in an image that carries one away and, as Boileau would say, "upends everything like a bolt of lightning." From the expert's point of view, the Burkean sublime still submits to moral rules, or, at least, when it chooses, to the rules of taste. Turner, who draws more from Burke than from Boileau, nonetheless writes, citing Tom Paine: "The sublime and the ridiculous

are often so nearly related that it is difficult to class them separately. One step above the sublime becomes ridiculous and one step above the ridiculous makes the sublime again."[12]

Delacroix

Delacroix is proof that these two sorts of sublime are compatible with each other. Taine sees it this way:

> He went looking everywhere for the highest human tragedy, in Byron, Dante, Tasso, and Shakespeare, in the Orient, in Greece, all around us in dreams and history. He inspired pity, despair, tenderness—always some wrenching or delicious emotion—from his strange, purplish hues, his wine-colored clouds streaked with coal smoke, his pallid seas and skies, like the feverish complexion of a sick man . . . his trembling, oversensitive flesh tones, sweating from the tempest within, his bodies twisted or stiff from rapture or spasms . . . one feels that, in moving beyond the old painters, he reveals a new world and interprets the times we live in.[13]

Yes, but Baudelaire corrects this portrait. His Delacroix is

> a curious mixture of skepticism, politeness, dandyism, and despotism. . . . Skeptical and aristocratic, he was acquainted with passion and the supernatural only through the forced visitation of dreams. He hated the multitudes, considered them hardly more than iconoclasts. . . . The inherited marks that the eighteenth century left on his nature seem to have been borrowed from a class as far from the Utopians as from the enraged masses, from the class of polite skeptics, victors and survivors who, in general, descended more from Voltaire than from Jean-Jacques.[14]

The Delacroix depicted in his *Journal* tends to support Baudelaire. He was a man of the world who read the French classics, particularly admired Rubens, Paolo Veronese, Titian, classical antiquity, and Poussin. His life of hard work and discipline was fairly solitary, but he forced himself to have a high-level social life. At the home of M. Thiers, the nineteenth-century French statesman, or of Princess Mathilde, patroness of the arts and Napoleon III's cousin, he dined and chatted, assuming the outward demeanor and manners of Mérimée, according to Baudelaire, "the same apparent, slightly affected indifference, the same mantle of ice covering a puritan sensibility and an ardent passion for the good and the beautiful."

Delacroix explained what he meant by "beautiful" in two essays, "Questions on the Beautiful," and "Variations on the Beautiful." Both communicate a serene philosophy that, far from departing from the classical spirit, restored it after the deformations and narrowness of academicism. In brief, the beautiful appears to blessed ages and to chosen men who know how to understand and

produce it. It is not far from Voltaire's *bon sens* and his historical view of certain privileged centuries. The beautiful is shared, but it has to be rediscovered time and again, incarnating itself in a great artist:

> To praise a man, we say that he is unique: can we not affirm, without fear of paradox, that it is that uniqueness, that personality, which enchants us in a great poet and a great artist; that the new face of things revealed by him astonishes as much as charms us, and that it produces the sensation of the beautiful in our souls, independent of the other revelations of the beautiful, which have become the spiritual patrimony of every age, and which are consecrated by long admiration?[15]

That is the best and purest Boileau, who concluded, speaking of the ancients: "The great age of a writer is not a clear sign of his merit; but the age-old and constant admiration always shown for his works is clear and infallible proof that they ought to be admired."[16]

If there is any movement in Delacroix's works, it might be described as a reflective return to the classics. Of course, it is not as if he moved from Burke to Boileau; rather, having liberated himself from the fashions of the time, he calmly took his place in the gallery of the great masters he admired the most: Rubens, Veronese, Poussin. In his early works, the Oriental's dagger is always poised to plunge into the tender, exposed breast of a passive, prostrate woman. The sadistic vein is at the root of this "period" sublime. Davidian energy transports us to dramatic hunts where men grapple with lions. In the Luxembourg, the Hôtel de Ville, and the library of the Palais Bourbon, Delacroix's subjects are drawn from the humanist repertoire of great seicento galleries, and he was sorry that the century had been discredited. At the Palais Bourbon, Theology occupies a cupola between Philosophy, Law, and Poetry. There is a movement toward a transcendent, calm synthesis, where the Voltairean skeptic and the man "passionate about passion" (Baudelaire) welcomes and unifies the legacy as a whole: Virgil and Trajan, the Orient and the Bible.

In his pictorial testament at the Chapel of the Holy Angels of Saint-Sulpice, the synthesis is complete. He has produced his masterpiece. The Promethean or Faustian or Napoleonic spirit of the struggle animates Jacob and puffs up his heroic torso. But the daydreaming angel, standing lightly, weightlessly, on the ground, defeats him "without toil," like a Greek god. In fact, he has the harmony and profile of the god, but not his hair. No, he has the thick, curly, long blond hair of a Florentine angel. In the background, three enormous, contemplative trees seem straight out of Poussin's majestic *Seasons,* though with a bushiness characteristic of Constable and a twisting effect proper to Delacroix. In the lower right-hand corner, a still life displays van Gogh's "flossy" style, and even his straw hat. The painting—like every masterpiece—transcends Hegelian clas-

sifications. The theme and subject, of course, refer to the Christian "romantic." But the angel's serene impassivity attests to "classical" art in its purest form. Finally, the three giant trees symbolize something—but what?—and introduce a mysterious discordance between the "form" and the inaccessible "content"—an object of intuition and not of thought—which, according to Hegel, characterizes the primitive "symbolic."

French Aesthetics

In terms of its reflection on art and the beautiful, the eighteenth century represents an interlude between two metaphysical eras. The classical doctrine of the beautiful, which relies on Platonic idealism, became weaker in France and in England, or persisted only in a meandering sort of way. It kept more vitality in erudite Germany, where the old academic philosophy still held its ground. It was this Germany that, on the still-standing ruins of ancient aesthetics and on newer currents, elaborated a new and equally metaphysical aesthetics. But in France, there was a movement within which aesthetics was no longer and not yet metaphysical. I wish to emphasize the nonmetaphysical character of French Enlightenment aesthetics, since it can be found again in the spirit of nineteenth-century critics and of the French public, in both Baudelaire and Fromentin.[17]

It is not true that there were no efforts made in eighteenth-century France and Britain to ground the idea of the beautiful in stable philosophical principles that would withstand variations in taste and the subjectivity of pleasure. In a work of the mind, for example, Father André defined the "beautiful" as "not what the imagination finds pleasing at first glance in certain dispositions of the soul or bodily organs, but what *has the right to please* reason and reflection because of its own excellence." Father André locates what he calls "essential beauty" not in the body proper but in the aspect of the body that recalls or imitates "that original, supreme, and eternal perfect unity," of which objects of art are only the shadow. Father André faithfully follows Augustine on this point. The beautiful has "the right to please" independent of conventions, because it is by rights prior and superior to the rules that codify it. It is linked to the divine substance and, at its extreme limits, is indistinguishable from that substance, which simultaneously confers being, unity, and beauty on the object.[18]

But such a declaration was necessarily shattered by the empiricism dominating the eighteenth century. Our ideas, writes Locke, are nothing but the momentary perceptions of our minds and cease to exist when we no longer perceive them.[19] The beautiful is no longer in things or in God, but in man. Hume goes

a step farther, claiming that beauty is not a quality intrinsic to objects in themselves, but that it exists only in the mind that contemplates them, and that every mind perceives a different beauty.[20] As a result, the only reality that is knowable is the reality of the sentient individual. The real processes by which the sentient individual manages to construct notions, particularly those of form, symmetry, relief, and beauty, remain to be studied by means of experiments, that is, safe from metaphysical prejudices and the ambiguities of introspection.

In questioning the man who was born blind, Diderot proceeds under experimental conditions. The results he achieves depart markedly from pure empiricism. Of course, the notions that are at the root of the idea of the beautiful are dependent on the proper functioning of the sense of sight. They are therefore relative. Nonetheless, the man born blind who has touched a sphere and a cube recognizes them quite well after his cataracts have been removed in an operation. This proves that the senses communicate, teach one another, and teach through reason as well. Man possesses an aptitude for organizing and coordinating sensorial data, which allows him to master reality, to know it and use it.[21]

At this point, however, an event occurs that cannot be explained logically by philosophy. The Lockean revolution, in abandoning ontology, in introducing a rupture between the object and being and between the artist and being, and in using empiricism to reduce reality to sensation and the beautiful to the individual subject's capricious and unstable subjectivity, ought to have led to a dramatic loss in the meaning of art, the very loss Hegel had diagnosed, that is, to an end of art. But if we observe Diderot and follow his gaze, we see both what he gains and what he loses. He takes his leave from metaphysics, from the divine, but only to seize hold of the external world, natural nature and social nature. What remains attractive in Marxian and Engelsian "materialism" is precisely its fidelity to the spirit of Diderot: its love of "matter" or nature, its confidence in the capacities of man, who is nature's owner and master. At the time the *Encyclopédie* was compiled, that appetite for conquest was still fresh, and had not yet degenerated into megalomaniacal "metamaterialism." Materialism can also be interpreted as a form of humanism, and can even be linked to the most Aristotelian artistic tradition—fine arts and the mechanical arts combined—as an imitation of *natura naturans*, an emulation of nature's creative processes by human ones.

The artist may have lost one of his points of reference—God—but his sense of organization has restored his dignity as a subject, which strict empiricism tended to dissipate, and hence his soul. In addition, delivered from the shackles of academicism's brittle spirituality, he goes cheerily to meet nature, to observe it, to take stock of it. A joy surges forth from that operation, spreading to all Enlightenment art, a luminous spirituality that remains religious, especially in

countries of the Christian faith (Bavaria, Austria, Bohemia), but which wears the same colors in the happily secular France of Louis XV and Louis XVI. If one recalls that, in France, what remained of official Catholicism was chained to late Jansenism—dry, somber, and subversive—it is possible to claim that the living Catholic spirit was less in the churches, whose furnishings were being stripped away and whose stained glass windows were being shattered, than in the nonreligious art of Watteau, Boucher, Chardin, and Fragonard. The image of God was no longer sought out, at least not in direct reproductions—though religious art was faring very well, even in France (I will come back to this point). But the reflection of that image—through the intermediary of gods in fables—illuminated profane art, provided a sense of well-being, a happiness about being in the world, which was also praise of its Creator. Sometimes, that praise was expressed directly in the "glories" of stucco and marble that proliferated in French cathedrals, in the cold light of transparent windows. Indirectly, in famous paintings by Jean-François de Troy, François Boucher, and Honoré Fragonard, it illuminated Oudry's hunting scenes, "ham dinners," and "oyster suppers," Miss O'Murphy's buttocks, the *Fête à Saint-Cloud,* and rested delicately on the meditative kettles of Chardin.

The inventory of the world undertaken by the *Encyclopédie* had equivalents in Redouté's and Audubon's exploratory series. But there is another aspect to Diderot's enterprise: the promotion of both the artisan and the artist. The Renaissance had wished to disassociate them, but Diderot brought them together under the shared category of *making.* The liberal arts have the same origin as the mechanical arts and are distinguished only by the fact that the former are "more the handiwork of the mind than of the hand," and the latter, "more the handiwork of the hand than of the mind." A good cobbler is an artisan. A good clockmaker can be a great artist. There is no discontinuity between them, there is simply an infinite number of degrees. Even at the lowest degree, inspiration is present, as is the spirit of divination, which is a share of genius. "The fine habit of doing experiments gives experts involved in the crudest operations a feeling that has the same characteristics as inspiration."[22] In the end, intelligence resides in the hand as well. Diderot's atheism, which transfers the divine substance to nature or to the hand or head of the artisan and artist, is so humanistic that we hesitate to take it altogether seriously. Unlike Nietzsche, he would not cry, when faced with the death of God: "The desert is growing!" The earth is still green and fertile.

In addition to *making,* the other main category of French aesthetics is *seeing.* Following Horace and Du Bos, classicism said that poetry was like painting. Batteux reduced the fine arts to "the imitation of beautiful nature." Sight is the

foremost of the five senses. Diderot writes: "Painting shows the object itself, poetry describes it, music barely excites an idea of it."[23] The first step in aesthetic apprenticeship, then, is to learn to see. For painters, it is to learn to see nature. At the Academy, artists learned to draw by copying the great masters. Coypel—whom Diderot cites with approval—tells artists: "Let us make sure, if possible, that the figures in our paintings are living models of antique statues, that these statues are the originals of the models we paint."[24] From beautiful nature seen through the masters' prism one gradually moves to the imitation of "true" nature.

The painter considers painting in its relation to nature, but the public, educated by him, also learns to look at it. The century was a school for connoisseurs. Travel, reviews of exhibitions, and salons educated the public, as the art market grew and reached its perfection. In reading Félibien, de Piles, Montesquieu, de Brosses, and Diderot in chronological order, we see the critical vocabulary growing richer and technical terms added to it. A pictorial language came into being. At the Chardin school, Diderot expanded his notion of "real beauty." The frequenting of studios and intimate knowledge of painters have remained a staple of French criticism. Critics wish to know how a painting was made, to distinguish, as Diderot says, the "making" from "magic," to know the ins of outs of undercoats and glazes. They want to become involved in the problems the painter sets out for himself.

A religious conversion to the things themselves, a respect for the artisan, a curiosity about the pictorial craft, the habit of considering a painting in terms of its quality as a painting, of judging it on the basis of its craftsmanship—all these features constituted the tone of French criticism down to Zola, the Goncourts, and Fénéon. These traits played a role in setting aside religious, moral, patriotic, and philosophical considerations, on which aesthetic judgment was based outside France. To paraphrase Maurice Denis, before knowing what a painting means, one must first know whether it exists as a "good painting"; otherwise, it does not exist at all. When Diderot writes, "Who has seen God? Raphael, Guido Reni. Who has seen Moses? Michelangelo,"[25] he means that one must paint like these artists to see God and Moses, that they see them only because they paint well, and make them visible only in that capacity.

Baudelaire

In the matter of aesthetics, there are two Baudelaires. One anticipates symbolism and sometimes rediscovers by his own pathways the aesthetics of the sublime, but without becoming too attached to it. But that is the music critic. He

writes to Wagner: "The characteristic that struck me the most was greatness. It represents the great and propels one toward the great. Everywhere in your works I rediscovered the solemnity of great sounds, great aspects of Nature, the solemnity of the great human passions. One feels simultaneously carried off and brought low."[26] When he came into contact with the great German, he entered German aesthetics on equal footing, with a poet's intuition. Describing his impression of *Tannhäuser,* he says he feels "lifted off the ground," "delivered from the bonds of gravity," and rediscovers "the extraordinary voluptuousness that moves in lofty places." "Thus I conceive fully the idea of a soul moving in a luminous medium, of an ecstasy *composed of voluptuousness and knowledge* floating above, far, far away from the natural world."[27] He describes a mystical experience in the romantic terms familiar to us: "spiritual and physical bliss," "isolation," the contemplation of something "infinitely great and infinitely beautiful," and finally, "the sensation of space extending to the farthest conceivable limits." It is at that point that Baudelaire introduces the famous theme of the correspondence between "perfumes, colors, and sounds." There has been a "reciprocal analogy" among things "since the day God proffered the world as a complex and indivisible totality."[28]

> La Nature est un temple où de vivants piliers
> Laissent parfois sortir de confuses paroles;
> L'homme y passe à travers des forêts de symboles
> Qui l'observent avec des regards familiers.
>
> Nature is a temple where the living pillars
> Permit, from time to time, confused words to escape;
> Here mankind will cross by, where symbols take the shape
> Of forests gazing on his progress like familiars.[29]

We stand on the brink of the "dynamic" sublime, where the artist is overcome from within by a unified vision, combined with the impossibility of accounting for it or conceptualizing it.

> Dans une ténébreuse et profonde unité,
> Vaste comme la nuit et comme la clarté.
>
> Together, mingling deep and shadowed harmony
> As vast as midnight and as vast as clarity.[30]

The Flowers of Evil contains many passages that accord with that intuition of the limits that the Wagnerian spectacle awakened in the poet. The image or Idea of God always presents itself at the peak of emotion. God is also associated with the horror of the world and with misanthropic disgust. He is the refuge the poet finally finds, beyond the reach of the mob, the common, spiteful herd.

Vers le ciel, où son oeil voit un trône splendide,
Le Poète serein lève ses bras pieux,
Et les vastes éclairs de son esprit lucide
Lui dérobent l'aspect des peuples furieux.

The Poet calmly lifts his pious arms in prayer
Toward Heaven where his eye beholds a splendid throne;
The lightning flashes of his mind, intense and clear,
Conceal him from the wrathful faces of the throng.[31]

Baudelaire belongs to a French Catholic tradition extending from Joseph de Maistre (to whom he often refers) to Claudel, where a supercilious attachment to the most severe dogma was also a way of showing contempt for the impious, stupid mob. "Do not lose me with the Voltaires, the Renans, the Michelets, the Hugos, and all the other scoundrels! Their souls are with the dead dogs, their books are on the dungheap."[32] Claudel's curse has a Baudelairean boastfulness, a sense of preeminence provided by his certainty that he is in the right and that others are in error—something that delights him. But for Baudelaire, the idea of God does not call for the jubilation of triumph; it emerges from an excess of suffering, as compensation.

Je sais que vous gardez une place au Poète
Dans les rangs bienheureux des saintes Légions,
Et que vous l'invitez à l'éternelle fête
Des Trônes, des Vertus et des Dominations.

Je sais que la douleur est la noblesse unique . . .

I know Thou dost reserve the Poet's special state
Amongst the happy echelons of holy Legions;
Summonst Thou him eternally to celebrate
With Thee, the Thrones, the Virtues, and Thy long Dominions.

I know that one nobility, that pain alone . . . [33]

Let us now turn to Baudelaire the art critic. There is a significant change in tone. Rather than open unknown paths toward modernity, he extends the paths opened in the eighteenth century and very consciously places himself under Diderot's patronage. He categorically rejects "philosophical art." To that end, he attacks Chenavard and specifically "the German school," without recognizing the climate shared between that school of painting and Wagnerian music. "Philosophical art" makes the claim to replace the book and teach history, ethics, and philosophy. In Baudelaire's view, it is a "monstrosity." It is a return to imagery, to "childish hieroglyphs." Overbeck studies beauty from the past only

to teach religion; Cornelius and Kaulbach, to teach history and philosophy. But that involves losing one's way as regards the end of art, which is to "create a suggestive magic containing both the object and the subject, the world external to the artist and the artist himself." Such creations require the artist to use only plastic means, which alone are capable of suggesting. Like the Germans, Chenavard "despises what we understand by 'painting.' " He despises the "appetizing and pleasurable" in art.[34]

The Salon of 1845 was extremely traditional. It was composed of a series of vignettes, classified by genre—history paintings, portraits, genre paintings, landscapes—the hierarchy the Academy had imposed for two centuries. Baudelaire, whose father was a distinguished amateur artist and who himself had quite a knack with a pencil, made his judgments as a connoisseur. What held his attention was "good" painting, what repelled him was bad.

The Salon of 1846 proceeded by themes: romanticism, Delacroix, color, the chic. The Salon of 1859, in its vast display, was rich and free. Nonetheless, criticism remained outside the system, outside all dogmatism. Baudelaire's tastes are known to us because he displayed them and based his criticism on them. They are automatically drawn to the great. "I prefer great things," he said. By "great" he means nobility, the vast beauty of gesture, pose, the harmony of colors, the poetic heights of the imagination. The great stands opposed to the petty, the lean, the minute. On one side Gérôme and Meissonier, on the other Daumier, Corot, Ingres (yes, Ingres), and Delacroix, because Delacroix produced high-quality paintings that express the well-born soul, a richly adorned imagination. The Baudelairean sublime is the opposite not of the beautiful but of the lowly. On this point as well, he follows Boileau, just as his model Delacroix followed Boileau. And it is Baudelaire himself who points this out.

Baudelaire's taste for lofty things means that he always pays respectful attention to religious painting. He honors Legros and Armand Gautier, not because they set out the teachings of the church, but because they "had sufficient faith for the object in view. They proved that, even in the nineteenth century, the artist can produce good religious paintings, provided his imagination can rise to such heights." He provides in-depth commentary—but still that of an art critic making comparisons with Veronese and Titian—on Delacroix's *Entombment, Heliodorus Expelled from the Temple,* and *Jacob Wrestling the Angel.* But he recognizes the same nobility animating the artist's soul and hand in a landscape by Corot, an engraving by Manet or Méryon, a sketch by Guys.[35]

The text on Constantin Guys is no exaggerated praise of the painter.[36] On the contrary, in the introduction Baudelaire announces that the Raphaels and Racines

should not blot out the vast horizon of art, and that there is something good, solid, and delicious about the *poetae minores* as well. There are not just superhuman "beacons" and "geniuses." Similarly, there is not just "general beauty," and it is wrong to neglect "particular beauty, the beauty of circumstance and the depiction of mores." For Baudelaire, everything is made to be looked at, and the artist's trained and sensitive eye transmits its essence to his page and canvas, even in the most ephemeral traits of modern life. "Modernity is the transient, the fleeting, the contingent," that is, costume, makeup, the lorette, the dandy, the soldier, and "that creature as terrible and incommunicative as God," woman. It may take the form of the sketch, the "synthetic and abbreviated gaze." Along with the Moreaus, the Saint-Aubins, the Lamis, the Gavarnis, Constantin Guys is one of those "exquisite artists who, though they never painted anything but the familiar and the pretty, are nonetheless serious historians."

The interest of painting lies not necessarily in the greatness of the subject or in the profundity of genius, but in an accurate relation to the world and to the self: to be able to see the world in its diversity and to draw from the most minor spectacle its rare and novel beauty; to acquire an utterly fresh sensitivity, an intellect that discriminates, eliminates, synthesizes, and reflects, the training and skill that confer the solid quality of a completed work on the canvas. In which case, art is not "a sterile imitation of nature," but, to return again to the best of the classical tradition, a relation of emulation that transforms matter into a work comparable to what nature might have produced, and the artist into a demiurge, the rival of nature in the creative process.

Hence, the most important thing is perception. And it is in perception that the faculty of genius can be found. It resides in force, in shock, in the extraordinary bluntness of perception as children naturally experience it:

> The child sees everything as new; he is always inebriated. Nothing better resembles what is called inspiration than the joy with which the child absorbs form and color. I dare go farther; I declare that every sublime thought is accompanied by a nervous tremor, more or less strong, that reverberates even in the cerebellum. The man of genius has solid nerves; the child, weak ones. In the former, reason has come to occupy a significant place; in the latter, sensibility occupies almost the entire being. But genius is only childhood recovered by the will.

This famous passage marvelously condenses Baudelaire's aesthetic credo. This intuition of genius and of the sublime is as far from Burke as from Kant— and has completely abandoned Boileau on this point. The intensity of feeling is not reached, as in Burke, by combining fear and horror, but simply by returning

to an age in life when impressions naturally had their maximum force and most deeply marked the soul and memory. The green paradise of childish loves was also the paradise where the magic of things was spontaneously impressed on the child's virgin soul. But "sublime thought" is also not the occasion to become proudly conscious of one's own vastness, one's commensurate or incommensurate size in relation to the absolute. On the contrary, it is the humble disposition by which the child—and the man, if he has genius—receives the gift of the artless truth of things, without evil, habit, prejudice, "stupidity, error, sin, or stinginess" coming to obscure his vision and obliterate his mind. The fresh impression, the ingenious gaze, thus rests on the innocent humility of childhood as recovered by the will. This is also what so many poems in verse and prose, so many fragments of *My Heart Laid Bare,* so many pages of correspondence communicate to us: the link between the unhappy but amazed and "inebriated" child's clairvoyance and maintained purity, "the eye, fixed and animalistically ecstatic before the *new.*" Clearly, Baudelaire is recalling the line from the Gospel: "Except ye . . . become as little children, ye shall not enter into the kingdom of heaven" (Matthew 18:3). Nor will ye be able to see heaven or earth or God or his images or reflections.

With the child's truly inspired simplicity, Baudelaire rediscovers the principle of modesty that has fed Western art ever since Pope Gregory fixed a limited and moderate program on it—in such clear contrast to the hubris of the Eastern icon, and to the aesthetic hubris cultivated by romanticism. That allows Baudelaire to see excellence and perfection everywhere, and in particular, in artists he knows are minor, and sometimes humble—Méryon, for example, to whom he feels a brotherly attachment.

At the same time, it is clear how we are to understand the Baudelairean theme of modernity: not as an essential superiority, not as a chronological transcendence, but simply as the present. Childish genius is no prisoner to the "cultural" past, no slave to the imaginary future. It simply enjoys the present moment and present things. Augustine fixed limits on the *distentio* of the soul, which allowed it to expand on either side, beyond the indivisible and fleeting point of the present instant, toward the past through memory and toward the future through expectation *(intentio, attentio).*[37] But these limits are more flexible in the child; the present lasts longer and submits less implacably to the crush of an equally imminent past and future. The instant stretches out and engulfs everything. And if it is combined with prayer, divine vision, it can become an intuition of the eternal present. The poetic ecstasy that *Tannhäuser* inspired in Baudelaire is not to be ranked far below Augustine's ecstasy in Ostia, as reported in his *Confessions*—and it feeds the prayers and "elevations" that punctuate *The Flowers of*

Evil. The world in which the artist finds himself is more prosaically "modern," its mobile locale full of "new" surprises, which he must perceive and from which he produces his works. "Modern" has nothing whatever in common with the notion of the avant-garde, which was alien to Baudelaire, and, in fact, was invented only after his death: "Progress: horror!"[38]

Fromentin

Hegel characterizes Dutch painting in terms of what it depicts: genre scenes, still lifes, landscapes. But Fromentin was little concerned with his subjects. It was not them he admired but rather *making.* He addressed painters as a painter, not to procure recipes and techniques from them, but to train them and prevent what he considered a deterioration in craftsmanship.

"It is as if the art of painting has long since become a lost secret, and that the last truly experienced masters who practiced it took the keys with them when they went away."[39] Never before had anyone written of painting with that degree of competence, that utter mastery of procedures, of the "ins and outs." His book was, of course, designed to exhort colleagues, but also to educate the public, and, as he explained, "high society" as well. Fromentin's book remains a classic of French-style aesthetics, based on the training of the eye, the art of judging painting by its "quality," the formation of taste. It is *the* guide for connoisseurs.

From that time on, the subject no longer counted, since quality can be found equally in every subject. Fromentin, who is today judged timid and a prisoner of his own culture, to such a point that he placed his Algerian caravans under the fleecy clouds of Zeeland's skies, lit by Ruysdael's light, is, despite that "nostalgia," as contemptuous of the motif and as "formalist" as Maurice Denis or André Lhote. This is how he describes Rubens's *Martyrdom of Saint Lievin:*

> *Forget* that it is the ignoble and savage murder of a holy bishop, whose tongue has just been torn out, who is vomiting blood and horribly contorted by convulsions; *forget* the three tormentors who are martyring him, one with his blood-soaked knife between his teeth, the other with his heavy tongs, holding out that hideous scrap of flesh to the dogs; *see* only the white horse rearing up against a white sky, the bishop's gold cope, his white stole, the black-and-white spotted dogs, four or five blacks, two red hats, ardent faces with ruddy skin, and all around them, in the vast field of the canvas, the delicious concert of grays, blues, light or dark silvers—and you will feel nothing but a radiant harmony.[40]

Fromentin still perceives an expressive contrast, a poetic antithesis, desired by Rubens in this "furious and heavenly, horrible and cheerful" painting. But one senses that this antithetical couple is about to dissolve, that pure painting is

about to rid itself of the *impedimentum* of the thing represented, that it is on the brink of retreating into itself in complete autonomy. Fromentin's *Les maîtres d'autrefois* (The masters of yesteryear) marks the beginning of the path that will lead French painting to an abstract art, in accordance with a logic diametrically opposed to the path leading to Kandinsky's and Malevich's abstraction. It is abstract in a different way, but still abstract, as profane and agnostic as the other form of abstraction is mystical, and barely distinguishable from it for anyone who discounts motives and intentions. The graceful and harmonious abstraction that distinguished the Paris school around 1950 is partly linked to the enchantment of "the delicious concert" of grays, blues, and silvers, savored for themselves and adequate in themselves. Via that pathway, the aesthetics of making and seeing leads to a new attitude toward the image, which I hesitate to attribute to iconoclasm, and which might be a form of iconophilia or even iconolatry. Through the disappearance of the thing represented, it opts for a hyperbolic exaltation of forms and colors—sometimes reduced to the worship of the geometrical scheme of the composition.

That is why, when he considers an image of God—*Descent from the Cross,* also by Rubens—Fromentin quite simply omits the divine: "Christ is one of the most elegant figures Rubens imagined to paint a God. He has an indefinable grace—elongated, pliant, almost spindly—which gives him all the delicacy of nature and all the distinction of a beautiful academic study."[41] And he details "the large, slightly swaying body," "the small, thin, fine head," and even the "bluish, stigmatized foot" that touches Mary Magdelene's naked shoulder at the bottom of the cross, and which Fromentin sees as a poignant allusion. The divine is reduced to the human, but the human can in turn vanish into pure paint, in the space that extends between the high-quality canvas and the connoisseur's discerning eye, attentive to brushstrokes, hues, and values.

The First Generation of Impressionists

We now come to the greatest explosion of painting since that for which the Netherlands served as theater in the seventeenth century. After the encounter between the picture framer Eugène Boudin and the schoolboy Claude Monet in the streets of Le Havre in about 1855, not a single year passed without a memorable event, a miracle, at least until the end of the century. Seven great painters—Manet, Monet, Degas, Cézanne, Seurat, van Gogh, and Gauguin—virtually lived together, watched one another, used one another as springboards. And, below them, Renoir, Pissarro, Lautrec, Bernard, Caillebotte, and ten others formed a second tier, sufficient to mark the glory of a less exceptionally pro-

ductive era. None of these men led sordid lives; they were always ennobled by the trait of courage and sometimes heroism. There was relatively little hatred, contempt, or jealousy among them, and often friendship, total generosity. That band of brave young men, who supported one another during hard times, gave the beginnings of impressionism the bright and tonic light that also illuminates *The Three Musketeers*. There is a swaggering but frank and joyful aspect to them, an essentially optimistic attitude, as in Rastaignac's challenge at the end of *Père Goriot:* "And now, Paris, I'm ready to take you on!"

Paris, at least part of Paris, was ready to welcome them. "The painting of democrats, of those who do not change their linen," said Count Nieuwerkerke, director of the Beaux Arts under Napoleon III, and official lover of Princess Mathilde. Yes, but if Paris was not the cleanest city in Europe, it was the only democratic one. Even the government was less than ferocious. It was His Majesty the Emperor, after all, who, "wishing to leave the public as judge of the legitimacy of these complaints [that is, the protests against the artworks rejected by the Salon], has decided that the rejected works of art will be exhibited in another part of the *Palais de l'Industrie.*"[42] The Republic was not so kind. But at least it let artists get along the best they could without intervening, without prohibiting, without subsidizing them. Huysmans recalled the words of Courier: "What the state encourages, languishes, what it protects, dies."[43] The impressionist painters rarely had their hands out, and, if they had, it would have been in vain.

As for society, it was diverse enough to offer a home or an opportunity to everyone. Manet was rich, Degas, Cézanne, and Seurat comfortable. The poorest—van Gogh, Monet, and Pissarro—found kindly men to help them out, among the petty bourgeoisie of artisans and merchants. In those years, literature in France was generally inferior to painting. But writers—Mallarmé, Zola, Duranty, Fénéon, Mirbeau, and Huysmans—sided with the painters, with uneven discernment but sincere enthusiasm, and when one—Zola, for example—gave way, the others held fast. Of course, the establishment of state ministers, salons, and the Beaux-Arts was hostile. But the blockade that would have been fatal to this kind of painting in Germany or England was porous in France, and left pockets of cultivated, bantering, independent bourgeois, and an ocean of anarchistic members of the lower classes, who very much liked these painters, whose very strangeness could be linked to "bohemia" (the status of which had been solid for generations). The artists' admirers could occasionally sniff out the quality of their works. With the exception perhaps of the great recluse Cézanne, none of these so-called accursed artists ever lacked an understanding environment. Not even van Gogh.

The novelty of their art, the difficulty of explaining it, dictated a few words with a revolutionary flavor to Pissarro and Monet. Pissarro declared many times that the Louvre needed to be burned down, which might well have come to pass if a few guards had not put out the fire set by the Communards at the Tuileries.[44] Monet wrote Bazille in 1868: "The further I go, the more I regret what little I know; that is what bothers me most."[45] These words must not be taken in the nihilistic and iconoclastic sense that similar declarations by Italian and Russian futurists had. They simply express an exasperation with academic formulas—which appealed to the authority of the museum—or the impatience of a young talent blazing his own trail. There is no need to revisit what all histories of the movement teach us: the impressionists' vast erudition, their intelligent meditation on the masters, and particularly on the masters close to them, namely, Delacroix, Ingres, Corot, the Spaniards in the Louis-Philippe collection, the English landscape painters discovered in London. The impressionists rejected a certain kind of modernity, the kind linked to the baser forms of their age's sensibility, to the slightly smutty eroticism of pompier painters, the sometimes nauseating sentimentality of Bouguereau or Cabanel, Helleu's empty stylishness, Meissonier's often pointless attention to details. The entire catalog of their victorious competitors was rightly skewered by Degas. Ignoring that fashionable form of painting, which they considered unworthy of being called painting, they looked to the old masters: Poussin, Vélazquez, and Rubens. They measured themselves against them and placed themselves beside them. Cézanne looked to the museum.

The aesthetics of the art infinitely surpassed the aesthetics of the theory. What the impressionists said of their ideas was oddly brief and concise, compared to the reflections of subsequent generations. The most likely reason is that they did not need to elaborate them. They wanted to make good paintings, in contrast to the paintings around them, which they considered bad. They made no intellectual claims to innovation. Manet never really understood why his canvases, which in his view deserved social recognition like any other, did not receive it. They suffered from the ostracism imposed on them, but with no spirit of revolt or revolution. They suffered innocently because they thought they were doing the right thing. They were conscious of following a tradition, even though, for a time, it was a narrow and impractical road. In terms of the artist's nobility, of what the artist owed himself, of his posture toward a society that could be sordid and hostile, it was Baudelaire's road. But it was also Diderot's (and again Baudelaire's) road, because of the primacy given to seeing and making over thinking, and because of the relation to "nature."

The relation was a happy one. "If it didn't amuse me, I beg you to believe that I wouldn't do it," Renoir said of painting.[46] And Monet added: "I found here a thousand charming things which I couldn't resist."[47] They were all possessed by the passion to paint. Think of their final years: Manet, tormented by tabes, painting *A Bar at the Folies-Bergère;* Degas, almost blind, working on pastel drawings he could not even imagine showing anyone; Monet, his eyes clouded by cataracts, frenetically transposing his garden onto gigantic canvases; Cézanne, hitching up his cariole every day to set himself up in front of Sainte-Victoire until he was brought down by an attack; van Gogh . . .

The impressionists' specifically pictorial discoveries concerning light and the interplay of different hues originated in an amazed contemplation of the world, in an art of vision able to transfigure any spectacle at all. Duranty writes:

> I have seen a large movement of groups formed by relations among people, where they met on different levels of life—at church, in the dining room, the drawing room, the cemetery, on the parade-ground, in the studio, the Chamber of Deputies, everywhere. Differences in dress played a big role and corresponded to the variations in physiognomy, carriage, feeling, and action. Everything appeared to me arranged as if the world had been made expressly for the joy of painters, the delight of the eye.[48]

Technical progress, that is, adapting procedures to art, was in itself a cause for joy, sometimes expressed in quasi-mystical terms: "The discovery properly consists in having recognized that full light decolorizes tones, that sunlight reflected by objects, by virtue of its clarity, tends to bring them back to the luminous unity which dissolves its seven spectral rays into a single colorless refulgence, which is light" (Duranty).[49] With only minor modifications, this could have been written by Plotinus or Pseudo-Dionysius.

We should not venture too far, however, from the simple and almost artisanal—in the most noble sense—world where the early impressionists remained, by their social nature and intellectual modesty. The elderly Pissarro, who, through his kindness, his sweet and peaceful temperament, was the affective center and linchpin of the group, in about 1896 gave the painter Louis Le Bail the following advice, which contains the aesthetic credo of that generation:

> Look for the kind of nature that suits your temperament [this comes from Zola: "nature seen through a temperament"]. The motif should be observed more for shape and color than for drawing. . . . Do not define too closely the outlines of things; it is the brush stroke of the right value and color which should produce the drawing. In a mass, the greatest difficulty is not to give the contour in detail, but to paint what is within. Paint the essential character of

things, try to convey it by any means whatsoever, without bothering about technique. When painting, make a choice of subject, see what is lying at the right and at the left, then work on everything simultaneously. Don't work bit by bit, but paint everything at once. . . . The eye should not be fixed on one point, but should take in everything, while observing the reflections which the colors produce on their surroundings. . . . Don't proceed according to rules and principles, but paint what you observe and feel. Paint generously and un-hesitatingly, for it is best not to lose the first impression. Don't be timid in front of nature: one must be bold, at the risk of being deceived and making mistakes. One must have only one master—nature; she is the one always to be consulted.[50]

The object of contemplation is nature. Respect for academic rules separates us from it. Drawing outlines too precisely prevents us from seeing its essence, its full "being-there," its immediate totality. Such an approach divides, relegates to the periphery what ought to be perceived from the center, in the simultaneous continuum of the object. One must take "everything at once," "simultane-ously." One must not be afraid to proceed intrepidly, with "generosity"—as people would have said in the seventeenth century—and never mind the mis-takes. Then a work of art remains, capturing the eye's ecstasy, reflecting it as the analogical equivalent of nature. To reverse Spinoza's famous saying, it is *natura sive Deus:* at this point, it is difficult to determine where that spiritual ascension leads. As Boudin had said, "middle-class people" ought to "be brought to our at-tention."[51] The desire for direct communication is so strong that even the *quid est* before the object, the judgment that names it, seems more like an obstacle to fusion. In 1899, Monet explained to the American painter Lilla Cabot Perry that he would have liked to have been born blind, then to have suddenly received the gift of sight (like Diderot's blind man). Then he would have begun to paint without knowing what the objects were that he saw in front of him.[52]

That opens the possibility of a reversal. The act of pure seeing, of rejecting the mediation of judgment, of rejecting any identity of objects other than their localized position on the continuum of colored space, leads to the equivalent of nonseeing. That is why Monet, afflicted with cataracts and no longer "distin-guishing" things clearly, far from abandoning his paintbrushes, painted more than ever, in a fusional state with nature, where the simple gesture of painting took the place of the finished product. At the Marmottan Museum, there is a long, horizontal rectangle where only jots of paint remain on a canvas left partly bare, with no reference to a sight the beholder can imagine, and which has the appearance of a kind of mystical, Japanese-style calligraphy, a zen look. One more step and the connection to the external world would be broken, with only

the torments of interiority remaining to be transcribed through gestures: Pollock, turning Monet on his head, came up with an artistic language based on nonseeing. But Monet did not take that step.

There is no stylistic unity among the early impressionists. Degas, Manet, Renoir, and Cézanne tried out the style invented by Monet and his entourage but developed their own idiom. But there is a philosophical unity, whose essential point—apart from the moral imperative of "good painting"—is the passionate interest taken in the external world, in things, light, life, and, as they said, nature. They faithfully nurtured that relationship throughout their lives, even though the impressionist movement as such had withered away or dispersed.

And yet, among those years so full that nearly every month seemed to bring a major event in the history of painting, let us focus on 1886 to 1890, when Gauguin and van Gogh blossomed. These two were men equal in talent to the early impressionists; they spoke a language of painting communicating with and understandable to the artistic world created by their elders; they felt they were following in their footsteps and, in the eyes of uncomprehending and hostile critics, were lumped together with them; but their fundamental philosophy was clearly discordant.

Monet and Cézanne respected Gauguin's painting, which emerged from their own and whose quality met the criteria of excellence that they had set. But "artistic will," *Kunstwollen,* to use Riegl's and Worringer's term, lay in the opposite direction. Consider this declaration by Gauguin to Schuffenecker (1888): "Don't copy too much from nature. Art is an abstraction; derive it from nature by indulging in dreams in the presence of nature, and think more of creation than of the result."[53] The imitation of nature—the anchor point of impressionism's classical tradition—drifted away. Nature was simply the occasion for a "daydream," elaborated within what Gauguin called a "synthesis" or an "abstraction" (in a sense soon adopted by a school of painting) and which, after an internal process of alchemy, constituted the artist's "creation."

The Slow Effacement of the French Exception

With such themes, we move away from the French exception and return to the dominant current of European art history, namely, symbolism. It took artists as great as Gauguin and van Gogh to give the decisive push and spin to the particular movement of French aesthetics that, via romanticism, realism, naturalism, and impressionism (not to mention academicism), had, in its relation to nature, remained within the classical orbit. But not altogether. In fact, the shift brought

about by Gauguin impelled significant works back to the center which, though admired by all, had been momentarily marginalized: those of Puvis and Gustave Moreau. In the last years of the century, the French exception was no longer quite so striking, and it is probably more precise to limit it to a particular school in pan-European painting. The French school rejoined Europe, but a Europe already transformed by the French school, which then called to mind the influences England and Germany had had on it. I shall have occasion to return to this question.

Can it really be claimed that the French exception—which had lasted since the violent separation of 1789—was now over? Certainly not. In the various aesthetic languages that existed simultaneously or by turns in Paris, a certain tone remained, a capacity to resist the general European aesthetic, which lasted until World War II. Degas, Renoir, Monet, and Cézanne lived to a ripe old age. They died in glory, surrounded by veneration, as "grand old men," hoary but productive to the end. Seurat's brief career was played out largely within the framework they had set out. One finds in his works a sense for the masters (he is, via Lehmann, an heir to Ingres; he admired Millet; the influence of Puvis can be seen in *Bathers at Asnières,* and even in *La Grande Jatte*), combined with the passionate observation of nature and light as objective data, which enter the mind through the senses and with which one must grapple.

Bonnard was part of the group of Nabis, but he broke off from it to return to his own brand of impressionism, which, in the originality of its style, was peculiarly consonant with the spirit of the 1870s.[54] Hence he remained not backward but free in relation to all the experimentation, including his own, until his death. Others, such as Marquet, Derain, and Dufy, who could not claim to be first-rate but were excellent in their own domains, kept the French flair. Theirs was not an analysis of the conditions of vision, which had been the method—but not the philosophy—of the impressionists. Rather, it was a philosophy of living in this world, of feeling amazement and pleasure at being here, the happiness to be painting and the happiness a painting ought to procure: this they fully retained and defended with humor.

Furthermore, that philosophy extended well beyond the circle of its followers and did not fail to color the work of its adversaries. Gauguin was not Böcklin, Sérusier was not Khnopff, and even van Gogh was not Munch.[55] There is something amicable, a true love of nature, to be precise, which separates the first group from the second. Whatever the weight of "ideas," feelings, and symbols with which they subsequently loaded the canvas, the work of art initially came into being through a confrontation with a reality observed for itself, which survived beneath the ideal "content" and brought it to life.

To be convinced of that, we have only to reflect on the work of the two painters who dominated the French scene in the twentieth century, Matisse and Picasso.

"What I dream of is an art of balance, purity, tranquillity, without any worrisome or trying subject, which would be, for anyone who works with his brain, for the businessman as well as the literary writer, for example, a tranquillizer, a sedative for the brain, something like a good armchair that rests him from his physical fatigue."[56] It would be impossible to dismiss with more mordant irony the aesthetics of the profound, of the sublime, of the tormented genius. Matisse is close to Valéry in his declaration of an intelligent and detached classicism. The deepest thing about us is our skin, Valéry said, more or less. Matisse would add that, in painting, the deepest thing is the surface. It must procure delight. "A painting must be at peace on the wall. It must not introduce an element of distress and worry in the beholder. . . . A painting must procure profound satisfaction, rest, and the purest pleasure for the contented mind."[57] "Oh, tell the Americans I am a normal man; that I am a father and a devoted husband, that I have three beautiful children, that I go to the theater and horseback riding, that I have a comfortable home, a beautiful garden that I love, flowers, and so on, just like everybody else."[58] Péladan's mystical affectations make him laugh: as if *that* were genius . . .

As for his views on the art of painting, they could have been written by Poussin or Félibien. Matisse was not satisfied with the "keen and fleeting sensations" of the impressionists. "I prefer to risk losing charm to achieve greater stability."[59] Matisse maintains that, like classical painters, Cézanne always repaints the same picture—both the same and different. Cézanne is his master because, of that generation, he is the one best able to "instill order in his brain." For Matisse, he is a kind of "God of painting." Matisse learns by copying. At Saint-Quentin, the adolescent copied the humble local painter, a student of Bouguereau. At the Louvre, he copied Raphael, Poussin, Carracci, Champaigne, the Flemish painters. He copied them as a painter, not slavishly. He sought his own path. Fauvism was a "brief moment," corresponding to the question: "What do I want?"[60] Cubism (which "had a key role in the battle against the deliquescence of impressionism") gave him a precision in drawing.[61]

Russia allowed him to see icons "equal to the French primitives."[62] So too for the masters, carefully studied in a spirit of freedom but also of docility, by a sincere and not boastful pupil. The relation to nature was as serenely classical as the relation to the masters. The painter "must have the simplicity of mind that will lead him to believe he painted only what he saw." He liked this line from Chardin: "I keep adding color until it's a good likeness," and this one from

Cézanne: "I want to make the image." And also this one from Rodin: "Copy nature." Da Vinci said: "Anyone who knows how to copy knows how to make." And Matisse writes: "People who opt for a style and intentionally move away from nature are on the side of truth. When he reasons, an artist must take into account the fact that his picture is artificial, but when he paints he must have the sense he has copied nature. And even when he has distanced himself from nature he must still keep the conviction that he did so only to render it all the more fully."[63]

It is not certain that Matisse's works can be deduced from his declarations. It is possible that these declarations conceal an irony, or are the counterpoint to or compensation for a pictorial audacity, which he did not want to lead the beholder astray. But that desire for classicism, for order, for devotion to the figure, for the female nude, that instinct for clarity, measure, and joy, are also found in the collages from the very end of his life, in the chapel of Vence, and in the commentaries the old painter provided to accompany them—a striking assertion of the aesthetics of the beautiful in the twentieth century.

It may seem paradoxical to place Picasso next to Matisse. Turn-of-the-century Barcelona, where he began, was Wagnerian, Pre-Raphaelite, *jugendstil*. Munch and Beardsley were worshiped there, and the city felt much closer to Munich and London than to Paris.[64] By temperament, Picasso was not the kind to turn humbly to nature, light, the landscape, or to render appearances scrupulously. His early paintings (blue and rose periods) were still in the symbolist vein: melancholy; spleen; languid, spindly bodies, dreamy faces, enigmatic meanings. He owed little to France, except perhaps to Puvis and Gauguin. He later went to Paris, but only to better strike up the band or bring governments down. "Astonish me," Diaghilev told Cocteau. Picasso did not need to be begged. *Les demoiselles d'Avignon;* cubism; *Parade; Large Bathers; Guernica:* he has the look of an institutional revolutionary. For the average French person, he embodied pictorial modernism, represented everything that was bewildering, contrary to good sense, systematically distorting, discordant, bizarre, unrealistic. Let us add that he lived like a king, that the universal acknowledgment of his genius freed him from all constraints and placed him above the law. He was venerated, adulated, photographed, filmed in his chateaus, among his women and illustrious friends. He was the superhuman artist par excellence and enjoyed a status to which neither Vélazquez nor da Vinci nor Rubens would have dreamed of aspiring. Hitler and even Stalin dared not touch him. He was fabulously rich.

His "genius," in the most Kantian sense, was obvious. He set his own rules for art—even though he was so overpowering that one cannot simply say he had students. No one knew, he did not know, where his manner came from, but it

was recognizable in the most insignificant scrawl, in a fragment of an engraving, a corner of a canvas: it was a Picasso and could not be confused with anything or anyone else. More than anyone, he was a world-renowned artist. He was a Spaniard living in France, and the boundaries of his "market" extended from California to Japan. And yet, if Picasso's career is placed against the backdrop of twentieth-century European painting, the claim can be made that the most universal of painters was also one of the ones who contributed the most toward perpetuating the French exception, the particular, marginal, archaic character French art maintained when compared to the dominant European aesthetic, and which linked it tenaciously to the classical tradition.

It is pointless to comment, after so many others, on the changes introduced into Picasso's style by the discovery of Lautrec, Gauguin, and the great stabilizer, Cézanne. But, because he turned Cézanne "upside down," for a few years the Catalan anarchist led the way for the "avant-garde," since that is the word that must be used from now on. This is the first time we have run into it, but it decisively took root as a conscious attitude and manifested itself in the theatrical coups of African "primitivism" and cubism.

I confess I understand very little about cubism.[65] If we are to believe its inventors—and more precisely Braque, who made the claim belatedly, when he was no longer a cubist—it was about getting to the heart of the object, showing its essence. In that respect, cubism invoked the patronage of Cézanne, who gradually abandoned perspective, invited, so to speak, the objects of the still life to place themselves within the beholder's reach, and finally reduced objects to geometrical forms: the cylinder, the cube, the sphere. The cubist painter claimed he was folding out, unpacking the object so as to present all its faces simultaneously, that he was laboring to suppress the continuity between objects, or at the very least to give intervals "as much energy as the figures that determine them" (André Masson). As Fermigier writes, "the cubist dematerialized the object somewhat by cutting it into open planes, and materialized space by condensing it into analogous planes."[66]

I wonder if we should believe a word of these explanations by the painters, since their cubist works have such a tendency to contradict them. Objects lost first their color, which, for a painter, is a key attribute of their being, then quickly their form and volume, which were decomposed beyond the cube and the cylinder. In the brief so-called analytical period, there is little formal difference between an abstract painting and a cubist painting, and that is why the early Russian and German abstract painters begged the cubists to make one last effort and to come join them. It is true they were not very far from them. When Braque (later) wrote: "One must not imitate what one wishes to create," adding

that the function of the painter is not "to reconstitute an anecdote, but to constitute a pictorial event," what was involved was not making a painting based on reality, but rather inventing, creating a new reality.[67] *Ut pictura musica:* the painter freely organizes forms the way a musician (or at least, so he thinks) proceeds with sounds. One more step, in fact, and he would have caught up with Kandinsky and Malevich.

But Picasso did not take that step. The Cézannian and hyperrealist declarations of the cubists, however unreliable they may be, at least claimed to have "good intentions" and not to break off from reality from the start. In fact, Picasso did not stay long with that gray, austere, severe painting. The cubist collages he made during the war show he had taken his distance, in his comical, improvisational, and playful fashion. He relaxed and enjoyed himself. At about the same time and until the end of his long life, Picasso parted ways with the avant-garde. He continued to embody it for the public at large, which he did not fail to keep in suspense with his "periods," each a resounding success when he unpacked his tricks. But although he prevailed because of his great talent as an artist and played the preeminent role, the true avant-garde artists were not wrong about him: he no longer belonged to their world.

I cited Valéry next to Picasso. We should also allude to the world of Diaghilev, Cocteau, the Beaumonts, the Noailles, the world of theater and high society, where he cut a fine figure in the 1920s. French neoclassicism, in an act of self-preservation after the slaughter, tried to co-opt Picasso—along with Giraudoux, Valéry, Maillol, and Derain—and he made a few pledges, later redeemed with a few nasty surprises.[68] But let us look, still from a great distance, at the flip side of Picasso's oeuvre. What are its themes? Portraits, nudes, women, children. There is no hostility between him and women (except domestically), none of that Schopenhauerian hostility or pessimism that are a constant of symbolism and expressionism, not to mention abstraction; on the contrary, a keen desire bounces from one canvas to another, from Olga to Dora to Françoise to Jacqueline—and let us not leave out Sylvette and all the others. In his nudes, always sensual, always at ease, never obscene, never squeamish, Picasso gave a nod to the painters of southern Catholic Europe, diametrically opposed to Dix or Schiele. For him, the sanest and most direct, the most compendious relation to the world was the nude female body, often loved, always desired. The most famous Picasso painting, *Guernica,* is a history painting packed full of allusions to the old masters, to Raphael's *Conflagration of the Town,* to Prud'hon's *Justice Pursuing Crime.*[69]

Let us meditate on the autumn of Picasso's life, the long postwar period extending from 1945 to his death. Let us forget the portion of his oeuvre marred by

ideology, the *Doves of Peace,* the *Korean Massacres,* since no one can be a communist with impunity, not even Picasso. The elderly painter, an addict to painting, drawing, engraving, and sculpture, a workaholic, was sometimes reduced to revisiting the catalog of his own works. But he also turned to his sources more openly than he had ever done before. In particular, he turned to ancient "popular" art, Greek vases, Etruscan mirrors, Hellenist and Roman statues, of which he had never lost sight. He turned to Vélazquez, Manet, and Delacroix, whom he copied, parodied, metabolized, and to portraits and self-portraits, which expressed not metaphysical despair but the sadness of an old man whose life is being drained from him. He turned, not to Beethoven or Brahms, but to the adagios of Vivaldi, where melancholy lodges in its natural place, between the joy of the beginning and the courageous, spontaneous leap to the final allegro.

With the exception of cubism, of which he was the coinventor, Picasso never became deeply involved in the "isms" of his century. He maintained an equally ironic distance from and proximity to fauvism, surrealism, and neoclassicism, where his friends wanted to lure him. That was Picasso's humorous side. What Hegel said about humor was true for Picasso, that, through it, the artist "enters the material, with the result that his chief activity, by the power of subjective notions, flashes of thought, striking modes of interpretation, consists in destroying and dissolving everything that proposes to make itself objective and win a firm shape for itself in reality."[70]

The spirit of parody and anarchistic violence sometimes turned to self-destruction and botched work. But at least Picasso never—not even in *Guernica*—took himself so seriously or lacked confidence in his abilities to such a point that he abandoned himself to the mute anxiety, nervous twitching, and apraxia that the aesthetics of the sublime carries with it. When, standing before a woman, a child, or a bull, he overcame the demon of "teasing," versatility, and parody, he effortlessly created success after success within the joyous bosom of the aesthetics of the beautiful. Certain portraits of Dora Maar make us think immediately of Raphael and Goya: they capture the idea of beauty.

Picasso, Matisse, Bonnard, Dufy, and Marquet died after the war. But if I had to propose a date marking the end of the French exception, I would venture 1940. A second Maginot Line was breached that year. The exception had been losing its sharpness and becoming blurred for a long time.

Many diverse currents are at work in French painting. Artists became expatriates or sought a public different from the French public, a public more in agreement with their intentions and more welcoming of their art. Marcel Duchamp settled in New York. Delaunay had one foot in Germany. Kandinsky, Malevich, and Mondrian had disciples in Paris. But universal history now car-

ried more weight than the internal logic of art history. France was defeated, and the deplorable conditions of that defeat reflected back on all things French, on France's literature and painting. New York was anxious to seize the torch Paris held out to it as it fell.

Yet, in the matter of painting, America was never a satellite of France. Its genius, the nature of the country, tended more toward grandiose naturalism, symbolism, the sublime, and it was able to find examples of these in northern Europe, central Europe, and eastern Europe. It was from those regions that the immigrants flowed in: art lovers, experts, and collectors who formed tastes and created the market. And finally, artists. Germans driven out by Hitler and Russians whose paintings no longer toed the "party line" settled on the East Coast and formed a school. After the war, French painters, snubbed by the new leaders of the market—woe to the defeated—were sometimes forced to work within American forms, though not without domesticating them, dressing them up, and softening them with the pretty craftsmanship and delicate colors preferred by Parisian tastes. But they seemed tame and no longer in tune with an age so complacent toward its own tragedy. They passed for artificial, as if two different aesthetics coexisted within a single form. Parisian abstract art, despite its merits, which may some day be revisited and given recognition, was diagnosed as derivative by international criticism.

2. Nineteenth-Century Religious Art

What Does "Religious Art" Mean?

In our excursus through French aesthetics, we have not yet encountered any sustained reflection on sacred art or on the divine image. Except perhaps for Baudelaire, it seems to be very marginal to the preoccupations of French painters and the best-known French critics. In contrast, it is altogether decisive in several great German, English, and Slavonic currents: the Nazarenes, the Pre-Raphaelites, the symbolists, the expressionists, and the abstract artists all place it at the center. Before taking a closer look at them, let us make a few distinctions.

A. Painting for Religious Ends

In general, these are works commissioned by religious establishments for the purpose of worship. There was an enormous number of such commissions. Remember that more churches were built in France in the nineteenth century than in any century since the Middle Ages. That was also true in northern Europe, if only because of the rapid growth of cities. These churches had to be decorated.

In France, at least among the clergy, Jansenism and the Jansenist influence within Gallicanism were in decline, and the taste for post-Tridentine exuberance returned. Bare stone, walls with the plaster removed, and sanctuaries stripped of statues and paintings would return only in the twentieth century.

The clergy and church councils normally proceeded in accordance with Catholic custom. The church wanted the illustration of Christian themes to be eloquent and beautiful. When Simon Vouet or Restout was asked to paint a Virgin with Child or an allegory of Charity, they were not asked to put in any personal "sentiment." They made a painting as beautiful as they could, gave the Virgin all the grace and decency appropriate to her, but they had no reason to transmit a personal "message." If there was a message, it was contained in the subject itself. Dogma was the business not of the painter but of the church, and the church simply made certain that the images did not depart from piety or decorum.

In 1786, Ricci, the bishop of Pistoia, under the influence of Jansenism and the scholarly current represented by Muratori, chose to react against the excesses of the Baroque. He recommended that representations of the Trinity and of the "heart of Jesus" be prohibited and that the "mantelets" veiling certain paintings be removed, to "completely wipe out the pernicious custom of distinguishing certain images, especially those of the Virgin, with particular titles and names, which are generally vain and puerile." The common people revolted, and Pope Pius VI judged they were in the right, condemning the prescriptions as "rash, pernicious, and insulting to the pious custom followed within the Church" (1794).[71] Given the limited role of the image, the authorities were not going to contradict the innocent preferences of the common people: that would have scandalized them and given more importance to the image than was necessary.

A particularity of modern Catholicism must also be taken into account. Catholics wanted for nothing. To achieve salvation, they did not need to read the Bible or even have an internal life or seriously worry about their faith. All such things were desirable but not required. For their salvation, they had attendance at mass and minor sacramental practices; they needed only to add to the observance of God's commandments the commandments of the church, which were extraordinarily mild.

The Catholic world as a whole was not fervent because it was satisfied. That is why it seemed almost pagan to Protestants, who, throughout the nineteenth century, from one revival to the next, were animated by the most anxious fervor. Protestants produced quantities of works to persuade themselves of the efficacy of grace. Catholics, without worrying their heads or taking the trouble to think about it, still believed, even more than Protestants, in salvation through grace,

confidently delivered themselves to it, and did not always bring more zeal to their works than grace inspired in them.

As a result, the Catholic Church did not demand on principle a personal commitment on the artist's part. It also did not ask him whether he believed. It asked that he make a good and pious painting, not that he himself be good and pious.[72] In addition, the church did not impose any aesthetic doctrine or particular style on the artist. Nonetheless, faithful to its rhetorical program of persuasion, storytelling, and emotion, it liked the illusionist techniques of modern painting. It favored the reconstitution of the spectacle, the emotive drama as Bolognese painting practiced it, and as the Academy still practices it. The faithful got used to seeing that sort of painting and the church had no reason to change their habits. In short, the principle seemed to be objectivity in two senses: there was no consideration of the artist's subjectivity; and there was no subversion of modes of representation whose aim was objectivity, that is, the optical reconstitution of the scene to be represented.

B. Paintings by Religious Souls

In this instance, the artist's subjectivity consciously manifests itself. Religious feeling often exists in its natural state in the artist; it is expressed in his work or sometimes as his work. But here again, distinctions must be made among:

1. THE RELIGIOUS ART OF CHRISTIAN ARTISTS Gleyre, Flandrin, and Maurice Denis, to cite only Frenchmen, were Catholic and devout. They confessed their religious faith in sacred subjects. They expressed it as well in profane subjects—portraits, family groups—in which they did not fail to slip into a religious tone. These artists enjoyed church commissions, as did others who did not boast of such dogmatic convictions (Delacroix, Ingres, Amaury-Duval), and faith marked their work. Their status as Christians was recognized, and, so to speak, officialized. They themselves had no doubts about it.

2. THE CHRISTIAN ART OF NON-CHRISTIANS This was a spontaneously religious art, substantially Christian in tone, by artists who did not profess the Christian faith, who may not have been altogether aware of what they were doing or what we think we see in their paintings. Such paintings were not done for the church and were not subject to its discipline.

In examining nineteenth-century works, we may be surprised at the number of paintings that belong to that category. Our museums are full of them, but we do not look at them. Two of the greatest artists can serve as an example.

Standing in front of Millet's *The Grafter,* Théophile Gautier exclaimed: "The man seems to be performing some rite in a mystical ceremony, and to be the ob-

scure priest of a rural deity."[73] Pagan religiosity, then? Nothing could be further from the truth. Millet's specifically Christian paintings are not evidence against the claim, but they exist nonetheless. Consider *Tobit,* in which the biblical story of Tobit is transposed into the rustic costume of the Norman countryside. And consider *The Stoning of Saint Stephen,* the tragic *Hagar and Ishmael,* and the beautiful drawings of Christ on the Cross, inspired by Michelangelo. At the time of his death, Millet had just accepted a commission for a set of drawings on the life of Saint Geneviève, destined for the Panthéon.

But Millet's religious feelings well up from infinitely greater depths in his profane paintings, and perhaps precisely because they do not claim to be expressly religious. Regarding *The Gleaners,* Edmond About wrote: "The painting draws you in from afar by a certain air of grandeur and serenity. I would almost say it presents itself as a religious painting."[74] And standing in front of *The Birth of the Calf,* Castagnary remarks: "It has been said that the two peasants walk with too much solemnity, as if, rather than a calf, they were carrying the Holy Sacrament itself."[75] Millet had come up with an idea for a picture of Ruth and Boaz. When the canvas was finished, he gave it the title *The Reapers at Rest,* as if the solemn aura of mystery would be more visible if it were not named. And, in fact, at the Salon of 1844 critics saw *Large Shepherdess* as a woman in prayer, even though she does not have her hands joined and is simply occupied with her knitting. Millet's characteristic approach was to give daily life a biblical gravity. A woman putting a loaf of bread in the oven, or churning, or washing clothes, seems to be doing her ordinary tasks under the attentive eye of her Creator, who envelops her in an august and benevolent design. The peasant woman returning from the well seems to be waiting, like Rebecca, to water Isaac's camels. The central figure of *Seamstress with Lamp* is lit by such a peaceful light, and her eyes are lowered in a meditation so calm and modest, that an angel of the Almighty seems to be close at hand.

Of all the painters of the nineteenth century—perhaps we ought to add "and of the previous century"—it is Millet who paints man as the creature of a God in whom "we live, and move, and have our being," as Saint Paul said, so that, surrounded by grandeur and dressed in the hard-working innocence Millet attributes to him, he is the lifelike icon of the invisible God. Weaned on the Bible, but not observant, living with a woman without benefit of clergy, not clerical in any way, yet "severe as a patriarch, good as a righteous man, and naive as a child" (Castagnary), Millet was the French Rembrandt, the affective, familiar, and discreet religious painter befitting his century, endowed, moreover, with Hugo's talent for expanding the "august gesture of the sower" (in Hugo's famous line) to embrace the stars.

The other great artist is, of course, van Gogh, and the veneration he had for Millet was most likely based on their shared religiosity. In reality, van Gogh's re-

ligiosity is less explicit, both in his writings and in his art. Van Gogh had an evangelical mind in the Dutch manner, that is, he was more directly mystical, had an avowed, cultured, sometimes fanatical mysticism. "It does me good to do difficult things," he wrote to Theo in 1888. "That does not prevent me from having a terrible need of—shall I say the word?—of religion. Then I go out at night to paint the stars."[76]

Of course, the tender-hearted Vincent was filled with an active and even effusive charity toward men. His affair with Sien, a prostitute and alcoholic, leaves us with a combination of admiration and uneasiness, like a novel by Dostoyevsky or Léon Bloy. All the same, van Gogh's heart was purer than that of those authors. The sincere friendship with Father Tanguy, Doctor Gachet, the postman, the Zouave, and the café owner from Arles animate his portraits, though these do not have the interiority that distinguished Millet or even Degas. Van Gogh captured life more than the soul but, considering what contemporary symbolists made of the word "soul," I will not complain about that.

Van Gogh's mysticism was definitely a more cosmic mysticism. The eleven tremendous stars that shine like suns above a flame-shaped cypress tree in *Starry Night* express this fully. "And all the same to feel the stars and infinite high clear above you. . . . Oh! those who don't believe in this sun here are real infidels."[77]

I associate that cosmic mysticism with a very strong sense of the next world, which, for example, he discerns in the eyes of a child in its cradle, who makes him aware of his "ignorance" and leads him to compare life to "a journey on the train": "You go fast, but cannot distinguish any object very clearly, and above all you do not see the engine."[78] That, combined with vitalism, or rather with the powerful, strong life that van Gogh puts into the most insignificant of his strokes—in three strokes of a reed pen he reveals a vast landscape to us—means that his intense religiosity lacks an object and a determination. Standing in front of the later paintings, *The Crows*, for example, we are struck by the omnipotence of a presence. But of what? Of whom? Hegel might say:

> It takes its departure from the present and the present's concrete existence in nature and spirit, and then and only then expands it to enshrine universal meanings whose significance is contained . . . in a rather restricted manner. . . . Symbolic art seizes on these objects only to create out of them by imagination a shape which makes the universality in them something that the mind can contemplate and picture in this particular reality. Therefore, as symbolic, artistic productions have not yet gained a form truly adequate to the spirit, because the spirit here is itself not yet inwardly clear to itself, as it would be if it were the free spirit.[79]

Who would say that van Gogh in Auvers had a "free" spirit? In van Gogh, there is an instinctive, raw, spontaneous symbolism elaborated at a remove from

the literary or theosophical doctrines of the time, which he does not want to delve into more deeply.[80] *Starry Night,* with its apocalyptic stars, has been the object of a number of exegeses. But van Gogh wrote simply that this work of art was close in its sentiments to works by Gauguin and Bernard. He invented his own symbolism of color to express intimate feelings. He did not define his religiosity. Regarding *Wheatfield with Reaper,* he wrote to his brother: "I saw in this reaper . . . the image of death, in the sense that humanity could be the wheat being reaped . . . but in that death, there is nothing sad, it occurs in bright light with a sun drenching everything with a light of spun gold. . . . It is an image of death such as the great book of nature tells us about—but what I sought was the almost, smiling."[81]

Is it wise to define that religiosity in his stead? It might seem to be a cousin of the religiosity of the symbolists and expressionists who embraced him. Nonetheless, one difference places it on the side of the Stoics, the Greeks, but also of the Christians: "What I sought was the almost, smiling." Not, therefore, an *amor fati,* but an *amor mundi,* a respect for nature as such: "Painters understand nature and love her and teach us to see her. Then there are painters who can only make good things, who cannot make anything bad, just as there are ordinary people who cannot do anything that doesn't turn out well."[82] Here is a portrait of van Gogh himself.

3. NON-CHRISTIAN RELIGIOUS ART I shall put off until the next chapter the consideration of this category of painting, the largest perhaps. It guides symbolism, expressionism, futurism, surrealism, abstractionism. That religiosity, no doubt more intense and more fervent than Christian religiosity, has also produced more pictorial schools and currents. But one ought not to imagine a strict line between these new forms of religiosity and Christianity. Many of these artists thought and spoke of themselves as Christian, not even knowing they were no longer so; others, in contrast, were more Christian than they supposed. Most were extremely confused in that respect. That confusion further intensified their torment and their religious quest, the pathos of which is reflected on their canvases, a pathos that goes far beyond the calm or lukewarm religiosity of sacred paintings by professed Catholics.

As for the tone of that other religiosity, there is no unity to it. Nonetheless, it will come into focus if we contrast it to one last category.

C. The Religious Overtones of Profane Painting

The oxymoron of this final category forces us to make explicit what is meant by "Christian art." It is an equivocal expression. The following distinctions must therefore be made.

—The art of the church—that is, the art of churches and objects of worship not located in churches. The term "Christian art" can be reserved for that class of objects. Nonetheless, Christian painting of Calvinist inspiration, which has no place in Protestant churches but which is an instrument of edification or pious illustration, a supplement and aid to the Word, should be added to this class as well.

—The art of Christians. Here again, the boundaries are blurry. I hold in my hands a little book called *Jewish Art*.[83] It lumps together the iconographic cycles of ancient synagogues, the manuscripts illustrated with paintings from the German Middle Ages, Pissarro, Modigliani, and Chagall. This mishmash, which obviously reduces the notion of Jewish art to dust, also obliterates the notion of Christian art. There are Jewish artists, and there are Christian artists.

But what does it mean to be Jewish or Christian? Does it mean formal membership (having a Jewish mother, for a Jew; being baptized, for a Christian), or does it also require a clear awareness of belonging, an awareness with infinite variations, in fact, and which may very well be barely or not at all religious?

—Art produced in historically Christian regions. In this case, the boundaries are extended as far as possible. They exist nevertheless. Remember that these regions are bordered by other, clearly heterogeneous zones: Muslim, Persian, Asian, African, and so on. The mode of art under Christianity, though displaying unity in relation to the other modes, is fragmented, and these fragments are themselves sometimes subdivided: Eastern Christianity, Western Christianity —itself divided into Catholic and Protestant facets, then into Spanish, Italian, French, English, and Germanic facets, then regional facets, which further diversify as each develops. And so on.

Let us consider one characteristic of art produced in the region of Western European Christianity: the division of that art into sacred and profane. In the Western region, both sacred art and profane art have a status and a right to existence. Both are permitted. Artists rarely practice one or the other exclusively. Most often, they practice both, in proportions that have to do with the commissions they receive or with their own temperaments. Religious institutions authorize profane art because it is compatible with theological norms. These norms assign nature as such a certain stability, a preeminent dignity, the dignity of creation. This means that profane art remains dependent on a theological judgment of *orthodoxy*.

Sacred art is subject to discipline, inasmuch as the church must oversee the salvation of souls, which the image may either compromise or favor. For its part, profane art is subject to no discipline. If it impudently deviates from decorum, it is up to the civil judge to intervene. But, once that art is realized, there is noth-

ing to prevent someone from making an objective judgment regarding its compatibility with the fundamental points of Christian doctrine, at least those directly at issue in the work.

These points, it seems, can be reduced to one: creation is good. The fact that everything visible, and visibility itself, is the work of God and refers back to him as to a source, places the artist in the situation of acting through grace, even if he is not Christian. That disposition, which may not be conscious, is what I will call "orthodoxy." The ancient Greeks had it, and pagans of various religions have it. Matisse gives an excellent modern expression of it in this reply to the question: "Do you believe in God?"

> Yes, when I'm working. When I am humble and modest, I feel altogether aided by someone who has me do things that are beyond me. I don't feel any gratitude toward *him,* however, since it's as if I were placed before a prestidigitator whose tricks I could not fathom. I thus find myself deprived of the benefit of experience, which ought to be the reward for my effort. I am ungrateful without remorse.[84]

The second part of this declaration leads us to suppose that Matisse did not personally feel Christian, in any case not in everyday life. But the first part guarantees the orthodoxy of his "labor."

This dogma may be unformulated. It is shared by paganism and biblical religions, though in the former it is not associated with the dogma of creation. It makes no difference to the artist whether God is immanent or transcendent to the world. In Christian regions, particular attention is given to the human body, which, to be beautiful, does not need to be idealized (as in the Greek manner) or stylized (as in the Asian, African, or Mesoamerican manner). As Hegel understood, it arises from the specifically Christian dogma of the Incarnation, shored up by the age-old reflection on the notion of person. The unrepeatable and continuing individuality of the human subject, the presence of a personal soul within, animates the portrait as it has been practiced in Europe since the Middle Ages. Other civilizations may have had an analogous intuition: there are portraits of men manifestly possessing an individual soul that are the handiwork of Roman and Japanese sculptors, or the mysterious bronze workers of Ife. But the entire appearance of the world also stems from a judgment of beauty: the landscape; society as one senses it in genre paintings; the natural or artificial objects the still life presents to us; and, finally, all human creations.

There is therefore a continuity between art under paganism and art under Christianity. If specifically religious art is discounted, the continuity is perfect, even though inflections imputable to that religion are visible in portraits or individualized nudes. In essence, what is true of morality is also true of art. There

is no *Christian morality* but only a *common morality.* In the same way, there is no *Christian art* but only a *common art,* which religion does not claim to push farther or cast higher than pagan arts. When it comes to representing the true God, the superiority claimed by Christianity does not lie in the order of art (the beautiful), but in the order of truth.

Hence, according to that conception, the notion of Christian art loses all its boundaries. All art, from any era or civilization whatever, can be for Christians the object of a judgment of orthodoxy, whose doctrinal criterion is linked to creation. The practical criterion will be love and respect for nature, fidelity and conformity (relative to the transpositions of art) to nature. This judgment is objective. It does not take the artist's subjectivity into account. One person may be ardently devout and produce a heterodox painting; another, who has never heard of God or his angels, may remain close to the rigors of doctrine.

Finally, in the Western tradition, the relation between profane and sacred art replicates the relation between nature and grace. Nature has its consistency and stability, even though, to a contemplative mind, it might look like a creation, a perpetual miracle, and finally, grace. Grace in the narrow sense is itself created, added to nature without destroying it. It completes, one might say, the construction of nature. Sacred art thus presupposes the infrastructure of profane art, just as the *Disputà* presupposes *The School of Athens* on the opposite wall of the room. The former painting would lose all its intelligibility if it were not shored up and highlighted by the latter, and the latter displays its full meaning only in the light of the former.

With these distinctions in mind, let us consider nineteenth-century religious art.

In France

A. Nineteenth-Century Religious Art

Religious art in France has been the subject of a pioneering study from which we can seek support. Bruno Foucart has discovered a lost continent, since for almost an entire century we have been accustomed to ignore or have contempt for that form of painting.[85]

The first glaring fact is that it was abundant, not only because the church was constructing and decorating buildings, but because the state itself was making enormous commissions, the public was eager to buy such paintings, and artists were eager to produce them. At the Salon of 1781, about 5 percent of works exhibited had a biblical subject; at the Salon of 1819, 10 percent; at the Salon of 1827, 12 percent; and at the Salon of 1842, nearly 14 percent. That proportion,

which was 0.5 percent at the Salon of 1801, rarely fell below 5 percent after the Restoration and peaked in the 1840s. It again surpassed 10 percent at the Salon of 1855. Of course, the market most easily absorbed portraits, landscapes, and genre scenes. But the "big genres," encouraged by the government, remained plentiful, and religious painting made inroads at the expense of history painting. It had become the "big genre" par excellence, and in this respect represented artists' loftiest ambitions.

But during that rapid expansion, religious painting began to depart from traditional approaches. Or rather, they continued to be followed, but others opened beside them and captured a different spirit. Chateaubriand illustrates as well as anyone, though ambiguously, what the classical approach may have been, namely, that

> the Christian religion, being spiritual and mystical in nature, provides painting with a more perfect and more divine ideal beauty than that arising from a worship of matter; that, in correcting the ugliness of passions and battling them with diligence, it gives a more sublime tenor to the human figure, and better captures the soul in the muscles and ligaments of matter; finally, that it provides the arts with more beautiful, richer, more dramatic, more touching subjects than mythological subjects.[86]

That is more or less what Fénelon would have said—if not Bossuet, who would have linked the perfection of ideal beauty not to mysticism but to the truth of a religion that can do without mysticism. In any case, Chateaubriand does not embrace any other kind of painting or style, nor does he require the painter's conversion.

In a country like France, the church is concerned with missionary efforts, and the Catholic *Reconquista* in the nineteenth century left no stone unturned. It did not neglect any show of good will toward artists or any style of art. Like the century itself, it was naturally eclectic. It wanted to touch people, to please; it accepted and sometimes sought out the sentimental and prettified. Foucart notes that such a program also suited post-Tridentine painting, which was also an art of reconquest. According to him, the adventure of religious painting in the nineteenth century was similar to that of the seventeenth century, from Carracci to Sassoferrato, and for the same reasons.[87]

The Saint-Sulpice style diffused its art via industrial means. Nonetheless, the church attempted—it no longer always had the means to succeed—to impose a certain amount of iconographic oversight. In the historicist and scholarly spirit of the century, it even refined the old symbolic language. In 1871, Abbot Auber published *Une histoire et théorie du symbolisme religieux* (A history and theory of religious symbolism), an exhumation of Christian antiquities that was a close

parallel to the Oxford movement. The six volumes of the archaeologist Grimouard de Saint Laurent, *Guide de l'art chrétien* (Guide to Christian art), published beginning in 1872, drew abundantly on historical treasures. In short, the church broadened the registry of subjects for painters' use much more than it tried to restrict or purge it.[88]

Faith was not always requisite. If it had been, religious art would have withered away, since the alliance between piety and talent was very rare. Ingres, Vernet, Delacroix, and Amaury-Duval, though more or less unbelievers, were thus in demand. Baudelaire's Catholic instincts coincided with the practice. He said that the absence of faith was in no way the cause of decadence, since the history of painting abounds in "impious and atheistic artists producing excellent religious works." It was enough that such painting be animated by a noble imagination, that it be "inspired."[89] And the Spirit visited wherever it liked.

"Religious painting," writes Foucart, "is so plentiful, and those who practice it so numerous and diverse, that its most powerful and almost exclusive patrons, the Catholic Church and the councils, accept more than they govern a pictorial production in which every sort of contemporary pursuit can be found."[90] This view presents us with a church liberal either because of tradition or because it cannot be otherwise. Diversity, currents going against tradition and doctrine, sectarian and fundamentalist currents also came from all sides, from within and outside the church. Religious art had no real unity in the nineteenth century. Nonetheless, for our purposes we must define the new elements that gradually shattered that unity and led to the current metamorphoses of the divine image.

The first is *medievalism*. It was in Paris that August Wilhelm von Schlegel published his 1817 monograph on Fra Angelico's *Coronation of the Virgin*. The guiding idea—which is also Hegel's view—is that there is an essential rupture between classical and medieval art: "Not only does the art of the ancients differ from that of the moderns, but they are even diametrically opposed in their very essence."[91]

For Nazarenes such as Overbeck, there was a specifically Christian art, which found its definitive style in the Middle Ages, a style whose validity was guaranteed by the truth of the religion. Subjects drawn from the Bible were intrinsically superior to subjects drawn from Homer; in the Middle Ages, Fra Angelico and especially the Germanic van Eyck gave them an adequate treatment, to which the painters of today ought to return. After a generation's delay, these ideas made inroads in France.

The critic Rio, who had a German education and was influenced by Schelling, was also marked by his encounters with the Nazarenes in Rome and by his conversations with Rumohr in Munich; he introduced the principles of the new

aesthetic to France. The quattrocento was the golden age of art, because it was both "learned and Catholic." That lesson sufficed. Just as neoclassicism had rejected the immorality and frivolity of Boucher, Rio rejected Renaissance art, Raphael and Michelangelo included, in favor of Fra Angelico. The same anti-Raphaelism can be found in another Catholic critic, Cartier, but this time in a more radical form. Neither Raphael's life nor his art was Christian. Could anyone ever pray in front of the *Virgin in Linen* in the Louvre? The medievalist current, then, presupposed a golden age of Christianity conceived as a retrospective utopia to which one had to return. It posited Catholicism as a system and imagined a complete, mythical Christianity, with its own society, unanimously shared beliefs, and its own art. It also betrayed the fact that the Catholic religion was drifting toward Catholic ideology, an understandable reaction to the precarious situation resulting from the French Revolution and the shakiness of modern faith.[92]

Curiously, then, a movement was forming in France analogous to the one that emerged in Russia in about 1910, based on the rediscovery and rehabilitation of icons. Nationalism was less developed—though it existed—but there was the same critique, extending even to iconoclasm, of art coming out of the Renaissance and the post-Tridentine reformation. As we shall see, the *L'Art Sacré* movement, so violently opposed to the nineteenth century, adopted the same iconoclastic stance in about 1950 and radicalized it.

From another angle, medievalism can also be understood as one of the earliest forms of primitivism. When the public's eye had been thoroughly trained by the techniques of post-Renaissance art, the style of the Middle Ages, which knew nothing of perspective and chiaroscuro, created the same shock as black African art in Apollinaire's time. It was a return to what Hegel called the "symbolic," from which artists hoped to draw a surplus of expressiveness, linked to the sense of the sacred, but a sacredness that was Christian. In short, there was an alliance between the "symbolic" and the "romantic" (again in Hegel's sense of the terms).

Medievalism certainly had less impressive consequences in the art of France than it did in England and Germany. In Paris, the neo-Gothic architectural offensive was confined to Sainte-Clotilde, while Trinity, Saint-François-Xavier, and many other churches were going up at the same time. Sometimes called "Romano-Byzantine," they were actually faithful to the spirit of the Baroque in its Second Empire incarnation. In the northern countries, the medieval fashion was more closely linked to nationalism or the search for a national style and less to a nostalgic utopianism, as it was in France.

Another element, which, like the first, was not dominant but also affected re-

ligious art, was the insistent call for personal commitment. In Migne's encyclopedia, we read: "The only artists who achieved some success as Christian painters were those who began as the blessed Brother Angelico of Fiesole began, making the sign of the cross and asking for inspiration from on high."[93] The artist is called upon to convert. He has a vocation for perfection and holiness. In Rome, under the patronage of Lacordaire and Angelico, the Brotherhood of Saint John was founded in 1839. Its ambitions were even loftier than those of the Nazarenes, since it went so far as to define a rule for living. Its goal was the "sanctification of art and artists by the Catholic faith and the propagation of the Catholic faith by art and artists." However, an examination of the activities of the brotherhood shows that it worked for individual sanctification and did not promote a particular aesthetics.

Montalembert wrote in 1837: "If we had the honor of being bishops or priests, we would never entrust on our own account the works of religious art to any artist whatsoever, without being assured not only of his talent but of his faith and knowledge in the matter of religion; . . . we would ask him: Do you believe in the symbol you are going to represent, in the event you are going to reproduce?"[94] Such a requirement overtaxes the artist, overloads the program, and adversely affects recruitment. It forces the artist to embrace religion in a part of his person that is distinct from the place where religious painting is elaborated.

Yet—this is a third element—even if the artist obeys that injunction, he may not locate himself within the Catholic religion, but rather within a religiosity that no one can convince him is heterodox. Spiritualism is obviously the state of mind that replaces Catholic spirituality. Its theory comes from Victor Cousin and his disciple, the aesthetician Abbot Jouve. Cousin writes: "True beauty is ideal beauty and ideal beauty is a reflection of the infinite. Thus art is in itself essentially moral and religious." Abbot Jouve adds: "It is the attribute of beauty not to excite and inflame desire, but to purify and ennoble it. . . . When an artist delights in reproducing voluptuous forms, in pleasing the senses, he troubles, he upsets our chaste idea of beauty."[95] These quotations suffice. In the first place, spiritualism professes a disgust for matter, a disgust that extends to the body, to nature, and even to social life. This leads to a separation between profane and sacred painting, a separation that goes further than the sacred genre requires. In earlier centuries, religious painting did not turn up its nose at "pleasing the senses." The Virgin and the saints wore clothing that did not contrast sharply with that of the other figures in the painting, or even with that of its beholders. The beauty of their faces and bodies was of this world. In spiritualism, these figures had to be wrested away from the world. Profane painting forced beholders

to make concessions to desire. But spiritualist religious painting provided the means for "elevation," for rising toward the infinite, the ethereal, toward what was above things in the hazy kingdom of "chaste beauty."

Most of the time, the depletion of all matter, represented by the blandness of the design, the timidity of the colors, the insipid charm of the sentiment, placed religious painting in an atmosphere of invincible boredom. Let us add that religious painting, under the rule of the Concordate, developed less within a context of faith than within an administrative context: the Ministry of Religion. A church or state bureaucracy is enough to cool the most fervent paintings.

But matter took its revenge, and the unsatisfied senses rebelled. Thus, religious painting exuded a sentimentality verging on hysteria and, as a counterreaction, a frankly troubling eroticism. This often happens when the supernatural breaks its moorings with the natural.

Other colorations became possible when nineteenth-century spiritualism developed into a humanitarian evolutionism and a millenarian socialism. In *The Sentimental Education*, Flaubert introduces the painter Pellerin. In the intellectual chaos of the revolution of 1848, Pellerin painted a picture: "It represented the Republic, or Progress, or Civilization, as Jesus Christ driving a locomotive through a virgin forest."[96] In one sentence, Flaubert gives a caricature that would fit Chenavard, the "painter priest." "Every religion," said Chenevard, "is, to my thinking, only the plastic form of ideas." These ideas amount to a social palingenesis located somewhere between Ballanche and Quinet. For the ground of the Panthéon's nave (there was talk of returning the Panthéon to the Catholic faith), Chenavard prepared a *Sermon on the Mount* attended by Jan Hus, Luther, Fénelon, Swedenborg, Rousseau, Saint-Simon, and Fourier. That was enough to worry Monsignor Sibour, archbishop of Paris at the time![97] At the Salon of 1837, Ary Scheffer exhibited *Christ the Comforter*. The critic Piel explains: "Christ . . . is breaking the chains of the dying Poland. . . . In the background the slave from ancient times lovingly contemplates the savior and master. . . . Then comes the medieval serf . . . a Negro extends his heavily chained arms to Christ. . . . On the right are three sweet and delicate creatures representing the heartbreak and suffering of the soul during the three ages of woman."[98]

It would be rash to make a global judgment of religious painting in France. The above remarks deal only with its claim to call itself Christian. But just as orthodoxy does not guarantee good painting, heterodoxy does not prevent it. Religious art is considered the "big genre," the serious genre par excellence. It thus calls forth artists' loftiest ambitions, and they produce numerous experiments ranging beyond the usual categories of art history. Not all fall within the "three schools"—classical, romantic, and naturalist. All sorts of factors weigh heavy on

art: the exaggerated rift between the sacred and the profane; effusive sentimentality; the quest for the pure, the elevated, the disincarnated, the asexual; the cost of spiritualism; humanitarian or socialist deviations. Yet the true religious spirit appears in a host of paintings, often outside churches, and in my view, never more elevated than in Millet. And there were many other successes. After all, the Sacré-Coeur complex has recently emerged from the aesthetic hell to which it had long been relegated. I have no wish to see the Fourvière basilica rehabilitated any time soon, but one never knows.

All the same, despite great and defensible creations, it must be admitted that there is a vast wasteland, with which the name "Saint-Sulpice" is associated, so often that we must consider the phenomenon.

B. Saint-Sulpice and "L'Art Sacré"

For the observant Christian, the divine image is often limited to colored plaster figures prominently located in the sanctuary. Like icons in Orthodox countries, these are objects of worship that awaken piety and provide a reason and support for prayer. They are not, in the first place, works of art. If we had to analyze them, we would say they seem to be the last wave of the kind of art desired by the Council of Trent: pedagogical, readable, affective, like a distant echo of the Bolognese school.

Even though, in its own domain and in terms of what was expected of it, the Saint-Sulpice style of art was satisfying, it was nonetheless the object of extremely virulent attacks, beginning in the early twentieth century and culminating in the review *L'Art Sacré*. It was now not artists but the clergy itself, led by Father Couturier and Father Regamey, who could no longer bear the gap between what was considered the vibrant current in the fine arts—postimpressionism and everything now classified as "avant-garde"—and Saint-Sulpice art, considered the shameful relic of the most degenerate form of academicism.

L'Art Sacré stood at the center of an attempt to reconcile "modern art" and the French Catholic Church. Published in two series, before and after World War II, and, between 1937 and 1954, edited by two Dominicans, Regamey and Couturier, it was the inspiration behind a few large-scale undertakings: the churches and chapels of Assy, Vence, Audincourt, and Ronchamp. In 1950, very aggressive resistance surfaced, a consequence, in particular, of the crucifix by Germaine Richier added to the church in Assy. "Fifty years from now," one article declared, "who will remember Reverend Father Regamey and Reverend Father Couturier, with all their smug, naive admiration of hideous works, some of them baroque, some burlesque, some monstrous, some Satanic?"[99] In 1947,

Pius XII's encyclical *Mediator Dei* came out in favor of finding new art forms, but counseled prudence and appealed to the "slow deliberation" required by the faith and the needs of believers. The church had always taken the side of the throngs of believers against the overly jolting and scandalizing initiative of artists or purist elites. A 30 June 1952 directive from the Holy See reminded readers that the role of sacred art was to contribute to the "decor" (*decorum* in Latin, that is, "propriety" and "dignity") of the house of God and to nurture the faith and piety of believers. It was appealing to a long-standing tradition. The same directive recommended commissioning only Catholics to produce sacred art, but refrained from "excluding unbelievers a priori from producing work for the church"; such judgments should be made not on the basis of an "evaluation of [the artists'] fitness," but rather on their "execution." Tradition once again. In 1954 Father Couturier died, and Father Regamey gave up the directorship of the review.

The two directors were not completely of the same mind. Father Regamey's theories were close to those of Maritain, that is, they were neo-Thomist. "Integrity," "proportion," "brilliance" (or splendor) were the attributes of beauty. Christian art was "the art of redeemed humanity." It celebrated the mystery of the Sabbath "by imitating the Incarnation of the Word and the spiritualization of the flesh," in keeping with the human means at the artist's disposal. The tradition, the liturgy, and the Beatitudes were the three sources from which the Christian artist drew. But what is tradition? This is not clear, since Father Regamey, even as he argued in its favor, also said he sympathized with a reaction against the recent tradition as a whole. He was confident that the artist could overcome that contradiction. But he also did not authorize the artist to assume an incommensurate autonomy and creative power. He feared the artist's Promethean mysticism "where the religion of the Incarnation gradually transforms itself into a religion of disincarnation." For the time being, he believed, the greatest danger was "the reign of money."[100]

Father Couturier was infinitely more radical, and, though Thomist, he abandoned himself entirely to the romantic doctrine of genius. Citing Delacroix, he said one must "always take the side of genius." According to his theory, genius was sufficient for Christian art. In the present crisis, it could, and even had to, substitute for faith. Christian art is dead, observed Father Couturier; life must therefore be sought where it lies, that is, outside the church. It is safer to "appeal to geniuses without faith than to believers without talent."[101] This can be defended, in fact, but can we go along with him when he declares that "the work of genius is a vicarious form of the sacred"? Or that the natural gifts of great artists function the same way that the gifts of the Holy Spirit act on saints? Or that

"masters do works like saints"? Or finally, that Our Lord is not only the Word incarnate but a "man of genius"? Neither Kant nor Hegel, to whom, nevertheless, such astonishing declarations must refer, would have dared assert so naively the "genius" of Jesus Christ.[102]

But the doctrines of these two Dominicans count less than their tastes. It is in this respect that they exerted an influence beyond the circle of the review's attentive readers. Their hatred was directed at "academicism." For Father Regamey, that notion encompassed a broad area. Academicism came into being during the Italian Renaissance. It took hold in the Bolognese academy and gained strength in the seventeenth century with Franco-Italian neoclassicism. It was further consolidated by David and Ingres. By then, there was nothing left but "vulgarity," "poverty," "lack of culture," "foolishness." Father Regamey condemned the nineteenth century as a whole. That rejection extended to the Nazarenes, the Pre-Raphaelites, and the "pastichers" of Christian art. Curiously, Father Regamey reproached them for seeking a Christian aesthetic, since, for this good Thomist, the church could not impose any aesthetic system. But did he not realize that his act of exclusion stemmed, precisely, from an aesthetic system? He did not approve of Viollet-le-Duc, who saw the Gothic style not only as a complete, rational, logical, and national art, but as the religious art par excellence. Father Regamey substituted the Romanesque for the Gothic as the source of regeneration. *L'Art Sacré* was thus in line with the broad-based fashion for the Romanesque, the spare Cistercian, and the stylized eleventh-century fresco: the symbolic capital that dominated the postwar period. Regamey was blind to the beauty of the Baroque, which he assimilated to academicism. In painting, like Rio and de Montalembert, he proposed Fra Angelico as the unparalleled model. *L'Art Sacré* thus promoted a widespread iconoclastic rejection of all Western art, beginning with the early Renaissance. In that respect, it ran along the same lines as the condemnations made by the Orthodox Church or by twentieth-century Russian aesthetes and theologians. A Romanesque sanctuary stripped bare, in which a reproduction of an Eastern icon hangs, lit by an abstract stained glass window and decorated with a violently expressionist Way of the Cross: such were the clerical tastes of that generation. After the overly exuberant nineteenth century, they recovered the old Jansenist spirit that had stripped the churches of France, preparing them for the complete defurnishing of the years following Vatican II.

But where is living art? *L'Art Sacré,* like the monuments it sponsored, pointed to the art of Maurice Denis, Rouault, Desvallières, Germaine Richier, Bazaine, Manessier. All were religious souls, and often Catholic souls. As for their aesthetic allegiances, they came out of symbolism via Gustave Moreau and Ber-

nard, and the youngest ones were moving toward expressionism or abstraction. In fact, this has been the typical itinerary of religious art in the nineteenth and twentieth centuries, as it was practiced outside the church by religious souls, whether Christian or not. This sensibility—symbolist, spiritualist, or even full of a still-muted expressionism—also surfaced within officially Catholic art and permeated the entire genre, official or not, of religious painting. The note of heterodoxy was simply reinforced when that art, having escaped the control of the church, was violently reinjected into the church by the *L'Art Sacré* movement.

Of course, Catholic art showed signs of exhaustion. But the art the movement sought to revive carried with it the seeds of another sort of exhaustion. In short, the art of Saint-Sulpice told believers—in a very weak voice, it is true—what they had learned of their faith and what they wanted to hear. The much more sentimental art of Desvallières or Rouault, just as prettified in its essence despite its more muscular appearance, told them different things they did not want to believe. The instinctive opposition of the majority of Catholics was finally overcome only by the victory, primarily in stained glass windows, of abstractionism, which, in devout painters such as Bazaine or Manessier, relied on a mysticism of light. The majority of Catholics understood nothing of that. Thus, standing in front of these stained glass windows, which they perceived as neutral, they finally came to prefer what they interpreted as an absence of image, a Muslim-style aniconism, to the symbolist or expressionist pathos that shocked them and shook their faith. In the end, Saint-Sulpice art and the modernist anti-Saint-Sulpice art canceled each other out, resulting in the nonfigurative.

C. Profane Orthodoxy

The preceding remarks are much too fragmentary to allow for an aesthetic judgment. But they are sufficient to provide guidance for a theological judgment, namely, that orthodoxy—in the sense of a spiritual conformity to Christianity and, in the case of France, to Catholicism—seems calmly to inhabit sacred painting less than it does the profane painting produced by artists uninterested in calling themselves Christian. If it were possible to measure religious tone and theological purity, French profane painting would rank higher than religious painting, particularly those paintings produced in and for the church. What made French painting world-famous in the last third of the nineteenth century was not only its aesthetic value in the strict sense, but the spiritual richness it dispensed and which made it so beloved.

The principal, and perhaps sole, criterion determining the orthodoxy of art

is, as I said, the benevolent attitude taken toward the creation, which implies a host of corollaries relating to faith, truth, the search for beauty, and the relationship with things. Which contemporary religious painter explains the spiritual meaning of light better than Monet, that of the female body and social pleasure better than Renoir, that of the truth of peoples and things better than Degas, that of their inexhaustible presence better than Manet or Cézanne? Despite their merits, it would not be Amaury-Duval, Chenavard, Lehmann, Lazerges, Cibot, Lafon, Signol, Janmot, or Ziegler, alas!

Of course, Monet, Renoir, Manet, and Cézanne were at best indifferent toward religion, and surely solidly anticlerical.[103] In addition, at least in Monet's case, what religiosity there was was not Christian at all. His naturalist ecstasy was spontaneously linked to Eastern pantheistic mysticism. His Japanese admirers were not mistaken, nor were the lyrical American abstractionists. But at least his relation to the divine in nature established common ground with the religion into which he was born and was faithful to the best part of himself. Monet's faithfulness was more in doubt for such artists as Rossetti, Burne-Jones, and Kandinsky, who criticized him for his lack of ideals, his distance from lofty thoughts and elevated feelings. The symbolist, spiritualist, and abstractionist criticisms of impressionism coincided with the Catholic criticism. But that is because the latter, contrary to what its practitioners believed, was no longer truly catholic.

In England

A. Pre-Raphaelite Devotion

With the great religious revivals at the end of the eighteenth century, the degree of fervor probably rose in England more than it did in France (if this can be measured), and, in any case, until the end of the nineteenth century, it was considered reprehensible to display contrary sentiments. That revival, born first in dissent, also touched the Church of England, and, in producing dissidence within it, benefited the Catholic Church. England's religious seriousness proceeded apace with the growth of the middle class. Romantic forms of libertine rebellion had to seek refuge in the castles of dissident aristocrats or in voluntary exile. The equivalent of both pious and socially preeminent figures such as the prominent Victorians Keble, Gladstone, Doctor Arnold, and Florence Nightingale seem to have been rare on the continent. The British Empire, given its intense missionary efforts, claimed to be Christian. As a result, religion embraced conformism and became an element of English nationalist consciousness, an element by which England distinguished itself advantageously from "impious"

France, "superstitious" Italy, and "fanatical" Spain. Religious art was therefore more central in England than in France, in all its forms: illustrations of the Bible, divine images of Christ and even of God the Father, homiletic and moralistic images, supernatural visions.

In contrast to what occurred in France, the public was not disaffected by that art, nor did they look down on it. There was no revolutionary break in English art. The Pre-Raphaelite Brotherhood arrived in force but did not change the way the English looked at their pictorial tradition. And, even when that movement also lost steam, when it shifted and gave way, the public remained faithful to it. Even when art criticism, won over by French criteria, held it in low esteem, the images it had produced remained popular, most popular by far, in fact. This is because it was "Englishness" that the movement expressed, the insular typology of faces, motifs, landscapes, color: everything about the technique of these paintings continued to elicit a feeling of tender complicity. On the continent, this same affection, combined with humor, with mockery, won the hearts of those who recognized the English world in these sometimes "impossible" paintings.

The most surprising form of religious art in England occurred only once. The visionary poet Blake invented a mythology, in which characters named Urizen, Los, Enitharmon, and Or engaged in a primordial battle. In about 1795, the most powerful images of the Creation, of the Book of Daniel, suddenly appeared: they were taken from the Bible, from Milton, from Blake's own heterodox gnosis, and, in the case of his artistic idiom, from Michelangelo apprehended through Flaxman. *The House of the Dead, God Judging Adam, Newton,* and *Nebuchadnezzar* plunge us into a universe where the grassy sod does not yet exist, where God the Father, depicted as the "Ancient of Days," governs the destiny of nude bodies: heroic, bearded, hairy, and awesome like him.

In a register similar in its imagination—though not, of course, in its painting, and even less in its merit—we might mention John Martin. He draws on the Burkean sublime, finding his aesthetic example in Turner's most dramatic works and in the technique of panorama making. His huge compositions provide a "large screen" for catastrophes and cataclysms. *The Fall of Niniva, The Flood,* and *The Last Judgment* effectively place us within a cosmic vision, far from inhabited earth, capable of eliciting a salutary fear that may lead to repentance. In short, Martin participates in the religious revival in its most populist and sincere form: modern-day terror and urgent conversion.

But great English art does not lie in these Miltonian visions of the hereafter, but rather in the landscape captured in the watercolor or on canvas. There is no doubt that the English imagination includes a glimpse of heaven, elevation of a religious nature. Nevertheless, it goes beyond the framework of a search for reli-

gious art in the narrow sense. Rather, it was only after Cozens, Turner, Palmer, and Constable, that is, after the brightest moment of that school's genius had passed, that its precise intentions and clear goals appeared.

The Pre-Raphaelite Brotherhood (PRB) was established in autumn 1848 as a secret society. The founders were Dante Gabriel Rossetti, W. H. Hunt, and J. E. Millais; it later welcomed J. Collinson, F. G. Stephens, the sculptor T. Woolner, and, as secretary and annalist, W. M. Rossetti, the painter's brother. Their goal, to reform and restore English painting to its former glory, was ambitious and somewhat poorly defined. They were not quite sure where to turn or where to place themselves among the numerous currents of European life. They were pulled in two directions, which continued to mingle and impinge on one another. The first was a return to nature, to a naturalist vision of things, in opposition to the academicism that had dominated the Royal Academy establishment since Reynolds. The second, also in opposition to academicism, consisted of returning to the pious and "natural" approach that characterized the old masters of the fourteenth and fifteenth centuries. After four or five years, the ideals and even the members of the PRB became dispersed. William Holman Hunt was left almost alone to look after things; at least, that is the honor he claimed.

The PRB might appear to be a late branch of the romantic movement. The bearded men in David's studio, the Nazarenes, had preceded them by half a century. In the memoirs he later composed on the early days of the movement, Hunt claimed he had proposed the name "Early Christian Brotherhood," but that it was not chosen because it would have sounded disturbingly propapist.[104] In fact, the Pre-Raphaelites did not wish to be accused of taking the wrong side in the quarrel pitting the Church of England against the Tractarians and the Oxford movement. With Ruskin's cooperation, the religious side of the movement linked itself instead to the low church. But naturalism, if it claims to bear witness to the divine creation, has a religious value in itself, and, under Ruskin's influence, such was the interpretation given it by American painters, who labored to express in religious terms the grandiose sublimity of the Hudson Valley, the Great Plains, and the Western deserts.

One of the very first paintings of "fellow traveler" Ford Madox Brown, painted in about 1847 or 1848, is *Wycliffe Reading the Translation of the New Testament to John of Gaunt.* The costumes and furnishings for this radically anti-Catholic canvas (reinforced by the very dark effigy of the papist church in the left-hand corner) were archaeologically documented through the careful questioning of specialists. But there are also two directly religious works, both painted in 1848–49. Rossetti, it seems, was not very prone to piety. He was always mad about women, to such a degree that the famous acronym "PRB" was

interpreted by his friends as "Penis Rather Better."[105] But his *Childhood of the Virgin Mary*, painted under the influence of Ford Madox Brown and under Hunt's oversight, is nonetheless a manifesto of Christian art. He adds numerous symbols to its Italian Renaissance stylization and explains them himself in sonnets written on the frame. There are lilies, which represent innocence, piles of books, the virtues, a palm tree with seven branches, and a heath with seven thorns, which expresses "great suffering and great rewards." Nonetheless, the painting is rendered naturalistically.

Millais's painting— *Christ in the House of His Parents*—is of higher quality. It too surrounds the symbols with naturalistic details, which transport the beholder to the Nazareth of New Testament times (sheep, loincloths, turbans) and simultaneously place him in an English studio, as George Eliot might have described it. But the most "modern" thing about the painting is the very English look of the worn-out, sorrowful Virgin, the robust, bald carpenter Joseph, and the Baby Jesus, a British cherub with red hair. That appalled Dickens, who found the baby in nightshirt hideous and his mother "so horrible in her ugliness" that "she would stand out from the rest of the company as a monster in the vilest cabaret in France."[106]

Religious fervor, combined with a taste for Italian Renaissance iconography, sometimes led the group to the brink of papist superstition. It was even suspected that Ford Madox Brown was thinking of the Virgin when he painted *The Pretty Baa Lamb* (1852). Does it not depict a young woman holding a child and receiving a few gentle lambs? But the artist protested, saying he had simply wanted to paint "a woman, a baby, two lambs, a servant girl, and a little grass." Collinson's *Convent Thoughts* was even more suspect. In fact, it did not take him long to convert to Catholicism, to take holy orders, and so to be lost to painting.

But perhaps the most characteristic of all was W. H. Hunt's *Light of the World*. In the chapel of Keble College at Oxford, where the painting is housed, a small group is always gathered around it. English piety finds a resonance in it. Its companion piece, *The Awakening Conscience,* sheds light on the painting. Hunt got the idea for it by reading Dickens and by questioning the fallen women who populated the poor neighborhoods of London. In a horribly cluttered interior (with a clock on the piano and a glass cover over the clock), a woman, in as much of a state of undress as possible—that is, in a dressing gown, open but covering her from her chin to her feet—tears herself away from her lover's arms. Her hands are joined. Her lips are parted. The scales have fallen from her eyes. The light of grace and imminent conversion illuminates the adulteress's face, while the coarsest vulgarity marks the face of her companion, mired in sin. Hunt had already treated this theme in *The Bad Shepherd* (1851) and, more alle-

gorically, in *The Lost Sheep* (1852). Many details of *The Awakening Conscience* enrich the painting's moral significance: above the piano, a painting of the biblical adulteress is visible; on the carpet, a cat is killing a bird; the wallpaper is laden with symbols.

But the spiritual meaning is provided by *Light of the World*. Against a nocturnal landscape stands a house, whose rusty door, obstructed by weeds, invaded by ivy and other sterile plants, has never been opened. A bat flies overhead. Such is the human soul, mired in ignorance and resistant to Christ's teachings. The Lord, with the crown of thorns on his head, a royal mantle across his shoulders, and a dark lantern in his hand—a symbol of conscience and grace—is knocking at the door.

With these paintings, the religious art of nineteenth-century England reached its high point. It combined the moralizing evangelism characteristic of English religious revivals, meticulous observation and the rendering of details down to the last blade of grass, archaeological precision (see, for example, Hunt's *Scapegoat*), and a still restrained symbolist weightiness. Hunt's faith is "beyond doubt," in both senses of that expression. "To Rossetti," writes Ruskin, sounding just the right note in this case,

> the Old and New Testaments were only the greatest poems he knew; and he painted scenes drawn from them with no more actual belief in their relation to the present life and business of men than he gave also to the "Morte d'Arthur" or the "Vita Nuova." But to Holman Hunt, the story of the New Testament, when once his mind entirely fastened on it, became what it was to an old Puritan, or an old Catholic of true blood,—not merely a Reality, not merely the greatest of Realities, but the only Reality. So that there is nothing in the earth for him any more that does not speak of that,—there is no course of thought nor force of skill for him, but it springs from and ends in that.[107]

B. The Last Days of the PRB

In the second half of the nineteenth century, religious subjects began to appear less frequently. There was Watts, of course, who was not one of the Pre-Raphaelites, but who, like them, turned his sights to Italy (the land of Tintoretto and Michelangelo) and used painting to dispense a moral lesson or incite a metaphysical meditation. Going further than the Pre-Raphaelites, he rediscovered the cosmic, extraterrestrial feeling that had transported John Martin and Blake. *Hope* shows a woman seated in an unnatural pose on the earthly globe, lost in interstellar space. The other painting that earned him celebrity was *The Sower of the Systems*. The Creator is depicted from the back, perhaps in keeping with the biblical words that warn Moses not to look at his face. Thus, a

Veronese green shape in drapery, with a glow reminiscent of Michelangelo, is disappearing into the infinite darkness; but the golden nebulae bud and germinate at the touch of his hand or foot.

But such paintings had long been the exception. Faith was cooling. The aesthetic currents that came to England, and the public that followed them, had so little taste for preachy works that even Hunt hardly dared tackle them anymore. The Grosvenor Gallery exhibited Tissot, Whistler, Burne-Jones. Aubrey Beardsley was on his way. Millais, perhaps the most gifted of his generation, succumbed to the most basely commercial kitsch.

In 1858, in his own words, Ruskin "unconverted" from the militant evangelism that had inspired the group. He now turned to Greek antiquity, the Venice of Titian and Tintoretto. He moved toward ideal beauty and the "pagan" formalism of the Renaissance, all of which were considered abominations by early Pre-Raphaelitism. Of the forces subverting the spirit of the movement, I can discern two, seemingly of unequal importance. The first would be "socialism," understood in the English sense of the term. Combined with anti-industrialism, it existed in William Morris and dominated the eventually industrialized Arts and Crafts movement, which was launched through the firm founded by Morris, Faulkner, and P. P. Marshall (a friend of Ford Madox Brown). With the collaboration of Liberty, this firm created fabrics, stained glass windows, furniture, and a still-vibrant decorative art. Socialism also existed in the extolling of labor (Ford Madox Brown's *Work* from 1856, John Brett's *The Stone Braker*). Through that ennobling attention to working-class England, it took the form of history painting. Its masterpiece, which attained the universal, may well be Ford Madox Brown's *The Last of England,* an unforgettable monument to the vast, heroic event of the British emigration.

The second force that led, not to a weakening of painting—on the contrary —but to an irremediable corruption of its religious quality, was, admittedly, eroticism. Or rather, a certain kind of poorly controlled lust, half unconscious perhaps, carefully dissimulated, and only the more obvious and irrepressible for all that. The Pre-Raphaelites had lifted the veils of convention that protected academic painting from such affects. Their aim was to resituate holy scenes within the framework of the everyday, like the old painters before Raphael, to which their political nonconformity also led them. As Hilton wrote, they wanted "a democratization of holiness."[108] But, in that familiar and secularized space, the affects appeared in a rather harsh light.

And never so harsh as in Rossetti. His 1850 Annunciation *(Ecce Ancilla Domini)* had already caused a certain uneasiness. The dreamy young woman in a nightdress, curled up on a bed, her hair unkempt, her mouth a sinuous line, her

eyes staring into space, had been deeply disturbing to the public, and the nimbus around her virginal head was utterly unable to dissipate that feeling. In a certain way, Rossetti's paintings became "purer" as the religious element was drained from them. Or perhaps it would be better to say: as the obsession progressed unhindered, the religious genre was eliminated and sexual obsession proved so invasive that a certain kind of sacredness—not at all Christian this time—was introduced into it.

The union between Rossetti and Elizabeth (Lizzy) Siddal could not be called happy. He neglected her, cheated on her, gave her little money. One evening, he found her dead, an empty bottle of laudanum beside her. By way of funerary monument, he then painted *Beata Beatrix*. A Beatrice, with Lizzy's features, sinks deep into ecstasy—an ecstasy more sexual than mystical, in the way people since Hume had spoken of Bernini's *Saint Theresa*, to make fun of it. Behind her, the shadow of Dante and of Eros can be discerned. A scarlet bird is placing a poppy flower in her hands—a symbol of passion, sleep, and the opium that had just killed her. Here, Rossetti has found a tone of sacred lust, which would become the mark of symbolism. That same mark is orchestrated to the point of obsession in the series of canvases depicting Jane Burden. The young woman, from a social milieu distinctly inferior to Rossetti's, had married his protégé William Morris. Rossetti's brother describes her this way: "Her face was at once tragic, mystical, passionate, calm, beautiful, and gracious, a sculptor's and painter's face, a face unique in England, not at all that of an Englishwoman, rather that of an Ionian Greek. . . . Her complexion was dark; she was pale, her eyes a deep, piercing gray, her hair massive and opulent, magnificently curled and verging on black, though not without a deep, subtle shine."[109] With that femme fatale, Rossetti succumbed to "romantic agony," in the manner explored by Mario Praz.[110] Their affair had the steaminess and intensity particular to adultery practiced between close friends. Everyone is familiar with the languorous portraits of the "Belle Dame sans merci," bowing under the weight of a heavy secret: *The Blessed Damozel, Monna Vanna, The Bower Meadow.* They were, in fact, very popular. It is "love painting"—in the sense one speaks of love poetry—a genre Rossetti may have invented, and whose heady atmosphere Klimt found in his portraits of Adele Bloch-Bauer and Emilie Flöge: eros and thanatos combined in equal measure. Soon thereafter, Rossetti, having taken to chloral, morphine, and laudanum, but without neglecting whiskey, bordeaux, and cognac, ingested in indeterminate quantities, applied himself to his decline, and thereby died. But not before committing to canvas the most sincere of his divine images, the one to which he had made the most complete sacrifice: Jane Burden as *Astarte Syriaca,* the fearsome goddess.

Today, French pompier painting strikes us as tending somewhat to flout decency. Certain nudes by Cabanel, Rochegrosse, and Lecomte du Noüy belong, sadly, to an aesthetics of the brothel, though a brothel ennobled and sanitized by the theatricality of academicism, which makes it more respectable by allowing it to appear permanently on the walls of a salon. The idealized brothel suggested by *The White Slave* certainly has little relation to the real brothel on Rue des Moulins as Lautrec painted it. But Lautrec painted the place without the fantasy, and Lecomte du Noüy the fantasy without the place. There is a way to render the same affect, but with more refinement and efficacy. It entails pushing idealization to the point where the libidinous intention can no longer be perceived as such, not by the beholder or by the painter, who both submit to it only the more profoundly as a result, without its being elaborated and sublimated by art. That, it seems to me, is the case in Burne-Jones.

Burne-Jones and William Morris had met at Oxford and together reveled in the chivalrous Arthurian Middle Ages, as Tennyson had captured them in poetry. Both dreamed of a clerical career and even planned to found a monastic order devoted to Sir Galahad. Unlike Morris, Burne-Jones did not abandon painting but placed himself under Rossetti's guidance, initially imitating him very closely. But in about 1863—Burne-Jones was then thirty years old—he emancipated himself and found his own style, from which he never varied and which did not undergo any sort of development during his lifetime, so much so that the chronology of his works is almost a matter of indifference.[111] How to characterize it? That immobility itself raises a question. Burne-Jones, once in possession of his idiom, his technique, indefinitely reproduces the same emotional note on a very limited scale, where it resonates with a captivating monotony. His paintings seem to stem from an internal obsession and not from an understanding of or exchange with reality.

Burne-Jones's pictorial grammar is borrowed from Botticelli (the *morbidezza* of faces, the transparent drapery, the sloping poses, the rhythmic lines), from Michelangelo (the anatomy), sometimes from Füssli, and even a bit from Rossetti. But what is particular to him is the languid atmosphere, the slow gestures, the weariness that makes arms hang, the lunar light, the absence of air, the indistinct colors with a bluish hue dominating, and everywhere the heaviness of sleep, of dropping off and dreaming, the kind of dream so deeply erotic that one is afraid to wake up.

In practical terms, there is only one woman and one female expression in Burne-Jones's paintings. The men, however sinewy, are more than effeminate: they are women, with female faces and bodies that inevitably show through their borrowed male anatomy. All the men and women are young. In *The Be-*

guiling of Merlin, Merlin has the face of Vivien, but made up, as it were, to appear a little older and to respect the story's conventions. In *The Golden Stairs,* eighteen absolutely identical young women are carefully arranged in graceful poses. In *The Mirror of Venus,* ten young women, also identical, lean over the mirror formed by a puddle of water, enveloped in the same thousand-fold drapery, which clings to their beautiful breasts and solid legs.

Young women or maids? How can we know? Let us consider their bearing, for example, that of the beggar maid contemplated by King Cophetua. This is one of the most famous of Burne-Jones's paintings, and Julien Gracq succumbed to its charm. The beggar maid is seated in front of us, facing us. The belly and navel show through her dress, and an open bolero both covers and reveals her breasts. The face is extremely pure. The forehead conceals a secret. The wide-open eyes look toward a foreign land. In Burne-Jones, women's eyes look neither at the beholder nor at the human figure facing them: the gaze is always directed elsewhere. We believe we can make out a deep-seated sorrow, a dissatisfaction, an incurable homesickness, but the permanent sadness, present even in the dreamy half-smile, does not disturb the calm serenity of the features. She is waiting. The look on the faces of Burne-Jones's women expresses the still-silent explosion of nascent love. They are going to make love, they may have just done so; or they already know that it is impossible, and that they stand on the brink of an eternal and painful separation.

All this intensifies an eroticism that is infinitely more penetrating than the frank and carnal desires that French pompier painters sought to excite. But, in Burne-Jones, it is never carried so far as in his few nudes. The nude, never widely practiced, was virtually banished from English painting when Queen Victoria was widowed. Burne-Jones's nudes *(Pan and Psyche, Perseus Slaying the Sea Serpent, The Depths of the Sea)* are particularly exquisite. Nothing is so sensual and, at the same time, so inaccessible. The English language distinguishes between "nude" and "naked," but Burne-Jones finds a way to fuse them: his painted figures have the too-perfect ideality of the academic nude, combined with an extreme sensitivity of the skin, as if these ideal women had just undressed for the first time and were going to get goose bumps in the cold dampness that covers the heather and lilies with dew.

Eros, that particular eros, is the foundation of Burne-Jones's religiosity, and in this respect he resembles Rossetti, but without fixing on an external object. Entirely absorbed in his dream, his art, the heavenly Venus, he had not met Jane Burden. The stained glass windows he produced for many churches (Christ Church in Oxford, notably) express the same nostalgia, but cooler and more dignified, as befits the place. It is clear that such an incandescent subterranean

sensuality was only waiting for the ground to crack for it to erupt like a volcano. And it was Aubrey Beardsley, a worshiper of Burne-Jones, who, in a few images with a somehow comforting and purifying obscenity, provided that liberating break in the earth, and, in revealing the truth of the Pre-Raphaelite movement, abruptly deprived it of its reason for existence.

In Germany

A. The Nazarenes

In 1810, several artists moved into the convent of Santo Isidoro in Rome, to lead a devout life and dedicate themselves to painting. They belonged to the most religious branch of romanticism. That is to say, unlike the French and the English, they were serious students of philosophy. They were acquainted with Tieck and Schlegel, who had pointed the way for the early masters. They reacted against Winckelmann and academicism, which, in their view, was antipatriotic and antireligious. Riepenhausen's scholarly work *(The History of Painting in Italy)* introduced Cimabue, Giotto, and Perugino to the young Overbeck (then fifteen years old) and convinced him of his vocation as a painter.

Overbeck and Pforr arrived from Vienna, Wächter from Swabia (via Paris, where he was the student of Regnault), Vogel and Hottinguer from Switzerland. They lived by a code that included getting together to criticize one another's works. On 10 July 1809, they took an oath to remain faithful to the truth, to fight academicism, and to bring about a revival in art, which was then mired in decadence. Hence, half a century before the Pre-Raphaelite Brotherhood, the first modern association of painters came into being. It took its name from Saint Luke, painter of the Virgin. Thanks to the director of the Académie de France, these young people established themselves in a deconsecrated convent belonging to Irish Franciscans. They were soon called the Fratelli de Santo Isidoro. Everyone had his own cell. The artists took their meals together. They posed for one another, refusing to paint women from life (much later, Overbeck finally used his own wife). They did not take their subjects from mythology or contemporary life, but from the Old and New Testaments. For them, painting was prayer and a ministry. After Pforr's death, Overbeck converted to Catholicism, which frightened Switzerland: Vogel and Hottinguer were forced to return home. But the group received Cornelius, a strong personality, to replace them.

In 1815, as a favor, since the brothers were living in extreme poverty, Bartholdy, consul of Prussia, commissioned them to decorate one room of his residence—al fresco, since, according to Cornelius, the salvation of German art hinged on it. *The Story of Joseph* in the Casa Bartholdy caused a stir. More than

five hundred German artists came to Rome, visiting the Casa Bartholdy and another large work by the group, the frescoes of the Casino Massimo, where Cornelius was inspired by Dante's *Paradiso,* Overbeck by *Jerusalem Delivered,* and Schnorr by *Orlando furioso.* Schlegel defended the works of the Nazarenes, particularly against Goethe's criticism. Louis I of Bavaria was mad about them and sought, not without success, to entice them. Cornelius was overwhelmed with commissions, took over the leadership of the academy in Düsseldorf, then the one in Munich. It was, of course, in Germany that the influence of the Nazarenes was strongest, but they were also admired in Italy by Minardi; in France by Chenavard and Flandrin, who were in contact with them; by Ingres, who knew them in Rome when he directed the Académie de France; and finally, in England, where Hunt and Rossetti took them as their example.

It was thus a movement of religious painting, animated by zealous, openly professed Christians, who put German painting back at the center of European attention, after many centuries of obscurity. But, in looking at the works, we cannot say that they fully transmit the sincerity of these enthusiastic and serious young men. We note rather the formal genius for pastiche (sometimes Fra Angelico, sometimes Dürer), the solid quality of the drawing, the frankness of the bright colors. These painters, who had taken a vow to hate academicism, and who, according to Schlegel, were supposed to be "like the early masters, faithful in their hearts, innocent, sensitive, reflective, artless in the execution of their works," may have been faithful, but they were by no means innocent, and they were certainly very far from artless. I am afraid that they transposed onto Perugino and Fra Angelico the academic respect their elders had shown for Raphael or the Bolognese school. They had the same obsession with the masters. Focillon was somewhat unfairly harsh, but not inaccurate, when he wrote:

> The deadly taste for imitation bursts forth . . . in that conscientious aesthetics, beholden to pedagogy, inflexibly applied by a scholarly, disciplined, patient people. . . . Perhaps this is only one aspect of the faith in the omnipotence of method in matters of art that characterizes modern Germany: through scholarship, through reflection, through the practice of virtue, in short, from the outside, German artists believed it was possible to replicate the great artists and appropriate their gifts. That is the mark of every sort of academicism, but, in these formidable believers, it acquired its maximum degree of weighty obviousness, and sometimes resulted in the most painful exaggeration. Exacerbated by that eternal symbolism, that need to signify a "content," it took the artificial and the academic up a notch, especially since art such as Cornelius's never lets itself be free. It is neither vibrant nor joyful.[112]

This was said in Germany as well. Goethe wrote Sulpice Boisserée: "It is the first time in the history of art that we have seen distinguished talents such as

Overbeck and Cornelius being content to go backward."[113] As for Hegel, his historicism, as we have seen, condemned in advance the attempt to reawaken Christian art, whose moment had passed. Thus it is not among the Nazarenes that the living branch of romantic aesthetics can be found. It is rather in Friedrich.

B. Friedrich, or, The Other Fatherland

The critical fortunes of Caspar David Friedrich (1774–1840) are instructive. The Nazarenes, who were a few years younger than he, and then the affable Biedermeier painting, had all but made him obsolete. In 1824, he failed to win the landscape chair at the academy of Dresden. Even in 1927, Focillon placed him side by side with the intimist Kersting, praising "their modest and heartfelt study of nature and of life."[114] At his peak, however, Friedrich was understood, and not by just anyone, but by Goethe, Brentano, Kleist, and Tieck. The king of Prussia bought his work, as did the Russian court.[115]

In our own time, after a long eclipse, his glory is once more on the rise. His body of work was almost complete in Germany, Russia, and Norway. The National Gallery and the Louvre are now proud to exhibit him. A major exhibit in Paris has canonized him. He is almost taken to be the equal of Constable and Turner—though the comparison seems shaky, since he was not a "landscape painter" in the same sense as the other two.

Friedrich's dates are almost the same as Hegel's. He "blossomed" between 1808 (the Teschen altarpiece) and 1835, when he was struck by a bout of poor health: he rode the wave of German romanticism. He shared its fate and, after succumbing to the countercurrents of realism, he returned with the triumph, shored up by all modern art, of romantic aesthetics.

In keeping with the spirit of that aesthetics, Friedrich had lofty ambitions, and from the outset they were beyond his reach. "Man is not the absolute model for man," he wrote. "The Divine, the Infinite is his goal." And yet, "art is infinite, but the knowledge and skill of all artists are finite." To offer the divine, the artist must become "profound."[116] German romanticism places truth at the vanishing point. It seeks less truth than the way to the depths of truth. For Friedrich, as Zerner remarks, the depths are not hidden, as they might be for Constable or the impressionists, they are glaringly obvious.[117] They are also religious, and ardently so. The divine is attained from within. "Keep the pure spirit of childhood within yourself and obey your internal voice absolutely; for it is the divine in us and does not lead us astray. Consider any pure movement of your soul sacred; respect any religious presentiment as sacred, since it is art within us!"[118]

But the divine is also attained from without: Friedrich is almost exclusively a painter of landscapes. That is because, for him, the landscape is a divine image; and Friedrich's originality and greatness lie in this conviction. On this point, he belongs to a movement. Moving beyond the cult of nature founded by Jean-Jacques Rousseau, romanticism sought an immediate, nondiscursive and—because it escapes convention—universally intelligible expression. Yet language is riven to convention. Perhaps there was a golden age when the Babel of languages did not yet exist and when the medium of language was continuous with dance, poetry, and music. Music retains the privilege of acting on the soul directly and without mediation. Art needs symbols and allegories to signify. But, to be understood, allegory also needs convention. Landscape painting can separate itself from convention. It puts the beholder in contact with pure nature. It can express not only nature's appearance but its hidden mystery, the infinite that lies behind things. Thus landscape painting allows us to penetrate the depths of the divine.

To find evidence of this, we must turn to Carus. A philosopher of nature, a geologist, a physician, something of a seer, and more fully a painter, he was the friend and disciple of Friedrich and often seems to have been writing at his behest. He wrote about Friedrich the landscape artist. He attested that "painting was for him a sort of divine calling. When he painted the sky, no one could enter his studio."[119] In 1831 Carus published his *Nine Letters on Landscape Painting*, on which he had been working since 1813. If we sort out and overlook some of the repetition in this text, which is awash in a permanent enthusiasm, we can distinguish the themes, or rather, the leitmotivs, of nature, art, and the artistic spirit. I will pass over the "scientific" considerations and the "correspondence of orders," which are in the tradition of Goethe and Schelling.

Nature is a revelation of the divine: "Every study of nature can but lead man to the threshold of higher mysteries."[120] "Every natural phenomenon is the revelation of a unique, infinitely sublime divinity. . . . That divinity must also be recognized in the world in its totality. . . . Man must recognize the divinity of nature, understood as corporeal revelation in the narrow sense, or, to express ourselves in human terms, of nature understood as the language of God."[121] For that, Carus adds, "a certain degree of philosophical training" is needed. Instinct does not suffice, nor does craftsmanship. Thought is necessary. The "artistic landscape," in fact, obviously presupposes "a higher level of education and a certain experience."

The landscape is understood as a *Dasein* of the divine. But that same divinity is also in the artist's soul. The "Almighty is revealed to us in reason and in nature, as interiority and exteriority; but we have the feeling that we are ourselves a part

of that revelation . . . we thus have the sense of our divinity."[122] Standing before nature, man feels "in God"; in art, he feels "God in him." "If, in nature, the feeling of a true and immediate incorporation of the divine essence elevates us," in art, conversely, we perceive "the divinity of the human spirit."[123] Through that dual communion, with the outside (the landscape), and with one's inner self (the artistic soul), beauty is achieved. "The beautiful is everything that purely expresses a divine essence in natural things, or everything in which nature reveals itself in keeping with its most intimate essence."[124]

God, nature, the soul: Is this not the classic doctrine, the vast triangle that, since Augustine, has structured the metaphysics of the artist? And yet, without noticing the fact, Carus has left it behind. He has advanced along the path of Gnosticism. He expects everything from an initiation or an exercise, by means of which the soul becomes aware of its divine nature and lodges within it the very secret of God, far from the appearances of the world. Nature, he says magnificently, is "mysterious in broad daylight."[125] But when the artist has purified himself, when he has renounced earthly goods, when he has liberated himself from the conventions and the techniques of art, when he has become holy as the church is holy, "the artist's soul will finally be, truly and absolutely, a blessed vessel ready to receive the luminous ray from on high. Then pictures of earthly life, of a new and superior kind, will appear, which will raise the contemplator himself toward a higher vision of nature, pictures that could be called mystical and orphic in that sense; then the art of representing earthly life will have achieved its apogee."[126]

Since what there is to be represented lies beyond things, Friedrich makes use of symbol and allegory. He does not seek to create a new symbolics from whole cloth. He uses very simple symbols, already in use among beholders: dark colors associated with sadness, the Cross of Christ, the anchor of hope, and the boat—symbol of fate and the journey through life. But he does so in such a way that the symbol does not appear added onto the landscape, but rather as part of it, as if it were there naturally, from time immemorial; hence the symbolism does not seem to come from the artist's will, but from the very language of nature, which always seems on the brink of divulging a secret. He likes backlighting because it expresses a transcendence, inasmuch as light coming from the back of the painting seems to be coming from much farther away. A backlit Claude Lorrain painting places the beholder at the center of his ideal fatherland. A backlit painting by Friedrich *(Large Enclosure near Dresden)* makes the beholder feel that his true fatherland lies elsewhere and, instead of satisfying him, fills him with longing and homesickness.

Let us now analyze a few of Friedrich's paintings. The Teschen altarpiece was

commissioned for a fishermen's chapel on Rügen Island, where the painter liked to stay. It was then purchased by Count von Thun Hohenstein, who hung it in his bedroom in his castle in Teschen. It is a simple composition. An overcast sky is illuminated by three rays of sunlight as the sun sets behind a hilltop. A few large rocks and a dark meadow occupy the hilltop, and fir trees—spruce to be exact, naturalistically represented—stand out in silhouette against the luminous sky. Amid the trees is a calvary: a large cross with a Christ and ivy winding around it.

The Teschen altarpiece was admired from the outset, and it was the beginning of Friedrich's celebrity. But it was also criticized. In 1809, the art critic Friedrich Wilhelm von Ramdohr harshly criticized the painter for having "hoisted a landscape onto the altar." In fact, it went against tradition. The considerations given above serve to explain how he could give such a strong spiritual value to the landscape. But let us listen to Friedrich's defense:

> Jesus Christ nailed to the tree, is turned here towards the sinking sun, the image of the eternal life-giving father. With Jesus' teaching an old world dies— that time when God the Father moved directly on the earth. This sun sank and the earth was not able to grasp the departing light any longer. There shines forth in the gold of the evening light the purest, noblest metal of the Saviour's figure on the cross, which thus reflects on earth in a softened glow. The cross stands erected on a rock, unshakably firm like our faith in Jesus Christ. The firs stand around the cross, evergreen, enduring through all the ages, like the hopes of man in Him, the crucified.[127]

This text echoes another: Jean Paul's *Dream,* and its transcription by Nerval. God is dead. Or God has withdrawn an infinite distance from creation, which he is abandoning. Jesus Christ is the guarantor of a blind hope that allows human beings to bear the exile of this world and to hold onto the desire for a reunion with the great beyond, which is the true fatherland.

In *Monk by the Sea* (1809), only the sky is visible, bright above, dark below, occupying four-fifths of the painting; then a band of black sea, a few white sheep; and, finally, a yellow shore, on which the tiny monk, red-headed like Friedrich himself, stands confronting the vastness. This celebrated painting was commented upon by Kleist: "How wonderful it is to sit completely alone by the sea under an overcast sky, gazing out over the endless expanse of water. But it is also because one has already gone and come back that the desire to return takes hold of us, impossible to satisfy at the moment, even though it remains necessary for life. . . . It is that demand that the heart made of the painting, that blunt refusal . . . that nature elicits in us."[128] Blunt refusal: the painting is designed to elicit

an estrangement in the soul, to make one feel the radical impossibility of inhabiting nature, a nature that represents an obstacle, a barrier, a boundary, and that separates us from the land beyond. Only the vast sky, the theater of a struggle between shadow and light, which impresses upon us our own mediocrity and powerlessness, may contain a precarious promise of crossing over.

Between the great beyond and earth, Friedrich produces many intermediate signs, beacons for the Gnostic quest. He offers us a coded painting, whose meaning we must decipher and whose symbols we must read. We need to know that a full moon—or a crescent moon—represents Christ; that the window represents the vision of the great beyond; that green or bare trees represent the states of spiritual life; that boats evoke the journey to the next world; that rocks symbolize faith; the Riesengebirge, the divine world; the high peak of the Rosenberg, God the Father. The true fatherland is represented by the mountain, the forest, or the huge, fantastic cathedral that appears behind a curtain of evergreen firs.

This is how one commentator analyzed one of Friedrich's most beautiful and famous paintings, *Woman at the Window*. At first glance, a young woman in a green pleated dress, the wife of the painter, leans out the studio window to look at a row of poplars. But only at first glance. On a second viewing,

> the narrow and relatively dark interior space symbolizes the smallness of our human universe, receiving its light only through that window open on the hereafter; the woman who leans slightly out the window contemplates the opposite shore, symbol of paradise; the river, in this case invisible, is death, and its presence is revealed to us by the mast of a ship moored nearby, and by another mast of a ship moored on the opposite shore. This is, in fact, a crossing: the ancient theme of the river of Hades that Charon had to cross in his bark resurfaces here, but with a Christian meaning. The poplars with their slender silhouette, reaching toward the heavens, express the yearning to die.

Everything is significant, down to the casement of the window, the slight swaying of the masts, and the slant of the woman's body: "These subtleties have nothing to do with aesthetic play, but signify that in our own universe nothing is stable."[129]

Most of Friedrich's paintings can be decrypted in this way. It is in this register, not in that of the art of painting, that they ask to be judged. The painter had disdain for art's virtuosity and its sensual aspect. Beside the works of Turner, Constable, and even Boilly, his paintings look thin and impoverished. Standing before an English engraving whose style he admired, he exclaimed: "Thanks to God, a German could not do so well." The craftsmanship is scant, very re-

strained, completely in the service of figuration. Friedrich claimed to be a painter of "content," of "subjects," of the religious, moral, and spiritual meaning of representation.

This painter of the other world, however, is extraordinarily careful to render things exactly. He meticulously details the branches, leaves, clouds, the shape of hills. Moreover, his exactitude goes beyond realism. He pushes it to the point of discomfort and hallucination. Let us take note of this feature, which will have a long posterity. Hyperrealism is, in fact, a way of devaluing reality. In looking too closely at a thing, you bring out its strangeness, its absence of relation to us, and we discover that our inhabited world is uninhabitable. Hyperrealism is a process of derealization. Friedrich, however, does not push it to the monstrous point pop art would later come to, making a woman's body repugnant or a table covered with food obscene. His Gnosticism leaves him detached from the world, but his gentle soul does not wish to destroy it.

Insofar as we know his temperament, solitary and melancholic, his opinions, those of a German patriot under Napoleon, and his beliefs, ardently Lutheran, we cannot relate them directly to the message of his art. But his contemporaries perceived that message very well. In 1817 O. H. von Loeben wrote:

> We see landscapes becoming a contemplation of the inner life. . . . Their deep meaning is neither joy nor gaiety, but rather homesickness and an intimate gravity. They seem to say: once upon a time art flourished, and man along with it; our passage through this life is brief and we die, and the transfigured farewell glance expresses the mystery of the life we have lived, and the hope that is reborn within us; Death will soon flee, we have got through the maze, and the fatherland is no longer far away. In the landscapes, the view of infinity—of air or sea, for example—awakens a feeling of peaceful melancholy; in contrast, the boundaries marked by the mountains, the trees, the rocks, the nearby objects, awaken a mysterious uneasiness. That sensation of losing oneself in the infinite into which art plunges us is always preceded by a desire to die and by an inner death.[130]

I believe that Friedrich is crucial to my inquiry. Let us try to disentangle the reasons.

—Up to this point, the aesthetics inaugurated by Kant and transformed and developed by Hegel has not encountered a painter who embraced it, or rather—since that cannot be asked of a painter—who might serve to illustrate it. In terms of the Kantian system, one cannot say that Friedrich exemplifies genius. He does not set the rules for art, and his impact has been slight. His manner of painting was modest and did not claim to innovate on the landscape techniques inherited from the Dutch. He was extremely original, but that originality was

hidden, and, to understand these paintings of initiation, one must first possess the keys to them.

The sublime—the other Kantian injunction—is present, however. It is visible in the subjects: ice floes, shipwrecks, huge mountains, breathtaking chalk cliffs from Rügen Island, grandiose sunsets, stormy skies, all of which corresponds fairly well to the "mathematical sublime." The landscape, writes Carus, and the laws of nature it imposes, oblige us to "turn our gaze toward a large circle, a vast circle of natural events. [These laws] wrest us from ourselves by instilling in us the feeling of our smallness and fragility." "You forget yourself, God is all."[131] But Friedrich is truly at home in the invisible sublime of the person, the "dynamic sublime," so much so that the most terrible landscapes are no more magical, no more frightening, no more "sublime" than the most intimate paintings, because, like them, they are for the most part steeped in the same inner sublimity of consciousness. In the face of that consciousness expanded by thought, the garden in the sun and the hurricane on the sea are equivalent. "Today, for the first time, this landscape, so splendid in different weather, reminds me of precariousness and death; usually, however, it has cheerfully presented me with only joy and life. The sky is gray and shifts about in the storm, and today, for the first time, it covers the mountains and fields, colored by its mantle of monochrome winter. All nature is stretched out before me, ghastly pale."[132]

The relation to Hegel is more difficult to define. If it exists, it lies more in the register of pathos than in that of the concept: the tragic feeling. David d'Angers said that Friedrich had felt the "tragedy of the landscape." And perhaps there is something in common between Hegel's triumphant and ultimately optimistic gnosis and Friedrich's melancholic and nostalgic gnosis: in both cases, the gods are no more and the divine is far away. But, for Friedrich, who is a believer, there is no question of resigning oneself to it; unlike in Hegel's formula expressing the identity and reconciliation of the real and the rational, for him, the rose of reason is not placed on the cross of modern times.

—God is not represented, for, although the landscape speaks to us about him, and although he is everywhere, he is also nowhere and faceless. Friedrich and Carus's vague pantheism coexists with a kind of mystical atheism. In this extreme form of Lutheranism, only Christ is the object of an ardent, but precarious, faith and hope. The icon of Christ is reduced to a pale and intentionally waning moon: a vestigial symbol of the "light of the world." Hunt, for his part, still depicted him in person.

These paintings, which Tieck reads as a "religious ardor reviving our German world,"[133] unable to represent the face of God, also seem unable to represent

the face of man. The only portrait of Friedrich is a self-portrait: two drawings, one done in 1800, the other in 1810, where he paints himself rather haggard-looking, his gaze fixed, dressed in a kind of monastic robe. Everywhere else, man is seen from the back (or, at most, in profile). He stands like the painter's double, contemplating the landscape, often with arms crossed, turned toward the distance, a tiny black silhouette lost in infinity.

Friedrich's pictorial mysticism, despite his passionate Lutheranism, slips away from Christianity because he has lost the sense of the Incarnation. His "extrinsic" Christ is a ghostly messenger from the inaccessible fatherland. The world itself is an obstacle to returning to it. The Platonic body as tomb has grown to the dimensions of the universe, of the vast and insubstantial landscape, with no nature specific to it, unstable, hanging like a veil of maya, of appearance, between the soul and the world beyond. That is why death is present everywhere, as desire and as deliverance. "His landscapes," writes Schopenhauer, "have a melancholic and mysterious religiosity. They affect the soul more than the eye."[134] That could only please the philosopher Schopenhauer, the enemy of the *will to live*.

Reality is less real than the symbol, because the symbol, or collection of symbols, points toward the other, and only true, reality. Take away Christ, replace him with the symbol, or with even more indirect symbols of symbols, and we enter a different kind of religious painting, which was victorious at the end of the nineteenth century, and was called "symbolism."

3. Symbolist Religiosity

In the mid-1880s, a continuity was reestablished in European painting. The French exception was no longer so clear, since the aesthetics that had overtaken Europe was introduced into France and even found precursors there (Puvis de Chavannes, Gustave Moreau), who were quite naturally reconnected with the general current. In addition, that same current drew from a rich reservoir of French forms, colors, and manners, and shaped them to fit its own aesthetics.

For the needs of my thesis, I may have exaggerated the French exception. Several European schools remained true to the Paris fashion, to seeing and making, to the celebration of the spectacle of the world. It is true they were more likely to thrive in the early part of the century. That was the case for a large portion of English painting—at least up to and including Turner. That was the case for Biedermeier genre painting, which was modest and sentimental. It was also the case for the delightful paintings of the Danish golden age. But let us not forget that Eckersberg had spent time in David's studio and that he had French broth-

ers in Boilly, Drolling, and Corot. In Italy, the Macchiaioli group belatedly combined a reaction against academicism with a reaction against romanticism: in about 1855, it moved on to French naturalism, after studying it during trips to Paris or in Barbizon paintings from the Demidov collection in Florence. "The appearance of volume in objects represented on a canvas," said painters from the Florentine Café Michelangelo, "is obtained simply by indicating the relation between bright and dark colors, and this relation can be represented in its true value only with jots or strokes that capture it exactly."[135] That discussion among Fattori, Lega, and their friends could have been held at the same moment at the Café Guerbois.

As might have been expected, such preoccupations were unable to meet the hopes of many painters. In their eyes, realism and naturalism suffered from an irremediable superficiality. *O curvae in terram animae et celestium inanes!* That kind of painting, since it is superficial, may appear frivolous, crude, impious, bourgeois, lower class. A polemic on these themes flourished in France itself (Planche, Huysmans), and, rightly or wrongly, laid claim to Delacroix, Baudelaire, Rimbaud, and Mallarmé. Outside France, there was the reprobation of the Pre-Raphaelites and of German "thought painting." One has only to stroll through Scandinavian museums to assess how foreign was the climate of Parisian insouciance. In Oslo in particular, the deathbed recurs as an obsessive theme. Throughout the nineteenth century, Norwegians, standing before these simply furnished bedrooms where a child, a young woman, a mother, or a father is dying, meditated on the religious gravity of the parents and the pastor surrounding the dying person. This harsh, tormented world had its own religion, which was internal and dark, and painting adequately reflected it. Its object was not to depict nature but to discover the meaning and signs of a deeper life. That need was felt as far away as France. Focillon articulated it eloquently:

> Beside the art of the phenomenon, the art of thought and symbol is developing; beside clear, shimmering paint applied in dabs, the art of shadowy depths. The inebriation with what shines, passes, and dies on the sparkling surface of the world gives way to the need for reflective harmony; the philosophy of mobility, to the philosophy of permanence; hot and sudden impression, to the continuity of the inner life.[136]

Of course, such a point of view requires that the spiritual value of the other school of painting be denied, that Monet and Degas be placed on the side of the "phenomenon" and that "the art of depths" be considered truly more profound. This is not self-evident, but the reasons for believing it are understandable. One reason may be a relic of the hierarchy of genres. The landscape, the still life, the genre scene did not rank highest among them. The pictorial revolution had to

run its course before a little woman's portrait by Renoir was taken as seriously as a historical fresco by Puvis, with no comparison made between them, since the criteria were completely different. The hierarchy of genres, justified by tradition, and perhaps by nature and reason, mounted a long resistance and continued to value a body of work where imagination, a grand subject, lofty thoughts, emulation of the ancients, and noble goals all converged. And, as we have seen, the high genre was increasingly linked to religious painting, which, throughout the nineteenth century, rivaled history painting in rank.

But, regardless of that consideration, the nineteenth century, like all the others, had a religious aspiration, which felt unsatisfied with so-called naturalist painting. That is why, in England, Germany, and Scandinavia, naturalism had to be combined with a clearly declared and openly expressed religious sentiment. And since, in Protestant countries, academicism was less firmly rooted than it was in France or Italy, the painter was free to turn to other forms, such as realism and naturalism, asking them to convey the message of religiosity. It was from this "hotbed" that symbolism was born.

Yet symbolist religiosity, though very intense—in that respect, "late romanticism" was more universally and directly religious than its earlier form—existed, with a few exceptions (Maurice Denis and others), apart from orthodox Christianity. Nevertheless, it had a philosophical and theological frame of reference. The cultural background of classical and even romantic painters was that of polite society. At his easel, Delacroix asked to be read from Tasso. Corot, Courbet, Manet, and Degas had received the general education corresponding to their respective backgrounds. It did not occur to them to read in order to paint. They increased their knowledge by learning their craft, not by studying doctrines and then translating them into art. The painters in the late nineteenth century wanted to unify their intellectual and spiritual lives more systematically than had been done previously. Their idea of painting rested in part on their conception of the world.

Schopenhauer

A central place must be given to Schopenhauer for his role in shaping the conception of the world. Let us not grant him the same status as Kant and Hegel, who were part of a higher philosophy and breathed loftier and purer air. Painters did not read them but simply absorbed them from the atmosphere of the time. Schopenhauer inaugurated a lesser lineage, which includes Marx, Nietzsche, and Freud. Nietzsche recognized Schopenhauer as his master, and he can be read as an anti-Schopenhauer, turning all Schopenhauer's theses on their

heads.[137] Freud, who was reluctant to acknowledge his masters, made an exception in Schopenhauer's case. The structure of their two systems is so similar that Freud could be called a psychiatric Schopenhauer. The misanthrope of Frankfurt had already imputed most of the attributes of the unconscious and the id to the "will to live." His was an attractive philosophy. It was written clearly, in an eloquent style. Anyone could read it. And everyone did read it, since it relied on familiar life experiences, the everyday, the *Erlebnis*.

From the 1870s on, Schopenhauer was the major inspiration for artists of all sorts. Even though he refused to look beyond Rossini and believed that Wagner, though a proponent of Schopenhauer's doctrine, "ought to hang up his music," he dominated the European interpretation of Wagnerianism. Tolstoy wanted to drop everything and translate Schopenhauer into Russian: Europeans attributed Tolstoy's rehash of "sympathy," the cornerstone of Schopenhauer's ethics, to Russian mysticism. Schopenhauer's unavowed posterity is innumerable and intermingles with his acknowledged heirs. Thus, in *La Mort de Baldassare Silvande*, Proust, a pure Schopenhauerian, imitated *The Death of Ivan Ilyich*, Tolstoy's Schopenhauerian novel. Strindberg, Wedekind, Maupassant, Gide, Céline, and Cendrars were readers of *The World as Will and Idea*, and especially of essays from *The Parerga and Paralipomena*, more accessible works that, after forty years of silence, inaugurated the worldwide success of the doctrine. In England, Schopenhauer influenced Hardy, Joyce, and Conrad; in France, via Conrad, he influenced Simenon. In Italy, D'Annunzio, Pirandello, and Svevo. In painting, Munch, Klimt, Schiele, Böcklin, and Kubin.[138]

A. Art and Genius

Schopenhauer's philosophy—or rather, his message—was simple, as he himself pointed out. For the technical details, allow me to refer to such skilled commentators as Philonenko, Rosset, Henry, Sans, and Raymond. Like Anne Henry, who put her finger on the Schopenhauerian key to the European landscape, I simply wonder what was so attractive about that doctrine for the artist as such, and to what extent it shaped his inspiration.

Schopenhauer borrowed the distinction between the noumenon and the phenomenon from Kant and hypostatized it. Thus, behind the multiple appearances of things, there is a fundamental reality, a substratum of all apprehensible physical or human reality, an obscure reality located outside space and time, unknowable as a result. That reality is unconscious, but it determines conscious thought, which does not know it is passive and acted upon but believes it is active and effective. That reality—which completely outstrips the Kantian

thing-in-itself—Schopenhauer calls the "Will" (though it does not "will" any-thing), which gives a blind and repetitive impetus to things. It is the sum of all the unconscious and conscious forces (the latter driven by the former) of the universe. That "other place," which subsequent thinkers called "life," "the will to power," "duration," or "id," is the site of Being and constitutes its great secret. It is ineffable, inaccessible, impenetrable, but it is the only thing worth the trou-ble of being expressed, grasped, penetrated.

Yet, confronted with the great secret, humanity is divided. As in every Gnos-tic system, humanity can be divided into the sleeping and the awake, the igno-rant and the initiated, or, as Schopenhauer says, between "ordinary men" and "geniuses." The ordinary man, "that manufacture of Nature which she produces by the thousand every day," is incapable of contemplation. He sees only what is directly related to him. He does not linger but "only seeks to know his own way in life." A prisoner of space and time, he perceives only the "phenomenon," the vain and hollow side of existence. He is the plaything, the perpetual dupe, of the Will.[139]

The genius, in contrast, is endowed with imagination and possesses a greater circle of vision, an infinitely broader horizon. The faculty of knowledge, rather than a mere instrument by which the Will aims toward its fulfillment, is, for the genius, an instrument of emancipation. The genius neglects to consider his own path in life and is usually awkward in his behavior. "While to the ordinary man his faculty of knowledge is a lamp to lighten his path, to the man of genius it is the sun which reveals the world." This difference in attitude even manifests itself physically: the keen, firm gaze of the solitary man of genius clashes with the mil-lions of vacant stares of ordinary men. The genius is like "a living man playing along with the large puppets of the famous puppet-show of Milan."[140]

The Will does not grant ordinary men what they need in the way of intellect to execute the task it obscurely points out to them. The genius, who possesses a surplus of intellect, applies it without concern for its destination, without any practical goal of grasping the objective essence of things. That exposes him to danger, to melancholic excess, to loneliness, to madness. "On account of the dis-similarity of the pace, the [genius] is not adapted for thinking in common, *i.e.* for conversation with the others: they will have as little pleasure in him and his op-pressive superiority as he will in them."[141] His giant's wings, as in Baudelaire's poem, prevent him from walking. The genius is alone and condemned in his own time. He does not participate in the development of existing civilization, "but flings his works far out on to the way in front (as the dying emperor flung his spear among the enemy), upon which time has first to overtake him."[142]

Schopenhauer further accentuates the Kantian and fundamentally romantic

gap between talent and genius. "The man of talent is like the marksman who hits a mark the others cannot hit; the man of genius is like the marksman who hits a mark they cannot even see."[143] That clairvoyance sets the man of genius apart and relegates the talented to ordinary humanity.

Schopenhauer proposed the relation between childhood and genius before Baudelaire did so. But where the Baudelairean child is ingenious in his ability to perceive the world's beauty with a maximum of naïveté, ingenuousness, and innocence, the Schopenhauerian child is ingenious primarily in his intellect, still free and predominant among his faculties because puberty has not yet introduced the "sexual instinct," a vehicle of the Will, which will soon submerge the intellect. Baudelaire's child is sensual; the Schopenhauerian child is a pure intellectual not yet trained and enslaved to the practical life imposed by the Will.[144]

The genius is able to liberate himself from the Will because he discerns its great secret. He considers things independent of their relation to the Will, that is, in a disinterested manner. From Kant, Schopenhauer borrows the Fénelonian idea of disinterested "pure love," which defines not only aesthetic satisfaction but a path of liberation in relation to "the oppression of the Will." "The wheel of Ixion stands still."[145] "This freeing of knowledge lifts us as wholly and entirely away from all that, as do sleep and dreams; happiness and unhappiness have disappeared; we are no longer individual; the individual is forgotten; we are only pure subject of knowledge; we are only that one eye of the world."[146] A sort of Gnostic ecstasy permits the ingenious initiate to accede to "that which alone is really essential to the world, the true content of its phenomenon." And that ecstasy is the attribute of the artist, the ingenious artist. This mode of knowledge is "*Art, the work of genius.*" Art is the independent contemplation of the principle of reason—that is, of understanding or experience, prisoners of the Will. It is a "perpendicular line" that, by choice, cuts across the horizontal line of rational knowledge and which, through direct intuition, reaches the schemata, the structures, that which, following Plato, Schopenhauer calls "Ideas."[147] He thus places the artist on the same plane as the philosopher, and even the Schopenhauerian philosopher. Both are equally well suited to "the purely objective apprehension of things" as an expression of the nature of life and existence. The artist answers the question "What is life?" in "the naive and childish language of perception," not in the abstract and serious language of reflection.[148]

The artist tears away the veil of maya that conceals the intimate essence of all existence. He provides a visible image of it, which tells others: "Look here, this is life."[149] Nonetheless, the image that deciphers the world must in turn be deciphered. "In the works of the representative arts all truth is certainly contained,

yet only *virtualiter* or *implicite.*" That is why one must stand before a painting as before a prince, "waiting to see whether and what it will speak." The superiority of the genius who sees remains with those whom he shows what he has seen. Ordinary men who choose to take the trouble can, in fact, participate modestly and incompletely in revelation: the artist "lets us see the world through his eyes."[150] In that way, the artist is raised to the rank of mediator: through his genius and his capacity to express himself and communicate his knowledge, he holds the key, opening or cutting off at will "ordinary men's" access to the universe.

B. The Sublime, the Pretty, and the Death of the Subject

In terms of aesthetics, *The World as Will and Idea* contains two points of interest to my thesis. First, it modifies the Kantian conception of the sublime, leading to a fourth sort of sublime (after the sublimes proposed by Kant, Burke, and Boileau), perhaps the most influential form in the modern period.[151]

As long as nature simply offers its richness of meaning and allows us to accede to the guiding Forms and individualized Ideas, we do no more than rise from servile knowledge to the Will and then to disinterested contemplation; we suspend our enslavement for an instant, set aside our selves and become knowing subjects exempt from the Will. We attain the beautiful. But if, in the course of this contemplation, the knowing subject confronts objects that the Will dreads and overcomes the conflict through serenity, by that very fact, he rises above himself, above his Will, above all Will. In that case, he is filled with the sublime. But if the Will prevails in that battle, the sublime dissolves and *anxiety* replaces it: the individual's effort to see his way clear completely clouds his thoughts. In Kant's notion of the sublime, what highlights the contrast between the knowing subject's weakness and his object is the magnitude of reason. For Schopenhauer, it is the magnitude of detachment.[152] For Kant, there is a difference of nature between the sense of the beautiful and the sense of the sublime. For Schopenhauer, it is a difference of degree, since, to be contemplated, every object requires that an effort be made to overcome the Will, a weaker effort in the case of the beautiful, a more heroic one for the sublime. It is in tragedy, or rather in the face of tragedy, that the sublime reaches its peak, and that the subject, absorbed in the contemplation of Ideas, becomes free, independent of all will and of all affliction.

As a corollary, the pretty is still continuous with the beautiful for Kant, whereas it is discontinuous for Schopenhauer; it is a lure of the Will and leads to the failure of contemplation. Therein lies a source for an aesthetics of ugliness, since overt ugliness is a means to break overtly with the "prettiness" of ordinary

men, to display one's membership in the kingdom of the beautiful and the sublime, peopled by men of genius, a means to enter the *Genialen-Republik*.[153]

Schopenhauer's second innovation is to remove all importance from the subject of a painting.[154] In an image, the "outward significance"—the subject in the conventional sense, the anecdote so to speak—needs to be distinguished from its "inward significance," which consists of "the depth of the insight into the Idea of man which it reveals in that it brings to light sides of that Idea." What counts is not the objectivity of the spectacle represented by the painter, but the painter's "depth of insight" regarding any scene whatever, even the most trivial and everyday. From the perspective of "inward significance," "it is all the same . . . whether ministers discuss the fate of countries and nations over a map, or boors wrangle in a beerhouse over cards and dice." Any image can be a keyhole through which the ordinary man, invited by the genius, shares the latter's vision.

Such a point of view annihilates the hierarchy of genres. Cézanne's *Card Players* is potentially ranked just as high as Vélazquez's *Surrender of Breda:* not because, in the terms of painting itself, it is just as well painted, but because what there is to see, to contemplate, is located on the other side of the canvas, in the clairvoyant artist who created it, in whose soul the infinite is reflected. In that respect, art—and, for once, Schopenhauer agrees with Hegel—is superior to nature. It synthesizes. It adds an incomparable depth of reflection:

> [The artist] recognizes the Idea in the particular thing, and thus, as it were, *understands the half-uttered speech of nature,* and articulates clearly what she only stammered forth. He expresses in the hard marble that beauty of form which in a thousand attempts she failed to produce, he presents it to nature, saying, as it were, to her: "That is what you wanted to say!" And whoever is able to judge replies: "Yes, that is it."[155]

But it is no longer clear whether one is contemplating nature or the artist's incomparable depths of reflection. The only subject is the artist.

I have deliberately set aside the philosophical machinery, the relation to Kant, the "principle of reason," and so forth, in an attempt to reconstitute what an "artistic reading" of Schopenhauer might be, since his posterity has consisted more of artists than of philosophers—or, at least, artists have been more frank in recognizing their debt to him. The artist is confirmed in his deepest ambitions (his spiritual election, genius, clairvoyance, mediating role) and consoled for the social and psychological miseries of his life. Let us add another trait: here is a philosopher who, instead of laying claim to the superiority of dialectics and reason, devalues them in favor of direct and immediate intuition, that which the artist, who is the least adept at arguments and demonstrations, experiences

within himself and, he thinks, is able to express as a work of art. Not only is Schopenhauer accessible, since his doctrine can be summarized and claims to clarify everything on the basis of a scaled-down, explanatory kernel, amply developed, repeated, and amplified by its author's limpid rhetoric, but he also suggests to the artist that he does not even need to study it and understand it, since everything he produces as an artist implicitly contains the conclusions and discoveries of philosophers. He is doing Schopenhauer unbeknownst to himself and proves him by his example. The doctrine of *The World as Will and Idea* is a boon for the fluency, laziness, and approximations of the "artistic mind."

C. A Gnosticism for the Artist

Schopenhauer's conclusions, contained in part 4 of *The World as Will and Idea*, have a family resemblance to Gnosticism, at least in the following respects.

—The world is bad, and it is fitting to wrest oneself away from it. The Will enslaves men, and it is through their particular will that it finds its determination and, in the end, consciously wills what it wills. The Will is without finality, but it always strives: "Striving is its sole nature." Thought seizes hold of matter, and every part of matter so invaded struggles against all the others and against itself to obey the striving Will. "The striving we see everywhere hindered in many ways, everywhere in conflict, and therefore always under the form of suffering," and the pain is unrelenting. The higher consciousness rises, the keener the pain, and "the man who is gifted with genius suffers most of all."[156]

The Will is assimilated to the bad God of Gnostic myth. Man is seized, enslaved, thrown onto the earth, abandoned to himself, uncertain of everything but his needs and his affliction, busy surviving, "for all human life is tossed backwards and forwards between pain and ennui."[157]

—The symbol, the sign, the icon of man's fall is sexuality. It is "the answer to the enigma" of the world, the site where its intimate essence is made clear. The sexual act is the core, the summation, the quintessence of the world, because it is the expression of the Will. It is everywhere, because it lies at the foundation of all passion. It is the prototypical example of the errors of the mind, because the Will can attain its goal only by creating in (the uninitiated) man, "a certain illusion . . . on account of which that which is only a good for the species appears to him as a good for himself." Love is a lie, an illusion, slavery. It is inseparable from death.[158]

—Salvation—the act of being wrested from this world—is achieved through knowledge, and then through the asceticism dictated by that knowledge. What must be conquered is our attachment to this world, which attests to our unconscious slavery to the Will, what Schopenhauer calls the "will to live."

The first stage consists of grasping the essence of things, that is, the omnipotence of the Will. Knowledge of the world permits man to discover his true situation and the path to his liberation. The second stage is a voluntary exercise, at the conclusion of which one abandons the will to live. "Voluntary and complete chastity is the first step in asceticism or the denial of the will to live." Schopenhauer preaches Encratism. That is how one becomes what is called a "perfect man" in Gnosticism, and what Schopenhauer calls a "saint."[159]

Let us note that the artist is a sort of mimic of the saint and does not attain true salvation. On the contrary.

> This purely knowable side of the world, and the copy of it in any art, is the element of the artist. He is chained to the contemplation of the play, the objectification of will, he remains beside it, does not tire of contemplating it and representing it in copies; and meanwhile he bears himself the cost of the production of that play, *i.e.,* he himself is the will which objectifies itself, and remains in constant suffering.

The artist suspends the will to live, but only for a few moments. Art is a "quieter of the Will," a sedative, a temporary consolation. For his part, the saint is "serious."[160]

—Schopenhauer's doctrine, like Gnosticism generally, bends Christian dogma to fit the system. Original sin is "obviously" the pleasure of the flesh:

> [Christianity] regards every individual as on one side identical with Adam, the representative of the assertion of life and so . . . subject to sin (original sin), suffering, and death; on the other side, the knowledge of the Idea of man enables it to regard every individual as identical with the saviour, the representative of the denial of the will to live, and so far as a partaker of his sacrifice of himself, saved through his merits, and delivered from the bands of sin and death, *i.e.* the world.[161]

In the Gospel, the world and evil are taken almost as synonymous terms. Schopenhauer can thus accommodate a religious syncretism within his system— once more in the Gnostic manner. "The inmost kernel and spirit of Christianity is identical with that of Brahmanism and Buddhism; they all teach a great guilt of the human race through its existence itself."[162] Never mind the dogma: all are equivalent, and Schopenhauer subsumes them all under his own doctrine, since they signify nothing but what he is teaching.

Horror of the World

I have considered Schopenhauer at length, and it is true that his direct influence on literature and art (even more than on philosophy, although the Nietzschean and Freudian branches must be taken into account) has been impressive. Can he

be considered a sort of maleficent Batman whose wings encompass several decades of European history? Certainly not. But he gives a coherence and philosophical form to a state of mind that gradually took root and of which there are many illustrations. He was read and had disciples only because his readers and enthusiasts were prepared by other readings, other objects of admiration, and by analogous vital experiences.

In France—and the same could undoubtedly be said of many in England and Germany—Baudelaire and Flaubert did not need to read Schopenhauer to experience disenchantment, the temptation of the void, the pride of the artist erected into a species apart from the "bourgeois," the search for salvation—or rescue—from art. Bénichou has shown that the posture of bitterness and loneliness, which is the dominant characteristic of the high literature of late romanticism, is less the consequence of misfortunes suffered than of a voluntary choice, which the later symbolist generation inherited.[163]

Chateaubriand's Catholic veneer rapidly rubbed off in the generation of 1820, the era of Hugo and Lamartine. The bright side of romanticism saw the poet leading the commonwealth as a new spiritual authority, guiding it toward progress: Bossuet reconciled with Condorcet. But this deism, heir to the Enlightenment, hardly survived in the leaden atmosphere toward the end of the July Monarchy—nor in the derision and hatefulness that began with the 1848 revolution. No one believed any longer in a providential future, in ascendant humanity, in progress (a "Belgian idea," according to Baudelaire): providence gave way to the "vast, dark void."

> The [romantic] Magus receives his light from God, and communicates it to Humanity. . . . The accursed Poet, caught between a meanly taciturn Ideal and a deaf audience, lives in failure; but he is supreme in his solitude; he can disdain what is refused him on either side; he incarnates infinite inspiration, which feeds on itself. It is in that sense, much more than in the vain religion of art where he willingly seeks refuge, that late romanticism may seem to reproduce, at a purer and more authentic level, the essence of early romanticism.[164]

In the dissatisfied and radically unhappy consciousness of the late nineteenth century, the discrediting of humanity, the bitterness, the sense of the grotesque and of the world's absurdity become the sign of artistic excellence and the mark of modernity. But, in that universal negation, the artist excepts himself from the general stupidity and thus retains his spiritual privilege. He is thus ripe to read Schopenhauer, who confirms him in his privilege. It was then that the recluse of Frankfurt finally became famous—a fame he savored in an un-Schopenhauerian manner—and entered through the wide-open doors of the *Zeitgeist*.

That is also why, in painting, specifically Schopenhauerian themes combine

with many others coming from other aspects of the spirit of the time. Let me simply point to one of these, the theme of evil sexuality and the maleficent woman. The images proliferate: animal women preparing to devour, as in Gustave Moreau's *Oedipus* and *Sphinx* (1864), or in Khnopff's *Art,* also called *Caresses* and *The Sphinx* (the multiple titles are significant), which depicts a panther woman with an enormous chin, reproducing the features of the artist's sister and which also appears in many other paintings by Khnopff. Characteristic of that sort of painting (by Burne-Jones, Rossetti, Khnopff, and Moreau) is the obsessional presence of a single female prototype over the artist's entire career.

There are decapitating women: Klimt's *Judith I* and *Judith II* (1901); Moreau's *The Apparition* (1856), *Salome at the Column* (1885), *Young Thracian Girl Bearing the Head of Orpheus* (1865); Beardsley's *Salome* (1895); Stuck's *Salome* (1906); Klinger's *Salome* (1909). In the case of Klinger, the painter takes the symbolism (or desymbolizing) of the Schopenhauerian-Freudian style to its extreme, since Salome, accompanied by a panther, a figure of lust, brandishes not the saint's severed head but his sex organs.

There are Medusa heads: Burne-Jones's *Evil Head* (1886–87); Khnopff's *Medusa Head* (1900). There are women who combine lust, corruption, and death: Rops's *The Sentimental Initiation* (the frontispiece for an 1887 novel by Péladan), *Corpse at the Ball* (1863), and *Pornocrates* (1896); Alfred Kubin's *The Fiancée of Death* (1900); Schwabe's *Death of the Gravedigger* (1893–1900); Malczewski's *Thanatos* (1898); Wiertz's *La Belle Rosine* (1847); Vedder's *The Cup of Death;* and Stuck's *The Sin* (1893), the bust of a nude women—her breasts illuminated, her face in shadow but eyes gleaming, viciously in the clutches of an enormous serpent, whose eyes also look out at you. The same painter also painted *Innocence* (1889), in which one senses that the young girl, though holding a lily, is not protected—alas!—from the worst sort of temptation. In this genre, one painting pushes sexual and macabre Schopenhauerism to the point of parody: *She* (1903) by Gustav-Adolf Mossa, a painter from Nice. A young woman, a giantess, with a doll's face but large breasts and a complicated hairdo held together by three human skulls, dominates a pile of bloody cadavers. And let us again cite Munch: *Death and the Maiden* (1893), *The Vampire* (1895), and so forth.

The theme of the femme fatale is deeply rooted in literature. We do not need to go as far back as Clytemnestra or Medea. "Belles dames sans merci" are found in the Gothic novel, in Mérimée, Flaubert, Keats, Swinburne, Baudelaire, Gautier. But in painting, this was a fairly new type.[165] The vein of cruelty belongs to every age, of course, and since the sixteenth century there has been no dearth of Judiths, Salomes, Lucretias, and Saint Catherines, followed by all the women

martyrs. But the woman of symbolism has a flavor all her own. A green-eyed redhead, languid, dreamy, always lascivious, she is less sensual than sexual. Rather than the vehicle of bliss, the symbol of living happily on this earth, rather than a representation of nature at its most cheerful and beneficent (and the nudes from the French school are still like this, from Delacroix—even in *The Death of Sardanapalus*—to Bonnard and Matisse), she introduces man to sadness, sorrow, and death. An evil destiny, the iron law of the world (Schopenhauer, Darwin, Haeckel, Freud) gives woman a fatal turn. But, where the old representations of woman, associated with the skeleton, the tomb, the decaying cadaver, invited the beholder to move away from the flesh and direct his love toward loftier and more lasting objects, modern representation is extremely eroticized. Death is sexual, and torture holds the promise of orgasm. Desire and pleasure, directed downward, aspire to annihilation. As in Baudelaire's prose poem bearing her name, Mlle Bistouri irresistibly attracts man to the garden of torments and delights. But, in doing so, the femme fatale becomes a figure for the sacred. Death-bearing desire becomes the prelude to some obscure sacrifice, in which woman is the priestess and mystagogue. So it is explicitly in Toorop's *Fate* (1893) or *The Three Fiancées* (1893).

A. Which Sacred?

In the aesthetic sphere of symbolism, what sort of divine image can be conceived? In the Schopenhauerian system, this question has little meaning. In the first place, there is no God. One can imagine a religion of the death of God—it exists, in fact—but it is more difficult to imagine a figurative representation of that absence. What the artistic genius contemplates through ideas is reality, alias the Will. Music does without that intermediary, and has direct access to the real: "It never expresses the phenomenon, but only the inner nature, the in-itself of the phenomena, the will itself—indirectly." It is not expressed through the mediation of art or of ideas, joy or pain: it *is* joy and pain, and "we might, therefore, just as well call the world embodied music as embodied will." But music is "abstract." In this, Schopenhauer introduces a new imperative for the painter: to conceive of a painting that can rival music in its immediacy and in its apprehension of the ultimate reality. This dream haunts symbolism and impels it to invent a form of painting as coded and "abstract" as a musical score. *Ut pictura musica.*[166]

It is nevertheless still true that figurative painting, by definition, has a tendency to remain confined by the phenomenon. But since the artist's ingenious mind transcends it, a gap remains between the represented image and the repre-

senter (the painter), and the problem the latter will have to resolve is how to represent the mind of the representer through the object represented. That is what the Dutch painters succeeded in doing: they "directed this purely objective perception to the most insignificant objects, and established a lasting monument of their objectivity and spiritual peace in their pictures of *still life*."[167] Through the mediation of these tables laden with food, these quiet robes, they exposed their souls, which had been emancipated by the knowledge of the Will. But is it not possible to do without that mediation and move directly to the shapes, colors, and primordial rhythms, which, as people increasingly believe, hold the secret of painting's effectiveness?

Let us admit that the death of God is not a satisfactory piece of news for an artist, since, among other things, it deprives him of the supreme image. That is what Nerval senses, translating Jean Paul's *Dream:*

J'ai cherché l'oeil de Dieu, je n'ai vue qu'une orbite
Vaste, noire, and sans fond, d'où la nuit qui l'habite
Rayonne sur le monde et s'épaissit toujours.

I sought the eye of God, I saw only a socket,
Vast, black, and bottomless, from which the night that dwells within it
Shines on the world, growing ever darker.

It is not true that the artist cannot represent the world. The withdrawal of God in no way prevents images from proliferating. They tend toward a tragedy of a new type—the tragedy Schopenhauer locates in the sublime—but that does not prevent them from giving new inspiration to the creative mind—on the contrary, perhaps. No matter that "ghastly, despotic Anxiety plants its black flag on my bowed skull" (as in Baudelaire's line), so long as it does not take away my creative powers, so long as it finds expression in a work of art.

Nonetheless, for artists, the spirit of nothingness and the radical absence of the divine is rarely (if ever) exempt from religious elements. Pure Schopenhauerism presents itself as a Gnostic cosmology, that is, as a "deep knowledge" of the laws that govern the physical world. It is an immanent metaphysics that results in a unique, ubiquitous, primitive reality, the Will. Declaring he is relying solely on experience, rejecting the speculative idealism of the "three great sophists" (Fichte, Schelling, and Hegel), Schopenhauer proposes a sort of "mystical positivism": it is positivism because it does not leave the world and it rejects natural theology, idealism, and materialism as outside the scope of experience; and it is mystical, because it is through intuition, contemplation, asceticism, the heroic evacuation of one's self (of the will to live) that one grasps the intimate essence of things and moves toward salvation. That is why, in Schopenhauer's

dark shadow, great literary, musical, and pictorial works came into being, with a unique undertone of metaphysical despair and religious gravity. The very contemplation of nothingness, or of the malevolent demiurge who pulls humanity's strings, cannot be exclusively profane. When this demiurge happens to take the form of the devil—we all know about the impressive wave of Satanism at the end of the century—there is a sacred shudder contained within the horror.

Nevertheless, in the nineteenth century, the idea of the death of God was difficult for the artist to tolerate, when it happened to occur to him. Indifference to religious matters was predominant in France and relatively cheerful, but it enjoyed the accumulated capital of the general well-being left behind by the Catholic religion. In Protestant countries, the question of God was raised in a more personal and poignant manner. It was also raised in France when souls, impelled by fin de siècle worries, went in quest of belief.

Painters very rarely discovered or rediscovered Christian orthodoxy. The spiritual journey was rambling and always muddled. Not that Christian iconography was abandoned altogether. After all, from Gauguin to Kirchner, symbolist and expressionist art produced many Christian motifs: the Nativity, the Passion, the Crucifix. But it seems that these motifs, with only a few exceptions (Maurice Denis), did not represent the core of symbolist religiosity but simply particular efflorescences sprouting against a religious background that was not stabilized by Christianity. Where Christianity did exist, it was within the framework of a syncretism that encompassed many different components. Thus, there was the reawakening of a romantic tradition. Nerval, the most Germanic poet of French literature, hoped for the return of the "ancient gods" and was initiated into esotericism.

Novalis and Hölderlin had experienced that homesickness. But it is not found in French paintings contemporary with those poets, which were not interested in the arcana and which turned to classical mythology in a spirit different from the magical Hellenism of the Germans. But when, in the late nineteenth century, French art intersected the general European current, it became permeated by esotericism. And with the return to the ancient gods, a plastic form was invented that took root in European painting. Let us use Goldwater's term and call it "primitivism." Primitivism and esotericism stand in a capricious relationship to each other. They are not the same thing. Moreau, Stuck, Böcklin, Watts, and Redon, all painters one suspects of a more or less systematic esoteric scaffolding, are not primitivist in their style.[168] Among the French fauves, moreover, the overt primitivism seems altogether foreign to the search for hidden depths. But when the two became joined, a crisis of symbol-

ism ensued that would lead to abstract art and a general crisis of the image. Kandinsky and Malevich exemplified that tragic "short circuit."

B. Primitivism

Let us note, first, the extreme rarity of primitive art's direct influence.[169] A few wood engravings by Gauguin, a few canvases from the Blaue Reiter group, Picasso's "Negro period," and that is just about all. That is, the reference to primitive artists is not of the same nature as the reference to the "great masters" as Delacroix and Ingres used them. There is no direct borrowing based on an admiration of formal qualities. Rather, there are allusions and suggestions. What is imitated is less the works themselves than the supposed attitude of the primitive artist.

That is why there is no need to be a connoisseur of that art to capture its spirit. Early on, the Germans had scientific museums, the French only heteroclite collections, cabinets full of black African and Oceanic curiosities.

Primitivism must be distinguished from exoticism. The Turkish world for Decamps, the Maghreb for Delacroix and Fromentin, and the banks of the Dead Sea for Hunt and Vernet provided a setting that enriched the dramatic and archaeological value of the painting, increased the range of landscapes, but did not affect the style. In contrast, peasant and populist themes played an adjunct role. As one of Turgenev's populist heroes said, it was a matter of "simplifying." The idea that the man of the people was free from the torments and complications afflicting the intellectual, that he was in immediate contact with the truth of the world and the basic realities of life, made inroads as the nineteenth century bent under the weight of its own culture. It thrived in literature—Tolstoy—and, also in Russia, with the *narodnik* painting of the Wanderers. But this was nothing more than social exoticism, since the idiom remained within the constraints of academic procedures.

Nonetheless, Millet turned the peasant theme to his own advantage to paint a biblical humanity. Van Gogh, who admired Millet, wanted his own art to contain "something more concise, more simple, more serious," something that "would have more soul, more love, and more heart" and that would be "true," like Millet or Israëls.[170] Hodler, the painters of the Brücke group, and Scandinavian, Polish, and Russian painters had the same concern.

The most far-reaching pioneer was, of course, Gauguin. His primitivism was fed by a conscious revolt against the world and society, as in Mallarmé's line: "Fuir! là-bas fuir! Je sens que les oiseaux sont ivres" (Flee! Flee far away! I sense

that the birds are inebriated). He does not aspire to the luxury and refinement that early romanticism attributed to the Orient, but rather to the simplicity and naturalness of the time before civilization. His models were very eclectic: within the framework of primitivism, he included Persia, Egypt, even the frieze of the Parthenon (which he took as his inspiration for his Tahitian horsemen), Borobudur, India, Easter Island, and, finally, the objects of the Marquesas and Tahiti, which he was inclined to call "Maori." His primitivism had its "peasant" phase in Brittany and, there as in Oceania, the religious motif was present.

Gauguin found his mature style and broke with impressionism in *The Vision after the Sermon* (1888). Jacob and the angel wrestle in a red meadow. Pissarro divined the break. He criticized Gauguin for having "pilfered all that from the Japanese, and from Byzantine painters," and, above all, for having rejected "our modern philosophy, which is absolutely social, antiauthoritarian, and antimystical." Pissarro interpreted that as a step backward, a return to spiritualism, a concession to symbolism, a nod to the Pre-Raphaelites. He was right. But Gauguin, in taking a decisive step toward the spirituality dominating outside France, linked it to the formal dynamism that had turned French painting upside down a generation earlier. He took from the Japanese, from Epinal images, from Breton Calvaries, and from children's drawings everything he needed to create his pictorial idiom, just as his friends, from whom he had taken his distance, did in their own way.

Christianity was an occasional theme. It was later combined with other religious components. *Orana Maria,* painted in Tahiti in 1891, transplanted prayer to the South Seas. The faces, even the Virgin's, were of the indigenous people. In *The Idol* (1897), he combined the pagan and the Christian, placing the Last Supper behind a black stone shape that presided with Christ. Even though Gauguin was very hostile to the established church and to the clergy as a whole, contrasting them with simple Breton piety or that of the first converts, even though he proclaimed the equivalence of all religions and intermingled different gods, he still upheld the contrast between the peaceful spirit of his Christian iconography and the troubling horror of the gods of the Pacific. He gave idols a menacing, even terrifying, quality, which led him to the mysterious center of the universe.[171]

Gauguin's primitivism was linked to his spiritualism. Fénéon was disturbed to see him drifting toward "literary hacks."[172] He feared he would see Gauguin slip into "Rosicrucian" painting, which would push symbolism toward mysticism and esoteric initiation. Gauguin did not let himself be recruited into the practices of the group, but that did not prevent him from reading assiduously—on the beaches of Tahiti—Joséphin Péladan, the Parisian magus of the Rosicru-

cians. Did not Swedenborg—whom Gauguin often cited—write: "The Beautiful, in fact, composes the true synthesis of all the spiritual truths that the Church of the New Jerusalem has the mission to spread throughout the world, through the language of correspondences, that is, through its symbolics."[173] Gauguin acquiesced to the artist's prophetic and redemptive mission. "Artist, you are a priest" (Péladan).

Gauguin's art is thus at the crossroads between the formal French tradition—since, despite the astonishment of Pissarro and his friends, he was part of their world all the same—and symbolist spiritualism: the character of his primitivism was the result of that encounter. The fauves are the proof that the synthesis was unstable. Vlaminck, Derain, and Matisse admired African objects, which they collected at random because they liked them, found them beautiful. Their technical innovations—the thicker line, the application of paint as it came out of the tube, the flat, unnuanced surfaces, ostentatious negligence (a nod to children's drawing)—stemmed from aesthetic concerns that appear to owe nothing to symbolist religiosity.

In contrast, that religiosity is very present in the painters of the Brücke group. Unlike the French, the Germans had museums that allowed them to look at African and Oceanic objects not as curiosities but as samples of an accomplished art stemming from a complete, though different, aesthetic. In that art, they admired, to cite Nolde, "its absolute primitiveness, its intense, often grotesque expression of strength and life in the very simple forms."[174] The landscapes from northern Germany by Nolde, Schmidt-Rottluff, and Pechstein have such violent colors that they seem "tropicalized" by them. This was not done in the interest of exoticism but because these paintings were seeking to express emotion and passion, and they always kept in mind the fundamental problems of human life and fate. The landscape was laden with symbolism; and, despite its brutality, that landscape was spiritually analogous to the landscapes of Friedrich and Carus.

The same "metaphysical" overload (for lack of a better term) also afflicts the genre scenes. When Toulouse-Lautrec painted a prostitute, he added irony by showing her as a human being like everyone else, deserving of sympathy and consideration by that very fact, and not by virtue of her profession. But he depicted her without pity or unseemly sentimentality. In contrast, Kirchner's and Grosz's prostitutes are surrounded by a sacred aura and bear witness not to the horror of their world but to that of the world in general, which their particular condition unveils to all human beings as their shared fate, if they truly choose to come to a Schopenhauerian consciousness. That is why there is no difference in tone or in genre between the Brandenburg landscape or cabaret scene and the

Passions, Entombments, Last Suppers, or Golden Calves that Nolde produced in great number. The crowded composition, the grimacing faces, the violence of the dominant emotion can be related to a "primitive" Christianity, a medievalism, a sermonizing that the Nazarenes seem to have pursued. Nonetheless, the academic propriety of the Nazarenes is stripped away, and the "primitive," where religious emotion and sexual energy are intimately combined, reveals the overpowering tuff of the universe.

C. Esotericism

Returning from Brittany, Gauguin read Schuré's *Les grands initiés*, and, in Tahiti, the works of "Sâr," alias Joséphin Péladan. The three founders of abstract art—Mondrian, Kandinsky, and Malevich—were familiar with Schuré, Mme Blavatsky, Steiner, and Uspenski: with their books, and often with the authors themselves. With the exception of Mondrian, an avowed theosophist all his life, it is difficult to establish how profoundly these artists were affected by esotericism. All the same, there is reason for not believing them too much when, as Kandinsky did late in life, they denied they had been influenced at all.

They participated as painters in the new religious climate. Aurier's pioneering article, "Symbolism in Painting: Paul Gauguin" (1891) is, in the first place, a spiritualist critique of French painting.[175] "Impressionism is and can only be a variety of realism, a refined, spiritualized, dilettantized realism, but still realism. The aim is still the imitation of matter." The French painters' calm religious indifference against a Catholic backdrop made possible a passionate and loving attention to natural objects. Monet, standing in front of water lilies under the light, would have been astonished at the thought of a dichotomy between matter and spirit. They were one, and precisely in the light. But the religious impulse of the end of the century sought the world beyond. Aurier writes that one must open "man's internal eye" to that other world, an eye of which Swedenborg speaks: "The art of ideas appears more pure and more elevated—with all the purity and elevation that separates matter from the idea." The artist is the "expresser of absolute Beings." The goal of painting is to "express ideas by translating them into a special language." Objects can have no value as objects. "They can appear only as *signs*. They are the letters of an enormous alphabet with which only the man of genius can spell." Here, Aurier asks Baudelaire—with his "living pillars" and "forests of symbols"—to give form to that neo-Platonic exaltation.

The formal consequence Aurier draws from that position also deserves to be noted: the imperative for representation, fidelity, and the resemblance between

image and object are suspended. "To protect himself from the perils of concrete truth," the artist must flee analysis. "Every detail is, in reality, only a partial symbol, generally useless for the total significance of the object. As a result, it is the strict duty of the painter of ideas to bring about a reasonable selection among the many objective elements combined, to use in his work only lines, shapes, and general and distinctive colors serving to clearly render the ideational meaning of the object, plus the few partial symbols that corroborate the general symbol." Such is the lesson Aurier draws from Gauguin. Would Gauguin have confirmed it? That is not certain, since his art retains a host of "material" and "concrete" elements. But, in fact, it points to such an orientation. It is, concludes Aurier, "ideationist," "symbolist," "synthetic" (that is, it "writ[es] the forms and signs following a mode of general comprehension"), "subjective" ("since the object is never considered an object but only a sign of an idea perceived by the subject"), and finally, "decorative." Decorative painting, as understood and practiced by the Egyptians, the Greeks, and by primitive artists, is all that, in fact. "It is true painting properly speaking."

Hence, Gauguin found the formula for a "simple, spontaneous, and primordial art." Aurier died in 1892, at the age of twenty-seven. But, beginning with Gauguin, he pulled a thread that would continue to unravel for a century. He anticipated a mass movement and foresaw its beginnings. What he articulated in 1891 applies to Kandinsky even more precisely than to Gauguin. *On the Spiritual in Art,* published twenty years later (1910), does no more than elaborate on his teachings.

The religious impulse at the end of the nineteenth century worked away at the image from the inside and undermined it. That religious impulse was mysticism, but a non-Christian mysticism. Historians have pointed out its sources: Schuré, Blavatsky, Steiner, and so forth, but have shown no interest in seriously examining the literature. This is understandable. Nonetheless, let us take the trouble to consider what attraction these doctrines exerted on artists as such.

In their desire to be traditional (the traditions of Egypt, Hermes, Orpheus, the Kabbalah), these doctrines display a real unity. The esotericism that concerns us, which had its roots in Masonry and other heterodox forms of eighteenth-century mysticism, revived by John Martin's and Swedenborg's movements, crystallized in the mid-nineteenth century. The important names were: Eliphas Levi, alias Alphonse Charles Constant (*Dogme et rituel de la haute magie,* 1856); Papus, alias Doctor Gérard d'Encausse, author of 260 books; Steiner, whose lectures were collected into 300 volumes; Mme Blavatsky; Uspenski, whose work on Gurdjieff (*In Search of the Miraculous: Fragments of an Unknown Teaching*) remains a "classic"; Edouard Schuré, whose *Les grands initiés: Histoire secrète des*

religions, constantly reprinted, was in its ninety-first edition in 1960. The literature as a whole has a recognizable exterior appearance. It is hugely verbose and repetitive, since it explains all aspects of reality and solves all the enigmas of humanity and of the universe. The scientistic climate of the time is responsible for the positivist and apparently demonstrative tone. Occult science, declares Steiner, "desires to speak about the non-sensory in the same way natural science speaks about the sensory. . . . It retains the mental attitude of the natural-scientific method; . . . For that reason it may call itself a science."[176] In fact, it consists of long chains of connections whose authority is grounded in a shameless use of analogy, allegory, metaphor, and myth. The most unbridled fiction is put forward with an assurance or aplomb we would find astonishing, were we to forget that the author is speaking from a kernel of certainty that he knows is uncommunicable, except to the reader who has achieved the same degree of initiation and unshakable conviction.

When the esotericist wave inundated Europe, Christian orthodoxy had long since lost its authority within the circle of writers and painters. Even after the Revolution, when so many men of letters declared themselves Catholic, their religion only rarely managed to withstand the screening of church censorship, which assigned them pell-mell—with Hugo, Lamartine, Balzac, and so forth—to the growing Index lists. The most ardent religion relied on more or less consciously Gnostic doctrines—an optimistic Gnosticism inherited from the Enlightenment, or a tragic Gnosticism inspired by romanticism. That is why, as we have seen, the most authentically Catholic form of painting was painting that was not seeking to be so, done by painters for whom Catholicism was a set of inherited habits, a way of seeing the world whose origin they had forgotten, and not a reflective conviction or a public piety.

Nonetheless, Gnosticism shifted over the course of the century and became an ideology. That is, the system of belief, whose kernel lay in a central myth from which crude rational explanations of the universe radiated, no longer grounded this kernel in a mystical intuition of a religious nature but rather in one or another scientific doctrine whose established certainty anchored and guaranteed belief. Haeckel, Darwin, Ricardo, and others provided the anchor point for scientific socialism, scientific racism, scientific psychoanalysis. Esotericism can be assigned to the intermediate stage separating Gnosticism from ideology. It is an extreme form of Gnosticism in the scientistic milieu, and often a reaction to the dominant scientism. But the Gnostic foundation survived, with its all-encompassing explanatory central vision.

It sometimes happened, however, that the esotericist crossed the border and found himself once again in the land of ideology. The upheavals of futurism, of

avant-gardism, and especially of war and revolution precipitated that crossing. One of the first major figures of the Bauhaus, whose president was Gropius at the time, was Johannes Itten. He was a dissident anthroposophist who had been taught by Steiner and had then opted for a version of Mazdaism elaborated by a typographer who called himself Doctor O. Z. A. Ha'nisch. Itten roamed the streets of Weimar, head shaved, dressed in an ample, homespun robe. He believed that all his students possessed the gift of creativity and that his Mazdaism would liberate him. With other prophets, such as Gustav Nagel, he converted many students, whom he urged to ingest a macrobiotic gruel with a garlic base.

In 1923, however, Itten was replaced by Moholy-Nagy. A Hungarian, Moholy-Nagy was a member of the Budapest soviet, along with Béla Kun. He was a Communist and thought that art was mass production, conceived, like it, by an engineer, and that the artist's individual creativity did not count when compared to the generic idea of productivity. In practical terms, this view intersected Itten's diametrically opposed position: if no one is an artist, then everyone is, and vice versa. Moholy-Nagy's usual attire was the opposite of Itten's, but of a similar nature, since it too was a disguise. The Hungarian wore the overalls and jacket of industrial workers, and his wire-rim glasses were designed to give him the cold, sober air of an enemy of sentimentality and transcendence, one who was at ease in the "constructivist" world of modern mechanization. The sudden substitution of the Bolshevist engineer for the initiated magus sums up a chapter in the modern spiritual history of the image.[177]

The arcana, inseparable from esotericism, are attractive to the artist. We have reached the end of the long intellectual dominance of positivism and scientism. This intellectual climate, which many found ponderous, was particularly so for the artistic world, whose natural religiosity, perhaps stronger than among common mortals, was long the object of persecution. A religiosity now presented itself that divided men between the ignoramus and the initiate, the ordinary and the superior, the unaware and the aware. And that division was the same one that romantic and postromantic aesthetics posited between the artist and everyone else (the Philistines, the "bourgeois," and so on). Since artistic life was conceived as initiatory, it was natural that the artist's religiosity should fit a similar mold. The artist is the person who rises above appearances, above phenomena, to touch reality itself: and that is what esotericism promises.

These two points—the arcana and superior knowledge—are summed up in the following text by Papus:

> Whereas science, as it is conceived by contemporary scholars, especially studies physical phenomena and the approachable and visible part of Nature and Man, occult science, as a result of its preferred method, analogy, works by

moving from physical facts to rise to the study of the invisible, or *occult,* part of nature and man: hence its first characteristic as "science of the hidden," *Scientia occultati.* Where contemporary science disseminates its discoveries and practices through journals and public experiments, occult science divides its research into two categories: one part, which can be published to aid in the progress of humanity; and another part that must be reserved for select men . . . *Scientia occultata.*[178]

To that end, and so that improper use is not made of higher knowledge, all the books relating to the secret part are written in accord with a "special symbolic method," *Scientia occultans.*

The artist's narcissism or worries are appeased because esotericism, or so he hopes, places him in communication with an infinite reservoir of forces. "It is possible for man, through the development of capacities slumbering within him, to penetrate into this hidden world."[179] He has only to cultivate "*another kind of cognition*" than that which gives access to the sensible world. At this point, the most implausible but impressive esoteric mythology unfolds. For Steiner, it begins with anthropology: the human being is composed of his physical body, his "ether body," his "astral body," and his "ego." This means that everyone is in communication with the universe as a whole, sphere upon sphere, and, if he does the appropriate exercise, he can capture its mysterious forces. An entire cosmology unfurls its fantastic rings from the earth to the supreme deity, from material powers to spiritual powers. Once recognized, that cosmic hierarchy itself actively helps in the formation of the organs of "spiritual" or "supersensorial" perception. Hence the initiate is endowed with superhuman powers. Many things are "super-" in esotericism, and they feed a feeling of omnipotence in the initiate, of absolute self-control.

In taking this journey, the initiate is not aware that he has changed his religion, if he ever had one. These doctrines declare themselves in full agreement with established religions, even if that entails giving them a different sense, which will then be considered the true sense. Schuré's book, which had such a long-lasting success in France, lists Rama, Krishna, Hermes, Moses, Orpheus, Pythagoras, Plato, and finally Jesus, the successive bearers of a substantially unified revelation, whose hidden meaning is loftier and more profound than the exoteric teachings of these sages. "Sâr" Péladan does not miss a chance to proclaim himself Catholic.[180]

Immersed in currents that are neither completely material nor completely spiritual, but rather "corporeal" (relating to the astral body, secret fire, cosmic energy, and so on), the esotericist demonstrates his knowledge and power through a kind of magic. That magic intersects many artistic techniques, and es-

pecially that of late nineteenth-century art. The method proper to esotericism is the systematic use of analogy and correspondences, which the artist also practices, but with a "seriousness" that allows the poetic to drift toward ontology. "The science of correspondences is the angelic science," writes Swedenborg. "The whole natural world corresponds to the spiritual world. . . . That is why every thing that exists in the natural world in accordance with a spiritual thing is called a correspondent."[181]

The ontological analogy permeates nature, makes it a totality, a Pleroma, a unified and diverse organism whose parts are joined together through solidarity, likeness, and proportion. The smallest is like the largest, the largest like the smallest. The whole universe is replicated in a drop of water. The microcosm (man) and the macrocosm are present in each other and in every point. An arithmosophy can be deduced from it. A magical meaning is attributed to all numbers and to the order in which they are arranged. The Divine Proportion, which painters use, is endowed with supernatural powers. Esotericists find it in minerals (the six cleavages in sphalerite), in plants (the arrangements of seeds in the sunflower), in animals (the logarithmic spiral of the ammonite), in human beings (Agrippa von Netesheim's pentagrammatic man), in the sky, which, if one considers the distances between planets, is like a vast diapason analogous to the intervals of the diatonic scale.[182] Hence *affinities* appear: under mere resemblance, they conceal a relation of conformity, between the fetus and the ear, for example, from which esotericists draw a medical practice or, rather, a form of magic. They act on one element to obtain an effect on another, larger element that corresponds to the first.

Colors themselves possess virtues and powers. According to Steiner,

the land of the spirits . . . has, in a certain respect, a similarity to the sense world. For example, just as in the world of the senses a color appears when an object impresses the eye, in the land of the spirits, when a spiritual being acts upon the ego, an experience is produced similar to one made by a color. . . . It is not as though the light struck the human inner being from without, but as though another being were acting directly upon the ego, causing it to portray this activity in a colored picture. Thus all beings of the spiritual environment of the ego express themselves in a world of radiating colors.[183]

These doctrines are enough to make painters giddy. From the beginning, they have dealt with analogy, correspondence, and affinity in their craft. Forms and colors are more eloquent, richer, for them than for the common man. Since Baudelaire and Wagner, an aesthetics has been devoted to explaining the importance and role of colors and shapes in the elaboration of the work of art. But these doctrines impelled them to radicalize their discoveries. Through artistic

318 • Chapter Seven

techniques, they glimpsed magical procedures and tried to appropriate them. For a century, philosophy had been inviting them to think of themselves as clairvoyants. Alone among men, they had access to a deeper reality. In a climate intermingling religion, Gnosticism, and initiation, esotericism summoned them to act magically on that reality, to "evoke" it in the strong sense. They became theurgists. No longer confined to representing the divine, they called it forth, manipulated it, produced it by presenting images whose power, to their minds, was infinitely superior to the impure effigies that locked the divine spark in the bodies of nude women, in landscapes, in the imitation of objects. They were chemists who drew out the active principle that was diluted in natural bodies; or, rather, they were alchemists who extracted the quintessence of these bodies from the crucibles in which they were burned, consumed, and reduced.

The attraction to esotericism can thus be attributed to the hubris to which the artist was driven by the nineteenth century as a whole. That magical pruritus also allowed him to bridge the gap between two apparently opposed attitudes: on one hand, "decadent" refinement, the languor of spirals, the decay of color; and, on the other, the primitivistic brutality of hard outlines and pure color. The two attitudes were almost contemporaneous. That is because, by opposing paths, the artist sought to assure himself of his new powers. Esoteric Orphism and the Maori mask; the occult arts that claimed Pythagoras, Hermes Trismegistus, the Kabbalah, and thirty centuries of tradition; the "primitive," naive, and spontaneous magic of the Oceanic fisherman: all these are appealed to and summoned, in order to capture something of the secret power with which they are believed to be charged.

The Russian Revolution

1. Russia's Aesthetic Education

This book will end with Malevich's *White on White,* which the artist exhibited in 1918. The paths by which the effacement of the representative image was arrived at must be recognized. There are several. I will particularly follow the religious motifs, implicit or explicit, that will allow us to link the birth of so-called abstract art to an iconoclastic impulse, in the narrow and "historical" sense of the term.

I suggested that this episode occurred through a sort of collision between the forms elaborated by French painting within the framework of a certain aesthetics and the spiritual imperatives of artists, generally outside France, who espoused a completely different aesthetics. The first group found they were in agreement with the second, who came to lodge within them like a hermit crab in another's shell.

Cézanne as a Crypto-Abstract Artist

A further complication is that French painting, in following its own path, also became disconnected from representation. As Dora Vallier so aptly sums it up:

> Under the influence of romanticism, throughout the nineteenth century the major current of art (especially in France) evolved toward an increasingly subjective, increasingly free expression, which distanced it from tradition. Nonetheless, the consciousness of a supreme, absolute, obscurely traditional

form persisted, and manifested itself at the end of the century. The subjective swerves of impressionism, and also of realism (despite his credo, did not Zola himself ask above all that the work of art reveal the artist's personality to him?) was followed by a call to order. This time, the order was straightforwardly that of form in itself, whether the artist embracing it was Seurat or Cézanne or Gauguin. Even Maurice Denis wrote this famous line in 1890: "Remember that a painting, before being a warhorse, a nude woman, or an anecdote of any kind, is essentially a flat surface covered with colors assembled in a certain order." At that moment, abstract art took on a virtual existence.[1]

Only a virtual existence, however, since the aforementioned abstract art came from elsewhere. In France, the logic of modern art sometimes came very close to it. Because of the way the century was going, the last intransigent guardians of tradition, of genres, and, especially, of the objective procedures of representation (perspective, modeling, outlines, anatomy) were inferior painters. Pompier artists, academicians, and high society painters may appeal to us once again, because of the ruins strewn on the other side of painting; all the same, it was on that other side that lofty imperatives, disinterestedness, the good and pure spirit of painting, and, in general, quality works were to be found. It was normal that, along their heroic journey, the impressionists and their friends abandoned to pompier painters what the latter were proud of, and which the former were gradually led to disregard and scorn. Degas's words ("he paints everything in iron except the armor," etc.) did not deflate a system but, rather, a certain baseness of soul—and hence of painting—that illegitimately protected itself with the increasingly thin mantle of tradition, and which these highly honored painters dishonored. Nonetheless, when this mantle was rejected and the procedures of representation were relegated to a subordinate rank, the intention, namely, to represent, remained the same and was more ardent than ever. Thus the spirit of abstraction remained foreign to that art, even in its greatest liberties, and even though, at times, "one no longer sees much" on certain canvases by Monet or Braque; an asymptotic gap remains where the reference to the natural order stands, spontaneously, naturally contemplated.

Let us consider Cézanne. He never stopped painting from life. Until the day he died, his cariole took him faithfully to the Jas-de-Bouffant, the Château-Noir, the Sainte-Victoire. "I paint as I see, and I have very strong sensations."[2] These are similar to Zola's words. Did he want to place impressionism back within the heart of the great tradition, of the "museum"? He declared he wanted to "revitalize Poussin with nature," that is, guide, on the basis of that illustrious model, the emotion and sensations that the spectacle of nature gave him, the richness of which he despaired of capturing. The year he died, he wrote to his

son: "Here on the riverbank, the motifs proliferate; the same subject seen from a different angle offers a subject of study of the most powerful interest, and so varied that I believe I could be occupied for months without changing places, leaning sometimes more to the right, sometimes more to the left."[3]

Yet this was the same man who, in the last Sainte-Victoire paintings, covered the canvas with a crystalline mosaic, which, in the part depicting the ground, leaves the vegetation, the earth, and the houses indecipherable, and which, in the sky, puts down green strokes that cannot refer to either the air or the pine branches: the "harmony," of course, is still "parallel to nature," as he wished, but the parallel lines are unquestionably moving farther apart. For his admirers, it was at that point that his work took on a new meaning. Recall his letter to Emile Bernard, of which so much would be made in the cubist years: "Treat nature with the cylinder, the sphere, and the cone." In 1943, Picasso told Brassaï: "Cézanne was my one and only master. I spent years studying his paintings. . . . Cézanne was like the father of us all."[4] Sérusier added: "He showed that the only goal is to deposit lines and colors on a given surface so that they charm the eyes, speak to the mind, and finally, create, by purely plastic means, a language."[5] This was an echo, in 1905—a delay of fifteen years—of Maurice Denis's formula. But Klee wrote in 1909: "For me, he was the master par excellence, better able to instruct me than van Gogh."[6] But what would the master have said had he seen this note, made the same year: "Nature again bores me. Perspective makes me yawn. Should I therefore distort it (as I have already been tempted to do 'mechanically')? How to bridge the gap from inside to outside in the freest manner possible?"[7] The bridge Cézanne might have built would have run from outside to inside.

Malevich's interpretation, as one might expect, was even more radical: Cézanne was not a primitivist, he was already a cubist. He turned away from nature.

> Evolution and revolution in art have the same aim, which is to arrive at unity of creation—the formation of signs instead of the repetition of nature. One can point to Cézanne as a clear example of this movement. Cézanne, the prominent and conscious individual, recognised the reason for geometricisation and, with full awareness of what he was doing, showed us the cone, cube, and sphere as characteristic shapes on the basis of which one should build nature, i.e. reduce the object to simple geometrical expressions. . . . With him comes to an end the art that kept our will on the chain of objective, imitative art whilst we dragged ourselves along behind the creative forms of life.[8]

According to Malevich, Cézanne was the Moses who saw from afar the Promised Land, the Faustian freedom of the cosmic creative man. But he did

not enter that land: "He was nevertheless unable to achieve the expression of plastic, painterly compositions without an objective basis; neither did he apply the tendency which was destined to develop in the great movement of Cubism." In counterpoint, let us quote this judgment by Bonnard: "He often lounged in the sun like a lizard, without even touching a paintbrush. He was able to wait until things again got to be the way he had first conceived of them. He was the purest, the most sincere painter, the one best armed to confront nature."[9]

We do not have to decide between Bonnard and Malevich. It is a fact that the cubists, and then the abstract painters, embraced Cézanne, as the Jacobins had embraced Rousseau. As a result, within the framework of an aesthetics that was still mimesis, a meticulous and faithful exploration of the motif, a humble admiration of the miracle of nature, forms developed that suited a resolutely subjective aesthetics that posited pictorial creation in a boastfully competitive encounter with the creation. To paraphrase Freud, where nature is, will painting be. To the objection that Cézanne did not want that, Malevich would have replied, he *did* it.

The Surrealist Bifurcation of Symbolism

The circumstances from which abstract art emerged were not at all inevitable. One faction of symbolism, in becoming surrealism, followed a different path. At first glance, surrealism in painting has the look of a leftist, secular, more cheerful, and more openly—though less effectively—erotic symbolism, since it lacks the Baudelairean mix "of intrigue and piety." At second glance, the movement is more contradictory, and moves in several different directions.

If we can agree that it began with Dada, surrealism was, in the first place, a revolt: against World War I, against the society responsible for it, against the art establishment—not the pompier painters any longer, but the newly installed establishment—and particularly against the "return to order" noted in French painting in the 1920s.[10] When the revolt went farther, it turned against art, against the work, and, in the end, against life, if suicide can be included as one of the various "manifestos" of surrealism.

Surrealism is also a form of irrationalism—and thus hardly in favor of the intellectualism that dominated France from Seurat to Matisse. This was its neo-romantic side: the depths, the reality, lie beyond appearances, unattainable by reason; in the psychological and Freudian version, they must be sought in dreams and the unconscious.[11] Humor is a surrealist "value," though it is somewhat rarely achieved. In Magritte's paintings, however, it brightens the pictorial fables of *This Is Not a Pipe* and *Empire of Lights*. Usually, the serious spirit pre-

vails and makes surrealist canvases equivalent to the most lugubrious Pre-Raphaelite canvases, whose meticulous techniques they often adopted. Or the humor deteriorates into sophomoric ridicule.

Two points in surrealism ought to be of interest to us: its religious attitude and the status of representation. Surrealism is distinguished from symbolism by its resolute anti-Christianity. This is so firmly established that, even though Dalí perpetrated equivocal Saint-Sulpice-style works—which the church, and even the pope, gratefully accepted—he did so by putting a different twist on surrealism. On the whole, the blasphemous tone prevailed. Let us simply cite Picabia's famous *Holy Virgin* (1920); Ernst's *Virgin Mary Correcting* [that is, spanking] *the Baby Jesus in Front of Three Witnesses: A. Breton, P. Eluard, and the Artist* (1926); and Clovis Trouille's dirty jokes.

That does not prevent surrealism from being pious. It is so in its sectarian spirit, its rituals, its hierarchy, its excommunications. It is so in its cult of woman, intersecting in that respect with Moreau, Rossetti, Khnopff, and Stuck. Delvaux, Labisse, Bellmer, and Léonor Fini glorify the voluptuous terror surrounding the deified woman, magnificent and maleficent. The surrealist landscape evokes a vision of the next world, sometimes extremely tropical in its luxuriance, sometimes a desert, a daydream by Le Douanier Rousseau, Patinir, and Altdorfer combined, always on the point of transforming itself into a nightmare. Tanguy wrote: "A horizon, fairly distinct at first, then hazy, separates the gray sky from a desert plain, teeming with beings with the biological form of palpi, peduncles, trochleas, pseudopods, and bony tentacles."[12] Paradise or hell? One or the other, but never earth.

Nonetheless, surrealist religiosity usually chooses the primitivist path, manufacturing magical idols. That was the effect sought by Ernst, Dalí himself, and Seligmann. That was the major ambition of Brauner, an alchemist and initiate into esotericism. He used the mysteries of Egypt, hieroglyphs, to produce multisexual, polymorphic, chimerical beings striving for the power of totems.

In addition, there is representation. In *The Conquest of the Irrational* (1935), Dalí writes: "My painterly ambition consists entirely of materializing, with the most imperialistic rage for precision, the images of concrete irrationality." This entailed passively translating, copying the images that arise from the unconscious or the dream, gates of ivory or of horn that open on a higher reality, "surreality." The surrealist artist, if we are to believe him, proceeds like the icon painter: he paints the motif, but what he offers to view is not of this world.

The difference is that the iconographer was guided by faith, dogmas, tradition, iconographic models. He did not claim to "sense" the images, experience them internally: he received them and transmitted them. The surrealist claimed

to transcribe the images that certain psychological states offered him. But this is untrue, and, if he is a painter, he constructs them, either from elements of reality that have undergone a transfigurative deformation, or by making up forms and assemblages from whole cloth, with no relation to visible reality. And that is why, in derealizing things, in trying to communicate the next world without using the go-between of space, natural light, or objects, surrealist painting fairly quickly converges with abstract painting. Canvases by Miró and Arp, and even by Masson and Ernst during certain periods, could be taken either as representations of the surreal, images of something, or as autonomous, self-sufficient forms; as images of the next world, or as the next world itself.

The Russian Outskirts

In the general history of art, the peripheries are often the site of two contradictory phenomena: on one hand, tag-along provincialism, everything that makes the art of the peripheries a weak and timid reflection of the triumphant production of the center; and, on the other, a potential for innovation and rupture, because the rules lose their force at the edges and the mere feeling of being on the fringe can lead to rivalry and focus the nascent energies of those distant regions on the rupture—all the more so since they receive the various external influences all at once, and not in their natural order.

Russia had occupied a marginal position in relation to two successive centers, Byzantium and the West. Russian icons lose something of their nobility and gain something in pungency when they are compared to their Byzantine model. But the genre was dying when the Petrine revolution showed Russia a different center of civilization. The icon survived, if not as living genre, then at least physically, in the circles that resisted that revolution with all their might: one part of the clergy, the *raskol,* even in the provinces farthest from Petersburg.

Russia was separated from that new center, Western Europe, by the entire width of a first periphery: Prussia, Sweden, and Poland. It was from these countries that it received most of its artisans and artists, who came to accept commissions from the aristocracy and the court, and who transmitted their techniques and craft to the Russians. Nevertheless, Italy, France, and England were wealthy enough to send a few great architects and second-rate painters. The nobility and the powerful were able to become collectors in the late eighteenth century. It is well known that a few famous French and German collections, at Catherine the Great's wish, made their way to the Hermitage. Art education was capped at the Academy of Fine Arts, whose regulations, approved by Catherine in 1764, were copied from those of the Académie Royale in Paris.

It was the center of nascent Russian painting, under the leadership of French, Italian, or German masters. The first steps were felicitous. The portraits and genre scenes by Levitski, Venetsianov, and Fedotov had a naive, fresh, and humorous charm that, along with the subtle note of exoticism, was on a par with contemporaneous works from Scandinavia and the Germanies.

Things began to go bad when Russia, aware of its power, tackled the big genres. Contrary to what it had expected, its search for self-affirmation increased its dependence. The provincialism of its art appeared more glaring when, in wishing to overcome it, it lost its piquancy and naïveté. Russian painting "caught up with and surpassed" the West in its depictions of the great machine of history (Brullov's *Last Day of Pompeii*), in the Nazarene genre (Ivanov's *Christ Appearing to the People*), and in the national epic (Vasnetsov).

In 1863, thirteen students from the Academy of Fine Arts refused to treat the subject proposed—the feast of the gods at Valhalla—and founded an *artel*. This reinvention of the German and English art brotherhoods placed itself under the patronage of the artisanal communities of traditional Russia. The *artel*—which soon took the name "Society of Wandering Exhibitions"—dominated artistic life until the end of the century.

The painting of the Wanderers *(peredvizhniki)* was closely linked to the contemporaneous literary movement. To borrow a term from American college campuses, its aim was "relevance." It wanted not only to reflect the real evils of Russian society—poverty, exploitation, drunkenness, the clergy's vices, the harsh fate of prisoners and students—but also to work toward their cure, following the lines of populist politics and ethics. The Wanderers kept the old genres: large history paintings, sometimes fanatical in their nationalism, sometimes dramatizing certain episodes from the past in a rebellious light (Repin, Surikov); genre paintings that embraced satire (Perov, Makovsky, Yaroshenko); sometimes vibrant portraits (Kramskoi); and, finally, religious painting, with a pathos fairly similar to that of Tolstoy and Dostoyevsky. In the paintings of Gay (a religious disciple of David Strauss and Tolstoy), Christ, more man than God, draws his sublimity from his powerlessness, from his nonviolent gentleness, from his failure. He is a miserable prince Myshkin dying on the cross, his feet at ground level *(Crucifixion)*.

The Wanderers were the aesthetic educators of far-flung Russia.[13] They "went to the people," that is, they reached out to the new strata of the intelligentsia, journalists, professors, small progressive circles in the provinces. They depicted the guilty conscience of the age. The social, national, and national-religious consciousness of Russia can be seen in their paintings. Like literature, painting had to preach, had to be an instrument in consciousness-raising and a

force for change. That lesson was later adopted at someone else's expense by the cubo-futurists and constructivists of the 1920s.

All the same, either because it happened to lack a great talent, or because militancy and moral duty prevented such a talent from emerging, the movement produced no one to compare to Tolstoy, Dostoyevsky, or even Shchedrin or Chekhov. It was incapable of the slightest formal innovation and probably never thought of such a thing, since its program exempted artists from feeling the need for it. In aesthetics, it reproduced German ideas, from idealism to realism, with the usual delay in diffusion to Russia. In painting, its horizons did not extend beyond Düsseldorf.

With this new "inward-looking" school, Russian boastfulness, which in the early part of the century aspired to a kind of painting that was "competitive" with the West, now preferred to transfigure its isolationism into a principle of superiority: the seriousness of the Wanderers put Western formalist frivolity, and particularly Parisian frivolity, to shame. This leftist painting, which repudiated the Slavophile "reaction," held on to the fundamental argument of Slavophilism: we are not inferior, we are different, and, since the West is denouncing itself as decadent, we are better and possess the keys to the future. The future henceforth lies in socialism, in its indigenous or international versions (populism and Marxism, respectively). That is why the painting of the Wanderers was the formal and ideological matrix of socialist realism.

The lid, kept on for thirty years, began to come off in the early twentieth century. With socialist censorship suspended, artistic life reawakened with a seething diversity. That renaissance is rightly dated to the founding of the review *The World of Art* by Alexandre Benois and Serge Diaghilev, in Saint Petersburg in 1898.[14] But the renaissance had an older forum. The Wanderers' primary patron was a Moscow merchant, an Old Believer named Tretyakov, who dedicated himself to creating a purely national collection. Nonetheless, one branch, which diverged somewhat from the Wanderers, found another patron, more modern in spirit and even in the source of his fortune (railroads and metallurgy): Mamontov. His very devout wife transformed her property in Abramtsevo into an art colony. She built a chapel there, which marked the return to the religious sources that had been forgotten by Russian art: it was then that people began to look at icons with different eyes (1880).

Mamontov was interested in theater and opera: he urged his painter friends (Vasnetsov, in particular) to paint the "Boyard"-style sets that caused such a stir when the works of Mussorgsky and Rimsky-Korsakov arrived on the Western stage. Mamontov supported the short career of Vrubel (1856–1910), who was

probably the first Russian artist who managed to impress the West. When he was very young, he had participated in the restoration of the medieval frescoes of Saint Cyril in Kiev. But he was not constricted by his choice to ground himself in a very recently rediscovered tradition. He discovered Venice and color, and his classical education did not keep him from immersing himself in Russo-German spiritualism, to the point of locating himself on the far side of the symbolist Kamchatka. His different versions of the Demon (after Lermontov) form a bridge to Russian romanticism at its most Byronic, but with a foundation in fin de siècle esotericism. His demon was an angel—an androgyn— suffering, afflicted, very young, very beautiful, very lonely, and with a desperate face capable of inspiring a compassion that was not completely free of sexual attraction. In the spirit of Péladan, it was a Russianized, "Dostoyevskified" version of Stuck's *Sin*. After completing a cycle on this theme, Vrubel was admitted to an insane asylum and never came out again (1902).

With the founding of *The World of Art* (1898) by Alexandre Benois and Serge Diaghilev, the Russian art world was transformed with a speed that continued to accelerate until the revolution. There is no need to retrace its tumultuous history, which is well known and well documented. For our purposes, let us simply make the following remarks.

The social milieu of art changed. Instead of Moscow, Petersburg was now setting the tone. Instead of the rigid intelligentsia, with its mores and canonical opinions, a better-educated, wealthier, better-informed, and more diverse "society" purchased, discussed, and supported the new kind of painting.

The goal of Benois, Diaghilev, and his friends was to make Petersburg one of the great European centers, on a par with Paris and Munich. To that end, they broke off from the protectionism of the previous half-century. Because they wanted to rival Paris, they organized exhibitions of French painting. Relations with Germany were even closer.

Nevertheless, it was in Paris that Diaghilev brought to fruition his most astounding exhibitions and spectacles. At the Salon d'Automne of 1906, he presented all of Russian art (except the Wanderers, henceforth despised and mocked), including a few icons. More could not be displayed because the cleaning off of the dross that completely obscured them, and the crude restoration that has given them their present appearance, were completed only in 1913. In 1909, he inaugurated the triumphant series of Russian ballets at the Châtelet. The Paris public, called upon to take note of the fact that Russian art, which was entirely unfamiliar to them, now spoke the common European language, perceived the exact opposite. They saw a "barbaric, Asian, Scythian splendor" in

the sets of Bakst, who was in fact an extremely refined Petersburg Jew, and who had attended the Beaux-Arts in Paris. That, in turn, spurred on primitivism and exoticism in French art. Productive exchanges, fertile misunderstandings.

One may say that, at that date, Russian painting was "up to date," "in the know," and that it took what it needed from the great pan-European market of "isms." Borisov-Musatov, for example, studied under Gustave Moreau, scrutinized Puvis de Chavannes, made many delicate landscapes in gray-green and soft blue—symbolist hues par excellence—and glorified the distinguished, modern Russia of crinoline dresses and white homes with Empire columns. Works from Tsarskoye Selo and Peterhof, and those by Benois, Serov, and Somov, displayed an aristocratic imperative: they thus fended off the profound fear inspired by the world below, the fringe intelligentsia, the prole-leaning intellectuals who were beginning to stir up and organize the peasant and working-class mob beneath them; they fended off the fear of tomorrow, the threat of the inevitable political crisis that was going to unleash the floodwaters, set off an eruption by the "people," and sweep away the fragile islet of civilization.

Contemporary art came to Russia through artworks. Two huge collections, that of the Morozovs (135 impressionist and Nabi paintings) and that of the Shchukins (221 impressionist and postimpressionist canvases, including fifty Matisses and Picassos) constituted two museums open to artists and often to the general public, for which no equivalent existed in the West.

The actions of *The World of Art* were adopted and diversified by other sumptuous reviews such as *The Golden Fleece* and *Apollo*. Every genre was practiced with brilliance: easel paintings, which sold very well to the now-numerous amateurs; society portraits (a Serov was worth as much as a Sargent or a Jacques-Emile Blanche); theatrical sets, often dazzling when Bakst or Benois was in charge; illustrations of deluxe editions. The goals of *The World of Art* were achieved: Russia had become a great center of art.

Aesthetic ideas reflected every stratum of Russian thought. If we dig a bit, we again find Schelling and Hegel at their foundation; they were the first pedagogues of Russian aesthetics, even before there were any paintings. Then there was populist realism, not yet dead, since its theorist, old Stasov, was still alive and, along with Plekhanov, thundered against the "formalism" of the new style of painting. Then there was the so-called philosophy of religious rebirth: Solovyov, Filosofov, Berdyaev, Merezhkovsky, Hippius, Florenski, and so on. This very muddled philosophy attempted to combine German idealism, international illuminism, the Orthodox tradition, and Russian messianism. Contemporary Russian art is steeped in it. Philosophers, painters, poets, writers, musicians, and academics formed a single milieu. In contrast to the Marxian

culture of the intelligentsia, it was a resolutely spiritualist counterculture. The musicians were friends of the painters, who put on operas, asking the poets for librettos. Nowhere was the symbolist ideal of communication among the arts, of correspondences among sounds, colors, and words, fostered so overtly and so fervently. Scriabin invented a piano of sorts with notes that directly produced color projections.

Finally, as throughout Europe, the artistic movement gave rise to internal rifts, secessions, revolts, and a race toward the avant-garde. The Russian fabric was now dense, broad, and rich enough to be ripped apart.

The rebellion erupted in 1905 and took *The World of Art* as its target, even though the review was only five years old. *The Golden Fleece* responded: the younger generation was protesting against erudition, historical allusions, and the rather snobbish and elitist bias for elegance taken by Bakst, Benois, and Lanceray. This younger generation took the Blue Rose as its emblem. It included students of Borisov-Musatov (that is, the most symbolist of their masters, whose paintings are sometimes reminiscent of Le Sidaner and Levy Dhurmer), and notably, Kuznetsov, Saryan, Larionov, and Goncharova. *The Golden Fleece* held exhibitions in Paris and Moscow (1908 and 1909). Within a single year, these painters were introduced to the Nabis (Bonnard, Vuillard, Sérusier, and, especially, Maurice Denis), then to the precubists and fauves (Braque, Matisse, Vlaminck, Rouault). This element must be taken into account: the abrupt concentration of works meant that a pictorial production spread out over one or two generations was received synchronically, as an explosion of multicolored rockets going off simultaneously in all directions. This was not destined to introduce calm and order into the development of Russian art. Larionov, who went back and forth from Paris to Moscow, shifted, within a few months' time, from the quasi impressionism of *Passage of Spring* (1905) to the extremely neoimpressionist fauvism of *Fish* (1906).

That rebellion might seem to be an "antibourgeois" reaction. These young painters tended to adopt the artist's ethos and the hobby painter's mores and, even though they stood apart from the populist phalanges and belonged to a freer society—or *because* they belonged to that society—had no intention of allowing themselves to be recruited into Petersburg high society. The rebellion can also be interpreted as a Muscovite reaction against Petersburg. In that respect, it was also a nationalist reaction.

In fact, nationalism was everywhere. It was vibrant in Petersburg, where people wanted to prove that nothing was beyond them. It was vibrant in Moscow, but this time motivated by the sense that things were different there, that pictorial cosmopolitanism did not satisfy the Russian soul, that this soul had already

found its modes of expression and that these simply needed to be rediscovered and developed. In the same year, 1909, that saw French art flood the market, the third exhibition of *The Golden Fleece* excluded it almost entirely. Larionov and Goncharova occupied almost the entire field. But the physical expulsion of French art did not mean it was formally eliminated. In fact, the form the nationalist reaction took was the very same that all of Western painting had already taken: primitivism.

There was a significant difference, however. In the West, the primitive was somewhere else. In Russia, it was within. It did not take you away from the fatherland, it rooted you in it. It did not flee "traditions," it rediscovered or reinvented them. In Russia, there were barely more than two traditions: the icon and popular images, engravings on wood called *lubki*. These "Epinal images" had existed since the eighteenth century, and patriotic folklorists had carefully collected and published them.

This primitivism enjoyed its best years between 1909 and 1911. Goncharova painted simplified icons that edged away from Moscow and toward Ethiopia (*Virgin with Child,* 1911; *Flight into Egypt,* 1909), since even the icon was influenced by primitivism. Larionov painted military histories and other pictures, not hesitating to incorporate texts and inscriptions into them, as in the *lubki*. The Burliuk brothers, whom Goncharova and Larionov saw often, played a role in pushing painting toward the "savage," toward enthusiastic vitalism, or toward children's drawings, to the point of deliberating verging on "bad painting" (Larionov's *Spring 1912*). But they all claimed to be nationalistic and thus intersected the patriotic intentions of the Abramtsevo colony.

French paintings, once so numerous, became rare. At exhibitions of the Knave of Diamonds—a marginal group that followed Cézannism in its evolution toward cubism—the minor painters were still there (Lhote, Gleizes, Le Fauconnier), but Picasso and Matisse were no longer sending anything.

This was because French art had done its job: it had given a form to specifically Russian aspirations. Of course, a superficial glance might link Larionov, Goncharova, or Mashkov to a kind of fauvism or an international paracubism. But this was merely a precarious union of opposing aesthetic horizons. That union ended in the prewar period. Let us now consider Kandinsky and Malevich.

2. The Spiritual: Kandinsky

Kandinsky's Career

We have not yet had occasion to meet Kandinsky, because he remained marginal to the main currents. In about 1910, the various small groups of painting in

Moscow, Petersburg, Kiev, and Odessa coalesced around the Knave of Diamonds and the Union of Youth. The latter, financed by another rich merchant, was permeated by the futurist spirit, which favored bizarre get-ups, startling declarations, and derision of the symbolists, who were made fun of for their distinguished and delicate good taste. Nonetheless, it was under the auspices of that union that an exhibition was held in Odessa introducing the Munich school, and, in particular, the core of the future Blaue Reiter. That is where Kandinsky exhibited in Russia for the first time and made the acquaintance of the Burliuk brothers and of Larionov and Goncharova. In Goncharova's view, Kandinsky was lagging behind. He was still part of *The World of Art*.

We shall trace Kandinsky's life through his writings. But first, let us briefly get to know him as a man and as a painter. Kandinsky became an artist fairly late in life. He was born in 1866, that is, twelve years before Malevich and four years before Alexandre Benois. He was older than Matisse and Picasso. Born into a good family, he spent his childhood in the enlightened times of Alexander II. He was never won over to the subsequent political radicalization and never denied his loyalty to the Orthodox Church. He was a brilliant law student in Moscow and believed he was destined for a great academic career. He was already a doctor and instructor at the University of Moscow when two events turned his life upside down: not his wedding, but the discovery of the French impressionists (the revelation was Monet's *The Haystack*), and then, at the court theater, that of *Lohengrin*. His emotion upon seeing the play was accompanied by a synesthetic experience: sounds produced the perception of colors. "In my mind, I saw all my colors standing before my eyes. Wild, almost crazy lines were being drawn in front of me."[15] His artistic vocation came into being. In 1896, he left Moscow for Munich. At the academy there, he studied painting under Stuck.

Kandinsky was a reserved, cultured, and very striking man. His personality made an impression. His first wife remained his friend; his second wife (or more precisely, his lady friend), Gabriele Münter, had a hard time getting over the breakup; and his third wife worshiped him.[16] His friends were loyal to him, and they were remarkable men, Franz Marc and Paul Klee, for example. There was never anything of the *artiste maudit* about him. It is certainly an exaggeration to write, as Michel Henry has done, that his art "at first elicited jeers, if not rage and spittle."[17] A milieu, narrow perhaps, but of great intellectual and social distinction, always supported and honored him. Cézanne could not have said as much.

If we provisionally agree to superficial classifications, his career as a painter falls quite neatly into periods. The first period extended from his beginnings to the moment he moved to Murnau in 1909. The early works (*Pair of Horsemen,*

1906; *Sunday,* 1904; *Life in Colors,* 1907) do not deviate from the general style of contemporary Russian painting. In contrast to German color schemes, which tended to be glaring, Russian colors were pleasant and charming. Think of the "Paris-Moscow" exhibition (Centre Pompidou, 1979), and how much more tax-ing—hard-core—was the "Paris-Berlin" exhibition of the following year. The color schemes of the young Kandinsky delicately married pink and blue, en-livening them when necessary with a touch of red or orange. As for the subject matter—since there was a subject matter—it was often "national populist." In 1889, on behalf of an anthropological organization, Kandinsky left on a mission to northern Russia to make a list of customs relating to peasant law and the relics of paganism persisting in Christian rites. He became imbued with what was called "peasant culture" and remained profoundly drawn to glittering cos-tumes and Orthodox cupolas. Moscow especially remained in his heart, as the core of the nationalist religious sentiment that linked him to Russia. "All my life, I did nothing but paint Moscow," he later said. His paintings of that period make many references to painters in love with this same "peasant culture" and with the Russian past. To cite only one, *Life in Colors,* an evocation of the Rus-sia of legend (popes, a woman in a *kokochnik,* bearded monks, elderly pilgrims, white domes and walls), can easily be linked to the illustrations Bilibin was mak-ing during that same time for Pushkin's tales.

But Kandinsky was now in Munich, the city of Lenbach, Stuck, Corinth, the "Secession." He was seeking his own way. An engraving of 1903, *The Singer,* might have been attributed to Munch; another, from 1907 *(Two Birds),* to Beardsley (minus the eroticism). *Beach Huts in Holland* (1904), with its thick blotches of paint and the prepared canvas showing through between them, makes use of the neoimpressionists' technique, but the effect is truly symbolist or expressionist, once more in the style of Munch.

In Munich, Kandinsky rediscovered compatriots—Jawlensky and Marianne von Werefkin—who had spent time in Paris and knew French painting better than he did. With them and a few German artists, he founded an avant-garde association: Phalanx. The group's first exhibitions bore the mark of art nouveau, and, as it turned out, Kandinsky saw the potential in this style for abstract forms that could be put to a use other than decorative. With his friend, the painter Gabriele Münter, he traveled, got to know Paris, Matisse, the fauves, the cubists. Then he settled in Murnau in 1909. At that date, he knew what he thought, and his style had achieved its full autonomy.

The second period found Kandinsky in his acknowledged place within the expressionist current. Russia was not forgotten, nor was the France of the Nabis, Matisse, and the fauves neglected, but his painting was now German. Even the

folkloric inspiration now came from popular Bavarian paintings. Kandinsky was part of two German groups, the NKV (Neue Künstlervereinigung München), and slightly later, the Blaue Reiter. His own originality did not rule out a family resemblance with Schmidt-Rottluff, Kirchner, Pechstein—a family related to the Brücke—or with Marc, Macke, Jawlensky, the Blaue Reiter's immediate family. His paintings were constructed in large, massive blocks, with pure, luminous colors and intense contrasts between dark and light or hot and cold. The sparkle of the colors was not incompatible with gaiety and harmony—a Russian trait (*Grundgasse in Murnau*, 1909; *My Dining Room*, 1909). But Kandinsky was reading the theosophy of Helena Blavatsky, studying Steiner, and corresponding with Schoenberg.[18]

Then the slow and powerful impulsion toward abstraction began: the famous series of *Impressions*, which still made reference to the representation of objects; the *Improvisations*, which translated the spontaneous movements of the soul; and, finally, the *Compositions*, which consciously moved toward the abstract. They mark the levels and stages of a heroic rupture, which was poorly understood by the German public. There were nationalist protests against his art, which was considered "foreign," that is, French and Russian. In 1911, the NKV rejected *Composition V.* Immediately, the group broke up and ceased to exist. It was now in the Blaue Reiter that Kandinsky found his support. The legendary exhibition of December 1911 displayed *Composition V* next to Marck, Macke, Münter, Le Douanier Rousseau, de Delaunay, and the Burliuk brothers. The title was a musical allusion. The luminous shapes surrounded by an aura owed something to the classic work of theosophy, Annie Besant's *The Forms of Thought*. The threshold had been crossed. Abstract painting was now conceived as such: it had a foundation. Nonetheless, either because he retained the pathos of his last figurative paintings or because his companions were dragged along with him in the same direction, Kandinsky remained within expressionism, in a sense to be explored later.

Kandinsky's third period opened with him teaching at the Bauhaus, beginning in 1922. Between 1914 and that date was a less felicitous, more tentative and hesitant interlude, the return to Russia. Kandinsky had never broken his ties with his native country. He continued to send reviews to the symbolist magazines *The World of Art* and *Apollo*. He had become interested in Scriabin's "color piano" and in the Lithuanian painter Ciurlionis, who was trying to transpose music into abstract paintings. He participated in the expositions for the Blue Rose, which was very advanced in its symbolist exploration of the relation between colors and sounds. In 1914 he published the Russian version of *On the Spiritual in Art*. He also published poems inspired by Maeterlinck, whom he

liked a great deal. But, on that point, he came up against the angry young men of the new avant-garde, Kliun, Lissitsky, Rodchenko, and Malevich. The critic Punin wrote: "Kandinsky's artistic productions are insignificant. So long as his work confines itself to the spheres of pure spiritualism, it imparts certain sensations, but as soon as he begins to speak the language of things, he becomes not only a bad craftsman (draftsman, painter), but quite simply a vulgar and altogether mediocre artist."[19] In the end, Muscovites, on the eve of revolution, tired of symbolism.

The war brought Kandinsky back to Russia. He married a second time. He painted canvases that returned somewhat to a fond depiction of Russia (*Moscow I*), with cupolas, modern buildings, and "naive" colors. Others persevered with abstraction, incorporating the geometric forms required by the "constructivist" and "suprematist" climate of the Moscow avant-garde. These oscillations make us wistful for the decisiveness of the Munich years.

Even though—or because—he was essentially apolitical, Kandinsky took on various duties within Lunacharsky's *narkompros*. He taught his theories on color and form, already recorded in *On the Spiritual in Art,* in ill-defined, improvised institutes. In these same institutes, Rodchenko, Stepanova, and Popova elaborated a diametrically opposed program, exalting the impersonality of the engineer and Bolshevik-style rationalism. Kandinsky managed to flee in 1921.

At the time, Berlin was participating in the *neue Sachlichkeit,* expressionism, Dada—everything but abstraction. Macke and Marc, Kandinsky's dear friend, were killed in battle. Gropius took him to the Bauhaus, along with Klee, Feininger, Itten, and the others. He resumed his Moscow teachings, still a spiritualist, still infatuated with the symbolics of colors, which he borrowed from Goethe and the occultist tradition. After Itten left and Moholy-Nagy arrived, Bolshevik-leaning constructivism and industrial aesthetics took root at the Bauhaus. Under Hannes Mayer, the Dessau school became frankly communist in its leanings. In addition, its focus moved decisively toward design and architecture. Kandinsky kept his own ideas, but he adapted to the new environment, as attested in his evolution toward geometrism, the play between angular and circular forms, and a less instinctive and more "scientific" use of color (*Composition VIII,* 1925; *A Few Circles,* 1926). Marginalized, but supported by his friendship with Klee, Kandinsky translated the total, collective art his colleagues were championing into symbolico-mystical terms. In 1928, he illustrated Mussorgsky's *Paintings for an Exhibition* with plays of light and moving shapes. This was his version of "synthetic art." Kandinsky gradually retreated and, when the school was attacked by the Nazis, sought refuge in Paris.

In 1934, Kandinsky was sixty-eight. The elderly artist's transformation was as

profound as it was unexpected. Revolutionary Moscow had changed nothing in his painting, other than to stifle it. But Paris seemed to liberate him from his own formulas. He was fairly isolated, however. In the 1920s and 1930s, French painting, against the assault of expressionism and abstraction, had put up an impregnable wall. His only old friend was Delaunay, whose career was as German as it was French, and whose wife was Russian. As new friends, he recognized only Miró, Arp, and Magnelli. He did not associate with Mondrian. Then, in his small, neat studio in Neuilly, he produced entirely new images, precious ones with delicate colors. Let us consider *Blue Sky* (1940): detached figurines float against a very finely painted azure ground. I say "figurines" rather than "forms," because they seem to be related to biological creatures (they are compact, with precise outlines) as seen through a microscope: plankton, protozoa, vermicles, jellyfish, dust mites, evoked allusively, devoid of the monstrous aspect the microscope can give them, and as gaily colored as candy or pictures for children.

Was that biomorphic abstraction still abstraction? Kandinsky's microscopic sea creatures were openly inspired by biology manuals, Ernst Haeckel's *Artistic Forms of Nature,* Karl Blossfeldt's photograph collections, and *Primitive Forms of Nature.*[20] He also looked to Arp's biomorphic forms and to the exclamation points, commas, and other *signs* used by Miró and especially Klee, his lifelong friend. Breton, who was now part of his circle, was pushing him toward figuration. To distinguish himself from abstract, surrealist, or geometrical artists, whom he did not like, Kandinsky now preferred the term "concrete art." He wrote: "Thus, beside the 'real' world, abstract art erects a new world that, externally, has nothing to do with 'reality.' Internally, it is subject to the general laws of the 'cosmic world.' One must therefore concur that a 'natural world' is placed next to the 'artificial world,' a world just as real, a concrete world. That is why I personally prefer 'concrete,' and not 'abstract' art."[21] He died in Neuilly-sur-Seine in 1944, at the age of seventy-eight.

"Reminiscences" (1913)

The opposition between the "external" and the "internal" was so important for Kandinsky that, now that I have introduced his career, which I wanted to do "externally" and superficially, it is fitting to let him speak for himself and to listen to how, according to him, he was formed "internally." Let us turn to his autobiography, "Reminiscences."[22]

In the beginning, virtually from his birth, he was fascinated with colors, which spoke to him as living beings: light green, white, crimson red. Then came

the "giant orchestra" of Moscow's colors. Early on, he felt the duality of nature and art within himself. He also felt, in a painfully confused manner, the "truth" he later arrived at, namely, that "the aims (and hence the resources too) of nature and of art were fundamentally, organically, and by the very nature of the world different—and equally great, which also means equally powerful."[23] This means that the same cosmic force that animates nature also animates the artist's soul, and therefore, that the subjective interior is "equally powerful" as the objective exterior. As a result, the two "world-elements," artistic subjectivity and natural objectivity, are separable, mystically related, sometimes in agreement, sometimes in opposition and rivalry.

In fact, he contemplated the things around him in a state of mystical pantheism. As the occultist doctrines would have it, everything has a soul, everything is alive: "Everything 'dead' trembled." Even a white trouser button in a puddle of water, a piece of bark being dragged by an ant, "everything showed me its face, its innermost being, its secret soul, inclined more often to silence than to speech."[24] That again gave him the intimate feeling that the art "which today is called 'abstract,' as opposed to 'objective' art" was possible. Regarding his law studies, Kandinsky noted that Russian peasant law determined its verdict "not by the external but exclusively by the internal," the state of the accused's soul.[25] Kandinsky adds that this was close to the foundations of art, as if art were formed and judged in the artist's soul, as if it preexisted the work of art and remained independent or separable from it.

Then came the two events that "stamped my whole life and shook me to the depths of my being."[26] The first was Monet's *Haystack*. Until then, he was most familiar with Repin and had long studied him. The important point is that he did not see the haystack in Monet's painting. Only the catalog told him of it. And precisely because "the object was lacking in this picture," the painting seized hold of him and "impressed itself ineradicably upon my memory."[27] What stood out was "the unsuspected power of the palette." "Painting took on a fairy-tale power and splendor. And albeit unconsciously, objects were discredited as an essential element within the picture." In fact, "the 'light and air' problem" of impressionism did not interest him: it had no relation to painting. More worthy of interest were the neoimpressionist speculations on the action of colors as such, which "left the atmosphere alone." Then there was *Lohengrin* and the already-reported synesthetic experience: "It became, however, quite clear to me that art in general was far more powerful than I had thought, and on the other hand, that painting could develop just such powers as music possesses." That symbolist article of faith was part of the Kandinsky credo.

Perhaps one should add a third event: his readings in modern physics. This

was more a spiritual experience, perhaps unleashed by reading Uspenski (who, in this instance, was a source Kandinsky shared with Malevich): the feeling of a loss of consistency and reality in the external world. "The collapse of the atom was equated, in my soul, with the collapse of the whole world. Suddenly, the stoutest walls crumbled. Everything became uncertain, precarious and insubstantial. I would not have been surprised had a stone dissolved into thin air before my eyes and become invisible."[28] It was as if the arm of the balance between the external and the internal worlds had tipped toward the internal, as if it were now weightier and more substantial. Kandinsky, who had long been fascinated by the spectacle of nature, and who was gifted with an extraordinary visual memory, gradually felt that memory decreasing and his attention to the world diminishing. "I realized later that my capacity for continual observation was being channeled in another direction by my improved powers of concentration, enabling me to achieve other things. . . . My capacity for engrossing myself in the inner life of art (and therefore, of my soul as well) increased to such an extent that I often passed by external events without noticing them."[29]

As one might expect, that gradual acosmism, that lack of interest in objects, peaked in his attitude toward the immemorial intermediary between the artist and the world considered in its beauty: the female body. In Munich, in the studio where he learned painting, the nude disgusted him. "In many positions of certain bodies I was put off by the effect of the lines." At the same moment, Paul Klee wrote in his *Journal*: "The dirty woman with spongy flesh, breasts swollen like wineskins, the disgusting body hair—that is what I have to draw at present with the tip of my pencil."[30]

It is clear that, in that state of mind indifferent to the external world, his own "ability to overlook objects in pictures also developed further." And this began with "the unintended effect that painting produces upon the painted object, causing it to become dissolved."[31] This is an important statement: the product of the act of painting—the picture, the forms and colors in the picture—acquires an autonomy so complete in relation to whatever external object may have initiated the inspiration that the object itself becomes useless, and even harmful, because it stands between the artist's soul and his creative act. This is what Kandinsky suddenly discovered during a fourth decisive experience. Coming into his studio at dusk, absorbed in his thoughts, he suddenly noticed a painting of indescribable beauty: "It was a picture I had painted, standing on its side against the wall." The painter concluded: "Now I could see clearly that objects harmed my pictures."[32]

Nonetheless, that fundamental decision cannot be explained solely by the painter's idiosyncratic state of mind. It rested on religious considerations.

Kandinsky had the feeling that he was inaugurating a new era in the history of art. It was not an elimination of what had preceded but, to repeat his own comparison, a bifurcation, a new branch that grew from the old trunk. He expressed himself using a mystical vocabulary. Art, he wrote, was in many respects similar to religion. Its evolution did not consist of new discoveries that canceled out the old truths. It consisted of "a sudden illumination, resembling a flash of lightning, of explosions that burst in the sky like fireworks," in short, the "organic development" of previous wisdom. "The new branch does not render the tree trunk superfluous: the trunk determines the possibility of the branch." What he inaugurated was "an uncommonly vital, primordial division of the one old trunk into two main branches of development, indispensable to the creation of the crown of the green tree."[33]

Kandinsky was a prophet, since that "revolution" declared itself throughout the entire world as a new era. Our age is on the brink of the "third revelation." In a language borrowed from Joachim of Fiore and communicated through the theosophical writings Kandinsky had read, after the age of Christ comes the age of the spirit. For him, that is a liberation. As long as he was riveted to objects, he was like "a beetle kept lying on its back," which desperately moves its legs. "How often I felt this hand at my back, and another that covered my eyes, so that I found myself plunged in deepest night while the sun shone."[34]

The elimination of the object from painting is thus a leap of faith; a salvation of the soul, whose eyes have been opened, and which, after so many tribulations, finally understands the profound meaning of art; an entryway to freedom, inseparably spiritual and artistic. And all because the requirement of the work's *inner* life has triumphed. According to Kandinsky, that conception of art, because it parallels the internalized ethic embraced by the Gospel, is Christian. At the same time, it bears within it "the elements necessary for receiving the 'third' revelation, the revelation of the spirit."[35]

The elimination of the object in painting subjects the painter and the beholder to "very considerable demands." They must learn to love "every form that has arisen of necessity out of the spirit, been created by the spirit," and to hate every form that has not. Kandinsky concludes:

> I believe the philosophy of the future, apart from the existence of phenomena, will also study their spirit with particular attention. Then the atmosphere will be created that will enable mankind in general to feel the spirit of things, to experience this spirit, even if wholly unconsciously, just as people in general today still experience the external aspect of phenomena unconsciously, which explains the public's delight in representational art. Then, however, it will be necessary for man initially to experience the spiritual in material phenomena,

in order subsequently to be able to experience the spiritual in abstract phenomena. And through this new capacity, conceived under the sign of the "spirit," an enjoyment of abstract (= absolute) art will come about.[36]

What is the background against which such declarations were made? Hegel, perhaps. According to him, in romantic—that is, Christian—art, "painting does of course bring to our vision the inner life in the form of an external object, but the real content which it expresses is the feeling of the individual subject. . . . The heart of these pictures is not the subjects themselves but the liveliness and soul of the subjective treatment and execution, the mind of the artist which is mirrored in his work and provides not a mere copy of these external things but at the same time himself and his inner soul" (*Aesthetics,* p. 804). We do not know whether Kandinsky was thinking of this passage, or of similar ones, but it accords with the common currency of romantic aesthetics, where he set up residence. The notion of moving from the age of Christ to the age of the Holy Spirit was also not unfamiliar to Hegel. It is more likely that the romantic ideas that had for a century constituted Russia's aesthetic education were adopted and filtered through the romantic revival of symbolism. During those years, the abhorrence of "materialism" was particularly keen in Russia, which had had to submit to a particularly brutal and primitive version of it. Pisarov, Chernyshevsky, Plekhanov, and Lenin repelled Kandinsky and sent him to the other extreme, where not only romanticism, not only Maeterlinck and Péladan, were waiting for him, but also Annie Besant, Steiner, and Mme Blavatsky.

Combined with these elements was Russian-style nationalism. His book was written on the eve of war and concluded with a hymn to Moscow, filled with a nostalgic tone, as Kandinsky himself remarks, similar to that of Chekhov's *Three Sisters:* "I regard this entire city of Moscow, both its internal and external aspect, as the origin of my artistic ambitions. It is the tuning fork for my painting."[37] This somewhat messianic nationalism was contagious, and Kandinsky was happy to acknowledge his faith in Russia and a firm faith in salvation from the east for Germany, Sweden, and Switzerland. The heart of the imminent new age would be Moscow. This messianism, in fact, was not without a millenarian, hence revolutionary, overtone. Speaking in Nietzschean terms, Kandinsky evokes the "future transvaluation of values" at the heart of art's internalization "in our day in a powerfully revolutionary form." That, combined with his attachment to Russia, explains how, through a complete misunderstanding, Kandinsky could for a time join forces with the Bolshevik powers: there is often a brief moment of union between mystical Gnosticism and ideology, which share a hatred of this world and an impatient expectation of the world to come.

On the Spiritual in Art

"Reminiscences" allows us to understand the genesis of Kandinsky's thought and personality; *On the Spiritual in Art,* in contrast, is his doctrinal charter. It was written in 1910, at the end of the intense search that led to the first "abstract" watercolor. It is rare for an artist to accompany his painted works with a theoretical book so dense and so ambitious. Kandinsky claimed that his concerns, his craft, and his style of painting depended on philosophico-religious concepts and that his paintings were a consequence and proof of them. *On the Spiritual in Art* is a manifesto, and, until the end of his life, Kandinsky, who wrote a great deal more, did not deviate from it.

In presenting this text, I believe I shall fare better if I do not follow it step by step: the themes are so entangled, the material so dense and closely argued that I would be driven to recopy or summarize it—and the result would be more muddled than the text itself. Let me simply bring out two broad motifs around which this little book can fairly easily be organized.

The first is a judgment about the contemporary world and a prophecy about the world to come. The second develops the need, in view of the new era, to detach oneself from the representation of natural forms, and it demonstrates the possibility of "abstract" art.

A. The Dawn of the "Great Spiritual"

"We are only now beginning to awaken after the long reign of materialism." That opinion corresponds to historical truth. Materialist doctrines were more brutal and grew more frenetically in Russia than anywhere else. That also explains the wild exuberance that, by way of contrast, symbolism assumed in that same country.

Imagine the spiritual life of humanity as a large triangle slowly extending forward and upward, so that "where the highest point is 'today'; the next division is 'tomorrow.'" At the extreme tip there is "only a single man."[38] The vision of that man is equaled by his infinite sadness. He is lonely so far above the others. Such a man was Moses, and such was Beethoven. Artists are located in every part of the triangle, but only the one at the tip is "the prophet of his environment," able to "see beyond the frontiers." Below him is the mob, hungry for spiritual bread to meet its needs. "This bread is given it by its artists, and tomorrow the next segment will reach for that same bread."[39] This is therefore a romantic vision of progress, for which the artist/savior is both the inspired driving force and the target of outrage. The artist would "gladly be rid of this higher gift," this

"heavy cross." He cannot be, and in spite of the hatred, he yokes himself to "the heavy cartload of struggling humanity" and pulls it forward.[40]

What can be seen in the lower part of the triangle? The materialist credo. Christians and Jews are atheists. God is dead. In politics, the people are republican and democratic. In economics, they are socialist. In science, they acknowledge only what can be measured and weighed: they are positivists. And in art? They are naturalists. The would-be artist seeks either a mere imitation of nature, which serves practical ends, or an interpretation—this is what impressionism does—or finally, *Stimmung,* states of mind disguised as natural forms.[41] The mob goes to the museum, book in hand, to try to understand, looks at these nude women, these portraits of socialites and excellencies, or a Christ on the Cross depicted by a painter who does not believe in Christ, and the mob comes out disappointed, as poor as when it entered. The mob drags itself from room to room and finds "pretty" or "sublime" canvases. This is what is called art for art's sake, and the famished souls go away, still famished. As for the artist in this moral void, he has done no more than satisfy his ambition and greed.[42]

But the spiritual triangle rises nonetheless, and near its tip new things are happening. After a phase of confusion and a phase of anguish, the higher level is attained. The anxiety has dissipated, and work is going on. Who are the residents of this new city, the new intercessors who announce the spiritual revolution? In religion, it is Mme Helena Blavatsky, at the origin of "one of the greatest spiritual movements, which today unites a large number of people and has even given material form to this spiritual union through the Theosophical Society." She believes she has established an "eternal truth" and new forms of language, and she imparts them to humanity. She predicts that, for humanity, the twenty-first century will be a paradise, compared to what it knows today. It is also Doctor Steiner, especially in his article, "The Path of Knowledge," in *Lucifer Gnosis.*[43] In literature, it is Maeterlinck, who paints "souls searching in the mist, threatened with suffocation, over whom hovers a dark invisible power." He is the prophet who announces the "decline" of our world. He knows how to restore to the word what lies beneath its external meaning: the "inner meaning," the "pure sound" that makes the soul feel a more "supersensible" emotion than the sound of a bell or a vibrating string. In music, it is Wagner, with his leitmotiv, which swathes the hero in a "spiritual ethos" (here Kandinsky is no doubt thinking of the "astral body"); Debussy, who moves beyond the note and "continues to exploit the inner value of appearances"; Mussorgsky and Scriabin, masters of inner beauty, which "is achieved by renouncing customary beauty, and is occasioned by the demands of internal necessity." That renunciation

leads us to regard "as sacred every means that serves the purpose of self-expression." And finally, there is Schoenberg, Kandinsky's friend, who makes it possible to enter a new kingdom, "where musical experiences are no longer acoustic, but purely spiritual."[44]

In painting, realism had already given way to impressionism, which remained naturalistic. But neoimpressionism "reaches out toward the abstract." Kandinsky does not invoke, as one might expect him to do, Seurat's scientism, the utopia of automatic effects of forms and colors which the Russian painter later systematically adopted in his classes at the Bauhaus.[45] Referring to Signac, however, he does very vaguely define neoimpressionism as an attempt to "represent the whole of nature in all its glory and splendor," and not just a fragment of nature chosen at random.[46]

But—and this is a point worth noting—Kandinsky does not think that the French school represents the obligatory and indispensable "avant-garde," as that school was beginning to believe, since he cites as equals three altogether symbolist schools: the Pre-Raphaelites, with Rossetti and Burne-Jones; Böcklin and Stuck; and Segantini. According to Kandinsky, Rossetti reanimates the abstract forms of quattrocentro painters. Böcklin clothed "his abstract figures . . . in strongly developed corporeal and material forms." In his meticulous reproductions of mountain chains, Segantini was able to create abstract images, despite realist appearances. These were paintings of the world beyond, which Kandinsky praised because, though they were apparently "realist," what counted was their inner content, the profound pathos behind the realist forms, which he considered abstract because what was stirred was shapeless and located deep in the soul. Conversely, the naturalism of the impressionists was forgiven because it gave rise to nonimitative forms. Hence the impressionists' false naturalism was equated with the symbolists' false realism: one offered an abstract outer form, the other an abstract inner form.

Thus came about the short-circuit I have already noted: that between French form and Central and Eastern European pathos, or, in Kandinsky's terms, between outer form and inner content. Of Cézanne he wrote: "He knows how to create a living being out of a teacup. . . . He can raise 'still-life' to a level where externally 'dead' objects come internally alive. . . . It is not a man, nor an apple, nor a tree that is represented; they are all used by Cézanne to create an object with an internal, painterly quality: a picture."[47]

And of Henri Matisse: "He paints 'pictures,' and in these 'pictures' he seeks to reproduce the 'divine.'" An astonishing claim! In 1910, Matisse was interested in icons, and he later maintained that he believed in God when he was working. But he did not express his belief, and it is very difficult to discern. It is true that

Kandinsky's notion of the "divine" is not necessarily Matisse's. As for Picasso, a cubist at the time, Kandinsky discerned in him a kind of Pythagoreanism of numbers.

But before entering into Kandinsky's specifically painterly aesthetics, let us cite the book's conclusion, which combines two themes: first, the conscious, deliberate, and even scientific character of tomorrow's art; and, second, the future new era.

> We are approaching the time when a conscious, reasoned system of composition will be possible, when the painter will be proud to be able to explain his works in constructional terms (as opposed to the Impressionists, who were proud of the fact that they were unable to explain anything). We see already before us an age of purposeful creation, and this spirit in painting stands in a direct, organic relationship to the creation of a new spiritual realm that is already beginning, for this spirit is the soul of the epoch of the great spiritual.[48]

This declaration was contemporary with Leninism, which was going to replace the blind forces of economy and history with rational, enlightened planning guided by science. It was also contemporary with Freudianism: "Where the id was, shall the ego be." On the eve of war, this meant the exertion of control in every domain, a control assured by a still secret, still disputed doctrine, but a doctrine sure of itself, guaranteed by a superior knowledge of which only a few were in possession.

B. Internal Necessity and Abstract Art

It was a given that "art is above nature" because it is the fruit of the artist's mind, "a breath of fruitful divinity." Goethe said so and Oscar Wilde confirmed it. Art "must serve the development and refinement of the human soul," and thereby it moves higher in the spiritual triangle. In art, the soul finds the "daily bread" it needs, and in the only form it can assimilate.[49] The artist's mission is thus supreme. He must nurture his talent. His acts and thoughts form the very spiritual atmosphere they transfigure or corrupt. "He is a 'king' as Sar Peladan calls him, not only in the sense that he has great power, but also in that he has great responsibilities." He is also a *priest*—and, if one includes his clairvoyance and vocation, a *prophet*. Hence, although Kandinsky does not emphasize this, he bears the three titles of Christ. Like him, he brings salvation.[50]

It is within the artist's heart that the miraculous alchemy occurs, and he must then transcribe it and transport it outside. He must obey his vocation, for that is his first duty. Kandinsky calls this "internal necessity." The notion recurs in the book with the frequency of a leitmotiv, like the leitmotiv in Wagner's music,

which surrounds the hero with a spiritual ethos. "The artist is the hand that purposefully sets the human soul vibrating by pressing this or that key [= form]. Thus it is clear that the harmony of forms can only be based upon the purposeful touching of the human soul. This is the principle we have called the principle of 'internal necessity.' "[51]

This internal necessity is made up of three mystical necessities: "1) every artist, as creator, must express what is peculiar to himself . . . 2) every artist . . . must express what is peculiar to his own time . . . 3) every artist, as servant of art, must express what is peculiar to art in general," namely, the element of pure eternal art, which can be found always and everywhere, among all peoples, and which is beyond the laws of time and space.[52] "The effect of internal necessity, and thus the development of art, is the advancing expression of the external-objective in terms of the temporal-subjective."[53] Think of Plato (Forms) and Hegel (the objectification of the absolute). Lastly, and by way of conclusion, is the famous saying, so often quoted: "Whatever arises from internal, spiritual necessity is beautiful. The beautiful is that which is inwardly beautiful."[54]

There is nothing earth-shattering about these declarations in themselves, taken literally. They may and do mean that the artist must remain faithful to his inspiration, to his own genius, that he must be completely true to his internal impulses and give little consideration to the social dictates, fashions, or prejudices of his time. Tolstoy preached the same ethic to young writers. It is the ethic of romanticism. Kandinsky goes a step further when he deduces from that ethic that the artist must free himself from the rules: the artist can use any form whatever to express himself. Here again, this might sound like one of those antiacademic declarations that were rife in the nineteenth century. But the crucial point is the relation to nature. It is here that subjectivism becomes more radical. Everything turns on the relation to nature.

Kandinsky thinks that natural things act through forms and colors, and that forms and colors—and this is the fundamental decision—act independently of natural things, which are the accidental and phenomenal signs of these natural things. That discovery marks what he calls the "spiritual turning-point" that, according to him, unfolds within time. "In all we have discussed above lie hidden the seeds of the struggle toward the nonnaturalistic, the abstract, toward inner nature."[55] In that sense, painting converges with music at a moment when all the arts converge. Forms and colors, as substantial forms (like angels, or souls detached from the body), act in the same manner as notes and melodies, that is, they act directly on the soul. Music, which has the advantage of unfolding in time, is matched by painting, which "can in an instant present the spectator with the entire content of the work."

The eye senses color. "At a higher level of development, however, there arises from this elementary impression a more profound effect, which occasions a deep emotional response." Color causes a "spiritual vibration" in the soul—red, for example, produces a vibration similar to that of a flame. Color has a "taste," a "scent," a "resonance." It also acts on the body and its ailments, as chromotherapy. The same is true of forms: the triangle, the circle, the broken or straight line. "Therefore, every form has an inner content."[56]

The Bauhaus teachings, recorded in the collection *Point and Line to Plane,* consist of a meticulous analysis of the autonomous action of forms on the soul, of the intrinsic value of angles, points, surfaces, of their capacity to relate to one another, of the changes that color brings to them and that they bring to color.

The work of composition consists of combining forms and colors until they bow to a "single overall form." The task of the artist is to arrive at the "overall form of the composition," a formal composition "because its own inner sound . . . necessarily requires it." This is a labor of abstraction: "In this way, the abstract element in art gradually has come increasingly to the fore, [the same element] which only yesterday concealed itself shyly, hardly visible behind purely materialistic strivings."[57] This is the final apotheosis of the abstract. In keeping with the principle of internal necessity, and to bring the composition into fuller agreement with its formal coherence on one hand and with the fundamental inner sound on the other, the artist can change the object, replace it with a more concordant object. The artist observes that nature changes endlessly, that it plays the strings of the soul, often in a confused and incoherent manner. Then he intervenes and, supremely free, he shuts out its influence. Taking the place of nature, he organizes and fashions color, form, and the object itself—that is, the very composition of the picture. He completely renounces representation and even the use of the forms and colors that nature offers him, keeping only the abstract element itself—spare, pure, and naked.[58] To deprive himself of whatever means are necessary to cause the "vibration" would amount to impoverishing the means of expression. It is a question of courage: art liberates itself and, once the step has been taken, an infinite series of artistic creations opens.[59]

"The artist may utilize every form as a means of expression." "The path upon which we find ourselves today, and which is the greatest good fortune of our times, leads us to rid ourselves of the eternal, to replace this basis by another diametrically opposed to it: the basis of internal necessity."[60] In a sort of Fichtean effort, the artist's ego applies itself to absorbing the heterogeneous element that natural forms offer, by building a universe to fit its own structure. For Kandinsky (but did he actually read Fichte?), there is no other reality than that of the spirit or will, capable of positing themselves, of producing themselves, and, as a

result, of creating. Through the indefinite progress of the ego, and of the spiritual triangle it has in tow, one thus reaches the reign of the spirit.

Kandinsky feels a sense of liberation in no longer bowing to the yoke of nature, in becoming master of the forms drawn from his own inner self. But these forms, these colors, nonetheless have constraining laws. Since they are more easily circumscribable than natural objects, they can enter into calculable and effectual operations. Colors provide two major oppositions, hot/cold and light/dark, which can be combined in various ways.

Yellow, blue, green, and the other colors all have their own properties. For Kandinsky, this might mark a return of "the science of art" as the tradition had survived since the quattrocento, and which had been revived in the nineteenth century. Seurat, relying on the optical studies of Rood, Helmholtz, Chevreul, and Charles Henry, thought that it would be possible to extract a sure science of painting from the exact sciences.[61] But instead of basing his science on physiology, or on the full gamut of human passions, Kandinsky grounds his treatise in a cosmosophy with a strong whiff of esotericism. Yellow is earthly. Blue is heavenly. White is absence, absolute silence. Black is a "nothingness." In Kandinsky's writings, the chromatic circle the neoimpressionists used becomes a figure imbued with magic. "The six colors that constitute the three great pairs of opposites confront us like a great circle, like a snake biting its own tail (the symbol of infinity and eternity)."[62] The diagram illustrating this thesis has the look of the tree of the Sefiroth. That is because the powers of the soul are in harmony with the invisible cosmic powers, which can be expressed only in abstract terms, and which natural forms screen.

According to Kandinsky, it is too early to move immediately and definitively to abstract art. The time is not ripe. The theory is not yet complete that would be the creation of "set procedures of pictorial harmonization," a basso continuo of painting.[63] Emancipation has hardly begun. If we break all ties with nature, we might fall into pure ornamentalism, a point not much higher, at first glance, than a necktie or carpet design. For some time yet, we must still draw our forms from nature—but in complete freedom. We are assured, however, that little time separates us from pure composition.[64]

A reflection on language can help familiarize us with the move toward the abstract: the distinction between the sound produced by the body and the meaning produced by the mind. Abstract art is the communication of meanings, and it considers the physical means secondary, accessory, and fortuitous.[65]

Before we become directly sensitive to the "pure effects of color," we must go through an apprenticeship and borrow one natural element or another, provided that in no case does it "produce any external or externally associated nar-

rative effect." Here, from within a completely different philosophy, Kandinsky intersects with what all contemporary painting, with French painting in the lead, was asserting at the time: that the content of the painting does not lie in the subject matter. Maurice Denis, whose famous words asserted that the "quality" of a painting could not be reduced to the subject, would never have said that the content of the painting is "the hidden type that emerges unnoticed from the picture and thus is less suited to the eye than to the soul."[66] Nor, especially, would he have subscribed to this Pythagorean assertion: "In every art, number remains the ultimate form of abstract expression." To follow that line, Kandinsky's iconoclasty, which tolerates art provided there is no image, would embrace the extreme point where even abstract painting would lose its reason for existence.

C. Michel Henry's Interpretation

On Kandinsky, as throughout this book, I have, as far as possible, avoided any judgment of taste. My aim is not to evaluate the painters but to examine their relation to the divine image. All the same, the fanaticism of Kandinsky, who was convinced he had opened the *via regia* to painting and to art in general (since he also has ideas about ballet, music, and architecture, and he dreams of a total art—or, as he says, a "monumental" art), obliges me to compare the theory to its results, which I can do only through a judgment of taste.

In the important exhibition of German expressionism dating from 1905 to 1914 (the glory years), held in Paris in autumn 1992, Kandinsky was abundantly represented and found himself in the company of his peers. For the canvases not yet given over to abstraction, there is no reason for the criteria of judgment to be any different than those applied to Macke, Marc, Heckel, and Kirchner. Kandinsky does not stand above the crowd. When he shifts to abstract art, do we recognize that jubilant liberation, the arrival in the promised land Kandinsky sensed? No. Perhaps, in this case, new keys must be used. The work of art then belongs to the set of those things that cannot be understood unless one has already accepted them, as is the case for Marxism-Leninism or Freudianism. Unless one is a believer, one cannot accept the pertinence of comments such as the following, which applies to the painting *Red Blot II* (1921). I cite only excerpts:

> A hook, composed of several sections in contrasting colors, circles the blot and intersects its upper portion. From the opposite direction, two sharp horns advance from below. These are traversed by different curved and lanceolated forms. A forced circle seems to be flattened under the larger, orange-colored horn. The new formal element represented by the circle is present for the first

time in this painting, with diverse variants. . . . In Kandinsky's view, the circle represents an important new sign in his basic analytical vocabulary. Moreover, the different sizes and positions of the circles create an indefinable spatial structure, perhaps a symbol of the enigmatic "fourth dimension," of the interpenetration of space and time that numerous modern artists—cubists and futurists—sought to express in their works.[67]

This commentary, which is precise and pertinent within the framework of "Kandinskyism" as doctrine, does not fall under the category of art criticism. Rather, it is an initiation into a system, or the exact description of the painter's intentions. In that case, it is a sort of iconology revealing hidden meanings, what Panofsky did for Dürer.

That is not the case, however, for Michel Henry's interpretation. Henry is a philosopher, and he devoted a forceful book to Kandinsky, in which he gives the painter a supereminent place in the history of twentieth-century art and spirituality. Let us quote the opening words: "Kandinsky is the inventor of abstract painting, which was to turn traditional conceptions of aesthetic representation on their heads, and defined a new era in this domain: the era of modernity. In that respect, he appears to be, in Tinguely's words, the 'Opener,' the 'Super-pioneer.' "[68]

All the great names that seem to define modern art, all the movements (impressionism, cubism, Cézanne, Picasso), and even the nonfigurative artists (Mondrian, Malevich, even Klee with his magical signs), "in fact carried out their work within the pictorial tradition of the West, outside the field opened by Kandinsky's radically innovative presuppositions." This enthusiastic tone is sustained throughout the book.

Henry radicalizes Kandinsky. He accepts as given that the pictorial revolution Kandinsky planned was a success; that it definitively made obsolete everything wrongly considered art, and that the space it cleared was vast; that it requires one to look anew at past artworks, using the principles of abstract art; that this revolution was necessary, because it was called forth by the crises of the nineteenth and twentieth centuries; and that it was sufficient, because art can henceforth flourish in complete freedom and productivity on the ground it liberated, and only on that ground. "In spite of its revolutionary character, abstract painting leads us back to the source of all painting—what is more, it alone allows us to understand the possibility of painting, because it is the unveiling of that possibility."[69]

Art is asked to provide "a true 'metaphysical' knowledge capable of moving beyond the external appearance of phenomena to deliver the intimate essence to us." That requirement, if I may say so, is classically romantic. But Michel

Henry's thesis is that this metaphysical knowledge comes about through the "internal" in Kandinsky's sense of the term, that it proceeds to break from the representation of external things, from the representation of the visible, in favor of a painting of the invisible. Even more radically, the pictorial means set in place in that representation of internal invisibility—colors, forms, lines, and so on—must be understood, through a dual abstraction, "as 'internal' in their significance and finally in their true reality—as 'invisible.'"[70]

In fact, according to Henry, Kandinsky was not satisfied to extract from natural sensible reality the "abstract" schemata of a geometrical construction or reconstruction of the world, as the most "abstract" cubists did. These cubists were still imprisoned within the project of figuration. They made reference to the external. They were the heirs of Galileo and Descartes, who reduced things to extension and its mathematical expression. What does Kandinsky represent, then? He represents life: "This 'abstract content' is the invisible life in its tireless coming into itself." He adds: "The starting point for painting, Kandinsky has just shown us, is an emotion, a more intense mode of life. The content of art is that emotion. . . . The knowledge of art develops entirely within life, it is the very movement of life, its tendency to grow and experience itself more intensely."[71]

Michel Henry discovers his own philosophy in Kandinsky, his mirror image in painting, the aesthetic proof of his most profoundly personal notions. That is why he takes him at face value and weighs his most insignificant words with the greatest seriousness, since they are the prefiguration of his own. He comments —as I shall not do—on the Bauhaus courses and Kandinsky's long considerations on the value of the point, the power of angles, of broken lines and curves, of the circle, the psychedelic properties of colors. In fact, the entire Kandinsky system, further developed by Michel Henry, rests on the intrinsic capacity of these "picturemes" and their combination to act on the "internal" world and its emotions. That deep communion with Kandinsky has impelled Henry to isolate him as a hapax, a unique case, in the history of art, and particularly of modern art. It seems to me, however, that if Kandinsky, in being situated among his fellows, loses something of his legendary stature, he actually gains something of his true worth: the spiritualist and antinaturalist impulse inaugurated by symbolism. The pathos of Aurier, whom Henry does not cite, was the same as that of *On the Spiritual in Art,* but it came twenty years earlier.

Henry grants little place either to the vast theosophic nebula in which Kandinsky is awash or to most of the contemporary artists he admired and cited as examples. By this, I do not mean his modern aesthetic sources, Worringer, for example, who made equivalent declarations: "To enjoy aesthetically means to enjoy myself in a sensuous object diverse from myself, to empathise myself into

it"; "The crucial factor is, therefore, rather the sensation itself, i.e. the inner motion, the inner life, the inner self-activation"; "Aesthetic enjoyment is an objectified self-enjoyment."[72] It is true that Worringer does not deduce the need for abstraction from that subjective interiority, and there is nothing to demonstrate that Kandinsky studied him. According to Dora Vallier, Kandinsky referred rather to one of Worringer's sources, the aesthetician Lipp. Lipp developed a system based on the omnipotence of psychological interiority; held naturalism in contempt; and distinguished representation of the external world from representation of the internal world, all themes that are also Kandinskyan motifs.[73]

Kandinsky's specifically artistic studies also had parallels. His friend Franz Marc had his own mystical theory of colors—which did not coincide with Kandinsky's, but which was in the same spirit: "Blue is the masculine, harsh, and spiritual principle. Yellow is the feminine, gentle, joyous, sensual principle."[74]

In contrast, Michel Henry analyzes perfectly well Schopenhauer's influence. He shows that his theory of music plays a decisive role in the genesis of the concept of abstraction. Music is immaterial. It is indifferent to the external world of ordinary perception. It is an immediate metaphysical knowledge of the nocturnal Will and needs no objectification or mediation from visible appearances. It thus places us in contact with the noumenal heart of the world, with life—life in a very dark light, but which can take a different direction, since Nietzsche (and, in his footsteps, Michel Henry) encourages optimism and confidently turns toward the will to live. In any case, Michel Henry remarks, "Does it not suffice to extend that perfect indifference of music 'in relation to the whole material side of events,' all facts both natural and social, to painting, to find oneself in the presence of the definition of abstract painting?" Of course, there are other Schopenhauerian aspects to Kandinsky: in the first place, the privilege given to the artist who has both intellectual and emotional knowledge, a privilege confirmed in both the romantic tradition and in esoteric literature.

Nonetheless, Michel Henry accentuates the revolutionary character of the shift to abstraction, of which Kandinsky was well aware. In fact, he gives this shift a sense of urgency and necessity because—according to Henry even more than to Kandinsky—when that revolution occurs, art is dead. Kandinsky, he writes, reflects nineteenth-century "materialism," which must be understood as the attempt to base the art on an "external" foundation, on the material world: "The massive failure of that attempt—apparent in realism, naturalism, academicism, and pompierism, but also in impressionism, cubism, and so on—implies . . . as a principle of aesthetic creation, the substitution of the invisible world for the material universe." Art, he adds, "has, since the eighteenth century

and the disappearance of religious feeling, rarely produced anything but weak works."[75] In fact, in Christian art, "what is represented is no longer even the world, it is explicitly, deliberately, tirelessly, life—invisible life."[76] Let us note that this is Hegel's judgment on the death of art, which Michel Henry has adopted as self-evident. But he is more absolute than Kandinsky in his condemnation of nineteenth-century art, to which Kandinsky owed everything, as he himself knew. He even blocks the narrow skylight through which Hegel claimed modern art could pass: blissful contemplation, in a religious sense, of real things within free society. That is why, in the field of art, according to Michel Henry's interpretation, it is Kandinsky or nothing at all.

But this field extends well beyond art, since the salvation of humanity is at stake. "Because art brings about the revelation of invisible reality in us, and with absolute certainty, it constitutes salvation and, in a society like our own, which disregards life . . . it is the only salvation possible."[77]

At this point, Henry takes Kandinsky's abstraction to the extreme. Abstraction, therefore, "would express" life. Having dismissed the world of things, abstract painting, like music, would simulate "the only world that truly matters, the invisible world of desire."[78] But, in that case, only the referent has changed: it is internal rather than external. Abstract art, like any other art, would be the expression of a reality apart from itself, hence once more a means. But such is not the case. Kandinsky's art is no more a useless and superfluous mimesis of life than it is an (equally useless) mimesis of nature. Life is simply present in what we feel on viewing the painting: the lines and colors evoke a pathos, which is life being realized within us, growing and developing as we move into the painting, and which the painting augments, intensifying the life within us, returning our vision to us and increasing our strength. Henry concludes that, as we stand before the biomorphic forms of the late Kandinskys, "the forces of the cosmos arise in us, they lead us outside time in the dance of their jubilation, and do not let us go. . . . Art is the resurrection of eternal life."[79]

We have already encountered that ecstasy, since that is what it is. It palpitates in Plotinus and in his vast posterity. Art produces a movement of the soul, a *reditus*, which makes it flee the external world and seek refuge within itself, pass through the invisible and transcendent structures of the world, and finally reach the mystical point where it experiences itself as one with the One and with eternity. Kandinsky's art is the medium for that spiritual experience, where everything is finally abandoned to the invisible, including, if I am not mistaken, Kandinsky's paintings themselves. Since there are states that transcend word and thought, and make the mystic forget even the spiritual treatise that guided him to his elevation, it is possible to conceive of a pictorial ineffability that

would be the endpoint of abstraction, and which, through it, would come to rest in the same region of the soul, where the painting—its forms and colors— is engulfed in spiritual darkness.

Hubris and Impotence

Let us come back to earth. What are we to think of the path blazed by Kandinsky and taken by so many others? Michel Henry's analysis, it seems to me, corresponds to the painter's intention, at least the principal orientation of his efforts. He should not be reproached for intensifying, extending, and systematizing it, for offering a somewhat hyperbolic version of it. It is the role of a philosopher to systematize and also to show enthusiasm when he finds a partner in philosophy.

Let us grant Kandinsky his spiritual imperative. Let us admit with him that art procures access to the spiritual world, that this world contains a surplus of truth, reality, and beauty, when compared to the phenomenal surface of things. That, it seems, has always been perceived, more or less confusedly, as long as there have been artists and men capable of reflecting and speaking about art. But what need is there to deduce from that imperative that things, nature, and their representation must therefore be given leave? All the ambitions of abstract painting, however high Michel Henry places them, have always been fulfilled, as much as they could be, by figurative painting. "All painting is abstract," Michel Henry asserts. That means that all painting worthy of the name is *capax Dei,* as one of Kandinsky's compositions claims to be.

Everything Michel Henry requires of painting has already been provided by it an infinite number of times. Mystical rapture, which, according to him, was made possible only by a foray outside external reality (a rapture that, by the way, is not necessary for apprehending the work of art, but which often occurs, and no doubt already occurred well before romanticism), has taken hold of popes, kings, and jealous collectors as they stood before a Correggio, a Raphael, or a Claude. That rapture, which was, of course, favored by the order of forms and the relation between colors—or rather, was permitted by them—was then attributed to the beauty of the thing represented, a woman, a landscape, the Virgin holding the Child, a reality at once represented, imitated, unveiled, and invented by the artist. In the beholder's amazed eyes, every image became an *invention* and a *transfiguration,* like the images that had taken the Invention of the Cross or the Transfiguration of Christ as their subject. Every image, even the must humble still life, a colocynth by Zurbarán, a basket of strawberries by Chardin, a corner of the suburbs by Monet, provided that it is a creation, par-

ticipates by rights in the divine, or, if one prefers, in Being. Even so, one has to avoid targeting Being directly, has to convert to the wisdom of mediation: external things and the rules of the craft. Thus it is fitting to reverse Henry's statement: every painting is concrete.[80]

Is Kandinsky "abstract"? He displays rectangles of canvas covered with colors and lines in a certain ordered arrangement. These things are not arranged in such a way as to refer to natural objects. The painting declares its artificiality: it is the artist who extracts colors and forms from nature and produces another world parallel to and different from the ordinary world, merely corresponding to the reflective impulse of "internal necessity." He does not paint his fantasies or the oneiric figures dear to the surrealists. He constructs a work of art by taking as his guide not merely "internal necessity" but quite simply *fitness,* of which his eyes inform him, as his canvas slowly comes to coincide with his plan by means of all sorts of *pentimenti* and corrections, by means of labor. He displays something visible.

But does he display the invisible, as Michel Henry claims? At the risk of shocking people, I will say: alas, no! So long as he was in contact with things, Kandinsky did not distinguish himself from his contemporaries, who were as gifted as he, or even more gifted. He experienced the break with the "external" and the "material" as the removal of obstacles. Everything became easy, painting was done in an enthusiastic state, the artist/demiurge freely created his world. From that moment on, it is no longer possible to compare him to anyone. He goes it all alone. He thinks he is producing the spectacle of what lies beyond things, a Gnostic deployment of the ultimate structures.

What if this were an illusion? What if the ease with which the secrets of the world were henceforth deciphered were the equivalent, in painting, of the great contemporary systems that explain it all, Marxism and Freudianism? What these systems have in common is that, once the ultimate laws that govern reality have been extracted from it, you are condemned to see reality only as these laws, or rather, to see only what corresponds to the reading grid within which reality is confined. You no longer perceive anything of reality but the schema injected into it by thought, and which reflects that thought as in a mirror, without taking into account the fact that, instead of reality, it accedes only to its own reflection. But that thought, which is no longer measured against reality, which has broken every instrument of measure, spins, like a free wheel, at a marvelous speed. The core of the system that finally gives access to the totality, the reward for a long preliminary effort, is experienced by its author as a "eureka," from which the operations of thought and the definitive decipherment of the world follow automatically. They follow effortlessly because reality offers no resis-

tance, no friction. It is this divine gift for effortlessly thinking and doing that confirms the illusion and makes it permanent.

Kandinsky no longer does battle with reality in order to introduce it into his painting. He does battle with himself to arrive at a good painting. But since he makes his own rules, the battle is easier (he recognizes this and attributes this ease to his decisive "eureka"), because there is no longer anything standing there in its opacity, obstinately concealing its secret and mystery. The mystery is known in advance and revealed by initiatory knowledge, and it transcends things to describe them more conveniently. But a painting cannot be deduced from a doctrine. Kandinsky's art is in no way comparable to "socialist realism," which seeks to make people believe, by the most figurative means, that external reality has obeyed the canons that Marxism-Leninism predicted for it, and which it claims are "realized." But, by these nonfigurative means, he imposes the belief that internal reality is "realized" on the canvas.

All the same, internal reality does not lend itself to judgments of taste. Such judgments presuppose that anyone who, standing in front of one of Kandinsky's canvases, freely experiences a pleasure, must regard it "as grounded on what he can presuppose in every other person. Consequently he must believe that he has reason for attributing a similar satisfaction to everyone."[81] That is because abstract painting, which has no direct relation to the world shared by men, refers only to the artist. The artist creates his manner and his style, of which idiosyncrasy is the primary, and even the only, characteristic. In front of such a canvas, commentary is difficult. "The judgment of taste," writes Kant, "requires the agreement of everyone, and he who describes anything as beautiful claims that everyone *ought* to give his approval to the object in question and also describe it as beautiful."[82]

But to form his judgment, the critic had only one reference point: nature, his daily experience of external things, of human faces, of bodies, of dramatic, sensual, comic scenes, of prayers, of celebrations. He could assess the artist's talent by comparing the kind of emotion these spectacles give him to the spectacle of the painting. He had at his disposal a triangulation: himself, his memory, and the canvas. Henceforth he stands face to face with the artist alone. If he embraces the artist's system, he can perceive an emotion. I have no reason to doubt Michel Henry's sincerity when he declares he is overwhelmed by one of Kandinsky's *Compositions* or *Improvisations*. But the only way he has to convince me is to explain the painter's project and intentions. As for the painting itself, which is "conceptless," it cannot be commented upon, as demonstrated by the greater part of contemporary criticism, which does no more than exclaim: "I like it!" or "I don't like it!"—an exclamation subject to a great number of variations. In

that way, a contact occurs between the beholder and the painter: the painter has shown his artist's soul through the painting; and the beholder, in looking at it, reveals his oneness with the artistic side of his soul. As Schopenhauer wished, the beholder becomes ingenious by induction or temporary proxy.

In reality, the beholder is not confined within the face-to-face relation, since he nonetheless possesses a point of comparison: other painters. This has always been an essential factor in the formation of judgments of taste. But how can one abstract painter be compared to another, since they are not joined in a shared struggle with external things? Rather, they battle among themselves to distinguish themselves from one another. This competition must not be conceived as resulting from snobbery or vanity: it is truly the uniqueness of their artistic souls that they must put forward, since it is that uniqueness that gives them their value. Among those who look at Jasper Jones, Twombly, or Soulages, as among those who looked at Kandinsky, there can be only affinities, or an indifference that easily turns to aversion, since it is mixed with disappointment: "I like it a great deal," "I don't like it at all."

But does the abstract painter truly show his artist's soul? In that case, he would in fact be showing something invisible—as all painters have shown, but by making use of things. But no, he does not do so, because his system of signs is readable only for those who have previously adopted it, and not for anyone else. At the end of his "Cologne Lecture" (1914), which brings together the familiar themes in a breathless and cryptic form, Kandinsky makes a sort of declaration of "negative painting" (as one speaks of "negative theology"). He declares: "I shall embark upon the negative path." "I do not want to paint music. I do not want to paint states of mind. I do not want to paint coloristically or uncoloristically." Yet that was precisely his ambition, proffered a thousand times. Why that denial, if not because he senses the difficulty of the path he has chosen, and which remains, deep within himself, a painter's normal ambition? "I only want to paint good, necessary, living pictures, which are experienced properly by at least a few viewers."[83]

In fact, he may have achieved that normal ambition at the end of his life, and through the usual means. In Paris in his "biomorphic" period, when he created graceful forms in refined colors *on the basis of* images drawn from nature (microscopic, unicellular creatures, to be sure) he seems to have abandoned the "apophatic" aesthetic which, in the Munich climate, was a way of taking the aesthetics of the sublime to its extreme, of undertaking a vast and age-old task. It was a way of putting the finishing touches on a tower of Babel whose initial foundations had been laid a hundred years before by the great German philosophers, a tower whose top is lost in the clouds; and, finally, a way of retreating

back toward the earth, toward the beautiful. There, Kandinsky participated in a game with living forms, a free game of the faculties of representation, and, with "this separation from every constraint of rule" (especially his own rules, systematized in the Bauhaus), "we have the case where taste can display its greatest perfection in the enterprises of the imagination."[84]

Kandinsky's iconoclasm is remotely related to classical and medieval iconoclasm; it is closer to modern iconoclasm, but that relation needs to be made explicit. It lies in the artist's general attitude toward his work. It is marked by gravity and seriousness. What he criticizes in nineteenth-century painting, whether realist or naturalist, is, in the first place, its futility. Painting this world is not worth an hour's trouble. Nothing but the absolute is worth representing.

This appears to be the opposite of iconoclasm, since the latter renounced depicting the divine because it considered such depictions an attack on the majesty of the divine; but it accepted the representation of things as honest recreation and even, indirectly (in Calvin, for example), as praise of the Creator via the honor shown his creatures and via human labor. By means of abstraction—which is itself a means of detaching oneself from appearance and moving toward essence—Kandinsky claims to render the intimate structure of the world. He assumes that in delving deep into his ego, guided by "internal necessity," he truly reaches the fundamental rhythms, the very pulse of the cosmos, with which his ego is mystically in sync. In that sense, Kandinsky is a perfect iconodule, an iconographer in the most rigorous sense. But that very rigor prevents him from resorting to a "circumscribed" figure. He resorts neither to the canonical figures of the Word incarnate nor to the divine Presence that remains in created things, which the artist is capable of seizing or rendering provided he "circumscribes" them in a certain way. That divine Presence is only in the artist's soul, and it is the artist who gnostically transmits secrets to the uninitiated part of humanity, which it may or may not be capable of understanding. The redemptive work is not assured by the divinity, to whom the artist's work expresses thanks, praise, and honor, but only by the artist himself, who is called upon to pull on the "spiritual triangle" of humanity, at whose tip he stands in superb and perilous isolation. It is at this limit that iconodulia exhausts itself and is lost.

Kandinsky no longer represents things—whose divine content he has forgotten—because he wants to represent only God himself. As we have seen, that is what happened after the iconoclastic crisis, when profane art vanished because, though it was now legitimate to represent God, it was no longer worth the trouble to represent anything else. But, since Kandinsky does not seek support from the canonical *perigraptos* of the Person, unless we embrace his system, the visible

representation of the invisible divine, as it might be received by the common mortal, is also lacking. There are neither things nor God, only an arbitrarily arranged assemblage of lines and colors, perhaps, remaining on the canvas. We read in Balzac that, on Frenhofer's canvas, after ten years of relentless work, the only thing that remained decipherable was a woman's foot, which miraculously escaped the shipwreck of the image: "The naked fragment of a foot that emerged from this chaos of colors, of hues, of indistinct nuances, a kind of formless fog; but a delicious foot, a living foot!" (Balzac, *The Unknown Masterpiece*).

But since there is not the slightest fragment of a living foot in any abstract painting to serve as a reference point, there is also no principle of discernment allowing us to judge with certainty and "universally" if we ought to "like" it or not, since we do not know if we are standing before the All or before the nothing at all.

3. THE SUPREME: MALEVICH

Is it really necessary to repeat what has just been said about Kandinsky, but this time regarding Malevich? Like him, Malevich found the path toward abstraction by virtue of an "internal necessity," of which he was able to give an account in vast theoretical and justificatory writings. Both men formed a supremely lofty idea of painterly activity, as a path toward the absolute and a means of starting the universe over again. Malevich, much more overtly than Kandinsky, returned to figuration—under very different circumstances, to be sure. Finally, both painters have, in recent years, reached the summit of the pantheon of arts. They have occupied a central place in aesthetic thought for more than a generation, and they occupy it together and almost by themselves. Mondrian, Klee, and very few others have the honor of sometimes standing beside them.

From another angle, the two artists are completely different. Kandinsky had a professor's demeanor, a polished, proper, distinguished, and cool appearance. He came from the old intelligentsia. Most of his life as a painter he spent abroad. He possessed a multilingual education that drew from the common store of European romanticism and symbolism. He was conservative in politics and in religion. In stark contrast stands Malevich's uncouth, pockmarked face; his obscure, semiforeign provincial childhood; his self-taught ways; his reclusiveness in Russia, except for a brief journey late in life; his deep involvement in the Bolshevik revolution; his distance from established religion; and so on. The only point the two shared was the attraction to theosophical or esotericist doctrines, though not exactly the same ones.

Toward Suprematism

Malevich, as his first name, Kazimir, indicates, was a Pole, born in Kiev in 1878.[85] His father, Seweryn, was a Polish and Catholic patriot; his mother, Ludwiga, was better educated than some have claimed. His great-uncle, a Catholic priest in Kiev, had been hanged as an example during the Polish uprising of 1863. His family wanted Kazimir to become a priest. He preferred painting, which he took up with the seriousness of a religious vocation. His father worked in the sugar industry and was therefore in contact with the peasant and industrial world of Ukraine. The variegated gaiety of the Ukrainian countryside is present in Malevich's work. He learned to paint as an amateur and did not enter a professional studio until about 1905, by which time he was living in Moscow. He had talent but not yet his own style. He oscillated between impressionism, art nouveau, and symbolism, and produced canvases in each register that had nothing in common with one another except a fine artistic temperament.

I can only advance an opinion, which would have to be supported by argument with his works in front of us: Malevich has the stuff of a great painter and is undoubtedly superior to Kandinsky. He was a great painter before his abstract period, and he was again, and even more so, once he returned to figuration. To judge the intermediate period, criteria other than the usual ones are required.

In Moscow, Malevich married a second time and entered into that churning atmosphere, still dominated by the Larionov couple and the Burliuks. Like everyone else, he discovered icons, popular art, and neoprimitivism. Within four years, between 1911 and 1915 (the year of his leap to the nonfigurative), he did many experiments and, as the age required, classified them into "isms," namely, in succession (or simultaneously, since there was some overlap), neoprimitivism, Cézannism, cubo-futurism, transmental realism, analytic cubism, and alogism. In 1913, Malevich produced the sets for a futurist opera (*Victory on the Sun,* with Matiuchin, Khlebnikov, and Khruchenykh), which historians have seen as the first signs of the eclipse of objects and the presence of the "quadrangle." With *Black Square* in late 1915, he took the great leap, giving it a meaning different from that given it around the same time by Mondrian and Kandinsky in their own farewells to figuration. Between *Black Square* and *White on White* (1917) stands the paroxysm of the suprematist adventure.

After the revolution, he abandoned painting for a fairly long time, in favor of writing and teaching. He joined the leftist artists' group and was elected to the soviet. In 1919, he taught in Vitebsk, at the school directed by the mild Chagall, who did not hold out very long in the face of Malevich's artistico-revolutionary brutality. A "shock" avant-gardiste, he created the Unovis (Affirmation of the

new)—and named his first daughter Una. He held office. He was director of the Museum for Artistic Education in Petrograd, which he transformed into the National Institute for Artistic Education (Ginkhuk), and which included five sections: Formal Theory, which he headed, Organic Culture (Matiushin), Material Culture (Tatlin), Experimental (Mansurov), and Methodology (Filonov). But in 1926 he was removed and the Ginkhuk liquidated: the era of socialist realism was beginning.

In 1927, Malevich went abroad for the first time, with a stop in Warsaw, another in Berlin, and finally one in Dessau, where the Bauhaus was meeting. He left part of his work there, as one might cast a bottle into the sea. After returning to the USSR, he was marginalized, arrested, released, but from time to time found a new *komandirovka* (for example, the reorganization of the Red Theater and the directorship of the experimental lab of the Russian Museum). He returned to painting in earnest and exhibited within the framework of the Union of Artists, that is, the organization that now brought all the movements together under the sole tutelage of the Party. These paintings, which are not at all abstract and which are very beautiful, were exhibited in official demonstrations next to socialist realist daubs. After his death, they were no longer shown. It was not until 1962 that the world became aware of this part of his work. Camilla Gray, though very well informed, knew nothing of it. Afflicted with cancer, Malevich died in 1935. Before being cremated, his body was placed in a coffin painted in a suprematist style. A monument was erected to him in a Moscow cemetery, a white cube with a black square (this monument was later destroyed). Malevich died with the conviction that his work, abandoned in Berlin or confiscated in the USSR, was entirely destroyed.

It is not my purpose to explain Malevich or to make a well-supported judgment of his work. This has been attempted by several authors (Marcadé, Martineau, Nakov), and the literature grows richer every day. I shall focus on the suprematist episode, attempting to discern what, from *Black Square* to *White on White,* can be linked to iconoclasm as a religious attitude.

Malevich truly entered the Russian avant-garde beginning in 1910. He was then part of the modernist group the Knave of Diamonds, which gravitated around Larionov. Following his example, Malevich was inspired by primitivism, peasant folklore, and the popular image: harvest time, woodcutters, peasant processions. Through the Shchukin collection, he was well aware of what was being done in Paris. He was a fauve, an expressionist; he passionately admired Cézanne and Matisse. In 1912—he had already taken his distance from Larionov—he turned toward geometrization, the decomposition of planes, which linked him to Parisian cubism and, more precisely, to Léger's "contrasting

forms." In 1912, Léger had held an exhibit at the Knave of Diamonds, and he maintained good relations with the Russian colony in Paris, but there is little evidence that Malevich was under its influence at the time. Alfred Barr believes rather that the 1912 *Woman with Pails* was clearly more advanced than Léger's works and stood in the same evolutionary line.[86]

Another spiritual and painterly current made its way into Malevich's painting at that same time: Italian futurism. The futurist climate had overtaken Russia with the very speed futurism glorified, and it reigned in Moscow by 1911. Marinetti wrote in 1909:

> Courage, audacity, and revolt will be essential elements of our poetry. . . . We intend to exalt aggressive action, a feverish insomnia. . . . We say that the world's magnificence has been enriched by a new beauty: the beauty of speed. . . . A roaring car that seems to ride on grapeshot . . . is more beautiful than the *Victory of Samothrace*. . . . We want to hymn the man at the wheel. . . . We will destroy the museums, libraries. . . . We will sing of great crowds excited by work, by pleasure, and by riot; we will sing of multicolored polyphonic tides of revolution in the modern capitals, we will sing of the vibrant nightly fervor of arsenals and shipyards with electric moons . . . deep-chested locomotives . . . and the sleek flight of planes.[87]

In browsing through the futurist manifestos, we find, all mixed up together, a little Nietzsche, a little fascism, a little anarchism, an antinostalgic, antiacademic modernism, a mechanized and technological modernism, and revolutionary leftism.

According to Marinetti, writing in 1924, futurism includes in particular: "Explosive art-life, the antimuseum, antilogic, the aesthetics of the machine, heroism and clownery in art and life, formal dynamism, abstract painting, the simultaneity of time and space." And he co-opts Russian Dada, rayonnism, cubo-futurism, and finally, Malevich's suprematism.[88] Futurism was in tune with prerevolutionary Russia, which was in the midst of economic and moral upheaval and lived in the expectation of apocalypse; and it was particularly in tune with the state of mind of the angry young men who formed the avant-garde and intended to hasten the great and liberating catastrophe desired. The provocative exuberance of these groups, which gave rise to a series of calculated scandals, found its justification, themes, and a ready-made form in futurism.

Futurism is also a kind of painting, illustrated by Boccioni, Carrà, Balla, and Severini. In the manifesto of futurist painters (1910), we read: "The gesture we wish to reproduce on the canvas will no longer be a fixed instant of universal dynamism. It will simply be the dynamic sensation itself."[89] French cubism and Italian futurism, once transported to Moscow, were mixed together: the product

was called "cubo-futurism." And that is why Larionov, Goncharova, and Male-vich—in 1912—accepted that designation. The gearing down of the movement in its Boccioni or Balla manifestation was carried out in *The Knife Grinder* (1912). Malevich did not stop at formulas, but he kept the ideal of a total dy-namism, even though the figurative elements disappeared—a dynamism linked, in his case, not to the kinetics of machines, not to the speed of the new modes of transportation, but to an esotericist cosmosophy.

In December 1915, at the last futurist exhibition in Petrograd, Malevich for the first time displayed his suprematist works, especially his famous *Black Square*. He had remained in seclusion the entire year, painting several dozen "objectless" canvases, and no one knew what was going on in his studio. It was quite a scandal.

Over the course of three years, Malevich's suprematist painting displayed the following forms, generally on a white ground: black or red squares; black, red, yellow, or green rectangles; crosses composed of two rectangles; crosses over cir-cles and ovals; and triangles. The composition was sometimes static, with one or two of these very sharp forms, and sometimes dynamic: the forms proliferated, the rectangles got longer and formed bands in an oblique arrangement. In 1917 the "white on whites" began to appear. In 1920, Malevich made this comment on the square period: "The white square is a purely economic movement of the form, which embodies the whole new white world building. It also evokes the establishment of the world building as 'pure action,' as self-knowledge in a purely utilitarian perfection of 'all man.' In the community they have received another significance: the black one as the sign of economy, the red one as the sig-nal for revolution, and the white one as pure action."[90]

Reproductions, contrary to what one might think, do not give a faithful idea of the canvas. A vibration, a vitality is lost. In addition, a sense of poverty wells up from these crackling pictures, from the disastrous quality of the canvas and the colors: they smell of poverty.

We still need to interpret these works to which Malevich attached the name "suprematism" (the word does not exist in Russian, but appears in Polish-lan-guage dictionaries). To do that, we must refer to Malevich's voluminous writings and interpret them in turn: a difficult ordeal. Malevich wrote in the futurist style then current in Russia, which is characterized by fist-pounding pronounce-ments, disjointed theses, endless paroxysms. Underneath, we can make out a whole world of allusions, difficult to identify, to secret and long-forgotten doc-trines. There is, in addition, the overexcitement, and probably confusion, of the author himself. And yet, we perceive a kind of desperate sincerity, a vast effort of thought, which knows it is on to something and tries violently to break through

a wall and communicate. Russian philosophical texts often give the sense of being a dark, glowing lava: that is all the more true of Malevich's writings, which intoxicate the brain and leave the rational mind in perplexity, uncertain whether it is in the presence of a great philosophy (as Marcadé and Martineau think) or of an inextricable hodgepodge.[91]

It is often said, and not without reason, that the writings of painters must not be taken too seriously, that their paintings judge them and carry their own interpretations within them. But one must refer to Malevich's writings to interpret the suprematist episode of his career, since *Black Square* or *White on White* cannot be its own interpreter, especially since Malevich, who conceived of his system as a kind of sermonizing and who intended to save the world, believed in this respect that there was an equivalence between his paintings and his writings, between form and word, and he relied on the linguistic theories that had also arisen within the avant-garde (those of Jakobson, in particular).

Black Square and White on White

Black Square scandalized Alexandre Benois, an old representative of the Russian-ballet style and of the most civilized Petersburg symbolism: "It is no longer futurism that we have before us at present, but the new icon of the square. Everything holy and sacred we possessed, everything we loved and which was our reason for living, has disappeared."[92] Malevich replied in the breathless style of futurism: "Futurism gave his taste a slap in the face and placed the machine on a pedestal . . . the new beauty of contemporaneity. . . . But the gods have died and will not rise again!" He, Malevich, was going to give the new era its true artistic fruit: "I too am a stage of development." Benois and his entourage are merely "illustrating anecdotes." "I have only a single bare and frameless icon of our times. . . . But my happiness in not being like you will give me the strength to go further and further into the empty wilderness. For it's only there that that transformation can take place."[93]

The futurist tone conceals the older pathos of 1860s nihilism, which Bakunin had defined: "The spirit of destruction is the same as the spirit of creation." That is the untamed version of the Hegelian dialectic, on which three generations of the revolutionary intelligentsia were weaned. First destroy; creation will come later. There was a religious version of this nihilism, in fact, which Dostoyevsky elaborated at length, with a feeling of horror and fascination combined: horror, because it led to the destruction of Russia; and fascination, because it entailed an affirmation of the Russian mission to destroy the old world, the self-satisfied, bourgeois, Western world. Malevich writes: "My phi-

losophy is the destruction of old towns and villages every fifty years, the driving of nature beyond the limits of art and the destruction of love and sincerity in art. But not the killing of man's living source (war)."[94] In this instance, the religious version rises to a sort of mystical theology of the death of God—which was also perceived and nurtured by Dostoyevsky, who was not sure he believed in God so much as in Christ-Russia.

But Malevich added an esotericist note to this pathos: "The Three Wise Men had a guiding star (the core of the universe). Have you a guide? . . . Won't you walk past it, as the Jews did Christ? Who knows, perhaps these new men meet constantly here in some side street." This is probably an allusion to Uspenski.

In that same year, 1916, Malevich published a brief manifesto (written in 1915), of which the later texts are often a rhapsody: "From Cubism and Futurism to Suprematism."[95] Let us attempt to impose order on this fervid text. We can untangle the following themes, which are all jumbled together.

1. A critique of figurative painting. It began with the first graffito of the savage, who, in drawing a dot and five little sticks, attempted to represent his fellow man. He invented the art of repetition, which became increasingly more complicated in antiquity and the Renaissance, even as it remained within the same limits: "the reflection, as in a mirror, of nature on the canvas." It was a project that could be refined indefinitely, leading finally to idealized forms, which were still inferior to reproduction. The Venus de Milo is a parody, Michelangelo's *David* a monstrosity. So long as it confined itself to reproducing, nineteenth-century realism was "much greater" than Greek or Renaissance idealization. But it remained the "idea of a savage": the desire to reproduce rather than to create a new form.

2. A critique of futurism. It revealed the novelty of modern life, the beauty of speed. The futurists banned—and therein lies the honor due them—"the painting of female hams [legs], the printing of portraits and guitars in moonlight." They gave up flesh and glorified the machine. In that respect, they were right, but they were wrong to follow the machine as their predecessors had followed the flesh. They pursued "the form of things." They substituted one sort of imitation for another, one sort of reproduction for another. Thus Malevich shouts: "Now with pride we spit on you!"[96]

3. A relatively obscure critique of cubism. Cubist painters clung to an integral reproduction of things, aimed at their essence, and believed that the very essence showed through in the crudeness or the simpleness of the lines. They painted different aspects of things, integrating the temporal elements that dwell within them, or anatomical elements (the grain of wood, for example), and used them as a means of construction for their paintings, using the effect of surprise

and dissonance produced by the encounter between two forms. But although the painting is constructed, the thing, its meaning, its vocation, and its essence disappear. What matters to the cubist painter is graphic value. Color is lost, and, with it, the "painterly task." The cubists did the opposite of Gauguin, who found the freedom of color but lost form, because he did not believe it possible to paint anything other than nature.

In short, nineteenth-century realism (the realism of the Wanderers' antiacademic critique in Russia), futurism, and cubism are almost equivalent in painterly terms. One step remained to be taken, and that was suprematism.

4. The suprematist program. The opening words set it out: "Only with the disappearance of a habit of mind which sees in pictures little corners of nature, madonnas and shameless *Venuses,* shall we witness a work of pure, living art. I have transformed myself *in the zero of form.*"[97]

In the disjointed spurt of pronouncements, we are able to extract three apparent themes. First, there is the idea of a pure creation ex nihilo. "Only in absolute creation will [the artist] acquire his right." That creation comes from the heart of intuition, from the subconscious. The futurists proclaimed it, but they were not faithful to their program. They followed "utilitarian reason." Yet, "the intuitive form should emerge from nothing." God creates forms from nothing. He orders the crystals to be what they are, and it is a miracle. "There should be a miracle in the creation of art, not as real forms and objects, but as material masses from which forms must be made."[98] They will emerge in the same way as utilitarian (that is, natural) forms arise.

Nonetheless, what was subconscious must become conscious, and "the artist should now know what, and why, things happen in his pictures." "Intuitive feeling is now becoming conscious, no longer is it subconscious." The creative painter must account for his intuition, must provide the intimate reasons that guide it. Enlightened by his internal knowledge, he is able to exert perfect control over what he does. "Being a painter, I ought to say why in pictures people's faces are painted green and red."[99] In the past, this was not known, because colors were subservient to "common sense," that is, to the necessity of representation. Colors were oppressed, and, in spite of everything, spread over the abhorred form of real things. But "common sense" was only half overcome. Henceforth, suprematism, emancipated from "common sense," constructs forms from nothing. It introduces the "creative will" into the independent life of the forms it creates.

The third idea, which is truly at the foundation of suprematism, and which makes it a decisive "transcendence" of futurism and cubism, is "objectlessness." Absolute creation is possible only if one suppresses the petty bourgeois idea of the subject. Nature is a *prima materia,* from which one can freely extract forms

that have nothing to do with the model. To reach the painterly essence, the painterly surface-plane (style and color), one must suppress objects. A sharp pentagon or hexagon is a pure form, far superior to the Venus de Milo or Michelangelo's *David*.

Painters must reject subjects and objects if they want to be pure painters. Up to this point, Malevich has simply radicalized the emancipation from figuration, as Kandinsky had already done. Kandinsky reached that point through his own experiments with symbolism and expressionism, whereas Malevich began with cubism and futurism: there is, then, a remarkable convergence of two currents, far from their source. They have been logically led to the same point, by virtue of the special climate of prerevolutionary Russia.

Nevertheless, it is not altogether the same point. To use a term with which the two painters were familiar, Kandinsky followed a "positive path" with respect to forms: he maintained that lines, angles, and surfaces, as well as colors, possess an energy in themselves and adequately "render" the invisible realities to be attained. Malevich followed a "negative path." It was in the elementary, basic, minimal character of forms that, according to Malevich, expressive force lies. In that sense, he followed a "negative path" toward the absolute. Hence this declaration, clearly mystical in tone: "I transformed myself in the zero of form and emerged from nothing to creation, that is to suprematism, to the new realism in painting—to non-objective creation."[100]

"Zero" is the negation of objects or subjects and the means for emerging from the "zero of creation" signified by the slavery of figuration. "Beyond the zero," the kingdom of autonomous creation opens: suprematism is a pictorial realism, that is, the construction of a new reality. The "savage" and the "ape,"—that is, the imitators of forms—are defeated. But the minimal form manifested by the square manifests as well a victory of "intuitive reason" over the sentimentalism of the old way of painting and over the subconscious of futurist precursors. A new man had just appeared, the face of the new art, and hence a "new civilization." This is a cosmic revolution. The surface-plane has come into being. "Every form is a world."[101]

An Aesthetic Gnosis

After this inaugural text, Malevich published two more important brief texts: "On New Systems in Art," written in Vitebsk in 1919, and "God Is Not Cast Down" (1920). Deciphering them is no pleasant task. Perhaps the meaning will be clearer if we refer to a treatise by Uspenski, which can be made out in the background. Uspenski was long a collaborator of Gurdjieff, with whom he

wrote a voluminous work *(Fragment of an Unknown Teaching)*. In 1911, he published his own treatise, which he gave the modest title *Tertium Organum: A Key to the Enigmas of the World*,[102] and which fits fairly well among contemporaneous works of the same kind. It referred to classic Gnostic authorities (Plotinus, Böhme, Lao-Tzu, the Sufis) and to those of his own time: Mme Blavatsky, Max Müller, Lodizhenski. Nonetheless, he preferred to rely on "science." He sought evidence in states of consciousness induced by chloroform and epilepsy, but, above all, in physico-mathematical considerations drawn from the very recent discoveries of relativity and quanta.

The system consists primarily of a gradual development in consciousness, as the universe is perceived in terms of one, two, three, or four dimensions. The first dimension corresponds to the vegetative life, the second to animal life, the third to human life. In human life, whose end Uspenski sees approaching, thought is regulated by Aristotelian logic and Euclidean mathematics; by ethics, by virtue of the clear distinction between good and evil and the injunctions of the group; by knowledge, by virtue of the incommunicability of the four forms of knowledge—religion, philosophy, science, and art; and by anthropology, by virtue of the struggle between flesh and spirit and the lack of internal harmony. But we are on the eve of a decisive shift, brought about by a dawning consciousness of the fourth dimension. Thought is enriched by new sensations, by a direct approach to the universe, a comprehension of symbolism, a cosmic sense. In the new logic, A is both A and not-A, and the part can be as large as the whole. Ethics is freed from external rules. Ecstasy and mystical knowledge give access to the infinite, to the unreality of the phenomenon, to the immediately perceived reality of the noumen. The four knowledges are coordinated with one another and become one. The religious spirit grasps the unity of God and the cosmos, of occultism and the exact sciences, of karma and the laws of relativity. The universe is perceived as a living and conscious being. The hour has come for the emergence of a new type of man, superpersonal, cosmic, immortal.

What does the man of the fourth dimension understand? He grasps the fact that time is spatial; that left, right, large, and small no longer have any meaning; that nothing is dead or unconscious; that everything is infinite and each thing is in everything; that the reality of the world is also its unreality; and so on. But what precisely is the fourth dimension? Well, it can be intuited by doing certain spiritual exercises linked to a meditation on transfinite numbers, non-Euclidean geometry, and relativity.

In conclusion, Uspenski proposes a gnosis of the usual kind but dressed up by the author's scientific veneer, a fairly lucid style of writing kept afloat by a con-

tagious conviction. That gnosis appears as such in many excerpts from Malevich, and we get the sense that it permeates his thought.

"I follow u-el-el-ul-el-te-ka my new path. Let rejection of the old world of art be traced on the palms of your hands." Such is the Dadaistic epigraph to the 1919 text "On New Systems in Art." What theses can we draw from the vaticinating confusion into which Malevich plunges us? The cosmos is in movement and in progress. Man, who is part of the cosmos, participates in this process, and especially in the aesthetic activity of nature. Nature beautifies forms, as does man. Like nature, man's aim is the simplicity of means. "Human creative thought has been trying to escape from weaving confused, if beautiful, patterns and designs to the simple *economic expression* of the action of energy."[103] Cubism, futurism, and suprematism are founded on that action.

Nature produces fields, mountains, seas, insects. It establishes a gradation of forms on its creative surface. So too the creative painter. He orders the fluid forces of pictorial and colored energy into forms, lines, and planes, and, with these elements, separated from their signs, he arrives at the unity of contradictions on his painterly surface. In that way, he contributes to "infinite progression." One cannot stop at beauty, because nature goes forward and we belong to nature. Art is thus in progress. True to its forward movement, it must renounce the past. Man creates mechanical beings similar to natural beings. He transforms the world and, in transforming it, transforms himself. He began by representing things exactly. That is what the Greeks and Romans did very well. But, since then, we have learned a host of things. To make naturalist art would be to remain within the ancient forms of social life. "The new life gives birth to a new art."[104]

On the basis of this generalized dynamism, Malevich judges modern art by placing it within the vector of progress. Cézanne, for example, grasped more consciously than his contemporaries the principle of geometrization. But "he was unable to achieve the expression of plastic, painterly compositions without an objective basis." In fact, the goal is to realize a tableau vivant apart from natural forms, a picture that may become in turn "a real part of the whole living world." One must not imitate nature but move exclusively toward creation. Let us interpret: up to this point, painters have imitated nature, ready-made nature. We must now participate in the labor of nature, nature being born as nature, and, like it, we must create.

The cubists were a great advance over Cézanne. They put painting on display. By "painting," we must understand a pure creation, a new being surging forth from the skull, the sole creative center. It is in that sense that Malevich can say,

in a startling turn of phrase, that Monet did not seek to render the light falling on the walls of his cathedral, but that, "cultivating the painting growing on the walls of the cathedral, [he] extracted the painterly like a pearl from its oyster."[105]

Cubism is fine, but suprematism goes ever further. Confronted with nonobjectivity, we must construct the new painterly forms without imitating readymade forms; in that way, we take the direct route toward creation. Why the "ism" in suprematism? Because nothing in the painterly world grows up outside a system.

At this point, Malevich indulges in a sort of cosmic millenarianism. The painterly revolution is extended in an economic and social revolution. Civilizations are bursting like soap bubbles, one after the other. The driving force resides in "man's skull," and the earthly globe is a psychic sphere, a sphere of wisdom that must roll along the paths of infinity, and whose axis is the psyche of the initiated artist. Art advances side by side with revolution, moved by the same energy, toward infinity. That infinity is the extra dimension (the fourth, or even the fifth) toward which "objectless" *(bespredmetnost)* suprematist art soars, after liquidating all the arts of the old world.

We must now attempt to extract a plausible meaning from Malevich's most important "theoretical" text. Published in 1922 in Vitebsk but (according to Nakov) possibly written in 1920, "God Is Not Cast Down" is considered by Marcadé to be "one of the most important philosophical texts of the twentieth century."[106] It may well be so from a historical viewpoint, if one considers the importance of Malevich and the artistic movement over which he presided. But, in itself, it is an extraordinarily confused flight of fancy.

According to Marcadé, this text is a response to an essay by the critic and philosopher Guerchenzon: *The Threefold Image of Perfection.* It is an attack in an irrationalist style against technological culture, which has depersonalized the world, cut man off from his roots, deprived him of his original unity, "the existence of the person in himself," and which represents an obstacle to his reconciliation in love. Guerchenzon repeats the old Slavophile theme of complete knowledge in love and combines it with contemporary critiques of modernity, plentiful both in Russia (Berdyayev, Ivanov) and in Germany (Heidegger).

More precisely, Malevich's short text is part of a semidissident current of Bolshevism called the "Constructors of God" *(Bogostroiteli).* Bogdanov, Lunarcharsky, and Gorky thought man needed a religious ideal, and that, in creating it, he created God: a religion of humanity understood in its material, and simultaneously, spiritual progress. Marxism in this sense is the last religion, replacing biblical religions, and the socialist revolution must mark its advent.

Some of the ideas of the Constructors of God are inherited from Feuerbach (God as ideal projection of man), combined, in the spirit of the times, with ideas stolen from Mach and Avenarius, reflections on the conditions of scientific knowledge, neo-Kantian positivism, and "empirical criticism." Lenin despised all of it and refuted it, even though he was unable to understand it. Malevich embraced it, though his intellectual baggage did not permit him to have a better grasp of what was at stake. But he adopted its vocabulary.

Finally, Malevich's crude mysticism and muddled religious aspirations were fed by Uspenski's esotericism, which no doubt added a surplus of cryptic opacity to the text we need to decipher. In the beginning was life—since the universe is entirely alive—whose principle and cause was the *stimulus*. As soon as life manifests itself, it complies to a primordial *rhythm*. The second principle of life is *thought*.[107] But, as it unfolds, primordial life is smashed to pieces, externalized, and thought is obliged to emerge from the internal to assess the external on the basis of conventional laws and shapes: somewhat the way children build and destroy cities or fortresses by following the rules of the game. The primordial, the infinite, the faceless thus crumbles into the finite and dead figure.

"Stimulus is a cosmic flame and lives on what is objective." It is only the cog of thought and, because of practical necessities, it cools into figures. But man seeks to return to a time before the objective or figurative, where the infinite and the absolute purity of the stimulus dwell. He wants to go back to the point where nothing is separated (into figures), where everything is linked, and where, as a result, neither barrier nor surface nor volume nor object in general can exist.[108] Every figure, every natural object is an indecipherable sign of the stimulus, the stuff of the universe. To represent something is a limitation. For man, "life and the infinite lie . . . in the fact that he cannot conceive anything—what he does conceive is as elusive in its infinity as everything else."[109] This sounds like a distant echo of Spinoza: *Omnis determinatio est negatio,* which, when applied to painting, prohibits the artist from circumscribing an object, since the object, once constructed, leaves aside reality and the infiniteness of the world, which is the life of the artist. Or think of the Kantian noumen, reconceptualized by Schopenhauer and reduced to a metaphor: "What we call reality is infinity without weight, measure, time or space, absolute or relative, never traced in a form. It can be neither conceived nor comprehended."[110]

The task of man is thus to wrest himself from the phenomenon, the figurative, and to sink into the mystery of the universe. The universe, considered in its perfection, is God: "The comprehension of God or of the universe, as perfection, [becomes] his prime objective."[111] But the universe—in other words, God—does not think. Only man thinks, and it is through thought that he will

identify with the universe, that is, with God. "He hopes to reach God or perfection through all that he produces, and prepares to reach the throne of thought, as the absolute end, on which he will act, no longer as a man but as God, for he will incarnate himself in Him and become perfection." Thus, through man, but on the universe's behalf, an epiphany of truth occurs. This epiphany is above men, thinks for them. Humanity moves toward absolute thought through man's creations. And, in the end, God is "built up" as the goal of life.[112]

The universe is limitless, it is perfect and without sin. It knows nothing of family systems, laws, borders, prohibitions. For his part, man is limited and imperfect, and sins by transgressing prohibitions. God has cast the entire burden of the world upon him. He bears that weight with difficulty and works to liberate himself, to transcend that overpowering zone of crime and punishments, in order to rejoin the divine. He wants "himself to become weightless, i.e. enter God."[113]

Thus man produces, and the aim of his productions is the "building up of God as absolute perfection." He produces figures, objects, which he sees as signs of the divine. He builds God by means of two approaches, religious systems and technological systems. But the two approaches reach a limit: "There stands before God the limit of all senses, but beyond the limit stands God in whom there is no sense." "God is not sense, but senselessness." Here Malevich (by means of what readings and personal intuition?) intersects the notions of negative theology: God is both sense and senselessness, being and nonbeing, figure and the nonfigurative. At this point, the two approaches, the religious and the technological systems, meet and simultaneously annihilate each other.[114]

Each system can be converted into the other. One seeks spiritual perfection, the other the perfection of bodies. And the spirit cannot live without matter, nor matter without spirit. Moreover, matter does not exist, since modern physics has evaporated it: there is merely a difference in density between matter and spirit. The materialist (the technological man), like the spiritualist (the religious man), the man nurtured on the machine and the man who thinks and feeds on God, both create the figures within their reach, where they themselves waste away. Nonetheless, beyond these ephemeral objects, beyond these two unsatisfying understandings of the world, "stands the same non-objectivity." All our practical, reasonable conceptions "are smashed to pieces on their non-objective truth or simply non-objectivity without any truth." The All escapes our grasp, the universe is infinite: can anyone "calculate all this incalculable material?" Religion sees God as a being, and "then any object in the world is also existence, for everything contains God within itself, a particle of perfection." Thus, with a certain precision, Malevich challenges the type of theology that

had authorized art, the theology that identifies God with being and which sees a vestige or trace of the divine in every thing, inasmuch as it possesses being. In his obscure speculations, Malevich sees God as being's beyond, radically separated from things, which, in their figuration, cannot refer to anything but nothingness.[115]

As Uspenski remarked, criticizing the world prior to the "fourth dimension," man, having divided his life into three paths—the religious, the scientific, and the artistic—has divided himself. Instead of a "single unity," he has constructed three "unities of truth" that argue among themselves.[116] Religion introduces the soul into the heavenly kingdom. The "factory" frees the laboring body. Both have the same aim, one by changing the soul, the other, the body. Through thought, they lead to God, who is rest and nonthought. So long as man has not yet reached that point, he labors in the image and likeness of the God he imagines. But God lies beyond, as does the man who has reached him, both of them as "nothingness," as nonfiguration or nonobjectivity. In that realm beyond, things change aspect, matter dissolves into energy, the visible disappears, but being does not, since it cannot be annihilated. And since being is God, "God is not cast down."[117]

Perhaps we know enough about Malevich. I defer to specialists on his paintings, to enthusiasts of his writings, for the aesthetic and philosophical analysis of the less central texts, which, in my opinion, do not change our picture of that great personality. Malevich arrived at the rejection of representation at the same time as Kandinsky, but via paths so different one might doubt that they would have agreed that their itineraries converged. They would not have admitted that *Black Square* and *Composition IV* belonged to the same aesthetic and conformed to the same intention, and, on this point, they must be believed. Their respective milieus separated them. Their political destinies set them against each other. Malevich ardently espoused the technological furor, the avant-garde modernism, and the revolutionary aspirations of his century. In the face of all that, Kandinsky maintained the reservations of an older man trained in romanticism and symbolist spiritualism, supported by elitist isolation. Nothing was more foreign to his character than futurist provocations or the plans for the aesthetic reeducation of the masses, though, for a moment, he seems to have participated in them. For Malevich, the promise of painterly salvation was addressed to humanity as a whole.

These two painters wrote a great deal and gave abundant justifications for their painterly decisions. It is important to emphasize that these decisions were as religious in Malevich as they were in Kandinsky. The iconoclastic choice can be clearly explained by the idea of the divine.

The mishmash of notions, the combination of revolutionary eschatology and daydreams about science and technology, and the scattered readings lead to a Gnostic system whose main lines appear quite clearly if one takes the trouble to examine its murky declarations. There is an evolution of the world and of art which, step by step, destruction after destruction, arrives at an endpoint, which is "God." This God transcends all representation and can be approached only by the negative path of objectlessness, the nonfigurative. This God beyond God, in whose nature the artist's soul participates, is intuited as a perfect void, as nothingness, as being/nonbeing, and all figuration—of objects and of the absolute itself—appears in that dark light as an idol. That is why Malevich took care to hang his *Black Square* high in a corner of the exhibition hall, which, for every Russian, meant he had placed it in the "red corner," the place reserved for holy icons.

Do we risk giving a misleading interpretation (but no more misleading, I daresay, than many glosses inspired by Malevich) to imagine that the *Black Square* has some relation to the divine, which Moses can "see" only from behind, and *White on White,* some relation to face-to-face vision? In any case, no one can see anything. The extraordinarily lofty and ambitious idea Malevich had of painting, of the painter's mission, of the transcendent salvation it promised, is fit to discourage the figure, to disqualify imitation. The infinite dignity of the object to be painted, the unworthiness of the means of figuration, the mystical ecstasy and direct intuition of the divine at the far point of consciousness: in these compact, unforgiving, opaque texts, written in a fever by a self-educated, powerful mind, we recognize the constants of iconoclasm.

Much is still unknown about Malevich. New canvases, drawings, and texts are coming to light after a period of more than fifty years, during which his works were locked away. What exactly happened during the two weeks he spent at the "great house" in autumn 1930? What did the KGB ask of him? What was contained in his archives, which his friends rushed to destroy? What was he thinking of when he painted a few canvases in the "socialist realist" genre?

Socialist realism can be considered diametrically opposed to abstraction. Abstract art challenges the evidence of the senses to make an invisible *reality* appear. Socialist realism also challenges the evidence of the senses, by participating in a repression of shared and visible reality, the existence of which is forbidden under the regime. It puts a *false* visibility in its place, that is, the realized utopia (beaming workers and peasants in a technologically advanced world). It thus needs all the resources of illusion, perspective, panorama techniques, and so on. In addition, abstraction claims to break totally with the art of the past. Conversely, socialist realism claims that it is the natural culmination of that past art.

That is why it wholly adopts the style of the Wanderers, raised to the pinnacle of art. The few canvases Malevich produced in this genre are artistic curiosities.

After this shock, he returned to the styles he had practiced before suprematism, but in a new light, and with a new spareness. What, precisely, do these silhouettes signify, these faceless—but not beardless—and sometimes armless peasants in Russian shirts, often in two contrasting colors, cut off mid-body by the horizon, with the blue sky of Ukrainian summers bursting forth behind them? Why are these paintings extremely cheerful and radiant, against the background of the great massacre of the peasantry that Stalin was carrying out at the same time, so much so that they radiate a sort of tragedy by way of contrast? We do not know enough about them.

But, despite all the artist's explanations, we know much less about the relationship that exists (at least in the painter's mind) between the declared suprematist mysticism of the years 1914–20 and the squares, rectangles, and large crosses that float and seem to move about in the unimaginable space of the "fourth dimension."

An unbridgeable gap exists between the theory and the deepest recesses of the artist's mind, between these recesses and the mysterious transcription of them onto paper and canvas, and, finally, between the suprematist works and the global repercussions they had among the general public and on painters who, in turn, attempted to decipher the enigma. But monotony, which is the price to be paid for subjective mysticism—and which must be likened to the monotony of the icon frozen by its canons and by the post-iconoclastic compromise—is in the long run unbearable, and "objectlessness," which was to be the endpoint of the history of art, was an unstable formula to which the world, and first of all Malevich himself, could not hold on for long.

Postscript

To say nothing at all about Mondrian would be to risk upsetting the balance of my thesis, leaving the impression that all abstract painting comes from Russia, when everyone knows that a third founder owes nothing to that nation.

I want simply to indicate how the path of Piet Mondrian is the same, despite differences of milieu, as that of Kandinsky and Malevich. And how the path is not the same.

In his early paintings, Mondrian docilely submitted to the manner of his masters, who were continuing the Dutch tradition: Mauve, Maris, Israëls. Compared to his Russian contemporaries, he thus acquired a more solid and standard classical training, from which he rapidly emancipated himself in about

1900, under two influences that coordinated all the more intimately in that they were already joined: theosophy and painterly symbolism.

Theosophy was central. Mondrian read Mme Blavatsky (for a long time, a photograph of that lady decorated the nearly bare walls of his studio), Schuré, Steiner, Annie Besant, and was a close friend to H. J. Schoenmakers, a former Catholic priest who had become a theosopher. He adopted part of Schoenmakers's vocabulary in his theoretical writings. Theosophy probably helped him relieve a few inner torments. His relationship to his father, an authoritarian man and a very strict Calvinist, had not been easy. Mondrian had considered becoming a preacher, and his painter's vocation had not been well received by his father, or, no doubt, by himself, since he was prone to remorse. Theosophy provided him with a more comfortable religious framework: it guaranteed access to the deep structures of the universe; it promised a path toward spiritual perfection, at the end of which the initiated mind would find itself endowed with great powers. Considered from Calvin's viewpoint, theosophy is an extreme Pelagianism, since the individual achieves his own salvation through asceticism, mediation, illuminative knowledge. In addition, theosophy fills the bottomless abyss that separates God from the human soul by positing a cosmos filled with the divine, an evolutionary continuum of matter and spirit in which matter becomes increasingly spiritualized, until it becomes "the autonomous life of the spirit conscious of itself."[118]

Mondrian's landscapes, dependent on these doctrines, are charged with mysterious intentions, and his manner sometimes resembles that of the Brücke, though calmer and "cleaner" than theirs (*Near Gein, Trees with Rising Moon,* 1902; *The Red Cloud,* 1908). Sometimes it also resembles Hodler, but more often Munch (*Devotion,* 1908; *The Dying Chrysanthemum; The Dying Sunflower,* 1908). The series of church towers and the first in the *Trees* series remain within the same register of pathos, even though Mondrian sometimes experimented with techniques originating in Paris. He had become the friend of Toorop, one of the most thoroughly "initiated" symbolists, who nevertheless deigned to try a bit of pointillism in about 1908. That added a certain cheerfulness to the *Church Tower of Zouteland,* especially in comparison to the *Church of Domburg.* Thus we come to the catastrophe—fortunately, the only one in his oeuvre—of the *Evolution* triptych (1910–11): three stylized, stiff-looking nude women. The first has her eyes closed, the second, wide open, the third, closed once more. If we look closely, we note that the first woman's breasts and navel are depicted as minuscule triangles pointing downward (toward the earth), those of the second as the same triangles pointing upward (toward heaven), and finally, those of the third, as little rectangles or diamonds: the synthesis of earth and heaven, nature

and spirit. Seuphor gives a plausible interpretation: slumber of the flesh, awakening of the spirit, internal vision. Dora Vallier adds: "The triangles achieve their equilibrium in the rectangle. How can we not see here—in germ—the entire future of Mondrian's work?"[119] But only in germ, because the painting could be used as a sign in front of a shop selling pentagrams, mandalas, tarots, incense sticks, and Mme Blavatsky's *Secret Doctrine.*

In 1911, however, Mondrian arrived in Paris. Immediately, the symbolist bric-a-brac disappeared. Considering everything he had done up to that point null and void, abruptly changing his manner, Mondrian took up cubism. He had been prepared for it by Cézanne, to whom Toorop had introduced him. Within a few months, he had moved deep into cubism, and emerged from it completely through abstraction. For him, cubism was not one moment in a long life's work, as it was for Picasso and Braque, but a system of forms, a departure from his own style—which no longer suited him—and a ready-made system that corresponded better to his deepest intuitions. These intuitions, when they took up residence in cubism, quickly made it explode. The *Trees* series was continued in Paris, but the theme was taken as a means to divide up the space of the canvas, in such a way that the structural pattern quickly became the true "subject." Henceforth, Mondrian pursued his logical development with the careful and inflexible stubbornness that was in his character. Theosophy remained present, justifying the choice of certain master forms: the oval (original cosmic energy), the T (accomplishment), the square (the world in its unity), the opposition between the horizontal and the vertical (the unity of the universal principles of masculine and feminine, of spiritual and material), and so on. What is miraculous is that, on the basis of these minimal elements—orthogonal composition (he quarreled with Van Doesburg, because the latter wanted to introduce the diagonal), the exclusive use of the three primary colors (blue, yellow, and red) and of two "noncolors" (black and white)—he created a coherent, vibrant body of work, which continued to renew itself until his death in 1944, and, by virtue of its sharpness and reflective calm, can be placed within the great Dutch tradition.

Mondrian lived in the style of his compatriot Spinoza: jealous of his independence, of his solitude, earning enough only for the bare necessities, chaste, reserved, proper in his dress and language, but also courteous and reasonably social. The only concession his meticulously organized studio, with no comforts, made to the forms of nature was an artificial tulip he had painted white.

To borrow Taine's terminology, Mondrian shared neither his "race" nor his "milieu" with Kandinsky and Malevich. But he shared the "moment." Like them, he was permeated with a mystical religiosity deeply informed by fin de siècle esotericism. Like Kandinsky, he had a symbolist phase, and like Malevich,

a cubist phase, arriving at an uncompromising nonfigurativeness to which, like the other two, he clung until the end, never turning back. For him as well, France (though he lived there by choice) provided not painting lessons but the *catalyst* that *precipitated* an artistic expression whose aesthetic, philosophical, and theological underpinnings had their roots elsewhere than in his adopted Paris.

Finally, like the two Russian painters, Mondrian made his pictorial innovations the manifesto of a cosmosophy and of a historiosophy, which was, in fact, much less ambitious and messianic in his case. "The life of man is today gradually turning away from natural things to become increasingly an abstract life." "Vital attention is fixing on internal things." "As a pure representation of the human mind, art will express itself in a purified, that is, an abstract, form."[120] The aim of "neoplasticism," the name Mondrian gave to his system, was an "equilibrium" that "annihilated individuals as particular personalities and thus created the future society as a real unity" (1926). This entailed constructing a "culture on the way to equilibrium," by turning one's back on the "night" of the past. Human life "will not always be dominated by nature." In the bright daylight of the future, man will be able to create a new reality, a *superreality*. "Under the influence of that *superreality*, human life, more natural up to now, will change more quickly into a truly human life" (*Cercle et carré*, 15 April 1930).

Were we to extend the parallels a step further, we would be exposing ourselves to grave misunderstandings. In fact, Mondrian, despite the systematic character of his artistic language, his Blavatskyan chimera, remained more modestly within the painter's craft than did the Russians. He presented abstraction as the form of painting that befit the "new times," but that did not imply any condemnation of the old forms of painting corresponding to ancient times. Contemporary man, to be sure, is separated from nature: painting must take that fact into account. When Mondrian, still something of a cubist, made reference to reality, it was to the "large buildings" in Montparnasse and to the scaffolding covering them. Similarly, he was interested in jazz as a significantly contemporary rhythm that could be transposed into painting (*Broadway Boogie Woogie*, 1943). In what he called "the exact representation of relations by themselves," or "the aesthetic relation accurately represented" and gradually extracted from natural forms and colors, he hoped that "modern life as a whole can be purely reflected in a picture." In short, the task Mondrian considered fundamental was the primary, foremost task of all painting: *vlakverdeling*, that is, "the division of the surface-plane." If Mondrian's paintings, extending beyond the limits of the frame, have invaded our streets and cities, it is because, as he believed, its inten-

tionally minimalist means touched some essential structure of our present condition.

It is possible that, as he gradually found his own way, in about 1920, let us say, painting became *stronger* than theosophy for him, and that theosophy was placed in the service of the painter's personal needs, not the reverse. The balance of power, so unfavorable at the beginning of his career, and which had led to the disastrous *Evolution,* reversed itself. If Mondrian has had an important influence on our world (auspicious or inauspicious, it is not for me to judge), it is because this Dutchman working in Paris, in Amsterdam, and in New York, that is, at the center of that world, never ceased to belong to it.

Mondrian wanted to "abstract" the forms of nature. Let us recall that, for half a century, French painting had applied itself to that same quest for the essential, the labor of stripping bare, of carefully organizing the canvas, of retreating to painting as to an autonomous reality. He could legitimately appropriate the famous pronouncement about the "flat surface, covered with colors arranged in a certain order." And what he had taken from Cézanne, after all, was *also* contained in Cézanne. This was the uninterrupted and specifically French path to abstraction, and, if Mondrian took the step that made the French recoil, it was undoubtedly because, unlike him, they did not find nature "tragic" or unbearable, as he often repeated, did not feel that they needed to turn their backs on it. On this single but decisive point, Mondrian embraced iconoclasm.

CONCLUSION

Different religious regimes do not favor the image in equal measure. In the pagan notion, the divine, immanent to the world, inhabits everything produced by nature or fabricated by human hands. It has an infinite variety of forms, encompassing a spring and a stone, or a monstrous mask and Phidias's *Athena*. Philosophy criticizes that ubiquity in the name of the concept. But it sometimes happens that the concept of the divine directs the image toward the inner mind where it is formed and leads the soul beyond itself, to a place where the image vanishes.

The biblical God—transcendent, invisible, unimaginable in his essence—is nonetheless the benevolent author of the world, which bears "vestiges" of him, and, in the case of man, also bears his "image." The servant of this God thus reveres, with as much piety as Hesiod or Virgil, the reflection of divine glory in everything on earth and in heaven.

If he is Christian, he also believes in a man whom God did not inhabit, but in whom he was "incarnated." This high point of divine benevolence further augments the dignity of creation, but it also shows a more beautiful and even more desirable world behind it, which decreases its value, as philosophy had also done. Moreover, what mode of worship and what status can be given to the image of Christ who, through his Ascension, now finds himself, in his "circumscribed" and representable body, one Person in the Trinity—mysterious, unknowable, and unrepresentable in itself?

It is clear that such a theological mechanism, which is much more problem-

atic than that of classical Judaism or Islam, raises a host of difficulties. If there is the slightest imbalance regarding the place of the Word in the Trinity or of the union of natures in the person of Christ, then either there is no longer any image at all or there is nothing left but an idol. The result is a return to a philosophical aniconism, based on the second biblical commandment. Hence, according to logic and theology, the image under the Christian system is in an unstable situation, and history consists of an alternation between glory and extinction.

Since men in general and the lower classes in particular tend naturally toward idolatry, it is usually within the elite, the educated, that the protest rises up against the idolatrous degradation of the image, and then against the image itself. It may be orthodox in its intention. What did Calvin say, if not, like Saint Paul, that God "dwell[s] in the light which no man can approach unto"?[1] At the same moment, Saint John of the Cross was refusing to confuse God with the most religious of images, or even with the concept of "God" or the truest mystical experience: he abandoned all that to the "night of spirit."

As historians have observed, despite these obstacles, the divine image thrived best, in the most luxuriant diversity, in the very heart of Christianity and Christian orthodoxy (even if that orthodoxy was forgotten); it was approved by the simple folk, learned people, and saints, and was encouraged by church authorities.

But for that to come about, not only was theological reflection necessary, so were certain circumstances, and these did not occur for a prolonged period of time except, but not always, in Latin-speaking Western Europe. The first circumstance was a certain attitude toward things (they were considered neither divine nor entirely lacking in divinity), to which the legacy of classical Greece and faith in Christianity both contributed, though in different ways. This allowed for a productive exchange between the divine image and the profane image, which have been like communicating vessels down through the ages.

Modern science has tended to introduce a break in that blissful relationship. When the divine is no longer seen in nature, the impressive silence of the deserted world enhances the majesty of the Idea of the divine, now devoid of any anthropomorphic or cosmomorphic attachment. From Pascal and Kant to Heisenberg, the spirit and mysticism of the old iconoclasm were revived in science, when it did not confine itself to mere positivism. Is nature worth contemplating when it can be *analyzed?* As Hegel saw, art became decidedly "a thing of the past." Nonetheless, in the artist's view, matter cannot be reduced to extension or light to particles and waves. The artist cannot represent things, even in the most naturalistic way—that is, by photographing them—without the

emergence of a surplus, which leads to admiration and praise, even though it is not altogether clear whether that surplus comes from things, from the artist, or from God. That is why, when religious art lost strength, the sacred found refuge in profane art, and orthodoxy found its vindication in the painters who least thought about it, but who knew how to look properly at the "phenomenon."

The second circumstance was a measured and moderate conception of the image, which the Latin West took as neither the equivalent of the prototype nor as completely untouched by it. Thus the image did not incur the Platonic criticism of being an illusion or the iconoclastic criticism of being an idol. Nor was it criticized as a sterile, vain, and useless reproduction. But the balance may be disturbed, as in modern times, when the image, emancipating itself from the prototype, itself becomes a prototype.

Freed from the obligation to have it out with nature—or with the divine— the absolute image, figurative or nonfigurative, but no longer taking into account its function as representation, became isolated and posited itself as a rival of the created world. It set itself up as an object of worship, celebrated in the museum, where people came to mystically consume the flesh and blood of the artist, mediator, savior, theurgist, in the form of his work.

The third circumstance was the artist's felicitous moral and social situation. It was beneficial to the image's vitality that the artist have an adequate level of autonomy in relation to spiritual authority. And, in Latin regions, this authority primarily required excellence in his craft. It did not assign him the quasi-priestly duty of communicating the divine, or of communicating with the divine. It assumed that task itself and did not inquire whether the artist, a mere believer, was personally capable of it. Although Western society made the artist subservient to the guild or the market, it left him some room for play. In exchange, it gave him the stimulus of a commission, a critique, training by masters, provided him with a rhetorical framework and a style, which he did not have to reinvent from whole cloth. The modern age has wrested the artist from his condition as an artisan, has introduced the reign of the name, the signature, has admitted painting into the ranks of the liberal arts. But it was at the happy moment when the artist obtained everything he could reasonably hope to obtain that the balance became threatened by the aesthetics of genius.

Genius is a spiritual attitude that in itself sets one apart. It is specific to the artist: political, military, and scientific geniuses now fit the artistic mold. Genius marks him as different and separates him from society. He is now without a master, the only one responsible for his manner and "originality." What counts is not so much the work but, as Nietzsche notes, "the sight of that power that a genius uses, *not in works,* but in the *elaboration* of *himself as work.*"[2] The quest for

stature, which was legitimate so long as the artist wanted to be recognized for what he did, overshot its goal when he demanded proskynesis and obtained it not for what he did but for what he was.

These imbalances, which were not exactly contemporaneous, accumulated, gradually ate away at the image, and impelled it toward a crisis. Just as there was a "consecration of the writer," there was a consecration of the artist. Genius and the sublime, before they became a burden, galvanized the artist and glorified his mission as the intermediary between the divine and the human, as one who transmitted divine fire. Since the divine was no longer visible in things, things had to be urged, forced, their forms deformed, to make them show their presence, a presence that was slipping away from them, until a few artists took the final step and decided to do without them altogether.

The founding of "abstraction" can therefore not be considered one formulation or pictorial path among others, similar to pointillism, fauvism, or cubism. Its founders experienced it as a revolution, and furthermore, as a complete shift, and not only in painting. I believe they were right. To account for this shift, I had to call up all of history to analyze a spiritual position that has been taken repeatedly since the most ancient times, which encompasses many things besides a style or artistic system.

In fact, if we consider what has happened since then—the attack on the figure, the rupture with the "object"—such changes have effectively brought about a wound that does not seem likely to heal in the near future. Thus it seems that the whole modern sequence of forms has been reorganized by this event, as if impressionism, symbolism, expressionism, cubism, and all the other "isms" were moving more and more quickly toward the breaking point, in spite of themselves, as toward a bottomless waterfall.

The movement was global, but the final victory came from America. That country was destined for the sublime, almost by nature: its nineteenth-century painters dared render its landscapes which, in the Hudson Valley and in the West, are, in fact, "absolutely great." The European emigration sowed seeds that grew like mad on that fertile soil: Germans fleeing Nazism, Russians fleeing Bolshevism, Mondrian, Duchamp—this last artist ill at ease in the French artistic climate and almost a pure example of the absolute artist, that is, the artist without works. Their principles and their mysticism were adopted with enthusiasm, reformulated by Rothko, implemented by Pollock, Kline, and others, with such force that America quivered with pride at the sight of the *translatio artis* between Paris and New York. It was in "abstract expressionism," and not in Hopper's anguished figures or in those of Norman Rockwell, overflowing with kindness,

that it has located its great art up to this time. But that can change. The figure, the image, is staging a comeback. It can be found in painting for the public at large, surrealism for ladies, true and false naive painters, comic strips, and in the vast world of photography, whose new breadth has made up for the eclipse of the painted image. It is reemerging—but in what a state!—in major painters: powerfully monstrous in Bacon, parodic in Botero, "raw" in Dubuffet. Let me say just a word about hyperrealism.

In this current, objects are endowed with an uncanny quality. *Imitatio*, pushed to the extreme, takes on the character of a hallucination and disorients in a manner commensurate with the minutiae rendered. The "difference" from the model, which Plato and Dionysius the Areopagite judged necessary, has now been erased, and hyperrealism produces a "Mme Tussaud" version of our world, which is frightening because nature returns like the ghost of a murder victim. The very effective pathos of that sort of painting lies in the way it displays the absurdity of natural forms, whose obsessive ugliness or emptiness (insistently included in the nudes are details that have never been shown before) does not elicit praise or an act of grace, because grace seems to have withdrawn forever.

And yet, despite what Hegel said on the matter, there is nothing inevitable about the death of the image. It may already be reviving unbeknownst to us, in unknown places, in forms we do not suspect. *Mensura, numerus,* and *pondus* may return in concert to regulate the sacred and the profane in terms of each other, to offer divine images that give life to things, and profane images that incarnate the divine. We know, in fact, that images thrive in a lasting manner only when they work together, one nourishing the other, a process Western Europe has exemplified for several centuries.

Our century has seen great revolutions, and, once they have abated, law, property, and other institutions long held sacred have had a great deal of trouble finding their footing again. Should we be surprised that it is taking time for the image, which another contemporary revolution dared attack, to reestablish itself?

NOTES

The vastness of my subject made an exhaustive bibliography prohibitive. A selective bibliography would have been risky and, at the same time, overly long. I have read more books than I cite. I cite only those to which I refer explicitly in the text. The authors' names are included in the index.

Introduction

1. Many recent books reflect a similar concern and seek to clear up the same perplexities. Let me cite, in very different genres, Jean Clair, *Considérations sur l'état des beaux arts* (Paris: Gallimard, 1983); Antoine Compagnon, *Les cinq paradoxes de la modernité* (Paris: Seuil, 1990); Luc Ferry, *Homo aestheticus* (Paris: Grasset, 1990); Jean-Marie Schaeffer, *L'âge de l'art moderne* (Paris: Gallimard, 1992); the reflections of Jean-Luc Marion; the February 1992 issue of *Esprit* on "the crisis of contemporary art"; and so on. Allow me as well to evoke the memory of a departed friend, Vladimir Veidle, and his beautiful, melancholic book *Les abeilles d'Aristée* (Paris: Gallimard, 1954). This European saw his native city, Petersburg, disappear, along with Vienna and Berlin, and saw dusk fall over London and Paris. But, as profound as his diagnosis may have been, it bears the mark of its time, the prewar period, and his judgments were "diverted" by the vagaries of criticism. That is why I wished to avoid the dangerous *laudatio temporis acti,* and the no less dangerous lament about the present.

Part One
Chapter One

1. See Kostas Papaioannou, *L'art grec* (Paris: Mazenod, 1972), p. 48.

2. Hesiod, *Theogony,* line 121, in *Theogony and Works and Days,* trans. Dorothea Wender (Baltimore: Penguin, 1973), p. 27.

3. Pindar, *Nemean Odes* 6.1–13, in *Nemean Odes, Isthmian Odes, Fragments,* ed. and

trans. William H. Race (Cambridge: Harvard University Press, 1997), p. 59; also cited in Papaioannou, *L'art grec,* p. 57.

4. See Aristotle, *Ethica Nicomachea,* in *The Works of Aristotle,* trans. W. D. Ross (London: Oxford University Press), 9:1177 b, 1178 a.

5. Plato, *Timaeus* 90 d, in *Dialogues of Plato,* trans. B. Jowett (London: Oxford, Clarendon Press, 1953), 3:666 [translation modified]; and *Republic* 6.500 c–d, in ibid., 2:361.

6. See Papaioannou, *L'art grec,* p. 114.

7. See Lionello Venturi, *History of Art Criticism* (New York: E. P. Dutton, 1936).

8. Cited by M. P. Nilsson, *Les croyances religieuses de la Grèce antique* (Paris: Payot, 1955), p. 79 [my translation from the French—J. M. T.]. Cf. the *Non nobis Domini* chanted by Shakespeare's Henry V after the victory of Azincourt.

9. There is a "democracy of beings," notes Papaioannou, because horses, cattle, and dogs are treated as perfect, archetypal forms.

10. Cited in G. W. F. Hegel, *Aesthetics: Lectures on Fine Art,* trans. T. M. Knox, 2 vols. (London: Oxford, Clarendon Press, 1975), p. 508.

11. See Jean-Pierre Vernant, "Mortels et immortels: Le corps divin," in *L'individu, la mort, l'amour* (Paris: Gallimard, 1989), pp. 7–39.

12. Saint Augustine, *The City of God,* 6.5–6, trans. Marcus Dods (New York: Random House, 1950), pp. 190–91.

13. See Werner Jaeger, *The Theology of the Early Greek Philosophers,* trans. Edward G. Robinson (London, Oxford, and New York: Oxford University Press, 1947). I draw heavily on this book.

14. Thales, A 22. Quoted in Plato, *Laws* 899 b, in *Dialogues of Plato,* 4:469.

15. See Jaeger, *Early Greek Philosophers,* p. 42.

16. Xenophanes of Colophon, *Fragments* 22, trans. J. H. Lesher (Toronto: University of Toronto Press, 1992), p. 31.

17. See Jaeger, *Early Greek Philosophers,* p. 49.

18. Xenophanes of Colophon, *Fragments* 25, p. 33.

19. Ibid., 26, p. 33.

20. Ibid., 15, p. 25.

21. Ibid., 16, p. 25.

22. Ibid., 11, p. 23.

23. Jaeger, *Early Greek Philosophers,* p. 72.

24. Xenophon, *Memorabilia* 3.10.6–8, in *Memorabilia and Oeconomicus,* with English translation by E. C. Marchant (Cambridge: Harvard University Press, 1959), pp. 235–37.

25. Jaeger, *Early Greek Philosophers,* p. 107.

26. Parmenides of Elea, *Fragments* 8.42–45, trans. David Gallop (Toronto: University of Toronto Press, 1989), p. 73. Note that Being possesses a limit and an outline, unlike the Milesian *apeiron.* The dispute concerning images lies in the question of whether God can be circumscribed on an icon. See below, 123 ff.

27. Heraclitus, *Fragments* 93, trans. T. M. Robinson (Toronto: University of Toronto Press, 1987), p. 57.

28. Ibid., 32, p. 27.

29. Ibid., 79, p. 49.

30. Ibid., 83, p. 51.

31. Empedocles 133 [my translation from the French].

32. Ibid., 134.

33. Ibid., 28.

34. Plato, *Protagoras* 321 a, in *Dialogues of Plato,* trans. B. Jowett (New York: Random House, 1937), 1:93.

35. Xenophon, *Memorabilia,* 1.4.13, in *Memorabilia and Oeconomicus,* p. 61.

36. See Cicero, *De natura deorum* 1.12.

37. Democritus 74 [my translation from the French].

38. See Eusebius of Caesarea, *Praeparatio Evangelica* 14.3.7.

39. Plato, *Laws* 4.716 c, in *Dialogues of Plato,* 4:286.

40. Plato, *Republic* 7.514 b and 515 e, in ibid., 2:376–77.

41. Plato, *The Sophist* 254 a–b, in ibid., 3:377.

42. See Auguste Diès, *Autour de Platon* (Paris: Les Belles Lettres, 1972), p. 555.

43. *Sed contra:* see Plato, *Phaedrus* 249 c.

44. See Victor Goldschmidt, *Platonisme et pensée contemporaine* (Paris: Aubier-Montaigne, 1970), pp. 37 ff.

45. Plato, *Republic* 6.509 b, in *Dialogues of Plato,* 2:372. See Goldschmidt, *Platonisme et pensée,* p. 39.

46. Plato, *Republic* 7.518 c, in *Dialogues of Plato,* 2:380; see also *The Sophist* 248 e.

47. Plato, *Republic* 7:517 b–c, in *Dialogues of Plato,* 2:379.

48. Plato, *Phaedo* 66 e, in *Dialogues of Plato,* 1:450.

49. Ibid., 67 a, 1:450.

50. Plato, *Timaeus* 92 c, in ibid., 3:667.

51. Plato, *Theaetetus* 176 b, in ibid., 3:215.

52. Plato, *Cratylus* 431–32, in ibid., 3:96.

53. Plato, *Republic* 10.595 b.

54. See Pierre-Maxime Schuhl, *Platon et l'art de son temps* (Paris: Alcan, 1933).

55. Plato, *Parmenides* 165 c–d, in *Dialogues of Plato,* 2:717.

56. See Plato, *Laws* 7.797 d–e.

57. Ibid., 7.656 e–657 a, in *Dialogues of Plato,* 4:222.

58. Plato, *Statesman* 299 d, in ibid., 3:515–16.

59. Plato, *Republic* 5.457 b, in ibid., 2:312.

60. Ibid., 5.398 a–b, in ibid., 2:245.

61. See Plato, *The Sophist* 265–68.

62. See ibid., 266 c; *Dialogues of Plato,* 3:425.

63. See Plato, *Republic* 10.595–96, in *Dialogues of Plato,* 2:468–69.

64. See Plato, *The Sophist* 234 d: The man capable of producing everything fabricates only "homonyms" of reality. The "simulacrum" is condemned.

65. Plato, *Dialogues of Plato,* 2:477.

66. See Plato, *Laws* 2.667 e–669 b.

67. Plato, *Republic* 10.607, in *Dialogues of Plato,* 2:483.

68. Ibid., 607 c.

69. See Plato, *Timaeus* 27–29, in ibid., 3:716–17.

70. See Plato, *Laws* 10.902 e–903 a.

71. See Plato, *Phaedo* 110.

72. Ibid., 109 c–d, in *Dialogues of Plato,* 1:494.

73. Plato, *Phaedrus* 247.

74. Plato, *Dialogues of Plato*, 3:154.

75. Plato, *Phaedrus* 247 c, in *Dialogues of Plato*, 3:154.

76. See Plato, *The Symposium* 201–12.

77. Plato, *Dialogues of Plato*, 1:326.

78. Ibid., 211 d.

79. See Plato, *Phaedrus* 248–49.

80. On the relation between the beautiful and measure, see Aristotle, *Poetica* 1450 b; *Politica* 1326 a–b.

81. See Aristotle, *Ethica Nicomachea*, in *The Works of Aristotle*, 9:1178 b.

82. Ibid., 9:1177–78 a.

83. See Aristotle, *Poetica* 1449 b.

84. Aristotle, *Ethica Eudemia*, in *The Works of Aristotle*, 9:1249 a.

85. See Aristotle, *Metaphysica* 1051 a.

86. Aristotle, *Ethica Nicomachea*, in *The Works of Aristotle*, 9:1177 b.

87. Aristotle, *Physica* 192 a, in ibid., 2:192 a.

88. See Papaioannou, *L'art grec*, p. 104.

89. Aristotle, *Metaphysica*, in *The Works of Aristotle* 8:1032 a.

90. Ibid., 1032 b.

91. Ibid.

92. Aristotle, *Physica*, in *The Works of Aristotle*, 2:199 a.

93. Aristotle, *Metaphysica*, in ibid., 8:1034 b.

94. See Aristotle, *Physica* 192 b.

95. Aristotle, *Ethica Nicomachea*, in *The Works of Aristotle*, 9:1140 a.

96. Ibid. [translation modified].

97. Aristotle, *Poetica*, in *The Works of Aristotle*, 11:1447 a.

98. Ibid., 1454 b.

99. Aristotle, *Rhetorica*, in *The Works of Aristotle*, 11:1371 b.

100. Aristotle, *Poetica*, in ibid., 11:1448 b. Saint Thomas Aquinas quotes this passage and makes it key to his aesthetics. See below, pp. 149 ff.

101. Aristotle, *De partibus animalium*, in *The Works of Aristotle*, 5:687 a.

102. See Cicero, *De natura deorum* 2.22, in *Cicero*, with English translation by H. Rackham (Cambridge: Harvard University Press, 1972), 19:179.

103. Ibid., 2.23, 19:179–81.

104. See ibid., 2.14, 19:159.

105. See ibid., 2.24.

106. See ibid 2.32–35.

107. Cicero, *Tusculanae Disputationes* 1.26, with English translation by J. E. Kind (Cambridge: Harvard University Press, 1960), p. 77.

108. See Irwin Panofsky, *Idea: A Concept in Art Theory*, trans. Joseph J. S. Peake (Columbia: University of South Carolina Press, 1968).

109. Cicero, *Orator ad Brutum* 2.7, quoted in Panofsky, *Idea*, p. 12.

110. See Seneca, *Ad Lucilium epistulae morales* 88.18.

111. See Pliny, *Naturalis historia* 35.17.

112. Philostratus the Elder, *Imagines* 1.1, with English translation by Arthur Fairbanks (Cambridge: Harvard University Press, 1960), p. 3.

113. See Pliny, *Naturalis historia* 35.64; and Cicero, *De inventione* 2.1.1.

114. Panofsky, *Idea,* p. 36 [translation slightly modified].

115. Dio Chrysostom, *Olympic Discourse,* in *Discourses,* with English translation by J. W. Cohoon (Cambridge: Harvard University Press, 1961), 2:63.

116. Plotinus, *The Enneads* 5.8.9, trans. Stephen Mackenna (London: Faber and Faber, 1956), pp. 429–30.

117. Ibid., 5.2.2, p. 381.

118. See ibid., 6.4.7.

119. See Henri-Charles Puech, *En quête de la gnose* (Paris: Gallimard, 1978); vol. 1, *Position spirituelle et signification de Plotin,* p. 68.

120. Plotinus, *The Enneads* 6.9.6, p. 619.

121. Ibid., 6.9.5, p. 619.

122. Ibid., 5.8.8, p. 429.

123. Ibid., 1.6.8.

124. See Puech, *En quête de la gnose,* 1:65.

125. Plotinus, *The Enneads* 4.8.1, p. 357.

126. Ibid., 1.6.8, p. 63.

127. Ibid., 6.9.4, p. 616.

128. Ibid., 6.9.8, pp. 621–22.

129. Ibid., 6.7.31, pp. 585–86.

130. Ibid., 6.9.10, p. 624.

131. Pierre Hadot, "La fin du paganisme," in Henri-Charles Puech, ed., *Histoire des religions* (Paris: Gallimard, "Encyclopédie de la Pléiade," 1972), 2:82.

132. Plotinus, *The Enneads* 6.7.34, p. 588.

133. Ibid., 2.9.18, p. 151.

134. Ibid., 5.8.9, p. 429.

135. Ibid., 5.8.1, p. 422.

136. Ibid., 5.8.1, p. 422–23.

137. Ibid., 1.6.2.

138. Ibid., 1.6.1. See Panofsky, *Idea,* pp. 29–30, 189.

139. André Grabar, "Plotin et les origines de l'esthétique médiévale," reprinted in *Les origines de l'esthétique médiévale* (Paris: Macula, 1992), p. 33. Grabar links certain traits of Byzantine art to neo-Platonism: elongated members, frontalization of volumes, emaciated figures, hieratic poses, and so on.

140. Plotinus, *The Enneads* 6.9.10, p. 624.

141. Plotinus, *The Enneads;* cited in Panofsky, *Idea,* p. 30.

142. See Panofsky, *Idea,* p. 30.

143. Plotinus, *The Enneads* 6.7.33, pp. 587–88.

144. See Puech, *En quête de la gnose* 1:79. See also Plotinus, *The Enneads* 6.7.33.

145. *Epinomis* 980 a, in Plato, *Philebus and Epinomis,* trans. A. E. Taylor (Toronto and New York: Thomas Nelson and Sons, 1956), p. 232. There are doubts about whether this appendix to *Laws* was written by Plato. It expresses the beliefs of the Academy during the first generation of his disciples. Festugière calls it "the gospel of a new religion" because it posits new gods.

146. Ibid., 983 e–984 a, p. 237.

147. Cited by A.-J. Festugière, *La révélation d'Hermès Trismégiste* (Paris: Les Belles Lettres, 1950–53), 2:233.

148. See ibid., p. 234.

149. Plutarch, *De tranquillitate animi* 20, in *Moralia,* with an English translation by W. C. Helmbold (Cambridge: Harvard Univesity Press, 1961), p. 239.

150. See Justin Martyr, *Dialogue with Trypho a Jew* 2, in *Marcus Aurelius and His Times: The Transition from Paganism to Christianity* (Roslyn, N.Y.: Walter J. Black, 1945), p. 251; also quoted in Festugière, *La révélation d'Hermès* 1:11.

151. Hermes Trismegistus, treatise 5.2–6 [my translation from the French].

152. Ibid., treatise 11.22.

153. See treatise 11.19.

154. Festugière, *La révélation d'Hermès* 2.63.

155. See Hermes Trismegistus, treatise 12.

156. See Festugière, *La révélation d'Hermès* 1:283 ff.

157. Hermes Trismegistus, *Asclepius* 23–24.

158. Augustine, *The City of God* 8.23.

159. See Frances Yates, *Giordano Bruno* (Chicago: University of Chicago Press, 1964), p. 44.

160. Iamblicus, *The Mysteries of Egypt* 1.19–20 [my translation from the French].

161. Ibid., 3.28, 29.

162. *Life of Proclus,* cited in Jean Trouillard, *La mystagogie de Proclus* (Paris: Les Belles Lettres, 1982), p. 34.

163. See Proclus, *In rem publicam* 1.40.1–4; quoted in Trouillard, *La mystagogie,* p. 42.

164. Yates, *Giordano Bruno,* p. 104.

165. Quoted in Pierre Levêque, *Le monde hellénistique* (Paris: Armand Colin, 1969), p. 169.

166. Plutarch, *Life of Antony* 75, in *Plutarch's Lives,* with English translation by Bernadotte Perrin (Cambridge: Harvard University Press, 1955), 9:309.

167. Celsus, *Against the Christians* 66 [my translation from the French].

168. See R. Minnerath, *Les Chrétiens et le monde* (Paris: Gabalda, 1973), p. 204.

169. See Henri-Irénée Marrou, *Nouvelle histoire de l'Église* (Paris: Éd. du Seuil, 1963), 1:104.

Chapter Two

1. Exodus 20:25. [Unless otherwise noted, biblical passages are from the King James Version].

2. Exodus 32:1–4.

3. See Exodus 32:28.

4. Leviticus 26:1.

5. Deuteronomy 4:15–18.

6. Deuteronomy 4:19–20.

7. Deuteronomy 27:15.

8. Exodus 23:24.

9. Exodus 34:12–14.

10. See *Dictionnaire de théologie catholique,* s.v. "idolâtrie."

11. Isaiah 37:19.

12. See Origen, *Homily on Exodus* 8.

13. In the great temple of Taipei, I saw statues put in the corner to do penance, face to the wall, because they had proved so ineffectual.

14. Plotinus, *The Enneads* 4.3.11, p. 332.

15. Thomas Aquinas, *Summa theologica* 2a.2ae, q. 94, art. 1., in *Summa Theologica of Saint Thomas Aquinas*, translated by the Fathers of the Dominican Province (Westminster, Md.: Christian Classics, 1981), 3:1590.

16. Ibid.

17. See Numbers 25:1–13.

18. 2 Machabees 12:40 [Douay Version].

19. Theodor Mommsen, *History of Rome*, bk. 6, chap. 11, "The Government of Herod" [my translation from the French].

20. Book of Wisdom 12:24, 12:25 [Douay Version].

21. Book of Wisdom 13:1, 2–3, 16, 17–18.

22. Book of Wisdom 14:12, 15:4–5, 16:6–7.

23. 1 Kings 19:9–13.

24. Exodus 3:6.

25. Isaiah 45:15.

26. Isaiah 55:8.

27. Longinus, *On the Sublime* 7, in *Aristotle*, trans. Doreen C. Innes (Cambridge: Harvard University Press, 1995), 23:191.

28. Genesis 3:7–8.

29. Genesis 32:30.

30. Exodus 33:11.

31. Exodus 33:18–23.

32. Psalms 27:8.

33. Exodus 24:9–11.

34. Ezekiel 1:26.

35. Numbers 21:8.

36. See 2 Kings 18:4.

37. See 2 Chronicles 3–4.

38. See Flavius Josephus, *Jewish Antiquities* 8.7.15.

39. Tacitus, *The Histories* 5.5, in *"The Histories" and "The Annals,"* with English translation by John Jackson (Cambridge: Harvard University Press, 1962), 2:183.

40. See the Jerusalem Talmud, *Abodah Zarah* 4:4; cited in Gabrielle Sed-Rajna, "L'argument de l'iconophobie juive," in François Boespflug and Nicolas Lossky, eds., *Nicée II* (Paris: Éd. du Cerf, 1987), p. 85 [my translation from the French].

41. Ibid.

42. See Marcel Simon, *La civilisation de l'Antiquité et le Christianisme* (Paris: Arthaud, 1972), p. 366. See also Gabrielle Sed-Rajna, *L'art juif* (Paris: PUF, 1985), pp. 31, 66.

43. Cited in Sed-Rajna, *L'art juif*, p. 86.

44. See Gershom Scholem, *Le nom et les symboles de Dieu dans la mystique juive* (Paris: Éd. du Cerf, 1983), p. 61.

45. See Moses Maimonides, *The Guide of the Perplexed* 1.57, trans. Shlomo Pines (Chicago and London: University of Chicago Press, 1963), p. 130.

46. Maimonides gives this very strange translation of Psalm 65:2 *(Lekha doumiâ tehilâ)* in ibid., 1.59.

47. See Roland Goetschell, *La Kabbale* (Paris: PUF, 1985), p. 105.

48. Gershom Scholem, *On the Kabbalah and Its Symbolism*, trans. Ralph Mannheim (New York: Schocken, 1965), pp. 103–4.

49. *The Holy Qur-ān,* with English translation and commentary, rev. and ed. Presidency of Islamic Researches, IFTA (Kingdom of Saudi Arabia: King Fahd Holy Qur-ān Printing Complex, 1990).

50. See Louis Gardet, *L'Islam* (Paris: Desclée de Brouwer, 1970), p. 63.

51. See *Le Coran,* trans. Denise Masson (Paris: Gallimard, 1967), and the translator's note on sura 112.

52. See Assadullah Souren Melikian-Chirvani, "L'islam, le verbe et l'image," in Boespflug and Lossky, *Nicée II,* p. 92.

53. See Richard Ettinghausen and Oleg Grabar, *The Art and Architecture of Islam* (New York: Pelican History of Art, 1987), pp. 45 ff.

54. Quoted in Melikian-Chirvani, "L'islam, le verbe et l'image," p. 114 [my translation from the French].

55. See ibid., pp. 99, 109.

56. Ferdowsi, cited ibid.

57. See Gardet, *L'Islam,* pp. 219–21.

58. Augustine, *De trinitate* 1.11 [my translation from the French].

59. Genesis 1:27.

60. John 14:8–9.

61. See Henri Crouzel, *Théologie de l'image de Dieu chez Origène* (Paris: Lethielleux, 1956), p. 47.

62. Philo, *De opificio mundi,* par. 25.

63. Ibid., par. 69, in *Philo,* with an English translation by F. H. Colson and G. H. Whitaker (Cambridge: Harvard University Press, 1962), 1:55.

64. Ibid., par. 134, 1:107.

65. Apparently, Saint John finds the word "image" inadequate to express the community of the two Persons. Christ is not only *eikōn,* he is *theos.*

66. Plotinus, *The Enneads* 2.9.8, p. 130.

67. Irenaeus, *Against Heresies* 4.39.2–3 [my translation from the French].

68. See ibid., 2.2.1, 4.7.4.

69. See ibid., 5.9.14.

70. Irenaeus, *Demonstration of Apostolic Preaching* 22 [my translation from the French].

71. Irenaeus, *Against Heresies* 5.16.2 [my translation from the French].

72. Ibid., 5.6.1.

73. Ibid., 2.9.1.

74. Ibid., 3.5.3.

75. Henri Crouzel, *Origène* (Paris: Lethielleux, 1985), p. 8.

76. Plato, *Theaetetus* 176 a–b, in *Dialogues of Plato,* 3:275.

77. Colossians 1:15.

78. Origen, *Treatise on Principles* 1.2.4 [my translation from the French].

79. Origen, *Commentary on John* 20.22 [my translation from the French].

80. Origen, *Homelies on Genesis* 13.4 [my translation from the French].

81. Origen, *Commentary on John* 2.16 [my translation from the French].

82. Ibid., 6.34.

83. Origen, *Treatise on Principles* 2.9.6.

84. Origen, *Against Celsus* 8.18 [my translation from the French].

85. Ibid., 8.17.

86. Cited in Jean Daniélou, *Platonisme et théologie mystique* (Paris: Aubier, 1944), p. 49 [my translation from the French].

87. Gregory of Nyssa, *On the Making of Man* 5 [my translation from the French].

88. Cited in Daniélou, *Platonisme et théologie mystique*, p. 55 [my translation from the French].

89. Ibid.

90. Gregory of Nyssa, *The Life of Moses* 189 ff. [my translation from the French].

91. See R. Leys, *L'image de Dieu chez saint Grégoire de Nysse* (Paris and Brussels, 1951), pp. 50–51.

92. Gregory of Nyssa, *Treatise on Psalms* 44.441 c.

93. See Leys, *L'image de Dieu*, p. 109.

94. Gregory of Nyssa, *Homily on the Fourth Beatitude;* cited in Daniélou, *Platonisme et théologie mystique*, p. 211 [my translation from the French].

95. Cited by Daniélou, *Platonisme et théologie mystique*, p. 222.

96. Gregory of Nyssa, *The Life of Moses* 162–63.

97. Ibid., 166.

98. Ibid., 220.

99. Ibid., 233.

100. Ibid., 238.

101. Ibid., 244.

102. Gregory of Nyssa, *On the Making of Man* 161 c–164 a.

103. See Robert Klein, *La forme et l'intelligible* (Paris: Gallimard, 1970), "L'éclipse de l'oeuvre d'art," pp. 403 ff.

104. Augustine, *De genesi ad litteram* 3.20.31 [my translation from the French].

105. Augustine, *De trinitate* 14.8.11 [my translation from the French].

106. Ibid., 14.4.6.

107. See Augustine, *De genesi ad litteram* 3.22.34.

108. See ibid., 6.19.30.

109. See Étienne Gilson, *Introduction à l'étude de saint Augustin* (Paris: Vrin, 1987), p. 219.

110. See ibid., p. 261.

111. Ibid., p. 146.

112. Ibid., p. 244.

113. Augustine, *Contra epistolam manichaei quam vocant Fundamenti* 36.41 [my translation from the French].

114. Augustine, *De musica*, 6.17.56 [my translation from the French].

115. See ibid., 6.11.29.

116. Gilson, *Introduction à l'étude de saint Augustin*, p. 263.

117. See Augustine, *De genesi ad litteram* 1.15.29; and Gilson, *Introduction à l'étude de saint Augustin*, p. 263.

118. Gilson, *Introduction à l'étude de saint Augustin*, pp. 267–68.

119. Augustine, *De vera religione* 33.59–60.

120. Augustine, *De genesi ad litteram* 1.7.13.

121. See Augustine, *De trinitate* 1.2.5, 11.4.7.

122. Bossuet, *Élévations sur les mystères*, 2d week, 7th elevation.

Chapter Three

1. Cited in Egon Sendler, *L'icône* (Paris: Desclée de Brouwer, 1981), p. 17 [my translation from the French].

2. See Marcel Pacaut, *L'iconographie chrétienne* (Paris: P.U.F., 1962), pp. 58–61.

3. Cited in Leonid Ouspensky, *Essai sur la théologie de l'icône* (Paris: Éd. de l'Exarchat patriarchal, 1960).

4. Isaiah 53:2.

5. Philippians 2:7.

6. Philosophy had already reflected upon the ugliness of Socrates.

7. John of Damascus, *The Orthodox Faith* 4.16.

8. See André Grabar, *L'iconoclasme byzantin* (Paris: Flammarion, 1984), pp. 33–38.

9. See Kostas Papaioannou, *La peinture byzantine et russe* (Lausanne: Rencontre), p. 12.

10. Ibid., p. 14.

11. Ibid., p. 15. See also Grabar, "Plotin et les origines de l'esthétique médiévale," and André Grabar, *Les voies de la création en iconographie chrétienne* (Paris: Flammarion, 1979).

12. For this paragraph, see Juan Miguel Garrigues, "Voir les cieux ouverts," *Vie spirituelle* 597 (1973).

13. Cited ibid., p. 538.

14. See Grabar, *L'iconoclasme byzantin,* p. 18.

15. See ibid., p. 29.

16. See Peter Brown, *Society and the Holy in Late Antiquity* (Berkeley: University of California Press, 1982).

17. See Christoph von Schönborn, *L'icône de Christ* (Freiburg: Éd. universitaires, 1976), and "L'icône du Verbe incarné," *Sources* 14 (1988).

18. Cited in Schönborn, *L'icône du Christ,* p. 26.

19. Ibid., p. 29.

20. "Lettre 38 of Saint Basil to His Brother Gregory," 8.19–30, in *Saint Basil: The Letters,* with English translation by Roy J. Defarrari (Cambridge: Harvard University Press, 1961), 1:225, 227. Cited in Schönborn [where the letter is attributed to Gregory of Nyssa—J.M.T.], *L'icône du Christ,* p. 42.

21. John 14:28.

22. Basil the Great, *On the Holy Spirit* 26; cited in Schönborn, *L'icône du Christ* [my translation from the French].

23. Cited in Schönborn, *L'icône du Christ,* p. 56.

24. Ibid., p. 70.

25. See H. Campenhausen, *The Fathers of the Greek Church,* trans. Stanley Goodman (New York: Pantheon, 1955), p. 145.

26. Maximus the Confessor, *Ambigua* 10; cited in Schönborn, *L'icône du Christ,* p. 132.

27. 2 Corinthians 3:18.

28. Nietzsche echoes: "deep by dint of being superficial." And Valéry: "The deepest thing about us is our skin."

29. See Ouspensky, *Essais sur la théologie,* p. 49.

30. Text in Boespflug and Lossky, *Nicée II,* pp. 33–35.

31. See Grabar, *L'iconoclasme byzantin,* p. 177.

32. See ibid., p. 135.

33. Cited in Schönborn, *L'icône du Christ,* p. 161.

34. Plotinus, *The Enneads* 1.6.8, p. 63.

35. On John of Damascus, see Schönborn, *L'icône du Christ,* pp. 191–200.

36. On Nicephorus, see ibid., pp. 203–17. Note that Nicephorus was in agreement with the Latin position: take the drama away from the question of the image, place it on a rhetorical and illustrative plane.

37. On Theodore the Studite, see Schönborn, *L'icône du Christ,* pp. 217–34. Theodore gives the most elegant and most complete solution in theology, but also the most extreme and the most likely to sacralize and fix the icon. He is diametrically opposed to the Latins. See below, 149 ff.

38. Cited in Sendler, *L'icône,* p. 36.

39. I owe this profound formulation to Father Rouleau, Society of Jesus.

40. The most reliable and competent exposition of this matter is in Sendler's *L'icône.*

41. Cited in Sendler, *L'icône,* p. 57.

42. See Xenophon, *Memorabilia* 1.4.13.

43. See Sendler, *L'icône,* p. 72.

44. Eugene Trubetzkoi, *Trois études sur l'icône* (Paris: Y.M.C.A., Press-L'oeil, 1986), p. 22.

45. Ibid., p. 49.

46. Ibid., p. 30.

47. Ibid., p. 16.

48. See Boris Bobrinskoy, "L'icône, sacrement du Royaume," in Boespflug and Lossky, *Nicée II,* pp. 367 ff.

49. Ibid., p. 373.

50. Vladimir Veidle, *Les icônes byzantines et russes* (Milan: Electra, 1962), p. 5.

51. Olivier Clément, "Bible et icône, de la parole aux images," *Les quatre fleuves* 4 (1974): 121.

52. See Ouspensky, *Essai sur la théologie,* pp. 124, 201.

53. Ibid., p. 216.

54. See ibid., p. 177.

55. See ibid., pp. 212–13.

56. Clément, "Bible et icône," p. 121.

57. Trubetzkoi, *Trois études sur l'icône,* p. 97.

58. Ibid., p. 35. There are no icons of the wedding of Canaan, the meal at the home of Levi, the meal at the home of Simon, or, in general, anything related to the corporeal human condition of Christ. The Monophysite current is shored up by the iconoclastic current.

59. John Beckwith, *Early Christian and Byzantine Art* (Harmondsworth, Middlesex: Penguin, 1970; repr. 1986), p. 346.

Part Two

1. The image in its sacred form, under surveillance and undermined by sacralization, became depleted. The profane image, devalued on principle, did not thrive.

Chapter Four

1. See Gregory the Great, *Epistola XIII. Ad Serenum Massiliensem episcopum,* Migne's patrology, vol. 77, cols. 1128–30. Text translated in Daniele Menozzi, *Les images, l'Église et les arts visuels* (Paris: Éd. du Cerf, 1991) [my translation from the French]. This anthology, judiciously glossed, provides the main texts of the authorities regarding images.

2. Cited by Aidan Nichols, *Le Christ et l'art divin* (Paris: Téqui, 1988), p. 67.

3. Horace, *Ars poetica,* line 361. On the humanist fate of this line and the reversal of its meaning, see Rensselaer W. Lee, *Ut pictura poesis: The Humanistic Theory of Painting* (New York: W. W. Norton, 1967).

4. See Menozzi, *Les images, l'Église,* p. 26.

5. See Jean-Claude Schmitt, "L'Occident, Nicée II et les images du VIIIe au XIIIe siècle," in Boespflug and Lossky, *Nicée II,* pp. 271–301.

6. Texts in Menozzi, *Les images, l'Église,* pp. 104 ff.

7. See Schmitt, "L'Occident, Nicée II et les images," p. 274.

8. See ibid.

9. Text in Menozzi, *Les images, l'Église,* p. 121.

10. See ibid., p. 128.

11. See Étienne Gilson, *La philosophie au Moyen Age* (Paris: Payot, 1962), pp. 88 ff.

12. See Dionysius the Areopagite, *Divine Names* 697 c.

13. Dionysius the Areopagite, *Celestial Hierarchy* 125 a [my translation from the French].

14. See ibid., 140 b.

15. See Thomas Aquinas, *Summa theologica* 1a, q. 1, art. 9.

16. See Marc Sherringham, *Introduction à la philosophie esthétique* (Paris: Payot, 1992), p. 113.

17. See ibid., p. 108. See also Edgar de Bruyne, *Études d'esthétique médiévale* (Bruges: De Tempel, 1946), vol. 3, chap. 6, "Saint Bonaventure," pp. 189–226.

18. Bonaventura, *Itinerarium mentis in Deum* 2.3 [my translation from the French].

19. Ibid., 2.5.

20. Ibid.

21. Cited by de Bruyne, *Études d'esthétique médievale,* 3:211.

22. Bonaventura, *Itinerarium mentis in Deum* 1.2.

23. Ibid., 1.15.

24. Ibid., 7.7.

25. Ibid., 7.5.

26. Bonaventura, *Liber sententiarum* 3.9., art. 1, q. 2: cited by Menozzi, *Les images, l'Église,* p. 132.

27. See de Bruyne, *Études d'esthétique médievale,* 3:213.

28. See Étienne Gilson, *Le Thomisme* (Paris: Vrin, 1965), and *Peinture et réalité* (Paris: Vrin, 1958); Jacques Maritain, *Art et scolastique* (Paris, 1928); de Bruyne, *Études d'esthétique médiévale;* and Umberto Eco, *The Aesthetics of Thomas Aquinas* (Cambridge: Harvard University Press, 1988).

29. See Thomas Aquinas, *Summa theologica* 1a, 2ae, q. 57, art. 4.

30. Ibid., art. 5, 2:831.

31. See ibid., 2a, 2ae, q. 169, art. 2, 4:1878 [translation slightly modified].

32. See ibid., q. 168, art. 2.

33. See de Bruyne, *Études d'esthétique médiévale*, 3:281 ff.
34. See Thomas Aquinas, *Summa theologica* 1a, q. 5, art. 4.
35. See Eco, *The Aesthetics of Thomas Aquinas*, p. 58.
36. See de Bruyne, *Études d'esthétique médiévale*, 3:286.
37. Thomas Aquinas, *Summa theologica* 1a, q. 91, art. 3, 1:464.
38. See de Bruyne, *Études d'esthétique médiévale*, 3:295.
39. Thomas Aquinas, *Summa theologica* 1a, q. 39, art. 8, 1:201.
40. Ibid.
41. See Eco, *The Aesthetics of Thomas Aquinas*, pp. 202 ff.
42. See ibid., p. 206.
43. See Thomas Aquinas, *Summa theologica*, 1a, q. 35, art. 1.
44. See ibid., art. 2.
45. Ibid., 3a, q. 25, art. 3, 4:2149.
46. Ibid., art. 4, 4:2151.
47. Ibid., art. 8, 4:2152.
48. See Menozzi, *Les images, l'Église*, p. 34.
49. See *Dictionnaire de théologie catholique*, s.v. "culte des images," 7:1, col. 826.
50. Except, perhaps, by allusion.

Chapter Five

1. See Menozzi, *Les images, l'Église*, p. 132.
2. See Abbot Broussole, "Le crucifix," in G. Bardy and A. Tricot, eds., *Le Christ* (Paris: Bloud et Gay, 1946), pp. 977–1048.
3. Cited ibid., p. 987.
4. Hegel, *Aesthetics,* p. 538.
5. Thomas of Celano, *Life of Saint Francis;* cited in Menozzi, *Les images, l'Église,* p. 129.
6. See Menozzi, *Les images, l'Église,* p. 36.
7. See Anthony Blunt, *Artistic Theory in Italy, 1450–1600* (London and New York: Oxford University Press, 1968), chap. 4.
8. See Leonardo da Vinci, *The Notebooks of Leonardo da Vinci,* trans. Edward Mac-Curdy (New York: George Braziller, 1958), 2:854.
9. See Jean Seznec, *La survivance des dieux antiques* (Paris: Flammarion, 1980), p. 21.
10. See ibid., p. 29.
11. See ibid., pp. 70–73.
12. See ibid., p. 85.
13. See ibid., p. 106.
14. Erasmus, *Enchiridion militis Christiani;* cited in Seznec, *La survivance des dieux antiques,* p. 93.
15. See Seznec, *La survivance des dieux antiques,* pp. 170, 193.
16. I am, of course, alluding to the rightly famous article by Irwin Panofsky, "Poussin and the Elegiac Tradition," in *Meaning in the Visual Arts* (New York: Doubleday, 1955), pp. 295–321.
17. Wycliffe, *Sermon* 13 (1375); text in Menozzi, *Les images, l'Église,* p. 148.
18. Savonarola, *Sermon on the Psalms* (1494); text in Menozzi, *Les images, l'Église,* p. 156.

19. Cited in Blunt, *Artistic Theory in Italy,* p. 71.

20. See Menozzi, *Les images, l'Église,* pp. 152–55.

21. "Injunctions given by Edward VI," *Documentary Annals of the Reformed Church of England,* ed. E. Cardwell (Oxford, 1844), p. 221; "Queen Elizabeth's Letters," ibid., p. 296. Edward VI's decree (1547) applied to the diocese of Canterbury; Elizabeth I extended it to the entire kingdom in 1559.

22. Text in Menozzi, *Les images, l'Église,* p. 189.

23. Blunt, *Artistic Theory in Italy,* p. 108.

24. Text in ibid., p. 206.

25. See François Boespflug, *Dieu dans l'art* (Paris: Éd. du Cerf, 1984).

26. Cited ibid., p. 253.

27. See ibid., p. 255.

28. Ibid., p. 259.

29. See ibid., p. 222.

30. The *Stoglav,* chap. 43. Response of the assembly regarding the painters of icons and venerable icons.

31. See Blunt, *Artistic Theory in Italy,* chap. 8.

32. Text in Menozzi, *Les images, l'Église,* p. 194.

33. See André Chastel, "Le concile de Nicée et les théologiens de la réforme catholique," in Boespflug and Lossky, *Nicée II,* pp. 333–54. Text of the *Discorso* of 1594 in Menozzi, *Les images, l'Église,* pp. 198 ff.

34. Francisco Pacheco, *Arte de la pintura* (1649) [my translation from the French].

35. See ibid.

36. See Seznec, *La survivance des dieux païens,* p. 237.

37. Cited ibid., p. 281.

38. See the Constitutions of the Society of Jesus, par. 518.

39. See Seznec, *La survivance des dieux païens,* p. 244.

40. Each week of *Exercices* begins with a contemplation of *place.*

41. Marc Fumaroli, *Ut pictura rhetorica divina,* unpublished lecture, Warburg Institute, 1993.

42. The touch-ups of the "Braghettone" corrected only the faults of decency and dealt neither with theology nor with the aesthetics of the fresco.

Part Three
Chapter Six

1. "And the children of Israel . . . borrowed of the Egyptians jewels of silver, and jewels of gold, and raiment And they spoiled the Egyptians" (Exodus 12:35–36). This text from Exodus, in which the Jews leaving Egypt take whatever spoils they can carry, has been the object of vast allegorical exegesis, both Jewish and Christian. The sense is always that the pagan inheritance is legitimately received by the people of God (Jews, then Christians).

2. See John Calvin, *Institutes of the Christian Religion,* trans. Henry Beveridle (Grand Rapids: William B. Eerdmans, 1970), bk. 1, chap. 14, pars. 3–12, pp. 144–50.

3. Ibid., chap. 11, par. 4, pp. 91–103. All subsequent quotations are taken from this chapter.

4. Ibid., par. 7, p. 96.

5. Ibid., par. 12, p. 100.

6. Hegel, *Aesthetics,* p. 885.

7. Ibid., p. 882.

8. Pascal, *Pensées,* ed. Léon Brunschvicg, no. 134. Here Pascal turns his back on Aristotle and Saint Thomas Aquinas, for whom it is not the original we admire in a painting but precisely the resemblance to the original, even if the latter is ugly. See Aristotle, *Poetica* 1448 b; *Rhetorica* 1371 b; and Thomas Aquinas, *Summa theologica* 1a, 2ae, q. 32, art. 8.

9. Pascal, *Pensées,* no. 242.

10. Ibid., no. 243.

11. According to the Eleventh Provinciale, Jesuits "slanderously" attributed a contempt of images to the nuns of Port-Royal.

12. See Pascal, *Pensées,* no. 678.

13. Ibid., no. 580.

14. Ibid., no. 72.

15. Immanuel Kant, *Critique of Judgment,* par. 25, trans. J. H. Bernard (New York and London; Hofner, 1968), p. 88.

16. "He is neither angel nor beast, but man" (Pascal, *Pensées,* no. 140).

17. Kant, *Critique of Judgment,* par. 1, p. 39.

18. See ibid., par. 5, p. 44.

19. Ibid.

20. Ibid., par. 2, p. 39.

21. Ibid., par. 14, p. 59.

22. Ibid., par. 7, p. 47.

23. Ibid., par. 33, p. 126.

24. Ibid., par. 8, p. 49.

25. Ibid., par. 32, p. 125.

26. Ibid., intro., p. 26.

27. Ibid., par. 11, p. 56.

28. Plato, *Greater Hippias* 290 e, in *The Collected Dialogues of Plato,* ed. Edith Hamilton and Huntington Cairns (New York: Random House, 1961), p. 1544. See Jean Lacoste, *L'idée de beau* (Paris: Bordas, 1986), p. 20.

29. Kant, *Critique of Judgment,* "Final Remark on Book 1."

30. Ibid., par. 15, pp. 64–65.

31. Ibid., par. 16, p. 66.

32. Ibid.

33. Ibid., par. 46, p. 150.

34. Ibid.

35. Ibid., par. 47, p. 152.

36. Ibid., "General Remark upon the Exposition of Aesthetical Reflective Judgments," p. 116.

37. See ibid., par. 26.

38. Immanuel Kant, *Observations on the Feeling of the Beautiful and Sublime,* trans. John T. Goldthwait (Berkeley and Los Angeles: University of California Press, 1960), p. 47.

39. Kant, *Critique of Judgment,* par. 23, p. 83.

40. Ibid., par. 25, p. 88.

41. Ibid.

42. Pascal, *Pensées*, no. 72.

43. Kant, *Critique of Judgment*, par. 26.

44. Ibid., par. 28, p. 101.

45. Pascal, *Pensées*, no. 347.

46. Kant, *Critique of Judgment*, par. 28, p. 104.

47. Ibid, p. 101.

48. Ibid., par. 26, p. 93.

49. Ibid., par. 27, p. 96.

50. See ibid., par. 59, pp. 197–98. See also Lacoste, *L'idée de beau*, pp. 37–40.

51. Kant, *Critique of Judgment*, par. 59, p. 198.

52. Ibid., "General Remark upon the Exposition of Aesthetical Reflective Judgments," p. 115.

53. Ibid.

54. Ibid., par. 23, p. 83.

55. Ibid., "General Remark upon the Exposition of Aesthetical Reflective Judgments."

56. See Kant, *Remarks on the Feeling of the Beautiful and Sublime*.

57. Hegel, *Aesthetics*, pp. 21–22.

58. Ibid., pp. 2, 12.

59. Ibid., p. 12 [translation modified].

60. Ibid, p. 8.

61. See ibid, p. 9.

62. Ibid., p. 30.

63. See ibid., p. 7.

64. Ibid., p. 10 [The first quotation in this paragraph is my translation from the French—J.M.T.].

65. Ibid., p. 12 [translation modified].

66. Ibid., pp. 20 ff.

67. Ibid., p. 70.

68. Ibid., pp. 83, 623.

69. Hegel, *Phenomenology of Spirit*, trans. A. V. Miller (Oxford: Oxford University Press, 1977), p. 427 [translation modified].

70. Hegel, *Aesthetics*, pp. 623–26.

71. Ibid., p. 305.

72. See ibid., p. 305.

73. See ibid, pp. 313–16.

74. Ibid., pp. 313, 316.

75. Ibid., p. 338 [translation modified].

76. Ibid., p. 318 [translation modified].

77. Ibid., p. 319 [translation modified].

78. Ibid., p. 363.

79. Ibid.

80. Ibid., p. 366.

81. Ibid., p. 371.

82. Ibid., p. 372.

83. Ibid., pp. 371–73 [translation modified].

84. Ibid., p. 433.

85. Ibid., pp. 378–79 [translation modified].

86. Ibid., p. 482.

87. Ibid., p. 732.

88. Ibid., p. 763.

89. Ibid., pp. 437–38.

90. Ibid., p. 484.

91. Ibid., p. 483.

92. Ibid.

93. Ibid., p. 535.

94. Ibid.

95. Ibid., pp. 537–38.

96. Ibid., 536.

97. Ibid. [translation modified].

98. See ibid.

99. Ibid., p. 540.

100. Ibid., pp. 541–42 [translation modified].

101. Ibid., p. 826.

102. Ibid., pp. 603–4.

103. Ibid.

104. See Raymond Vancourt, *La pensée religieuse de Hegel* (Paris: P.U.F., 1971), pp. 128–29.

105. Hegel, *Aesthetics,* p. 545.

106. This is also Friedrich's Christ.

107. Hegel, *The Spirit of Christianity and Its Fate,* in *On Christianity: Early Theological Writings by Friedrich Hegel,* trans. T. M. Knox (New York: Harper and Brothers, 1948), pp. 252–53.

108. Hegel, *Aesthetics,* p. 872.

109. Ibid., pp. 872–82. Ten pages in all, once and for all.

110. Ibid., p. 11.

111. Ibid., p. 513.

112. Ibid., p. 1092.

113. Ibid., pp. 594–95.

114. Ibid., p. 604–5.

115. Ibid, p. 605.

116. Ibid., p. 886.

117. Ibid., pp. 886–87.

118. Ibid., p. 14.

119. Kant, *Critique of Judgment,* par. 47, p. 150.

120. See Hegel, *Aesthetics,* p. 606.

121. Ibid.

Chapter Seven

1. It is true that, next to the others, there were a host of Biedermeier painters who unpretentiously stood at a distance from the loftiest ambitions. Hegel may have been thinking of them when he saw the coming of the end of art.

2. Antoine Schnapper, "La peinture française de 1774 à 1830," in the catalog *De David*

à Delacroix (Paris: R.M.N., 1974), p. 101. See also his *David* (Paris: Bibliothèque des Arts, 1980).

3. Boileau, *Traité du sublime,* in *Oeuvres complètes* (Paris: Gallimard, "Bibliothèque de la Pléiade," 1966), preface, p. 338.

4. Ibid., p. 340.

5. Diderot, *Pensées détachées sur la peinture,* in *Oeuvres esthétiques* (Paris: Garnier, 1988), p. 794.

6. See Jacques Chouillet, *L'esthétique des Lumières* (Paris: P.U.F., 1974), p. 173.

7. See Baldine Saint-Girons, preface to the French translation of Edmund Burke, *Recherche philosophique sur l'origine de nos idées du sublime et du beau* (Paris: Vrin, 1990), p. 28. See also Baldine Saint-Girons, *Fiat lux: Une philosophie du sublime* (Pau: Quai Voltaire, 1993).

8. See Burke, *Philosophical Inquiry into the Origin of Our Ideas of the Sublime and Beautiful,* Harvard Classics, ed. Charles W. Eliot, vol. 24 (New York: P. F. Collier and Son, 1909).

9. Cited by Saint-Girons, preface to Burke, *Recherche philosophique,* p. 32.

10. Burke, *The Sublime and Beautiful,* p. 36.

11. Ibid., p. 64.

12. Written in 1809 on a sketch pad; cited by L. Gowing, "Turner and the Sublime," *Times Literary Supplement,* 10 July 1981, p. 783.

13. Taine, *L'école des beaux-arts et les beaux-arts en France,* in *Essais de critique et d'histoire* (1874).

14. Baudelaire, *L'oeuvre et la vie d'Eugène Delacroix.*

15. Delacroix, "Des variations sur le beau," conclusion, in *Écrits sur l'art.*

16. Boileau, *Réflexions critiques sur quelques passages du rhéteur Longin,* in *Oeuvres complètes,* reflection 8, p. 527.

17. And also because it echoed the nonmetaphysical but rhetorical and "technical" spirit of medieval aesthetics and Latin theology. See above, pp. 149 ff.

18. In *Essai sur le beau,* cited by Chouillet, *L'ésthétique des Lumières,* p. 141. See also Augustine, *The True Religion,* 30, 31, 32.

19. John Locke, *An Essay concerning Human Understanding,* ed. J. W. Yolton (London: Everyman's Library, 1961), 1:118.

20. David Hume, *Standard of Taste, Four Dissertations* (London, 1757), pp. 208–9.

21. See Chouillet, *L'ésthétique des Lumières,* pp. 65–66.

22. Ibid., p. 81.

23. Diderot, *Lettre sur les sourds et muets à l'usage de ceux qui entendent et qui parlent.*

24. Diderot, *Pensées détachées sur la peinture,* p. 816.

25. Ibid., p. 820.

26. Baudelaire, *Lettre à Richard Wagner* (1860).

27. Baudelaire, *Richard Wagner et Tannhäuser à Paris.*

28. Ibid.

29. Charles Baudelaire, "Correspondences," in *"The Flowers of Evil" and "Paris Spleen,"* trans. William H. Crosby (Rochester, N.Y.: BOA Editions, Ltd., 1991), p. 29.

30. Ibid.

31. Baudelaire, "Benediction," ibid., p. 25.

32. Claudel, *Cinq grandes odes.*

33. Baudelaire, "Benediction," p. 27.

34. Baudelaire, *L'art philosophique.*

35. See Baudelaire, *Salon de 1859.*

36. See Baudelaire, *Le peintre de la vie moderne.*

37. See Augustine, *Confessions* 11.28.3.

38. Baudelaire, *Mon coeur mis à nu.*

39. Fromentin, *Les maîtres d'autrefois* (Paris: Le Livre de Poche, 1965), p. 235.

40. Ibid., p. 47.

41. Ibid., p. 106.

42. Cited in John Rewald, *History of Impressionism,* p. 80.

43. Joris-Karl Huysmans, "L'exposition des Indépendants," cited in Denys Riout, *Les écrivains devant l'impressionisme* (Paris: Macula, 1989), p. 296.

44. See Rewald, *History of Impressionism,* p. 30.

45. Cited ibid., p. 190 [translation modified].

46. Cited ibid., p. 71.

47. Cited ibid., p. 93.

48. Cited ibid., p. 376.

49. Cited ibid., p. 377.

50. Cited ibid., pp. 457–58.

51. Cited ibid., p. 44.

52. See ibid., p. 551.

53. Cited ibid., p. 548.

54. How quickly the Nabis evolved! Challenged by Sérusier and Aurier to take the path of spiritualist interiority, Vuillard and Bonnard preferred the painting of *interiors* to the painting of *interiority.*

55. Munch's travels through France led to a rather long "break" in his work.

56. Matisse, *Écrits et propos sur l'art* (Paris: Hermann, 1972), p. 50.

57. Ibid.

58. Ibid., p. 53.

59. Ibid., p. 45.

60. Ibid., p. 116.

61. See ibid., p. 120.

62. Ibid., p. 57.

63. Ibid., p. 51.

64. See André Fermigier, *Picasso* (Paris: Le Livre de Poche, 1968), p. 16.

65. John Golding's *Cubism* was of little help to me.

66. Fermigier, *Picasso,* p. 94.

67. See ibid., p. 68.

68. See ibid., p. 261.

69. See ibid.

70. Hegel, *Aesthetics,* pp. 600–601.

71. Texts in Menozzi, *Les images, l'Église,* pp. 222 ff.

72. See above, pt. 2. It was no always so. In French Catholic circles, there were also pockets of anxiety and of shadow. Horror of things relating to the flesh was often present in the schools and elsewhere. The very precarious situation of Catholicism in French political life fed a current of despair, apocalypticism, or a spiritualism of refuge. These torments are reflected and concentrated in religious painting.

73. Cited by André Fermigier, *Millet* (Geneva: Skira, 1987), p. 73.

74. Cited ibid., p. 92.

75. Cited by Bruno Foucart, *Le renouveau de la peinture religieuse en France* (Paris: Arthena, 1987), p. 297.

76. Van Gogh, *The Complete Letters of Vincent van Gogh,* 3 vols. (Boston: Little, Brown, 1991), letter 543, 3:56.

77. Ibid., letter 520, 3:7.

78. Ibid., letter 518, 3:2.

79. Hegel, *Aesthetics,* pp. 351–52.

80. See Pierre-Louis Mathieu, *La génération symboliste* (Geneva: Skira, 1990), p. 80.

81. Cited ibid., p. 81.

82. Van Gogh, *The Complete Letters,* letter 13, 1:18.

83. See Sed-Rajna, *L'art juif.*

84. Matisse, *Écrits et propos sur l'art,* p. 238.

85. See Foucart, *Le renouveau de la peinture religieuse.*

86. Chateaubriand, *Génie du christianisme,* pt. 3, bk. 1, chap. 3.

87. See Foucart, *Le renouveau de la peinture religieuse,* p. 103.

88. See ibid., p. 69.

89. See Baudelaire, *Salon de 1859.*

90. Foucart, *Le renouveau de la peinture religieuse,* p. 336.

91. Cited ibid., p. 27.

92. See ibid., p. 39.

93. Cited ibid., p. 43.

94. Cited ibid., p. 336.

95. Cited ibid., pp. 17–18.

96. Flaubert, *L'éducation sentimentale,* pt. 3, chap. 1.

97. See Foucart, *Le renouveau de la peinture religieuse,* p. 266.

98. Cited ibid., p. 133.

99. Cited by Sabine de Lavergne, *Art sacré et modernité* (Paris: Culture et Vérité, 1992), p. 134.

100. Cited ibid., p. 196.

101. Cited ibid.

102. See ibid., p. 199.

103. Cézanne began attending church again in his old age.

104. See Steven Adams, *The Art of the Pre-Raphaelites* (London: Apple Press, 1988), p. 18.

105. See Timothy Hilton, *The Pre-Raphaelites* (London: Thames and Hudson, 1970), p. 35.

106. Cited by Adams, *The Art of the Pre-Raphaelites,* p. 35.

107. John Ruskin, *The Art of England,* pt. 1, "Realistic Schools of Painting," in *The Works of Ruskin,* 39 vols. (New York: Longmans, Green, 1908), 33:271.

108. Hilton, *The Pre-Raphaelites,* p. 59.

109. Cited by Gérard-Georges Lemaire, *Les préraphaélites entre l'enfer et le ciel* (Paris: Christian Bourgois, 1989), p. 322.

110. *Romantic Agony* is the English title of the famous book by Mario Praz, *La carne, la morte e il diavolo nella letteratura romantica* (1966).

111. In *The Pre-Raphaelites,* Hilton speaks of a "standstill" (p. 189).

112. Henri Focillon, *La peinture au XIX^e siècle* (Paris: Flammarion, 1991), 1:362.

113. See *Dictionnaire des courants picturaux* (Paris: Larousse, 1990), s.v. "nazaréens."

114. Focillon, *La peinture au XIX^e siècle,* 1:101.

115. The Russian poet and diplomat was posted in Berlin and admired Friedrich. He recommended him to Alexander I and Nicholas I.

116. Carl Gustav Carus and Caspar David Friedrich, *Neuen Briefe über Landschafts-malerei zuvor ein Brief von Goethe als Einleitung* (Leipzig, 1831); translated into French as *De la peinture de paysage dans l'Allemagne romantique* (Paris: Klincksieck, 1983), p. 155 [my translation from the French].

117. See Henri Zerner and Helmut Börsch-Supan, *Caspar David Friedrich* (Milan: Rizzoli Editore, 1976); translated into French as *Caspar David Friedrich* (Paris: Flammarion, 1976), p. 5 [my translation from the French].

118. Carus and Friedrich, *De la peinture de paysage,* p. 154.

119. Ibid., p. 12.

120. Ibid., p. 59.

121. Ibid., p. 91.

122. Ibid., p. 67.

123. Ibid., p. 80.

124. Ibid., p. 123.

125. Ibid., p. 131.

126. Ibid., p. 128.

127. Cited by Helmut Börsch-Supan, *Caspar David Friedrich* (New York: George Braziller, 1974), p. 78.

128. Cited ibid., pp. 82–83 [translation modified].

129. Ibid., p. 134.

130. Cited by Zerner and Börsch-Supan, *Caspar David Friedrich,* p. 12.

131. Carus and Friedrich, *De la peinture de paysage,* p. 149.

132. Cited by Zerner and Börsch-Supan, *Caspar David Friedrich,* p. 12.

133. Cited ibid.

134. Cited ibid.

135. *Dictionnaire des courants picturaux,* s.v. "macchiaioli."

136. Focillon, *La peinture au XIX^e siècle,* 2:251.

137. On the relation between Nietzsche and Schopenhauer, see Philippe Raynaud, "Nietzsche, la philosophie et les philosophes" (unpublished article).

138. See Anne Henry, ed., *Schopenhauer et la création littéraire en Europe* (Paris: Klincksieck, 1989), pp. 17 ff.

139. See Arthur Schopenhauer, *The World as Will and Idea,* trans. R. B. Haldane and J. Kemp, 3 vols. (New York: AMS, 1977), 1:242–433.

140. Ibid., 1:243, 3:152.

141. Ibid., 3:156–57.

142. Ibid., 3:157.

143. Ibid., 3:158.

144. See ibid., 3:163–65.

145. Ibid., 1:254.

146. Ibid., 1:256.

147. Ibid., 1:238–39.

148. Ibid., 3:176.
149. Ibid., 3:177.
150. Ibid., 1:252.
151. See ibid., 1:259–70.
152. See Clément Rosset, *L'esthétique de Schopenhauer* (Paris: P.U.F., 1989), p. 51.
153. See Schopenhauer, *The World as Will and Idea*, 1:268–70.
154. See ibid., 1:297–301.
155. Ibid., 1:287.
156. Ibid., 1:399–400.
157. Ibid., 1:406.
158. Ibid., 3:346.
159. Ibid., 1:491.
160. Ibid.
161. Ibid., 1:424.
162. Ibid., 3:421.
163. See Paul Bénichou, *L'école du désenchantement* (Paris: Gallimard, 1992), p. 578.
164. Ibid., p. 584.
165. See Praz, *La carne, la morte e il diavolo nella literatura romantica,* chap. 4.
166. Schopenhauer, *The World as Will and Idea*, 1:340. I have not attempted to draw a parallel between what was happening in music and what was happening in painting at the turn of the last century.
167. Ibid., 1:255.
168. Redon's charming and delicate journal betrays no such views, however. See Odilon Redon, *A soi-même, Journal* (Paris: José Corti, 1961).
169. See Robert Goldwater, *Primitivism in Modern Art,* enlarged ed. (Cambridge and London: Harvard University Press, Belknap Press, 1986).
170. See ibid., p. 60.
171. Ibid., pp. 74–78.
172. See Françoise Cachin, *Gauguin* (Paris: Hachette, 1989), p. 129.
173. Cited ibid., p. 198.
174. Goldwater, *Primitivism*, p. 105.
175. See Georges-Albert Aurier, *Le symbolisme en peinture* (Paris: L'Echoppe, 1991).
176. Rudolf Steiner, *An Outline of Occult Science,* trans. Maud Monges and Henry B. Monges (Spring Valley, N.Y.: Anthroposophic Press, 1972), p. 6.
177. See Frank Whitford, *The Bauhaus* (London: Thames and Hudson, 1989).
178. Papus, *Qu'est-ce que l'occultisme?* (Paris: Leymarie, 1989), pp. 17–18.
179. Steiner, *An Outline of Occult Science*, pp. 11–13.
180. See Sâr Mérodack Péladan, *Comment on devient artiste, Esthétique* (1894).
181. Cited by Pierre A. Riffard, *L'ésotérisme* (Paris: Robert Laffont, coll. Bouquins, 1990), p. 336.
182. See ibid., p. 339.
183. Steiner, *An Outline of Occult Science*, pp. 75–76.

Chapter Eight
1. Dora Vallier, *L'art abstrait* (Paris: Le Livre de Poche, 1980), pp. 14–15.
2. Cited by Michel Hoog, *Cézanne* (Paris: Gallimard, 1989), p. 66.

3. Cited ibid., p. 117.

4. Cited ibid., p. 154.

5. Cited ibid.

6. Paul Klee, *Journal* (Paris: Grasset, 1959), p. 234.

7. Ibid., p. 226.

8. Kazimir Malevich, "On New Systems in Art," in *Essays on Art, 1915–1933* (New York: George Wittenborn, 1971), p. 94.

9. Ibid., p. 91; Bonnard cited by Hoog, *Cézanne,* p. 156.

10. See Kenneth Silver, *Esprit de Corps: The Art of the Parisian Avant-Garde and the First World War* (Princeton: Princeton University Press, 1989).

11. With a certain audacity, Alquié can thus compare Cartesian doubt to Breton's discourse on "the lack of reality." See Ferdinand Alquié, *Philosophie du surréalisme* (Paris: Flammarion, 1977).

12. Cited by René Passeron, *Histoire de la peinture surréaliste* (Paris: Le Livre de Poche, 1968), p. 125.

13. There are many books on the Wanderers. One of the most helpful is Elizabeth Valkenier, *Russian Realist Art* (Ann Arbor: Ardis, 1977).

14. The best book on the history of Russian painting after the Wanderers remains Camilla Gray, *The Russian Experiment in Art* (London: Thames and Hudson, 1962).

15. Cited by Hajo Düchting, *Vassili Kandinsky* (Cologne: Benedikt Taschen, 1990), p. 10 [my translation from the French].

16. See Nina Kandinsky, *Kandinsky et moi* (Paris: Flammarion, 1978).

17. Michel Henry, *Voir l'invisible: Sur Kandinsky* (Paris: François Bourin, 1988), p. 9.

18. Although Dora Vallier denies it, he may also have read Worringer's thesis, *Abstraction and Empathy.*

19. Cited by Düchting, *Vassili Kandinsky,* p. 58.

20. See ibid., p. 80.

21. Cited ibid., p. 86.

22. In *Kandinsky: Complete Writings on Art,* ed. Kenneth C. Lindsay and Peter Vergo, 2 vols. (Boston: G. K. Hall, 1982).

23. Ibid., 1:360.

24. Ibid., 1:361.

25. Ibid.

26. See ibid., 1:362n, 363.

27. Ibid., 1:363.

28. Ibid., 1:364.

29. Ibid., 1:371.

30. Klee, *Journal,* p. 24.

31. Wassily Kandinsky, "Reminiscences," in *Complete Writings on Art,* 1:369.

32. Ibid., 1:369–70.

33. Ibid., 1:377–78.

34. Ibid., 1:377.

35. Ibid., 1:379.

36. Ibid., 1:380–81.

37. Ibid., 1:382.

38. Wassily Kandinsky, *On the Spiritual in Art,* in *Complete Writings on Art,* 1:133.

39. Ibid., 1:134.

40. Ibid., 1:131.

41. See ibid., 1:140.

42. See ibid., 1:129.

43. Ibid., 1:143, 145n.

44. Ibid., 1:148–49.

45. See Françoise Cachin, *Seurat, le rêve de l'art-science* (Paris: Gallimard, 1991).

46. See Kandinsky, *On the Spiritual in Art,* in *Complete Writings on Art,* 1:149.

47. Ibid., 1:151.

48. Ibid., 1:218–19.

49. Ibid., 1:208, 208n, 212.

50. Ibid., 1:214.

51. Ibid., 1:165 [brackets in English translation of Kandinsky].

52. Ibid., 1:173–74.

53. Ibid., 1:175.

54. Ibid., 1:214.

55. Ibid., 1:153.

56. Ibid., 1:154, 157, 158–60, 165.

57. Ibid., 1:167–68.

58. Ibid., 1:173.

59. Ibid., 1:175.

60. Ibid., 1:177.

61. See Cachin, *Seurat,* pp. 58 ff.

62. Kandinsky, *On the Spiritual in Art,* in *Complete Writings on Art,* 1:189.

63. Ibid., 1:196.

64. See ibid., 1:197.

65. See ibid., 1:202.

66. Ibid., 1:209.

67. Düchting, *Vassili Kandinsky,* p. 92.

68. Michel Henry, *Voir l'invisible,* p. 9.

69. Ibid., p. 12.

70. Ibid., pp. 13–14, 23.

71. Ibid., pp. 33, 37.

72. Wilhelm Worringer, *Abstraction and Empathy,* trans. Michael Bullock (Chicago: Ivan R. Dee, 1997), p. 5.

73. See Dora Vallier, preface to Wilhelm Worringer, *Abstraction et Einfühlung* (Paris: Klincksieck, 1978), p. 24.

74. Franz Marc, letter to Macke, 12 December 1910. See the catalog *L'expressionisme en Allemagne, 1903–1914* (Paris: Musée d'art moderne de la Ville de Paris), p. 358 [my translation from the French].

75. Henry, *Voir l'invisible,* p. 228.

76. Ibid., p. 219.

77. Ibid., p. 41.

78. Ibid., p. 203.

79. Ibid., p. 244.

80. A painting, by being "concrete" and linked to the world through the intermediary

of things, becomes inexhaustible, since the artist finds more in it than what he put into it. The "creative" effect is not a creation but rather a procreation, which is the occasion for a creative grace that comes to be added when the work is finished because of it. It was on the occasion of that sense of collaboration with the creative forces at work in the world that Matisse declared he believed in God while he was working. But the abstract artist does not have these mediations and deprives himself of the world; he thus risks finding in his painting only what he put there. In that case, the difference between abstract canvases and those that are not abstract is the same as that depicted in Hans Christian Andersen's tale, between the emperor of China's brilliantly colored artificial nightingale, made of precious materials, and the real nightingale, which was humble but had a piercing song.

81. Kant, *Critique of Judgment,* par. 6, p. 46.

82. Ibid., par. 19, p. 74.

83. W. Kandinsky, "Cologne Lecture," in *Complete Writings on Art,* 1:400.

84. Kant, *Critique of Judgment,* "Final Remark on Book 1."

85. For these biographical indications, I have based myself primarily (but not exclusively) on Jean-Claude Marcadé, *Malevitch* (Paris: Casterman, 1990), and on Andréi Nakov's introduction to Malevitch, *Écrits,* ed. Andréi Nakov, trans. Andrée Robel (Paris: Gérard Lebovici, 1986), p. 336. These two authors, who do not seem to harbor any great respect for each other, do not always agree. It is true that many points in Malevich's life and work remain obscure.

86. See Alfred Barr, *Cubism and Abstract Art* (1936).

87. Text in the collection of Giovanni Lista, *Futurisme, documents, proclamations* (Lausanne: L'Age d'homme, 1973), p. 87 [my translation from the French].

88. See ibid., p. 98.

89. Ibid., p. 163.

90. Malevich, "Suprematism. 34 Drawings," in *Essays on Art,* pp. 126–27.

91. See Emmanuel Martineau, *Malevitch et la philosophie* (Lausanne: L'Age d'homme, 1977). I was not able to draw anything, alas! from this Heideggerian exegesis of Malevich's writings. Marcadé relies on Martineau.

92. Cited by Nakov in Malevitch, *Écrits,* pp. 135–36.

93. "A Letter from Malevich to Benois," May 1916, in Malevich, *Essays on Art,* pp. 42–45.

94. Ibid., p. 46.

95. In Malevich, *Essays on Art,* pp. 19–41.

96. Ibid., pp. 27–28. I give the hatred of the female nude the value of a litmus test, in relation to the world and creation in general. We have already encountered it in Klee and Kandinsky.

97. Ibid., p. 19.

98. Ibid., pp. 25, 31–32.

99. Ibid., pp. 32–33.

100. Ibid., p. 37.

101. Ibid., p. 38.

102. Piotr Uspenski, *Tertium Organum: A Key to the Enigmas of the World* (London and New York, 1922).

103. Malevich, "On New Systems in Art," in *Essays on Art,* p. 84.

104. Ibid., p. 89.
105. Ibid., p. 108.
106. Marcadé, *Malevitch,* p. 199.
107. See Malevich, "God Is Not Cast Down," in *Essays on Art,* pars. 1–2, p. 183.
108. See ibid., par. 5, p. 190.
109. Ibid., par. 9, p. 194.
110. Ibid., par. 11, p. 195.
111. Ibid., par. 13, p. 195.
112. Ibid., pars. 13–14, pp. 196–98.
113. Ibid., par. 16, p. 201.
114. Ibid., par. 18, p. 204.
115. Ibid., pars. 23 and 26, pp. 212 and 215.
116. See ibid., pars. 27–31, pp. 216–21.
117. Ibid., par. 33, p. 223.
118. Piet Mondrian, *De Stijl* 1 (1917–18) [my translation from the French].
119. Vallier, *L'art abstrait,* p. 100.
120. Mondrian, *De Stijl* 1.

Conclusion

1. 1 Timothy 6:16.
2. Nietzsche, *Dawn of Day,* par. 548 [my translation from the French].

INDEX